The Orientalists
Delacroix to Matisse

EUROPEAN PAINTERS IN NORTH AFRICA
AND THE NEAR EAST

The Orientalists: Delacroix to Matisse

EUROPEAN PAINTERS IN NORTH AFRICA AND THE NEAR EAST

Edited by Mary Anne Stevens

ROYAL ACADEMY OF ARTS, LONDON 1984

Catalogue published in association with Weidenfeld and Nicolson London

Copyright © Royal Academy of Arts 1984

All rights reserved. No part of this publication may
be reproduced, stored in a retrieval system, or trans-
mitted, in any form or by any means, electronic, mechanical,
photocopying or other use, without the prior permission
of the copyright owner.

House editor Denny Hemming
Designed by Trevor Vincent for
George Weidenfeld and Nicolson Limited
91 Clapham High Street, London SW4 7TA
ISBN 0 297 78417 X (casebound)
 0 297 78435 8 (paperback)

Set in Palatino
Printed by BAS Printers Limited, Over Wallop, Hampshire
Colour separations by Newsele Litho Limited, Italy
Colour printed in Italy by Printers Srl, Trento, Italy

Contents

Photographic Acknowledgements

Map produced by Constance and Brian Dear Ltd.

The exhibition organisers would like to thank the following
for making photographs available.
All other photographs were provided by the owners of the paintings.
Cliché des Musées Nationaux 3, 7, 9, 24, 67, 68, 97, 100, 109
A.C. Cooper 88, 95
Birmingham City Art Gallery fig. 10
Prudence Cuming Associates Ltd. 69, 90, 92, 111
The Fine Art Society, London 83, 89, 93, 96, 101, 112, 115, 117
P J Gates Photography 112
Kunsthalle, Hamburg fig. 14
Manchester City Art Gallery fig. 12
Musée d'Orsay, Paris fig. 15
Royal Academy of Arts 1, 19, 20, 23, 27, 28, 33, 35, 36, 38, 39, 40, 41, 75, 116
Sotheby's Belgravia 84
Sotheby Parke Bernet, London 90, 96
The Wallace Collection, London figs. 1, 9

Acknowledgements

The Royal Academy extend their thanks to the following individuals and institutions
who have contributed in many ways to the organisation of the exhibition
and the preparation of the catalogue.

Eve Alonso
Alex Apsis
The Library, Arizona State University
Rachel Astor
Wendy Baron
Agnès de la Baumelle
David P. Becker
Kenneth Bendiner
The Bodleian Library, Oxford
Eugene N. Borza
Richard Brettell
The Library of the University of
 British Columbia
British Council, Fine Art Department
Roger Cardinal
Tony Carroll
Roger Clarke
Timothy Clifford
Patrick Conner
A. Cohen Esq.
Claire Constant
Malcolm Cormack
Roy David
Paul Devautour
Joanna Drew
Lorraine Dyess
Simon Edsor
André El Zenny
The Fine Art Society
Anne Gilbert
Michael Gilsenan
Lucas Gloor
Helen Guiterman
Robin Hamlyn
Vicky Hayward
Denny Hemming
The Houghton Library, Harvard
The Huntington Library, San Marino
Richard Hussey
Francina Irwin
Kenneth Jay Lane
Lee Johnson
Sona Johnston
William Johnston
Samuel Josefowitz
Isabelle Julia
Robert Kashey
Margaret Kelly
Vivien Knight
Geneviève Lacambre

Michel Laclotte
Ronald de Leeuw
Leggatt Brothers
Michael Levey
Major-General J.M.H. Lewis
Richard Lockett
Brian MacDermot
Caroline Mathieu
James and Else Melvin
Denis Milhau
Dewey F. Mosby
Jean-Marie Moulin
Alison Munro-Faure
Alexandra Murphey
John Myerscough
Gail Naughton
The New York Public Library
Parick Noon
Richard Ormond
Mattieu Pinette
Princeton University Library
Benedict Read
Brenda Richardson
Joseph Richell
Phillippe Robert-Jones
Michael Rogers
Anne Roquebert
Melvin Rose
Pierre Rosenberg
Donald Rosenthal
John Rylands University Library of Manchester
Barbara Shapiro
Peyton Skipwith
Tom Sokolowski
Stephen Somerville
Claude Souviron
Ted Stebbins
Timothy Stevens
Peter Stocks
Geoffrey Stowe
Richard Thompson
Lynne Thornton
Gary Tinterow
Germain Viatte
Clive Wake
Michael Wentworth
Arnold Wilson
The Staff of the Witt Library
M. Xavier
Eric Zaffran

Index of Lenders

FRANCE
Autun, Musée Rolin 119
Montpellier, Musée Fabre 11
Nantes, Musée des Beaux-Arts 12, 26, 42, 64, 104
Paris, Pierre Bergé Collection 86
Paris, Musée du Louvre 9, 97
Paris, Musée National d'Art Moderne 100
Paris, Musée d'Orsay 3, 7, 24, 67, 68, 109
Toulouse, Museé des Augustins 15
Versailles, Museé National du Château de Versailles 8

GREAT BRITAIN
Aberdeen Art Gallery and Museums 121
Bristol, City of Bristol Museum and Art Gallery 103, 110
Burt, Mrs Elisabeth 75
Edinburgh, Scottish National Portrait Gallery 115
Liverpool, Walker Art Gallery 71
London, The Fine Art Society 85
London, Guildhall Art Gallery 63
London, H. Fritz-Denneville Fine Arts Ltd 84
London, National Portrait Gallery 105
London, Royal Academy of Arts 111
London, Royal Holloway College, London University 113
London, Trustees of the Tate Gallery 81, 91, 123
Manchester, Whitworth Art Gallery, University of Manchester 73
Mynors, Sir Humphrey, Bt. 76
Oldham Art Gallery 72
Oxford, The Visitors of the Ashmolean Museum 74, 78
Preston, Harris Museum and Art Gallery 88
Rice, Mr. and Mrs. T. 101
Sheffield City Art Galleries 70
Southampton Art Gallery 77

ITALY
Florence, Gallerie degli Uffizi 79

SWEDEN
Stockholm, Moderna Museet 99a
Stockholm, Nationalmuseum 16

SWITZERLAND
Lausanne, Musée cantonal des Beaux-Arts 49, 53, 56, 58, 60, 120

UNITED STATES OF AMERICA
Baltimore, Maryland Institute, College of Art 5
Baltimore Museum of Art 98
Baltimore, The Walters Art Gallery 80
Boston, Museum of Fine Arts 31, 34, 65
Boston, The Lowell Institute 43, 44, 45, 46, 47, 48, 50, 51, 52, 54, 55, 57, 59, 61, 62
Brooklyn Museum 82
Chicago, Art Institute 10, 25
Dayton Art Institute 29
Denver Art Museum 114
Detroit Institute of Fine Arts 66
Minneapolis Institute of Arts 13, 37, 118
New Haven, Yale Center for British Art 89
New York, Forbes Magazine Collection 4
New York, Metropolitan Museum of Art 6, 21, 32
Norfolk, Chrysler Museum 22
Philadelphia, Henry McIlhenny Collection 14
Princeton University, The Art Museum 30
Washington D.C., The Library of Congress 18
Washington D.C., National Gallery of Art 17, 99c, 106
Williamstown, Sterling and Francine Clark Art Institute 108
Worcester Art Museum 107

Also owners who prefer to remain anonymous

Glossary *Compiled by Peter Stocks*

Transliteration generally follows the old British Museum system. However, localities within the former French sphere of influence retain their French transliteration, except where it would cause confusion.
A = Arabic; T = Turkish; P = Persian.

'almah (A) lit. 'learned woman' but popularly in the nineteenth century a singer and entertainer and by extension a prostitute.

Arnavut (T) Albanian, a group particularly favoured by Muḥammad 'Alī for his army. He was in fact one himself, and used them to counter the strength of the *Bays* (q.v.) and their retainers.

asāwir (A) bracelet.

babush (T from P) slippers.

baqshish (A from P) a present, more commonly a gratuity

bashibazuk (T) lit. 'headless', an irregular soldier, unpaid but allowed to partake of plunder.

Bay (T) highest rank among the *mamlūks* (q.v.) of Egypt from the sixteenth to the nineteenth centuries.

burnūs (A) voluminous, hooded cloak worn on desert journeys.

cami (T from A *jāmi'*) an assembly mosque.

Copt (from A *qibt*) a Christian of the Egyptian Monophysite Church.

dahabiyyah (A) house boat.

daqq (A) tattoo and the application thereof, usually performed on children.

darābukah (A) clay drum.

dervish (P) an itinerant *sufi* (q.v.).

dhikr (A) lit. 'remembrance', part of a *sufi* (q.v.) ceremony in which the name of Allah is invoked. These exercises take various forms among the many *sufi* brotherhoods.

durqā'ah (A) the central area of the *qā'ah* (q.v.) with a sunken central area often with a fountain, and an elevated tower rising above the *līwāns* (q.v.).

dūsah (A) lit. 'trampling', a ritual of the Sa'diyyah *sufis* (q.v.) of Egypt in which the Shaykh rode over the bodies of his followers. Banned in 1881.

fellāḥ f. *fellāḥah*, pl. *fellāḥīn* (A) a land worker, a farmer or peasant.

frank (from A. *franji*) a European.

giaour (from P from A) Kafir, a non-believer (in Islam).

gūzah (A) water pipe (from A for nut).

ḥajj (A) the pilgrimage to Mecca, therefore *ḥajj*, one who has made the pilgrimage.

harem (from A *ḥaram*) forbidden, the women's quarters in a house.

ḥawsh (A) an enclosure including the courtyard of a house.

Islam (A) lit. 'surrender', the religion having the *Qur'ān* (q.v.) as the revealed scripture and teaching that there is only one God and that Muḥammad is his prophet.

jihād (A) lit. a war of Muslims against non-believers.

jinn (A) being created of fire by Allah whose destiny is other that that of man.

kamangah (A) two-stringed viol.

kātib (A) scribe.

katirji (T) muleteer.

khān (A from P) hostel for merchants and their goods.

kavas (T from A) an armed policeman.

khamsīn lit, 'fifty', hot sand-laden wind of spring in Egypt, so-called because it lasts about fifty days.

khānqah (P) a mosque built specifically for *sufis* (q.v.).

khirka (T) black cloak worn by *Malawiyyah* (q.v.) *sufis* (q.v.).

kiosk (from T *koshk*) a light, open-sided pavilion.

kohl (A) powdered antimony used as mascara in the Near East.

ksour (from A *qusūr*) fortified villages in oases.

līwān (A from P) vaulted chamber leading from the *durqā'ah* (q.v.)

lokhanda (A from Italian) inn, hotel for travellers.

madrasah (A) a mosque built specifically for teaching, usually belonging to one or more of the four schools of law.

maq'ad (A) lit. 'sitting place', a pillared loggia overlooking the courtyard of a house.

mashrabiyyah (A) a decorative lattice formed of turned wooden units assembled without the use of glue and made up into casements and screens.

Malawiyyah (A) a *sufi* (q.v.) brotherhood founded by Jalāl al-Dīn Rīmī (d.1273), known to Europeans as the whirling dervishes (T. *Mevlevi*). Their name is derived from their title for Rīmī, *mawlana*, 'master'.

mamlūk (A) lit. 'owned', one of the innumerable slaves brought from S. Russia and Europe into the armies of Egypt and Syria. They ruled Egypt from 1250–1517 and after the Ottoman conquest still formed the single most powerful group. Finally extinguished during the reign of Muḥammad 'Alī.

Medina (A Madīnah) city to the north of Mecca to which Muḥammad escaped and where he made his home and died. His tomb is often visited after the pilgrimage.

Mecca (A Makkah) a city in W. Arabia containing the Ka'bah, the object of the pilgrimage, and the holiest city of Islam, where Muḥammad was born.

mihrāb (A) niche in the wall of a mosque indicating the direction of Mecca.

minbar (A) a stepped chair to the right of the *miḥrāb* from which the *khutbah* (Friday sermon) is given.

mu'adhdin (A) the man who calls (*adhān*) the faithful to prayer five times each day.

Muḥammad (?570–632 AD) The last prophet of Islam. Born in Mecca he received the first revelation in 610 but, after much privation, persecution forced him to escape to Medina in 622. After several battles Mecca was opened to him and Islam was established throughout Arabia.

Muslim (A) a believer in the religion of Islam (q.v.), adj.

nargīlah (P) a water pipe (from P. for nut).

nizām (A) a regular soldier.

odalisque (from T *odalik*) lit. 'belonging to the chamber'.

Ottomans Turkish tribe who, in 1453, conquered the shrunken Byzantine Empire by taking Constantinople. They established themselves as the most powerful force in the Near East until modern times.

pasha (T) high Ottoman official of the third rank; provincial governors were usually appointed from this class.

qū'ah (A) main chambers of a house usually consisting of the *durqā'ah* (q.v.) off which lead the *līwāns*) (q.v.).

qangah (A) a long boat used on the Nile.

qanūn (A from Greek?) a framed stringed instrument played with a soft hammer.

qibla (A) the direction of Mecca.

quftān (A) a coat-like robe, sometimes of rich fabric usually worn with a belt.

qullah (A) a wide-mouthed, unglazed water pot.

Qur'ān (A) lit. 'recitations', collected texts of the revelation to Muḥammad, believed by Muslims to be the infallible 'word' of God.

qusūr (A) fortified villages in oases.

safā (A) hair ornaments.

sarvel (T) baggy trousers.

shaykh (A) from the root *shakh* 'to age'. It therefore has many meanings eg. head of tribe or family, elder, master of a *sufi* (q.v.) brotherhood etc.

shibriyyah (A) arched camel litter.

shibbuk (T) long pipe.

sikke (T) high felt hat worn by Malawiyyah *sufis* (q.v.).

simoun (from A. *simūm*) hot, suffocating wind.

sirocco (Italian, from A. *sharqi*), name for the hot winds of southern Europe.

sufi (A) a member of one of innumerable brotherhoods following a *tariqah* (way) in an active search for knowledge of Allah under the guidance of a *shaykh*. Examples are Bayūmiyyah, 'Isawiyyah, Malawiyyah.

sultān (A) ruler.

takhtabush (T) as *maq'ad* (q.v.).

takhtrawān (T) two-camel vehicle.

tarbouka (A) see *darābuka*.

tarbūsh (A from P) lit. head covering; a felt cap originally worn under a turban.

ṭarḥah (A) a veil.

'uqd (A) necklace.

valide sulṭān (T. from A.) lit. 'mother of the ruler', i.e. queen mother.

yelek (T) a light coat either short or long.

zummarah (A) double reed pipe.

Editorial Note

Works indicated with an asterisk (*) are exhibited at the National Gallery of Art, Washington D.C. only; those indicated with a dagger (†) are exhibited at the Royal Academy of Arts only.

Artists appear in alphabetical order and their works are arranged in chronological sequence, with watercolours listed before works in oil.

Titles of works in the exhibition are given first in English, followed by the title in the original language. Where possible, pictures are given the title by which they were originally known, or otherwise that by which they are best known. Contemporary spelling of proper nouns has been followed in all cases.

A single date after a title indicates that the work was executed, or completed, in that year. Two dates separated by a hyphen indicates that the work was definitely executed between these two years, thus: 1860–65. Two dates separated by an oblique stroke indicates that the work was definitely executed at some point during this time span, thus: 1860/65. A date preceded by 'c.' indicates that the work was executed at around this date, thus: c. 1865. When no date occurs, insufficient evidence is available to suggest an accurate date within the system given above.

All works are in oil on canvas unless otherwise stated.

Dimensions are given in centimetres; height precedes width.

Inscriptions on a picture, on the verso or on a label attached to the work are transcribed literally, and their location specified. They are recorded below the dimension of the work and always given in italics.

Provenances of the works have been checked as far as possible.

Published sources referred to throughout the catalogue have been abbreviated as follows:
Lane 1836, E.W. Lane, *An Account of the Manners and Customs of the Modern Egyptians*, London, 1836
Lenoir 1872, P. Lenoir, *Le Fayoum, le Sinaï et Petra. Expéditions dans la Moyenne Egypte et l'Arabie Petrée sous la direction de J. L. Gérôme*, Paris, 1872 (English translation, London 1873)
Steegmuller, ed., 1979 F. Steegmuller, ed. and transl., *Flaubert in Egypt: A Sensibility on Tour*, Chicago, 1979
Thornton 1983, L. Thornton, *Les Orientalistes. Peintres voyageurs 1828–1908*, Paris, 1983

Sources referred to frequently within the catalogue entries of an artist have also been abbreviated and are given in Abbreviated References immediately below the artist's biography. When a source occurs both in the text and in the Reference section of an individual catalogue entry, it is referred to in the text by the author's surname and the date of the publication. All references are given in chronological order, Abbreviated References preceding those given in full.

Exhibition details have been given in full wherever possible. For exhibitions listed as 'Paris, Salon' which occurred after 1884, 'Salon des Champs-Elysees' refers to the Salon de la Societé des Artistes Français, reorganised in 1881, and 'Salon du Champ de Mars' refers to the Salon of the exhibition body, La Societé Nationales des Beaux-Arts, founded in 1890.

The transliteration of Arabic words generally follows the old British Museum system (for further details, see *Glossary*) and in the text, they occur in italics.

The authors of the catalogue entries are noted by the following initials:
J.E.B.	Judith Bronkhurst
C.B.	Caroline Bugler
W.H.	William Hauptmann
B.L.	Briony Llewellyn
J.M.	Jane Munro
MA.S	MaryAnne Stevens
J.T.	James Thompson
M.W.	Malcolm Warner

Arab Advisor
Peter Stocks

Exhibition Assistants
Annette Bradshaw
Simonetta Fraquelli
Elisabeth McCrae

Exhibition Designer
Brian Griggs

Graphic Designer
Gordon House

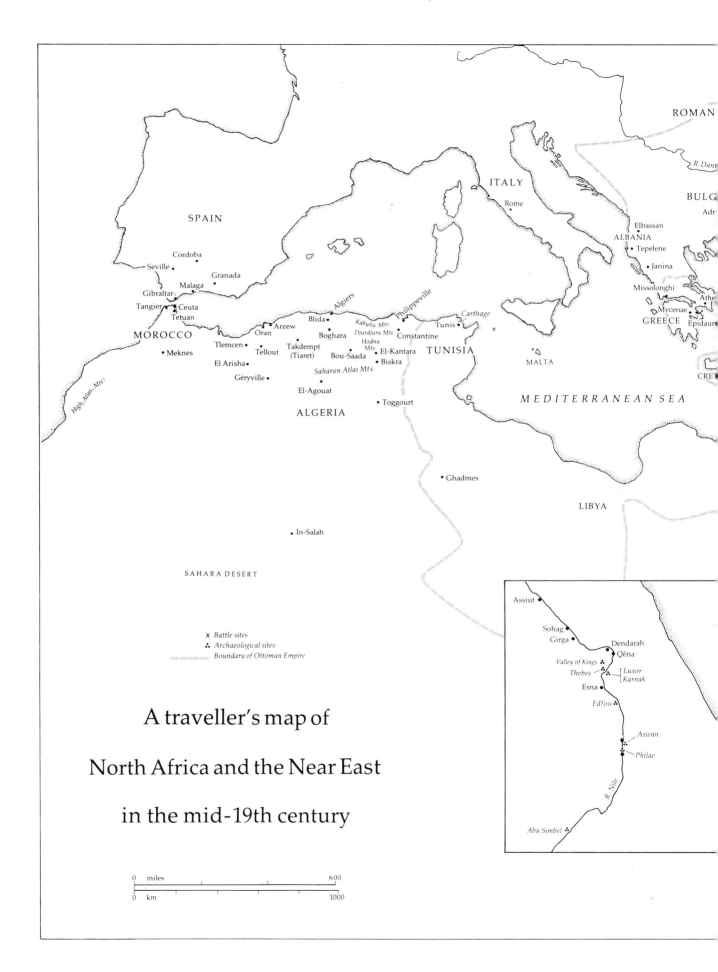

ROMAN

R. Dan

BULG

SPAIN

Rome •

ITALY

Adr

Elbassan •

ALBANIA

• Tepelene

• Janina

Missolonghi •

• Cordoba

Seville •

Granada •

Malaga •

Gibraltar •

Tangier •

Ceuta

Tetuan

MOROCCO

• Meknes

Tlemcen •

El Arisha •

• Tellout

Géryville •

Oran

Arzew

Takdempt
(Tiaret)

• Blida

Boghara •

Bou-Saada •

Algiers

Kabylia Mts

Djurdjura Mts

Hodna
Mts

• El-Kantara

• Biskra

Saharan Atlas Mts

Philippeville

Tunis •

Carthage

Constantine •

TUNISIA

MALTA

Mycenae •

GREECE

Athe

Epidaur

CRE

El-Agouat •

• Toggourt

ALGERIA

MEDITERRANEAN SEA

• Ghadmes

LIBYA

• In-Salah

SAHARA DESERT

x *Battle sites*

⁂ *Archaeological sites*

▬▬▬ *Boundary of Ottoman Empire*

A traveller's map of

North Africa and the Near East

in the mid-19th century

Assiut •

Sohag •

Girga •

Dendarah ⁂

Qēna •

Valley of Kings ⁂

Thebes

Esna •

Edfou

┌ *Luxor*
└ *Karnak*

Aswan ⁂

Philae

R. Nile

Abu Simbel ⁂

0	miles		600
0	km		1000

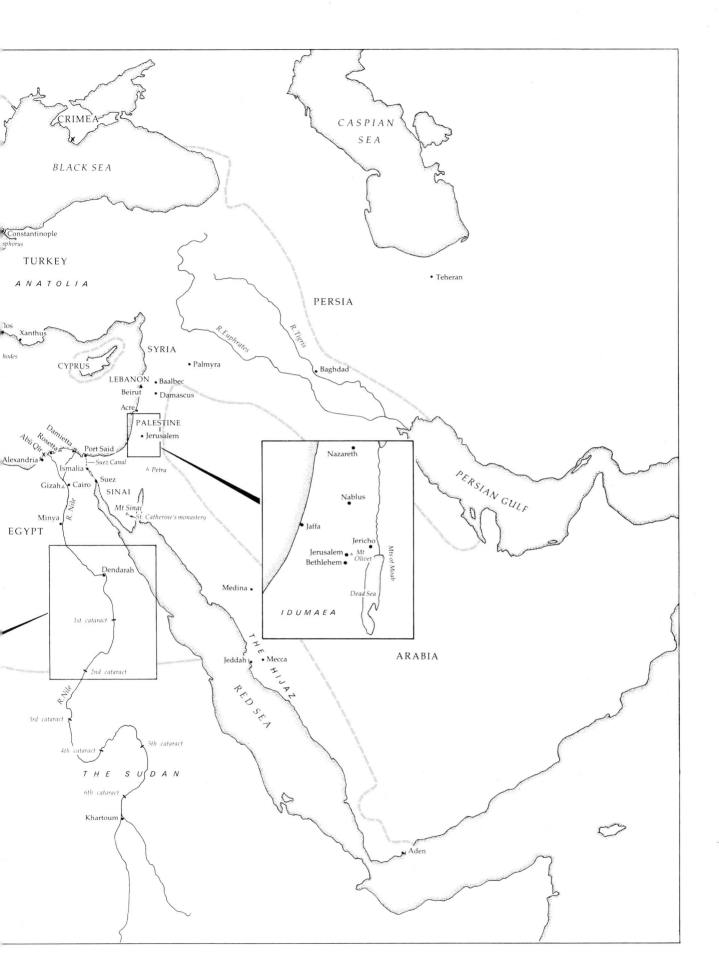

CRIMEA

BLACK SEA

Constantinople
sphorus

TURKEY

ANATOLIA

CASPIAN
SEA

• Teheran

PERSIA

los
Xanthus

hodes

CYPRUS

SYRIA

R Euphrates

R Tigris

• Palmyra

• Baghdad

LEBANON • Baalbec
Beirut • Damascus
Acre

PALESTINE
• Jerusalem

Damietta
Rosetta
Abū Qīr
Alexandria
Ismalia
— Suez Canal
Port Said

✧ Petra

PERSIAN GULF

Gizah • Cairo
Minya
Suez
SINAI

Mt Sinai
St. Catherine's monastery

EGYPT

R. Nile

Nazareth •

Nablus
•

Jaffa •

Jericho •
Jerusalem • ⌂ Mt
Bethlehem • Olivet

Mts of Moab

Dendarah •

1st cataract

Medina
•

Dead Sea

IDUMAEA

ARABIA

R. Nile

2nd cataract

Jeddah •
• Mecca

THE HIJAZ

3rd cataract

RED SEA

4th cataract 5th cataract

THE SUDAN

6th cataract

Khartoum

Aden

Foreword

A visit to the Near East and North Africa in the nineteenth century involved both dangers and delights. William Holman Hunt's experience was certainly no exception as he sat by the Dead Sea with a paint brush in his right hand and a loaded rifle in his left — to ward off wild animals and unruly Bedouins. Stories abound of intrepid travellers, determined to experience and to record these exotic lands: Belly went up the River Nile on a boat to the strains of Gluck played on a grand piano hired for the journey; Lenoir and Gérôme suffered sand in their sandwiches as they made their way to the Great Pyramids of Gizah.

The artist-travellers brought back to Europe a rich array of sketches and photographs and crate-loads of Islamic objects — tiles, brass work, costumes and carpets. These provided the basis for paintings, lithographs and albums of daguerreotypes depicting the debris of the ancient Egyptian civilisation, the bustle of bazaars, the secrets of the harem and the quiet world of the mosque, by artists as diverse as Delacroix, J. F. Lewis, Gérôme and Matisse.

The political and commercial involvement of Britain and France in the Near East and North Africa, from Napoleon's Egyptian campaigns of 1798 to the opening of the Suez Canal and the establishment of the British Protectorate over Egypt, encouraged their artists to explore, record and celebrate these non-Christian lands. Some were unmoved, their work retaining quintessentially European characteristics. For others, however, the strangeness of the terrain and the unfamiliar light provoked both a rethinking of European artistic conventions and a discovery of brilliant colour. This exhibition illustrates not only the subject-matter which fascinated them but also the profound effect that it had upon their art.

Many individuals have worked over the past two years to make this exhibition possible, in particular MaryAnne Stevens, who has been responsible for the selection of the works and the editing of the catalogue. We are most grateful to all the public institutions and private individuals who have lent so generously to the exhibition. The show has been organised in association with the National Gallery of Art, Washington D.C., where it will open on 1 July 1984. We are particularly grateful for the constant support given to us by that gallery's director, J. Carter Brown, and by his staff, especially Dodge Thompson and Betsey Coman. Finally, we would wish to thank the anonymous benefactors whose generosity has permitted us to realise so rich a display of nineteenth-century art. We hope that it will be enjoyed by our many visitors.

Hugh Casson
President, Royal Academy of Arts

MARYANNE STEVENS

Western Art and its Encounter with the Islamic World 1798–1914

'The question amounts to knowing whether the Orient yields to interpretation, to what extent it is open to this and, if to interpret it is not to destroy it . . . The Orient is extraordinary . . . It escapes conventions, it lies outside all disciplines, it transposes, it inverts everything, it overturns the harmonies with which landscape painting has for centuries functioned. I do not talk here of a fictional Orient.'

Eugène Fromentin, *Une Année dans le Sahel*

The Orient to which Fromentin, the French painter and writer, was referring in 1858 was not the Far East of China and Japan, but the lands of North Africa and the Ottoman Empire, Turkey and Asia Minor, Egypt and Syria, including the Holy Land, Palestine and the Lebanon.[2] Fromentin, in his struggle to come to terms with the Orient which so tantalised him, expresses many of the paradoxes and challenges that artists from Europe and America faced in their encounter with this alien culture.[3] Between 1798 and 1914, North Africa and the Near East, as the closest non-Christian region to Europe, exercised a fascination upon the West, which responded in a variety of ways: the scholarly study of ancient civilisations and of contemporary cultures, imaginary evocations in poems and novels, literary descriptions and tourists' enthusiasms, as well as representations by artists.

Whilst for many of the numerous painters who visited the Orient the encounter had no lasting effect, the concern of this exhibition is with the succession of artists who for more than a century found their work fundamentally influenced by the experience of at least one visit to the Near East. The repercussions of such visits can be seen in their effects on two broad areas of artistic concern, subject-matter and technique. Whereas Gérôme, Lewis and Bauernfeind, for example, found themselves returning regularly to the distinctive scenes and subjects of the Near East, in the case of Delacroix, Fromentin, Renoir and Matisse, the influence of the Orient was on their technical development as painters, specifically in their handling of light and colour.

Whilst there are many ways of exploring an encounter between two cultures, and many issues might be raised thereby,[4] this exhibition adopts an historical, European viewpoint in its approach to the study of artists, not limited necessarily to great masters, in contact with a foreign culture. It illustrates the range of subject-matter depicted by the Orientalist painters: landscapes of ancient sites, the Holy Land, the River Nile, the desert, caravans and encampments, the bustling life of the cities, harems, baths and odalisques, and the religious manifestations of Islam. It excludes, however, history paintings, such as Poynter's *Israel in Egypt* (1867),[5] since they involved the historical reconstruction of the Orient rather than a commitment, in varying degrees, to direct observation of the contemporary culture. The exhibition also explores the relationship between Orientalist painting and movements in European art during the nineteenth century. The shift from Romanticism to Realism, and then to Impressionism and early Modernism, sees its reflection in the Orientalist works of Delacroix, then of Holman Hunt, Lewis and Gérôme, and finally in the Orientalist paintings of Renoir, Brangwyn and Matisse. The exhibition also confronts the issues raised by Orientalism, which cut across the chronology of European painting, such as the various attempts to evoke an exotic, remote world, and the artistic solutions to the challenge of depicting unfamiliar terrain, customs, light and colour.

Prior to the Napoleonic campaigns of 1798–99,[6] Western interest in the Near East and North Africa had been fostered mainly through the medium of trade, intermittent political contact and

a small quantity of travel books and imaginative literature concentrated primarily on the Ottoman Empire.[7] The early nineteenth century saw a particular conjunction of political events and artistic concerns which brought a rapid expansion of the West's contact with the Near East.[8] Whilst the development of the Picturesque aesthetic extended the interest in topography to the visiting and recording of unfamiliar lands, the growth of scientific and historical curiosity also called for accurate surveys and careful depictions of peoples and places in strange lands. This scientific impetus further produced a more empirical approach to the exploration of the Holy Land and to the understanding of the events of the Bible.[9] Finally, the political and commercial aspirations notably of France and Britain established their territorial hegemony over Egypt and North Africa, and saw the settlement of the Greek War of Independence, their support for the semi-autonomous ruler of Egypt, Muḥammad 'Alī, reforms within the Ottoman Empire and extensive investment in public utilities, including railways and the Suez Canal.[10]

The gradual penetration of the Near East and North Africa by an expansive Europe increased the variety of contacts with the Islamic lands. Some Europeans, like the writer, Trollope, were in the employ of pashas and potentates. Others swelled the growing ranks of tourists who found Thomas Cook's package tours, steamboats on the Nile and a burgeoning railway network at their service in the quest for visual, religious and historical experience.[11] Yet others went to the Near East with the intention of transmitting to Europe, in either paint or the written word, a world culturally remote, though physically increasingly accessible. Some artists — Delacroix, Bonnat, Makart, Roberts and Gleyre — visited the Orient only once in their careers. Others chose to return, sometimes frequently, as was the case with Gérôme, Holman Hunt, L. C. Müller and Horace Vernet. A few became addicted to the Islamic lands and stayed for long periods; Lewis lived in Cairo for ten years, Bauernfeind spent the end of his life in Jerusalem and Fromentin undertook protracted visits to the Sahara and the Sahel in North Africa,[12] as did Girardet and Guillaumet.[13]

Alexandre-Gabriel Decamps (1803–1860), who went only once to Asia Minor but whose Oriental experience was so powerful that it established him as a leading Orientalist of his day, is omitted from the exhibition.[14] Decamps had travelled to Greece and then settled in Smyrna (Izmir) for over a year in 1828–29. He made a dramatic mark upon the Salon of 1831 with a group of Turkish scenes which shaped the pattern of most of his subsequent oeuvre (fig. 1). Praised at the time for their rich colour and varied Turkish subject-matter, most of his works have suffered badly from deterioration of their surfaces due to Decamps's extensive use of bitumen varnish, mixed into a coarse, thick impasto.[15]

The works of two artists, Baron Gros and Jean-Auguste-Dominique Ingres, who never travelled to North Africa or to the Near East, are nevertheless included in the exhibition because their particular visions of these regions profoundly marked Europe's expectations and interpretations of the Orient. Gros had been the

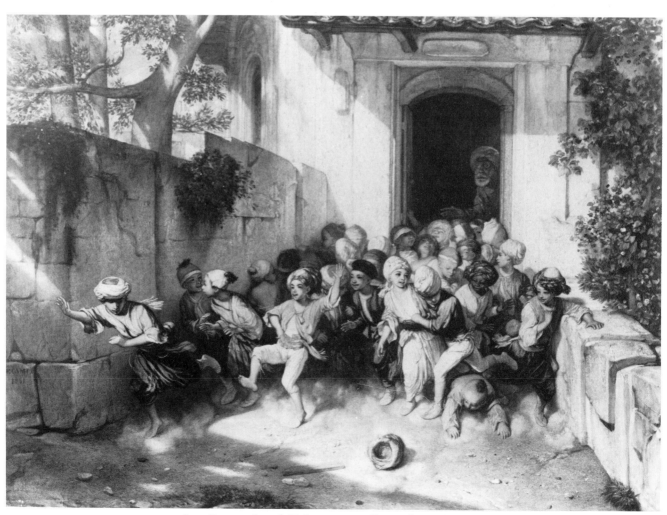

fig. 1 Decamps *Sortie de l'école* 1841 [Wallace Collection, London]

'propagandist' of Napoleon's military campaigns in northern Italy during the 1790s, and he was thus the obvious choice to produce a favourable, official interpretation of the ultimately-doomed Egyptian campaign. He painted three pictures which celebrate the exploits of Napoleon's armies, *The Battle of Nazareth* (Cat. 64), *The Battle of Abū Qīr* (Cat. 66) and *The Pesthouse at Jaffa* (Cat. 65), but he was prevented from travelling to the Near East to survey the sites of these events by the British naval control of the eastern Mediterranean. Instead, he relied upon eye-witness accounts through which he conjured up an exotic world of brilliant colour, dramatic turmoil and unfamiliar settings, which was to fix certain European preconceptions about the Near East. In addition, Gros recorded the events which instigated a lasting French cultural interest in the Near East: the exploration of archaeological sites under Vivant Denon (Cat. 18), the geographical survey of Egypt and the foundation of the Institut d'Egypte (1798), as well as many subsequent manifestations, such as the Egyptian Revival style in the decorative arts and Champollion's deciphering of the Rosetta stone.[16]

Like Gros, Ingres never went further south or east than Italy and yet, despite the position he was accorded as the leader of the French classical school, he had already displayed a more catholic taste early in his career. His interest in archaeologically-correct settings for his classical history paintings extended to the use of appropriate backgrounds and technique for his portraits and genre scenes.[17] Furthermore, his detailed rendering of the texture and colour of fabrics gave to his paintings a rich tone and a luxurious tactile surface. These two elements in his work were ideally suited to adding an Oriental dimension to the influential sequence of bathers (fig. 2) and odalisques (Cat. 80), which he created throughout his career. These nudes were derived from antique sculpture and delineated in clean, pure outline, but were given an exotic, Orientalist context by the magical colours and textures of Islamic interiors, derived from eighteenth-century illustrations and the descriptions found in the letters of Lady Mary Wortley Montague[18] and in Montesquieu's *Lettres persanes* (1721).

Ingres was not alone in gaining his understanding of the Islamic world through eighteenth-century images which had been shaped, with certain notable exceptions, more by exotic imagination than by fact.[19] Together with Gros's paintings of tumultuous drama and heightened colour, Ingres's representations of the Orient were to shape the expectations of both artists and the public throughout much of the nineteenth century. For some, even a visit to the Near East failed to displace these expectations. For others, the encounter with the Orient forced a modification of these expectations, the effects of which upon the resulting works of art were often radical.

One of the preoccupations which profoundly affected the Western understanding of the Near East was the belief that this region could satisfy the West's urge for exotic experience. Exoticism meant the artistic exploration of territories and ages in which the free flights of the imagination were possible because they lay

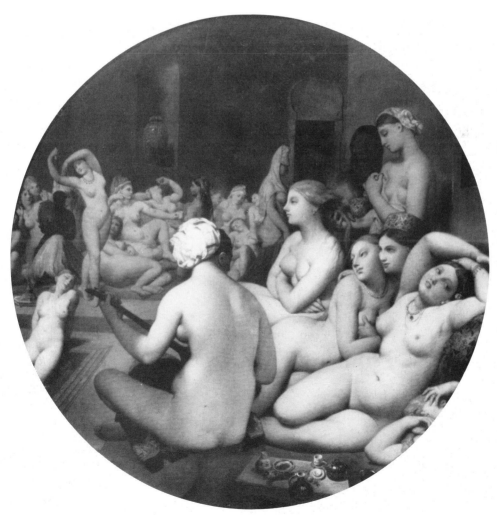

fig. 2 Ingres *Le Bain turc* 1862 [Musée du Louvre, Paris]

outside the restrictive operation of classical rules. Despite the existence of 'Turqueries' in the eighteenth century, Romanticism's celebration of the primacy of the imagination, together with the pattern of early nineteenth-century political and scholarly interests, guaranteed a position for the Islamic lands as one of the most effective locations for Western expressions of exoticism. Before he actually went to Algeria and Morocco in 1832, Delacroix, for example, had been attracted by an exotic Orient conjured up in the poems of Byron and in Hugo's *Orientales* (1829). In a sequence of powerful Oriental paintings he also drew upon the brutal events of the Greek War of Independence as well as a collection of Persian and Indian miniatures and Islamic objets d'art assembled by the traveller and artist, Jules-Robert Auguste (1789–1850).[20] Delacroix's works such as *The Combat between the Giaour and the Pasha* (Cat. 10) and *The Death of Sardanapalus* (Salon of 1827; see Cat. 14)[21] were flamboyant confirmations of the imaginary force of the exotic idea in art, which he shared with other artists in his circle, notably Géricault and Bonington, all of whom sought to extend their subject-matter and technique beyond the classical sphere.

The vision of an exotic Orient – passionate, cruel and intoxicating – which fired Delacroix to accept with alacrity an invitation to visit North Africa in 1832, was shared by many Western visitors to the Near East. In 1868, Paul Lenoir, the artist who gives one of the most revealing accounts of a visit to the Near East, confirmed the persistence of the idea of the exotic Orient when he embarked upon his journey to Egypt, Sinai and Petra, in the company of Gérôme, Edmond About[22] and Frédéric Masson. He described it as *'cette grande féerie* [enchantment] *qu'on appelle un voyage en Orient'*, the beginning of which he likened to the 'raising of the curtain',[23] as if he were setting forth on a voyage into a theatrical world where illusion rather than reality was to be the guiding principle. The imaginary exotic Orient was also given a more particular focus in the fascination which Western visitors had for the women of the East. These unobtainable women, with their veils and secretive lives, haunted the Western visitor and goaded him to seek access, if only in his imagination,

to the forbidden quarters of the harem and the bath.[24] Renoir, when in Algiers, noted that Arab women were 'clever enough to know the value of mystery. An eye half-seen through a veil becomes really alluring!',[25] while Gérard de Nerval related his own fascination in more literary terms: 'Does one not dream of adventure and mysteries at the sight of these tall houses, these latticed windows, where so often one sees the sparkle of the inquiring eyes of young girls?'[26] It is symptomatic of the strength of this image that, despite the heightened interest in the truthful representation of the Near East and North Africa during the nineteenth century, the harem, the bath and the guard to the seraglio remained amongst the most popular manifestations of Orientalism in both painting and literature. While Gérôme (Cat. 31), Ingres (Cat. 80), Lewis (Cat. 95) and Benjamin-Constant (Cat. 5) could produce infinite variations on these themes, so too the subject could be celebrated in the imaginary literature of de Molines[27] and the Princesse Belgiojoso,[28] and in the lyrical novel of Pierre Loti, *Aziyadé*,[29] part fact and part fiction.

Parallel to such popular images of an exotic Orient, which coloured many Western perceptions of the Near East, was a range of hostile opinion which found much to condemn in particular facets of Muslim culture. The critic Emile Galichon, for example, discussed Gérôme's *Le Prisonnier du Nil* (fig. 3) as a painting which possessed 'all the Orient', by which he meant 'implacable fatalism', 'passive submission' and 'blatant cruelty',[30] a conclusion with which the artist, Benjamin-Constant, concurred in his work, *L'Exécution des rebelles*, which deliberately lingers on the wanton cruelty of an Arab potentate (see Cat. 4). J. C. M. Bellows,[31] Lamartine[32] and E. W. Lane[33] all deplored the indolence which they saw as the prime cause of the ruinous state of the contemporary Ottoman Empire. The painter, David Roberts, went further and blamed indolence, in conjunction with Islam, as the root cause of the deplorable condition of Egypt: 'Splendid cities once teeming with a busy population and embellished with temples and edifices, the wonder of the world, now deserted and lonely, or reduced by mismanagement and the barbarism of the Muslim creed to a state as savage as wild animals by which they are surrounded. Often

fig. 3 Gérôme *Le Prisonnier du Nil* 1861 [Musée des Beaux-Arts, Nantes]

have I gazed on them till my heart actually sickened within me.'[34] The theme of the 'barbarism of the Muslim creed' was taken up by Lenoir in his description of the departure of the great caravan of pilgrims from Cairo to Mecca as an example of *une religion idiote et barbare*'.[35] By the same token, K. Bendiner[36] has pointed out how, in the many views of Jerusalem painted during the nineteenth century, the Mosque of Omar frequently appears to stand like a predatory animal over the destroyed Temple of Solomon (see Cat. 21, 75, 83).

At the same time, many artists travelling in the Near East and North Africa found much to admire. When Delacroix made his brief trip in 1832, he willingly adjusted his imaginary preconceptions in the face of the unsurpassed beauty of Morocco and Algeria and the nobility of their peoples, who became for him, paradoxically, the reincarnation of the classical ideal of Greece and Rome:

'I am truly sorry for the artists gifted with imagination who can never have any idea of this virgin, sublime nature . . . I can only look forward with sadness to the moment when I shall leave forever the land of beautiful orange trees covered with flowers and fruit, of the beautiful sun, of the beautiful eyes and of a thousand other beauties . . . Rome is no longer in Rome . . . Imagine, my friend, what it is to see figures of the Age of the Consuls, Catos, Brutuses, seated in the sun, walking in the streets, mending old shoes . . . The Antique has nothing that is more beautiful.'[37]

Similarly Gautier, a most perceptive commentator on the Orient, noted the discrepancy between his own exotic preconceptions of a Muslim husband's relationship with his wives and the dignified reality as he saw it:

'If one becomes aware of the dignity and even the chastity which exist between a Muslim and his wives, one would renounce all this voluptuous mirage which our writers of the eighteenth century have created, the idea of these harems described by the author of the Lettres persanes.'[38]

Sympathetic observation could also be found in Lady Duff Gordon's letters, written during her five-year sojourn in Egypt (1863–69), which repeatedly refer to the excellence, the industry and the nobility of modern Egyptians.[39] Above all, many Westerners responded with awe and considerable respect to the practices of the Muslim faith. The scenes of mosque interiors by Gérôme (Cat. 32, 38) and Deutsch (Cat. 20) stress the equality of worshippers in the sight of Allah and the solemnity of the religious celebrations. Belly's *Pilgrims going to Mecca* (Cat. 3) and Gérôme's *Mu'adhdin's Call to Prayer* (Cat. 36) illustrate Islam's regulation of all aspects of the believer's life.

Some visitors carried their enthusiasm for the Orient even further and saw the influence of the West as potentially disastrous to North Africa and the Near East. The artist Guillaumet, who spent a considerable time in the remote, southern regions of Algeria, deplored the march of modernisation in that country, especially the 'frenchification' of the capital, Algiers: 'They demolish without letting up in Algiers, the mauresque peristyles, the gateways of sculpted marble . . . Life here no longer seems as before, held together by dreams and bringing life to the shadows.'[40] For many commentators,[41] the pastoral primitive life and the biblical atmosphere of the Arab villages appealed to an almost Rousseauesque desire to escape from the debasement of the human spirit supposedly brought about by Western civilisation.

The degree to which Orientalist painters ever fully compre-

hended the Muslim world or considered the consequences, if any, for the indigenous population of their celebration of primitivism is problematical. Some commentators have tried to view all Orientalist manifestations as an aspect of cultural imperialism.[42] Yet, the evidence would suggest that this is too simplistic an interpretation of both Western visitors' intentions and their artistic work. The Western approach to the Orient was neither unchanging, without its own inconsistencies, nor closed to the influence of observation. Flaubert attempted in 1850 to analyse the shift which had taken place in his own attitudes to the Orient since his arrival in Egypt in late 1849. His comment is most revealing:

'You ask me whether the Orient is up to what I imagined it to be. Yes it is; and more than that, it extends far beyond the narrow idea I had of it. I have found, clearly delineated, everything that was hazy in my mind. Facts have taken the place of supposition.'[43]

Flaubert's encounter with Egypt illustrates the meeting point of Western prejudice and the observation of the Orient, and his response was to redefine certain of his attitudes. By the same token, many painters faced the need to modify their artistic conventions, which they brought with them from Europe, such as the Picturesque approach to landscape and the established means for notating light and colour. This process may be closer to a 'dialogue' between cultures than a 'discourse', to pick up Edward Said's terminology as laid out in his book *Orientalism*.[44] In this sense Delacroix had already engaged in a 'dialogue' with North Africa, albeit idiosyncratically. The emergence in the next generation of European painters in the 1850s of a more Realist approach to subject-matter, further developed this 'dialogue', coinciding as it did with the first flood of artists to the Near East and North Africa.[45]

One of the major impulses for artists travelling to the Orient in the wake of the Napoleonic campaigns had been to provide a record of the topography and the customs of places and peoples unfamiliar to the West.[46] During the eighteenth century, European artists had already undertaken such an exercise with the landscapes of Italy and northern Europe, and had devised the artistic conventions of the Picturesque, whereby a landscape painting was composed according to the rules of the ideal landscapes of Poussin and Claude. At first sight, the Oriental landscapes of Dauzats (Cat. 9), Marilhat (Cat. 97), Lear (Cat. 82), Roberts (Cat. 112) and Frère (Cat. 21) seem perfectly to exemplify the application of Picturesque conventions. The spectator's eye is carefully directed to proceed from a foreground composed of native figures or fragments of ruined monuments, framed by trees, buildings or a projection of higher land, toward the middle distance containing the main subject of the view (a monastery, a ruined mosque, the Island of Philae, the City of Jerusalem), and finally to the background where land meets sky in a misty horizon. However, on closer inspection, it can be seen that in order to accommodate these strange landscape subjects each of these artists has modified in various ways the conventions of the Picturesque. David Roberts, for example, in *The Island of Philae, Nubia* (Cat. 112) adopts a 'fisheye' lens view as the only means by which he is able to frame an object in the middle distance of an empty landscape devoid of 'natural' Picturesque elements. For Lear, in his view of the same subject (Cat. 82), it is the Picturesque handling of light which he modifies rather than the composition, emphasising, by means of translucent glazes over a thick, smooth, white ground, the range and intensity of a landscape lit by an Egyptian sunset.

The need to invent new compositional structures to compensate for the absence of conveniently placed vegetation and

undulating hills in a vast, often barren and featureless landscape, was a major formal problem for Orientalist painters, which Belly and Guillaumet above all confronted. In his 1857 Salon review, Gautier had remarked upon the impressive increase in the number of pictures depicting strange lands and peoples and concluded that, while these outnumbered the traditionally dominant subjects of classical nudes and history paintings, their presence did not necessarily threaten the future of French painting. He argued that the need to come to terms with foreign subject-matter might indeed prove to be the basis for exciting aesthetic innovations:

'From these effortless journeys is born a varied art, changeable, many faceted, whose chief characteristic is not to have one. What master can be consulted for models as yet unexpressed? What tradition can be followed where there is no tradition? Each artist searches, invents and renders in his own way that which he sees and that which he feels. Where there is no ready-made formula for a subject, individualism is truly forced to come to the fore.'[47]

The transcription of a flat, featureless desert, a subject handled by both Belly and Guillaumet, reveals the willingness of artists to invent their own visual vocabularies. Guillaumet's *The Desert* (Cat. 67) blatantly accepts the emptiness, the extreme horizontality and the remarkable light effects of his subject. He makes no concessions to existing Western conventions, apart from the inclusion of the camel's carcass in the foreground as a *'memento mori'*. Belly, in his *Pilgrims going to Mecca* (Cat. 3), takes the pilgrims as the compositional anchor for the work, piling them pyramidally at the centre of the composition and letting the flat desert slip off the edges of the canvas, a device which conveys the limitless expanse of the landscape. Furthermore, by placing the figures against the blinding light of the desert, he monumentalises the group in their solemn, arduous and hazardous journey and, at the same time, stresses the impact of the burning sun which catches the line of pilgrims winding back through the composition.

Belly's concern with capturing strange light as much as with compositional innovation points to a second area in which artists were challenged by what they found in the Near East: the relationship between an Oriental light and a Western palette. For a number of Orientalist painters, exoticism and Orientalism were synonymous with brilliant, explosive colour. In the wake of Gros, artists such as Dehodencq, Decamps, Benjamin-Constant and to

a certain extent Lewis and Bauernfeind, all adopted the kind of palette which Gautier had in mind when he observed that 'normally one represents hot lands in a flamboyant, torrid manner'.[48] But Gautier then added the important qualification that 'extreme light under its streaming whiteness drains colour from the sky, from the land'.[49] It was indeed no new proposition to be reminded that the intensity of light in the sky determined the hue of the landscape. But under the extreme illumination of the Oriental latitudes, the palette of the artist had to be that much more responsive. This awareness of the properties of light and its translation into paint were already seen in France, in 1864, as the most prominent contribution of Orientalist painting to French art. Five years before the emergence of a fully-fledged Impressionist style, Hector de Callias could declare: 'French painting owes a great debt to the passion for the Orient. This passion has given it what until now has been lacking, light and the sun. What is, in effect, missing from the French gallery at the Louvre? It is neither style in drawing nor the science of composition, nor again the harmony of colour. It is the rays of the sun.'[50]

Orientalist painters did not respond uniformly to their encounter with this alien light. Delacroix, for example, found in the light and colour of North Africa the justification of his system of complementary colours by which he intensified the tonal range of his palette and introduced pure colour into shadow, as in the remarkable shadow areas of *Les Femmes d'Alger* (fig. 4) and the *Sultān of Morocco* (Cat. 15). It was the example of Delacroix that encouraged Renoir twice to visit Algeria. He wished to test the efficacy of Delacroix's colour system as well as hoping to find new inspiration which might help him escape from the apparent limitations of Impressionism. Although he produced only a small number of pictures during his brief visits, Renoir reveals his exuberant response to the distinctive landscapes, townscapes and people, interpreted by a renewed enthusiasm for pure colour and a serious commitment to the modification of the handling of his paint.

However, both Delacroix and Renoir also discovered that the light of North Africa contained a whiteness which cloaked all colours in a delicate grey film. Baudelaire, in his 'Salon de 1845', noted this effect in Delacroix's *Sultān of Morocco*: 'In spite of the splendour of its hues, this picture is so harmonious that it is grey — as grey as nature, as grey as the summer atmosphere when the sun spreads over each object a sort of twilight film of trembling dust.'[51] Indeed, this was the very quality which Fromentin also observed in his extensive discussion of the problems of painting in North Africa and which he attempted to express in his own works, such as *Windstorm on the Esparto Plains of the Sahara* (Cat. 23): 'I talk of this country, dusty, bleached, somewhat raw when it becomes coloured, rather gloomy when no live colour awakens it, thus uniform and hiding an infinite number of particles of nuances and values under this apparent unity of tones ... In fact, never before us, as far as I know, has anyone bothered to do battle with this capital obstacle, the sun, nor dreamt that one of the aims of painting was to be able to express, with the poor means that you know we have, the excess of solar light, enhanced by its diffusion.'[52]

Fromentin's forthright acceptance of the challenge presented by the light of North Africa points to a further ingredient in Orientalist painting, namely the influence of Realism. For Delacroix and Decamps, the careful recording of incidental detail in North Africa and Asia Minor was not their primary concern. But, by the mid-nineteenth century, the truthful representation of the external world, based upon objective observation, set an aesthetic standard

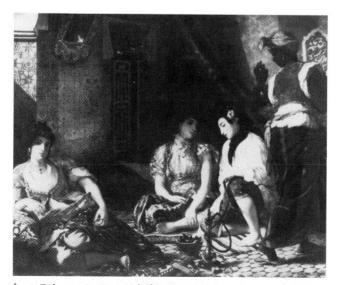

fig. 4 Delacroix *Les Femmes d'Alger* 1834 [Musée du Louvre, Paris]

for artists and patrons alike. Flaubert[53] and Richard Burton[54] noted with meticulous detail their respective Near Eastern journeys. When Lenoir discussed the purpose of his 1868 Egyptian trip, he said: 'Without having pretentions to seeing everything, we wanted to look carefully in order to paint *dal vero* that which we saw.'[55] Similarly, William Holman Hunt, writing from Jerusalem, counselled humility in a foreign land:' I have a notion that painters should go out, two by two, like merchants of nature, and bring back precious merchandise in faithful pictures of scenes interesting from historical considerations or from the strangeness of the subject itself.'[56]

The influence of Realism on Orientalist painting was felt throughout the second half of the nineteenth century. On the one hand, it generated a new school of religious painting. No longer content with religious images derived from Renaissance models, artists such as Tissot and Holman Hunt travelled in the Holy Land to search out the peoples and landscapes which could provide material for a more authentic reconstruction of the events and locations described in the Bible.[57] On the other hand, Realism called forth a new category of art, known as 'ethnographic' painting. By 1850, European painters had already developed an interest in the study of social and regional types which encouraged them to differentiate more precisely the landscapes and inhabitants of specific geographic locations. The Orientalists carried this concern into less familiar territory.[58] While Pierre Loti carefully located his novels, *Aziyadé* (1877) and *Le Roman d'un spahi* (1881), in Asia Minor and the Sahara respectively, Gérôme headed a school of painters who took pride in being able to distinguish between the physiognomies of Circassians, Turks and Egyptians as well as between the finer shades of Mauresque, Mamlūk, Ottoman and Byzantine architecture and decorative detail.

The high finish and meticulous rendering of detail in most 'ethnographic' paintings encouraged the spectator to accept them as literally truthful images. Yet closer inspection of pictures in this genre can reveal some observational inaccuracies. Despite the fact that since 1834 all 'ālmahs, or prostitutes, had been banned from Cairo, Gérôme's *Dance of the 'Ālmah* (1864; Cat. 29) still includes a glimpse of the characteristic pink- and yellow-banded buildings of Cairo through the door. Lecomte-du-Nouÿ's *Guard of the Seraglio* (1876; Cat. 86) introduces jumbled architectural elements in the manner of a *capriccio* into a painting subtitled 'Souvenir of Cairo'. And, as Linda Nochlin has pointed out, there are no images which describe the poverty, dirt and disease which almost all travellers to the region commented upon with varying degrees of sympathy.

Both *Dance of the 'Ālmah* and *The Guard of the Seraglio* proved to be immensely popular images. The latter found a purchaser even before it was exhibited at the Salon of 1876, whilst the former received ecstatic public acclaim and a generally favourable response from the critics when it was shown at the Salon of 1864. The enthusiastic taste for such Orientalist paintings yields no ready explanations.[59] These paintings were available in increasing numbers during the nineteenth century in keeping with other genres through annual exhibitions at the Royal Academy and at the Paris Salon.[60] They were displayed at the International Exhibitions, through dealers – both those who owned galleries, such as Goupil in Paris and Gambart in London and those who worked privately, such as George Lucas in Paris – and in widely-circulated engravings. Some Orientalist painters certainly commanded high prices for their works, notably Fromentin,[61] Lewis,[62] Gérôme[63] and Decamps, a factor which might also explain the frequent production of copies or variants of popular paintings. There seemed

to be no end to the combinations of light filtering through latticed screens into cool interiors replete with graceful, pale women and Oriental bric-à-brac which Lewis could conjure up. Equally, Gérôme and Deutsch could produce endless variations on the theme of bashibazuks carousing, 'ālmahs dancing, Arnavuts smoking and Muslims praying. In terms of the demand for Oriental paintings, several significant collections were assembled at the time, notably those of John Walters in Baltimore, the Marquis of Hertford (later the Wallace Collection), the Duc d'Aumâle at Chantilly and David in Nantes. Yet the reasons for such concentrations of Orientalist works are far from simple. All four men collected a variety of nineteenth-century paintings and, while the Duc d'Aumâle had ample reason for collecting Orientalist works, since he had actually campaigned in North Africa, and Wallace was ambassador in Constantinople, neither Walters nor David appear ever to have set foot in the Orient.

Orientalism also touches upon two further artistic issues of the period, namely the protracted search for 'modern' painting and the relationship between art and photography. The difficulty of finding an artistic idiom capable of expressing the aspirations of the contemporary world became a matter of great urgency in mid-nineteenth-century Britain and even more so in France. Both Jules Janin[64] and Théophile Gautier[65] proposed that Orientalist painting might have an answer to this problem. Realism demanded that the artist should paint in front of nature. Yet, in contemporary Europe, this laid Realism open to the possibility of including low subject-matter rendered in coarse technique, evident in the art of Courbet, which prevented any reference to the principles of eternal beauty. The advantage of Orientalist painting was that by depicting living scenes in a world sufficiently remote and timeless the artist could make a record according to the principles of Realism and simultaneously intend the result to stand as an example of eternal beauty.

The debate over the relationship between art and photography in the nineteenth century centred primarily on the degree to which the one would usurp the role of the other. For the Orientalist painter, however, the photograph was early accorded an important position. On his trip to Egypt in 1839, Horace Vernet became one of the first artists to employ the daguerreotype as a faster and more accurate method of sketching.[66] His example was followed by almost all the Orientalist painters, from Holman Hunt

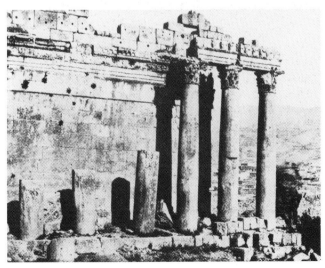

fig. 5 Maxime du Camp, Baalbec, Lebanon Daguerreotype 1850

fig. 6 Francis Frith, Dahabiyyahs and a freighter tied up at Luxor
Daguerreotype 1856–59

and Seddon to Gérôme, Deutsch, Roberts and William Müller. The advantages of the mechanical eye were considered overwhelming and Gautier was quick to recognise this fact:

'*[Art] has set off in all directions on the wing of steam: new countries, unexplored climates, unknown types, unrecorded races present themselves to it in all parts. After 6000 years, it takes possession of a real world which up until now it had only viewed indistinctly. The photograph, this humble servant, takes notes for [art], and the sun draws upon its travel notebooks the men, the animals, the plants, the rocks, the monuments, the statues, the remarkable sites with an infallible certainty and a mathematical precision; vast quantities of material, sketches almost devoid of labour, are at the disposition [of art]*'.[67]

In this regard, Orientalist painting also fostered the professional photographer. Individuals such as Le Gray, Maxime du Camp, Beato and Francis Frith, together with survey teams under the auspices of the Ordnance Survey and the Palestine Exploration Fund provided accurate delineations of ancient sites and local customs for a diverse public of archaeologists, anthropologists, tourists, and even artists themselves.[68]

The last two decades of the nineteenth century saw a significant diversification in Orientalist painting. To be sure, Gérôme, and his followers Aublet, Ernst and Deutsch, continued to produce their highly wrought transcriptions of the Near East, but as early as 1876, the critic Castagnary was fervently looking forward to the demise of Orientalist painting: 'In a few years, we shall be able to erect a stone and engrave upon it these comforting words: "Orientalism has lived in French painting".'[69] Castagnary's wish was not, however, fully granted. The Orientalist painters in France were sufficiently numerous and well-organised to arrange from 1894[70] an annual salon devoted to their work, and the discoveries of Impressionism encouraged a school of 'colonialist' painters in North Africa which survived until the Second World War.[71]

In addition, there was a younger generation of artists whose encounter with the Orient ensued from a set of new artistic objectives. Renoir, Sargent, Brangwyn, Emile Bernard, Matisse and Kandinsky had all cast their art within the new pictorial tradition in Europe which asserted that painting should achieve something more than the mere transcription of the external world. For some of these artists, the trip to North Africa and the Near East provided the basis for the discovery of fresh ways to handle paint and a new perception of colour, as in the case of Renoir, Brangwyn and Sargent. For Matisse and Kandinsky, the Orient confirmed a style which, through reference to a combination of the primitive elements and the intense colour of the Oriental world, consolidated the radical innovations introduced earlier in their artistic careers, which were to prove central to the evolution of Modern art.

Matisse's and Kandinsky's individual responses to the Orient represent one aspect of the encounter of the West with the Near East and North Africa. The resulting works of art tell us less about the 'reality' of North Africa than they inform us about each artist's own position on the issues facing European art at the beginning of the twentieth century. In contrast, Fromentin's admission of his technical and intellectual impotence, when confronted with the Orient, reveals the degree to which Western artists could conscientiously seek adequate visual formulations by which the essence of these strange lands could be captured on canvas. Apart from the exploration of the exotic idea in art and the interaction with Realism as an artistic principle, perhaps the encounter with light is the most enduring quality of Orientalist art. Hector de Callias, in his article of 1864, correctly identified this particular characteristic of the Orientalists.[72] So too Flaubert awoke to the intense colour provoked by the light of these lands in his description of the sun rising over the Great Pyramids of Gizah:

'*The sun was rising just opposite; the whole valley of the Nile, bathed in mist, seemed to be a still white sea; and the desert behind us with its hillocks of sand, another ocean, deep purple, its waves all petrified. But as the sun climbed behind the Arabian Chain the mist was torn into great shreds of filmy gauze; the meadows, cut by canals, were like green lawns with winding borders. To sum up: three colours — immense green at my feet in the foreground; the sky pale red — worn vermillion; behind and to the right, a rolling expanse looking scorched and irridescent . . . Finally the sky shows a streak of orange where the sun is about to rise. Everything between the horizon and us is white and looks like an ocean; this recedes and lifts. The sun, it seems, is moving fast and climbing along the oblong clouds that look like swan's down of an inexpressible softness. . . . The light increases. There are two things: the dry desert behind us and before us an immense, delightful expanse of green.*'[73]

Indeed, whatever their motives, the fact that artists chose to explore the Near East and North Africa during the nineteenth century opened up a vast store of pictorial motifs and presented a challenge to the conventions of their Western artistic learning. And to be sure, almost all the paintings which emerged from this encounter between two cultures speak of an enthusiasm for these foreign lands, witnesses to their splendour, their enchantment and their powerful fascination.

NOTES

1 E. Fromentin, *Une Année dans le Sahel*, Paris, 1858, 1981 ed., pp. 174–75, 177.

2 The phrase 'Middle East' was coined only in 1902, by the American historian, A. T. Mahon, to distinguish the region of the eastern Mediterranean from the Far East; see A. Williams, *Britain and France in the Middle East and North Africa*, London, 1968, chap. 1. Prior to that date, the terms 'Near East' and 'Orient' were used to describe this region.

3 K. P. Bendiner, 'The Portrayal of the Middle East in British Painting, 1835–1860', Ph. D. thesis, Columbia University, 1979, gives a careful discussion of the problems of defining the term 'Orientalism'. He concludes that, although Greece could be included within the term, 'Classicism is too intimately connected to the culture and history of Western Europe to be classified as an Orientalist subject' (p. iii).

4 These range from the strictly art historical issues, through the study of art within its cultural context to the analysis of art as an aspect of politics, whereby the encounter is seen as the domination of one culture by another. See L. Nochlin, 'The Imaginary Orient', *Art in America*, May 1983, pp. 119–31, 187–91; E. Said, *Orientalism*, New York, 1978.

5 Guildhall Art Gallery, London.

6 See Irwin, p. 24, Cat. 30, 64, 65, 66.

7 See S. Searight, *The British in the Middle East*, London, 1969, Part I; P. Martino, *L'Orient dans la littérature française au XVIIᵉ et au XVIIIᵉ siècles*, Paris, 1908; P. Hughes, *Eighteenth-century France and the East* (Wallace Collection Monographs, 4), London, 1981; Rochester, New York, Memorial Art Gallery, *Orientalism*, catalogue by D. Rosenthal, chap. 1.

8 Both political and cultural historians have seen the arrival of Napoleon in 1798 as an event of dramatic consequence for Europe and Near East alike; see B. Lewis, *The Middle East and the West*, London 1964, p. 34; J. Alazard, *L'Orient dans la peinture française au XIXᵉ siècle*, Paris, 1930, chap. 1, especially p. 21.

9 See Warner, pp. 32–35.

10 See D. S. Landes, *Bankers and Pashas*, London, 1958.

11 See Bugler, pp. 29–30.

12 Fromentin recorded his experiences in two books, *Un Eté dans le Sahara*, Paris, 1856, and *Une Année dans le Sahel*, Paris, 1858.

13 See G. Guillaumet, *Tableaux algériens*, Paris, 1888.

14 For a comprehensive study of Decamps, see D. Mosby, *Alexandre-Gabriel Decamps*, New York, 1977.

15 The best examples of Decamps's work are to be found in the Château de Chantilly and the Wallace Collection, London, neither of which institution is permitted to lend works from its collection.

16 See N. Pevsner and S. Lang, 'The Egyptian Revival', *Architectural Review*, May 1956, pp. 242–54; J. Stevens Curl, *The Egyptian Revival, an Introductory Study of a Recurring Theme in the History of Taste*, London. 1982.

17 See, for example, the use of Flemish fifteenth-century background and technique in *Mlle. Rivière* (1805; Louvre, Paris).

18 Lady Mary Wortley Montague, *Letters*, London, 1727.

19 Throughout the eighteenth century, the Orient was visually conveyed in 'turqueries', or 'fêtes galantes' transposed into a Turkish setting, for example, in the works of Van Loo and Nattier. It was also evoked in the turbaned figures introduced into the Western port scenes of Claude-Joseph Vernet. Exceptionally, there were the paintings by the Swiss artist, J.-F. Liotard, which were derived from actual observation, as were a few illustrated publications such as Comte de Fériol's, *Recueil de cents estampes représentant différentes nations du Levant*, Paris 1712, and L. F. Cassas, *Voyage pittoresque en Syrie*, Paris, c. 1785. See A. Maubert, 'L'Exotisme dans la peinture française du XVIIIᵉ siècle', dissertation, Paris, 1943; A. Boppe, *Les Introducteurs des ambassadeurs*, Paris, 1901; A. Boppe, *Les Peintres du Bosphore au XVIIIᵉ siècle*, Paris, 1911.

20 For a full study of Jules-Robert Auguste, see D. Rosenthal, 'Jules-Robert Auguste and the Early Romantic Circle', Ph.D. thesis, Columbia University, 1978.

21 Musée du Louvre, Paris.

22 Critic and writer whose novel, *Le Fellah, Souvenir d'Egypte*, Paris, 1869, was based upon his experiences on the 1868 trip and was dedicated to J.-L. Gérôme.

23 P. Lenoir, *Le Fayoum, le Sinaï et Pétra*, Paris, 1872, p. 3.

24 See Th. Gautier, *Constantinople*, Paris, 1853, pp. 164–65, 166, 189, 199–200.

25 Quoted J. Renoir, *Renoir*, Paris, 1962, p. 228.

26 G. de Nerval, *Voyage en Orient*, Paris, 1851.

27 P. de Molines, 'Aisha Rosa, Souvenirs des rives du Bosphore', *Revue des Deux Mondes*, 15 December 1856.

28 Princesse Belgiojoso, 'Récits turco-asiatiques', *Revue des Deux Mondes*, 1856–58.

29 *Aziyadé*, Paris, 1877.

30 E. Galichon, 'M. Gérôme, peintre ethnographe', *Gazette des Beaux-Arts*, Iʳᵉ période, XXIV, February 1868, p. 150.

31 J. C. M. Bellows, 'The Seven Churches of Asia Minor', *Art Journal*, February 1863, p. 36.

32 A. de Lamartine, *Souvenirs, impressions, pensées et paysages pendant un voyage en Orient*, Paris, 1835, vol. II, p. 8.

33 E. W. Lane, *An Account of the Manners and Customs of the Modern Egyptians*, London, 1836, 1895 ed., p. 285.

34 D. Roberts, quoted J. Ballantine, *The Life of David Roberts*, London, 1866, pp. 104–05.

35 P. Lenoir, *op. cit.*, p. 134.

36 K. Bendiner, *op. cit.*, p. 41.

37 E. Delacroix, *Correspondance générale de Eugène Delacroix*, A. Joubin, ed. Paris, I, 23 February 1832, p. 313; I, 29 February 1832, p. 319.

38 Th. Gautier, *op. cit.*, pp. 164–65.

39 Lady Duff Gordon, *Letters from Egypt*, partial ed., London, 1865, 1983 ed., especially pp. 59, 79.

40 G. Guillaumet, *op. cit.*, pp. 312–13.

41 See P. Lenoir, *op. cit.*, pp. 123, 145; also Warner, pp. 32–33.

42 This is a position held notably by E. Said, *Orientalism*, New York, 1978. Said claims that the West's political and economic engagement in the Near East and North Africa during the nineteenth century constituted Imperialist domination of these regions and that all art, be it literary or pictorial, was created to reinforce Western superiority vis à vis these lands, rather than as an attempt to understand the multifarious aspects of their cultures. See also the reviews of E. Said's book, eg. Sadik Jalal al'-Azm, 'Orientalism and Orientalism in Reverse', *Khamsin*, No. 8, 1981, pp. 5–25, Basim Masallam, 'Power and Knowledge', *MERIP Reports*, no. 79, pp. 19–26. This question is also discussed in L. Nochlin, *loc. cit.* An alternative critique of E. Said is given in eg. A. Hourani, *New York Review of Books*, 8 March 1979, pp. 27–30.

43 *Flaubert in Egypt*, transl. and ed. F. Steegmuller, Chicago, 1979, p. 75.

44 E. Said, *op. cit.*, p. 3.

45 X. Marmier, *Les Voyageurs nouveaux*, Paris, 1851, pp. 369–71, 390.

46 See Bugler, p. 27.

47 Th. Gautier, 'Salon de 1857–1', *L'Artiste*, 14 June 1857, p. 190.

48 Th. Gautier, 'Salon de 1857–IV: MM. Gérôme, Mottez', *L'Artiste*, 5 July 1857, p. 247.

49 *Idem*.

50 H. de Callias, 'Le Salon de 1864–XVII: Les Italiens et les orientaux', *L'Artiste*, 1864, vol. I, p. 198.

51 Ch. Baudelaire, 'The Salon of 1845', *Art in Paris 1845–1862*, transl. J. Mayne, London, 1965, p. 6.

52 E. Fromentin, *op. cit.*, p. 177.

53 G. Flaubert, *Notes de voyage*, Paris, 1910.

54 R. Burton, *Personal Narrative of a Pilgrimage to El-Medinah and Mecca*, 3 vols., London, 1855.

55 P. Lenoir, *op. cit.*, p. 1.

56 Letter dated 'Jerusalem, 12 August 1855', quoted K. Bendiner, *op. cit.*, p. 14.

57 See Warner, pp. 33–34.

58 Th. Gautier, 'Le Salon de 1857–IV: MM. Gérôme, Mottez', *L'Artiste*, 5 July 1857, p. 245.

59 It has been suggested that Orientalist painting contrived to make available experiences forbidden to the prurient West (see L. Nochlin, *loc. cit.*). E. Said, *op. cit.*, implies that the ownership of Orientalist painting denotes the desire of the West both to dominate the Near East and to reinforce the West's own sense of cultural superiority.

60 Further research is needed in analysing the quantity of Orientalist paintings shown at the major annual exhibitions as an indication of changing patterns of taste.

61 Eg. Cat. 22 fetched 19,000 francs in 1881.

62 Eg. Cat. 90 would not be sold by its owner in 1874, despite an offer of £10,000.

63 See L. M. C. Randall (ed.), *The Diary of George A. Lucas*, Princeton, 1979.

64 J. Janin, 'Le Salon de 1839: 5ᵉ article', *L'Artiste*, 1939, vol. II, p. 269.

65 Th. Gautier, 'Le Salon de 1857–IV: MM. Gérôme, Mottez', *L'Artiste*, 5 July 1857, p. 245.

66 H. Vernet, *Voyage daguerrienne*, Paris, 1841.

67 Th. Gautier, 'Le Salon de 1857–I', *L'Artiste*, 14 June 1857, p. 190.

68 See L. Vaczek and G. Buckland, *Travellers in Ancient Lands. A Portrait of the Middle East 1839–1919*, New York, 1981.

69 Castagnary, 'Salon de 1876', *Salons*, Paris, 1892 p. 224.

70 Société des Peintres Orientalistes Français, founded by Léonce Bénédite, 1893.

71 Société des Peintres Algériens et Orientalistes, founded in Algiers, 1897; the Villa Abd el Tif founded by M. Jonnart, Governor of Algeria in 1907, for French artists wishing to work in North Africa. Scholarships were offered to two artists for a year each and, from 1920, one of the Scholarships was extended to two years.

72 H. de Callias, *loc. cit.*

73 G. Flaubert, *op. cit.* pp. 52–53.

ROBERT IRWIN

The Orient and the West from Bonaparte to T. E. Lawrence

On 1 July 1798 Napoleon Bonaparte's flagship, the *Orient*, with an armada of ships of the line, frigates and transports, appeared off the coast of Egypt. Alexandria was swiftly occupied and three weeks later the French army won an easy victory over the disorderly cavalry of the Mamlūk Bays at the Battle of the Pyramids actually fought at Imbaba, almost nine miles away from the Pyramids (see Cat. 64, 65, 66). The Mamlūks, mostly Circassian, Turk or Slav, were of slave origin or descent and formed a caste of military aristocrats which had ruled Egypt since the thirteenth century. Although Egypt and Syria had been conquered by the Ottoman Turks in 1516–17, and were subsequently governed in the name of the Ottoman Sultān by the Pasha, the Bays, or heads of the Mamlūk household, retained their financial and military position, and by the late eighteenth century the jurisdiction of the Ottoman Sultān over Egypt was scarcely more than nominal. The military prestige of the Mamlūks was damaged by their defeat in 1798 at the hands of the armies of the French Directorate. An attempt in 1799 by the Ottoman army to land on the Nile delta, drive the French army out of Egypt and restore the Sultān's authority resulted in a defeat at Abū Qīr (see Cat. 66) which was even more humiliating for the prestige of Turkish arms.

Before the Battle of Abū Qīr Bonaparte told General Murat that 'this battle will decide the fate of the world'. It is not clear why he thought this would be the case. The aims of the French expedition were from the first ill-defined. The French Directorate had thought vaguely of threatening British possessions in India and the British naval presence in the Mediterranean, and certainly they wanted the troublesome Bonaparte out of France. Later, Napoleon was to talk grandiosely of his scheme to march through Syria and return to Europe via Constantinople. In the event, his invasion of Palestine in 1799 (see Cat. 64) turned into a disaster. Although 2000 of the Turkish garrison at Jaffa were massacred after surrending, Jezzar Pasha, the warlord governor of Acre, undeterred, successfully resisted a two-month siege by the French. Meanwhile, plague ravaged the French army (see Cat. 65) and Bonaparte, before withdrawing to Egypt, gave orders at Jaffa that those too sick to be moved should be poisoned with overdoses of opium, orders which were not obeyed.

Muslim observers of the French occupation of Egypt were less impressed with the wonders of Western civilisation than might have been expected, though al-Jabarti did commend the discipline of the French army. Its readiness to obey orders had few parallels in the slave corps, war bands, tribal levies or militias of the Near East (see Cat. 28, 94). Whatever the intentions of the French in Egypt, their long-term tenure of the country was made impossible by Nelson's destruction of most of the French fleet at the Battle of the Nile (Bay of Abū Qīr) in August 1798, so that by 1801 the entire French force had been evacuated from Egypt. However, the multi-volume *Description de l'Egypte* (1808–29), subsequently produced by the *savants* whom Bonaparte had taken with him on his invasion force, stimulated in Europe a greater interest in Near Eastern matters, and the French expedition of 1798 proved the harbinger of future European interventions in the region and of the colonisation of North Africa.

In the first decade of the nineteenth century the Ottoman Sultān still ruled, or at least pretended to rule, Greece, Crete, Cyprus, the greater part of the Balkans, Asia Minor, the south-western provinces of the Caucasus, Iraq, Syria, Lebanon, Palestine, Egypt, Libya, Tunisia and Algeria. Millions of the Sultān's subject in Europe and in Asia were Christians – Orthodox, Armenian, Jacobite, Maronite, Coptic or Catholic. Most of his subjects in the Near East and North Africa were Arab or Berber. But in all

provinces the ruling élite, the pashas, viziers, bays, mamlūks and janissaries, were Muslims and were recruited for the most part from the Turks, Albanians and Circassians. The successful Greek revolt of 1821–29 began the erosion of Turkey's power in Europe, and by 1914 very little of the Balkans was still in Turkish hands, while the North African provinces had passed into the hands of France, Italy and Britain.

Although in the mid-nineteenth century Tsar Nicholas I may have observed of the Sultān that 'we have on our hands, gentlemen, a sick man, a very sick man', in fact the century saw a revival of the Sultān's central control over Anatolia, Syria and Palestine and the re-establishment of his suzerainty over the Muslim holy places of the Hijāz. Indeed the increased, though still imperfect, policing and administration of the Levant by the Sultān's servants was one of the factors which facilitated its penetration by European merchants, missionaries, pilgrims and tourists (see Bugler, pp. 27–31). Sir Andrew Ryan, last of the dragomans at the British embassy in Constantinople, looked back on the final decades of Ottoman rule, as an 'Indian summer'. To some extent the Ottoman revival resulted from the reform of its institutions. The sultans laboured, in the first instance, to create a Turkish army with European standards of discipline and weaponry. With the massacre of the old janissary corps on the 'Auspicious Day' in June 1826, one of the most important obstacles to autocratic reform was removed. Broader constitutional reforms, notably the Tanzimat reforms, followed in the years 1839–78.

Reform and improvement drew in European advisers and necessitated European loans. As Kinglake's fantastical pasha told the Eastern traveller: 'My mind comprehends locomotives. The armies of the English ride upon the vapours of boiling cauldrons, and their horses are flaming coals! – whirr! whirr! all by wheels! – whiz! whiz! all by steam!' In the decade that followed the publication of Kinglake's *Eothen* (1844), the British began to build a railway along the coast of Asia Minor. Later, more ambitious projects, such as the Berlin–Baghdad Railway, were predominantly German in their engineering and funding. Similarly, the Germans, in due course, replaced the French as advisors and instructors of the Ottoman army, and the great munitions firms of Krupp and Mauser maintained important branches in Istanbul. Boards of health, staffed by European consuls and doctors, took control of medical and sanitary affairs in many Ottoman regions following the first appearance of cholera in the Near East in the 1830s. Plague had been endemic in this region for centuries and quarantine restrictions were still enforced on the frontiers of the Ottoman Empire in the nineteenth century.

By virtue of capitulatory or treaty rights, the nationals of many European powers enjoyed important commercial and legal privileges in the Ottoman lands. Their consuls were also able to offer such concessions to the indigenous Christians and Jews who worked for them, and indeed to other interested Turkish citizens who could afford to pay for them. Although beneficial to the European recipients, capitulatory rights were a corrosive phenomenon in Egypt and North Africa. At the same time the Russian Tsar claimed rights as the protector of all Orthodox Christians living under Ottoman rule, while France declared its special interest in the Maronites. In 1860 religious and economic resentments boiled over and Christians in Damascus and the Lebanon were massacred by Muslims and Druze. This provoked European intervention, and through the Organic Regulation of 1861, the special status of the Lebanon was established under Western supervision.

Modernisation and reform in the Ottoman Empire proved to be as costly a process as the persistent corruption and court extravagance. Turkish indebtedness to European banks led to the formation of the Public Debt Administration in 1881 and the supervision by foreigners of many areas of Turkish finance. A similar sequence of modernisation, indebtedness and surrender to Western demands for supervision or actual control, was followed in Egypt and the autonomous regencies of Tunis and Algiers. Indeed, many of the Ottoman reforms of the early nineteenth century followed Western models only at one remove and it was the reforms initiated in Egypt by Muḥammad 'Alī that furnished their more direct source of inspiration.

Muḥammad 'Alī, a military adventurer of Albanian origin, seized power in Egypt in 1805, after outmanoeuvring both the janissary garrison sent from Turkey and the Mamlūk Bays. In 1811 the Mamlūk Bays and their retinues were invited to a feast at the Cairo Citadel and were swiftly massacred. Mamlūk power was destroyed forever, though mamlūks continued to be imported and employed in Egypt, and even to sit for Western portraitists (see Cat. 94), until the late nineteenth century.

Under Muḥammad 'Alī's enlightened, if sanguinary, rule, in Egypt, land tenure was restructured and the tax burden increased. He called in European experts to establish new industries and to remodel the army, which undertook campaigns with some success in the Hijāz, Greece and Syria. In this way Sudan was made a province of Egypt.

Muḥammad 'Alī died in 1849, the founder of a khedivial dynasty which came to an end only with the expulsion of Farouk in 1952. Although financial returns, largely from irrigation improvements and vastly increased cotton exports, reinforced Muḥammad 'Alī's effective independence from the Turkish Sultān and the European powers, his successors, less ruthless and more extravagant, drifted into debt. The construction of the Suez Canal was a particularly heavy drain on Egypt's resources, as were the celebrations to mark its opening in 1869. These included the staging of the première of *Aida*. 'I've never travelled . . . but I dare say, dear, that you can't judge Egypt by *Aida*' (Ronald Firbank, *The Eccentricities of Cardinal Pirelli*), but in the nineteenth century many Europeans did. Growing insolvency induced the Ismail Pasha to sell his shares in the Suez Canal to Disraeli which , coupled with a concern for the security of British merchants resident in Alexandria, furnished the pretext for British intervention and the occupation of Egypt in 1882. Thereafter, Britain became involved in Egypt's attempts to retain and then regain control of the Sudan. The deaths of Hicks Pasha and General Gordon at the hands of the Mahdi's dervish following were only avenged by Kitchener at Ūmdurman in 1898.

Dervishes and Muslim mystics (see Cat. 39), furnished Western writers and artists with unedifying scenes of fanaticism and superstition. Less obvious was the role of some individual dervish orders, particularly in North Africa, in renewing and purifying the Islamic faith. At times the dervishes spearheaded resistance to colonialism as did the Qadiris in Algeria in the 1830s, or the Sanusis in Libya in the early twentieth century. However, resistance to colonialism was more usually tribal in character. After a complex series of wrangles about debts and consular privileges, and the notorious incident in 1827 when the Day of Algiers struck the French consul with a fly whisk, the French were able easily to occupy Algiers in 1830. The subjugation of the tribal interior took much longer. French generals and land-hungry colonists favoured different policies and Abd al-Qādir, leader of the tribal resistance in western Algeria until 1847, became a hero in the

eyes of many in metropolitan France. The last major revolt was bloodily quelled in 1880, by which time there were almost a quarter of a million colonists in Algeria.

The suggestion in the 1887 edition of Murray's *Handbook for Travellers in Algeria and Tunis* that Tunis, once 'an independent Beylick', had since become 'as much an integral part of France as the neighbouring colony of Algeria', is misleading. Tunisia was only occupied by the French in 1881. However, before that date its independence had been heavily compromised by ineffective and expensive attempts to modernise its army and administration. Some reforms were undertaken under European pressure, and some precisely to pre-empt that pressure. Muslim authority in Tunis, as elsewhere along the coast, had been undermined by the privileged communities of French, Spanish and Maltese (British) subjects, who were resident there. Tunis, like Algiers and Morocco, had also been adversely affected by the decline of privateering in the early nineteenth century. On the other hand Tunisia was never as intensively colonised as Algeria and consequently was to regain its independence much more easily in the twentieth century.

Morocco had never formed part of the Ottoman Empire, and since the seventeenth century had been ruled by the Alawite Sharifs, claiming descent from the Prophet Muḥammad. Until 1830 the country, apart from Tangier, was largely inaccessible to foreigners. Thereafter French difficulties in western Algeria and the undefined frontier between Morocco and Algeria prompted the Sharif 'Abd al-Rahmān (see Cat. 15) to offer assistance against the French to the rebel Abd al-Qādir and protection to the town of Tlemcen. Such provocations came to an end when the Moroccan army was humiliatingly defeated by the French at Isly in 1844. Hardly less humiliating was the capitulatory treaty signed with the British in 1856. The more the Sharifs ceded to the Western powers the more their prestige declined in the eyes of their subjects, and when France declared Morocco a protectorate in 1912, it was primarily to protect the Sharif from his own rebellious tribesmen. Only the jealousy of other European powers had prevented the French from taking this step earlier.

In the second half of the century, Arabian deserts and Moroccan mountain passes provided appropriate backdrops for daring exploits. The French Foreign Legion, founded in 1831, performed most spectacularly at the Battle of Ischeriden (1857) during the conquest of the Kabylia region of eastern Algeria, when they took at bayonet point a high ridge defended by musketry. G. M. Young wrote: 'Still armies might march into the mountains and be lost for weeks, as Roberts marched on Kandahar: into the desert and be lost forever, as Hicks was lost at al-Obeid. Still false prophets might arise in the wastes beyond Wadi Halfa, still Lhassa was unvisited, and a man might make himself as famous in fact by riding to Khiva, as by discovering King Solomon's mines in fiction.'

A less romantic contact with the Orient was Thomas Cook's association with Egyptian tourism which began in 1869. The firm was granted in 1880 exclusive control of all passenger steamers on the Nile, which subsequently led to contracts for supply and transport of the British army in Egypt and the Sudan. Murray's *Handbook for Travellers in the Ionian Islands, Greece, Turkey, Asia Minor and Constantinople* first appeared in 1840, the volume for Egypt in 1847. The Librairie Hachette's *Itinéraire descriptif, historique et archéologique de l'Orient* was published in 1861. Baedeker guides to the region followed. Most serious tourists were attracted by pre-Islamic antiquities in the area (see Cat. 26, 59, 69, 82, 91, 110, 111). When sand was removed from the base of the Great Sphinx during the festivities for the opening of the Suez Canal in 1869, intense public interest was aroused, as was the case with other great moments in Egyptology in the nineteenth century: Champollion's decipherment of the Rosetta Stone (1820s), Layard's excavations at Nineveh (1840s), Schliemann's in the Troad (1870s) and Maspero's work in Egypt (1880s). A clearer idea of what the antiquities actually looked like could also be gained from the new science of photography in such publications as Maxime du Camp's *Egypte, Nubie, Palestine et Syrie* (1852).

Interest in Islamic art grew more slowly. Prisse d'Avennes's *L'Art arabe d'après les monuments du Caire* appeared only in 1877, and, though Delacroix had told du Camp that 'the most beautiful pictures I have seen are certain Persian carpets', the first major carpet exhibition only took place in 1891 in Vienna. In the last quarter of the century there was a huge increase in the production of Anatolian rugs, which, thanks to the introduction of Western synthetic dyes, could now be produced more cheaply.

Other Westerners went to Africa and Asia to rescue bodies and souls. In the Levant, Christian missionaries, among whom American Presbyterians were particularly prominent, concentrated their efforts on the Jews and native Christians. In Algeria the more aggressive Cardinal Lavigerie and the White Fathers attempted to convert the Muslims, to their mutual peril. The Christian missions were of course closely involved in the anti-slavery movement. A particularly vigorous campaign was conducted against the white slave trade in Circassian women, for the Circassians were Christians and besides there was a certain prurient concern about the details of harem life (see Cat. 33, 80, 86). In 1846, the Tunis slave market had been closed, followed, in 1854–55, by the prohibition by the Ottoman Sultān of the white slave trade and two years later by the black slave trade. Nonetheless, slavery and the surreptitious trade in slaves survived into the twentieth century.

Since the Ottoman Empire had closest links with the German Empire and few reasons to trust Russia, Britain or France, Turkey entered the First World War on the side of Germany and the Sultān urged the Jihād against the infidel rules of Muslim peoples. Despite fears of a Pan-Islamic conspiracy against the British Empire voiced in *The Times's* editorials and popular works of fiction such as Talbot Mundy's *King of the Khyber Rifles* (1916), the Turkish Jihād was no real threat to the Allies. Indeed, the British were successful in persuading the Sharif of Mecca, formerly a more or less loyal subject of the Sultān to declare a Jihād against the Turks. The Arab revolt which followed in the Hijāz and Syria drew upon British gold, and advisers like T. E. Lawrence. But it also fed upon the new belief in an Arab nation and a growing sense that the Arab and the Turk had different destinies, which was in part a reaction to the ethnocentrism of the Young Turks in Constantinople. During the First World War many hypothetical partitions of the Near East were proposed and many contradictory promises made. At the end of the war not only did the Allies retain all their possessions in Africa, but France became the 'protecting' power in Syria and the Lebanon, while Britain acquired the same responsibility in Palestine, Trans-Jordan and Iraq. The Ottoman Empire was dismembered and in November 1922 the British battleship *Malaya* took the last Ottoman Sultān to his exile in San Remo.

CAROLINE BUGLER

'Innocents Abroad': Nineteenth-Century Artists and Travellers in the Near East and North Africa

'Travelling here is the strangest mixture of fun, danger, inconvenience, good living, and starving', enthused William Bartlett about his journey through the Holy Land in 1834. *'One night we are entertained in a convent, and live in clover; the next finds us in a village khan, sleeping under a shed, and supping on milk and eggs; a third, we are dining and supping out. Sometimes kept all night awake by fleas – the next sleeping like a top on good sheets.'*[1]

Bartlett was one of the earliest British topographical artists to tour the Near East with the express purpose of systematically recording its features, and his comments express succinctly the attractions that were to lure many of his fellow artists to the comparatively unknown regions of the Holy Land, the Levant, Egypt and North Africa. Despite the constant threats of plague and war, the trickle of visitors, which had begun in the eighteenth century with early expeditions led by gentlemen antiquarians, such as the Reverend Richard Pococke and James Bruce of Kinnaird,[2] grew steadily throughout the early years of the nineteenth century, transforming these countries into fashionable venues for tourism of a more popular nature (fig. 7).

For artists, there were particular reasons for visiting North Africa and the Near East. Initially, many went simply as topographical draughtsmen and as the chroniclers of military victories, attached to expeditions or armies. From Napoleon's Egyptian campaigns onwards the French were particularly good at furnishing some pretext of a political mission for sending their artists abroad. In 1830 Horace Vernet was sent to Algeria to document the battles leading to the French conquest of that country. Adrien Dauzats followed in his footsteps when he accompanied the Duc d'Orléans and his army to the towns of Philippeville and Constantine during the later stages of the French Algerian campaign. Delacroix went to Morocco in 1832 as part of the Comte de Mornay's diplomatic mission to negotiate with the Sultān of Morocco (see Cat. 15), who was encroaching upon French Algerian territory. Yet, it soon became economically viable for artists to initiate their own travels, recouping their outlay in the sale of paintings and volumes of lithographs on their return. As early as 1835, the Swiss artist Gleyre commented upon the large numbers of painters in Cairo,[3] complaining that their presence had quite spoiled his stay in the city. By 1838, David Roberts was sufficiently confident of the financial rewards to undertake a journey in the Near East in order to collect material for the ambitious publishing project that became the highly successful *The Holy Land, Syria, Idumea, Arabia, Egypt and Nubia* (1842–49). Thackeray, on his visit to Cairo in 1844, was quick to identify the sources of such commercial success: 'There is a fortune to be made for painters in Cairo', he mused. 'I never saw such a variety of architecture, of life, of picturesqueness, of brilliant colour, of light and shade. There is a picture in every street, and at every bazaar stall'.[4]

But there were several difficulties that stood in the way of artists in the Near East, many of which stemmed from the Islamic aversion to graven images. Holman Hunt was accused of collecting the likenesses of people to sell to the devil,[5] and Edward Lear was denounced as Satan incarnate while drawing in Albania. His journals recall how, on a sketching expedition at Elbassān, a universal shout burst forth from the crowd surrounding him, and 'one of those tiresome dervishes – in whom, with their green turbans, Elbassān is rich – soon came up and yelled "Shaitan scroo! – Shaitan!" (the Devil draws! – the Devil!) in my ears with all his force; seizing my book also, with an awful frown, shutting it, and pointing to the sky, as intimating that heaven would not

fig. 7 Anon., *Tourists with servants at Karnak, c. 1870*

allow such impiety. It was in vain after this to attempt more.'[6] Even if artists were not always subjected to such witch-hunts, they had to suffer various inconveniences. While drawing in the dusty town streets, they might be jostled and stared at all day long. 'No-one in looking over my sketches will ever think of the trouble the collection of them has cost me',[7] complained David Roberts after one such day's drawing in Cairo. Nor was it easy to obtain models, especially female ones. However, the dearth could sometimes be remedied either by using Jewish female models (an expedient resorted to by artists such as Chassériau), or by bribery. As Delacroix put it, 'their prejudices against the art of painting are great, but a few coins here and there take care of their scruples.'[8] Renoir was later to complain bitterly that this procedure, especially amongst British artists, had made access to models financially prohibitive when he visited Algeria in 1882.[9]

It was also difficult to gain entry to most religious monuments. *Firmans*, or passes, generally had to be negotiated in advance, parties arranged and guides procured. In some areas of the Near East, modification of Western appearance was essential. David Roberts had to shave off his whiskers (and refrain from using hog's hair brushes) in order to sketch in the mosques in Cairo, but this was nothing compared to the elaborate disguise donned by Robert Catherwood. As part of Robert Hay's expedition to the Levant in 1833, Catherwood was commissioned by Muḥammad 'Alī, Pasha of Egypt (see Cat. 123) to inspect a number of mosques with a view to assessing what repairs were necessary, including the Mosque of the Dome of the Rock in Jerusalem. Despite the fact that Franks, or foreigners, had reportedly been put to death for merely entering the outer court, he twice went into the mosque dressed as an Egyptian officer. On the second occasion, an ugly scene ensued when Catherwood sat down to sketch. The suspicion and hostility of the crowds was aroused, and matters worsened when the cap of one of the dervishes was accidentally knocked off. It was only the personal intervention of the Governor of Jerusalem, who convinced the crowd of the value of Catherwood's mission, that saved his life.[10] Gradually, however, as the Western presence in the Near East grew, mosques and holy places opened up to the Christian visitor, and *baqshish* replaced the *firman* as a means of access to sacred buildings.

By the middle of the century, tourism was well established. Recognised itineraries and destinations were proposed, supported by a rapidly expanding corpus of travel literature.[11] Turkey was the starting point for many visitors, and the 1854 edition of *Murray's Guide to Turkey* gives details of a bewildering variety of routes available for travellers to Constantinople. They could sail down the Danube to the Black Sea to arrive ten days after leaving London; they could travel to Italy and embark on a steamer at Trieste; or they could sail direct from Marseille or Southampton. On their arrival at Constantinople, travellers were steered by their guidebooks round the Palace of the Ottoman sultāns, the mosques, the bazaars, baths, antiquities, and the shores of the Bosphorus where Europe and Asia met. While visitors to Constantinople were presented with a reasonable selection of hotels in that city, such facilities did not exist in the rest of Asia Minor, where they would have been obliged to stay in *lokandas* or *khāns* of dubious salubrity in the smaller towns. Bayard Taylor vividly describes the sight that frequently greeted the newly-arrived guest at one of these establishments in his account of his travels through Asia Minor. He recalled that while eating supper, 'in the midst of our enjoyment, happening to cast my eye on the walls, I saw a sight that turned all our honey to gall. Scores on scores – nay hundreds on hundreds – of enormous bed-bugs swarmed

up the plaster, and were already descending to our beds and baggage. To sleep there was impossible, but we succeeded in getting possession of one of the outside balconies, where we made our beds after searching them thoroughly.'[12]

Where there were no *khāns*, convents could usually be relied upon to provide accommodation, and sometimes the hospitality of the chief man in the village was extended to travellers. Nonetheless, it was generally advisable to take a tent, together with a cumbersome array of medicines, culinary utensils, umbrellas, straw hats, lamps, saddles, navigational aids and tea-making equipment. There were three modes of travel in the Near East as described in Murray's guide to Turkey: 'The most agreeable and comfortable is that adopted by a Turkish gentleman. It consists in having several native servants, tents, and either one's own horses or those hired from a *katirji*. The speed is slow, the caravan rarely accomplishing more than 20 or 25m. a day. The tents are pitched in the evening near some running stream or some pleasant gardens . . . This mode of travelling is comparatively cheap, but requires some acquaintance with the language and customs of the people . . . The second mode is that adopted by the Englishman of certain means. It consists in hiring one or two Greeks who speak some European language, paying so much a day, and leaving every arrangement in his or their hands. Some trouble may be spared, but the traveller will learn little of the manners and language of the people amongst whom he is travelling – will be imposed upon in every way – and will pay ten times the real price for everything . . . The third mode is the best for one who desires to become thoroughly acquainted with the country and people, and to learn something of the language. It consists in buying a couple of horses, one for a riding-horse, the other for a pack-saddle, on which his luggage – reduced to the smallest compass – can be placed, and, above it, a native youth hired as a servant.'[13]

Despite these attractive possibilities, the only really well-known parts of Turkey were Constantinople and Smyrna (now Izmir), mainly because of their convenient locations as stopping-off points for excursions further afield, generally south to the Holy Land, rather than east to Persia. In addition to the overland route to the Holy Land, there was the option of travel by steamer from Constantinople, Smyrna or Alexandria in Egypt. Jerusalem was only a day's ride on horseback from the port of Jaffa, and it was the most common destination of visitors to the Holy Land, especially around Easter, when thousands of pilgrims of all denominations converged on the city. Visits to the holy sites were recommended, but often these were spoilt by scenes of sectarian antagonism. It was a terrible scramble to get a place at the Easter service in the Church of the Holy Sepulchre, while each sect conducted its own observances under the same roof. The anonymous narrator of *Three Weeks in Palestine and Lebanon*, published in 1833, relates how his janissary was obliged to clear a path through the thronging masses 'after the manner of the Turks . . . laying his cane most lustily upon the heads and shoulders of all before him.'[14] The city itself did not always arouse much enthusiasm. Many commentators noted with distaste its curiously primitive, dismal appearance, and the melancholy air of its inhabitants. Edward Lear was not alone in recalling the interior of the city as 'horrid dreams of squalor & filth, clamour & uneasiness, hatred & malice & all uncharitableness.'[15] However, Lear went on to comment that the outside of the city was 'full of melancholy glory, exquisite beauty & a world of past history of all ages . . . The Arab & his sheep are alone the wanderers on the pleasant vallies and breezy hills round Zion: – the file of slow camels all that brings to mind the com-

merce of Tyre & other bygone merchandize.' The lack of pic-turesque subject matter, apart from the sacred monuments within the city itself, may help to explain the preponderance of panoramic views taken from the environs of the city (see Cat. 83), and the dearth of the bazaar and street scenes that countless artists painted in Cairo (see Cat. 96).

For those who were making the combined trip to the Holy Land and Egypt, and who were prepared to forego the comfort of the steamer, there was the overland route that passed through Petraea and the Sinai desert, following the journey of the Exodus. This route was particularly popular with artists, as it took them through such spectacular scenery. Preparations for the voyage were often elaborate; Gérôme's journal for his visit in 1868 to the Sinai desert reveals that he took forty-seven camels, twenty servants and six companions.[16] There was a certain safety in num-bers as, despite the blithe assertions of some guidebooks[17] that travel in the desert was no more dangerous than in certain parts of Europe, predatory attacks by Bedouin Arabs, particularly around Petra, were by no means uncommon. Gérôme's own party had a narrow escape from a hostile tribe of that region[18], and Edward Lear found himself in the middle of a dispute between the Arabs who had agreed to act as his escort, and the local fellāḥīn of that area, who demanded an extortionate fee for letting him pass through their territories.[19]

On the other hand, some Europeans were fortunate enough to observe the elaborate code of hospitality that some Arabs could extend to strangers. Major Fridolin, travelling through Syria en route to Mecca, was invited by the shaykh of the Anésis Arabs to dine in his tent. Even the dread of the culinary experience failed to measure up to the reality. 'The torture began with a cup of coffee', he wrote, 'which I swallowed heroically, brandy and liqueur. Followed by a plate of dates dressed with mutton fat, in front of which I felt my heart sink . . . but that was only the prelude to my tribulations. The crowd pressing round the tent came in, and I saw, carried on the shoulders of four men, something extraordinary and fabulous . . . On the gleaming slopes of a moun-tain of rice, a young camel, undoubtedly a suckling, an innocent victim slaughtered for my welcome, was lying with its legs folded and its neck straight, in the most realistic of attitudes.'[20]

Of all the countries of the Near East, Egypt undoubtedly pro-vided the highest degree of comfort and sophistication for the traveller. Many Europeans rented houses in Cairo in the Frank quarter of the city (having first taken the precaution of sending three of four fellāḥīn through the apartments to carry off the worst of the fleas). For those who did not anticipate a long stay, there were always the well-equipped hotels. And there were no prob-lems of access to the city. By the time Thackeray visited Cairo in 1844, he found it easy and convenient to have his journey arranged by the P & O Company. Had he waited another eleven years, he would have been able to take the train from Alexandria to Cairo on the railway line built between the two cities in 1855. Twenty-five years after Thackeray's trip it was possible to travel up the Nile in the comfort afforded by Thomas Cook's organised tours, which began in 1869. By the 1890s, Thomas Cook & Co. even had their own well-appointed steamships travelling up and down the river, complete with electric lights, a daily delivery of newspapers, porridge for breakfast and afternoon tea.[21]

The diverse attractions of Egypt brought tourists of all descrip-tions. Amelia Edwards, whose journey up the Nile in 1873 is memorably recorded in *A Thousand Miles up the Nile*, remarked of her fellow guests at Shepheard's Hotel in Cairo (fig. 8) that 'nine-tenths . . . are English or American. The rest will be mostly

fig. 8 J. Pascal Sébah, Terrace of Shepheard's Hotel, Cairo, after 1868

German with a sprinkling of Belgian and French ... Here are invalids in search of health, artists in search of subjects, sportsmen keen upon crocodiles, statesmen out for a holiday, special correspondents alert for gossip, collectors on the scent of papyri and mummies, men of science with scientific ends in mind.'[22] As the summer months were unbearably hot, the majority of tourists visited Egypt between October and April, when the climate was deemed particularly beneficial to the health. The Prince of Wales participated in the fashion when he wintered in Egypt in 1872–73 for health reasons, and among the hotels that sprang up to cater for the tourist trade, there were a number that specialised in the treatment of the sick. Some invalids stayed far longer: Lucie Duff Gordon went to Luxor in 1864 hoping to alleviate the symptoms of her tuberculosis, and spent the last five years of her life chronicling the daily life of village Egyptians and British expatriates in her letters home.[23]

Organised tourism was not to everyone's taste, and its growth allowed those who travelled independently the luxury of a certain sense of superiority. Amelia Edwards maintained that one could distinguish at first sight between a Cook's tourist and the autonomous traveller. In the same way, those who went up the Nile as far as the second cataract could look down on those who only ventured as far as the first. Of the various types of boat available for hire on the Nile, the wooden *dahabiyyah* provided the most leisurely and delightful conveyance. Miss Edward's *dahabiyyah*, the 'Philae', afforded the ultimate in gracious living. It was 100 feet long, possessed seven sleeping cabins, a spacious dining saloon with white panels picked out in gold and equipped with a piano, a bathroom, and a stern cabin saloon. None of these well-appointed rooms was reserved for the sleeping-quarters of the twenty members of crew, who simply rolled themselves up at night in rough blankets and 'lay about the lower deck like dogs'.[24] It was, of course, possible to hire craft of more modest dimensions. Gustave Flaubert and Maxime du Camp travelled up the Nile in a smaller *qangah*, with a crew of eight or nine, as did many artists of the time, including David Roberts, who insisted on having his craft submerged in the river to rid it of vermin before he set off.[25] By mid-century, it was not really necessary for a European to wear Eastern dress on the Nile trip, but Flaubert and Du Camp took great delight in putting on Nubian shirts trimmed with pompons, shaving their heads and wearing red *tarbooshes* (a form of fez), growing beards and smoking a *nargilah* (a native pipe). Several artists, including J. F. Lewis, Carl Haag and Frederick Goodall, wore native dress in Cairo, but it seems to have been largely for the fun of dressing up, and perhaps as a means of distinguishing themselves from the more temporary visitors to the city. Certainly, by the 1870s, Murray's guides were strongly advising tourists against wearing Oriental clothes in Egypt unless they were fluent in Egyptian, recommending suits of flannel in their place.[26]

The prodigious growth of tourism in Egypt soon had the effect of making some parts of the country as over-familiar and as spoilt as certain picturesque parts of Europe. There were complaints that the old quarters of Cairo were disappearing and that the city was being 'Haussmannised'[27] due to the influx of foreigners and the pro-Western attitudes adopted by successive Egyptian pashas. Graffiti were appearing on many of the monuments: Flaubert lamented that after climbing to the top of the Great Pyramid, he was confronted with the name and address of a Parisian wallpaper manufacturer inscribed in block capitals on the stone.[28] Of course, all tourists habitually complain about the presence of other tourists, and artists and writers often exhibited no more respect towards Egypt's heritage than the very people they despised. Flaubert's companion, Maxime du Camp, broke up mummies in the Crocodile Grotto and carried off pieces of the embalmed bodies,[29] and Gérôme committed a similar act of vandalism when he unravelled a mummy he had plundered from its tomb and watched the white bandages float down the Nile before removing the hands and feet for souvenirs.[30]

The most sensitive Western observers realised the potentially destructive character of this contact with the East, which brought not only the wanton defacement of monuments, but also a serious threat to the indigenous way of life. William Holman Hunt was concerned that 'traditional manners were threatening to pass away, together with the ancient costume and hereditary taste ... in another generation it would be too late to reconstruct the past, save in rural and desert life, if even then.'[31] The process of Westernisation was especially evident in the French colony of Algeria, where the colonial government, as part of its *mission civilisatrice*, was systematically re-organising the entire country, and successfully re-modelling the capital, Algiers, into a French provincial city. Only a day's journey from Marseille, the city soon boasted several good hotels, European doctors, French schools, a library, a museum, and a theatre. While the harbour, fortifications and Grand Mosque of Algiers provided subjects for painters, its warm climate recommended the city to sufferers from consumption, lung disease, coughs and rheumatism. Excursions to other coastal towns were facilitated by the construction of the coastal railway which, by 1873 (when Murray's published their first *Handbook for Travellers in Algeria*), ran between Algiers and Oran, Constantine and Philippeville.

Following the initial conquest of the north of Algeria in 1830, French control spread southwards in a series of military campaigns in the 1830s and 1840s. In their wake, visitors and artists began to venture into the heart of the country in search of an uncorrupted life and picturesque scenes. Eugène Fromentin's three Algerian journeys of 1846, 1847–48 and 1852–53 took him first to the Sahel, south of Algiers, and later to the oasis town of El-Agouat in the Sahara, where he stayed for some months.[32] In 1862, the artist Gustave Guillaumet went to live in the inland town of Bou-Saada, where he chose to share in the hard lives of the native Ouled-Naïll.[33] These second generation artists made a far more concerted attempt to understand the landscape and the indigenous population of Algeria than either Delacroix and Dauzats before them, or Renoir and Matisse after them.

The two countries which flanked Algeria, Morocco and Tunisia, lacked the reassuring presence of European garrisons in their interiors and so presented a more daunting prospect to the mid-century traveller. Yet, while Tunisia was usually discussed in travel literature merely as an extension to Algeria, Morocco's cultural links with, and proximity to Spain, made it the subject of frequent visits. A desire to see Moorish buildings in their place of origin led David Roberts, in southern Spain in 1833, to undertake the easy trip across the narrow strait that separated Spain from the capital city, Tangier. J. F. Lewis made the same journey, also in 1833, to gain his first impressions of the Islamic world. The French artist E. A. A. Dehodencq (1822–1882) even established his family in southern Spain while he went on artistic excursions to Tangier in the 1850s, and Henri Regnault (1843–1871) and Mariano Fortuny (1838–1874) also approached Morocco through a knowledge of Spain. Initially, at least, visitors restricted themselves to Tangier, where the city's large Jewish population gave a warmer welcome to Christian travellers than did the Muslims of the interior. Delacroix, while on the Comte de Mornay's diplomatic

expedition to the interior city of Meknes in 1832, found the experience of venturing into the streets intolerable. 'Christian dress and faces are anathema to those people' he wrote. 'One always has to be escorted by soldiers. I am escorted every time I go out by an enormous crowd of spectators who do not spare me the insults of dog, infidel, *caracco*, and who push towards me to grimace with contempt.'[34] Even as late as the 1890s, guidebooks were still advising that the short journey between the coastal towns of Ceuta, Tangier and Tetuan could not always be guaranteed free from attack by hostile tribesmen.[35]

Religious fanaticism and anti-Western feelings may have created problems in North Africa for the traveller, but by far the most difficult feat that a European could accomplish was the annual pilgrimage to Mecca performed by thousands of Muslims. Given that recognition as an unbeliever would bring death, only a handful of the most intrepid travellers ever managed to complete the journey. As early as 1812, J. L. Burckhardt had visited Mecca with a tribe of Bedouins. He lived to tell the story although he was obliged to hide the notes he was taking from his companions.[36] Sir Richard Burton, the inveterate adventurer, linguist, and subsequently consul, went on the pilgrimage in 1853. Dressed as an Arab *shaykh* but pretending to be a Pathan doctor, he supported his claims to Muslim identity with an excellent knowledge of Arabic and a fervent display of devotion to Islam.[37] Charles Doughty, who did not share Burton's fascination with Islam, also joined the Mecca caravan during his twenty months of wandering in the 'empty quarter' of north-western Arabia from 1876 to 1878. Such was the rashness of his undertaking in venturing into areas where no European had been before, that the Governor of Syria felt unable to give any guarantee of his personal safety. Nor did Doughty make life any easier for himself by attempting to disguise his Christian origins as Burton had done, a stubborness that nearly cost him his life.[38]

The majority of travellers, however, stayed within the territories charted by guidebooks and popular literature. Imbued with the attitude of confident superiority embodied in the guidebook assertion that Arabs 'occupy a much lower grade in the scale of civilisation than most of the Western nations'[39], tourists were not able, or did not wish to participate in local life to any significant degree. There were notable exceptions, of course, such as Lucie Duff Gordon, who became a figure of some consequence among the Egyptians at Luxor through ministering to the sick. But the average visitor neither overcame the frustration of the language barrier, nor stayed long enough to gain more than a superficial impression of Near Eastern life.

NOTES

1 W. Beattie, *Brief Memoirs of the Late William Henry Bartlett*, London, 1855, p. 20.
2 The Reverend Richard Pococke visited the Near East from 1737 to 1740 and James Bruce of Kinnaird travelled to Egypt and Abyssinia from 1768 to 1778.
3 Gleyre's diary quoted in P. Jullian, *The Orientalists*, Oxford, 1977, p. 136.
4 W. M. Thackeray, *Notes on a Journey from Cornhill to Grand Cairo*, London, 1846, pp. 278–79.
5 W. Holman Hunt, *Pre-Raphaelitism and the Pre-Raphaelite Brotherhood*, London, I, 1905, pp. 387–88.
6 E. Lear, *Journals of a Landscape Painter in Albania and Ilyria*, London, 1851, p. 92.
7 J. Ballantine, *The Life of David Roberts R.A.*, Edinburgh, 1866, p. 107.
8 P. Burty, *Lettres de Eugène Delacroix*, Paris, 1878, p. 121.
9 Letter from Renoir to Durand-Ruel dated March 1882, reprinted in *Renoir en Italie et en Algérie*, Paris, 1955, n.p.
10 Letter from Catherwood published in W. Bartlett, *Walks about the City and Environs of Jerusalem*, London, 1844, pp. 148–65.
11 For a full English bibliography see R. Bevis, *Bibliotheca Cisorientalia: An Annotated Checklist of Early English Travel Books on the Near and Middle East*, Boston, Mass., 1973.
12 Bayard Taylor, *Pictures of Palestine, Asia Minor, Sicily and Spain; or The Lands of the Saracens*, London, 1855, p. 291
13 *A Handbook for Travellers in Turkey*, 3rd ed., London, 1854, pp. 17–18.
14 pp. 25–26
15 Lady Strachey, *Letters of Edward Lear*, London, 1907, p. 106.
16 See Morgan-Vauthier, *Gérôme. peintre et sculpteur*, Paris, 1906, p. 224.
17 Baedeker, Egypt. *Handbook for Travellers. Part First: Lower Egypt . . . etc.* Leipzig, 1878, p. 16.
18 P. Lenoir, *Le Fayoûm, Le Sinaï et Pétra*, Paris, 1872, pp. 315–20.
19 Sir Franklin Lushington, 'A Leaf from the Journals of a Landscape Painter,' *MacMillan Magazine*, 75, pp. 421–25.
20 Major Fridolin, 'Scènes de la vie religieuse en Orient', *Revue des Deux Mondes*, Nouvelle période, 2e série, 1854, VI, p. 90.
21 See S. Searight, *The British in the Middle East*, London, 1979 ed., p. 229.
22 A. Edwards, *A Thousand Miles up the Nile* (first published 1876), London, 1982, pp. 2–3.
23 Lady Duff Gordon, *Letters from Egypt*, partial ed., London, 1865, 1983 ed.
24 A. Edwards, *op. cit.*, p. 41.
25 J. Ballantine, *op. cit.*, p. 104.
26 S. Searight, *op. cit.*, p. 230.
27 Lady Brassey quoted in Norman Daniel, *Islam, Europe and Empire*, Edinburgh, 1966, p. 50.
28 F. Steegmuller, *Flaubert in Egypt*, London, 1972, p. 54.
29 *Ibid*, p. 206.
30 C. Moreau-Vauthier, *op. cit.*, pp. 119–20.
31 W. Holman Hunt, *op. cit.*, I, p. 275.
32 See E. Fromentin, *Une Année dans le Sahel*, Paris, 1859, and *Un Eté dans le Sahara*, Paris, 1857.
33 See G. Guillaumet, *Tableaux algériens*, Paris, 1888.
34 P. Burty, *op. cit.*, p. 127.
35 See Murray's *Handbook to the Mediterranean*, London, 1890 ed. p. 5.
36 See J. L. Burckhardt, *Travels in Arabia, comprehending an Account of those Territories in Hedjaz which the Mohammedans regard as Sacred*, London, 1829.
37 Sir Richard Burton, *Personal Narrative of a Pilgrimage to El-Medinah and Mecca*, 3 vols., London, 1855–6.
38 C. Doughty, *Passages from Arabia deserta*, London, 1888, 1983, ed., pp. 290–92.
39 Baedeker, *op cit.*, p. 12.

MALCOLM WARNER

The Question of Faith: Orientalism, Christianity and Islam

Most nineteenth-century travellers in the Near East, whether painters, writers, archaeologists or tourists, were also pilgrims, the high point of whose journey was a visit to the Holy Land. Seeking not just the divine aura of Chateaubriand's 'land weathered by miracles', but eye-witness knowledge that would explain and confirm the Scriptures, they were pilgrims very much of the scientific age. With the first thorough, critical investigation of biblical sites made by the American scholar Edward Robinson in 1838, the foundation of the Palestine Exploration Fund in London in 1865 and the publication of its *Survey of Western Palestine* in 1881–84, styled as 'the most valuable contribution to the illustration of the Bible since its translation into the vulgar tongue', the middle years of the century were a boom period for biblical archaeology.[1] But this was just the academic manifestation of a prevalent feeling that it was important to find the roots of the Christian truth in a concrete, observable reality. In art, it showed itself first in the views of biblical sites produced by British topographical artists: the draughtsmen whose on-the-spot sketches were redrawn by Turner and others, and engraved by the Findens in the *Landscape Illustrations of the Bible* (1836), W. H. Bartlett and Thomas Allom, who illustrated John Carne's *Syria, the Holy Land, Asia Minor, etc.* (1836–38) and David Roberts in his volumes of lithographs published in the 1840s. As makers of visual records, they played a part that was gradually taken over, as the century progressed, by photography.

For other artists, the people, dress and customs of the contemporary Near East were as important a link with its biblical past as its geography and archaeological remains. It was generally accepted that these had been left miraculously unaffected by the passing millennia. When David Wilkie said that the Arabs 'look as if they had never changed since the time of Abraham', he was stating a commonplace.[2] 'The unchanged habits of the East', wrote Dean Stanley, 'render it a kind of living Pompeii.'[3] The idea went together with a concern that this source of religious knowledge would soon be polluted by contact with the West, that 'in a short time the exact meaning of many things which find their correspondences in the Bible will have perished.'[4] Modernisation in the Near East seemed almost a travesty; as Gustave Guillaumet said, 'you can hardly imagine Abraham coming forth from his tent to mix up some tarmac.'[5]

From seeing the Near East as a timeless, albeit imperilled world, it was a short step to finding the living image of figures and incidents from the Bible in everyday sights. Horace Vernet looked at an Arab girl in Algeria giving a soldier a drink at a well and saw Rebecca and Eliezer; David Roberts watched a caravan leave Cairo and imagined the Israelites carrying the Ark through the wilderness; W. J. Müller declared that a Holy Family, just fled from Bethlehem presumably, was to be seen in every Egyptian village.[6] The artist, more than any other traveller, was bound to notice the discrepancy between the scenes before him and the way scriptural subjects had traditionally been represented in Western art, with European facial types and vaguely classical draperies. The first to be forcibly struck by this was Horace Vernet in the 1830s. As a result, he undertook a campaign for a new, authentic kind of biblical painting. The Arabs, he argued, provided an accurate idea of how characters in the Bible really looked and modern religious art should take account of the fact, as Raphael and Titian would have done if as much information had been available to them. 'Once the connection between Arab manners and customs and those of the ancient Hebrews takes hold of your thoughts ... then the richest vein is yours to be mined!', he exclaimed in a letter of 1840. 'Here is the way to do something

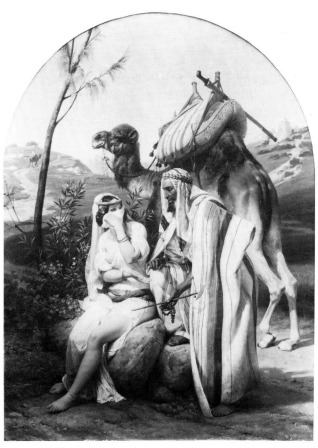

fig. 9 Vernet *Judah and Tamar* 1840 [Wallace Collection, London]

new that's not merely freakish' (fig. 9).[7] Vernet was primarily a military painter. He seems to have seen no contradiction in imagining the Arabs in Algeria as patriarchs and celebrating the French occupation of their country in a series of vast battle pictures. His own attempts to put his principle of veracity in biblical painting into practice are few and, despite what he said, more than a little freakish. But in his effort to bring religious art into line with modern knowledge, he set an important precedent.

Vernet concerned himself with Old Testament subjects. The first artist seriously to consider painting an authentic Near Eastern Christ, in an archaeologically accurate setting, was David Wilkie. He went to the Holy Land in 1841 but died on the return voyage to England, never bringing any of his projects for biblical pictures to completion. Wilkie translated Vernet's idea into Protestant terms, saying that 'a Martin Luther, in painting, is as much called for as in theology, to sweep away the abuses by which our divine pursuit is encumbered.'[8] But it is hard to imagine the leader of an artistic Reformation being as anxious as Wilkie was that the facts might turn out to be inconvenient. What if Christ and the disciples had eaten the Last Supper sitting in an undignified fashion on the floor? The task of the religious painter, he decided, must be to gather as much reliable information as possible, then 'to consider what will serve and what will not serve.'[9] He acknowledged that Christ ought to look Jewish but could not bring himself to show him as such, and in his unfinished *Christ before Pilate* used as his model a European-looking Persian prince.

Perhaps Wilkie would have recognised his Luther of painting in William Holman Hunt, member of the Pre-Raphaelite Brotherhood. Hunt's fellow Pre-Raphaelites, Rossetti and Millais, painted scenes from the lives of the Virgin Mary and Christ in London,

and their work, in its defiant refusal to idealise, can be called realistic. But Hunt went further, taking the Brotherhood's principles to their logical conclusion and insisting that to paint holy subjects, he must go to the Holy Land and see at first hand the places and the kind of people biblical painting purports to depict. To represent Christ among the doctors of the Temple, he must himself be among real Jews on the spot in Jerusalem (fig. 10). The resulting pictures were, like Hunt's previous work, replete with detailed, erudite symbolism that conveys their spiritual meaning. It was the amount of historical research, far beyond anything envisaged by Vernet or Wilkie, that made them innovatory. The word 'truth' is the keynote of everything Hunt said about his aims as a religious artist. 'Truth, wherever it leads, being above price, must increase the beauty of the story of the Divine Man', he told his friend Augustus Egg just before his first trip to the Near East in 1854. 'Art of the highest, illustrating it, has mostly dwelt upon the supernatural and ignored the human aspect.'[10] Hunt shared Wilkie's feeling that the painting of historically accurate bibilical pictures was a distinctly Protestant endeavour. Here was an alternative to the decadent Italian tradition of Catholic devotional art, an advertisement to the world that Protestantism could accept scientific enquiry as a means of approaching God.

The Orientalist vision of the Scriptures became familiar not only through exhibition pictures at the Salon and Royal Academy (and engravings after them), but also through illustrated editions of the Bible. The first of these to pretend to some degree of historical authenticity was Gustave Doré's of 1866, which contained a great deal of fantasy but a certain amount of Orientalist observation too. The Dalziel Brothers' *Bible Gallery*, begun in the 1860s and eventually published in 1880, included engravings after a

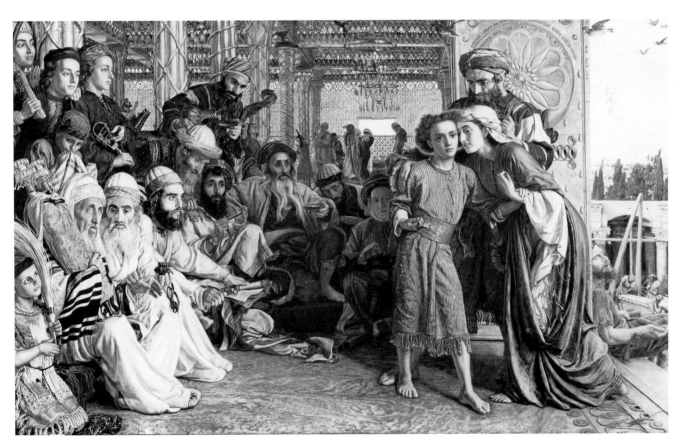

fig. 10 Holman Hunt *The Finding of the Saviour in the Temple* 1854–55 and 1856–60 [Birmingham Museum and Art Gallery]

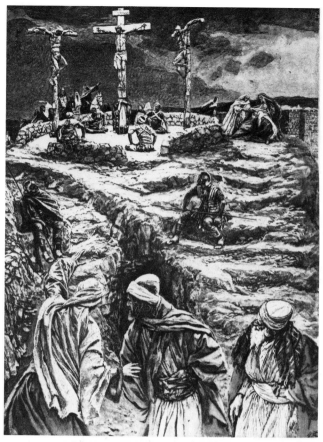

fig. 11 Tissot, 'Eloi, Eloi, Lama Sabachtani!', from
La Vie de Notre-Seigneur Jésus Christ,
vol. II, Tours, 1897

being headed by a Bedouin Jesus in an Arab Jerusalem', struck Théophile Gautier as undermining the whole dignity of the subject, moving him sternly to warn that 'those who islamicise sacred themes are on a dangerous path'.[13] Burne-Jones felt similarly that Tissot's authenticity got in the way of the real meaning of what he represented, that his *Annunciation* was all Arab costume and no Virgin Mary.[14] Eugène Fromentin, who devoted, probably, the fullest discussion to the issue in *Un Eté dans le Sahara*, concluded that 'to put the Bible into costume is to destroy it. It's like dressing a demi-god: you turn him into an ordinary mortal. Set the Bible in a recognisable location and it is no longer itself. You are making history of an anti-historical text. It is certainly necessary to find some kind of clothing for the essential idea, but, as the Old Masters realised, the best way to capture the truth is to simplify the form and eliminate all "local colour".'[15]

Though opposed to Orientalist paintings of Bible subjects, Fromentin could not but admit that the appeal of the Arabs was that they did retain 'that something we call "biblical", like a perfume of ancient times'.[16] Fromentin himself found this only in the very humblest scenes from Arab life, the 'Arab-ness' of which was not too insistent. For him, a Bedouin in full *burnūs* was a Bedouin and nothing more; a half-naked shepherd, on the other hand, might well turn his imagination to thoughts of Jacob tending the flocks of Laban. Most Orientalists were willing to see the shepherd as Jacob and the Bedouin as Abraham too. A great deal of Orientalist painting that is not explicitly biblical is none the less full of biblical resonances and to understand its meaning fully, the spectator must be willing, before the most contemporary-looking genre scene, to recognise its correspondence with some scriptural prototype.

The urge to find the Bible in the actuality of the Near East arose out of the crisis of religious faith in nineteenth-century Europe. The authority of Bible and Church, both Protestant and Roman Catholic, was being undermined, not just by famous controversies such as that surrounding Darwin, but by the spirit of scientific materialism that characterised the age. As Charles Lyell produced evidence against the biblical chronology in his *Principles of Geology* (1830) and Darwin against the Genesis account of the Creation in his *Origin of Species* (1859), thinking believers set about re-examining their faith, attempting, amidst much debate, disagreement and confusion, to sort out what they could still believe and what they could not. There was no shortage of critical writings on the Bible, the conclusions of which were all the more worrying for being supported by heavyweight German scholarship. In his *Geschichte des Volkes Israel bis Christus* (1843–52), for example, Georg Heinrich August von Ewald argued that Moses was the first historical figure in the Bible and that the patriarchs were entirely legendary. By 1900 this idea was to be widely accepted and not regarded as a serious threat to Christian belief, but in the mid century it seemed exactly that. There were any number of responses to the German school of biblical criticism and the general debate about religion and science. The most relevant to our theme is that of liberal Christians who accepted a little of the new learning but not too much, men such as H. H. Milman, Dean of St. Paul's, who prepared educated opinion in Britain for the impending shocks from Germany in his *History of the Jews* (1829) and would occasionally cause a stir during sermons by referring to Abraham as a *shaykh*.

The New Testament came in for the same kind of critical analysis and interpretation as the Old. For those whose faith rested on a conviction that the Gospels were historical fact, pure and simple, it was disturbing to read D. F. Strauss's *Leben Jesu* (1836)

number of artists, some idealised, the majority in the style of Holman Hunt, or by Hunt himself. But the most whole-heartedly 'Orientalised' of all the illustrated Bibles was by James Tissot. This featured not only well-researched impressions of sacred events, but also landscape views, maps, sketches of architecture and vignettes showing Near Eastern ethnic types. The Preface carried Tissot's assertion, crusading in tone but hardly original in 1896, that 'the imagination of the Christian world has been led astray by the fancies of artists'. The man putting it back on the right track in this case was a spiritualist and his images of the supernatural, especially his angels, had the air of the séance about them. For the rest, the Near Eastern details were painstakingly authentic, which of course lent credibility to the supernatural side. Tissot was well aware of his forerunners in this kind of project and determined to take the level of accuracy higher, basing his illustrations on countless sketches and photographs made in the Holy Land, and on authoritative archaeological texts. Through his designs he would tell the misguided Christian world, as he told his astounded father on returning from one of his research missions, that Calvary was not the sizeable hill usually depicted, but only 'from 20 to 22 feet high at the most' (fig. 11).[11]

The argument often raised against the literalist approach to the Bible was summed up by Charles Blanc when he criticised Vernet for 'sacrificing its broad, human side for the narrow, Arab side, replacing the substance with the shadow, the spirit of the thing with the letter of mere costume'.[12] A *Christ at the Pool of Bethesda* in the Orientalist manner by Charles Ronot, with *fellāḥīn*

and be told they were just myths embodying spiritual truth. Conventional belief was hardly reassured when Ernest Renan gave Christ back his historicity in the widely-read and influential *Vie de Jésus* (1863) but stripped him of his divinity. Writing in the Holy Land, working from on-the-spot observation like an Orientalist painter, Renan portrayed Christ the man, greatest of the sons of man but no greater than that, allowing a place in religion for the insights of the heart but definitely not for the supernatural. In being free from 'old religious priest teaching', Holman Hunt felt that his picture of *The Shadow of Death* (fig. 12) was 'more fitted by itself for the Renan class of thinkers who have been studying the life of Christ as one particular branch of history'.[17] Without agreeing with Renan's wholly materialistic approach,

Hunt, Wilkie and Tissot were in the same business of trying to create an image of Christ for the scientific age. As Hunt said, 'we must show that we are not afraid of the truth.'[18]

Some Christian thinkers were led by the same spirit of inquiry that was exciting debate over the veracity of the Holy Book to take an interest in other religious beliefs. The period saw the rise of Comparative Religion as a respectable academic discipline and it is no coincidence that, at the same time, European painters began to represent non-Christian worship in a fairly accurate, serious manner. If the biblical subject, authentically treated, is the first contribution of Orientalism to religious art, the second is the scene of worship, occasionally Jewish but in the vast majority of cases Muslim: the call to prayer, the prayer in the mosque, at the tomb,

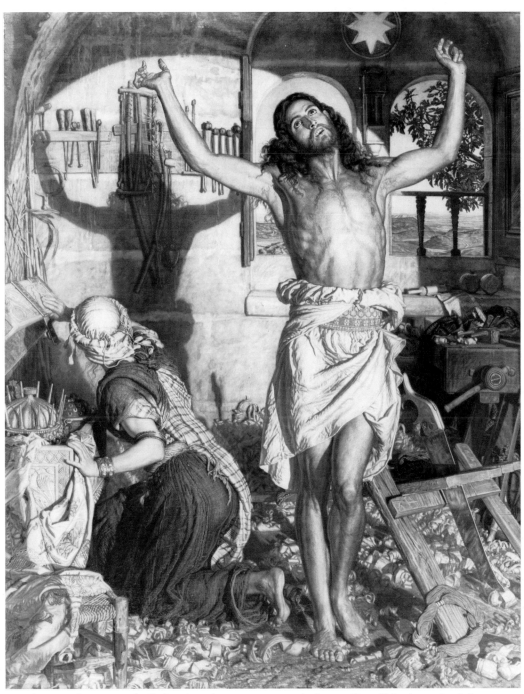

fig. 12 Holman Hunt *The Shadow of Death* 1870–73, retouched 1886 [City of Manchester Art Galleries]

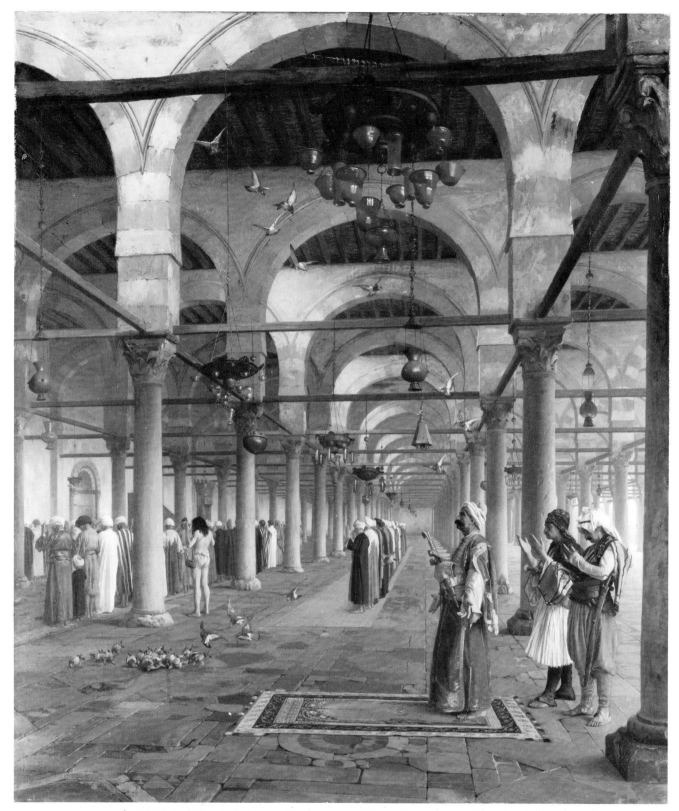

fig. 13 Gérôme *Prayer in the Mosque of 'Amr* *c.* 1872 [Metropolitan Museum of Art, New York]

on the rooftop and in the desert, and the pilgrim caravan bound for Mecca (figs. 13, 14).

By and large, the European view of Islam was ignorant and bigoted. Muslims were traditionally held to be superstitious, immoral, corrupt, cruel, and liable to commit fanatical outrages against Christians, an impression that reports of Turkish conduct during the Greek War of Independence and the massacres of 1860 in the Lebanon and Damascus did much to reinforce. David Roberts, who equated Islam with barbarism, demonstrates another aspect of the usual picture of the Muslim – his extreme laziness

– when he shows Arabs idling away their time chatting and smoking as the great monuments behind them crumble from neglect. On the other hand, there was a movement in European thought towards a view of Islam that was sympathetic and occasionally, though by no means always, well-informed. While condemning the fatalism of Muslims, Lamartine praised the depth of their faith, their charity, tolerance and administration of justice, claiming that the teaching of the *Qur'ān* is essentially no different from Christianity.[19] For Thomas Carlyle, Islam was 'a bastard kind of Christianity but a living kind, with a heart-life in it', and Muḥammad, far from the evil impostor of the normal European conception, was a great religious leader of unquestionable sincerity.[20] Richard Burton argued that whereas Christianity debased Man by conceiving of him as a fallen being, Islam exalts and teaches respect for human dignity.[21]

For many, the principal attraction of the Islamic world was its supposed voluptuousness. Muslim men were thought to be dedicated sensualists (an idea that Muslims themselves would have found astonishing) and Islam a religion without morality. The harems and slave markets of Orientalist painting held a prurient fascination as places where Christianity did not apply, where the would-be adventurer could, in his imagination, indulge his every carnal desire. The degree of eroticism would have been unthinkable in images of life in contemporary Europe. But with the Near East there was an excuse, since the work of a 'peintre ethnographe' such as Gérôme was ostensibly a matter of scientific observation. It was the stuff of sexual fantasy with the appearance of a documentary record. It titillated its audience and at the same time confirmed 'objectively' their assumption that the people it depicted were morally inferior.[22]

The Orientalist portrayal of all-male gatherings of Muslims at prayer might seem just a corollary to the idea of the Muslim as lord of the harem, an apotheosis of the men's club. This may well have been part of the meaning of the subject, but it seems to have carried other, genuinely religious implications as well. In their devotion, as in their dress, Muslims were looked upon as a relic of another age, and it was quite usual to compare Islam with European Christianity in the Middle Ages. Eugène-Melchior de Vogüé, for example, declared that 'the intellectual and social horizons of the Islamic world are in many respects comparable to those of our medieval forefathers'.[23] The association was strengthened by the widely-held belief that Gothic architecture, enjoying revival as a link with the Age of Faith, was Islamic in origin. Some were moved to reflect on the Muslim kind of mentality as a good thing disastrously lost to modern Europe. Describing the evening prayer of pilgrims to Mecca, Major Fridolin wrote: 'There before your eyes is the East, just as Muḥammad left it so long ago, just as it will endure until the spirit of incredulity and revolt, the so-called Enlightenment, will undermine the edifice of Islam as it has undermined society and Christianity in Europe.'[24] Fridolin was expressing the mood of nostalgic religiosity that fostered countless paintings of 'primitive' devotion, images of Muslim worship by Orientalists as well as scenes of peasant piety in Europe, especially among Bretons in picturesque folk costume.

In 1839–40 the painter Frédéric Goupil-Fesquet, visited the Near East with Horace Vernet and saw Muslims at prayer in a mosque. 'A holy respect comes over the spectator in the presence of this silent gathering', he wrote. 'The expression of humility and veneration imprinted on every face, which no distraction can alter, gives their features a stately grandeur that seems to harmonise with the building itself. Prayer makes all men equal: the half-naked *fellāḥ* next to the rich man in his silk *qufṭān* and

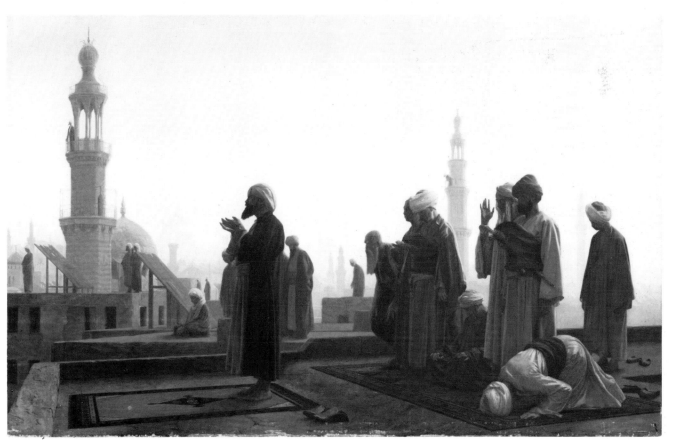

fig. 14 Gérôme *Prayer on the Rooftops* 1865 [Kunsthalle, Hamburg]

gold-embroidered turban, his ornate weapons removed for the moment, both believing in the same God, both come to worship with the same fervour.'[25] When Gérôme went to the area in 1868, he also took a friend and fellow artist who documented their travels. This was Paul Lenoir, whose account of their visit to the Mosque of Sultān Hasan in Cairo is of particular interest, not only because it sums up the sense of inadequacy that could be felt by the modern Christian at an exhibition of 'medieval' piety, but also because of Gérôme's special concern with the mosque interior as a subject. 'The thing that strikes you most when you visit mosques is their exclusively religious, almost poetic, atmosphere. These are not our pretty-pretty Parisian cathedrals, nor our phoney-Greek temples, which are just theatres where the performance is the Mass. Seeing quiet, serious Arabs prostrate themselves without affectation before the wall of the mihrāb, I could not help thinking of my good old Madeleine, where the one-o'clock service is just like the opening night of a show . . . In Cairo, it's fanaticism if you like, but at least it's real religious faith, and it expresses itself without any of that elegant, frivolous piety that characterises the Roman Catholic mosque back home.'[26]

The Arab of the desert was even more likely to be regarded as shamingly devout than his urban counterpart. The desert of the European imagination is harsh but also purgative, conducive to deep religious thought, a place in which to communicate with the Godhead. The idea is an ancient one of course, and many are the prophets and saints who spent periods of meditation in the wilderness. Richard Burton found in the desert 'the type of Liberty, which is Life' and was constantly aware of 'the idea of Immensity, of Sublimity, of Infinity'.[27] The fact that the three great revealed religions of Judaism, Christianity and Islam originated in the Near East was attributed to the influence of the desert and men such as Burton assumed the Bedouin to be possessed of an instinctive godliness by virtue of his environment. The scene of Arabs praying in the desert was a stock Orientalist subject. In his *Tableaux algériens*, Gustave Guillaumet provided what could be an accompanying line for his own (fig. 15), or almost any other treatment of the theme: 'The murmur of piety, which no temple imprisons, spreads its harmony into the infinity of the universe.'[28]

The image of the Arab at prayer appealed far more in Roman Catholic France than Protestant Britain, perhaps because of the Protestant's reluctance to set any store by the outward forms of worship. In France there was a traditionalist current of opinion within the Church that ran against those who would try to reconcile religion with modern science, advocating instead an uncompromising return to the rule of faith and transcendental revelation. By the 1870s it constituted a 'Catholic Revival'.[29] A conspicuous manifestation of this was the upsurge in pilgrimages, notably to the new centre of Lourdes, a parallel to the interest in the pilgrimage to Mecca shown by many Orientalist artists and writers. The Catholic Revivalists looked longingly to Islam, as they looked to the Middle Ages, as a pre-scientific society bound together by religious belief. Before becoming a leading scholar of Islam, Henri de Castries served during the 1870s as an officer in the colonial cavalry in Algeria. His feelings on seeing the Muslim troops under his command engaged in communal prayer came out of a yearning for religious identity felt by a large section of the Catholic community: 'I heard the invocation "Allah akbar!" ring out loud and clear. God is Supreme! That simple concept of divinity took on a meaning in my soul beyond anything theology or metaphysics had taught me. I was struck down by an inexpressible malaise, a mixture of shame and anger. I felt that, in this moment of prayer, these Arab cavalrymen, so subordinate just a short time ago, were asserting their superiority over me. How I wished I could have cried out to them that I too believed, that I too knew how to worship my God!'[30]

There was sympathy, respect, reverence and occasionally envy towards Islam, but very few conversions. Among painters, the case of Alphonse-Etienne Dinet, who settled in Algeria, became a Muslim, made the pilgrimage to Mecca and became Hadj Nasr Ed Dine Dini, may well be unique. For the most part, painters of devout Muslims no more thought of converting to Islam than painters of devout Bretons thought of becoming peasants. Given the traditional distaste of Muslims for the representation in art of living creatures, an attitude derived from verses in the *Qur'ān*

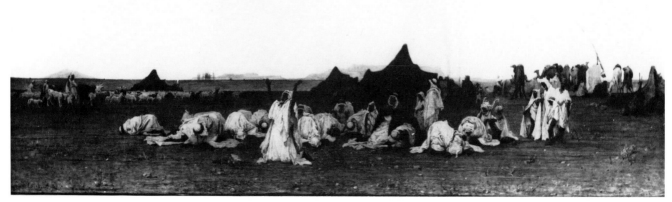

fig. 15 Guillaumet *Arabs Praying in the Desert* 1863 [Musée d'Orsay, Paris]

forbidding idolatry, the idea of painting Islamic devotion was in a sense anomalous. Furthermore, the naturalistic style in which most scenes of Muslim worship were treated implied a scientific, fact-finding approach that was alien to the transcendental state of mind they depicted. They embodied a relationship between European and Muslim, some would say an essentially colonialist relationship, in which there was little or no potential for common experience or communication. Like the harem or slave market scene, they suggested both fascination with the subject and distance from it. They ostensibly held up Muslims as a model of devotion yet at the same time, by the means of representation, emphasised the gulf between 'us' and 'them'. The scenes of 'primitive' religion treated in a correspondingly 'primitive' style by Gauguin and his followers were a resolution of this contradiction. Developing from the idea that religious content could reside in style as much as subject, the main form of religious art in the twentieth century has been abstract.

The issue at stake in the portrayal of Islam in nineteenth-century art was not Islam at all, but Christianity. Both types of Orientalist religious subject, the Muslim and the biblical, illustrated arguments arising from the debate on what relationship, if any, could exist between Christianity and science in the modern world. Biblical Orientalism expressed the desire of the liberal Christian to reconcile his religion as far as possible with modern knowledge and show, to borrow Holman Hunt's phrase, that he was not afraid of the truth. The painter of Muslim devotion represented the more reactionary face of Christianity, the yearning for the old days when religion was a matter of Faith. This meant not trying to take science on at its own game but producing evidence of what the scientific mentality was destroying. The Orientalist painter was not an innocent eye. His vision of the Near East was conditioned by his own concerns as a European and a Christian. Looked at from the religious point of view, as from others, Orientalism tells us something about the Near East but far more about the state of mind of nineteenth-century Europe.

NOTES

1 See Robinson's *Biblical Researches in Palestine, Mount Sinai and Arabia Petraea*, London, 1841, and F. Jones Bliss, *The Development of Palestine Exploration*, London, 1906.

2 A. Cunningham, *The Life of Sir David Wilkie*, London, 1843, III, p. 442.

3 *Lectures on the History of the Jewish Church*, Part I, London, 1863, p. 11.

4 Palestine Exploration Fund, *Twenty-One Years' Work in the Holy Land*, London, 1886, p. 19.

5 *Tableaux algériens*, Paris, 1888, p. 85.

6 See A. Durande, *Joseph, Carle et Horace Vernet. Correspondance et biographies*, Paris, 1864, p. 329; J. Ballantine, *The Life of David Roberts, R.A.*, Edinburgh, 1866, p. 109; N. Neal Solly, *Memoir of the Life of William James Müller*, London, 1875, p. 71.

7 Durande, *op. cit.*, p. 149. A brief survey of biblical Orientalism amongst French painters, beginning with Vernet, is given in J. Alazard, *L'Orient et la peinture française au XIXe siècle, d'Eugène Delacroix à Auguste Renoir*, Paris, 1930, pp. 131–34.

8 See Cunningham, *op. cit.*, p. 427. For a scholarly account of British Orientalism, with special reference to Wilkie, Roberts, Holman Hunt and J. F. Lewis, and containing many insights into the religious aspect of their work, see K.P. Bendiner, 'The Portrayal of the Middle East in British Paintings 1835–1860', Ph.D. thesis, Columbia University, 1979.

9 Cunningham, *op. cit.*, p. 376.

10 W. Holman Hunt, *Pre-Raphaelitism and the Pre-Raphaelite Brotherhood*, 2nd edition, London, 1913, II, pp. 255–56.

11 For a fuller account of Tissot as an Orientalist biblical painter, and his artistic and archaeological sources, see the exhibition catalogue *J. James Tissot, Biblical Paintings*, Jewish Museum, New York, 1982, especially the essay 'Tissot's Illustrations for the Hebrew Bible' by Gert Schiff.

12 *Une Famille d'artistes. Les Trois Vernets. Joseph – Carle – Horace*, Paris, 1898, pp. 160–63.

13 *Les Beaux-Arts en Europe*, 2nd series, Paris, 1855, II, p. 19.

14 G. Burne-Jones, *Memorials of Edward Burne-Jones*, London, 1904, II, p. 281.

15 1874 edition, pp. 79–80.

16 *Ibid.*, p. 81.

17 See Tate Gallery, *The Pre-Raphaelites*, 1984, cat. no. 143.

18 'Religion and Art', *Contemporary Review*, January 1897, LXXI, p. 50.

19 See his *Souvenirs, impressions, pensées et paysages pendant un voyage en Orient*, Paris, 1835.

20 See 'The Hero as Prophet. Mahomet: Islam' in *On Heroes, Hero-Worship and the Heroic in History*, London, 1841. For discussions of the image of Islam in Europe, with reference mostly to literature, see Byron Porter Smith, *Islam in English Literature*, Beirut, 1939; P.K. Hitti, *Islam and the West. A Historical Cultural Survey*, Princeton, 1962; N. Daniel, *Islam, Europe and Empire*, Edinburgh, 1966; S. J. Nasir, *The Arabs and the English*, London, 1976; and, most recent and most provocative, E.W. Said, *Orientalism*, New York, 1978. Said defines Orientalism as 'a Western style for dominating, restructuring, and having authority over the Orient' (p. 3).

21 See his essay 'El Islam, or the Rank of Muhammedanism among the Religions of the World', probably written in 1853, in *The Jew, the Gypsy and El Islam*, London, 1898.

22 Linda Nochlin has analysed Orientalist painting using the methods applied to literature by Edward Said in her article 'The Imaginary Orient', *Art in America*, May 1983, vol. 71, pp. 118–31, 187–91, to which the present author is indebted.

23 *Syrie, Palestine, Mont Athos: Voyage aux pays du passé*, Paris, 1876, p. 74.

24 'Scènes de la vie religieuse en Orient', *Revue des Deux Mondes*, 1 April 1854, nouvelle période, 2° série, 16, p. 96.

25 *Voyage en Orient fait avec Horace Vernet en 1839 et 1840*, Paris, 1843, p. 99.

26 *Le Fayoum, le Sinaï et Pétra. Expédition dans la Moyenne Egypte et l'Arabie Petrée sous la direction de J. L. Gérôme*, Paris, 1872, pp. 167–68.

27 *Personal Narrative of a Pilgrimage to El-Medinah and Meccah*, London, 1855–56, I, p. 149. On the British fascination with the desert, see Kathryn Tidrick, *Heart-beguiling Araby*, Cambridge, 1981.

28 *Tableaux algériens*, Paris, 1888, p. 139.

29 See Richard Griffiths, *The Reactionary Revolution. The Catholic Revival in French Literature, 1870–1914*, London, 1966.

30 *L'Islam: Impressions et études*, Paris, 1896, p. 4.

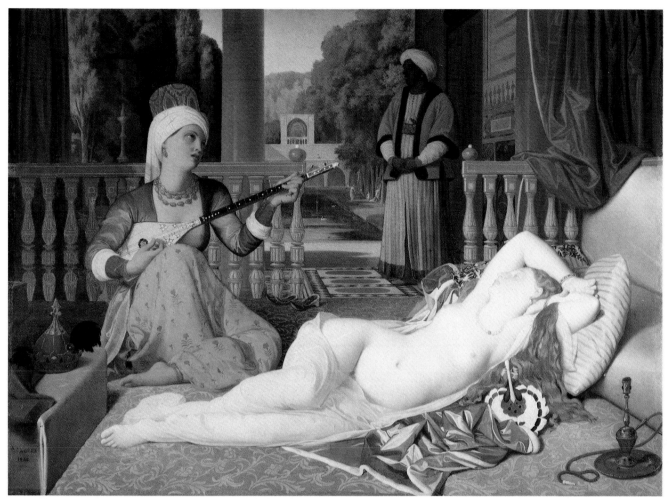

80 Ingres *Odalisque and Slave*

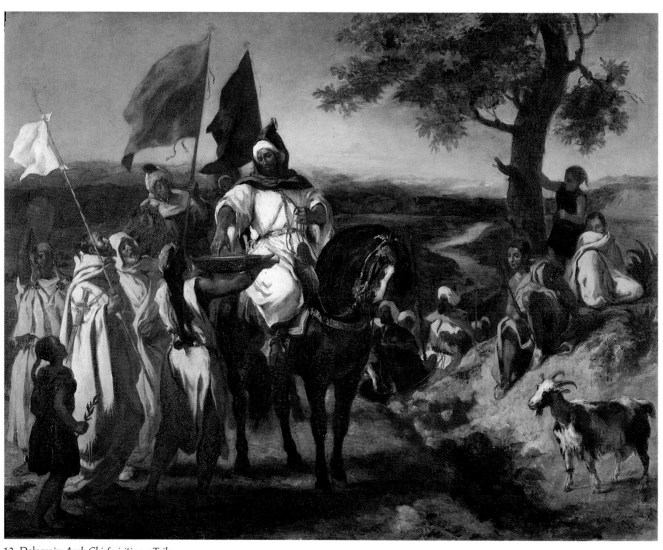

12 Delacroix *Arab Chief visiting a Tribe*

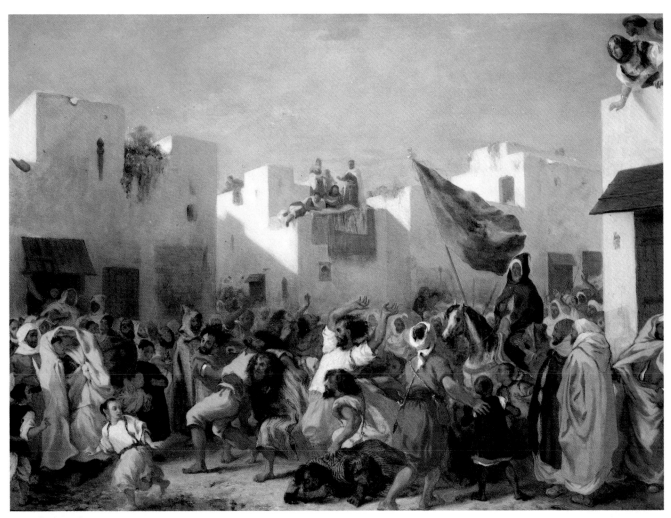

13 Delacroix *The Fanatics of Tangier*

16 Delacroix *The Lion Hunt*

17 Delacroix *The Collection of Arab Taxes*

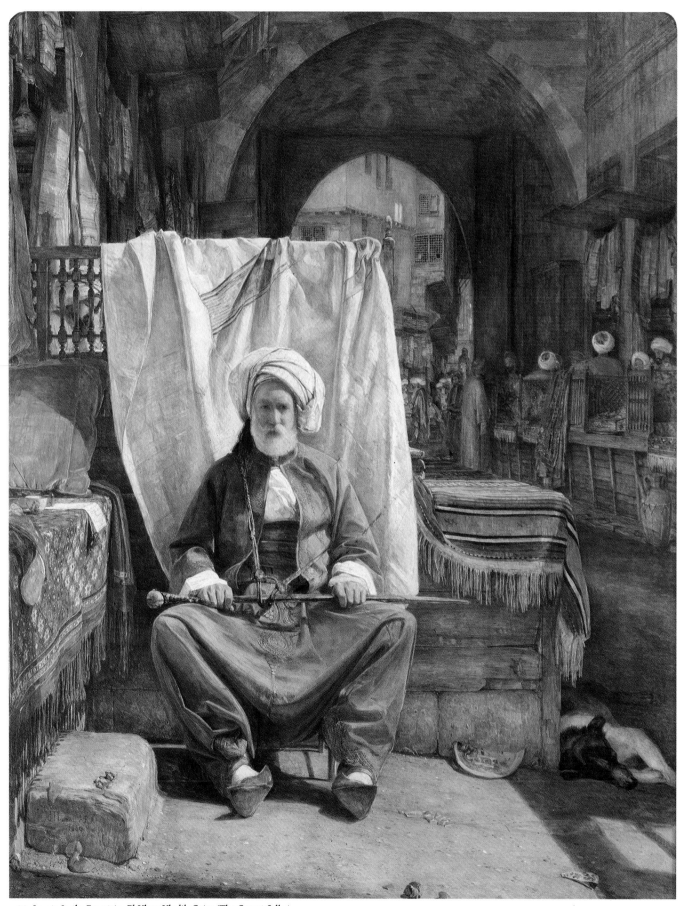

90 Lewis *In the Bezestein, El Khan Khalil, Cairo (The Carpet Seller)*

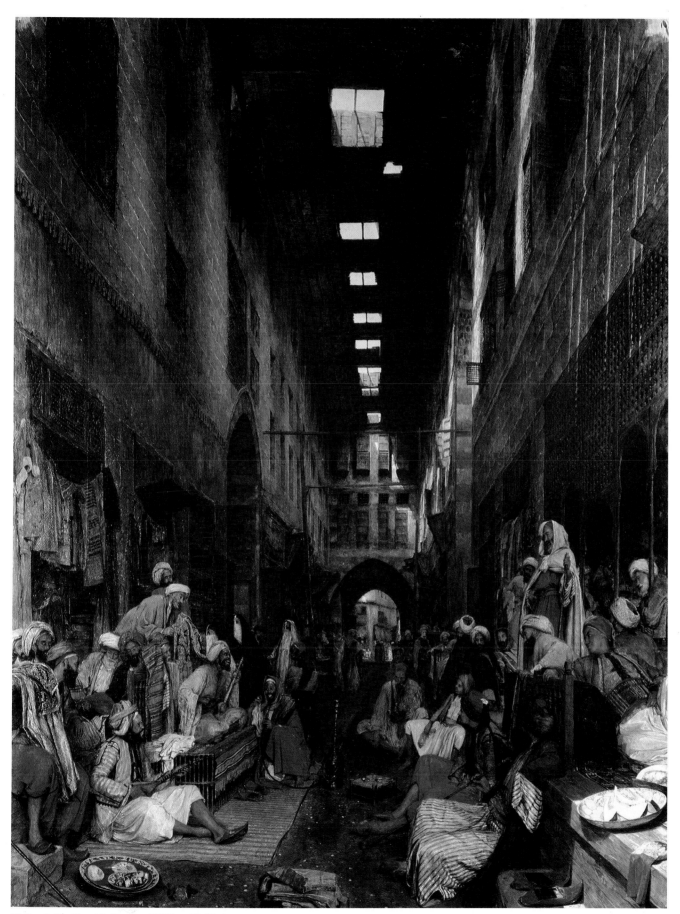

96 Lewis *The Bezestein Bazaar of El Khan Khalil, Cairo*

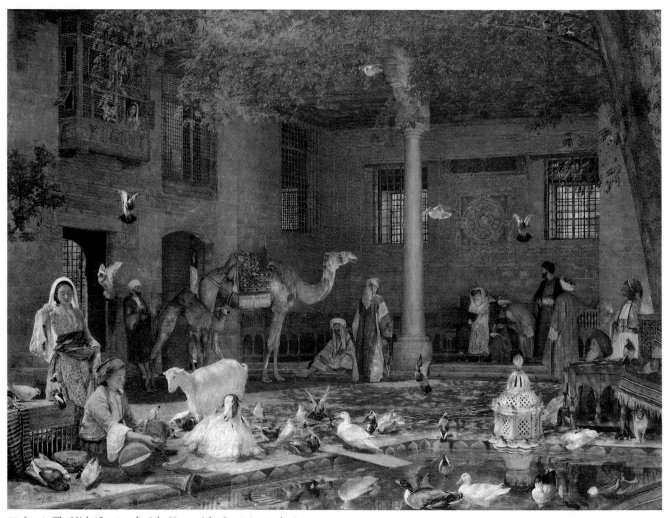

92 Lewis *The Hósh (Courtyard) of the House of the Coptic Patriarch, Cairo*

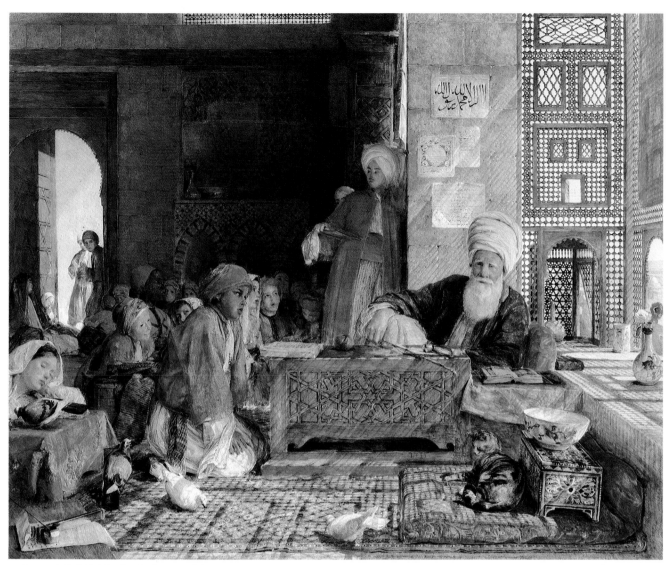

93 Lewis *A Turkish School in the Vicinity of Cairo*

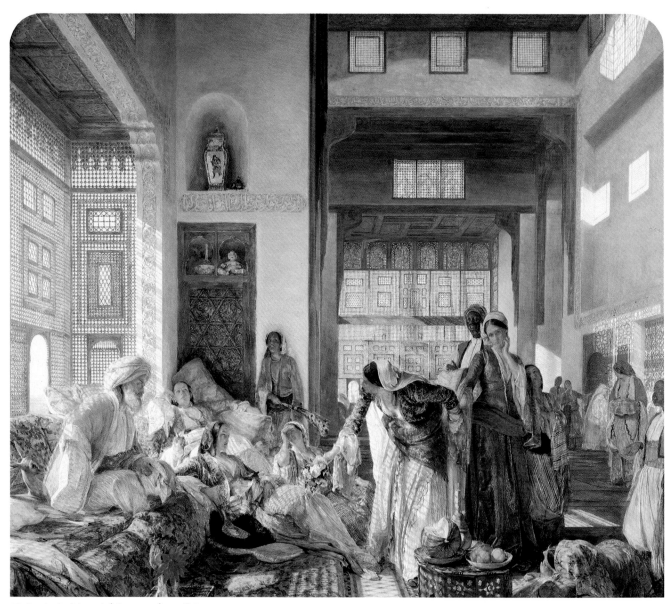

95 Lewis *An Intercepted Correspondence, Cairo*

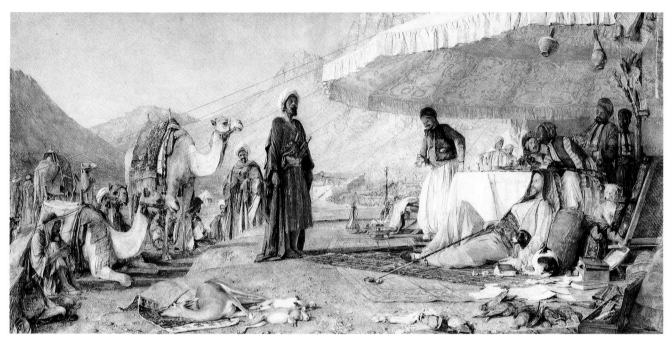

89 Lewis *A Frank Encampment in the Desert of Mount Sinai, 1842 – The Convent of St. Catherine in the distance*

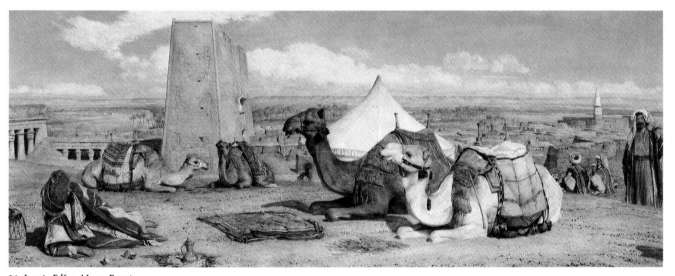

91 Lewis *Edfou, Upper Egypt*

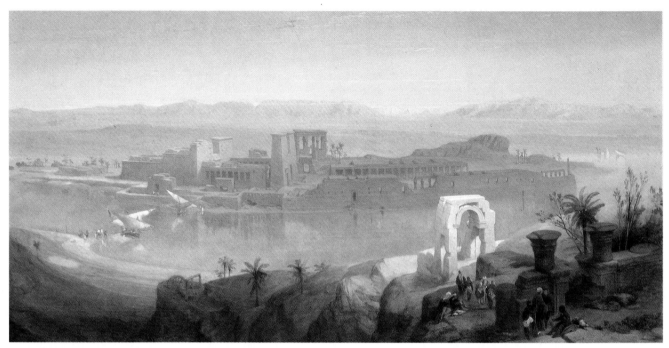

112 Roberts *The Island of Philae, Nubia*

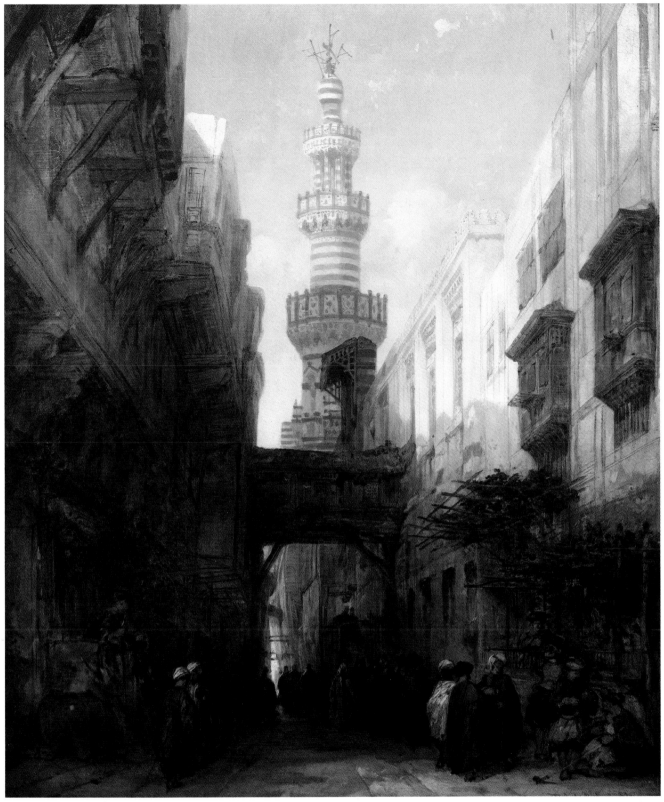

113 Roberts *A Street in Cairo*

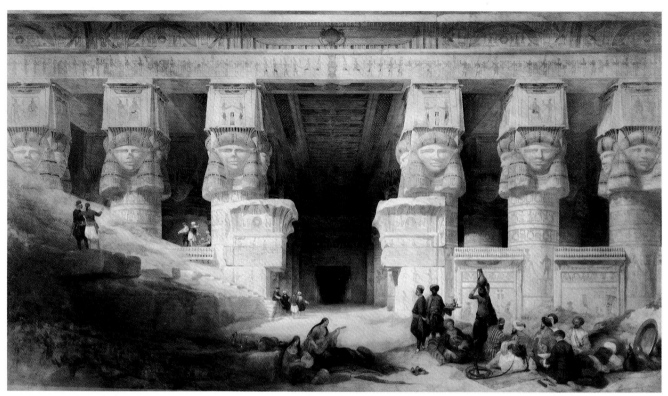

110 Roberts *The Temple of Dendereh*

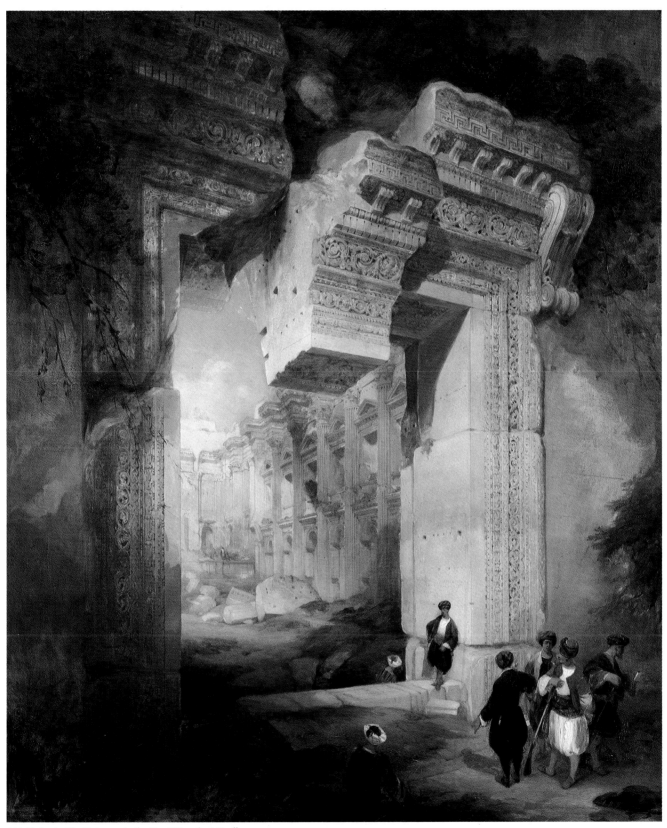

111 Roberts *The Gateway to the Great Temple at Baalbec*

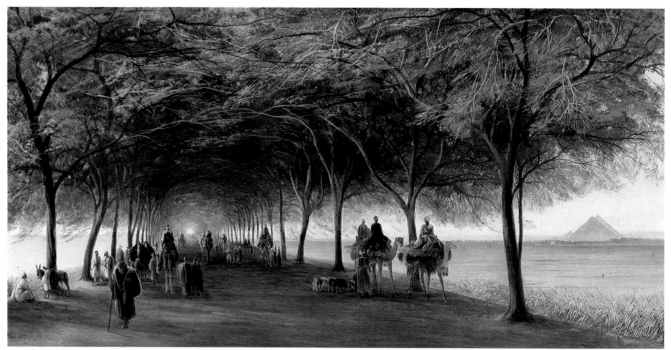

85 Lear *The Pyramids Road, Gizah*

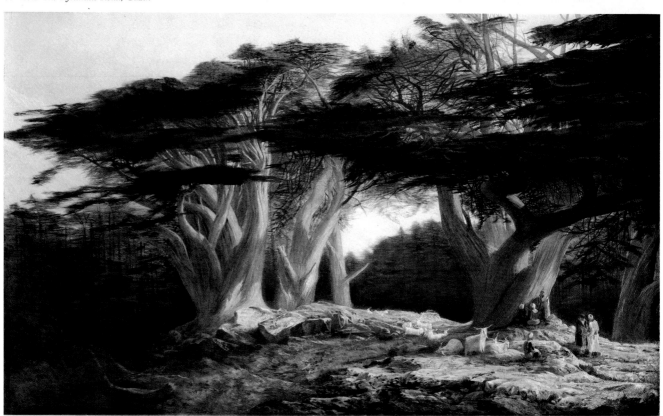

84 Lear *The Cedars of Lebanon*

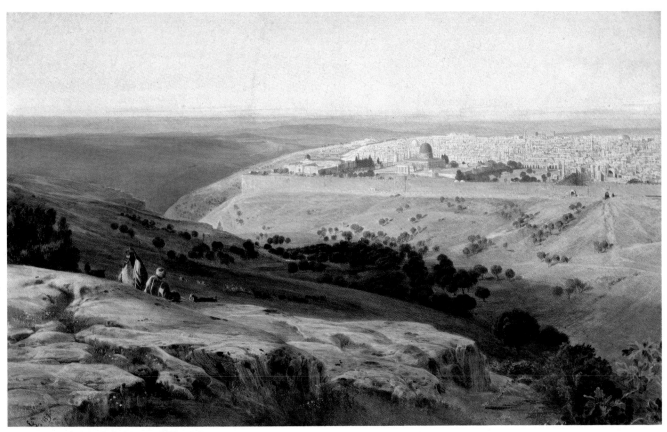

83 Lear *Jerusalem from the Mount of Olives, Sunrise*

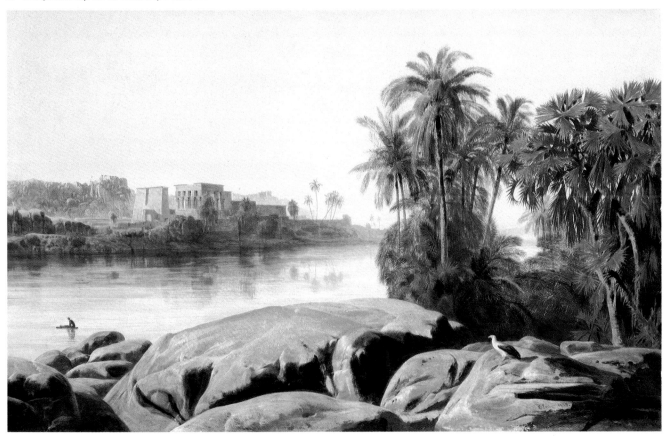

82 Lear *Philae on the Nile*

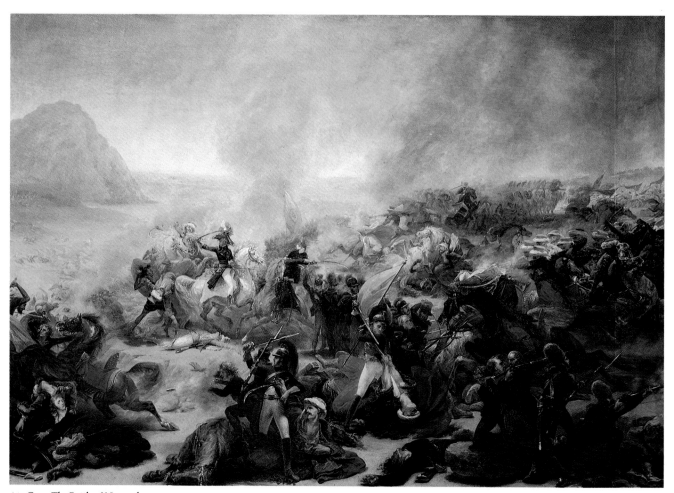

64 Gros *The Battle of Nazareth*

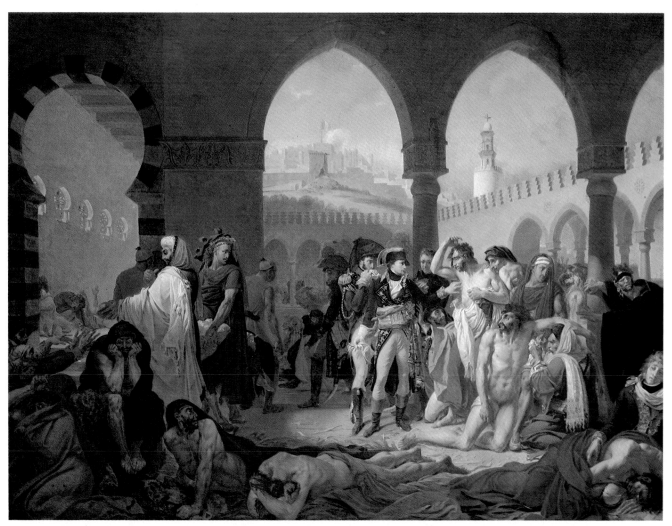

65 Gros *The Pesthouse at Jaffa*

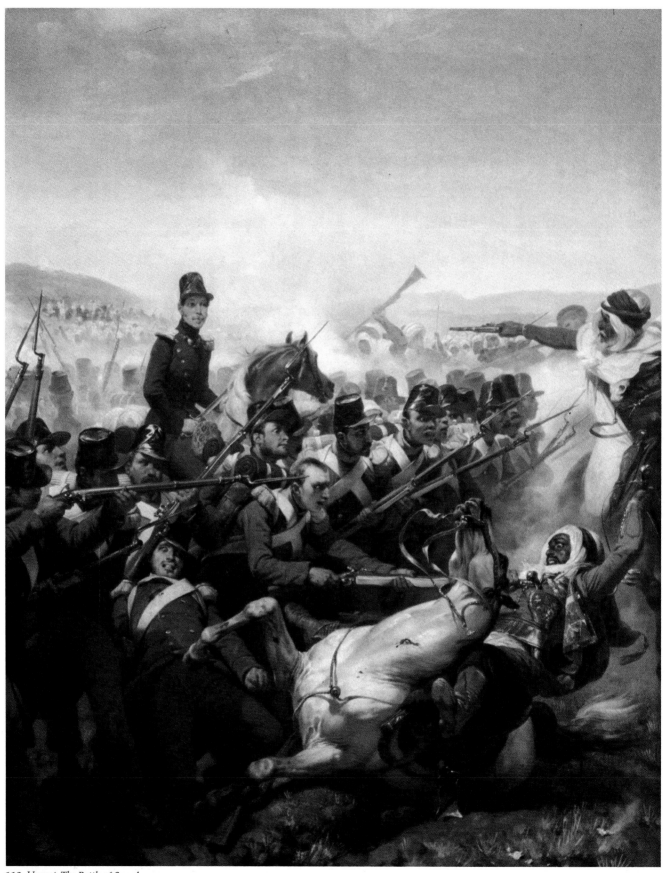

119 Vernet *The Battle of Somah*

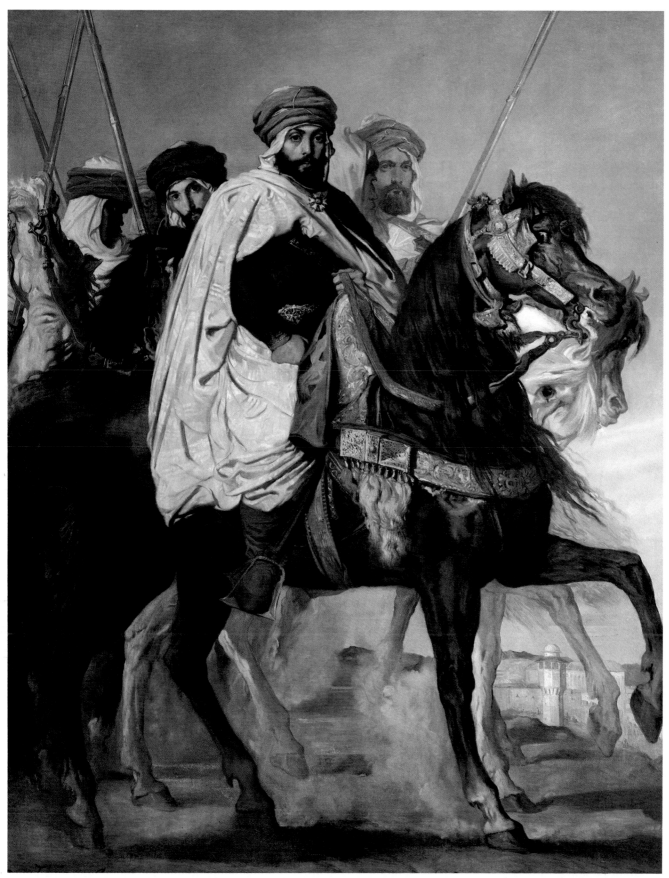

8 Chassériau *Ali Ben Hamed, Caliph of Constantine, followed by his Escort*

36 Gérôme *The Muezzin's Call to Prayer*

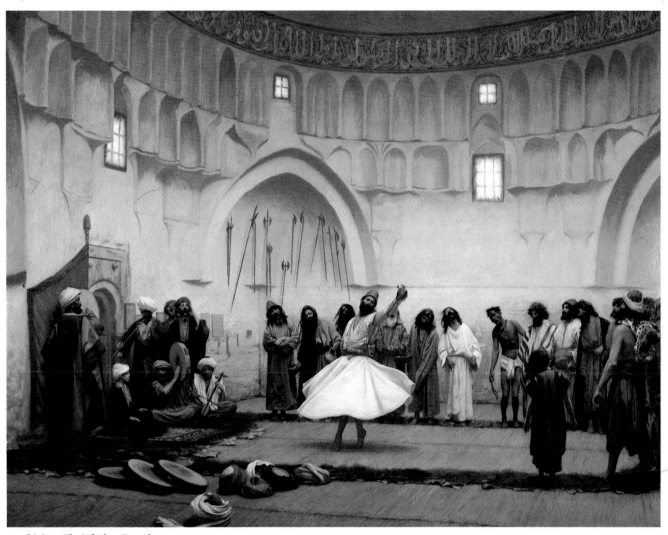

39 Gérôme *The Whirling Dervishes*

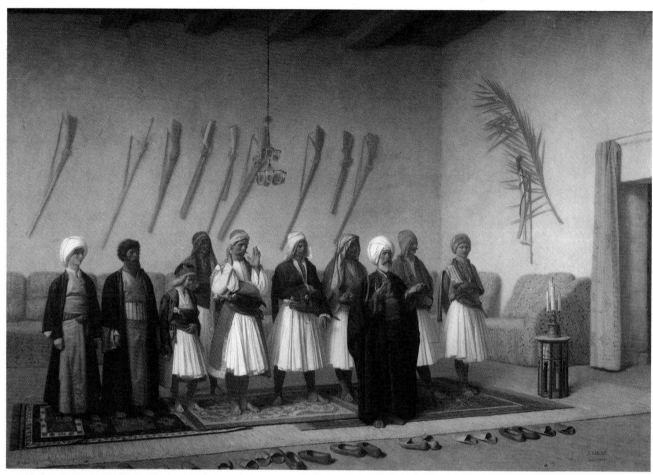

28 Gérôme *Prayer in the House of an Arnaut Chief*

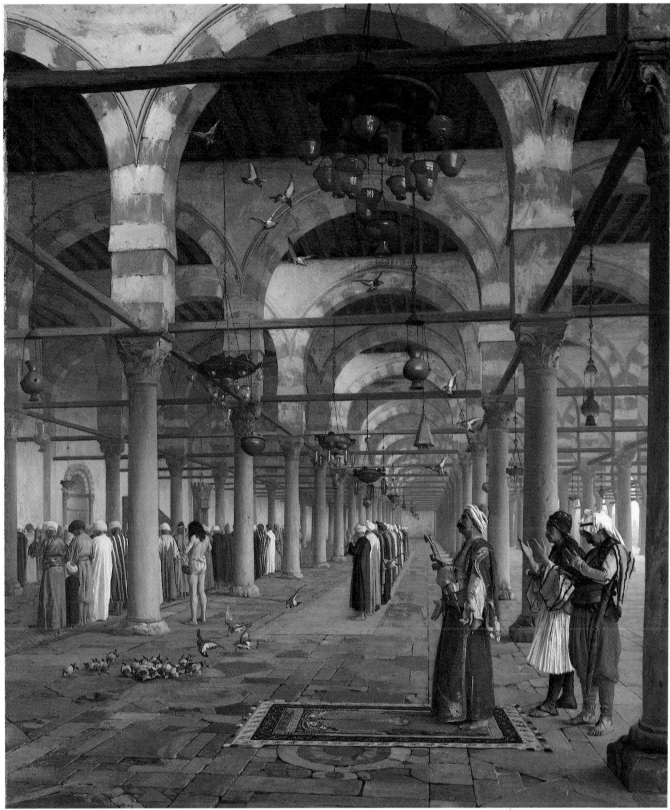

32 Gérôme *Prayer in the Mosque of 'Amr*

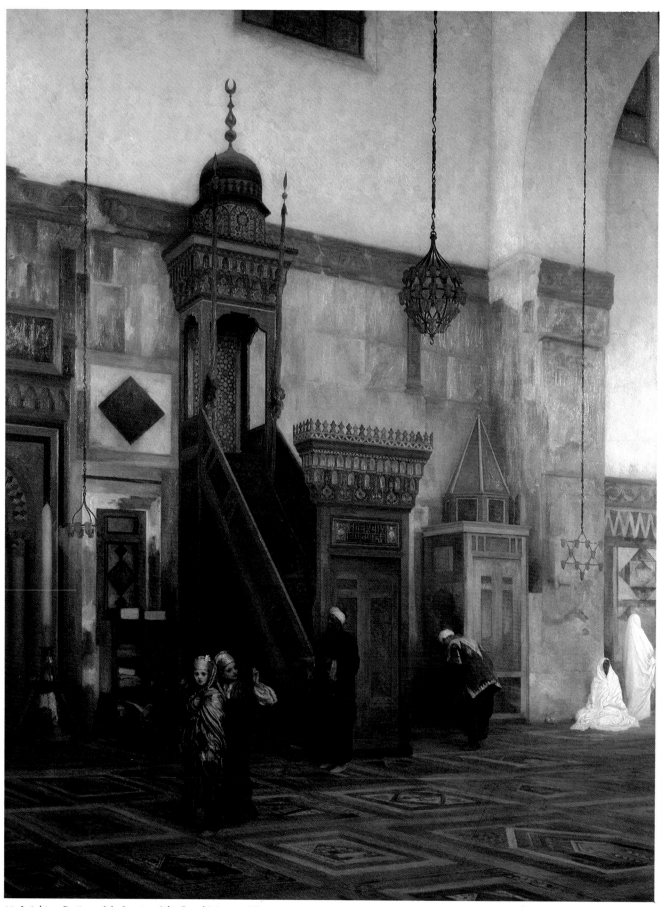

88 Leighton *Portions of the Interior of the Grand Mosque of Damascus*

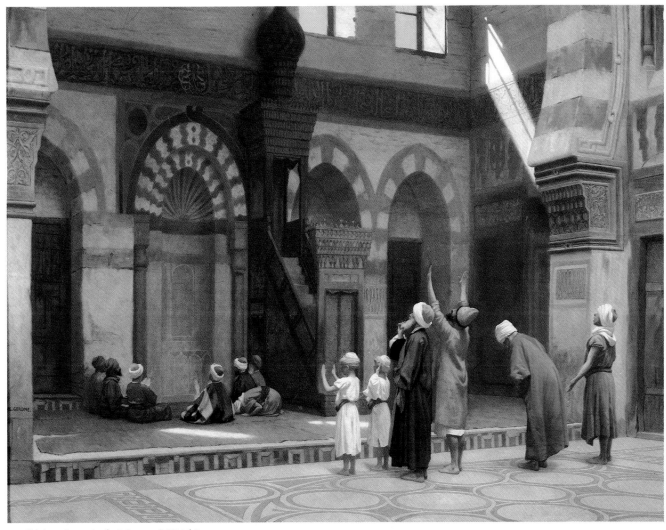

38 Gérôme *Prayer in the Mosque of Qāyt-bāy*

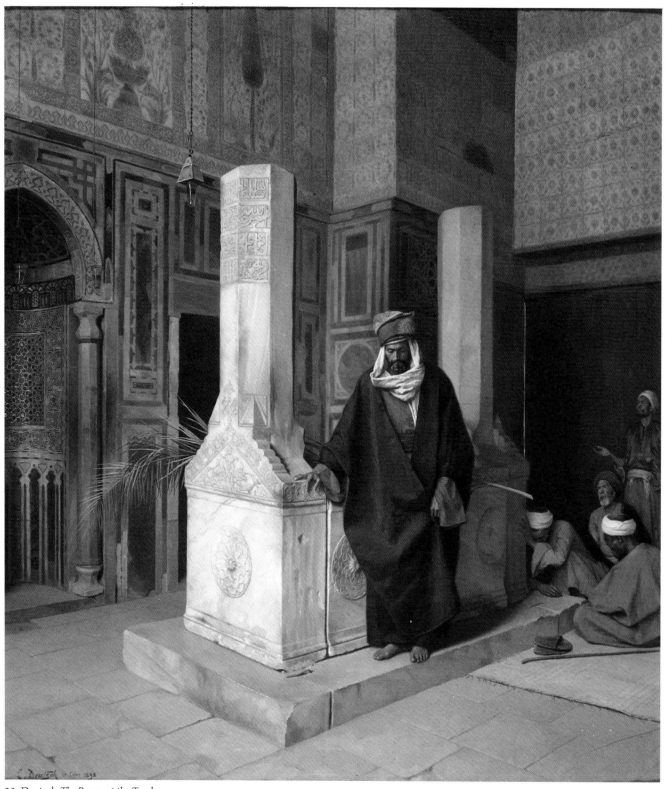

20 Deutsch *The Prayer at the Tomb*

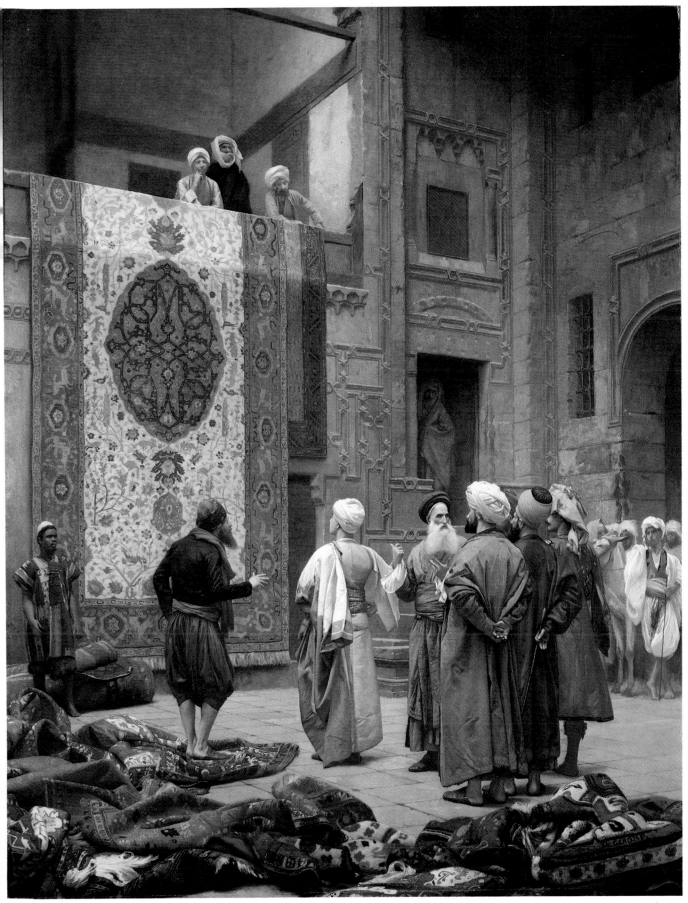

37 Gérôme *The Carpet Merchant*

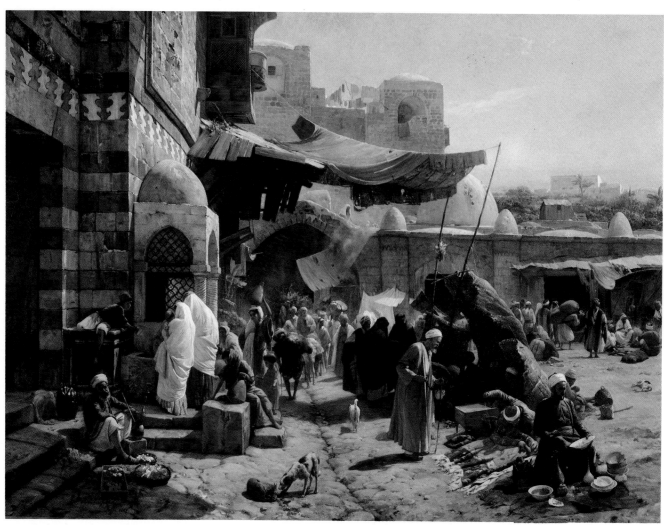

1 Bauernfeind *Market in Jaffa*

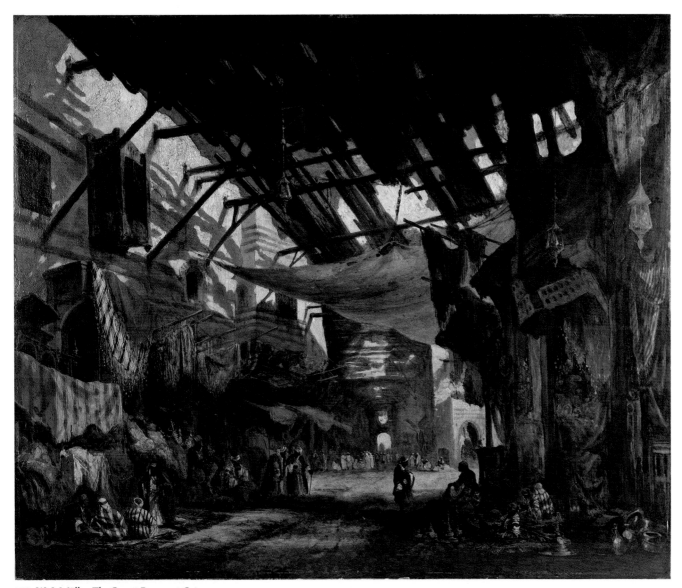

103 W. J. Müller *The Carpet Bazaar at Cairo*

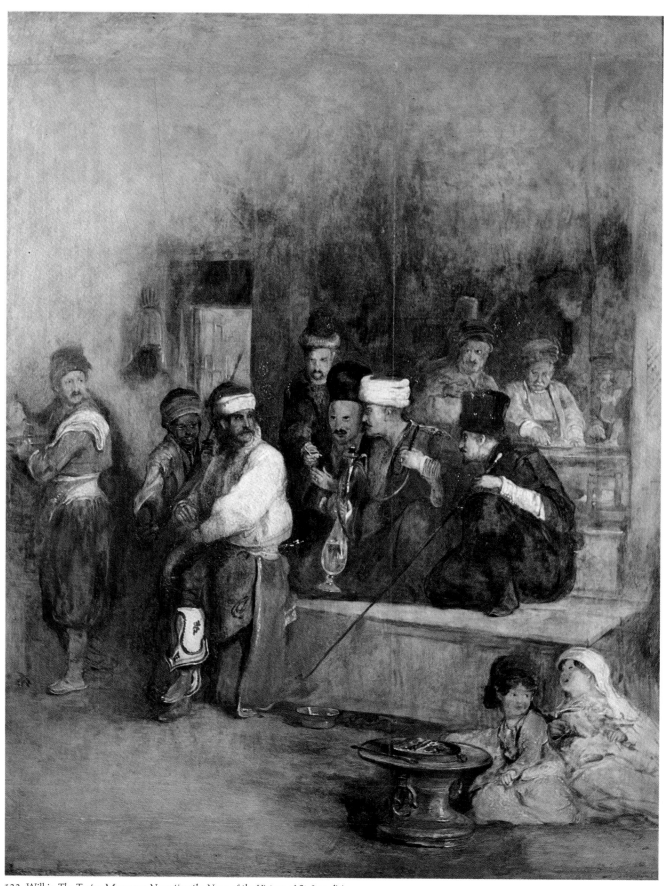

122 Wilkie *The Tartar Messenger Narrating the News of the Victory of St. Jean d'Acre*

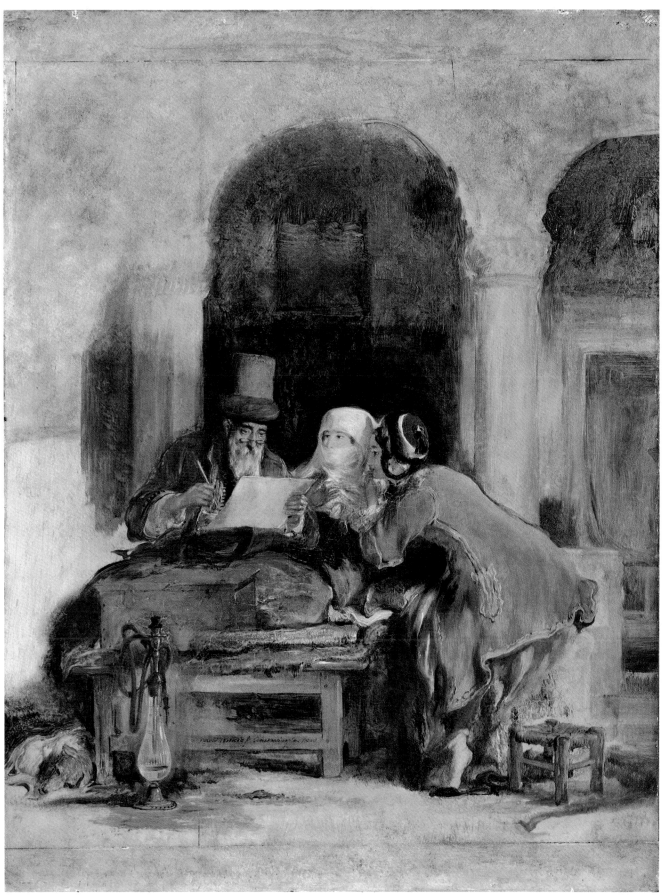

121 Wilkie *The Turkish Letter Writer*

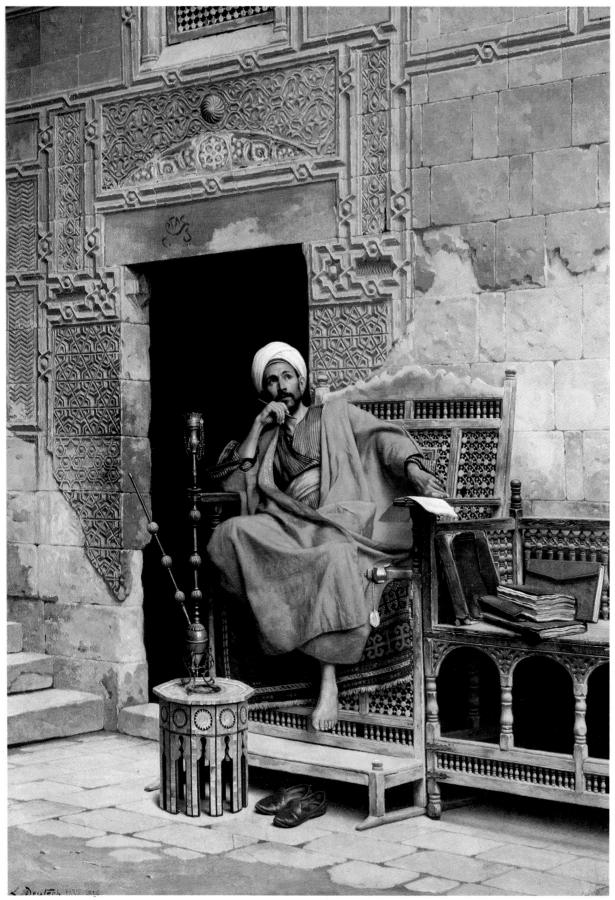

19 Deutsch *The Scribe*

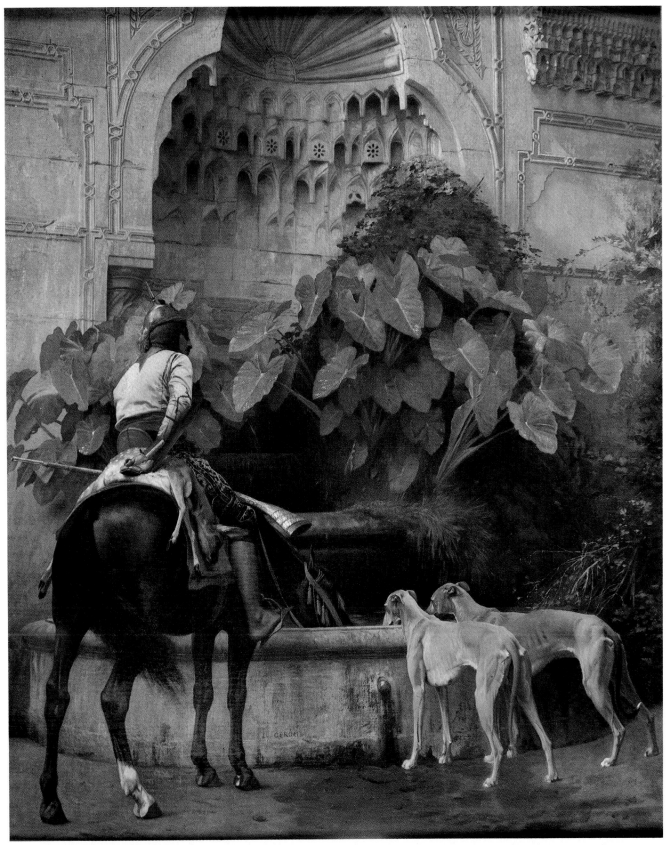

35 Gérôme *The Return from the Hunt*

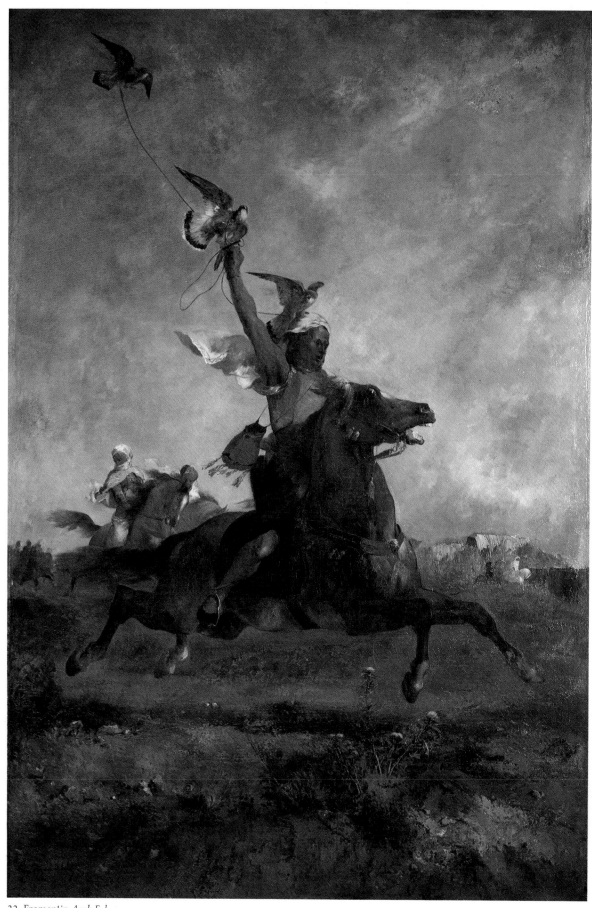

22 Fromentin *Arab Falconer*

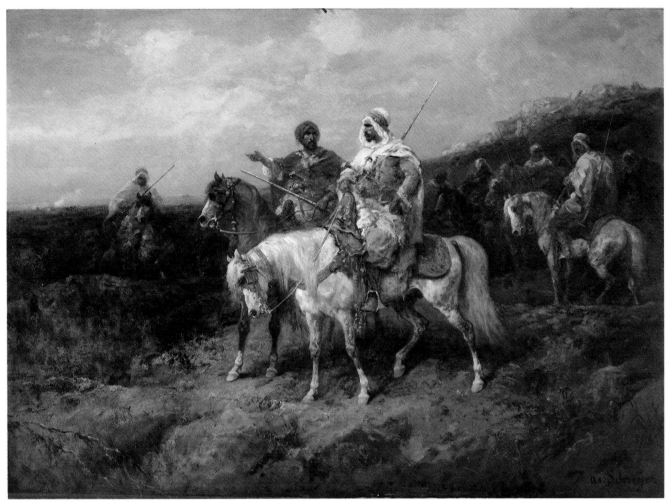

114 Schreyer *Arab Horsemen*

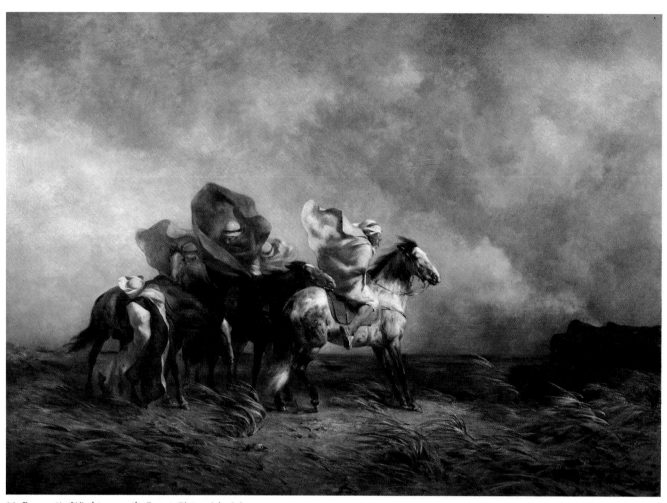

23 Fromentin *Windstorm on the Esparto Plains of the Sahara*

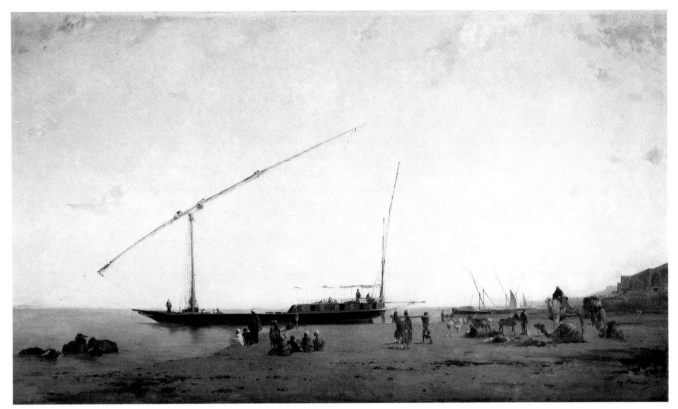

25 Fromentin *Dahabeeyah on the Nile at Luxor*

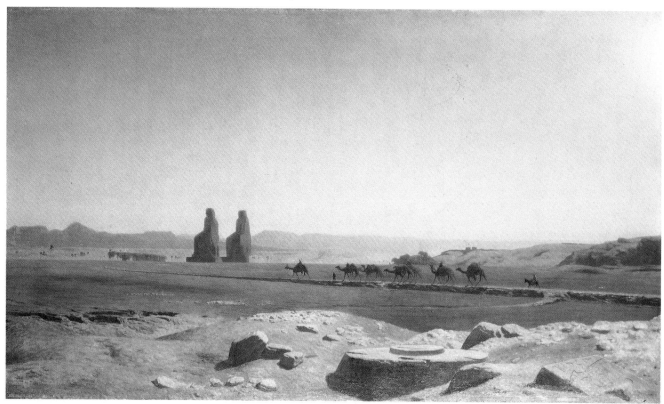

26 Gérôme *The Plain of Thebes, Upper Egypt*

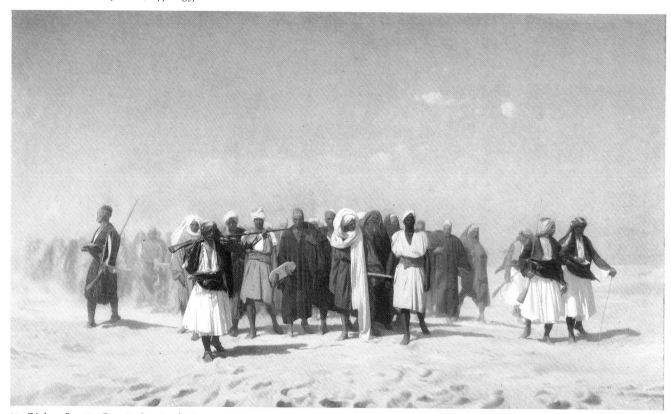

27 Gérôme *Egyptian Recruits Crossing the Desert*

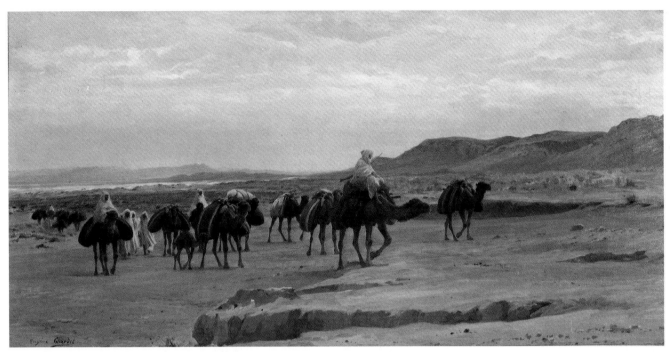

40 Girardet *Salt Caravans in the Desert*

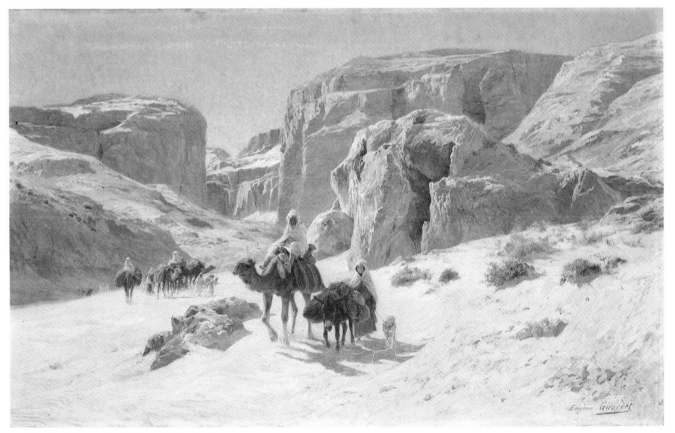

42 Girardet *Caravans in the Dunes at Bou-Saada*

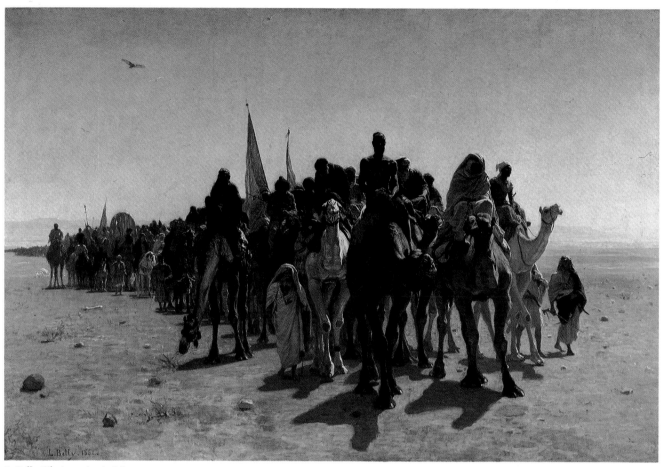

3 Belly *Pilgrims going to Mecca*

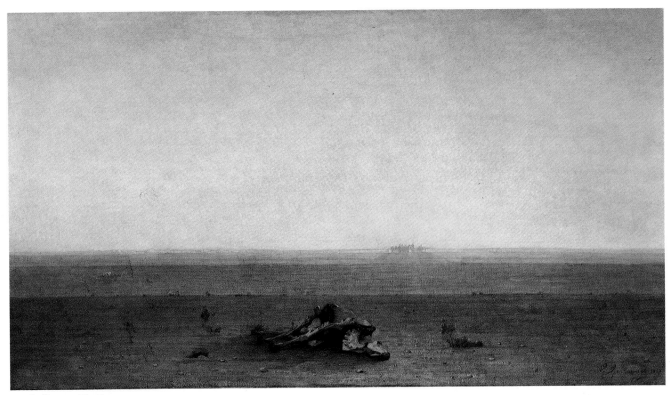

67 Guillaumet *The Desert*

41 Girardet *The Tailor's House in an Arab Town*

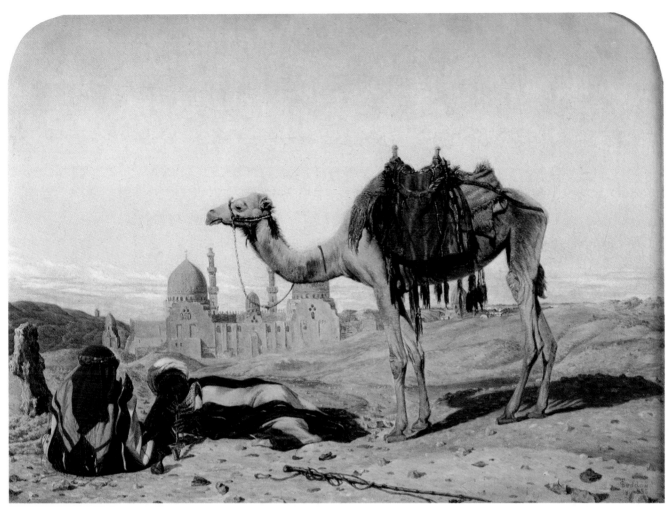

116 Seddon *Dromedary and Arabs at the City of the Dead, Cairo, with the Tomb of Sultan El Barkook in the background*

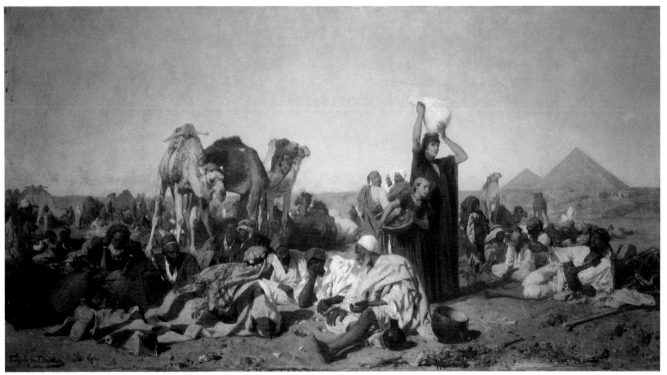

102 L. C. Müller *Encampment in the Desert at Gizah*

85

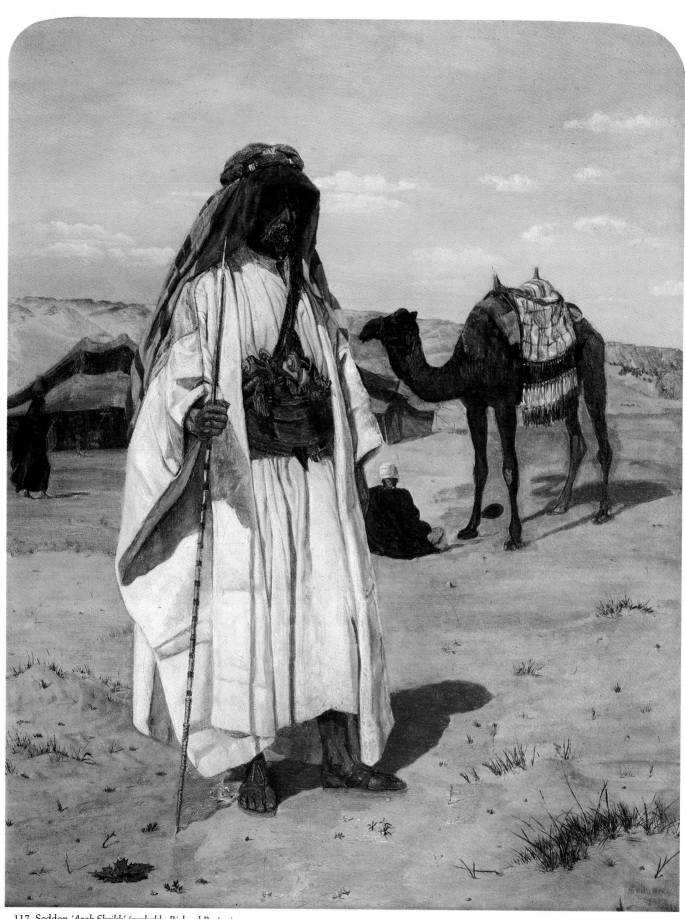

117 Seddon *'Arab Sheikh' (probably Richard Burton)*

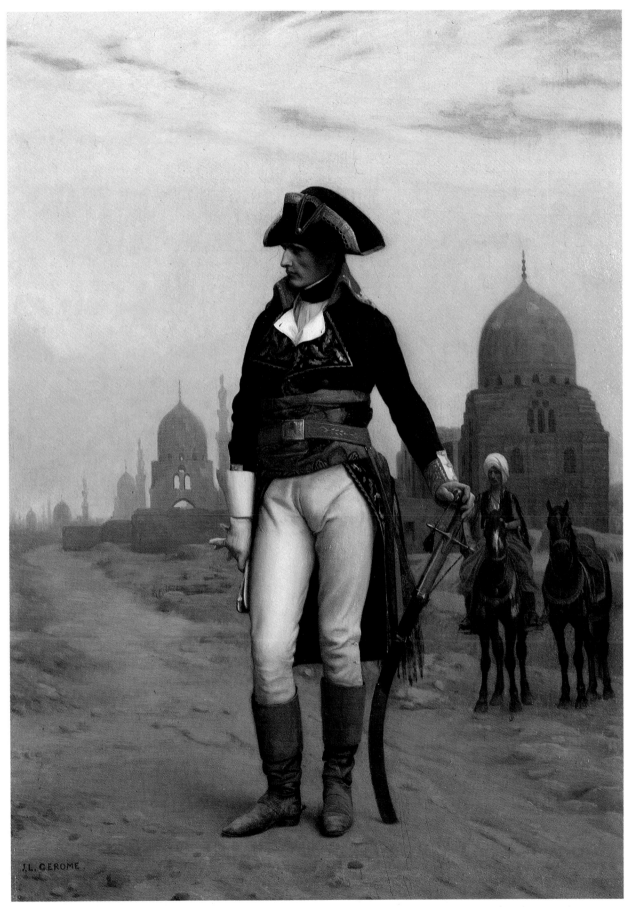

30 Gérôme *General Bonaparte in Cairo*

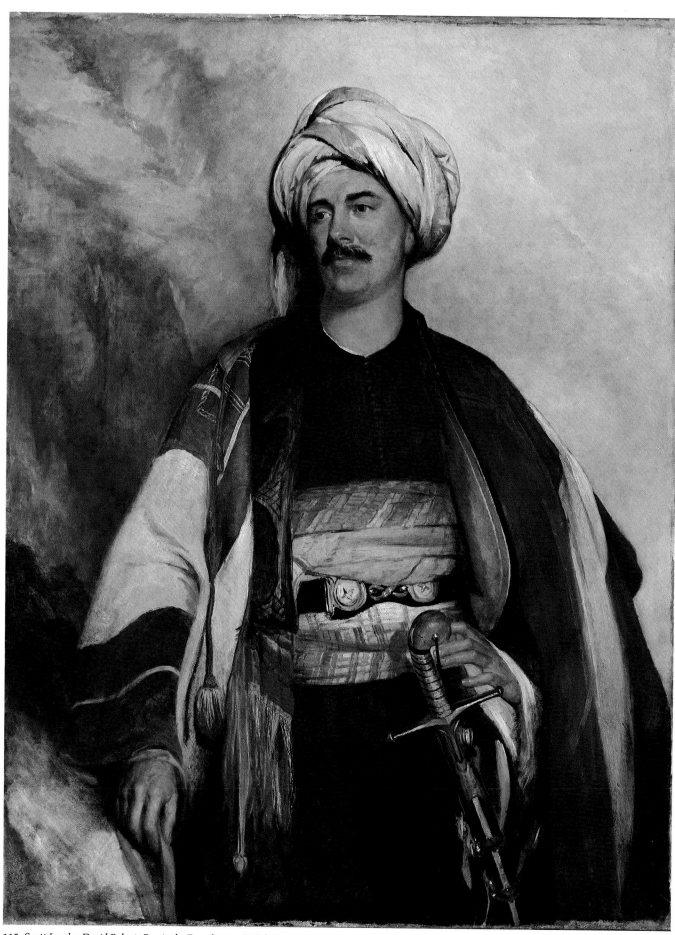

115 Scott Lauder *David Roberts Esq. in the Dress he wore in Palestine*

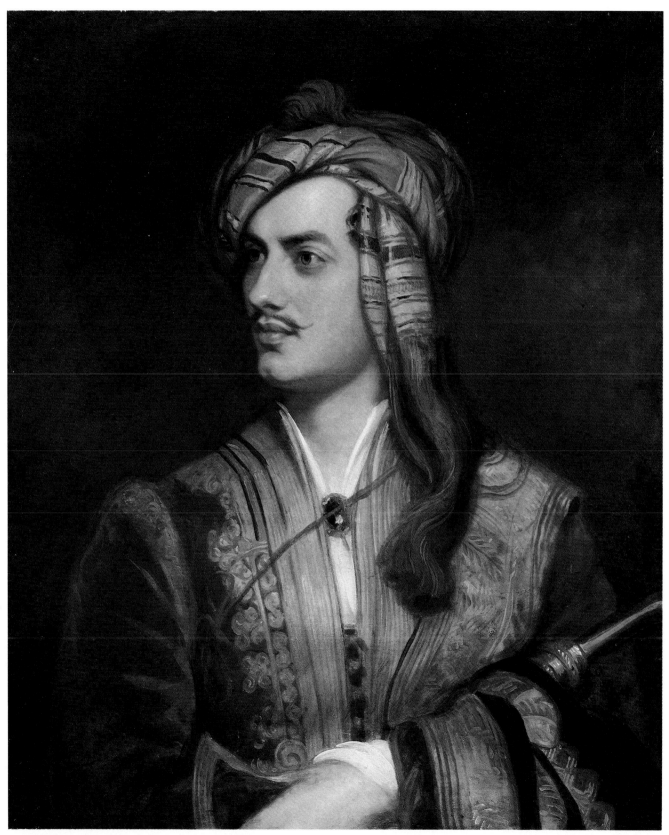

105 Phillips *Portrait of Lord Byron*

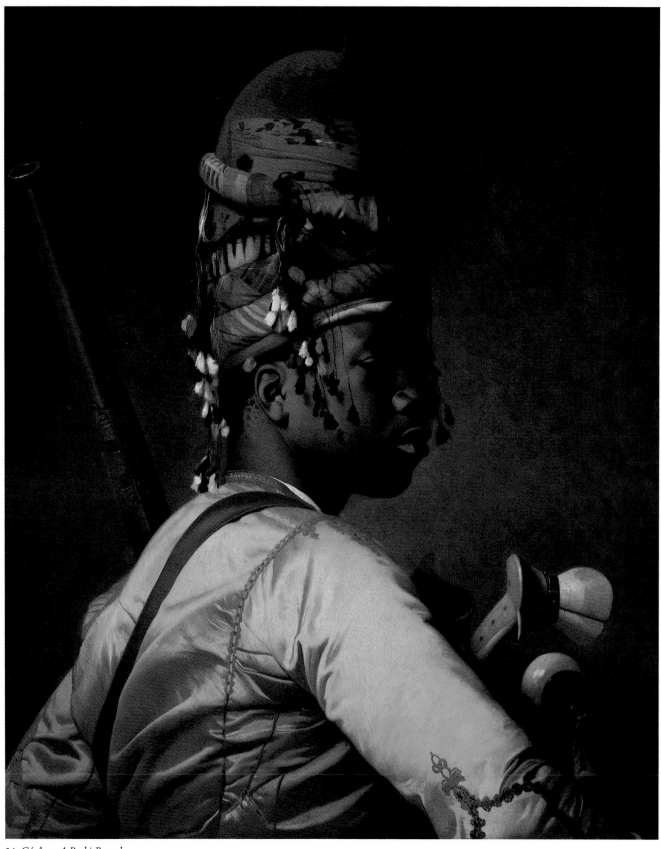

34 Gérôme *A Bashi-Bazouk*

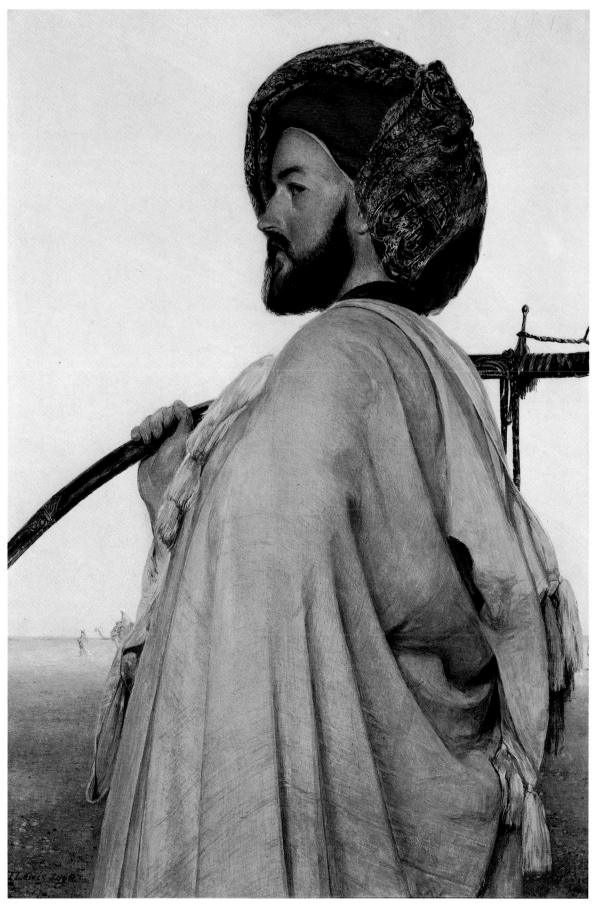

94 Lewis *A Memlook Bey, Egypt*

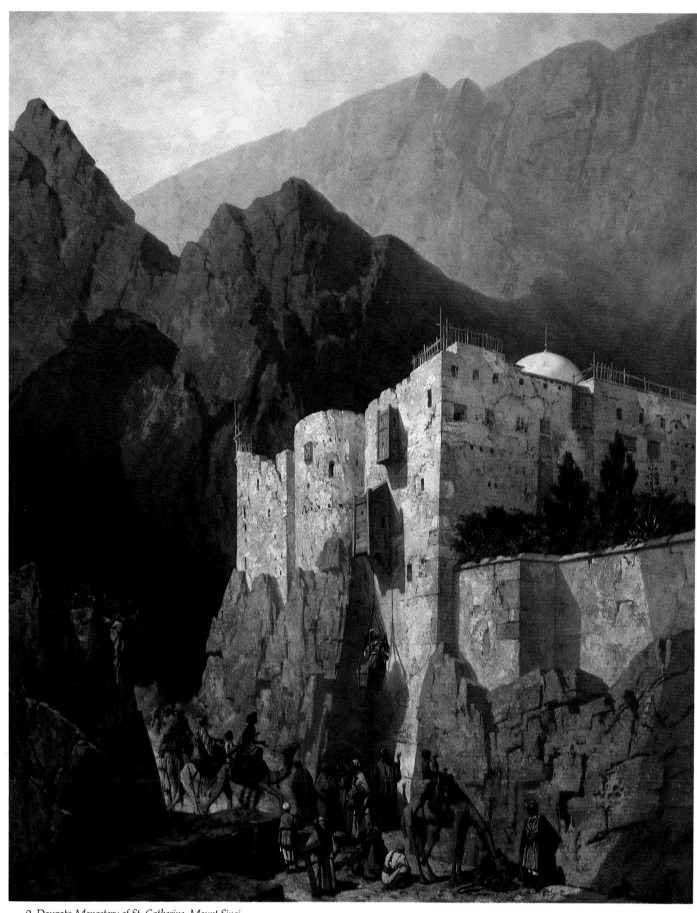

9 Dauzats *Monastery of St. Catherine, Mount Sinai*

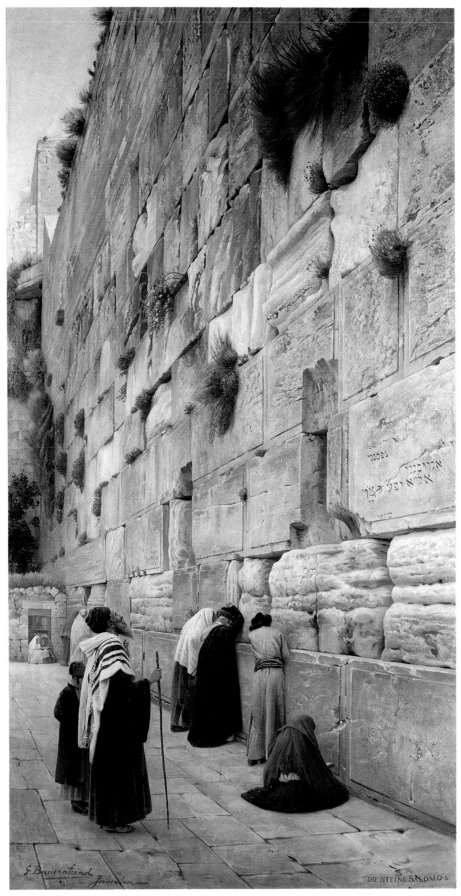

2 Bauernfeind *Lament of the Faithful at the Wailing Wall, Jerusalem*

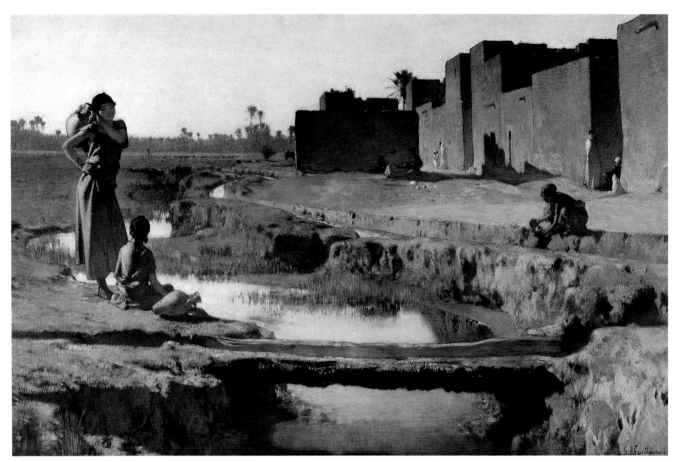

68 Guillaumet *The 'Seguia', Biskra*

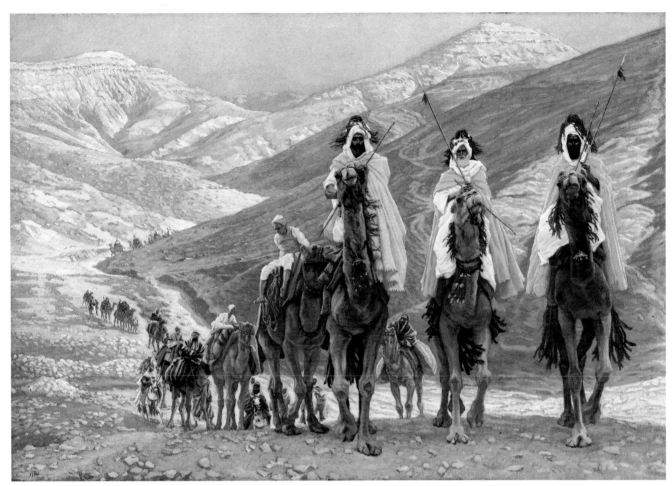

118 Tissot *The Journey of the Magi*

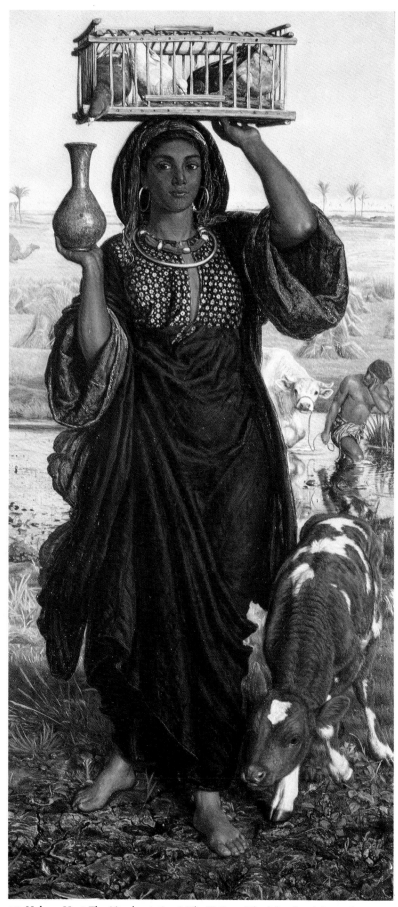

78 Holman Hunt *The Afterglow in Egypt (The Visitors of the Ashmolean Museum)*

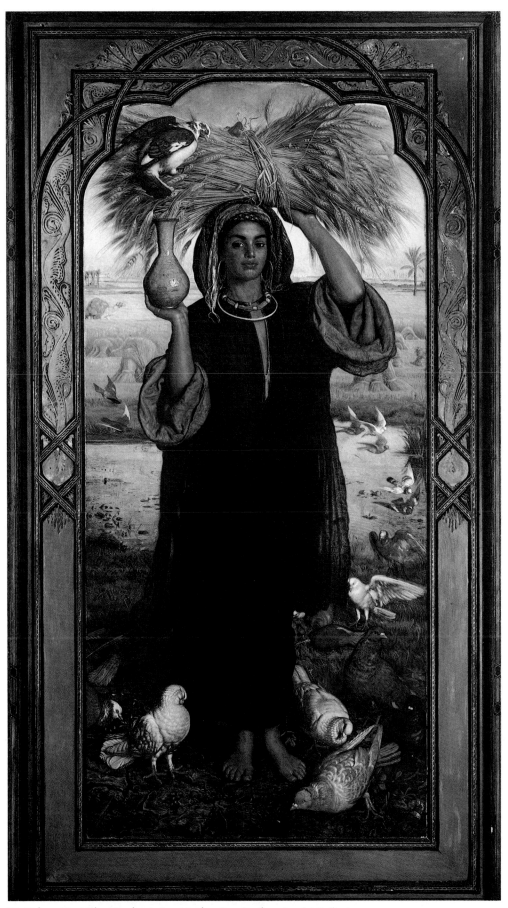

77 Holman Hunt *The Afterglow in Egypt (on loan from Southampton Art Gallery)*

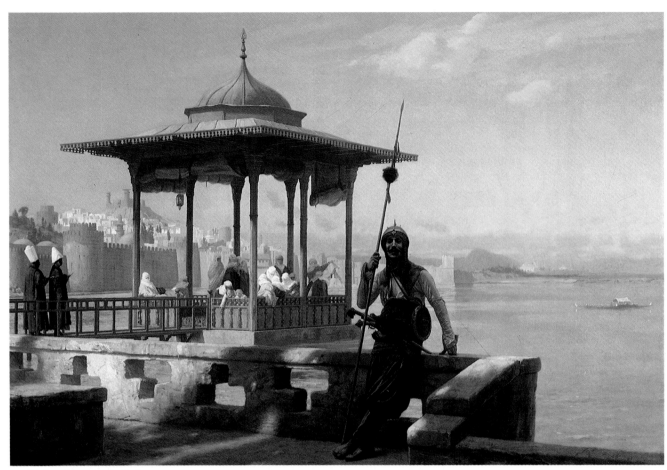

33 Gérôme *Harem in the Kiosk*

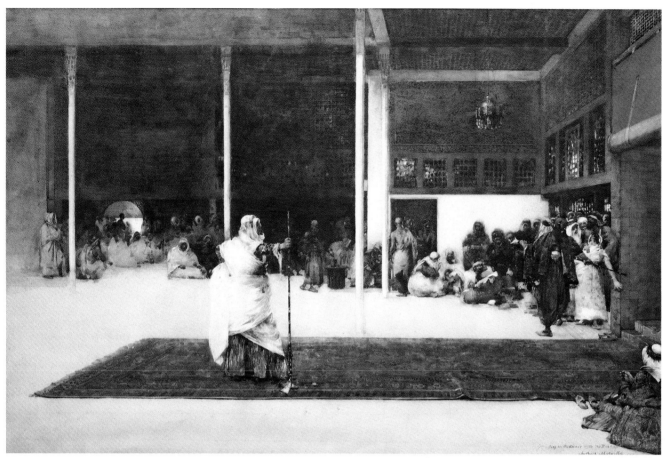

101 Melville *Awaiting an Audience with the Pasha*

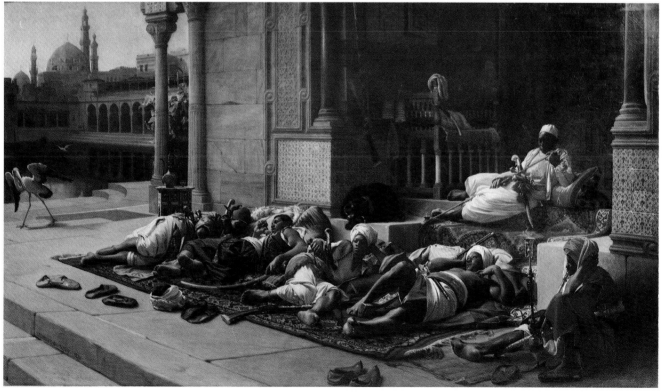

86 Lecomte du Nouÿ *The Guard of the Seraglio (Souvenir of Cairo)*

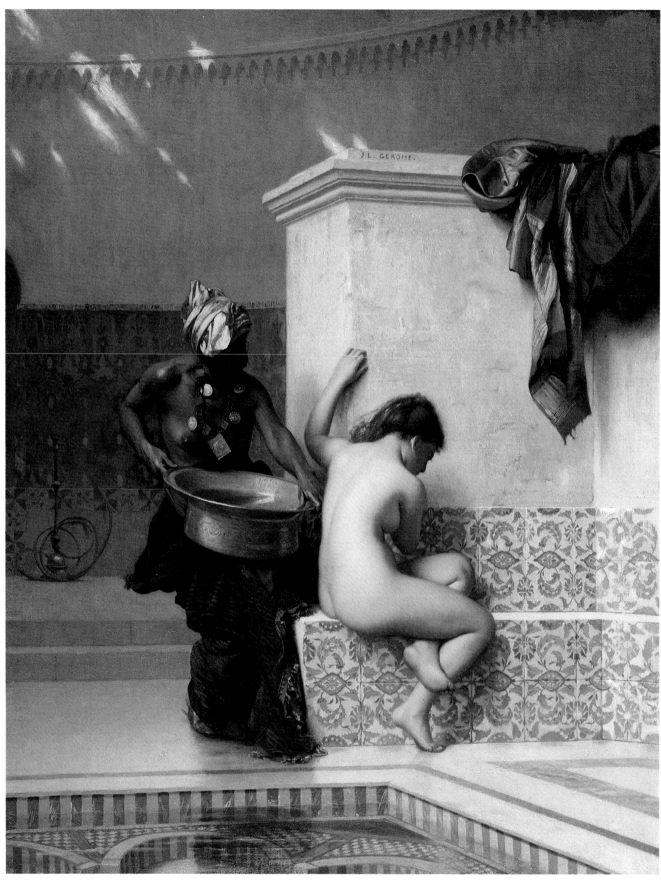

31 Gérôme *The Moorish Bath*

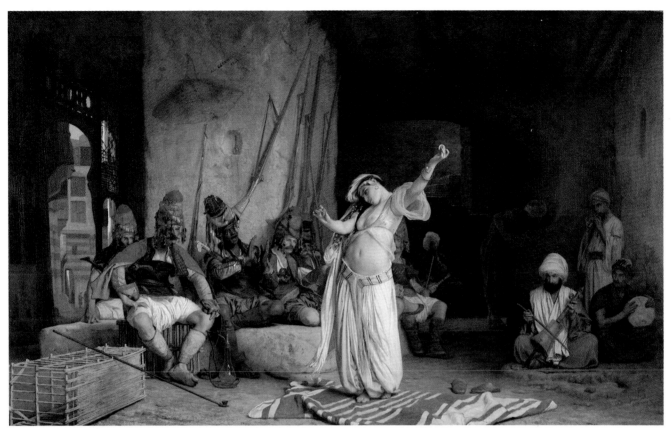

29 Gérôme *Dance of the Almeh*

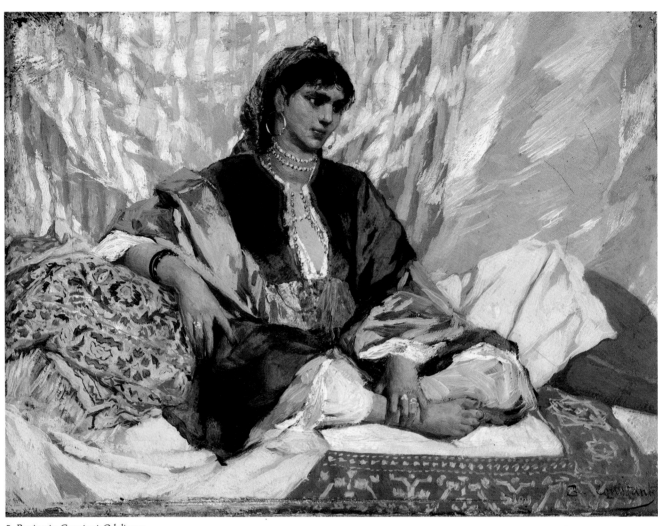

5 Benjamin-Constant *Odalisque*

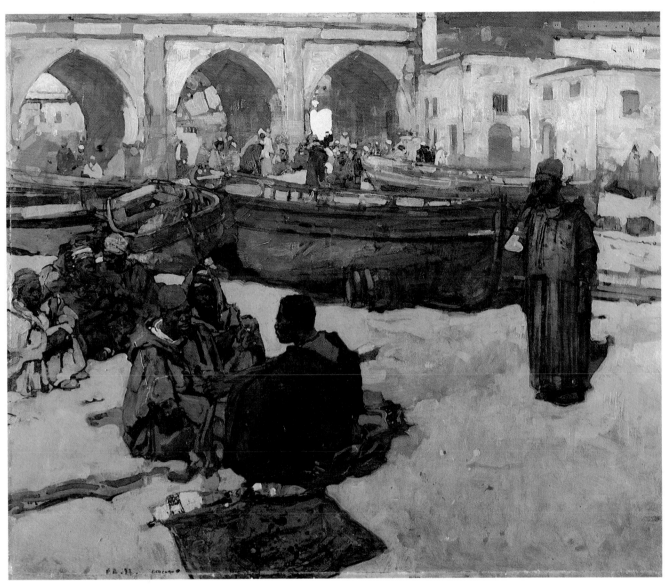

7 Brangwyn *A Trade on the Beach*

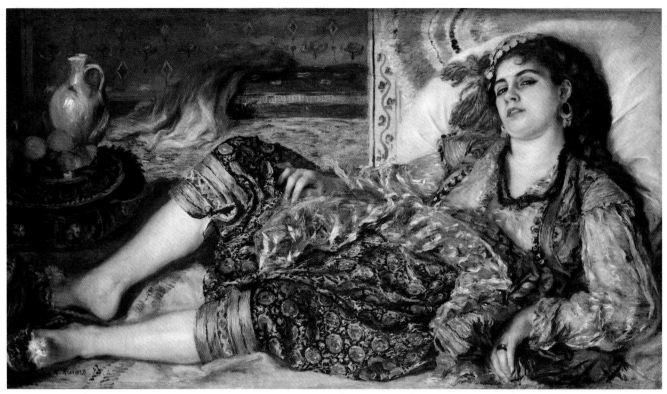

106 Renoir *Woman of Algiers* or *Odalisque*

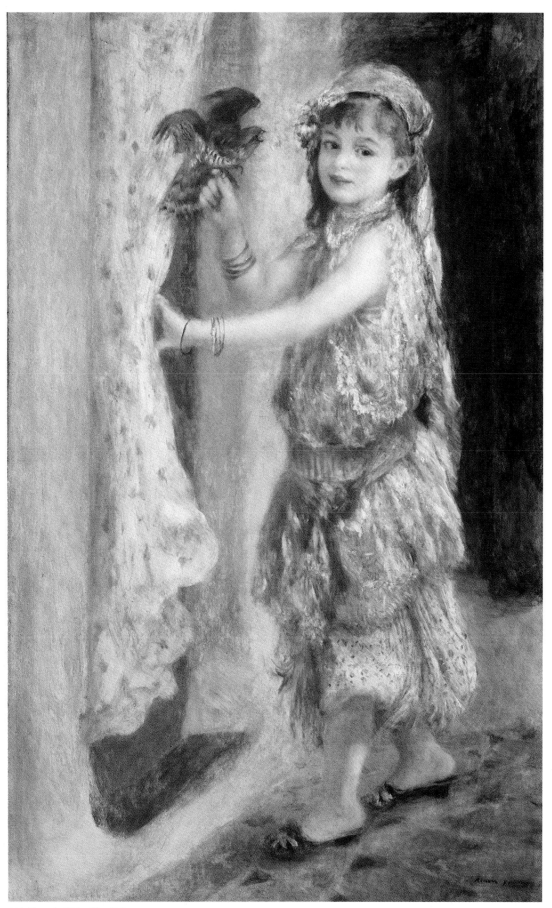

108 Renoir *Girl with a Falcon*

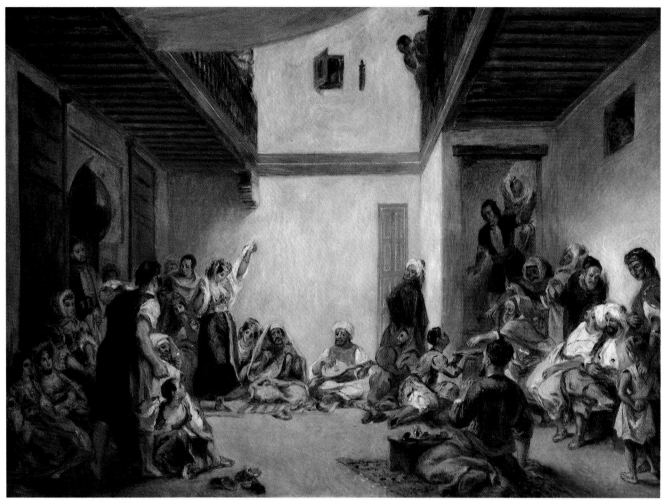

107 Renoir *The Jewish Wedding (after Delacroix)*

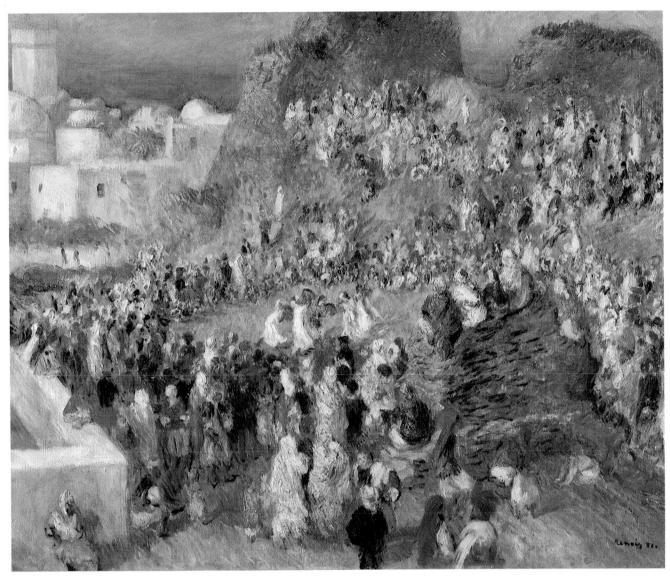

109 Renoir *Arab Festival*

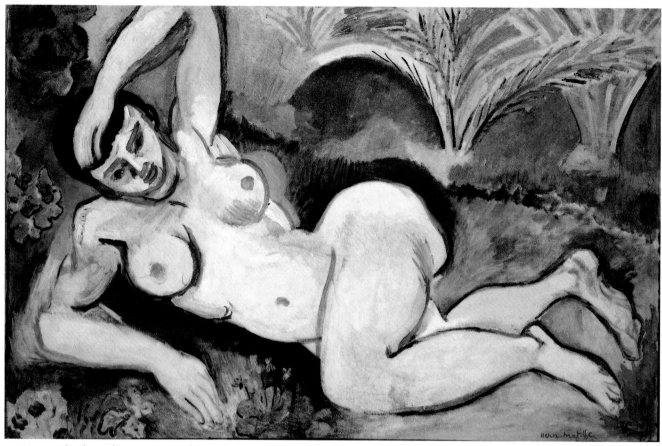

98 Matisse *The Blue Nude – Souvenir of Biskra*

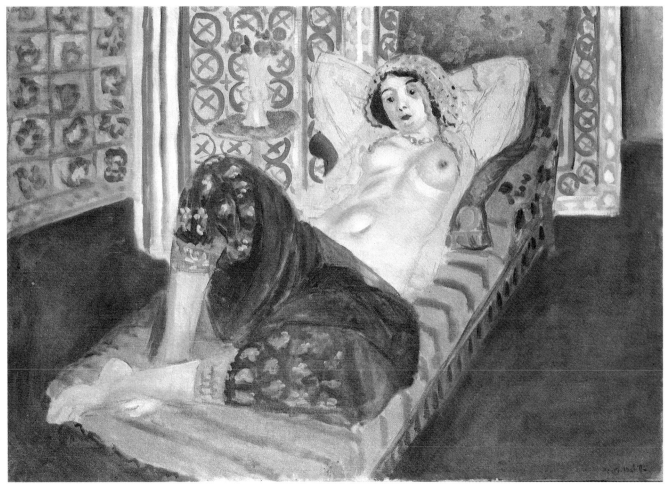

100 Matisse *Odalisque in Red Trousers*

99b Matisse *Moroccan Garden*

110

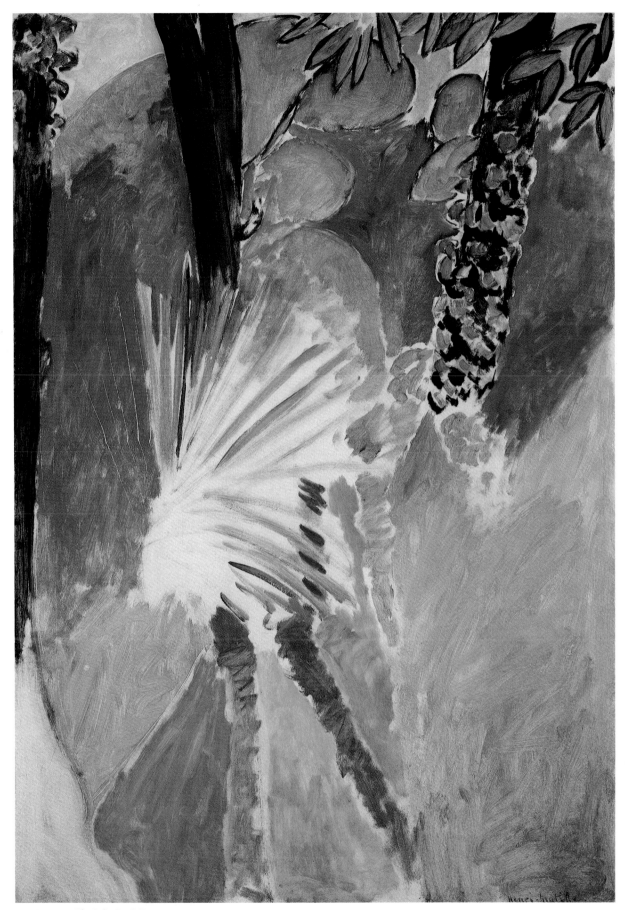

99c Matisse *The Palm Leaf, Tangier*

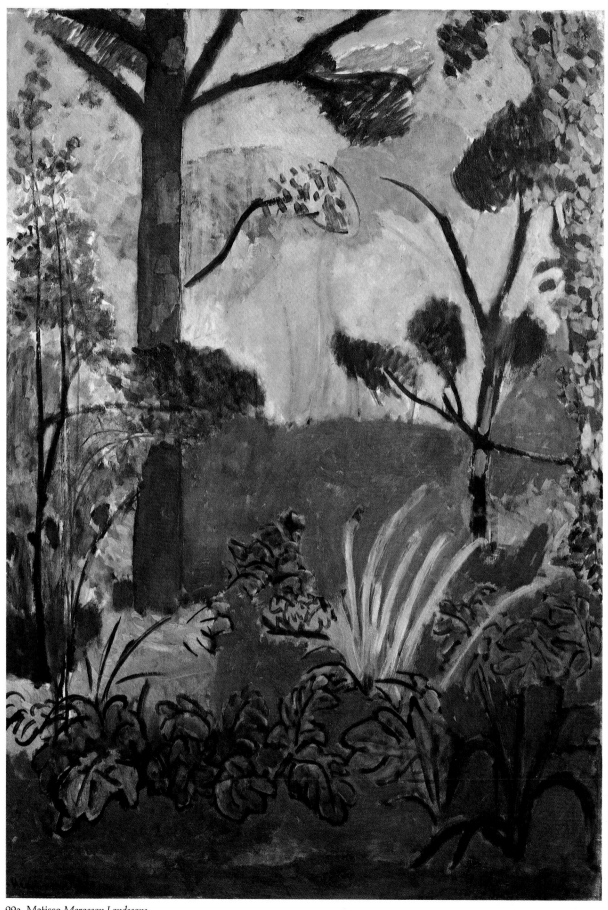

99a Matisse *Moroccan Landscape*

THE CATALOGUE

Bauernfeind, Gustav 1848–1904

Bauernfeind's first career was in architecture, which he studied and practised in his native Stuttgart. On visits to Switzerland and Italy he began making topographical sketches and paintings, mostly townscapes, and eventually decided to pursue art professionally. He trained under Ludwig von Löfftz in Munich, where he afterwards set up his own studio. In 1880–82 he travelled extensively in the Near East, sketching street scenes in Cairo, Jaffa, Jerusalem and Damascus. In 1888 he visited Damascus again, and Palmyra, and in 1898 settled in Jerusalem, where he died in 1904.

1

Market in Jaffa 1887
Markt in Jaffa

81 × 109 cm
Signed and dated bottom left: *G. Bauernfeind/Jaffa 1887*
Private Collection, Houston, Texas
[*repr. in colour on p. 70*]

The ancient port of Jaffa (sometimes called 'Joppa'), now subsumed by Israel's main commercial and industrial centre Tel Aviv, was for centuries Jerusalem's natural outlet to the sea and the landing-point from which most pilgrims and travellers began their journeys into Palestine. It was devastated during the Napoleonic campaigns (1798–99; see Cat. 30, 64) and largely rebuilt in the early nineteenth century. The place was a favourite subject of Bauernfeind from the time he first visited it on his Near Eastern trip of 1880–82. This market scene may have been painted on the spot, as the inscription implies, or in Munich from sketches made in Jaffa at an earlier date. A work with the same title was shown by Bauernfeind at the International Exhibition in Munich in 1883. For another Jaffa street scene, dated 1890, see M. Verrier, *The Orientalists*, New York and London, 1979, no. 21, ill. M.W.

PROVENANCE
1981, June, acquired by The Fine Art Society, London; acquired by Kurt E. Schon Ltd, New Orleans; Priv. Coll., Houston, Texas

REFERENCE
Coral Petroleum, *A Near Eastern Adventure*, n.d., n.p., ill.

2

Lament of the Faithful
at the Wailing Wall, Jerusalem
Klage der Gläubigen an den Tempelmauern Jerusalems

193·5 × 98 cm
Signed bottom left: *G. Bauernfeind/Jerusalem*
Inscribed bottom right: *DIE STEINE SALOMO'S*
Private Collection
[*repr. in colour on p. 93*]

The Wailing Wall in Jerusalem is a stretch of the western side of the stone platform on which stood the Temple of Solomon, a site occupied since the eighth century by the Muslim Qubbat al-Sakhrah, or Dome of the Rock. It is traditionally where orthodox Jews come to pray and bewail the capture of the city by the Romans. Bauernfeind was resident in Jerusalem for the final six years of his life and a larger version of this subject (250 × 150 cm) is said to have been the last picture he completed. M.W.

PROVENANCE
1983, 21 June, sale of the artist's grand-niece, Sotheby's, London (lot 25); acquired by the present owner
REFERENCES
Thorton 1983, ill. pp. 200–01.
H. Schmid, *Der Maler Gustav Bauernfeind, 1848–1904*, Sulz, 1981, n.p., ill.

1

2

Belly, Léon-Adolphe-Auguste 1827–1877

A native of Saint-Omer (Pas-de-Calais), Belly passed briefly through the studio of Picot (1786–1868) before receiving his formative training with Constant Troyon (1810–1865). Early in his career he was attracted to the work of Decamps and Marilhat (*q.v.*), and in 1849 visited Barbizon, where he came under the influence of Millet, Corot and especially Rousseau.

Belly made three trips to the Orient, the first in 1850–51, when he travelled to Greece, Syria and the Black Sea in the company of de Saulcy and Edouard Delessert. In 1855–56 he returned to Egypt with the painter Edouard Imer, and, with a piano, together made their way up the Nile to the strains of Mozart, Glück and Bach. A final voyage in 1857 was largely spent making preparatory studies for *Pilgrims going to Mecca*.

The four landscapes from the suburbs of Nablus and Beirut, and from the shores of the Dead Sea, with which he made his Salon debut in 1853, won him immediate critical acclaim, and thereafter he rose quickly to fame, gaining a first class medal in 1861, and a Croix de la Légion d'Honneur the following year.

From 1861 he held weekly soirées with his mother at their home on the Quai d'Orsay, which were frequented by leading artists of the 1860s, including Rousseau, Corot, Fromentin (*q.v.*) and Puvis de Chavannes. Though captivated by Egypt, Belly continued to execute portraits and landscapes of Normandy and the Sologne, and in 1867 acquired land at Montauban, where he spent an increasing amount of time in the forests and pasture lands of the Sauldre.

Belly was plagued by illness during the last five years of his life, and died in Paris at the age of fifty.

ABBREVIATED REFERENCE
Mandach 1913 Conrad de Mandach, 'Artistes Contemporains. Léon Belly (1827–1877)', *Gazette des Beaux-Arts*, January 1913, pp. 73–84; February 1913, pp. 143–57

3

Pilgrims going to Mecca 1861
Pèlerins allant à la Mecque

161 × 242 cm
Signed and dated bottom left: *L Belly 1861*
Musée d'Orsay, Paris
[*repr. in colour on p. 82*]

The initial idea for this painting came during Belly's second trip to Egypt in 1855–56. In a letter of 1 June 1856, he recorded his intention to paint a desert scene with Arabs and dromedaries, and to reproduce, like Courbet, 'the truly beautiful and interesting features of the everyday life of our fellow men' (Mandach 1913), p. 149).

The Ḥajj (pilgrimage to Mecca) is one of the five pillars of Islam, commanded by the *Qur'ān* to be made, if possible, at least once during a Muslim's life. The official caravan was a highly organised affair travelling between carefully placed water stations and taking thirty-seven days from Cairo. Belly faithfully depicts the social cross-section of the procession with the *Shaykh al-Ḥajj* (director of the pilgrimage) leading the way, followed by the poorer pilgrims, probably slaves or substitutes for the infirm rich; behind them the wealthy identified by the sumptuous *shibriyyah* (rounded) or *takhtrawān* (to camel) litters, with the most beautiful camel in the middle distance bearing the Khedive's gifts. In an original idea for the *Pilgrims going to Mecca* (Musée des Beaux-Arts, Tours; inv. 925-301-4), Belly experimented with a higher horizon line. Here it is considerably lowered to give greater force to the composition and to stress the awesome proportions of the foreground figures. The rhythmical diminution of the caravan to the very back of the canvas suggests both the inexorable progress of the pilgrims, and the

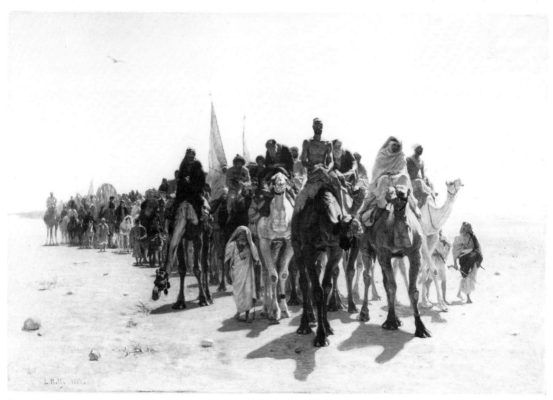

3

measureless expanse of desert and sky beyond. On the left of the procession, a hunched figure leading a woman and child on an ass, makes an allusion to the biblical flight into Egypt which, together with the ferocity of the sunlight, sparse landscape, and ascetic tonalities, contributes to the solemnity of the occasion, and the feeling that one is here participating in an ancient religious rite.

En route to Syria in 1850, Belly had noted the emotional sobriety of mural painting in Padua and Milan, and the calm rationality of Greek religious architecture. It was this grandeur of effect that he recaptured in the present painting creating a sense of respect and an admiration for what he considered to be a very humane religion. For Belly, the occasion represented more than a mere ethnographical curiosity, as his comments on the advanced intelligence of the Egyptians reveal: 'In what way are we superior to this people who precede us by three thousand years?' (Mandach 1913, p. 152). In this he reflected the concern of painters in the latter half of the century to describe not only the picturesque qualities, but the full realities of Oriental life.

Belly was very conscious of the significance of his visual experiences in the Near East and, as a result of his time spent there, his brushstroke became looser and his handling broader. Indeed, his Orientalist work effectively summarises the attractions of the East for the artist; divorced from the mainstream of European art, he found 'the most beautiful form all around! a complete spiritual freedom. The sole concern to paint well for the pleasure of being true, without worrying about the opinion of anyone else. Sometimes it even seems as if I might become a real painter' (Mandach 1913, p. 148). J.M.

PROVENANCE
1861, acquired by the State from the Salon and placed in the office of Comte Waleski; 1863, August, transferred to Musée du Luxembourg; 1874, 3 May, attributed to Musées nationaux by decree, and added to the inventory of paintings; 1881, 10 February, transferred to the Louvre; 1949, deposited in Musée des Colonies after exhibition in *Histoire de l'Exotisme*; 1968, returned to the Louvre; transferred to the Musée d'Orsay

EXHIBITIONS
1861, Paris, Salon (no. 214)
1867, Paris, *Exposition Universelle* (no. 28)
1873, Vienna, *Exposition universelle internationale, Oeuvres d'art français*, Groupe 1, Classe 1 (no. 35)
1878, Paris, Ecole Nationale des Beaux-Arts, *Exposition des oeuvres de Léon Belly* (no. 39)
1928, Cairo, *Exposition d'Art Français* (no. 1)
1931, Paris, *Exposition coloniale, Beaux-Arts, section rétrospective* (p. 29)
1947, Paris, Musée des Colonies, *Histoire de l'Exotisme*
1974, Paris, Grand Palais, *Le Musée du Luxembourg en 1874* (no. 14)
1975, Marseille, Musée Cantini, *L'Orient en Question* (no. 6)
1977, Saint-Omer, Musée de l'Hôtel Sandelin, *Léon Belly 1827–1877 Rétrospective* (no. 38)
1982, Rochester, New York, Memorial Art Gallery, *Orientalism* (no. 72)

REFERENCES
Mandach 1913, pp. 148–49
Thornton 1983, pp. 96–97, ill.
Ch. Tardieu, 'Silhouettes d'artistes contemporains', *L'Art*, 1878, 10 February, pp. 132, 133
J.K. Huysmans, 'Art Contemporain – Belly', *Les Chefs d'oeuvre d'art au Luxembourg*, Paris, 1881, pp. 61, 62
Ch. Timbal, *Notes et causeries sur l'art et les artistes*, Paris, 1881, pp. 395, 396, 400, 401
E. Michel, *Les maîtres du paysage*, Paris, 1906, pp. 500–02

Benjamin-Constant, Jean-Joseph 1845–1902

Considered 'one of the last romantic orientalists' (Ary Renan, *Gazette des Beaux-Arts*, vol. XI, January 1894, p. 51), Benjamin-Constant was born in Paris in 1845, but studied first at the Academy in Toulouse. In 1866 he travelled to Paris to complete his training and the following year entered the Ecole de la Rue Bonaparte under Cabanel (1823–1889). In 1870, when his career was interrupted by the Franco-Prussian War, he left for Spain, visiting Madrid, Toledo, Cordoba and Granada. From there, he travelled to North Africa in the suite of Charles Joseph Tissot, French plenipotentiary to Morocco, and returned to France in 1873 with a vast collection of Islamic artefacts. Throughout the 1870s and 1880s he regularly included Orientalist paintings among his exhibits at the Salon, his first submission being *Les Femmes du Riff* (Musée des Beaux-Arts, Carcassonne) in 1873. In the last two decades of his life, however, he devoted himself almost exclusively to portraiture and decorative painting. As a portraitist, Benjamin-Constant enjoyed great popularity with both British and American collectors, and could count among his patrons Princess Beatrice, the Marquis of Lorne, and the future Edward VII. In 1888 he executed a decorative cycle for the Sorbonne in Paris, the first of several schemes of the 1890s which included work at the Hôtel de Ville, the Capitole in Toulouse, and the Nouvel Opéra Comique in Paris.

4*

Sketch for 'The Last Rebels' c. 1880
Les Derniers Rebelles

99 × 133·3 cm
Signed bottom right: *B. Constant*
Forbes Magazine Collection, New York

In 1880 Benjamin-Constant exhibited at the Salon *Les Derniers Rebelles*, also known under the title *L'Exécution des Rebelles à Tanger*. This is probably a sketch for the final version, originally in the Musée du Luxembourg, but now lost.

Like that of many painters in the latter half of the nineteenth century, including Dehodencq, Rochegrosse and Renoir (*q.v.*), Constant's vision of the Near East reflected the profound artistic

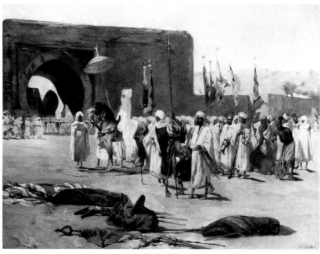

4

impact of Delacroix's Orientalist oeuvre; *Le Harem: Maroc* (1878; present location unknown, ill. Archives du Musée d'Orsay) owes much to the compositional structure of Delacroix's *Noce juive* of 1839, and in this painting there is an unequivocal debt to the *Sultān of Morocco* (Cat. 15). However, the picture lacks the harmonious balance of the Delacroix prototype; both colour and incident distract the eye from the central theme of the picture, and dilute the expression of the solemnity of the occasion. In his 'Salon de 1876', Emile Zola noted the opposing forces in Constant's Orientalism, 'a good pupil of Cabanel, tormented by the long shadow of Delacroix' (*Mon Salon*, 1959, p. 179). In paintings such as his *Entrée de Mahomet II à Constantinople* (Musée des Augustins, Toulouse), exhibited that year, Constant very self-consciously sought to produce an Orientalist work in the 'Grand style', but in the profusion of exotic detail created an image suitable only as a 'tapestry design' (V. Cherbuliez, 'Salon de 1876', *Revue des Deux Mondes*, June 1870, p. 881). A similar excess of ambition is found in the finished version of this painting, where the disproportionate scale of the foreground rebels illustrates Constant's strong taste for the dramatic. By the 1880s, the curiosity value and picturesque qualities of the Orient had long lost their initial sensuous appeal, and were being regarded with a growing sense of déjà vu. In 1870, Henri Delaborde drew attention to the superficiality of the majority of Orientalist paintings, and complained of 'the ease by which one is seduced by the striking aspect of certain objects, or by the oddity of certain fittings' ('Salon de 1870', *Revue des Deux Mondes*, June 1870, p. 708). Painters, he felt, were blinded by the proliferation of empty, if colourful, detail, substituting 'impartial copying for selective imitation, the external features for the expression of the intimate life, the puppet for the moral being' (*ibid*. p. 708).

Constant's choice of Near Eastern subject-matter and exotic locations highlighted the continuing relevance of Orientalism for French artists in the late nineteenth century. The critics' lukewarm reception of his work, however, also reflected the contemporary need for a deeper awareness of the countries in question, and a reassessment of their artistic potentialities. J.M.

PROVENANCE
The Fine Art Society, London; bought by the Forbes Magazine Collection, New York

EXHIBITION
1982, Rochester, New York, Memorial Art Gallery *Orientalism* (no. 15, fig. 88)

REFERENCES
J. Buisson, 'Le Salon de 1881', *Gazette des Beaux-Arts*, July 1881, pp. 52–53
J. Landrigan, 'The Forbes Magazine Collection at the Palais Mendoub, Tangier', *Antiques*, June 1982, p. 1387, ill. pl. VII

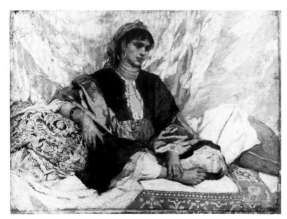

5

5†

Odalisque
Odalisque

22 × 29·8 cm
Signed bottom right: *B. Constant*
The George A. Lucas Collection of the Maryland Institute, College of Art, on indefinite loan to The Baltimore Museum of Art (BMA L.1934.48.73)
[*repr. in colour on p. 102*]

The odalisque, as the embodiment of the untold secrets of the harem, held a powerful and enduring fascination for French Orientalist painters from Delacroix and Ingres to Matisse. Benjamin-Constant took up this theme on several occasions, particularly in the late 1870s, beginning with the *Femmes du harem au Maroc*, exhibited at the Salon in 1875 (present location unknown), and including *Le Harem: Maroc* (1878; see Cat. 4) and *Le Soir sur les terrasses* (1879; Museum of Art, Montreal). Writers, too, were enchanted by the quiet but redolent sensuality of the Eastern woman. Baron Denon, in his seminal work of 1802 (see Cat. 18) was shocked by the extreme voluptuousness of the native women, and the explicit lasciviousness of the movements of their dance, which the more inhibited European mores '*ne permet que dans l'ombre du mystère*' (p. 59). Both Gérard de Nerval and Flaubert took a less morally exclusive stand, and the latter described in great detail his encounters with Kuchuk Hanem, his 'Pretty Little Princess', at Esna (Steegmuller, ed., 1979, pp. 113–16; see Cat. 29, 33). Access to Muslim households and harems was notoriously difficult throughout the century, and even in the 1880s Renoir complained of the difficulty of finding suitable models (see Cat. 108). In general, artists drew their subjects from the local Jewish population, with the notable exception of Delacroix, who was finally admitted to a Muslim household a few days before his return to Toulon in June 1832.

Though highly appealing, Constant's odalisque is hardly ethnographically true to life, but rather an artistic confection, representing the artist's attempt to interpret Eastern beauty according to Western ideals. In fact, she has more in common with the lusty Spanish gypsy in Henri Regnault's *Salomé* (1870; Metropolitan Museum of Art, New York) than with the melancholic interpretations of Chassériau, or the more classical vision of Ingres (see Cat. 80). Like Chassériau, Gérôme and Marilhat, Constant was a fanatical collector of the Oriental: his atelier in the Pigalle was draped with Persian and Turkish rugs, Eastern costumes, and objets d'art. Indeed, in this painting the 'orientalism' seems to lie in the exotic enrichments of decor and accessories rather than in the figure itself. Constant had established his reputation as a colourist in 1869 with *Hamlet et le Roi* (Musée d'Orsay, Paris), and subsequent Orientalist works allowed him to indulge this preference for strong colour. While his very painterly handling often weakened the impact of his large-scale didactic works, the broad, textural brushwork in this smaller painting enlivens the surface, and creates an image of great decorative beauty. J.M.

PROVENANCE
Acquired from the artist by George A. Lucas; indefinite loan to The Baltimore Museum of Art

EXHIBITIONS
1965, Baltimore Museum of Art, *The George A. Lucas Collection of the Maryland Institute* (no. 64)
1969, Baltimore Museum of Art, *19th Century European Painting*
1982, Rochester, New York, Memorial Art Gallery, *Orientalism* (no. 85, ill.)

REFERENCES
Baltimore, *The George A. Lucas Collection of the Maryland Institute*, 1965, p. 30
L.M.C. Randall (ed.), *The Diary of George A. Lucas*, Princeton, 1979, I, fig. 53
Rochester, New York, Memorial Art Gallery, *Orientalism*, catalogue by D. Rosenthal, 1982, p. 85–88

Bonnat, Joseph-Florentin-Léon 1833–1922

A native of Bayonne, Bonnat received his formative training
under Federico Madrazo in Madrid. Recalled to France by the
death of his father, he entered in 1854 the atelier of Léon Cogniet
(1794–1880), and spent three years in Italy from 1858 to 1861,
where he studied at the French Academy in Rome with Degas,
Jules Lefebvre, Jean-Jacques Henner and Gustave Moreau.

Bonnat made his first and only voyage to the Orient in 1868,
as one of a party headed by Jean-Léon Gérôme (q.v.), which
included the painter Paul Lenoir and the writer Edmond About.
They visited Egypt, Sinai, Palestine and parts of Turkey and
Greece, and in 1869 witnessed the opening of the Suez Canal.

Bonnat's prestigious career was marked by a number of official
honours: he became a member of the Institut de France and
President of the Société des Artistes Français in 1881, Chevalier
de la Légion d'Honneur in 1882, and was appointed Director of
the Ecole des Beaux-Arts in 1905. Apart from portraits of artistic
figures and political dignitaries of the Third Republic, biblical and
historical paintings formed the major part of his output, though
he also executed Italian genre scenes after his return from Rome,
as well as some landscapes in a fairly traditional style. Bonnat
received several important commissions to execute decorative
cycles for churches and public buildings in Paris, including work
at the Panthéon in 1886 with Puvis de Chavannes, Baudry and
Cabanel.

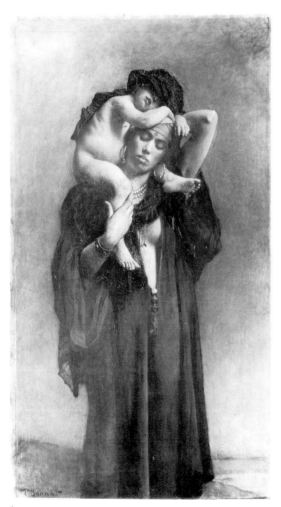

6

6

An Egyptian Peasant Woman and her Child 1870

Femme Fellah et son enfant

186·7 × 105·4 cm
Signed bottom left: *Lⁿ Bonnat*
Metropolitan Museum of Art, New York

Bonnat is best known as a portraitist; his Orientalist work forms
a small, but significant part of his total oeuvre. *An Egyptian
Peasant Woman and her Child* is one of his first Orientalist
paintings, exhibited with *Une Rue à Jérusalem* at the Salon of
1870. Critics were far from unanimous in their praise of Bonnat's
new subject-matter, some considering the painting heavy, ugly
and beneath the artist's capabilities (Chaumelin, 1873, p. 431;
Ménard, July 1870, p. 39). With its thick impasto, severely
sculptural forms and dark tonalities, the painting technically
reflects little of the impact of Bonnat's eastern travels in 1868–69.
Instead, the handsome *fellāḥah* recalls the robust realism which
he so admired in Velasquez, and possesses the imposing stature
of a Michelangelo sibyl. Bonnat experimented only briefly with
bolder colours after 1869, most noticeably in the *Chieks d'Akabah*
(1872; present location unknown), where reds, yellows and
greens are set in bold opposition.

Gautier, for whom the Oriental woman personified the
romantic and melancholy mystery of the East, praised Bonnat's
portrayal of her Egyptian physiognomy, which was based on his
sketch of a peasant woman thought to have been made at the
ceremony of the opening of the Suez Canal (Musée Bonnat,
Bayonne, inv. no. 635). Bonnat may also have used photographs
since he is known to have found this medium helpful in achieving
a high degree of realism, particularly in his later portraits, which
are distinguished by a characteristic firmness of outline and
subdued tones.

The complex but graceful pose of the two figures echo that
of a Madonna and Child and refer back to his *Ascension de la
Vièrge*, painted in 1868 for St. André, Bayonne. One of Bonnat's
fellow travellers in fact drew attention to the similarities between
the *Egyptian Peasant Woman and her Child* and scenes painted by
Mattia Preti in the Chapel of Saint Joan which they had visited
in Malta en route for Egypt (K. Bertrand, *L'Artiste*, June 1870,
p. 298).

The juxtaposition of biblical and exotic imagery in the present
painting looks forward to Gauguin's experiences in Tahiti at the
end of the century, and recalls in particular the pose of *La Orana
Maria* (1891; Metropolitan Museum of Art, New York). J.M.

PROVENANCE
By 1879, John Wolfe, New York; 1882, 5–6 April, Leavitt's sale, New York, (lot 95); 1882
Catherine Lorillard Wolfe, New York; 1887, bequeathed by Catherine Lorillard Wolfe to
the Metropolitan Museum of Art

EXHIBITIONS
1870, Paris, Salon (no. 298)
1963, Claremont, California, Pomona College Gallery, *Muse or Ego, Salon and Independent
 Artists of the 1880s* (no. 8)

REFERENCES
K. Bertrand, 'Salon de 1870 – Peinture', *L'Artiste*, June 1870, p. 298
R. Ménard, 'Salon de 1870', *Gazette des Beaux-Arts*, 2^e période, III, 1870 p. 39
M. Chaumelin, 'Salon de 1870', *L'Art contemporain*, Paris, 1873, p. 431
J. Castagnary, 'Salon de 1870', *Salons (1857–1870)*, I, Paris, 1892, p. 421
Ch. Sterling and M. Salinger, *French Paintings: A Catalogue of the Collection in the Metropolitan
 Museum*, New York, 1966, pp. 187–88

Brangwyn, Sir Frank 1867–1956

The work of this astonishingly prolific and versatile artist is characterised by a love of brilliant colour and a Baroque exuberance of design. He was born in Bruges of Anglo-Welsh parentage. His father was an architect. Brangwyn began to study art after his family settled in London in 1875, and he made his Royal Academy debut in 1885. His early paintings are largely based on his experiences of travel on a cargo boat in the Mediterranean. In 1891 he went to Spain with Arthur Melville (*q.v.*) and in 1893 to Morocco. The 1890s saw the development of his distinctive painterly style, and with it his reputation, especially on the Continent. He began to paint large murals, for which he received commissions throughout his career, culminating in his *magnum opus*, the 'British Empire Panels'. Painted in 1925–33, these were intended for the House of Lords but were rejected and placed instead in the 'Brangwyn Hall', Swansea. He was made an Associate of the Royal Academy in 1904 and a full Academician in 1919. In 1936 he donated his art collection and many of his own works to become part of the collection of the William Morris Gallery in Walthamstow. In the same year he made another substantial gift of his work to his birthplace, Bruges, to form the Brangwyn Museum. The Royal Academy honoured him in 1952 with its first-ever retrospective exhibition devoted to a living artist.

7†

A Trade on the Beach 1893

102 × 127 cm
Signed with initials and dated bottom left: *F.B. '93* [?]
Musée d'Orsay, Paris
[*repr. in colour on p. 103*]

Brangwyn was a devotee of the exotic and travelled extensively throughout his life. The sea voyages he made as a young man took him to Constantinople and in 1891 he visited both Spain and South Africa. He was in Spain with Arthur Melville (*q.v.*), who exercised a considerable influence over his early work and may have been responsible for his decision to visit North Africa in 1893. In the spring of that year he spent several weeks in Tangier with his friend and fellow artist, Dudley Hardy. There he made sketches, mostly watercolours, which he worked up into larger-scale works after his return to England. The painting exhibited here shows the beach market at Tangier, and is the most important of these. When first exhibited in London it received mixed reviews. The *Athenaeum* pronounced it a failure but the *Saturday Review* was enthusiastic in its praise: 'The decorative quality and arrangement of this work are beyond criticism. The general buff and grey tone of the picture is set aglow with rich colours that fall upon it in well-placed patches balanced with rare art . . . The work is perfectly executed; the detail all subordinated to the decorative scheme – every little form and patch of colour as splendidly placed as in the best Japanese art. Above all, the artist has caught the spirit of the people as only genius can catch it' (quoted Brangwyn, 1978). It was widely admired when shown at the Salon the following year and, much to the enhancement of Brangwyn's prestige on both sides of the Channel, was bought by the French government.

Galloway's catalogue lists an untraced oil study painted in Tangier (no. 703). M.W.

PROVENANCE
1895, acquired from the Salon des Champs-Elysées for the Musée du Luxembourg, Paris
EXHIBITIONS
1894–95, London, Institute of Painters in Oil Colours (no. 7)
1895, Paris, Salon des Champs-Elysées (no. 281)
1952, London, Royal Academy, *Exhibition of Works by Sir Frank Brangwyn, R.A.* (no. 463)
REFERENCES
V. Galloway, *The Oils and Murals of Sir Frank Brangwyn, R.A., 1867–1956*, Leigh-on-Sea, 1962, p. 62, no. 702
R. Brangwyn, *Brangwyn*, London, 1978, pp. 68–69
A. Brejon de Lavergnée and D. Thiebaut, *Catalogue sommaire illustré des peintures du Musée du Louvre: II. Italie, Espagne, Allemagne, Grande-Bretagne et divers*, Paris, 1981, p. 80 (ill.)

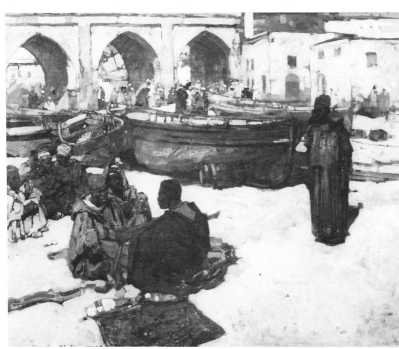

7

Chassériau, Théodore 1819–1856

Born in Santo Domingo (now Dominican Republic), Chassériau moved with his family to Paris in 1820. He entered the atelier of Ingres (q.v.), together with Amaury Duval and Ziegler, in 1830, and made his Salon debut in 1836 with two biblical subjects and two portraits in the classicising manner of his master. However, after a period of almost a year in Italy, from 1840 to 1841, Chassériau became disillusioned with his academic training, complaining of its lack of relevance to the modern-day painter: 'Ce n'est pas à Rome que nous pouvons voir la vie actuelle' (9 September 1840; quoted R. Escholier, 'L'Orientalisme de Chassériau', *Gazette des Beaux-Arts*, 5e période, III, 1921, p. 95). After this date the influence of Delacroix is revealed both in his iconography and in his freer, more assured technique.

Chassériau was attracted to Oriental subject-matter early in his career and drawings of Arabs and Mamlūks copied from popular prints and *images d'Epinal* date from as early as 1828. Possibly due to this youthful fascination, and his friendship with Dauzats (q.v.) and Marilhat (q.v.), Chassériau's brief stay in Algeria from May to July 1846 left a profound impression upon his work. The numerous detailed watercolours made during these two months continued to fire his imagination and provide material for work executed during the remaining ten years of his life.

In 1841, Chassériau received a commission to decorate the church of St.-Mérri, the first of a series of religious and allegorical paintings executed between 1844 and 1854 for public buildings. It was at the Cour des Comptes (1844–48; now destroyed) that Chassériau most firmly established himself as one of the leading decorative artists of the nineteenth century.

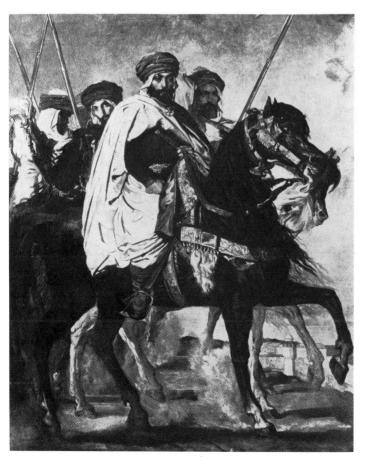

8

8

'Alī ibn Hāmid, Caliph of Constantine, followed by his Escort 1845

'Alī-Ben-Hamed, Kalife de Constantine, suivi de son escorte

320 × 261 cm
Signed and dated bottom left: *Théodore Chassériau 1845*
Musée National du Château de Versailles, Versailles
[*repr. in colour on p. 61*]

The Salon of 1845, to which this portrait was sent, saw an interesting confrontation of Orientalist styles, with works exhibited by Decamps and Dauzats (see Cat. 9), four paintings by Delacroix (see Cat. 15) and Vernet's monumental *Prise de la Smala d'Abd-el-Kader* (Versailles). While the jury accepted this portrait of the Caliph of Constantine, they refused Chassériau's *Cléopâtre se donnant la mort*, subsequently destroyed by the artist in a fit of resentment. Critics inevitably drew comparisons between this portrait and Delacroix's equally grandiose portrayal of the Sultān of Morocco (see Cat. 15). Both Baudelaire ('Salon de 1845', p. 37) and Thoré ('Salon de 1845', p. 121) judged Chassériau's painting to be a weak emulation of the older master and reiterated accusations of copying which had been levelled at his lithographic illustrations to *Othello* in 1844. In fact the paintings differ in many respects: the scale of the figures in relation to the background, the degree of attention to detail, but above all, the mood. While Delacroix's painting is based on an actual event, albeit transformed through the artist's personal vision and memory, Chassériau's work pre-dates his journey to Algeria and, as Sandoz has suggested, may have been inspired by an evocative passage describing the pageantry of the Druse warriors in Lamartine's *Voyage en Orient* published in 1835 (Sandoz, 1974, p. 84). In its scale, and in the decorative effects created by the denial of perspectival illusionism, the painting recalls early Renaissance frescoes, and reflects the artist's contemporary involvement in mural decorations for the Cour des Comptes from 1844 to 1848, as well as his earlier work at St.-Mérri, regarded as his 'masterpiece in classicism' (A. Renan, 'Theodore Chassériau et les Peintures au Palais de la Cour de Comptes', *Gazette des Beaux-Arts*, 3e période, XIX, February 1898, p. 91). Whatever its relative merits, Chassériau successfully evokes the nobility and intellectual vigour of the Arab leader, who, from his introduction to French salon society in 1837, had charmed the Parisian *beau monde* and subsequently, after the capture and deportation of Abd-al-Qādir in 1847, was promoted by the French as leader of Arab affairs in Algeria.

The source for the accurate view of Constantine in the distance may possibly be accredited to Dauzats, who had travelled there in 1839, and in 1840 painted *L'Intérieur de la tente du Kaïd Aly, chef ou kaïd des Arabes* (present location unknown), thought to be a representation of 'Alī ibn Hāmid (Bénédite, 1932, p. 236). J.M.

PROVENANCE
1896, gift of M. Arthur Chassériau to the Musée National du Château de Versailles (inv. MV. 5407

EXHIBITIONS
1845, Paris, Salon (no. 305)
1968–69, Paris, Petit Palais, *Le Centenaire de Baudelaire*, no. 125

REFERENCES
C. Baudelaire, 'Salon de 1845', *Baudelaire Critique d'Art*, Paris, 1965, p. 37
Th. Thoré, 'Salon de 1845', *Salons de 1844 à 1848*, Paris, 1868 ed., p. 121
A. Bagnères, 'Théodore Chassériau', *Gazette des Beaux-Arts*, 2e période, vol. XXXIII, March 1886, pp. 209–18
L. Bénédite, *Théodore Chassériau, sa vie et son oeuvre*, Paris, 1932, p. 235f.
M. Sandoz, *Théodore Chassériau 1819–1856*, Paris, 1974, pp. 84–85
P. Jullian, *The Orientalists. European Painters of Eastern Scenes*, Oxford, 1977, p. 50, ill. p. 51
Rochester, New York, Memorial Art Gallery, *Orientalism*, catalogue by D. Rosenthal, 1982, p. 57

Dauzats, Adrien 1804–1868

Born in Bordeaux in 1804, Dauzats worked first under Pierre Lacour in his home town and later, in 1821, became assistant to the scene painter Thomas Olivier (1772–1839), chief decorator at the Grand Théâtre in Bordeaux. In Paris he joined the atelier of Julien Michel Gué (1789–1843), and was recommended by him to the decorators of the Théâtre Italien – Mattis, Desroches and Blanchard.

Dauzats's association with Baron Taylor dated from 1827, when, together with J.-B. Isabey, Bonington, Villeneuve and Ebeniste Fragonard, he contributed designs for lithographs to the *Voyages pittoresques dans l'ancienne France* (1820–78). It was through Taylor that he made his first voyage to Egypt, Syria, Palestine and Turkey in 1830, as lithographer on a *mission civilisatrice*, the main purpose of which was to secure from Muḥammad 'Alī two obelisks from the ruins of Thebes.

In subsequent years Dauzats spent much time in Spain, Portugal and the French provinces, and in 1839 accompanied the Duc d'Orléans on the expedition to the Gates of Iron, an impressive fortress in the Djurdjura mountains in southern Algeria.

Throughout his career, Dauzats maintained an active interest in the recently established provincial art societies, and overcame a deteriorating asthmatic condition to serve on the 1862 selection committee for the London International Exhibition, and as a member of the jury at the Exposition Universelle of 1867.

9

Monastery of St. Catherine, Mount Sinai 1845

Le Couvent de Ste. Catherine au Mont Sinaï

130 × 104 cm
Signed bottom right: *A. Dauzats*
Musée du Louvre, Paris
[*repr. in colour on p. 92*]

Having arrived in Alexandria on 20 April 1830, Dauzats's party spent several weeks in Cairo, before setting off at the beginning of July with guides from the Awlad Saʿīd tribe to cross the Sinai desert. After a rough and hazardous journey, lasting nearly three weeks, they reached the monastery of St. Catherine. The next four days, spent sketching and familiarising themselves with the environs, were, according to Dauzats, 'the most perfectly spent and happiest of my life' (A. Dauzats and Dumas [père], *Quinze jours au Sinaï*, 1841, p. 112). The monastery was frequently visited by artists and writers in the nineteenth century; both David Roberts (*q.v.*) and J.F. Lewis (*q.v.*) executed versions of the scene in 1842, and Alberto Pasini (*q.v.*) exhibited a view at the Salon of 1863. Access to the monastery was itself treacherous, and though the walled-up gateway was opened on the visit of the patriarch, the less-esteemed pilgrim was required to scale almost forty feet of sheer rockface to enter by chair lift through a skylight.

Dauzats's training in the theatre, with his ability to create the *pittoresque* within the confines of a stage set, is very apparent in this imposing image. The high horizon, deep shadow and dramatically illuminated cliffs form a backdrop to the monastery, 'suspended in space like the eyrie of an eagle' (P. Lenoir, *The*

Fayoûm, or Artists in Egypt, 1873, p. 213). The allusion to the insignificance of man in the face of the mighty forces of nature occurs too in Dauzats's earlier lithographic work, as in the evocative *Fontfroide, cloître de l'abbaye cistercienne, XIII siècle* (Priv. Coll., Toulouse). Contemporary writers were aware of the similarities between Gothic and Oriental architecture; as one observer noted, in providing the ogival arch as a point of departure, Oriental architecture might even be said to be 'the mother of our Gothic architecture' (N. L'Hôte, 'Egypte sous le point de vue pittoresque', *L'Artiste*, V, 1833, p. 244). For the English artist W.J. Müller (*q.v.*), Turkish costume brought to mind scenes from the Gothick novel *Vathek*, and Dauzats's later works, such as the *Portes de Fer* (1853: Musée des Beaux-Arts, Lille) and *Sinbad le marin* (1865; Musée des Beaux-Arts, Bordeaux) reveal his fascination with the emotive and picturesque qualities of the architecture, overlaid with its literary associations and fairy-tale allusions.

Oriental subject-matter provided scope for Dauzats's natural predilection for strong colour and powerful effects, which had in some cases been out of place in views of French buildings such as *Vue de l'abbaye de St. Denis* (1833).

Delacroix (*q.v.*) is known to have admired Dauzats's technical command as an architectural painter, and consulted him for the background of the *Deux Foscari* (B.710; 1855). For his part, Dauzats helped to promote local interest in Delacroix in Bordeaux, and for a time exercised a favourable influence on his behalf at the Orléans court. J.M.

PROVENANCE
1845, acquired by the State from the Salon

EXHIBITIONS
1845, Paris, Salon (no. 45)
1968–69, Paris, Petit Palais, *Le Centenaire de Baudelaire* (no. 129, ill.)
1975, Marseille, Musée Cantini, *L'Orient en question* (no. 40)
1982, Rochester, New York, Memorial Art Gallery, *Orientalism* (no. 44)

REFERENCES
Thornton 1983, p. 30, ill.
W.J. Müller, 'Letters from Xanthus by W. Müller', *Art-Union*, VI, April 1844, p. 357
Ch. Baudelaire, 'Salon de 1845, *Le Centenaire de Baudelaire*, I, Paris, 1965, p. 64
Ph. Jullian, *The Orientalists. European Painters of Eastern Scenes*, Oxford, 1977, ill. p. 145

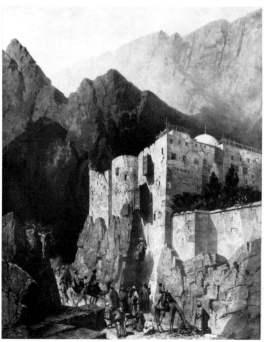

9

Delacroix, Ferdinand Victor Eugène

1798–1863

Delacroix was born in Charenton-St-Maurice (Val de Marne), but moved to Paris in 1805 on the death of his father. At the age of seventeen, encouraged by his uncle, the painter Henri Riesener, he entered the private atelier of Pierre-Narcisse Guérin (1774–1833), and subsequently passed into his class at the Ecole des Beaux-Arts. Delacroix gained much of his formative training through his frequent visits to the Louvre, where, until 1815, he could study the Old Master paintings pillaged by Napoleon during his European campaigns.

In 1822, he made a remarkable, and controversial, Salon debut with *La Barque de Dante* (Louvre, Paris), and the emotional turbulence of his early works led him to be hailed as the Victor Hugo of painting and leader of the Romantic school.

Delacroix made his only voyage to North Africa in 1832, as a late replacement for the painter M. E. Isabay in the suite of the Comte de Mornay. Though the trip lasted only six months, its impact on his artistic career was both iconographically and technically profound. His vision of a living, sublime Antiquity in these countries enabled him to strike a balance between the romantic and classical elements in his work.

The year after his return from North Africa, Delacroix was asked to decorate the Salon du Roi (Palais Bourbon), the first of several large-scale works commissioned by the State. Subsequent cycles were executed for the Library (Palais Bourbon, 1833–47), the Library in the Palais du Luxembourg (1840–46), the ceiling of the Galérie d'Apollon in the Louvre (1850–51), decorations at the Salon de la Paix, Hôtel de Ville (1852–54, destroyed in 1871), and finally at the Chapelle des Anges, St. Sulpice (1853–61). Delacroix's repertoire was enormous. Though he frequently returned to themes later in his career, they never dominated his œuvre to the exclusion of other genre, which included literary, mythological and allegorical subject-matter, battle-pieces, portraits, animal paintings and still-lifes.

ABBREVIATED REFERENCES
Robaut A. Robaut and E. Chesneau, *L'Oeuvre complète de Eugène Delacroix, peintures, dessins, gravures, lithographies*, Paris, 1885
Journal E. Delacroix, *Journal de Eugène Delacroix* (ed. A. Joubin), Paris, 1932, 3 vols.
Corr. E. Delacroix, *Correspondance Générale de Eugène Delacroix* (ed. A. Joubin), Paris, 1936–38, 5 vols.
B. L. Rosi Bortolatto, *L'Opera completa di Delacroix*, Classica dell'arte, Milan, 1972
J. L. Johnson, *The Paintings of Eugène Delacroix. A critical catalogue 1816–1831*, Oxford, 1981, 2 vols.

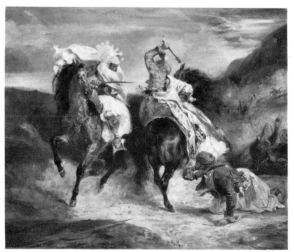

10

10*

Combat between the Giaour and the Pasha 1826

Le Combat du Giaour et du Pasha

59·6 × 73·4 cm
Signed bottom left: *Eug. Delacroix*
The Art Institute of Chicago

This painting is one of at least six versions of a theme inspired by Lord Byron's poem *The Giaour, a Fragment of a Turkish Tale* (1813), which were executed between 1824 and 1856. All vary considerably in composition and in their relative dependance upon the original poem. Like many nineteenth-century artists, Delacroix acquired a foretaste of the East through Romantic literature. He had become familiar with Byron's poetry through the translations of Amedée Pichot (1822–25) and in an entry in his journal of 11 May 1824, he referred to specific passages as potential sources of artistic inspiration: 'The poet is very rich, keep in mind forever certain passages of Byron to excite the imagination. They suit you well . . . the end of the *Bride of Abdyos*, the *Death of Selim*, his body tossed about by the waves . . . the *Death of Hassan* in the *Giaour* . . . the *Curses of Mazeppa* against those who have bound him to his steed' (Journal, I, pp. 99–100). As in other works inspired by such literary sources as Shakespeare, Dante, Scott and Milton, the original text of Byron's poem is not rigidly interpreted, but acts as a catalyst for Delacroix's powerful imagination. Here, the exoticism of the setting and violence of action are successfully combined with a nascent Orientalism; studies of Turkish weapons (J.27) and Greek costume (J.28) date from 1824, the year in which Delacroix is known to have made sketches of costumes and artefacts in the collection of the artist and traveller, M. Auguste (Journal, I, p. 117; 8 July 1824). As in the *Scène de la guerre actuelle entre les Turcs et les Grecs* (Salon 1824; J.115), the flamboyant dress and Oriental arms are not merely decorative additions but are subservient to the overall sense of the picture. The billowing cloaks of the combatants form a sweeping central diagonal, intensified by the horses' windswept manes, and the height of the dramatic conflict is held in suspension by the fiery glint of the armour, the poised weapons and the passionate gaze of the 'accursed Giaour'.

Rejected on two occasions by the Salon, this painting was exhibited at the Galerie Lebrun in September 1826 in aid of the Greek Wars of Independence, together with *L'Officier turc tué dans les montaignes* (1826; J.113) and *L'Exécution de Marino Faliero* (1826, J.112). As may be judged from *La Grèce sur les ruines de Missolonghi* (1826; J.98), Delacroix was fully aware of Byron's involvement in the Greek Wars, a sympathy he himself shared in the *Scènes des Massacres de Chios* (J.105), exhibited at the 1824 Salon. In these paintings, as in the *Combat between the Giaour and the Pasha*, Delacroix's ability to relate contemporary events to romantic verse served as a suitable prelude to his confrontation with the poetic actuality of life in North Africa.

There are six works relating to this painting: *Scène de la guerre actuelle entre les Turcs et les Grecs* (1827; B.168); *Un officier turc tué dans les montaignes* (1827; B.94); *Combat du Giaour et du Pasha* (1835; B.270); *Combat du Giaour et du Pasha* (1856; B.733); *Le Giaour poursuivant les ravisseurs de sa femme* (1849; B.541); *Giaour au bord de la mer* (1849/50; no B. no.). J.M.

PROVENANCE
c.1827–May 1848, Alexandre Dumas, père; 1848, May, to at least 1885, Charles Mahler; by 1889, Mr Potter Palmer, Chicago; 1902, Mrs Berthe Honore Palmer, his widow; 1918, Mr Potter Palmer Jr.; 1943, Mrs Pauline Kohlsaat Potter Palmer, his widow; 1956, joint ownership of her four heirs; 1962, 28 December, donated by them to the permanent collection of the Art Institute of Chicago

EXHIBITIONS
1826, Paris, Galerie Lebrun (no. 44)
?1827, Paris Salon
1827, Douai (no. 94)
1829, Paris, Musée Colbert (no. 8)
1846, Paris, Galerie des Beaux-Arts, Suites du supplément (no. 98)
1860, Paris, Boulevard Italiens (supp. no. 345)
1864, Paris, Boulevard Italiens (no. 78)
1885, Paris, Ecole des Beaux-Arts, Exposition Eugène Delacroix (no. 135)
1889–1890, New York, American Art Association, Catalogue of the Works of Antoine-Louis Barye . . . for the benefit of the Barye Monument Fund (no. 613)
1910, Paris, Galeries Georges Petit, Exposition des chefs d'oeuvres de l'Ecole Française (no. 62)
1930, Chicago, Art Institute, Loan Exhibition of Paintings, Watercolors and Drawings by Eugène Delacroix (no. 3, ill.)
1930, Paris, Louvre, Exposition Eugène Delacroix. Centenaire du Romantisme (no. 40)
1938–1939 New York, Knoedler & Co. and Chicago, Art Institute, Gros, Géricault, Delacroix (no. 41, ill.)
1945, Washington, Phillips Memorial Art Gallery, Delacroix, A Loan Exhibition (no. 2)
1955, Paris, Musée de l'Orangerie, De David à Toulouse-Lautrec, Chefs d'oeuvres des collections américaines (no. 23, ill. pl. 13)
1974, London, Victoria and Albert Museum, Byron (no. 69. ill.)

REFERENCES
Robaut 202
Journal, I, pp. 99–100
Corr., I, p. 128
B. 130
J. 114
Th. Gautier, Les Beaux-Arts en Europe, Paris, 1855, pp. 184, 185
G. H. Hamilton, 'Eugène Delacroix and Lord Byron', Gazette des Beaux-Arts, 6ᵉ période, XXIII, 1943, pp. 99–110

11

Moroccan Military Exercises 1832

Exercices militaires des Marocains

59 × 73 cm
Signed and dated bottom centre: *Eug. Delacroix 1832*
Musée Fabre, Montpellier

During his stay in North Africa, particularly en route from Tangier to Meknes, Delacroix witnessed several spirited 'powder plays', or dramatic displays of horsemanship in mock battle. He referred to a *course de poudre* at Alcassar-el-Kebir (Journal, I, p. 131; 9 April 1832), and to a noisy reception at Souk el-Hadat Rharbia (which he called Garbia), when his party was welcomed by a riotous volley of crossfire (Corr., I, p. 321; 6 March 1832).

The *Moroccan Military Exercises* (also known as *Fantasia arabe* and *Marocains courant le poudre*) is the first of five oil paintings (*Fantasia arabe*, 1833, B.244; *Rencontre des cavaliers maures*, 1833, B.245; *Rencontre des cavaliers maures*, 1847, Robaut 1268bis; *Exercises militaires des marocains*, 1847, no B. no.) and one watercolour (Louvre, Paris; RF.3372) inspired by these events, and executed between 1832 and 1847.

The almost contemporary *Fantasia arabe* of 1833 is similar to the painting exhibited here, although the composition has been reversed and is less dynamic, Delacroix having substituted a seated Arab for the rearing horseman as a block to the furious horizontal thrust of the group of riders. In *Moroccan Military Exercises*, the landscape background all but disappears in the gunsmoke and the dust raised by the horses' hooves. The unremitting forward impulse is unchecked by the least detail of costume and physiognomy, and only the headdress in the foreground brings the fantasy earthbound.

Throughout his career, Delacroix was captivated by the horse, both as a creature of untamed passions and as an animal of great refinement and sensibility. In his work, the horse became 'almost

a human being: it is associated with the actions of his heroes, and identified with their passions' (H. de la Madelène, *Eug. Delacroix à l'Exposition du Boulevard des Italiens*, 1864, p. 18). Letters and notes from the Moroccan period contain frequent references to horses and Delacroix was particularly exhilarated by the sight of two horses fighting in a stable, noting 'all the furies of Gros and Rubens are tame by comparison' (Corr., I, p. 311; 8 February 1832). In 1860, some twenty-eight years after witnessing the scene, Delacroix recorded the battle in a painting now in the Louvre, Paris (B.779). Significantly, the lyrical *Chevaux sortant de la mer* (B.780) dates from the same year and, though also based on his Algerian experiences, it differs entirely in spirit and rhythm. In many respects Delacroix's representation of the horse may be taken to symbolise the dualities which he confronted in North Africa, and which are so prevalent in his Orientalist work. Possessing both Rubensian fury and Apollonian refinement, it captured in essence the unspoilt, vital beauty of the country. J.M.

PROVENANCE
Sold by Delacroix to Mr Wertheimer; 1861, acquired by Alfred Bruyas at Wertheimer sale; 1868, presented by Alfred Bruyas to the Musée Fabre, Montpellier

EXHIBITIONS
?1847, Paris, Salon (no. 460)
1864, Paris, Exposition des oeuvres de Delacroix, (no. 300, as Charge des cavaliers arabes)
1900, Paris, Exposition centennale (no. 215)
1930, Paris, Petit Palais, Exposition du centenaire de la conquête de l'Algérie (no. 177)
1931, Paris, Exposition coloniale
19?, Bern, Kunsthalle, Meisterwerke des Museums in Montpellier (no. 32)
1936, Paris, Petit Palais, Gros, ses amis, ses élèves (no. 237)
1963, Paris, Louvre, Exposition du Centenaire de la mort d'Eugène Delacroix (no. 189)
1983, Tokyo, Yamaguchi, Osaka and Kamakura, Peintures des XVII, XVIII, XIXe siècles dans les collections françaises

REFERENCES
Robaut 408
B. 238
M. Sérullaz, 'Les Chefs d'Oeuvres du Musée de Montpellier', Chronique d'Art, April 1939, p. 243
L. Johnson, 'Delacroix's "Rencontre des Cavaliers maures"', Burlington Magazine, CIII, October 1961, pp. 417, 418 (fig. 14)

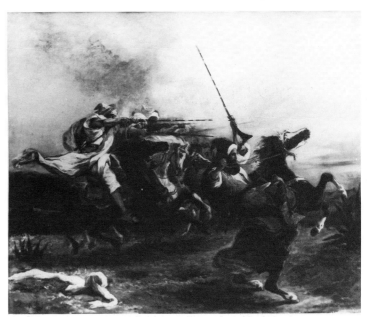

11

12

Arab Chief visiting a Tribe 1837

Le Kaïd, chef marocain

98·3 × 125·7 cm
Signed and dated bottom right: *Eug. Delacroix 1837*
Musée des Beaux-Arts, Nantes
[*repr. in colour on p. 42*]

Like the *Moroccan Military Exercises* (Cat. 11), and the *Sultān of Morocco* (Cat. 15), this painting was directly inspired by an incident which took place during Delacroix's travels through the North African countryside between Meknes and Tangier and is recorded in his notebooks on 9 April 1832. In the Salon *livret* of 1838 Delacroix explained the ceremony at Alcassar-el-Kebir: 'He [the Arab chief] is at the head of a troop of soldiers. The inhabitants of the village come to pay him homage on his way. A woman presents him with a bowl of milk into which he dips his fingers, and lifts it to his lips.' As in Delacroix's other Orientalist work, the realistic portrayal of the actual event is not the predominant concern. Instead, the portrayal of the incident is modified to meet specific pictorial demands; illumination is naturalistic but carefully directed to highlight the central group of figures; the lines of composition converge on the Qā'id through the turning movement of the woman who presents the milk and the horsemen approaching from the rear. These figures also draw the eye through the river valley into the distant landscape and enhance the pictorial unity, while a selective choice of colour relates the figures to the overall tonalities. As in *The Fanatics of Tangier* (Cat. 13), and in the earlier *La Liberté guidant le peuple* (1830; J.144), Delacroix uses the device of a flag to highlight key areas of the painting. Here, the generalised features of the Arab leader are framed above the horizon as he looks down towards the offering, thus drawing attention to the powerful but quiet gesture and hence to the very meaning of the ceremony. Exhibited in the same year as *The Fanatics of Tangier*, this calm pastoral scene dramatically differs in both spirit and composition. It evokes the innate grandeur and lyricism of the Arab people, which had immediately struck Delacroix on arrival in Tangier. In a famous letter to J. B. Pierret, he likened the dignified disposition and flowing *burnūs* of the natives to those of decorous Roman patricians: 'Imagine, my friend, what it is to see lying in the sun, walking about the streets, cobbling old

shoes, figures like Roman consuls, like Catos or Brutuses, with even that disdainful look which those rulers of the world must have worn' (Corr., I, p. 319; 29 February 1832). For Delacroix, the Antique was not to be found in the insipid copying of plaster casts, as recommended by academic training, but in the living realities of these exotic climes. In 1862 Delacroix painted a second version of this theme (B.794), in which the number and size of the figures have been reduced and their relationship with the landscape considerably altered. J.M.

PROVENANCE
1839, acquired by the Musée des Beaux-Arts, Nantes following the Salon des Artistes vivants
EXHIBITIONS
1838, Paris, Salon (no. 458)
1839, Nantes, Salon des Artistes vivants (no. 71)
1864, Paris, *Exposition des oeuvres de Delacroix* (no. 3, as *Chef marocain visitant un tribu*)
1930, Paris, Louvre, *Exposition Eugène Delacroix. Centenaire du Romantisme* (no. 84)
1933, Paris, Orangerie, *Voyage de Delacroix au Maroc* (no. 180)
1939, Zürich, Kunsthaus (no. 326)
1947–48, Brussels, Palais des Beaux-Arts, *De David à Cézanne* (no. 26)
1963, Paris, Louvre, *Exposition du centenaire de la mort d'Eugène Delacroix* (no. 261, ill.)
1963–64, Bern, Kunstmuseum, *Eugène Delacroix* (no. 42)
1973, Paris, Atelier Delacroix, *Delacroix et la peinture liberté*
1980, Nantes, Musée des Beaux-Arts, *Orients* (no. 4, ill.)
REFERENCES
Robaut 647
Journal, I, p. 148
B.296
M. Nicolle, *Catalogue, Musée des Beaux-Arts, Nantes*, 1913, no. 892

13

The Fanatics of Tangier 1838

Les Convulsionnaires de Tanger

98 × 131 cm
Signed and dated bottom right centre: *Eug. Delacroix, 1838*
The Minneapolis Institute of Arts, bequest of Jerome Hill
[*repr. in colour on p. 143*]

The 'Isāwiyyah sufi brotherhood was founded in Meknes by Sīdī Muḥammad ibn 'Isā (1452–1524) who had been a follower of the immense Shadhilī brotherhood. It spread throughout western Islamic lands. Its ceremonies were particularly strenuous involving jumping, leaping and other activities noted below and seemed particularly to have alarmed European observers, although as with all sufis they were controlled strictly by their

12

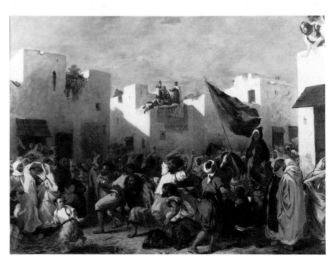

13

shaykh. Delacroix depicts in this work the fanaticism of their religious devotion, when, having been confined in the courtyard of a house, they burst forth into the streets of Tangier, screaming, gesticulating wildly and foaming at the mouth. Both the local populace and visiting foreigners found themselves spellbound by the spectacle with its throbbing musical accompaniment. In particular, it captured the romantic imagination of Théophile Gautier, who had witnessed the event during a voyage to North Africa: 'By means of prayer, the prolonged swaying of the upper body, the insistent rhythmical pounding of *tarboukas* and the odour of perfumes, perhaps mingled with that of hashish, these brothers reach a state of ecstasy or hallucination which enables them to roll on burning coals, eat scorpions, snakes or cactus leaves, lick red-hot irons and walk bare-footed on sword blades, apparently without noticing their injuries' (*L'Artiste*, 1870, p. 77).

Delacroix successfully evokes the frenzy of the occasion in the fervent colouring and convulsive gestures of the central group of fanatics and in places even the rhythmic staccato of the brushwork accentuates the ecstatic state of the participants. A note of sobriety is introduced in the stately bearing of the Arab chief and in the figures suspended over the balconies in curious wonderment. The sharp geometrical volumes of the architecture act as stabilisers to the emotional excess, as do the purer limpid blues and whites in the upper half of the picture. In the sharp contrast of action and passive observation, Delacroix, like Flaubert (see Cat. 39), clearly expresses the confrontation of a European rationality with a totally alien culture, steeped in mysticism and secret rites.

In 1857, Delacroix painted a second and much reduced variant of this theme, with a freedom of brushwork characteristic of his later style (B.743). In this later picture, far greater stress is placed on the violent gestures of the individual fanatics and the architectural framework becomes less defined and more atmospheric. J.M.

PROVENANCE
Van Isacker; 1852, Jourdan; 1855, Melá; 1860, Boulevard des Italiens, sale; 1863, acquired by Marquis de Lau; 1869, Edwards; 1881 Salensi (or Feder); 1885, Faure; 1888, George I. Seney, New York; 1895, James J. Hill; 1973, bequeathed by Jerome Hill to the Minneapolis Institute of Arts

EXHIBITIONS
1838, Paris, Salon (no. 457)
1855, Paris, *Exposition Universelle* (no. 2933)
1860, Paris, Boulevard des Italiens
1864, Paris, *L'Exposition du cercle de la Rue du Choiseuil*
1878, Paris, Galerie Durand-Ruel (no. 145)
1930, Paris, Louvre, *Exposition Eugène Delacroix. Centenaire du Romantisme* (no. 85)
1941, Minneapolis, Institute of Arts, *Exhibition of Private Collectors*
1963, Paris, Louvre, *Exposition du centenaire de la mort d'Eugène Delacroix* (no. 259)

REFERENCES
Robaut 647
B. 293
Th. Gautier, 'Une Galerie romantique', *L'Artiste*, April 1870, p. 77
P. de Saint-Victor, 'L'Ecole moderne', *L'Artiste*, April 1870, pp. 81–82
E. Moreau Nelaton, *Eugène Delacroix raconté par lui-même*, Paris, 1916, pp. 163–64
J. Meier-Graefe, *Eugène Delacroix, Betruge und einer Analyse*, Munich, 1922, p. 128
R. Eschólier, *Delacroix, peintre, graveur, écrivain*, II, Paris, 1927, p. 72

14*

The Death of Sardanapalus 1844
La Mort de Sardanaple

74 × 93 cm
Henry McIlhenny Collection, Philadelphia

Painted in 1844, this is a smaller variant of the monumental *Death of Sardanapalus* (Salon 1827; J.125) now in the Louvre, Paris. The scene is partly inspired by Lord Byron's dramatic poem of 1821, itself ultimately drawn from a legend dating from the beginning of the fourth century BC. As in the *Combat between the Giaour and the Pasha* (Cat. 10), Delacroix took significant pictorial liberties and, while he followed the poet's characterisation of the dignified *ennui* of the king of Nineveh, he departed from the text in several details. In an exhaustive analysis of the picture, Lee Johnson has suggested a wide range of pictorial and literary sources, drawn from classical legend, pseudo-Etruscan reliefs, '"licentious paintings from Delhi"' and Romantic drama. He has also pointed to the spatial anomalies of the composition, in which the diagonal thrust of Rubens's *Descent from the Cross* is combined with the frieze-like disposition of the foreground figures (J., pp. 116–20). As an image of the Orient, *The Death of Sardanapalus* has provoked some controversial interpretations. Edward Said sees it as encapsulating and even encouraging the continuing desire by the West to dominate and oppress Eastern culture (*Orientalism*, New York, 1978, chap. 3). For Linda Nochlin, on the other hand, the erotic and sadistic elements in the painting powerfully suggest the 'ideology of male domination: the connection between sexual possession and murder as an assertion of absolute domination' (Nochlin, 1983, p. 125), with the Orientalist setting used to enchance 'an extreme state of psychic intensity '(*ibid.*, p. 124). However, Sardanapalus and the legendary slaughter of his retinue continued to fire his imagination. While this later version differs in its looser handling and less aggressive colouring, it remains similar in spirit and theme.

The ease with which very diverse sources are combined in this painting finds a parallel in the transformation of certain themes within Delacroix's work and is explained too by his belief that the imagination is 'the foremost quality of the artist' (Journal, III, p. 44; 25 January 1857). Thus, *La Liberté guidant le peuple* of 1830 (J.144) combines an allegory of a modern-day event, references to a classical 'Victory' pose, the gesture of the angel freeing St. Peter in Raphael's Vatican Stanze, and a character in Act III of Byron's *Sardanapalus*, without overwhelming the central theme

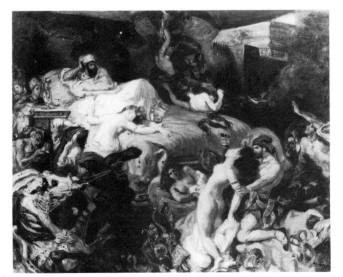

14

by the disparate nature of the sources. In the same way, Delacroix re-explores the format of the *Barque de Don Juan* (1847; B.351) in a series of pictures of Christ on Lake Gethsemane executed between 1853 and 1854.

Unlike artist-converts to Orientalism, such as Frère (*q.v.*), and, to a lesser extent, Guillaumet (*q.v.*) and Girardet (*q.v.*), Delacroix absorbed his experiences in Morocco both iconographically and technically into his wider artistic vocabulary. Literary, religious and mythological subject-matter was not rejected in the frantic desire to recapture the myriad picturesque facets of the East, but continued to occupy a considerable proportion of his output. J.M.

PROVENANCE
Legrand; Crabbe, Brussels; Bellino; Paul Rosenberg, Paris; Henry McIlhenny

EXHIBITIONS
1944, New York, Wildenstein (no. 18)
1947, Philadelphia, Museum of Art (no. 4)
1949, Philadelphia, Museum of Art (loan)
1950–51, Philadelphia, Museum of Art (no. 52)
1962, San Francisco, California Palace of the Legion of Honour
1970, Philadelphia, Museum of Art (loan)
1977, Allentown, Penn., Allentown Art Museum, *French Masterpieces of the Nineteenth Century from the Henry P. McIlhenny Collection* (p. 30, ill. p. 31)
1982, Rochester, New York, Memorial Art Gallery, *Orientalism* (no. 27, ill.)

REFERENCES
Robaut 791
B.416
J., pp. 116–20
G. H. Hamilton, 'Delacroix and Lord Byron', *Gazette des Beaux-Arts*, 6ᵉ période, 23, February 1943, pp. 105–22
E. Porada, 'The Assyrians in the last hundred years', *Bulletin of the Metropolitan Museum of Art*, 1945, no. 4, p. 39, ill.
B. Farwell, 'Sources for Delacroix's "Death of Sardanapalus"', *Art Bulletin*, March 1958, pp. 66–71
J.J. Spector, *Delacroix: The Death of Sardanapalus*, London, 1974, pp. 43, 44, ill. p. 102
H. Toussaint, *La Liberté guidant le peuple de Delacroix*, Musées nationaux, Les Dossiers du département des peintures, 26, 1982
L. Nochlin, 'The Imaginary Orient', *Art in America*, 71, May 1983, pp. 119–31, 186–91

15*

'Abd al-Rahmān, Sultān of Morocco, leaving his Palace at Meknes, surrounded by his Guard and his Principal Officers 1845

'Abd er-Rahman, Sultan du Maroc, sortant de son Palais de Mequinez entouré de sa garde et de ses principaux officiers

384 × 343 cm
Signed and dated bottom left centre: *Eug. Delacroix 1845*
Musée des Augustins, Toulouse

Delacroix's party was officially received by the Sultān of Morocco, 'Abd al-Rahmān, on 22 March 1832, having been confined for several days in a house in Meknes. This painting, exhibited at the Salon of 1845, was intended to commemorate the signing of a treaty between the Moroccan leader and the French government, the principal aim of the diplomatic mission led by the Comte de Mornay in 1832, which in the event was never ratified. Subsequent diplomatic negotiations met with a similar lack of success. In 1844 relationships between the two countries reached a nadir when 'Abd al-Rahmān joined forces with 'Abd al-Qādir against the French and war nearly broke out in Spain after the murder of a consular agent, Victor Darmoni. With the support of a multinational fleet in the Mediterranean, the French navy bombarded the combined Moroccan forces at Mogador in the Battle of Isly on 13 August 1844 and the Sultān capitulated to the French. The French victory was reported in

L'Illustration of 21 September 1844. A compositional drawing in the Louvre, Paris (RF.9383) reveals Delacroix's initial intention to include members of the French diplomatic mission in the foreground, a solution rejected in the final version, possibly because it was considered inappropriate in the light of subsequent political developments.

The easy grace of the Sultān gives neither an indication of the turbulent events of the intervening years, nor any suggestion of his position as a defeated leader. The pose rivals in grandeur Chassériau's portrait of 'Alī ibn Hāmid (see Cat. 8), also exhibited in the Salon of 1845. In his account of the audience (Journal, I, 22 March 1832, p. 141), Delacroix remarked on the resemblance of the Sultān to King Louis-Philippe and noted the striking blue and white silks, as well as the effect of the parasol, so forcefully recreated in the painting. The pose itself possibly derives from a large etching of the Turkish Emperor Selim III in Antoine Melling's *Voyage pittoresque de Constantinople et des Rives de Bosphore* (1808–19). It is also similar to a wash drawing by Delacroix of 1831 for *Duqueslin au Château de Pontsoron* and to a copy by Thales Fielding after Richard Westall's *Wellington's Entry into Toulouse*. By using these sources, realism is characteristically sacrificed to pictorial considerations. Even the location of the ceremony is 'fictionalised', set outside the monumental Bāb Mansour gate on the outer wall of Meknes, and not in the inner courtyard, where the visitors were actually received.

The image is one of stability, created by the frame of the architecture and the *repoussoir* foreground figures, with only the very slightest movement in the billowing draperies of the figure who holds the Sultān's horse. The subtle, oblique lines of the soldiers' rifles and the long parasol handle, together with the turning movements of the figures on the extreme right and left, draw the eye gently but resolutely to the self-possessed figure of the Sultān. In contrast to the other lines in the composition, this central group is composed of a series of easy curves, the convex shape of the parasol echoed in the Sultān's hood and shoulders, and his right leg continuing the soft serpentine line formed by the poised head of his thoroughbred mount.

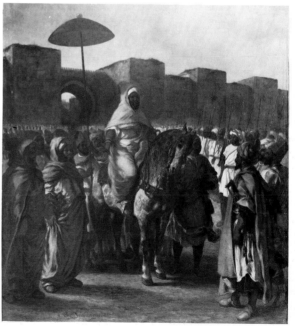

15

Baudelaire, in his review of the Salon of 1845, referred to the 'real and natural' effects of the composition, and to the harmonious and spiritual colouring of this *'grande coquetterie musicale'* : 'In spite of the splendour of its tones, this painting is so harmonious that it is grey – grey as in a summer's atmosphere, when the sun spreads out on each object an aura of trembling dust' (1965, I pp. 26–27).

Delacroix blends bright colours to create a luminosity which suggests not only the vibrant intensity of the light, but also the ferocious dry heat of the Orient. In this, and in the repetition of greens, blues and reds in the costumes and shadows, the painting conforms to Delacroix's concept of 'liaison', which he defined as 'this air, these reflections which make of the most disparately coloured objects a whole' (Journal, III, p. 14, 13 January 1857). J.M.

PROVENANCE
Brought by the State; deposited by the State in the Musée des Augustins, Toulouse

EXHIBITION
1845, Paris, Salon (no. 438)

REFERENCES
Robaut 1744
Journal, I, p. 141
Corr., I, p. 323
B.423
J. Guiffrey, *Le Voyage de Eugène Delacroix au Maroc*, Paris, 1909, II, p. 7
E. Lambert, *Histoire d'un tableau. L'Abd-Er-Rahman, Sultan du Maroc de Delacroix*, Institut des Hautes Etudes Marocaines, No. XIV, Paris, 1953
C. Baudelaire, 'Salon de 1845', *Baudelaire Critique d'Art*, I, Paris, 1965, pp. 26–27
F. A. Trapp, *The Attainment of Delacroix*, Baltimore and London, 1971, p. 136
L. Johnson, 'Towards Delacroix's Oriental Sources', *Burlington Magazine*, CXX, 1978, pp. 144–51
L. Johnson, 'Delacroix's Road to the Sultan of Morocco', Apollo, CXV, 1982, pp. 186–89

16

The Lion Hunt 1855

La Chasse aux lions

56·8 × 73·8 cm
Signed and dated bottom centre right: *Eug. Delacroix 1855*
Nationalmuseum, Stockholm
[*repr. in colour on p. 44*]

Like Delacroix's images of the horse (see Cat. 11), his depictions of lion hunts were not exclusively inspired by recollections of North Africa, but were part of the development of a theme which had interested the artist early in his career. Following the

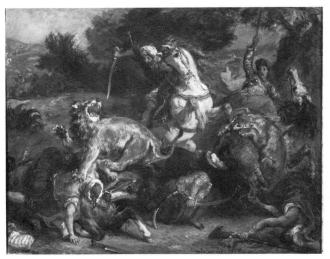

16

example of Géricault, Delacroix frequented the menageries at St.-Cloud from 1828, together with the sculptor Antoine Barye, and in 1829 produced two lithographs and one oil painting (J.55) which reveal his close anatomical study of these animals. Throughout the 1830s, he sustained an interest in lions and tigers and took up the theme with renewed enthusiasm in the 1840s. The present painting is one of a series of complex hunting scenes executed between 1854 and 1861. In each of these Delacroix is preoccupied less with the recording of a specific event than with the more general expression of the relationship between Man and Nature and with the technical solution to a purely artistic problem.

In terms of visual sources, *The Lion Hunt* is the most 'European' of all Delacroix's Orientalist works. As well as referring to contemporary albums and prints, such as Jules Gérard's *La Chasse aux Lions* (1854), Delacroix from c. 1830 is known to have been familiar with Rubens's hunting scenes, mainly through the engravings of Pieter Claesz. Soutman, but also through those of Bolswert and Suyderhoff. In his journal entry for 25 January 1847, he commented on the admirable execution of Rubens's *Lion Hunt* (Alte Pinakothek, Munich), and on the striking effect of 'the rearing horse, the shaggy manes and tails, a thousand props, unbuckled shields and tangled bridles.' However, he found 'the point of view confused: the eye does not know where to rest; one has the impression of fearful conflict, but it appears that art is not sufficiently in control to enhance through careful arrangement or selectivity the effect of so many brilliant inventions' (Journal, I, p. 168).

While it follows Rubens in spirit and composition, this painting, based on a highly coloured oil sketch (B.698) for the badly damaged *Chasse aux Lions* at Bordeaux (B.703), differs in the greater clarity of the groupings and the agitated, overtly constructive brushstrokes. Less abstract than its sketch, the Bordeaux picture with its jewel-like colouring was generally badly received by critics at the Exposition Universelle in 1855: 'The colour is very brilliant, but it vibrates, pulsates, and in this chaos of reds, greens, yellows and violets, all of the same tonal values, the *Lion Hunt*, resembles a tapestry' (Petroz, *La Presse*, 5 April 1855; quoted Sérullaz, 1963, p. 154). Here, the picture space, while slightly deeper than in the Bordeaux painting, still forms a tightly-packed foreground running parallel to the picture plane, creating a strong, two-dimensional effect. Later versions at Boston (B.756) and Chicago (B.790) are formal variations on the theme, differing most obviously in their more open picture space, greater fluidity of composition and in the relationship of the figures to the landscape. Common to each is the subordination of anatomical and realistic detail to the expression of upheaval and the sense of the inherent struggle between Man and the forces of Nature. J.M.

PROVENANCE
1970, gift of Professor Sandblom to the Nationalmuseum

REFERENCES
Robaut 1278
Journal, I, p. 111 n. 1, p. 168
B. 704
M. Sérullaz, *Memorial de l'Exposition du Centenaire de la mort d'Eugène Delacroix*, Paris, 1963, p. 144
F. A. Trapp, *The Attainment of Delacroix*, London, 1971, pp. 209–12
E. T. Kliman, 'Delacroix's lions and tigers: a link between man and nature', *Art Bulletin*, LXIV September 1982, pp. 446–66

17*

The Collection of Arab Taxes 1863
La Perception de l'impôt arabe

92·5 × 74·2 cm
Signed and dated bottom left of centre: *Eug. Delacroix 1863*
National Gallery of Art Washington Chester Dale Collection 1966
[*repr. in colour on p. 45*]

Completed in the year of his death, this painting typifies Delacroix's later Orientalist work in which fantasy is given full reign and a mellowed recollection replaces any concern for realistic detail. Robaut catalogued this painting as *La Perception de l'impôt arabe* (1448), an interpretation upheld by Johnson, who has suggested that the subject was inspired by a conversation with Amin Bias, the Minister of Foreign Affairs in Morocco, who spoke of enforcing 'the imposition of taxes and arrest for sedition' (Journal, I, p. 137; Johnson, 1962, p. 60).

In the last years of his life, Delacroix became increasingly preoccupied with Man's relationship to his environment. This interest was reflected in his concern to integrate the subject and landscape settings of his pictures. The violent clashes between Man and Nature, in its wild and passionate state, find expression in the hunt scenes of the mid-1850s (see Cat. 16) and in several variations on the theme of Christ on Lake Gethsemane executed between 1853 and 1854, in which Delacroix explores the dramatic potential of waves and clouds to heighten the urgency of expression (B.651–60). These turbulent confrontations are balanced by the more serene landscapes executed during visits to Champrosay in the late 1840s and 1853 (B.672–79), as well as in the nostalgic, often melancholic reminiscences of his Moroccan trip. On several occasions, Delacroix returned to

themes from his early post-Moroccan period (see Cats. 11, 12, 13). The sharp contrast in mood is perhaps best stated in a comparison betweeen the vibrant colour and immediacy of the 1834 *Femmes d'Alger* (B.257); fig. 4) and its more subdued variant of 1849, now in the Musée Fabre, Montpellier (B.534). Although *The Collection of Arab Taxes* makes a tentative reference to the 1832 *Moroccan Military Exercises* (Cat. 11) in the figure with the rifle on the extreme right, its link with actual experience is far more tenuous and reveals a marked reduction in emotional intensity

The potential violence of the theme is tempered by the lyrical movements of the Arab gunmen and the overall dream-like quality of the battle. Technically, the work is a good example of Delacroix's mature style. In the bold contrasts of reds and greens and the stage-set composition, it reflects the enormous influence of his mural decorations on his stylistic development. Working in poorly-lit buildings and difficult architectural settings, he was faced with the problem of relating the murals to their surroundings and sought a greater luminosity in the use of white underpainting and contrasts of pure colour. The rapid, almost dappled, brushstrokes in areas of the soil and vegetation recall Delacroix's mural decorations at the Chapelle des Anges, St. Sulpice (1853–61) where the *Lutte de Jacob et l'Ange* evokes the same poetic sense of suspended animation. J.M.

PROVENANCE
1863, 12 April, sold by Delacroix to Tedesco, a Parisian dealer; by 1878 to *c.* 1890, Edouard André, Paris; A. Smit; by 1893, Durand-Ruel, Paris and New York; 1896, Matthew Challoner Durfee Borden; 1913, 14 February, American Art Association sale, New York (lot 77); acquired by Holst; by 1916, James J. Hill, St. Paul, Minnesota; by 1930, to his son, Louis W. Hill, St. Paul, Minnesota; by 1965, Jerome Hill, New York; 1966, bought by the National Gallery of Art, Washington, D.C.

EXHIBITIONS
1878, Paris, Tuileries, *Exposition du Pavillon de Flore* (no. 77)
1885, Paris, Ecole des Beaux-Arts, *Exposition Eugène Delacroix* (no. 2398)
1930, Chicago, Art Institute, *Loan Exhibition of Paintings, Drawings, Prints by Eugène Delacroix* (no. 45)
1930, Paris, Musées nationaux, Louvre, *Centenaire du Romantisme. Exposition E. Delacroix*, (no. 199a)
1940, New York, World's Fair (no. 249)
1958, Minneapolis, Institute of Arts, *The James J. Hill Collection* (no cat.)
1962–63, Toronto, Art Gallery; Ottawa, National Gallery of Canada, *Delacroix* (no. 25)
1963, Paris, Louvre, *Exposition du centenaire de la mort d'Eugène Delacroix* (no. 527) as *Le perception de l'impôt arabe*)
1965, Minnesota, St. Paul, Jerome Hill: *Film Maker, Collector* (no. 178 as *The Arab Tax*)
1979, Washington, National Gallery of Art, *French Romanticism*

REFERENCES
Robaut 1448
Journal, I, p. 137
Corr., IV, p. 372
B.805
Toronto, Art Gallery of Ontario, *Eugène Delacroix 1798–1863*, catalogue by L. Johnson, 1962, p. 60
M. Sérullaz, *Mémorial de l'exposition Eugène Delacroix organisée au Musée du Louvre à l'occasion du centenaire de la mort de l'artiste*, Paris, 1963, p. 409, no. 532 (as *La Perception de l'impôt arabe*)

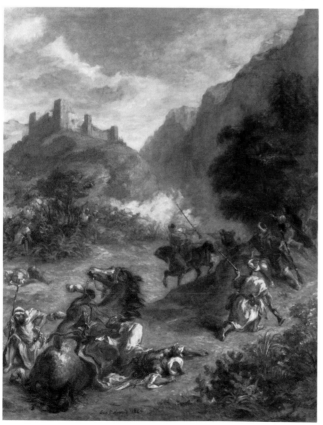

17

Denon, Baron Vivant 1747–1825

Born in Burgundy, Denon had the good fortune to survive five changes of political régime in one of the most troubled eras of French history. At one time the engraving master to Madame de Pompadour, he later served as diplomatic attaché in St. Petersburg, Stockholm and Naples under Louis XVI, and became a member of the Comité du Salut Public during the Reign of Terror. In 1797 he was introduced to Napoleon by Talleyrand, and the following year was invited to join the French expedition to Egypt. He subsequently accompanied the army on campaigns to Austria, Spain and Poland, and in 1800 was appointed Director General of Museums, with the task of establishing the Musée des Monuments français, one of the first attempts systematically to classify a public collection of ancient monuments.

18*

Voyage dans la Basse et la Haute Egypte pendant les campagnes du Général Bonaparte

1802

Paris, 2 vols., 141 plates
The Library of Congress, Washington, D.C.

The two large volumes produced by Vivant Denon in 1802 occupied a crucial position in the awakening of European interest in Eastern culture, and was a stimulating source of reference for French Orientalist painters at the beginning of the nineteenth century.

Among the invading forces which landed in Alexandria in July 1798 was a distinguished group of scholars and artists, who accumulated a vast range of information on all aspects of the country. Scientific investigations in the fields of astronomy, zoology, geography and natural history were initiated and military and civilian hospitals were established. Napoleon himself led a party of scientists to investigate, and later survey, the ruins of the ancient Suez Canal, a project finally realised by de Lesseps in 1859. Within a month, Napoleon had established the Institut d'Egypte, still in existence today, and a report on the Rosetta Stone enabled Champollion to decipher Egyptian hieroglyphics, laying the foundation for modern Egyptology. One of the greatest technological benefits introduced to the country was the printing press. Though much of the equipment brought from France had been destroyed during the crossing, printing presses were soon improvised through the ingenuity of Conte, head of the balloon corps, and equipped to print in Arabic, Greek and French.

Denon was one of several artists and architects to record details of the country and its inhabitants, which as he himself acknowledged, was all but unknown to Europeans (vol. I, Preface). He accompanied the movements of the army under General Desaix and General Beliard, and Denon was present at many of the decisive battles of the campaign, including the Battle of Abū Qīr (see Cat. 66). Despite this, the *Voyage* is not purely a record of military events, but contains illustrations of towns and cities, architectural details and hieroglyphic tablets, views of ancient monuments, portraits of ethnic types and descriptions of religious customs, local costume, interiors, and even culinary

practices. This comprehensive range of material was not always handled objectively by Baron Denon, whose position was very much that of the 'enlightened' European. While in some places he was blatantly anti-Jewish, in others he complained of the 'fantastic ignorance of the Arabs', which led them into idolatry and false worship (p. 59).

The *Voyage*, dedicated in the most laudatory terms to Napoleon, was the first of many investigative reports on the Near East and North Africa to be published in the course of the nineteenth century. By far the most ambitious of these was the *Description de l'Egypte*, published by the Institut d'Egypte between 1809 and 1829, though journals and periodicals such as the *Revue des Deux Mondes* and *L'Illustration* regularly carried articles on the political, social and economic conditions of North African countries, especially Algeria.

Growing knowledge of these countries was matched by a gradual erosion of native culture by the imposition of foreign ideas. By the mid-century it became fashionable to live, dress, and decorate one's palace 'à la française', so that, by the time of his voyage of 1849–51, Flaubert could complain of the 'deplorable' taste of Muḥammad 'Alī's tomb, 'rococo Canova, Europo-oriental, painted and festooned like cabarets' (Steegmuller, ed., 1979, p. 64). Whatever its long-term implications, the *Voyage* remained a valuable source for artists who sought authentically to portray the Near East. Baron Gros, who relied heavily on details from the volumes (see Cats. 64, 66) praised Denon's pioneering spirit, which had inspired him to 'cross burning deserts with the French army'. He was, Gros acknowledged, 'the first to teach us that it [Egypt] did not stop at the imposing aspect of the Ruins of Thebes' (1825, p. 2). J.M.

REFERENCES
Baron A.-J. Gros, *Funérailles de M. le Baron Denon*, Institut Royal de France, Académie Royale des Beaux-Arts, Paris, 1825, pp. 1–3
A. France *Notice Historique sur Vivant Denon*, Paris, 1890

Deutsch, Ludwig 1855–1930

Though Austrian by birth, Deutsch worked mainly in France, where he achieved great popularity in the 1890s with his minutely detailed scenes of life in Egypt. He was born in Vienna and briefly attended the Vienna Academy but received most of his artistic training at the Ecole des Beaux-Arts in Paris under Jean-Paul Laurens. He exhibited his first picture at the Salon in 1879 and was a regular contributor for the rest of his life, winning a gold medal in 1892. He won a further gold medal at the Exposition Universelle in Paris in 1900 and was made Chevalier de la Légion d'Honneur by the French government. He derived the material for his pictures both from on-the-spot observation and from the large collection of Near Eastern artefacts, *mashrabiyyah* woodwork and painted tiles that decorated his studios in Paris and the South of France. His later work, from around 1909, tends to be more imposing in scale, theatrical in content and painterly in execution. Towards the end of his life he took French nationality.

19

The Scribe 1896
Le Scribe

Oil on panel: 53 × 38 cm
Signed and dated bottom left: *L.Deutsch PARIS 1896*
Private Collection, Houston, Texas
[*repr. in colour on p. 74*]

Although from earliest times Islamic society stressed the importance of literacy, the public scribe, well versed in subtleties of style and officialese, and with an elegant script, was much in demand by all classes. This was particularly true in cities, as here in Cairo, especially as there was the complication of two languages – Arabic, the language of the mass of the people, and Turkish, the language of state (Cat. 121, 122). In this picture, a scribe waits for custom in the street, perhaps at the doorway of his own house. His upward gaze may indicate boredom but also recalls the way writers have traditionally been represented in European art, both in portraiture and religious subjects such as St. John on Patmos, with their eyes fixed on heaven as if awaiting divine inspiration. The loving care and attention Deutsch devotes to the painting of exotic features such as the tiles, chair, table and *gūzah* (pipe) clearly shows the influence of earlier Salon Orientalists, above all Gérôme (*q.v.*).

Deutsch executed further versions of this subject. An almost identical composition dated 1911 (sold 28 November 1980, Christie's, London, lot 113), differs only in the model, the tiles set around the doorway and the colour of the scribe's costume. M.W.

PROVENANCE
1906, 5 May, Christie's, London (lot 98); 1961, 23 June, Christie's, London (lot 114); 1976, 20 February, Christie's, London (lot 125); 1980, 20 June, Christie's, London (lot 146); P. and V. Berko, Brussels; 1980, October, acquired by The Fine Art Society, London; 1981, June, acquired by Kurt E. Schon Ltd, New Orleans; Priv. Coll., Houston, Texas

REFERENCES
H. Fuchs, *Die Österreichischen Maler des 19. Jahrhunderts*, Vienna, 1972, vol. I, fig. 84
P. and V. Berko, *Peinture Orientalistes*, Brussels, 1982, p. 115, ill.
Coral Petroleum, *A Near Eastern Adventure*, n.d., n.p., ill.

20

The Prayer at the Tomb 1898
La Prière au tombeau

Oil on panel: 68·5 × 59·5 cm
Signed and dated bottom left: *L. Deutsch Le Caire 1898*
Private Collection, Houston, Texas
[*repr. in colour on p. 68*]

The setting of this painstakingly executed study of a wealthy Muslim is identifiable as the tomb chamber of the Amīr Aqsunqur in the Mosque of Aqsunqur (the 'Blue Mosque') in Cairo. The tomb itself dates from the time the mosque was built in 1346, but the impressive panels of provincial Ottoman tiles, which give the mosque its alternative name, were installed during the remodelling undertaken by Ibrahim Agha in 1652. M.W.

PROVENANCE
1977, 3 November, Christie's, London (lot 115); 1978, The Fine Art Society, London; Priv. Coll; 1980, June, acquired again by The Fine Art Society; acquired by Kurt E. Schon Ltd, New Orleans; Priv. Coll., Houston, Texas

EXHIBITIONS
1898, Paris, Salon des Champs-Elysées (no. 666)
1978, London, The Fine Art Society, *Eastern Encounters* (no. 24)

REFERENCES
J. Harding, *Artistes Pompiers: French Academic Art in the 19th Century*, London, 1979, p. 78, ill.
Coral Petroleum, *A Near Eastern Adventure*, n.d., n.p., ill.

19

20

Frère, Théodore 1814–1888

Brother of the popular realist painter Edouard Frère, Théodore was born in Paris in 1814, and studied first under Cogniet (1794–1880) and later under Roqueplan (1800–1855).

Frère began his career by painting interiors and views of the French countryside derived from his travels round Normandy, Alsace and the Auvergne. Following some months in Algeria, however, during which he witnessed the taking of Constantine, Frère devoted himself solely to Oriental subject-matter, exhibiting his first Orientalist work at the Salon of 1839.

In 1851 he undertook a second and longer voyage through Greece, Asia Minor, Constantinople (where he remained for eighteen months), Syria, Palestine and Egypt. This journey provided him with a wealth of material and impressions which he worked up in a series of paintings of the late 1850s. In the course of a final trip to the Near East in 1869, as part of the suite of Empress Eugénie, he produced a number of impressive watercolours, a medium which allowed him to capture the luminous, bleached tonalities of the landscape.

Frère also designed woodcuts and lithographs using Oriental subject-matter, such as his imaginary view of the Arab in Paris for Desnoyer's *Les Etrangers à Paris* (1846). His emotionless but picturesque views of architecture, ruins, bazaars, coffee house interiors and landscapes proved immensely popular with collectors in Europe, notably the King of Würtemburg and Louis-Philippe, and from the early 1860s he was on intimate terms with the American art dealer George Lucas.

21

Jerusalem, View from the Valley of Jehoshaphat 1881

Jérusalem, Vue prise de la vallée de Josaphat

74 × 110·5 cm
Signed bottom right: *TH.FRÈRE/JÉRUSALEM TERRE SAINTE*
Metropolitan Museum of Art, New York

Possibly exhibited at the 1881 Salon as *Jérusalem, Vue prise de la vallée de Josaphat*, (no. 925 bis.), it seems likely that the panorama was painted from the Mount of Olives to the north-east of the city, recommended to travellers in handbooks of the nineteenth century for its commanding vista.

Frère picked out the prominent features of the city: the Golden Gate, the Church of the Holy Sepulchre, the Hamra minaret, and the impressive parapets of the Turkish wall with its solid, square bastions, flanked to the south of the city by the Valley of Hinnem. Against the soft, opalescent mists of the distant mountains of Ammon and Moab, the foreground encampment of Arabs introduces a strong touch of local colour. The precise rendering of their costumes and tents gives the painting a highly finished quality, almost photographic in its insistence on realistic detail. In fact, from the 1850s, as the Near East became increasingly familiar through photographs, it was not uncommon for artists to refer to them as a visual reminder of scenes or locations viewed in these countries. Maxime du Camp recorded his impressions of landscapes and monuments in a series of photographs taken during his travels through Egypt and Nubia with Gustave Flaubert from 1849 to 1851, and the British artist Thomas Seddon (see Cat. 116) is known to have used photographic material in, for example, his *Jerusalem and the Valley*

of Jehoshaphat from the Hill of Evil Counsel (1854–55; Tate Gallery, London).

As access to the Holy Land grew easier in the latter half of the century, Jerusalem gradually assumed for the European traveller the popularity which Paris or Rome had enjoyed in the itinerary of the eighteenth-century gentleman, albeit of a religious, rather than purely cultural significance. French and British travellers from Chateaubriand onwards hastened to the City of David and, despite the filth and pestilence of the city itself, many were overwhelmed by the very sight of it: 'The scene was grand in its simplicity. . . . Now, indeed, for one brief moment, I knew that I was in Palestine; that I saw Mount Olivet and Mount Zion; and – I know not how it was – my sight grew weak, and all objects trembled and wavered in a watery film' (B. Taylor, *Pictures of Palestine, Asia Minor, Sicily and Spain* or *The Land of the Saracens*, 1855, p. 58).

Frère's view reflects the battered history of the city which, from the siege of Titus in AD 37 onwards, had continually changed hands between the Turks, the Saracens and the Christians. Inevitably, the Christian visitor was struck by the moral significance of the dominant position of the Omar and El Aska mosques among the mass of grey buildings, and saddened by the eternal theological dissentions which had plagued the city, the 'temple par excellence of peace and charity' (E. Melchior de Vogüé, 'Journées de voyage en Syrie, III', *Revue des Deux Mondes*, III, 1875, p. 552), ironically translated from the Hebrew as 'possession of peace'. J.M.

PROVENANCE
1887, bequeathed by Catherine Lorillard Wolfe to the Metropolitan Museum of Art
EXHIBITION
1881, Paris, Salon (no. 925 bis)
REFERENCES
E. Montrosier, *Artistes Modernes, II*, Paris, 1896, pp. 9–11
Ch. Sterling and M. Salinger, *French Paintings: A Catalogue of the Collection in the Metropolitan Museum*, II, New York, 1966, p. 146
Rochester, New York, Memorial Art Gallery, *Orientalism*, catalogue by D. Rosenthal, 1982, fig. 104

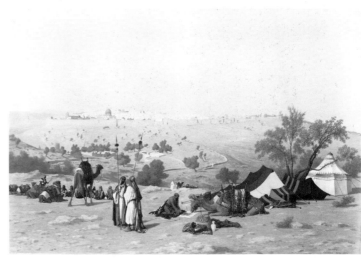

21

Fromentin, Eugène-Samuel-Auguste
1820–1876

Eugène Fromentin's birthplace, La Rochelle, is a port in western France where the flatness and dramatic skies recall Holland, an analogy lost neither on the artist nor on his subsequent critics. After passing his law exams in Paris, Fromentin persisted in his desire to be a painter. His father sent him to train under the classical landscapist Rémond, but Fromentin decided to study with the more naturalistic Cabat.

In 1846 Fromentin made a secret trip to Algeria with Charles Labbé, who also became an Orientalist painter. The following year Fromentin's first three submissions, two of which were Orientalist works, were accepted by the Salon. Their favourable reception encouraged him to pay a longer visit to Algeria after the Salon. His eleven Orientalist pictures in the Salon of 1850–51 established his reputation for such subject-matter. After his honeymoon in 1853 he made a final extended stay in Algeria that was to result not only in two books but also in a store of sketches and visual images upon which he was to draw throughout his career.

Fromentin's most successful Salon was that of 1859, when he gained conventional Second Empire kudos with a First Class medal and the Légion d'Honneur, as well as praise from more progressive critics like Baudelaire, and from the young Degas. He exhibited throughout the 1860s and 1870s before his sudden death in 1876.

Fromentin is remembered today more as a writer than a painter. After his travel books, *Un Été dans la Sahara* (1856) and *Une Année dans le Sahel* (1858), came his single celebrated novel *Dominique*, and in the year of his death he published his eloquent study of Dutch and Flemish art, *Les Maîtres du passé*.

ABBREVIATED REFERENCES
Gonse 1881 Louis Gonse, *Eugène Fromentin: Peintre et Ecrivain*, Paris, 1881

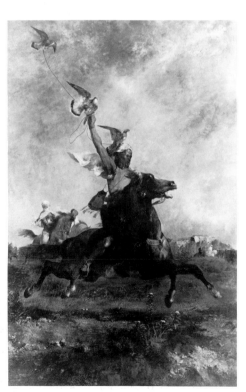

22

22

Arab Falconer 1863
Fauconnier arabe

108 × 73 cm
Signed bottom left: *Eug. Fromentin*
Chrysler Museum, Norfolk, Virginia, gift of Walter P. Chrysler Jr.
[*repr. in colour on p. 76*]

The Arab cavalier is the central image in Fromentin's art. His first Oriental works divide fairly evenly between Arabs astride camels and those mounted on horseback, but in the last two decades of his life the balance shifted decisively towards the ancestor of Western thoroughbreds. This preference may well relate to a message of 1857 from Fromentin's dealer Beugniet, conveyed to the artist by Gustave Moreau, stating that pictures with horses were more saleable than those with camels (B. Wright and P. Moisey, *Gustave Moreau et Eugène Fromentin: documents inédits*, La Rochelle, 1972, p. 97).

In the Arab and his horse Fromentin found the 'accord of the two most intelligent and fully developed creatures that God has made', and he argued that the Greeks had invented a composite creature to represent this harmony, evoking the centaur as an analogue for the Arab's perfect communion with his animal (*Une Année dans le Sahel*, Paris, 1963 ed., p. 247).

The most obvious precedent for the central figure in this composition is one of the galloping trio in the 1861 Salon picture, *Courriers du pays de l'Ouled Nayls* (acquired by the State, Musée du Luxembourg). The horseman to the left in this horizontal composition, known only through engravings, reaches upward with his left hand, apparently to grasp some leaves from an overhanging tree. Two years later, in the *Arab Falconer*, Fromentin was to focus on a single figure, constructing a vertical composition around the diagonal sweep of his right arm holding a perch and leather traces that lead to an airborne falcon. The horse has both fore and rear legs extended in that conventional representation of the gallop, which two decades later was to be discredited by Muybridge and Degas.

Western images of the Arab were ordered according to Western cultural archetypes. In contrast to the industrialising West, he was seen as an unspoiled child of Nature. For many writers and artists, the Arab was a man from the Bible (see Warner, p. 32), while Delacroix saw him as a living Greek or Roman (see Cat. 12). Fromentin referred to all these archetypes, but clearly added a suggestion of the medieval *seigneur*; some scholars have claimed that falconry and chivalry came to the West from the East via the Crusades. The obvious association between the hunt and the battle, seen by Fromentin as a significant characteristic of Arab life, is implicit in this spirited image of a former foe.

On one level this picture can be read as a trophy, the image of a subdued enemy. Louis-Napoleon patronised what he called, in his only recorded remarks to the artist, Fromentin's 'pretty pictures'. Yet the falconer has genuine grandeur and can also be seen as a tribute, an elegy for a noble way of life fast disappearing. Fromentin often referred in his writing to the harmful effect the French were having upon their Algerian subjects and was most anxious to visit towns where the influence of his government had not yet been felt.

Fromentin sent three major works to the Salon of 1863, and the critical response was almost universally favourable. Théophile Thoré said he would rather have painted Fromentin's

three contributions to the show than the three celebrated 'Venuses' of Cabanel, Baudry and Amaury-Duval. To Thoré, Fromentin's lightness of touch and execution was a positive quality. Gautier, like Mantz, doubted the durability of the thin paint, but he was full of praise for the conception. Fromentin, he felt, no longer copied Oriental types but had begun to create them. Such an imaginative approach was also noted by Maxime du Camp, who said that Fromentin would never be a realist, and what was most lovable in his paintings was not Nature but his manner of interpreting it. Emile Cantrell praised Fromentin as 'at once the truest, the most exact, the most picturesque of our Orientalists'. Finally, the most poetic appreciation of the picture came from Paul de Saint-Victor, who thought the falconer traversed the plain like a flash of lightening across the sky. Saint-Victor could hear the cry coming out of the mouth of the horseman, drunk with speed, the dust and the wind in his face. To him the fierce falconer looked like a magician from *The Arabian Nights*, setting off astride a griffon, with *jinns* and friendly demons, to fight some distant evil spell.

There are several studies related to this picture. The most outstanding are watercolours in the Cleveland Museum (CMA 73.7) and the collection of Fromentin's family. An exciting study of the horse was reproduced in a book containing drawings by Fromentin, Géricault and Gleyre. An attractive watercolour of a falcon in Rouen relates either to this picture or to another of Fromentin's entries in the same Salon, *La Curée* (Louvre, Paris), which has a predator similarly posed. The year after this picture Fromentin executed a variant (Metropolitan Museum of Art, New York), with the falconer coming from the opposite direction. It is a polished performance, a step perhaps in the direction of Horace Vernet, but it lacks the verve and power of the original. J.T.

PROVENANCE
1877, Lepel-Cointet Coll., Paris; 1881, Lepel-Cointet sale, Paris; 1889, B. Wall Coll., Providence, Rhode Island; 1898, David V. Powers, New York; Durand-Ruel, New York; Samuel Untermeyer, New York; Baron Casil Von Doorn, New York; 1958, 16–17 May, Parke-Bernet, New York (lot 297); Mrs Paul B. Wertheimer Coll.; Walter P. Chrysler, Jr. Coll.; presented by him to the Chrysler Museum, Norfolk

EXHIBITIONS
1863, Paris, *Salon*, (no. 735)
1877, Paris, Ecole des Beaux-Arts, *Exposition posthume*, (no. 32)
1893, Chicago, *Columbian Exposition*
1904, New York, *National Exhibition of Foreign Artists*

REFERENCES
Gonse 1881, p. 80, ill. opp. p. 180 (engr. by Leo Flameng)
E. Cantrel, 'Salon de 1863', *L'Artiste*, 1863, I, p. 200
M. du Camp, 'Salon de 1863', *Revue des Deux Mondes*, 15 June 1863, p. 896
Th. Gautier, 'Salon de 1863', *Moniteur Universel*, 20 June 1863
P. Mantz, 'Salon de 1863', *Gazette des Beaux-Arts*, 1863, vol. XIV, p. 496
P. de Saint-Victor, 'Salon de 1863', *La Presse*, 29 June 1863
Th. Thoré, 'Salon de 1863', in *Salons de W. Bürger: 1861 à 1868*, Paris 1870, II, p. 385
E. Strahan, *Art Treasures of America*, Philadelphia, 1879, III, p. 88
C. H. Stranahan, *A History of French Painting*, London, 1889, p. 305
E. Fromentin, *Correspondance* (ed. P. Blanchon), Paris, 1912, pp. 179, 184
C. Sterling and M. Salinger, *French Paintings: A Catalogue of the Collections of the Metropolitan Museum II*, New York, 1966, p. 157

23
Windstorm on the Esparto Plains of the Sahara 1864
Coup de vent dans les plaines d'alfa (Sahara)

116·5 × 152 cm
Signed bottom right: *Eug. Fromentin*
Dated bottom left: *-1864-*
Private Collection, Houston, Texas
[repr. in colour on p. 78]

The essence of Fromentin's art, both literary and pictorial, is its descriptive subtlety, a subtlety through which both as writer and artist he sometimes succeeded in expressing the inexpressible. Thus Edmond de Goncourt credited Fromentin with the introduction of an auditory aspect to literature in his evocation of the silence of the desert (E. and J. de Goncourt, *Journal*, Paris, 1856 ed., III, p. 353). Similarly Gautier, in discussing one of Fromentin's entries for the Salon of 1859, *L'Isière d'Oasis pendant le Sirocco* (present location unknown), wrote: 'One would think that the wind could not be painted, being a colourless and formless thing, yet it blows visibly through M. Fromentin's picture' (Th. Gautier, 'Salon de 1859,' *Le Moniteur*, 28 May, 1859).

Windstorm on the Esparto Plains of the Sahara represents the culmination of the artist's efforts to portray the existence of an invisible force through its physical effects. As early as 1857 Fromentin had attempted paintings of cavaliers caught in a windstorm. Though the whereabouts of these paintings are unknown, preliminary drawings exist in the Musée des Beaux-Arts in Ghent and in the collection of the Fromentin family. In *L'Isière d'Oasis pendant le Sirocco*, Fromentin widened his perspective to take in a sweeping landscape, in which the wind blows on the backs of a clump of flattened camels and against a small Bedouin woman struggling forwards; but the power of its blast is principally recorded in the straining fronds and slanted trunks of date palms and underlined by diagonal ridges of cloud, which register the storm like ripples on water.

In *Windstorm on the Esparto Plains of the Sahara* clouds and plants again have much to do with defining the force of the wind. The main measure of the wind's gust, however, is the group of five horsemen. Three of the four horses face into the wind. Only

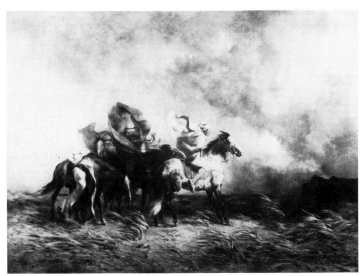

23

one cavalier follows suit. The other Arabs, their *burnūses* billowing, turn away from the blast. They are exposed by the low horizon line and silhouetted against a bank of cottony cloud. A rock outcrop in the right distance provides a more solid, slightly ironic balancing bulwark.

Fromentin here demonstrated his mastery of values within a limited colour range, an approach partly inspired by Corot. 'Too knowledgeable in the greys', according to Henri Focillon's unfavourable judgement (H. Focillon, *La Peinture au XVIIIe siècle*, Paris, 1927, II, p. 219), Fromentin here put that knowledge to good use, in a picture whose sombre palette suits its subject.

The painting has been much admired. Théophile Thoré, possibly the sanest critic of the century, picked it out of the Salon of 1864 as 'one of the best pictures in the whole exhibition'. Thoré was particularly struck by the figure of the grey horse, whose legs were like 'bars of steel' bracing it as firmly as the supports of the old harquebus rifles. Louis Gonze paired it with *L'Isière d'Oasis pendant le Sirocco*, which he considered Fromentin's greatest work. He found *Windstorm on the Esparto Plains of the Sahara* equally energetic as a conception and almost as beautiful in execution. Gonse referred to the wind as the '*khamsīn*', Victor Fournel as the '*simoun*'; both these hot desert winds, as well as the '*sirocco*', have been used as titles for the painting. Echoing Gonse's sensitivity to the 'terrifying impression' made by the picture, Fournel spoke of the 'overwhelming and sinister effect' of the wind on a nature 'crushed and mute with horror'. Fournel also remarked that Fromentin's normally restrained palette was even more gloomy in this scene. Maxime du Camp did not like the painting on account of its 'harmony in grey minor', which to him suggested Normandy rather than North Africa. Léon Lagrange also doubted the truth of its colour but said it was nonetheless 'the most oriental painting in the Salon'.

There are at least two smaller versions of this painting, both about 45 × 60 cm, one on panel and the other on canvas. The latter, which is signed bottom left, was sold at Sotheby Parke Bernet in 1982. The former, autographed bottom right like this painting, is the only version in which the most prominent horse draws his muzzle back. J.T.

PROVENANCE
Thoré claimed that the Salon painting was bought by an 'amateur from Manchester' (see References); David Sellar Coll.; 1918, Galerie Georges Petit, Paris, Sarlin sale (lot 46); Tanenbaum Coll., Toronto; Kurt E. Schon Ltd, New Orleans; Priv. Coll., Houston, Texas

EXHIBITION
1864, Paris, *Salon*, no. 758

REFERENCES
Gonse 1881, pp. 79–80, ill. opp. p. 58 (engr. by M. Lalanne as *Le Simoon*)
M. du Camp, 'Salon de 1864', *Revue des Deux Mondes*, 1 June 1864, pp. 694, 695
L. Lagrange, 'Salon de 1864', *Gazette des Beaux-Arts*, 1864, XVII, p. 20
H. Roujon, *Fromentin*, Paris, 1912 (ill. pl. IV as *Le Sirocco à l'oasis*)
Th. Thoré, 'Salon de 1864' in *Salons de W. Burger: 1861–1868*, Paris, 1870, p. 87
V. Fournel, *Les Artistes français contemporains*, Tours, 1884, p. 388
P. Dorbec, *Eugène Fromentin*, Paris, 1926, p. 83 (ill. p. 67 as *Le Khamsin*)
H. Focillon, *La Peinture au XIXe siècle*, Paris, 1927, II, p. 219
La Rochelle, *Fromentin: le Peintre et l'Ecrivain*, 1970, p. 100, no. 63

24†

Land of Thirst *c.* 1869
Pays de Soif

103 × 143 cm
Signed bottom left: *Eug. Fromentin*
Musée d'Orsay, Paris

Nineteenth-century Salons featured a succession of 'disaster pictures', which provided large-scale, eye-catching excitement for the general public. The godfather of the genre, one of the first and best, was Géricault's *Radeau de la Méduse* (1819; Louvre, Paris), and it is patently this picture from which Fromentin borrowed his composition. Both works feature a pyramid of dying figures culminating in an upraised arm, in the Géricault a gesture of hopeful entreaty, in the Fromentin of futility, or desperate defiance in the face of death. In both works men are dying of thirst, Fromentin's in a sea of sand, Géricault's in the South Atlantic.

The title of this painting is instantly recognisable to readers of Fromentin's travel books, for it is the phrase with which he concluded his book on the Sahara: 'I fear that I must soon go back to the North, and the day when I leave the gateway of the East never to return I will reside bitterly in that strange city and salute with profound regret this menacing horizon, so desolate that it is justly called: "Land of Thirst" ' (*Un Eté dans le Sahara*, Paris, 1938 ed., p. 279). A page earlier he had given an account of a desert convoy disastrously decimated by a heat as sweltering as 'a shower of fire' which 'bore through your skull like a corkscrew', killing eight persons and most of their animals (*ibid.* p. 278).

This picture is one of at least four works in the late 1860s where Fromentin returned to his own writings as a source of subject matter, choosing those with the greatest dramatic potential. For the previous twenty years Fromentin had won solid Salon success as a purveyor of 'Orientalist genre' scenes, but the pictorial formulae of such works were going stale for both the artist and his critics. At a time when the nascent Impressionist movement was challenging the sacrosanct distinctions of subject-matter, Fromentin was moving in an opposite direction, aiming more at the by-gone glories of dramatic history painting. The ambition of this attempt exceeded his abilities, and he was unable to grasp the crude representation of dramatic grandeur which

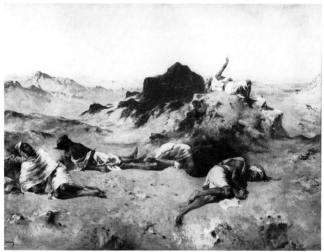

24

established the pictorial credibility of a history painting. In a devastatingly accurate moment of self-analysis he once said, 'I see "pretty" and not "grand"' (E. Fromentin, *Lettres de Jeunesse*, P. Blanchon ed., Paris, 1909. p. 250).

Although never publicly exhibited in the artist's lifetime, this painting has not lacked admirers. Writing in 1877, the critic M. Proth said it 'nearly ranks as a masterpiece', while Fromentin's friend and biographer Louis Gonse was reminded of Berlioz's *Requiem* and remarked that the artist had never produced anything more powerful.

There is another major variant of this picture (1869; Musée des Beaux-Arts, Brussels), which includes a dead horse on the right (thus relating more closely to the written description) and lacks the upward gesture of the top figure. Various preliminary studies for the painting have passed through sale rooms this century; they reveal the almost classical care with which Fromentin found the contours for the figures which compose this major work. J.T.

PROVENANCE
1876, posthumous sale, Paris (lot. 5); 1879, Verdé-Delisle sale, Paris (lot. 28); 1881, Lepel-Cointet sale, Paris; 1929, bequeathed by M. E. Martell to the Louvre, Paris (inv. no. RF 2671)

EXHIBITIONS
1877, Paris, École des Beaux-Arts, *Exposition posthume* (no. 20)
1970, La Rochelle, *Fromentin: Le Peintre et L'Ecrivain* (p. 85, no. 32)
1973, Paris, Musée des Arts Décoratifs, *Equivoques*

REFERENCES
Gronse 1881, p. 100
H. Houssaye, 'Eugène Fromentin', *Revue des Deux Mondes*, April 1877
P. Dorbec, *Eugène Fromentin*, Paris, 1926, p. 83
J. Alazard, *L'Orient et la peinture française au XIXe siècle, d'Eugène Delacroix à Auguste Renoir*, Paris, 1930, p. 281
Ch. Sterling, and H. Adhémar, *Musée Nationale du Louvre, Peintures: Ecole française, XIXe siècle*, 1959, p. 310, no. 885
M. Proth, 'Voyage au pays des peintres', *Salon de 1877*, quoted 1973, Paris, Musée des Arts Décoratifs, *Equivoques*
P. Jullian, *The Orientalists: European Painters of Eastern Scenes*, Oxford, 1977, p. 64
J. Marti, *On Art and Literature: Critical Writings*, edited with an introduction by Philip S. Foner, translated by Elinor Randall, New York, 1982, pp. 85

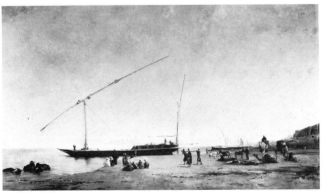

25

25*

Dahabiyyah on the Nile at Luxor 1871
Dahabieh sur le Nil à Luxor

63 × 109·5 cm
Signed and dated bottom right: *Eug. Fromentin -71-*
The Art Institute of Chicago
[*repr. in colour on p. 79*]

In 1869, as one of sixty select guests, Fromentin took a three-month trip to Egypt to witness the opening of the Suez Canal, travelling with a distinguished delegation of painters including Bonnat (*q.v.*), Belly (*q.v.*), Berchère and Gérôme (*q.v.*), as well as writers like Théophile Gautier. The inauguration of the canal marked a new era of colonial imperialism and at the same time represented the twilight of a certain type of pictorial Orientalism. Fromentin was not anxious to go; taking few artistic materials, he planned to write rather than draw, adding, 'moreover we have our photographers' (E. Fromentin, *Correspondance*, P. Blanchon ed., Paris, 1912, p. 223).

Although Orientalists like Horace Vernet had used photographs as artistic tools in their depiction of the East from the moment the process was made public, it is difficult to imagine Fromentin considering their extensive use earlier in his life. Later he explained what photographic documents of Egypt lacked: 'They will only give you quite an imperfect idea of the beauty of these things; you will see neither the incomparable quality of the light, nor the distances (all diminished), nor the colour, less varied than in the Sahara, but special and perhaps still more delicate' (*ibid*. p. 227). In fact, Fromentin's main resource in recreating Egyptian views was to be his memory, and he even claimed to Edmond de Goncourt that he did not take any notes (an exaggeration) but often found that as much as a few years later he could recapture a precise perception of place (E. and J. de Goncourt, *Journal*, Paris, 1956, II, p. 1051). Fromentin began painting Egyptian scenes soon after his return, but he did not exhibit any in the Salon until the last year of his life. Critical reaction to these paintings in 1876 was unfavourable. Georges du Four excepted them from his general condemnation of the show, but Jules Castagnary was not so charitable. Resurrecting a pet theme he had propounded as early as 1872 on the end of Orientalism, he provided in his 1876 Salon review an abridged history of the movement. Castagnary nostalgically remembered 'the brilliant epoch of Fromentin' (p. 248), and his sparkling cavaliers, but found the Egyptian pictures unexciting and unconvincing: 'In this make-believe High Egypt, a chocolate Nile flows between chocolate banks, while women with chocolate complexions plunge chocolate vases into chocolate waves' (J. Castagnary, 'Salon de 1876' in *Salons 1872–79*, Paris, 1892, pp. 224, 249). Castagnary saw the end of Orientalism as parallel to the end of Fromentin as a painter. Perhaps aware of the artist's canvassing for a place as a writer in the Académie Française, he described Fromentin's dilemma: 'Powerless to renew himself, he appears to ask if the moment is not right to choose between painting and writing'.

This painting represents one of the Nile's large passenger boats, called a *dahabiyyah*. A striking feature of this boat was the enormous yard of the mainsail, which was tilted at an angle of forty-five degrees to the vertical when its lateen sail was unfurled. Fromentin often undercut the severe horizontality of the Egyptian landscape with diagonals drawn by these graceful rigs, whose great length he has here slightly exaggerated. The

traditional title, 'On the Nile, near Philae', is probably based on the ruins to the right, which are certainly not Philae, but most likely Luxor. Their location would indicate a view descending the Nile. Fromentin was most struck by the colour and character of the Egyptian sky and the waters of the Nile, which he found 'incomparably pure, and soft, and tender', and was impressed by the river's muddy thickness. He had never seen water denser nor richer in fertility, and anticipating Castagnary's criticism, he described the Nile as 'clear chocolate' (Gonse 1881, p. 266).

Perhaps the most interesting critique of Fromentin's Egyptian contribution to the 1876 Salon came from the artist himself. In an anonymously published review of the exhibition he also discussed Orientalism in general, reiterating views already given with reference to Delacroix in his book *Une Année dans le Sahel* (Paris, 1963 ed., pp. 208–09). To Fromentin the Orient's pictorial essence lay in its more general qualities. To be too particular was to produce 'ethnography and not art' (E. Fromentin, 'Salon de 1876: Chronique parisienne. Juin 1876', *Bibliothèque universelle et Revue suisse*, Lausanne, LVI, p. 355). The self-critical Fromentin thought he had succeeded in capturing 'the overwhelming melancholy of the flat and monotonous expanses' of Egypt. He also asked why the artist had to go so far in search of subjects rather than seeking them nearer to home, and perhaps here was a hint that in another attempt to break away from the Oriental genre mould, he might have again essayed the French landscape with which he began his studies under Cabat.

Gérôme and 'ethnographic orientalism' (Cat. 28, 34), was the wave of the future, and perhaps some of the sadness so many critics have seen in Fromentin's work comes from the end of an old Orient and an old Orientalism in the new age of camera and Canal. J.T.

PROVENANCE
Chicago, Nickerson Coll.; the Art Institute of Chicago

EXHIBITIONS
1935, Providence, Rhode Island School of Design, *French Painting in Africa*
1942–43, Portland, Oregon, Museum of Art, *50th Anniversary Exhibition, 1892–1942* (no. 26)

REFERENCES
Gonse 1881, p. 313
Yearbook, Rhode Island School of Design, Providence, April 1934, p. 167
'Paintings in the Art Institute of Chicago: A Catalogue of the Picture Collections', Chicago, 1961, pp. 166–67

Gérôme, Jean-Léon 1824–1904

The leader of the 'Néo-grec' School of painting, an influential teacher at the Ecole des Beaux-Arts and son-in-law of the powerful Parisian art dealer and editor, Goupil, Jean-Léon Gérôme was born at Vesoul (Haute-Sâone). After studying between 1842 and 1845 under Delaroche (1797–1856) and from 1846 to 1847 with Gleyre (*q.v.*), he exhibited a classical genre painting, *Le Combat des coqs*, at the Paris Salon of 1847. Following excellent critical notices, Gérôme was launched on his career as a society portraitist and executor of large-scale state commissions. He visited Egypt for the first time in 1856; subsequent trips to the Near East took place in 1862, 1868, 1871, 1872 and 1874, together with two visits to Constantinople and Asia Minor in 1871 and 1875. Appointed Professor at the Ecole des Beaux-Arts in 1863 and elected to the Institut de France in 1865, Gérôme regularly exhibited at the Salon a brilliantly varied range of meticulously detailed classical history and genre paintings, costume pieces and scenes of the Near East. In 1878 he exhibited his first sculpture, an art form in which he worked increasingly during the later years of his life. Although he remained a life-long friend of Degas, his position as an arch-opponent of Impressionism was sealed by his vociferous objection to the receipt by the State of the Caillebotte Bequest of Impressionist paintings, 1895–97.

ABBREVIATED REFERENCES
Galichon 1868 E. Galichon, 'M. Gérôme. Peintre ethnographe', *Gazette des Beaux-Arts*, I, 1868, pp. 147–251
Lenoir 1872 P. Lenoir, *Le Fayoum, Le Sinaï et Petra*, Paris, 1872
Timbal 1876 C. Timbal, 'Les Artistes contemporains: Gérôme (étude biographique)', *Gazette des Beaux-Arts*, 14, 1876, pp. 218ff., pp. 334ff.
Shinn-Strahan E. Shinn under the pseudonym of Edward Strahan, *Gérôme, a Collection of the Works of J-L Gérôme in One Hundred Photogravures*, 2 vols. New York, 1881–83

26

26
The Plain of Thebes, Upper Egypt 1857
La Plaine de Thèbes en Haute-Egypte

76·8 × 131 cm
Signed and dated near the column in the foreground: *J. L. GÉRÔME MDCCCLVII*
Musée des Beaux-Arts, Nantes
[*repr. in colour on p. 80*]

The Colossi of Memnon, standing some fifty-two feet high, lie on the west bank of the River Nile opposite the ancient city of Thebes and south-west of the Ramasseum which formed part of the Necropolis of Thebes (see Cat. 59). They represent Amenoph III (*c.* 1417–1379 BC), and once fronted his immense mortuary chapel, now entirely despoiled. During the Roman occupation of Egypt, they were believed to be the statues of Memnon, the son of Eos and Tithounas, who slew Antilochus, son of Nestor, in the Trojan Wars and was himself slain by Achilles. The northern colossus had been famous in Roman times for the musical sounds it was said to have emitted. Given their prominent position overlooking the Nile, and deprived of their related temple, the two colossi were visible over a great distance from all sides. In the nineteenth century they were one of the most notable archaeological monuments of the area around Thebes and Luxor, outstripped in scale and grandeur only by the shattered colossus of 'Ozymandias' in the Ramasseum (see Cat. 59). The view looks south-west from the base of the Libyan Hills across the Nile towards Luxor.

Gérôme undertook his first trip to Egypt in 1856, financed by a commission of 20,000 francs, which he had received from the French Government the previous year for *Le Siècle d'Auguste: naissance de N.-S. Jésus Christ* (present location unknown). Possibly inspired by the earlier voyage to the Near East of his teacher, Gleyre (*q.v.*), and certainly fired with enthusiasm for distant places by his own trip down the Danube to Constantinople in 1854, Gérôme embarked with four friends to spend four months in Cairo, and a further four months on a boat or *qangah* sailing up the Nile. On his return to France, he exhibited six paintings at the Salon of 1857, five of which were based on his Egyptian trip: *Prayer in the House of an Arnavut Chief* (Cat. 28), *Egyptian Recruits Crossing the Desert* (Cat. 27), *Memnon et Sesostris, Chameaux à l'Abreuvoir* and the present painting.

This major monument of antiquity had been recorded many times by Western artists since at least 1785 and Gérôme's approach was not uninfluenced by traditional landscape conventions, as contemporary critics were quick to note. Timbal referred to 'the old Egypt, the debris of which is devoured every year by the sand' (1876, p. 335), and Théophile Gautier, in describing Gérôme's other painting of the colossi also exhibited in 1857, alerted the spectator to Gérôme's concern to record the collapse of empires and the passage of time: 'These two mountains carved in human form . . . which neither time, nor earthquakes, nor even the most terrible of conquerors were able to dislodge from their bases! They stand there, crushing their knees with their colossal hands, mishapen, monstrous, flesh reverting slowly to stone' (Gautier, p. 247). Furthermore, the caravan of camels in the middle distance serves as a stock means to highlight through the use of contrast the vast scale of the colossi themselves.

Yet, even in this early representation of an aspect of Egypt, Gérôme moved further than his predecessors in his desire to record with hyper-accuracy the contemporary appearance of specific scenes and sites. The harsh, stony terrain in the foreground and the winding column of camels hint at the presence of the expansive, implacable desert which lies behind the Necropolis of Thebes. The application of a thin film of light brushwork in the sky and the intense clarity in the rendering of the detail provide the technical means by which Gérôme translated that specific quality of overpowering heat and glaring light which prompted Gautier to remark on this painting's 'sky hazy with heat which is dispelled behind the luminous shimmer of the atmosphere' (p. 247).

The painting still hangs in its original frame. Designed to complement the ancient Egyptian subject, it received favourable comment from Gautier in the Salon of 1857 for the way it reinforced the painting's 'thoroughly Egyptian appearance' (p. 248).

There are two variants of this work, *Le Colosse de Memnon* (1857; with Joseph J. Dodge, Jacksonville, 1972) and *Memnon et Sesostris* (Salon of 1857; present location unknown, see Shinn-Strahan I, pl. XLIX). There is also a preliminary drawing, almost certainly executed on the spot (Musée des Beaux-Arts, Nantes; inv. 977.2.1.D). MA.S.

PROVENANCE
1858, bought from the Salon des Artistes vivants by the Musée des Beaux-Arts, Nantes
EXHIBITIONS
1857, Paris, Salon (no. 1160)
1858, Nantes, Salon des Artistes vivants (no. 182)
1975, Marseille, Musée Cantini, *L'Orient en question* (no. 88)
1982, Nantes, Musée des Beaux-Arts, *Orients* (no. 17)
REFERENCES
Timbal 1876, p. 335
Shinn-Strahan II, pl. XCIX
Th. Gautier, 'Salon de 1857 (I)', *l'Artiste*, 14 June 1857, p. 191
Th. Gautier, 'Salon de 1857 (IV): MM. Gérôme, Mottez', *l'Artiste*, 5 July 1857, pp. 247–48

27
Egyptian Recruits Crossing the Desert 1857
Les Recrues égyptiennes trasversant le désert

61·9 × 106 cm
Signed and dated bottom right: *J. L. GEROME 1857*
Private Collection, Houston, Texas
[*repr. in colour on p. 80*]

This is one of the five paintings derived from Gérôme's first visit to Egypt in 1856, which he exhibited at the Salon of 1857 (see Cat. 26, 28). It represents a scene, apparently common in Egypt during the nineteenth century, when young men from the villages were forcibly conscripted into the army of the pasha, a

27

process which dated back to the first attempt by Muḥammad 'Alī (see Cat.123), to build up a regular army in 1824. The recruits trudge across the desert handcuffed and guarded by Arnavuts (see Cat. 28). Théophile Gautier was full of praise for this work when he reviewed the Salon of 1857, devoting an extensive part of his article on Gérôme to this painting. Possibly drawing upon his own experience of the desert, Gautier noted that Gérôme had succeeded in capturing three distinctive features of the Orient: the ethnic diversity, the typical range of Oriental responses, from the resignation of the recruits and the 'quiet and fatalistic contempt' (p. 247) of the Arnavut who leads the group, to the peculiar qualities of light and heat unique to the Egyptian desert. Gautier elaborated this latter point by arguing that, contrary to the current fashion for representing hot countries as torrid and highly coloured, Gérôme had observed that extreme light drains all colour from objects and renders the sky and land white: 'A white sand, like china clay, blown into ripples of water by the wind, bearing the stamp of the passing caravans, and rising up in opaque flurries; a sky veiled beneath a dusty mist and burnt up by the shafts of a sun baked white; in front, behind, to the right and to the left, above and below, a leaden, arid waste, pale, dry, overwhelmed and overwhelming, where no moisture falls but drops of sweat, where nothing breathes but the asphyxiating *khamsin* [desert wind]' (p. 247). Gautier's description of the effect of blinding light on the desert was confirmed in Lenoir's own account of the departure of Gérôme's caravan to cross the desert towards Sinai in 1868: 'In the afternoon, the full light of the sun turned all [the objects] an intense white, softened by some grey and gold tinges to create a most brilliant effect' (Lenoir 1872, p. 199). The problem of imposing a compositional structure on a flat, featureless landscape punctuated only by a group of figures was tackled by a number of artists (eg. Belly, Cat. 3) and the issue of translating into pictorial terms an alien, blinding light was confronted by Fromentin (Cat. 24) and Guillaumet (Cat. 67), among others. However, as Gautier perceived, in the handling of the composition, the recording of the reactions of individual figures, the role of the guards, the description of nature and the light, Gérôme contrived to imbue the subject with greater significance. The painting becomes the expression of the two universal characteristics of the Orient: 'L'implacabilité de la nature et l'implacabilité du despotisme' (Gautier, p. 247).

The smaller version of this painting, which is now in the Tanenbaum Collection, Ottawa, was previously considered to be the one exhibited at the Salon of 1857. Professor Gerald Ackerman now holds that, on the grounds of its size and its relatively higher degree of finish, the larger painting exhibited here was the one accepted by the Salon of 1857. MA.S.

PROVENANCE
Kurt E. Schon Ltd, New Orleans; Priv. Coll., Houston, Texas
EXHIBITION
1857, Paris, Salon (no. 1157)
REFERENCES
Galichon 1868, p. 149
Timbal 1876, p. 335
Shinn-Strahan, II, pl. XC
Th. Gautier, 'Salon de 1857 (I)', *L'Artiste*, 14 June 1857, p. 191
Th. Gautier, 'Salon de 1857 (IV): MM. Gérôme, Mottez', *L'Artiste*, 5 July 1857, p. 247
F. Field Hering, *Gérôme, His Life and Works*, New York, 1892, p. 65

28

Prayer in the House of an Arnavut Chief
1857

Prière chez un chef arnaute

63·7 × 91·9 cm
Signed and dated bottom right: *J. L. GÉRÔME MDCCCLVII*
Private Collection, Houston, Texas
[*repr. in colour on p. 64*]

Arnavuts were Albanian soldiers favoured by Muḥammad 'Alī, not least because he was one himself. He used them for his regular army to counter the resurgent power of the Bays and their Mamlūk retainers. This painting is one of the five Orientalist paintings which Gérôme exhibited at the Salon of 1857 (see Cat. 26, 27), the fruits of his first visit to Egypt in 1856.

The line of variously-clad and ethnically diverse soldiers at prayer, set in a discreet, domestic interior, rather than in a mosque, appears consciously to eschew all the picturesque possibilities of the subject. A mood of solemnity, which Lenoir certainly did not regard as an attribute of these military men, is cast over the scene. Indeed, Lenoir described the Arnavuts in Cairo as 'these sentries out of a comic opera' who have nothing

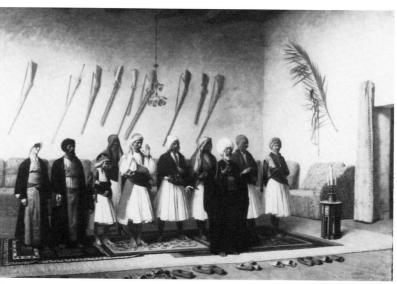

28

better to do than 'to take into custody the photographers who wish to favour them with their confidences . . . Their costume is artistically dishevelled, their costly weapons as glittering as they are inoffensive, their proud and disdainful poses, their slightest gestures, everything about them seems to have been studied in its effect' (Lenoir, 1872, p. 27).

Whilst some critics attacked this painting for its stilted figures, rejection of the picturesque and total absence of any Oriental feeling (Clément de Ris, 1858), Théophile Gautier was particularly enthusiastic about the work, which he regarded as a masterpiece. He even judged it superior to Gérôme's popularly-acclaimed painting at the same Salon, *Le Duel des masqués* (three versions: Musée Condé, Chantilly; The Hermitage, Leningrad; The Walters Art Gallery, Baltimore). Gautier praised the painting for its calm air, its cool tonalities, the careful differentiation between racial types and the intense, deeply felt faith in Islam, where all classes and races are considered equal in the sight of Allah (see Cat. 32). From these characteristics, Gautier derived what for him were the most significant features of contemporary French painting: the pursuit of realism in the depiction of individual details such that their veracity could not be faulted, a concern with ethnography, and the accumulation of information about unknown peoples and landscapes which Gautier saw as the means of providing a more appropriate definition for the term 'exotic'.

Gérôme's interest in ethnographic subjects had been awakened on his trip down the Danube in 1854 and given visual expression in his first ethnographic painting exhibited at the Salon of 1855, *Musiciens russes* (present location unknown). It was on the strength of this painting together with *Prayer in the House of an Arnavut Chief* that his reputation as a *'peintre ethnographique'* was established. Throughout his subsequent career, Gérôme repeatedly depicted Arnavuts and meticulously recorded the myriad racial groups which populated the streets, bazaars and mosques of his Oriental world (see Cat. 32, 37). M A.S.

PROVENANCE
1860, Wertheimer sale, Paris; 1869, Poutalès sale, Paris; 1956, Charles Peltier Gallery, Rheims; Benedict Coll., New York; Kurt E. Schon, Ltd, New Orleans; Priv. Coll., Houston, Texas

EXHIBITIONS
1857, Paris, Salon (no. 1158)
1967, Vassar College Art Gallery, *Gérôme* (no. 1)

REFERENCES
Galichon 1868, p. 149
Timbal 1876, p. 335
Shinn-Strahan, II, pl. LXXIX
Th. Gautier, 'Salon de 1857 (I)', *L'Artiste*, 14 June 1857, p. 191
Th. Gautier, 'Salon de 1857 (IV): MM. Gérôme, Mottez', *L'Artiste*, 5 July 1857, pp. 246–47
Cte. L. Clément de Ris, 'Les Notabilités de l'art depuis dix ans-II', *L'Artiste*, 27 June 1858, p. 117

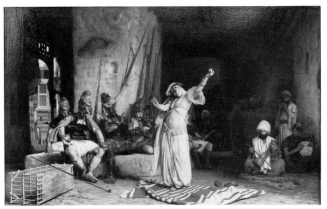

29

29
Dance of the 'Ālmah 1863
La Danse de l'almée

Oil on panel: 50·2 × 81·3 cm
Signed and dated on the wall top left: *J. L. GEROME 1863*
The Dayton Art Institute, gift of Mr Robert Badenhop
[repr. in colour on p. 101]

The name *'ālmah* (from the arabic *analeim*, learned women) was originally applied to professional female improvisers of songs and poems. It came to mean any female entertainer, and by 1850 referred to little more than dancing girls who were also prostitutes. In an attempt to clean up the morals of Cairo, Muḥammad 'Alī (Cat. 123) issued in 1834 an edict which banned female dancers and prostitutes in Cairo and ordered the deportation of all prostitutes to three cities: Qenā, Esnā and Aswān. Flaubert, deploring the absence of dancers and good brothels in Cairo (Steegmuller, ed., 1979, p. 83) visited all three of these cities in search of their illicit pleasures on his trip up the Nile.

The dances for which the *'ālmahs* were renowned were varied, ranging from the very static to the extremely energetic; the most famous and alluring was the *'bee'*, a striptease dance described by many European visitors to Egypt. Accompanied by a *darābukah* (clay drum), *kamangah* (two stringed cello) and a *zummarah*, (double reed pipe), the dance would start slowly and accelerate with the music to an increasingly frenetic pitch, clothing being shed during this ultimate crescendo.

Gérôme's *Dance of the 'Ālmah* portrays many of the characteristics of *'ālmah* dances meticulously described by Flaubert (Steegmuller, ed., 1979, p. 121), though probably not in this case the *bee*. Accompanied by three musical instruments on the right, the *'ālmah* claps small castanettes as she twists her body towards the applauding audience of *bashibazuks*, identified by their elaborate headgear (see Cat. 34).

The subject of the *'ālmah* was as alluring to the nineteenth-century European as that of the harem, the baths or the slave market. Flaubert pointed out that a dance performed for his party at Esnā reminded him of a dance illustrated on an ancient Greek vase (Steegmuller, ed., 1979, p. 155), while Hector de Callias remarked that the *'ālmah's* dance is strictly of the Orient, having no connection whatsoever with those dances performed in the Paris Opéra or at the Bal de l'Opéra (p. 196). Preparatory evocations of such dancing girls and the promises which they held out to the European traveller were part of the anticipatory pleasure of a journey to the Orient. Lenoir described how his party had constructed a 'mirage' of these dancers while still in Paris (Lenoir, 1872, p. 98), and when confronted with the reality, his vocabulary expressed the exoticism of this experience: 'strange', 'picturesque', 'erotic' (p. 106).

This painting attracted much controversy when it was exhibited at the Salon of 1864. It was a major success with the public and with certain critics such as Timbal and Hector de Callias, the latter noting the brilliance with which Gérôme captured this universal combination of the frenetic movement of the arms and the torso set upon the 'legs of marble' (p. 196). Yet the painting also provoked an intense and complex reaction which epitomises the contradictory responses of Europeans to the Near East. For example, Lagrange deplored the overt titillation of public sensibilities which the subject provoked, suggesting that it was too immoral to be placed in front of

Parisians, men and women alike. On the other hand, he measured the degree of realism in Gérôme's painting against his own voyeuristic experience of the dance ('ce plaisir exotique' [p. 529]) during his visit to Egypt. He deplored the lack of honest representation in the beauty of the dancer and pointed to Gérôme's failure to capture the shame which he felt he noted in her. It is here that Lagrange exhibits a possible double standard: he was quite prepared to observe the dance himself, but, by attributing to the performer the European concept of shame, he demonstrated his lack of real understanding of this particular cultural phenomenon.

In keeping with this Western fascination with the *'almah*, Gérôme executed a number of paintings based on this theme, for example *La Danse à l'épée* (Shinn-Strahan, I, pl. XVI) and *Almées jouant aux échecs* (Shinn-Strahan, II, pl. XLIII).

There are two related studies for this work, one for the *'almah*, and another for the seated bashibazuk (Dayton Art Institute, inv. nos. 83.4, 83.15) MA.S.

PROVENANCE
By 1889, John Hoey, New York; Robert Badenhop, Newark, New Jersey; 1951, given by him to Dayton Art Institute, Ohio

EXHIBITIONS
1864, Paris, Salon (no. 794)
1867, Paris, Exposition universelle (no. 297)
1958, Grand Rapids, Michigan, Art Gallery; Minneapolis, University of Minnesota Art Gallery, *Music and Art* (p. 8)
1972–73, Dayton, Art Institute; Minneapolis, Institute of Arts; Baltimore, The Walters Art Gallery, *Jean-Léon Gérôme (1824–1904)* (no. 14)
1982, Rochester, New York, Memorial Art Gallery, *Orientalism* (no. 39)

REFERENCES
Timbal 1876, p. 340
Shinn-Strahan, vol. II, pl. LXXXVII
E. About, *Salon de 1864*, Paris, 1864, p. 82
H. de Callias, 'Salon de 1864', *L'Artiste*, 1864, I, p. 196
H. de Callias, 'Salon de 1864 (VII): M. Gérôme', *l'Artiste*, 1864, I, p. 198
Th. Gautier, *Moniteur universel*, 4 June 1864
L. Lagrange, 'Le Salon de 1864', *Gazette des Beaux-Arts*, June 1864, 16, pp. 529–30.
E. Strahan, *The Art Treasures of America*, Philadelphia, 1879, II, p. 108, ill. pl. 33
F. Field Hering, *Gérôme, His Life and Works*, New York, 1892, pp. 106–07
B. H. Evans, *Fifty Treasures of the Dayton Art Institute*, Dayton, 1969, p. 118
Rochester, New York, Memorial Art Gallery, *Orientalism*, catalogue by D. Rosenthal, 1982, p. 164, fig. 76

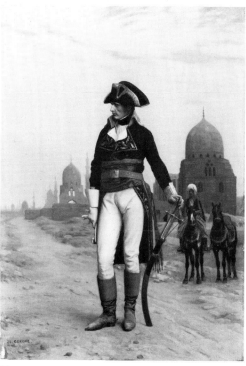

30

140

30*

General Bonaparte in Cairo *c.1863*
Le Général Bonaparte au Caire

Oil on panel: 35·5 × 25 cm
Signed bottom left: *J. L. GEROME*
The Art Museum, Princeton University, John Maclean Magie and Gertrude Magie Fund
[*repr. in colour on p. 87*]

In this posthumous picture of Napoleon Bonaparte (1769–1821), Gérôme set the general in contemplative pose against a backdrop of the Mamlūk tombs in the Eastern Cemetery of Cairo. The pose was probably derived from the portraits of Napoleon's officers painted by André Dutertre which were exhibited at the Salons between 1804 and 1812 and hung in the Musée de Versailles. While the handling of the background is somewhat loose, the figure of Napoleon himself is solid and carefully painted, suggesting that it was almost certainly executed from a model in Gérôme's studio.

Napoleon Bonaparte arrived in Egypt in July 1798 on receipt of the supreme command of the French forces in the battle against the British. Determined to oust the British from the Mediterranean, Bonaparte occupied Malta and then landed at Alexandria with a substantial military and naval force, as well as 175 engineers and scholars (see Cat. 18). He defeated the Bays at the Battle of the Pyramids (21 July 1798) and entered Cairo three days later. While the attempt to establish French rule over Syria was thwarted at Jaffa and Acre (see Cat. 64–66), the French remained in control of Egypt until the Peace of Amiens, signed in March 1802.

This painting is one of four compositions depicting Napoleon on campaign in Egypt and Syria (*Le Général Bonaparte au Caire*, 1868, Shinn-Strahan, II, pl. XXV; *Le Général Bonaparte en Egypte*, Shinn-Strahan, II, pl. XLIV; *Oedipe: Bonaparte et le sphinx*, c.1886, Hearst Memorial Museum, St. Simeon, California). Together with such works as *La Mort du Maréchal Ney, le 7 décembre 1851, neuf heures du matin* (1868; City Art Gallery, Sheffield), these paintings reflect the enthusiasm for Napoleonic themes amongst artists during the second half of the nineteenth century. The declaration of the Second Empire in 1852 under Napoleon's nephew, Louis-Napoléon, fuelled renewed interest in the Consulate and the First Empire. In line with the new régime's determination to establish its own political legitimacy, Yvon, Doré and de Neuville provided important large-scale records of great French military battles for the walls of the Galeries des Batailles at Versailles. Meisonnier, Gérôme, Clairin and Detaille, who provided images of the military achievements of the Second Empire, also drew heavily upon this renewed enthusiasm for Napoleon I. The same interest was also reflected in contemporary literature, for example A. Thiers, *Histoire du Consulat et de l'Empire* (1862). After the collapse of the Second Empire in 1870, the images of Napoleon became increasingly imbued with a sense of nostalgia. Gérôme's painting of *'le petit caporal'*, with his glance directed away from the spectator and his hat casting a shadow over his face, would appear to convey a premonition of the imminent loss of Cairo. Thus the painting, despite its similarities in precise brushwork and in scale to the Napoleonic paintings by Meisonnier, forms an image which carries a meaning beyond that of mere anecdote. MA.S.

PROVENANCE
1953, Van Doorn Estate sale; acquired by the Art Museum, University of Princeton

EXHIBITIONS
1972–73, Dayton, Art Institute; Minneapolis, Institute of Arts; Baltimore, The Walters Art Gallery, *Jean-Léon Gérôme (1824–1904)* (no. 16)
1982, Rochester, New York, Memorial Art Gallery, *Orientalism* (no. 40)

31

The Moorish Bath *c. 1870*

Le Bain maure

51 × 41 cm
Signed upper edge of partition: *J. L. GEROME*
Museum of Fine Arts, Boston, gift of Robert Jordan from the
Collection of Ebden D. Jordan
[*repr. in colour on p. 100*]

The sunken fountain pool in the foreground with the two-colour
marble inlay, the silver water bowl with a Mamlūk blazon and
the Sudanese serving girl have suggested to R. Ettinghausen
(Dayton Art Institute, 1972, p. 20) that this picture does not
represent a Moorish bath but an Egyptian scene. Given the
pattern of Gérôme's travels in the Near East, it would seem that
a Cairene location is more likely. Gérôme visited at least two
baths while he was in the city in 1868: a very large bath, entered
through a 'mysterious' door which opened onto *'une salle immense
tout en marbre blanc'* (Lenoir, 1872, p. 186), and the private bath
of the Persian ambassador *'tout en faïence de perse, et les boiseries
peintes des plafonds furent particulièrement l'objet de notre admiration'*
(Lenoir, 1872, p. 173).

To the Western visitor, the Turkish bath had both a real and
an imaginary significance. In the former sense, it represented a
luxurious and wholly un-European sensation. Lenoir likened the
experience to 'an opera in five, very distinct and regulated acts'
(p. 186). Flaubert, who gave a lengthy description of his own
visit to a Cairene bath, openly welcomed the cultural dislocation
engendered by these baths: 'I was alone in the hot room,
watching the daylight fade through the great circles of glass in
the dome . . . It is very voluptuous and sweetly melancholy to
take a bath like that, quite alone, lost in those dim rooms where
the slightest noise resounds like a canon shot' (Steegmuller, ed.,
1979, p. 85). Gérôme's painting attempts to capture elements of
both Lenoir's and Flaubert's experiences. The Persian tiles could
have been inspired by the Persian ambassador's private bath. The
high vaulted room and the dim light are depicted by Gérôme,
who lays special emphasis on the half-light of the dim interior,
in contrast to the shafts of intense light filtering through the
dome beyond the top of the picture, touching the wall in the
background, the Sudanese woman's turban, the bowl of water
and, more diffused, the *nargīlah*.

In the realm of the imagination, Gérôme's *Moorish Bath*
belongs to an iconographic tradition which goes back to
eighteenth-century engravings and to descriptions of the baths
in Montesquieu's *Lettres persanes* (1721). Typically, such
iconography involved one or more partially nude, fair-skinned
women attended by darker-skinned serving women. By the
middle of the nineteenth century, this iconography had become
an accepted format in the hands of Ingres and Chassériau (eg.
Le Bain mauresque, Musée des Beaux-Arts, Strasbourg), which
fulfilled two related aesthetic intentions. At its most simple, the
juxtaposition of white nude and dark semi-nude highlights the
former's perfection in Western eyes (L. Nochlin, 1983, p. 126, ill.
p. 131). Yet this perfection was obviously not set within the
Western tradition of the classical ideal of Beauty. Hence *The
Moorish Bath*, as in Ingres's *Odalisque and Slave* (Cat. 80), with
its combination of exotic setting and pure classical beauty,
permitted the integration of Eastern motifs with Western artistic
principles, yet without denying their inherent exotic overtones.
In this painting not only could the white nude sit as comfortably
as in one of the artist's 'Néo-grec' paintings, but by placing her

beyond the pool he invites the spectator to become a voyeur.

Some critics felt that this marriage between Eastern exotic and
eternal Western beauty was inappropriate. Paul Mantz upbraided
Gérôme with regard to two of his Turkish bath paintings, *Femmes
au bain* and *Bain turc*: 'A little frison of voluptuousness would
perhaps animate the oriental pictures of the *Femmes au bain* and
the *Bain turc*, if these women were not made of ivory: they are
all just as moving as billiard balls' ('L'exposition universelle: la
peinture française', *Gazette des Beaux-Arts*, 1878, XVIII, p. 437).
Gérôme executed several paintings on the theme of the Turkish
bath, some more explicit in their reference to harem settings, for
example *Le Bain* (Memorial Art Museum, San Francisco) and
Dans le harem (The Hermitage, Leningrad). MA.S.

PROVENANCE
1870, presented to H. J. Turner, London; 1903, 4 April, Christie's, London (lot 138); Arthur
Tooth, London and New York; Ebden D. Jordan; Robert Jordan; 1924, gift of Robert Jordan
to the Museum of Fine Arts, Boston (24.217)

EXHIBITIONS
1873, Vienna, *Welt Ausstellung* (no. 276)
1895, London, Guildhall, *Loan Collection of Pictures* (no. 51)
1898, London, Guildhall, *Pictures of the French School* (no. 123)
1979–81, Atlanta, The High Museum of Art; Tokyo, Seibu Museum, Nagoya, City Museum;
 Kyoto, National Museum of Modern Art; Denver, Art Museum; Boston, Museum
 of Fine Arts (at Faneuil Hall), *Corot to Bargue* (no. 27)

REFERENCES
Shinn-Strahan, I, pl. IV
Dayton, Art Institute, 'Jean-Léon Gérôme, as a Painter of Near Eastern Subjects', R.
 Ettinghausen, in *Jean-Léon Gérôme (1824–1904)*, 1972, p. 20
L. Nochlin, 'The Imaginary Orient', *Art in America*, May 1983, p. 126, ill. p. 131

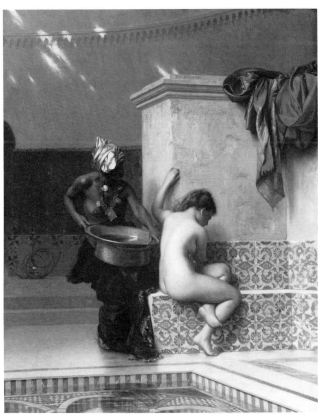

31

32

Prayer in the Mosque of 'Amr c.1872

Prière à la mosquée d'Amron

88·9 × 74·9 cm
Signed top right on the beam: *J. L. GEROME*
Metropolitan Museum of Art, New York
[*repr. in colour on p. 65*]

The precision of detail in this painting suggests that it must be based upon careful sketches of the Mosque of 'Amr made during Gérôme's visit to Egypt in the company of Paul Lenoir in 1868. Furthermore, the sharp linear style and tight handling of paint place the execution of this painting in the early years of the 1870s.

The picture shows one of the five prayer hours of the day. A diverse group of Muslims celebrate the moment in the sanctuary of the Mosque of 'Amr. Standing to the south-west corner of Cairo amongst the ruins of the city of Fusṭāt, which it had once dominated, this mosque was the first on the continent of Africa. It was erected by 'Amr ibn al-'As, who conquered Egypt for the Khalif 'Umar in AD640. Despite partial destruction by earthquakes and fires, the mosque, according to Lenoir, still retained in 1868 its vast square courtyard flanked on two sides by colonnades of 230 columns with, in the centre, a fountain sheltered by a palm tree. The sanctuary, with its *minbar* (pulpit) and *miḥrāb* (sacred niche) set in the wall turned towards Mecca, was composed of six rows of columns whose Corinthian capitals had been removed from classical or coptic buildings elsewhere in Cairo.

Gérôme's painting discloses a number of typical European responses to Islamic architecture and religious practices in the nineteenth century. The careful delineation of the Corinthian capitals, the serried ranks of deeply plunging columns, the simple polychromy of the Arab arches and the patterned tiles on the floor form a visual counterpart to Lenoir's awe-struck response

to the Mosque of 'Amr, where 'the naivety and character of Arabian architecture is at its most primitive, its most simple and consequently its most beautiful' (Lenoir, 1872, p. 43). The deliberate alignment of the praying figures and the columns, turned south-east towards the *miḥrāb* and to Mecca, integrate the figures and the architecture into a solemn religious statement. The differentiation between rich and poor, Egyptian and Arnavut, serves to underline that equality of all Muslims in front of Allah which was so much admired by the West and commented upon, for example, by Lady Duff Gordon, Renoir and Lenoir.

Yet Gérôme's painting studiously avoids reference to two notable features of the Mosque of 'Amr. By 1868 the mosque had already fallen into decay (Lenoir, 1872, p. 44). Second, the mosque was noted in popular folklore for three objects: a holy stone, a pair of columns and a single column miraculously transported from Mecca. The tales surrounding these objects were confirmation to many Westerners that Islam was a superstitious, barbaric and pagan religion (Steegmuller, ed., 1979, p. 71; Galichon, 1868, p. 150). Thus, whilst avoiding reference to these features of the mosque, Gérôme may have jeopardised the veracity of this image. He may also have succeeded in evoking a favourable response on the part of the Western spectator to the power of Islam by conveying the standing of the mosque as the oldest in Egypt, hence the symbolic and actual cradle of Islam in that country. MA.S.

PROVENANCE
Catherine Lorillard Woolfe, New York; 1887, bequest of Catherine Lorillard Woolfe to the Metropolitan Museum of Art, New York

REFERENCES
Shinn-Strahan, II, pl. LVIII
E. Strahan, *Art Treasures of America*, Philadelphia, 1879, I, p. 126
F. Field Hering, *Gérôme, His Life and Works*, New York, 1892, p. 126
G. Haller, *Nos grands peintres*, Paris, 1899, p. 101
A. Hoeber, *The Treasures of the Metropolitan Museum of Art*, 1900, p. 80
Ch. Sterling and M. Salinger, *French Paintings: Catalogue of the Metropolitan Museum of Art*, II, XIX Century, New York, 1966, p. 171
Dayton, Art Institute, 'Jean-Léon Gérôme as a Painter of Near Eastern Subjects', R. Ettinghausen, in *Jean-Léon Gérôme (1824–1904)*, 1972, p. 22

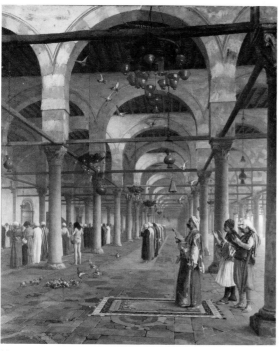

32

33

Harem in the Kiosk *c.* 1875–80

L'Harem à la kiosque

76·2 × 115 cm
Signed bottom right on parapet: *J. L. GEROME*
Private Collection, Houston, Texas
[*repr. in colour on p. 98*]

The schematic yet instantly recognisable silhouette of the Golden Horn in the background sets this harem scene in Constantinople rather than Egypt. Gérôme had visited the capital of the Ottoman Empire on his first foreign tour in 1854, which had taken him, in the company of his friend, the actor Got, down the Danube, through Greece to Constantinople. He visited the capital in 1871 and again in 1875 as the guest of the court painter, Abdullah Sirez, who provided him with aide-mémoire photographs of the major sights and buildings of Constantinople. The architectural background, the tight handling of the paint and the fact that the work was with Gérôme's father-in-law, the dealer Goupil, by 1881, suggest a date for the painting of *c.* 1875–80.

The only description which we have of Gérôme at the entrance to a harem comes from his visit to the Persian

ambassador's residence in Cairo in 1868. Lenoir, who accompanied him, had two observations to make about harems. They were a luxury, not a common social institution, and the number of their women and guards was an expression of the owner's worldly wealth. Second, for the West the harem was accessible only to women and hence was prey to 'the imagination of some writers . . . to give the most unbelievable and false descriptions' (Lenoir, 1872, p. 173–74).

Despite Shinn-Strahan's conviction that this painting is 'absolutely free from this most inartistic sin of moralising', the *Harem in the Kiosk* plays to the Western myth surrounding harems as morally reprehensible but appealingly erotic institutions. By setting the scene in Constantinople, Gérôme evaded his own Cairene experience, whilst exciting the Western imagination through reference to the fabled luxury of the Sultān's harem already captured in the eighteenth-century 'turqueries' of van Loo and Montesquieu's *Lettres persanes*. Indeed, the play of light and shade, the separation of the pampered women from the immediate gaze of the spectator, the emphasis on surface texture and the richness of the colour reinforce this interpretation.

Certain nineteenth-century writers recognised the gap between the Western myth and the reality of harems in the Near East. Gautier, for example, stressed the nobility of the relationship between the Muslim and his wives. Lady Duff Gordon reported that harems were not a licence for debauched living but rather the source of heavy responsibilities, both financial and moral (*Letters from Egypt*, 1893 ed., pp. 73, 79). Yet the West continued to demand the myth of the inaccessible woman aptly captured by Gérard de Nerval in his description of Smyrna (*Voyage en Orient*, 1856, I, p. 160). Gautier attacked the subject more ironically: 'The first question that one addresses to every traveller who returns from the Orient is this: "and the women?" Nothing decorates better a voyage to the east than an old woman who, at the turning of a deserted alleyway, makes a sign for you to follow her and leads you by a secret door into an apartment decked with all the most sought-after objects of Asian luxury, where awaiting you, seated on squares of brocade, is a Sultana shimmering in gold and precious stones' (*Constantinople*, 1853, p. 88). MA.S.

PROVENANCE
1881, Goupil and Co., Paris; Jay Gould, New York: 1968, Parke Bernet, New York, Knox Coll. sale; Bernard K. Crawford, Montclair, New Jersey; The Fine Art Society, London; Kurt E. Schon Ltd, New Orleans; Priv. Coll., Houston, Texas
EXHIBITIONS
1972–73, Dayton, Art Institute; Minneapolis, Institute of Arts; Baltimore, The Walters Art Gallery, *Jean-Léon Gérôme (1824–1904)* (no. 22)
1978, London, The Fine Art Society, *Eastern Encounters: Orientalist Painters of the Nineteenth Century* (no. 4)
REFERENCES
Shinn-Strahan, I, pl. XXXVII
F. Field Hering, *Gérôme, His Life and His Works*, New York, 1892, p. 241

34*

A Bashibazuk *c.*1878

Un Bashi-Bazouk

81 × 66 cm
Signed centre left: *J. L. GEROME*
Anonymous loan to the Museum of Fine Arts, Boston
[*repr. in colour on p. 90*]

A *bashibazuk* was a mercenary soldier belonging to the irregular troops of the Turkish army. Racially diverse, they were unpaid but supported themselves by living off permitted plunder. They were also notorious for their lawlessness and savage brutality.

Gérôme's persistent interest in ethnographic types, awakened during his trip down the Danube in 1854 (see Cat. 28), was frequently remarked upon by contemporary critics. Gautier, for example, praised Gérôme for his 'ethnographic veracity', believing that his paintings, such as the *bashibazuk*, not only provided information sufficiently reliable for them to be consulted by scholars – 'M. Serres, the anthropologist, would be able to consult with absolute certainty these specimens of unrecorded races' ('Salon de 1857 IV', *l'Artiste*, 5 July 1857, p. 246) – but also fulfilled a current thirst for precise and reliable information about the human race: 'M. Gérôme satisfies one of the most demanding instincts of the age: the desire which people have to know more about each other than that which is revealed in imaginary portraits. He has everything which is needed in order to fulfull this important mission' (*loc.cit.*).

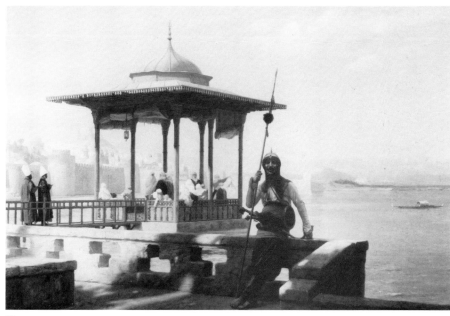

33

The attention to exact detail in this painting would fully support Gautier's claim. Set against a sombre, grey background, the head is turned in profile to reveal the distinctive physiognomy of the sitter. The characteristic cut of the pink coat with its grey braiding and the organisation of the complex head-dress with its overlapping reds, dull yellows, greens and patterned areas are handled with brushstrokes which are deceptive in their looseness. The figure is lit by a careful pool of light. The overall effect is statuesque, yet, in character with such works as *The Return from the Hunt* (Cat. 35) and *The Moorish Bath* (Cat. 31), the palette is carefully limited and, by highlighting the creases and the cut of the pink jacket, the individual parts of the painting are all given equal weight within the composition as a whole. The quiet monumentality of the image belies the ferocious reputation of the sitter and, as in the *Prayer in the House of an Arnavut Chief* (Cat. 28), creates an icon which is more sympathetic than the popular view of *bashibazuks* held by the West. While Galichon maintained that this superb finish and attention to individual detail lay at the base of Gérôme's contemporary popularity among connoisseurs (1868, pp. 150–51), Timbal and Paul Mantz ('Salon de 1867', *Gazette des Beaux-Arts*, vol. 22, 1867) expressed a certain unease about the technical facility of such highly polished paintings. Timbal, for example, felt that the perfection threatened to impose a certain monotony on his paintings, which he could however overcome through diversification of his subject-matter (1876, p. 338). Mantz was more scathing. Noting the transformation of Gérôme from a painter of classical anecdotal scenes to Orientalist subjects, he stated: 'With all his talent of execution, with the rare dexterity of his subtle paintbrush, this Greek has become like a Dutch painter of the Decadent Period' (p. 531).

Bashibazuks are incorporated in many of Gérôme's paintings: *Dance of the ʼĀlmah* (Cat. 29), *Le Coulage de balles des Bashi-Bazouks* (Metropolitan Museum of Art, New York) *Bashi-Bazouks chantant* (The Walters Art Gallery, Baltimore), *Bashi-Bazouks dansant* (present location unknown, Shinn-Strahan II, pl. LIX). MA.S.

PROVENANCE
1981, 23 June, Sotheby's, London (lot 29); bought by present owner

35

The Return from the Hunt *c.* 1878
Le Retour de la chasse

73·6 × 58·4 cm
Signed bottom centre on fountain base: *J. L. GEROME*
Private Collection, Houston, Texas
[repr. in colour on p. 75]

Circassians, noted for their noble beauty and pale skin, came from the Caucasus Mountains and provided the Ottoman Empire with excellent horsemen and much sought-after women for their harems. Characteristically depicted on horseback, this figure of a Caucasian is one of numerous compositions of individuals or groups which record the ethnic types noted by Gérôme during his visits to the Near East (see Cat. 34). However, the colcasia plant, the doe, the fountain and the niche, albeit Orientalised occur in paintings by Gérôme as early as the 1850s (eg. *L'Idylle*, 1852, Musée Massey, Tarbes), and thus suggest that this painting was executed in Paris, the pink jacket and rifle being familiar studio props.

Despite its modest dimensions, *The Return from the Hunt* demonstrates several characteristics of Gérôme's oeuvre. In keeping with Timbal's analysis of the nature of realism in Gérôme's work (1876), the painting maintains a subtle balance between the intense detail of different textured surfaces – the satin jacket, the stone, the plants, the architectural decoration – and the overall unity of the composition. The resulting image is one in which the figure of the Circassian and his horse exist within, rather than dominate, the assemblage of compositional elements.

The absence of an explicit message in this work casts it within the mould of genre paintings whose primary function was to entertain the eye rather than to instruct the mind. Some critics, notably Paul Mantz, took Gérôme to task for this negation of the moral power of painting, accusing him of 'small mindedness' (*Gazette des Beaux-Arts*, XXIII, 1867, p. 531). Others, such as Galichon, however, considered that Gérôme's intense

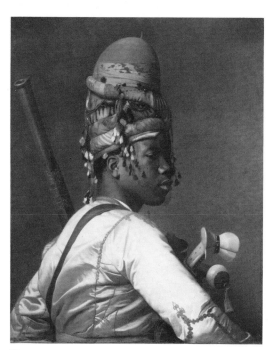

34

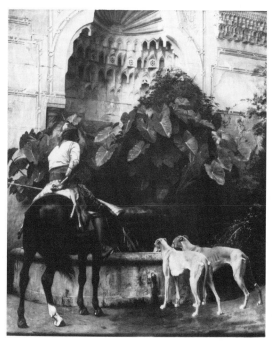

35

understanding of the Near East enabled him to convert a genre scene into a picture which encapsulated the very spirit of Orientalism (1868, p. 150). The fact that a debate over the acceptability of genre painting could be provoked by works such as *The Return from the Hunt* points to the links which existed in mid-nineteenth-century French painting between realism and anecdotal, or genre, works. Contemporary critical opinion demanded of Orientalist paintings both sound information and aesthetic pleasure. To achieve these ends, the genre scenes of everyday Orientalist life, executed by artists such as Girardet (see Cat. 41) and Gérôme, could seek out simultaneously intense veracity and rely for composition and effect upon, as Paul Mantz noted, Dutch seventeenth-century precedents. In this light, both the atmosphere and intense finish in Gérôme's painting suggest parallels with Metsu and Terborch. MA.S.

PROVENANCE
Priv. Coll., New York; Kurt E. Schon, Ltd, New Orleans; Priv. Coll., Houston, Texas
EXHIBITION
Paris, Exposition universelle, 1878 (no. 365)
REFERENCES
Shinn-Strahan, II, pl. LXVIII
F. Field Hering, *Gérôme, His Life and Works*, New York, 1892, pl. 193

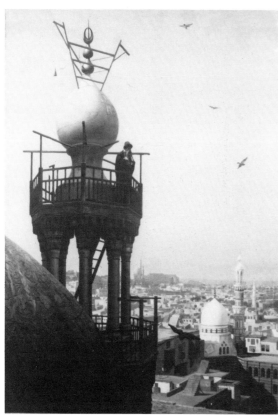

36

36

The Mu'adhdin's Call to Prayer *c.1879–80*

L'Appel du muezzin à la prière

90·5 × 65·4 cm
Private Collection, Houston, Texas
[*repr. in colour on p. 62*]

In *The Mu'adhdin's Call to Prayer*, as with his interior views of mosques (see Cat. 32, 38), Gérôme exactly describes the exterior dome, minaret and *mu'adhdin* in order to provide careful information about specific manifestations of the Islamic faith. The dome, or cupola, covers the chamber in which the tomb of the mosque's founder is placed (see Cat. 20). The minaret, described by Lenoir (1872, p. 164) as the *'clocher'* or belfry, is the most elevated place of the mosque, and the point from which the *mu'adhdin* calls the faithful to prayer five times a day. By intoning a *'psalmodie langoureuse'* (Lenoir, 1872, p. 164), the *mu'adhdin* reminds the Muslim faithful of the need to cease all work and pray: 'Allah is great; I testify that there is no god but Allah, and Muḥammad is the prophet of Allah; come to prayer; come to prosperity; Allah is greatest, there is no god but Allah.' The five Calls to Prayer also serve as the divisions of the day and as in the mosque, where architecture and liturgy are integrated, so the Call to Prayer regulates the actions of daily life by a constant reminder of the need for religious observance.

The vertiginous view in this painting, a detail of the dome of the mosque of Amir Khaykbak over a *capriccio* of the city of Cairo, is taken from the old walls of the city, looking north-west towards the mosque of Sultān Hassan with the Mosque of Amir Khaykbak in the middle ground. It recalls a view enjoyed by Flaubert during a visit to an unidentified Cairo mosque in 1849: 'We climb the minaret; the stones are worn, chipped. On the steps near the top, debris of birds come here to die, the highest they could come, almost in the air. From there I have Cairo beneath me; to the right the desert with camels gliding over it and their shadows beside them as escorts; opposite beyond the plains and the Nile, the Pyramids . . . The sky is completely blue, hawks wheel above us; below far down, men are small, moving noiselessly. The liquid light seems to penetrate the surface of things and enter into them' (Steegmuller, ed., 1979, pp. 46–47).

The translucent effect of the light together with the characteristically meticulous detail and the cut-off cupola on the left suggest that Gérôme may have derived the composition of this painting from a photograph rather than from a sketch. By the time of Gérôme's first visit to Egypt in 1856, photography had become an accepted method of recording scenes of contemporary life and the remains of antiquity. For example, Maxime du Camp, who had accompanied Flaubert, undertook an exhaustive photographic record during their trip to Egypt in 1849–51, and Horace Vernet used the daguerreotype on his Egyptian visit of 1839. Indeed, Gautier, reviewing the character of French painting exhibited at the Salon of 1857, remarked on the replacement of the idealised human figure by a vastly increased range of geographic and ethnic subjects, including Oriental ones, which he attribed to the commendable and extensive use of the daguerreotype ('Salon de 1857 (I)', *L'Artiste*, 14 June 1857, pp. 189–90). MA.S.

PROVENANCE
J. W. Drexel, Philadelphia; San Francisco Art Association; Oakland Art Museum (on long loan); 1979, 18 June, Sotheby's; Mr and Mrs Joseph M. Tanenbaum, Parke Bernet, Los Angeles (lot 46); Toronto; Kurt E. Schon Ltd, New Orleans; Priv. Coll., Houston, Texas
REFERENCES
Shinn-Strahan, II, pl. LXXXI

37

The Carpet Merchant *c.*1887

Le Marchand de tapis au Caire

83·5 × 64·7 cm
Signed bottom right: *J. L. GEROME*
Minneapolis Institute of Arts, The William Hood Dunwoody Fund
[*repr. in colour on p. 69*]

In 1902, Baedeker's guide described the extensive bazaar of Cairo as 'inferior to those of Damascus and Constantinople' yet able to 'present to the European visitor many novel features and many interesting traits of Oriental character' (p. 38). Previously Lenoir had identified these 'oriental traits' in his evocative description of the courtyard of the carpet merchant's house, based on a visit to Cairo in 1868. Beyond the glittering clutter of jewellery, fabrics, harness and weapons, Lenoir, in the company of Gérôme, Edmond About and Frédéric Masson, stumbled into a courtyard whose architecture equalled the beauty of the magnificent Persian carpets piled high on its floor. As an artist himself, Lenoir noted the particular quality of light which filtered through the opening in the roof, fell on the merchandise on the floor and increased the '*tons éclatants*' of the carpets. He concluded that the courtyard and the carpets created '*un des interieurs les plus pittoresques que nous ayons rencontrés au Caire*' (Lenoir, 1872, p. 161). Very often on his travels through Egypt, prompted perhaps by Gérôme, Lenoir identified subjects which he considered were admirably suited to paintings for a Western audience. In *The Carpet Merchant* Gérôme has confirmed, like Lewis (Cat. 90, 96) and W. J. Müller (Cat. 103), Lenoir's choice of a 'picturesque' subject: the colourful pile of carpets in the foreground, the careful detailing of architectural decoration and the characteristically varied group of merchants and clients. Although there are no Europeans in the painting, Lenoir reported that all his party bought rugs with great enthusiasm, ordering their purchases to be crated and sent ahead of them to France.

By 1880 Gérôme had begun to execute polychrome sculpture in keeping with the realisation that classical Greek sculpture had itself been coloured. It has been suggested by Gerald Ackerman (Dayton Art Institute, 1972, no. 39) that the donkey in this painting on the right had 'escaped' from two earlier groups of sculpture by Gérôme, *Le Christ entrant dans Jérusalem* and *La Fuite en Egypte*. MA.S.

PROVENANCE
William Shaus, New York; Crocker family, San Francisco; Sloan and Roman Inc., New York; Institute of Arts, Minneapolis
EXHIBITIONS
1969, University of California at Davis, *Pre-Impressionism*
1972–73, Dayton, Art Institute; Minneapolis, Institute of Arts; Baltimore, The Walters Art Gallery, *Jean-Léon Gérôme (1824–1904)* (no. 39)
REFERENCES
F. Field Hering, *Gérôme, His life and Works*, New York, 1892, p. 225
J. C. van Dyke, *Modern French Masters*, New York, 1896, ill. opp. p. 36

38

Prayer at the Mosque of Qāyt-bāy *c.*1895

La Prière dans la mosquée de Caïd Bay

77·5 × 101·6 cm
Signed bottom left on the wall: *J. L. GEROME*
Private Collection, Houston, Texas
[*repr. in colour on p. 67*]

This scene of private prayer is set in the prayer hall of the *Madrassah* (religious school) and tomb of the Mamlūk sultān, Qāyt-bāy (1468–1496) in Cairo. The mosque was erected in the Eastern Cemetery of Cairo and was completed by one of the most graceful minarets in the city. Unlike the columnar hall of the Mosque of 'Amr (see Cat. 32), the interior is a simple, open hall, the decorative stress being laid upon the rich detailing of the *qiblā* wall, facing Mecca, with its marble *miḥrāb* (niche), the focal point of prayer, and its *minbar* (pulpit), embellished with intricate wooden carving, from which the Friday sermon is delivered. The predominant colours of green and red highlight the arabesques on the frieze and determine the rhythm of the individual architectural features. The carved inscriptions on panels set above the arches are painted in gold and blue against a blue-green ground.

Gérôme and Lenoir certainly visited this mosque during their

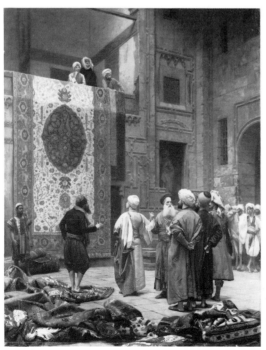

37

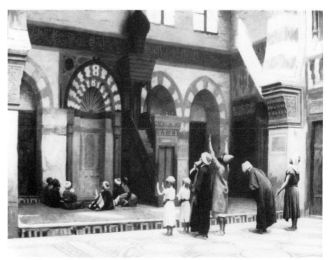

38

trip to Egypt in 1868, when Lenoir noted that its interior was characteristic of many of Cairo's 400 mosques. Given the freer handling of the paint and the sophistication of the composition, this painting, however, appears to have been executed *c.* 1895, some twenty years after Gérôme's last visit to Cairo. It has been suggested, therefore, that Gérôme must have relied upon stock poses taken from his sketchbooks for the figures and upon photographs for the architectural setting (G. Ackerman, Ottawa, National Gallery of Canada, 1978, p. 118). Despite the lapse of time, Gérôme had nonetheless retained a remarkable recollection of the intense light peculiar to Egypt. The shaft of light coming through the window at the top right of the picture both obliterates all colour and creates a dominant white 'dust' or haze. This drains the detail of the carved inscriptions and, at the same time, intensifies the colours of the figures standing in the shade. Timbal (1876) had earlier commented upon Gérôme's fascination with light, especially its effect when falling on buildings and figures. In his view, however, this did not make Gérôme a 'colourist', since he did not use colour with the eye of the imagination but rather in keeping with his concern for realism as '*un homme scrupuleux*' (p. 342).

As in *Prayer in the Mosque of 'Amr* (Cat. 32), the artist has both accentuated the distinct architectural characteristics of the Mosque of Qāyt-bāy and underlined its function as '*le rendez-vous de la prière*' (Lenoir, 1872, p. 164). Indeed, the variety of poses, the expanse of grey marble in the foreground and the direct confrontation with the *qiblā* suggest that the artist sought in this painting to convey to Western spectators that 'impression which dominates in a visit to the mosques . . . that exclusively religious and almost poetic character of these monuments' (Lenoir, 1872, pp. 164, 167). MA.S.

PROVENANCE
Mr and Mrs Joseph M. Tanenbaum Coll., Toronto; Kurt E. Schon, Ltd, New Orleans; Priv. Coll., Houston, Texas

EXHIBITION
1978, Ottawa, The National Gallery of Canada, *The Other Nineteenth Century: Paintings and Sculpture in the Collection of Mr and Mrs Joseph M. Tanenbaum* (no. 38)

REFERENCES
Dayton Art Institute, 'Jean-Léon Gérôme as a Painter of Near Eastern subjects', R. Ettinghausen, in *Jean-Léon Gérôme 1824–1904*, 1972, p. 23

39

The Whirling Dervishes *c.*1895

Les Derviches tourneurs

70·4 × 91·3 cm
Signed bottom right: *J. L. GEROME*
Private Collection, Houston, Texas
[*repr. in colour on p. 63*]

Since monasticism is expressly forbidden in Islam, those for whom the prescribed religious observances were not enough became itinerants, receiving the Persian name, *dervish*. They devoted themselves to the mystical life whereby the soul journeys through a series of stages, ultimately entering into an ecstatic dialogue with Allah. From these beginnings various great *sufi* brotherhoods developed and the terms *dervish* and *sufi* became virtually synonymous. The *dhikr* (remembrance), a ceremony common to all the brotherhoods, was a means of encouraging the attainment of a heightened state of mystical awareness, in various forms, which alarmed innocent European observers, who described the dervishes variously as whirling,

shouting and howling, as well as eating glowing embers, live serpents, scorpions and glass, or passing needles through their bodies and spikes through their eyes.

The *dhikr* which is depicted in Gérôme's painting is almost certainly set in the mosque of Ma'bad al-Riffā'ī in the Eastern Cemetery of Cairo. Many dervishes belonged to more than one brotherhood and occasionally they held joint ceremonies, as seems to be the case here. Framed by a line of *Bayūmmiyyah* (howling dervishes) the *Malawiyyah* (whirling dervish), has cast off his *khirka* (black coat), the symbol of death; he still wears his *sikke* (hat), the symbol of the tomb, retained during the ceremony. Rotating on his right foot, his increasingly frenzied dance is accompanied by a small ensemble of instruments on the left: reed flute, tambourines, rebeck and drum. It is suggested that the founder of the whirling dervishes, Jalāl al-Dīn Rumī (d. Konya, 1273), adopted this ritual as a means of attaining an ecstatic communion with Allah because of the tradition for dance in his native Asia Minor.

Western visitors to the Near East eagerly sought out the dervishes' *dhikrs*. Their reaction was one of fascination and disbelief. Gautier, Lamartine, Maxime du Camp and Flaubert all attended such ceremonies. For Flaubert, who witnessed in Cairo both the *dūsah* (trampling) of the dervishes and what would appear to have been a howling *dhikr*, the latter event provoked a curiously sober response. He saw the tradition of Western rationalism challenged by an intense, enthralling emotionalism: 'we saw one [dervish] fall into convulsions from shouting "Allah!" These are very fine sights, which would have brought many a good laugh from M. de Voltaire (*sic*). Imagine his remarks about the poor old human mind! About fanaticism! Superstition! None of it made me laugh in the slightest, and it is all too absorbing to be appalling' (Steegmuller, ed., 1979, pp. 93, 94). Gautier and Lamartine visited Pera specifically to see whirling dervishes, which prompted Gautier to draw upon the full range of exotic, Orientalist imagery in an intensely poetic description of the ecstatic state of the dancers, their 'eyes fixed, contemplating the splendours of Allah' (*Constantinople*, Paris, 1863, p. 88). MA.S.

PROVENANCE
Bessonneau d'Angers Coll.; Mr Willian Schauss, New York; Mr T. H. Burchell; John Levey Galleries, New York; Mr Francis R. Welch; 1938, Parke Bernet, New York (lot 512); 1939, Parke Bernet, New York (lot 413); 1954, 23 July Hôtel Drouot, Paris; Schickman, New York; Kurt E. Schon, Ltd, New Orleans; Priv. Coll., Houston, Texas

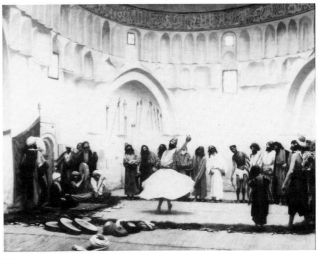

39

Girardet, Eugène 1853–1907

Eugène Girardet was the eldest son of a third generation of Swiss artists. He began his artistic training under his father, Paul Girardet (1821–1893), and later became a pupil of Gérôme (*q.v.*) at the Ecole des Beaux-Arts, Paris. Fired with his master's enthusiasm for the East, and perhaps inspired, too, by the voyages of his uncle Karl Girardet (1813–1871), he travelled to Spain and Morocco in 1874, and in 1879 visited Algeria for the first time. In all Girardet made eight trips to this country, and, like Guillaumet, preferred the southern towns of Biskra, Boghara, El-Kantara and Bou-Saada. It was in Bou-Saada that Girardet met the writer and painter A. E. Dinet (1861–1929), one of the most committed Orientalists, who accepted the Islamic faith in 1913. Later, he also visited Egypt, Turkey and Palestine, where he is believed to have contracted a painful and disfiguring illness.

Girardet exhibited Orientalist genre scenes and landscapes of Normandy and Calvados from 1874, and from the mid-1880s his work was exhibited frequently in Geneva, Zürich, London, and at the Glasgow Institute of Fine Arts. In the last decades of his life, Girardet was beset by ill-health, and died in Paris in 1907.

The uniformly blond tonalities and unbroken surfaces of the desert would seem to offer little scope for the artist. In a scientific analysis of the Sahara desert, Charles Martins examined the various soils, climates and vegetation, from the coastal plains to the beautiful cedars of the Djurdjura and Teniet-el-Had mountain ranges in the south, characterising the general aspect of the desert as, 'vast, denuded surfaces, interspersed with salt lakes or *chotts*, devoid of arborescent vegetation, and overrun in summer by immense flocks of sheep which strip the plants down to their very roots' ('Le Sahara et la végétation du désert', *Revue des Deux Mondes*, July–August 1864, p. 304). Only the bare mountains relieved the severe horizontality of the skyline; even the alfalfa, one of the few grasses to withstand the arid conditions, conformed to the overall silvery whiteness. Girardet captures the neutral tonalities caused by the ferocity of the heat and sun. By the addition of a strip of vegetation in the middle distance and the pinks and violets of the distant mountains, he successfully alleviates the potential monotony of the scene, without detracting from the sensation of the caravan's laborious journey. J.M.

PROVENANCE
Priv. Coll., Paris; Kurt E. Schon Ltd, New Orleans; Priv. Coll., Houston, Texas

40

Salt Caravans in the Desert
Caravanes de sel dans le désert

48·5 × 99 cm
Signed bottom left: *Eugène Girardet*
Private Collection, Houston, Texas
[*repr. in colour on p. 81*]

Salt was by no means a rare commodity in Algeria, but because of transportation difficulties usually served only local requirements. This was the case at Tellout, one of the major sources of salt located some twenty miles east of Tlemcen, and in the lakes in the southern part of the district of Constantine. Only the salt mines at Bou-Zian and Arzew in the Oran region were fully exploited, the latter being highly esteemed for the purity of the mineral.

In the course of his eight visits to the southern part of Algeria, Girardet experienced native customs and life at first hand, and came to specialise in the depiction of nomadic tribes and desert views. This painting highlights the sheer physical effort required in moving the salt from its sources across wide expanses of desert by setting the few, scattered figures in a vast, inhospitable landscape.

41†

The Tailor's House in an Arab Town
La Maison du tailleur dans une ville arabe

48·3 × 72 cm
Signed bottom right: *Eugène Girardet*
Private Collection, Houston, Texas
[*repr. in colour on p. 84*]

Though regarded as primarily an Orientalist painter (Bénédite, 1908, p. 10), Girardet continued throughout his career to execute both landscape paintings and genre scenes from the environs of Houlgate (Calvados) where he spent his summers. He made his Salon debut in 1874 with a genre scene *La Faim fait sortir le loup du bois* (present location unknown), and in many respects his representations of life in Algeria were coloured by the same

40

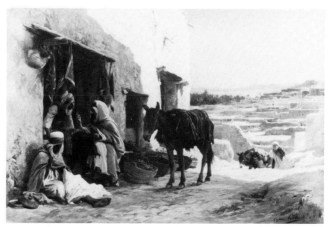

41

anecdotal approach. Léonce Bénédite has pointed to the artist's predominantly painterly preoccupations, noting that 'his canvases are far from being mere remembrances of his travels or ethnographical descriptions, but true portraits done by an artist who sees them with a painter's eye' (*op. cit*: p. 9). On a purely technical level, *The Tailor's House in an Arab Town* reveals Girardet's attempt to come to terms with the almost overwhelming intensity of sunlight. Fromentin, in *Une Année dans le Sahel*, (1859) stressed the total reversal of traditional formulae for the illumination of certain areas of the picture. In Europe, he wrote, 'paintings are composed in shadow, with a dark centre and corners of light', and to comprehend the effects of light in the Orient, the artist should imagine himself as, 'a sort of Rembrandt in reverse' (*op. cit*, 1898 ed., p. 228). Girardet shows an understanding of the distinctive quality of the light in the application of pure white paint to the areas exposed to the full brilliance of the sun. Only in the shadows do colours attain their fullest value: in the bold oppositions of reds and greens of the tailor's material, and in the range of atmospheric colours overlaid in brisk brushstrokes across the foreground.

The group of figures in the doorway become the focal point of attention in the painting with their expressive physiognomies, lively gestures and animated discussion. Girardet's views of Arab villages and desert landscapes are rarely unpopulated, and, like Guillaumet, he treated the theme of peasant labour with sympathy. Nevertheless it was the curiosity value and pictorial priorities rather than the documentary element which predominated in his genre work. A similar concentration on narrative detail occurs to a lesser extent in *Camels in the Dunes at Bou-Saada* (Cat. 42), and very clearly in the *Caravane passant un gué* (1877–78; Priv. Coll., Houston, Texas), where even the animals are made to exude an affable charm.

There are at least two related works: *Le Tailleur sur le pas de sa porte à Bou-Saâda* (n.d., Atelier sale 1908; present location unknown), and *Le Tailleur d'El-Kantara* (n.d., Musée des Beaux-Arts, Saintes). J.M.

PROVENANCE
1977, Hôtel Drouot; Priv. Coll. New York; Kurt E. Schon Ltd., New Orleans; Priv. Coll., Houston, Texas

REFERENCES
Thornton 1983, ill. pp. 183–84
L. Bénédite, *Catalogue des tableaux provenant de l'atelier Eugène Girardet*, 1908, pp. 5–10

foot leads the ass carrying the kitchen utensils and the women act as faggot bearers, while the men, on camels, oversee the entire procession. It was precisely to be exposed to the social realities of native existence that artists such as Girardet, Guillaumet and Dinet chose to live in the southern extremities of Algeria, where French influence was yet to impinge on the indigenous culture. Nevertheless, from the 1870s these regions were of increasing economic interest to the French government who sought to re-establish commercial links with the Sudan through the oases of the Sahara. French domination of tribes in the Sahara was largely assured by the permanent occupation of Géryville, El-Agouat, Biskra and Touggourt; expeditions which hoped to penetrate as far as Ghadmes and In-Salah were dependent on the goodwill and protection of the Touareg tribe. Girardet, in his depiction of all aspects of native life, was clearly very conscious of the imposition of colonialism in these regions and of the resulting eradication of native customs. A similar awareness consituted the very *raison d'être* of the Société des Peintres Orientalistes Français, founded in 1893. According to Bénédite, the Orientalist painter had more than a purely artistic role to fulfill; he held the responsibility of retaining from 'all this Oriental fantasy . . . at least the image, all that still remains of its colour, poetry, strangeness and seductive charm' (1899, I, p. 240).

As a result of the close observation of the effects of light and atmosphere made during his stays in the Orient, Girardet's palette brightened considerably and his brushstroke became more rapid. Here he effectively conveys the vibrant luminosity of the scene in the greens and blues of the deep shadows, which contrast boldly with the touches of ochre, orange, beiges and greys in the rock face.

The painting remains in its original ornate frame of decorative arabesques. J.M.

PROVENANCE
Acquired by 'an amateur' (probably David) following the exhibition at Nantes in 1898; given by David to the Musée des Beaux-Arts, Nantes

EXHIBITIONS
1898, Nantes, *Exposition de la Société des Amis des Arts de Nantes* (no. 107)
1908, Paris, Salon des Peintres Orientalistes Français (no. 30)
1980, Nantes, Musée des Beaux-Arts, *Orients* (no. 37)

REFERENCES
L. Bénédite, 'Les Peintres orientalistes français', *Gazette des Beaux-Arts*, March 1899, I, p. 240
R. Burnard, *L'Étonnante Histoire des Girardet, artistes suisses*, 1944, p. 261

42

Camels in the Dunes at Bou-Saada

Chameaux dans les dunes à Bou-Saâda

67·7 × 108·7 cm
Signed bottom right: *Eugène Girardet*
Musée des Beaux-Arts, Nantes
[*repr. in colour on p. 81*]

First exhibited in Nantes in 1898, this scene depicts a tribe of nomads emerging from the Saharan Atlas mountains in southern Algerian. From each of his 'Algeria campaigns' (quoted R. Burnard, 1944, p. 261), Girardet brought back numerous studies of the inhabitants and the landscape as an aide-mémoire of ethnographical details. In this picture he accurately records not only costumes, animals and accoutrements, but also the functions fulfilled by different members of the caravan: the little girl on

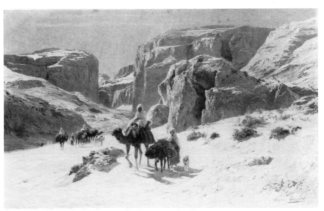

42

Gleyre, Charles 1806–1874

Born in Chevilly, near Lausanne, Switzerland, Gleyre spent his early youth in Lyon after the death of his parents. He began his formal art studies there under Bonnefond (1796–1860) and in 1825 went to Paris where he enrolled in the Ecole des Beaux-Arts under Hersent (1777–1860). He also attended the Académie Suisse and learned watercolour technique in the studio of Bonington. In 1828 he left for Rome where he was associated with Horace Vernet, the Director of the French Academy. It was Vernet who suggested to John Lowell, Jr., an American travelling to the Near East, that Gleyre would be an artist capable of recording the voyage. They left Italy in the spring of 1834, first visiting Greece and Turkey, and then Egypt, where they remained until late 1835; both Gleyre and Lowell kept journals of the trip, the latter in eight unpublished volumes. Lowell continued to Bombay, where he died shortly afterwards; Gleyre made his way through Egypt and Syria before returning to Paris, ill and almost blind, in 1838.

Although Gleyre remained in the Near East for almost four years, he rarely used Oriental imagery in his later work, preferring historical, classical and religious subjects. His great success of 1843, *Les Illusions perdues* (Louvre, Paris), with its characteristic blend of classical subject-matter, Egyptian background and highly polished academic technique, brought him considerable public attention, as well as the leadership of Paul Delaroche's studio, then the most important private teaching atelier in Paris. For almost a quarter of a century, he directed some 600 students, including Gérôme (*q.v.*), Hamon, Toulmouche, and the future Impressionists, Bazille, Renoir (*q.v.*), Sisley and, briefly, Monet.

The works that Gleyre produced for Lowell from 1834 to 1835 were intended essentially as visual documents of sites and ethnic types; as such, these works differ in purpose and scope from other artists' works in the Near East. In November 1835, when Gleyre and Lowell separated, the latter sent to his family in Boston 158 works by Gleyre, of which 154 remain deposited in the Museum of Fine Arts, Boston. Gleyre requested the loan of these works in 1840 in order to make copies for himself, and these copies, together with many other studies, remained in his studio, unseen, until his death in 1874, when they were inherited by Charles Clément. The majority of these were bought by the Musée cantonal des Beaux-Arts, Lausanne, from Clément's widow in 1908.

ABBREVIATED REFERENCES
BMFA Boston Museum of Fine Arts
MCBA Musée cantonal des Beaux-Arts, Lausanne
Clément 1878 C. Clément, *Gleyre*, Geneva, Neuchâtel and Paris, 1878, including a catalogue raisonné
Berger 1974 J.-E. Berger, 'Gleyre et l'Orient' in *Charles Gleyre ou les illusions perdues*, Winterthur, 1974, pp. 50–69
Newhouse 1980 N.S. Newhouse, 'From Rome to Khartoum: Gleyre, Lowell, and the Evidence of the Boston Watercolours and Drawings', *Charles Gleyre, 1806–1874*, Grey Art Gallery and Study Center, New York University, 1980, pp. 79–117
Lowell MS. John Lowell, 'Journal', 8 vols. (unpublished), John Lowell Coll., Boston

Note 1 Charles Gleyre, 'Journal d'orient', reproduced with some changes in Clément (see above). Original MS. on deposit in the Musée cantonal des Beaux-Arts, Lausanne (dossier 999)

2 All titles of Gleyre's works are given in English as they were commissioned by John Lowell, Boston, Mass., with the exception of Cat. 58

43†

Demetrius Papiandriopolos July 1834

Watercolour and pencil on paper: 32·3 × 23·5 cm
The Lowell Institute, Boston
[*repr. in colour on p. 156*]

Lowell had hired Gleyre for his voyage to the Near East not only to capture the celebrated sights but also to delineate the ethnic types and costumes encountered during the trip. This latter objective was fully in keeping with Lowell's own sociological and ethnographic interests, for in his journal he emphasised that he desired costume pieces and physiognomic records as much as archaeological souvenirs; Horace Vernet had stressed to Lowell that Gleyre excelled in this genre as well as in landscape painting. Thus, the corpus of works in Boston and Lausanne that document the eighteen-month trip is a unique record, its appreciation extending beyond purely artistic considerations. Gleyre's portrayal of individuals in pencil and watercolour, almost always executed *in situ*, is virtually without precedent in the iconography of Orientalism and differs substantially from figure subjects which were usually worked on or perfected in the studio, and intended for exhibition before Western viewers. A large proportion of Gleyre's Oriental work was devoted to portrait or figure studies; the pencil studies were finished on the spot under hurried conditions, while the watercolours were completed usually within three days.

Demetrius Papiandriopolos was the guide Lowell had hired, probably in Malta, in June 1834. He acted as interpreter, valet, and above all as guide to Lowell and Gleyre through the Aegean; he stayed with the company until they reached Thebes. As a native of Missolonghi, Demetrius took great pride in directing them to the graves of Byron and the legendary Greek leader Marco Botzaris; Gleyre commented in his journal that not even a stone marked their graves. Demetrius also introduced Lowell and Gleyre to a number of his friends on the Greek

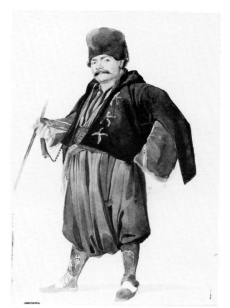

43

mainland, as well as in Turkey: in October at Smyrna, he was the intermediary between the travellers and a Greek captain, a meeting from which the remarkable portrait of Angelica was to result (Cat. 49).

Gleyre's execution of the present watercolour reveals the painter's assured and fluid technique which marks his work during this phase of his career. Demetrius assumes a tourist's pose, clearly proud to be the object of the painter's brush. The building up of the tones and volumes of drapery is representative of Gleyre's almost effortless manner in depicting costumes in the precise documentary manner desired by Lowell. Gleyre did not recopy the work in Paris, but frequently used the same pose for other figure studies executed in Greece and Turkey (see especially BMFA 64.49 and 124.49). W.H.

PROVENANCE
Commissioned by Lowell; The Lowell Institute, Boston; 1949, on loan to the Museum of Fine Arts, Boston (BMFA 114.49)

EXHIBITION
1980, New York, The Grey Art Gallery and Study Center, New York University, *Charles Gleyre, 1806–1874* (no. 12)

REFERENCE
Newhouse 1980, p. 82

44†

View of the Parthenon — Athens
August/September 1834

Watercolour on paper: 22·2 × 36·5 cm
The Lowell Institute, Boston
[*repr. in colour on p. 154*]

Lowell and Gleyre left Corfu for the Albanian coast in late June, 1834. They first explored the Albanian mountains, recording impressions and collecting data. By July they had reached Janina and during that month they slowly worked their way southward, with no fewer than twenty horses for carrying the necessary supplies, to Missolonghi, following as much as possible in Byron's footsteps. From there they travelled westward, but Gleyre, debilitated by a fever, made no illustrations of Mycenae and Epidaurus. The company reached Athens in late August.

Their arrival in the city coincided with the establishment of an

independent monarchy under the Bavarian Wittelsbach, Otto I. Gleyre noted in his journal that he had little sympathy for these German soldiers who where inhabiting Greek soil after centuries of Turkish rule. Nevertheless, he must have admired Otto's plans to restore the Acropolis (see Cat. 45) which was in a state of dilapidation. Lowell and Gleyre even witnessed King Otto laying the first stone for the restoration of the Parthenon in early September, Lowell noting in his diary (Lowell MS., vol. III, 10 September) that the architect Leo von Klenze had made a speech in German for the occasion.

Lowell also noted that in Athens Gleyre was especially industrious, producing numerous watercolours and drawings of high quality. Several views of the Acropolis were executed including a variant of this watercolour (BMFA 165.49), and two views taken directly from the site (BMFA 131.49 and 169.49). The view exhibited here was taken from the plain below the Pnyx looking eastward toward the Propylaeum and the western façade of the Parthenon. Directly below, in the foreground, is the Odeon of Herodes Atticus and, leading towards the right of the composition, the Stoa of Eumenes. To the right stands the Arch of Hadrian while the Temple of the Olympic Jupiter, here somewhat abbreviated, can be seen in the far distance.

In many ways this view of the Acropolis is typical of the topographical views Gleyre produced during his Near Eastern voyage. The site is emphasised in its immediate setting; the brushwork is precise for the actual monument, but sketchy and generalised for the surrounding landscape. The colours are extremely rich, recalling Gleyre's own impression that the Athenian light has no equal. In the copy of this watercolour, painted later in Paris (MCBA D.1224), it is clear that he was now much more impressed by the remaining sculpture than the architecture. Gleyre in fact produced several highly detailed studies of the statuary which he did not give to Lowell, all of which are now in private collections in Paris and Fleurier. W.H.

PROVENANCE
Commissioned by Lowell; The Lowell Institute, Boston; 1949, on loan to the Museum of Fine Arts, Boston (BMFA 151.49)

EXHIBITION
1974, Winterthur, Kunstmuseum, *Charles Gleyre ou les illusions perdues* (no. 127; MCBA copy)

REFERENCES
Clément 1878, pp.73f., no. 514
Newhouse 1980, p. 85

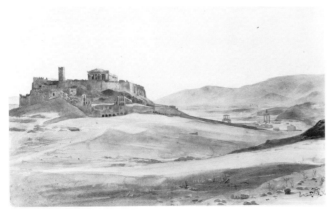

44

45†

Interior of the Parthenon September 1834

Watercolour on paper: 36·2 × 51·5 cm
The Lowell Institute, Boston
[*repr. in colour on p. 155*]

Most early nineteenth-century artists chose to depict the
Parthenon from the outside. This viewpoint avoided the need to
refer to the aesthetic intrusion of so anticlassical an element as
the large Turkish mosque erected in the *cella*. Chateaubriand
noted in his widely read *Itinéraire* (originally published 1811,
Pléiade ed. 1969, II, p. 872) that the mosque was not only in bad
taste, but that it seriously prohibited the appreciation of the
classical structure. The mosque was actually built by the Turkish
forces shortly after the disastrous bombardment of the Acropolis
by the Venetians in 1687. In the restoration plans of 1834 it was
decided to destroy the mosque as early as possible, but it
remained intact until 1842; Ippolito Caffi's interior view of the
Parthenon (Museo d'arte moderna, Ca' Pesaro, Venice), painted
in that year, shows that all traces of the mosque had vanished.

Gleyre's view of the mosque is, therefore, one of the rare,
detailed representations of the structure before its demolition. It
is probable that this watercolour was especially commissioned by
Lowell who greatly appreciated Islamic architecture (see Cat. 46).
It was executed from a low vantage point, and shows the view
immediately inside the west entrance; the remnants of the east
façade may be seen in the distance and a column from the north
face is visible at the left. Lycabettus Hill rises in the distance,
almost in the centre of the composition, its rich purple tones
typical of Gleyre's representations of the Athenian landscape. As
in the previous view of the Acropolis (Cat. 44), Gleyre's
proficiency in watercolour is evident in the areas of light and
shade in the marble and on the mosque.

Gleyre did not copy the present work after his return to Paris.
However, he did paint another view of the mosque, somewhat
blocked by the east façade, which shows more clearly the
relationship of the building to the Parthenon as a whole (BMFA
167.49). This can be compared to Karl Wilhelm Heydeck's similar
view of 1834 (Benaki Museum, Athens). W.H.

PROVENANCE
Commissioned by Lowell; The Lowell Institute, Boston; 1949, on loan to the Museum of
Fine Arts, Boston (BMFA 168.49)

EXHIBITION
1980, New York, The Grey Art Gallery and Study Center, New York University, *Charles
Gleyre, 1806–1874* (no. 18)

45

46†

Mosque at Athens September 1834

Watercolour on paper: 19 × 29·2 cm
The Lowell Institute, Boston
[*repr. in colour on p. 154*]

In Athens Gleyre produced relatively few drawings or
watercolours of the city. The view shown here represents
virtually the only watercolour in the Athenian series which
records the contemporary architecture of the city free from
classical monuments and ruins. Indeed, the precision of this
watercolour makes it possible to identify the site as well as the
main structure depicted, despite the fact that neither Gleyre nor
Lowell mention in their respective journals the circumstances in
which the work was produced. The citadel at the top left,
silhouetted in beautifully controlled tints of greys and blues, is
the Acropolis seen from the north. The mosque in the centre is
the Djami Tou Parazou, built in 1759, on Monastiraki Square.
Immediately to the right is the Agora, as yet unrestored, while
the Plaka stands to the left with the Pnyx in the distance to the
right. The actual site, with the mosque's dome barely perceptible,
may be seen in one of the views Gleyre made from the Acropolis
hill (BMFA 131.49).

This watercolour fully exemplifies Gleyre's mastery in
delineating the complex forms of a dense cityscape. Although he
included many details, such as the two large cracks in the house
on the left, the absence of archaeological details suggest that he
did not attempt to portray the scene in the quasi-photographic
manner which was to mark later topographical views of Egypt
(Cat. 59, 61). Here the forms and colours are more loosely
applied, creating a general impression of the site. The delicate
patterns of light and shade, as well as the cubic organisation of
space, reaffirm Gleyre's artistic interests as independent from
topographical needs, making this work in many ways one of the
most modern of the group in its geometric massing and emphasis
on formal relationships. Only rarely did Gleyre return to such
concerns in Paris.

Gleyre's copy of this watercolour is in the Musée cantonal des
Beaux-Arts, Lausanne (D. 1227). W.H.

PROVENANCE
Commissioned by Lowell; The Lowell Institute, Boston; 1949, on loan to the Museum of
Fine Arts, Boston (BMFA 154.49)

EXHIBITIONS
1974, Winterthur, Kunstmuseum, *Charles Gleyre ou les illusions perdues* (no. 30; MCBA copy)
1980, New York, The Grey Art Gallery and Study Center, New York University, *Charles
Gleyre, 1806–1874* (no. 20)

REFERENCES
Clément 1878, no. 517 (as *Ville de Grèce*)
Newhouse 1980, p. 111

46

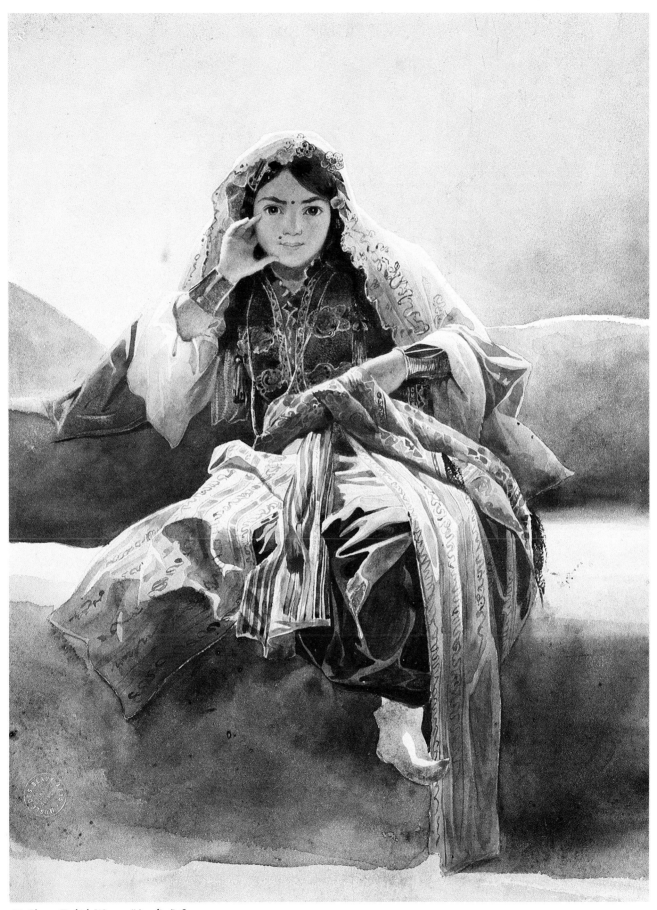

49 Gleyre *Turkish Woman ('Angelica'), Smyrna*

44 Gleyre *View of the Parthenon – Athens*

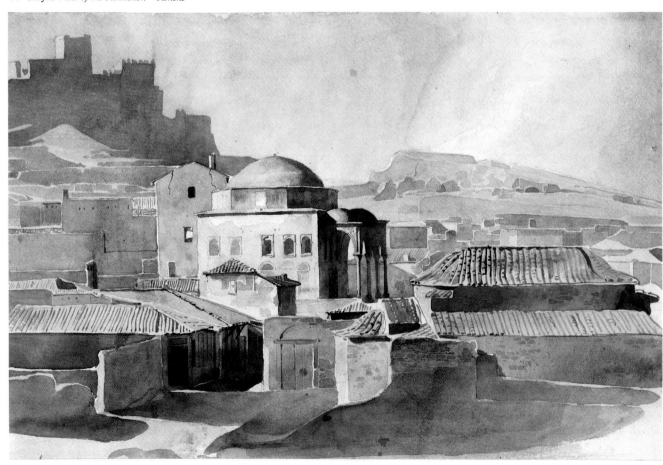

46 Gleyre *Mosque at Athens*

154

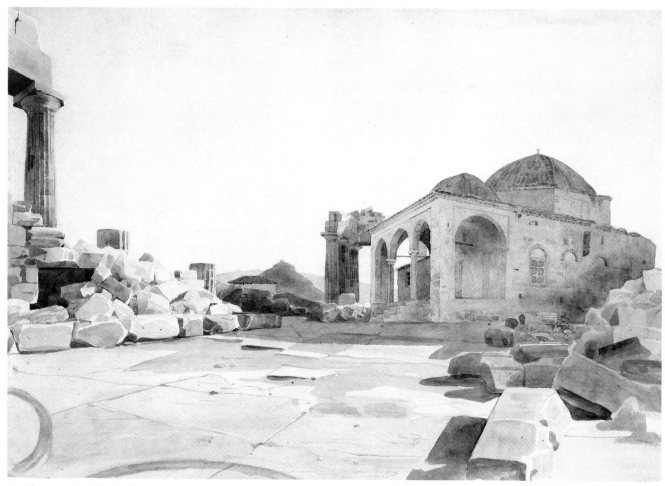

45 Gleyre *Interior of the Parthenon*

59 Gleyre *Rhamseion, Thebes*

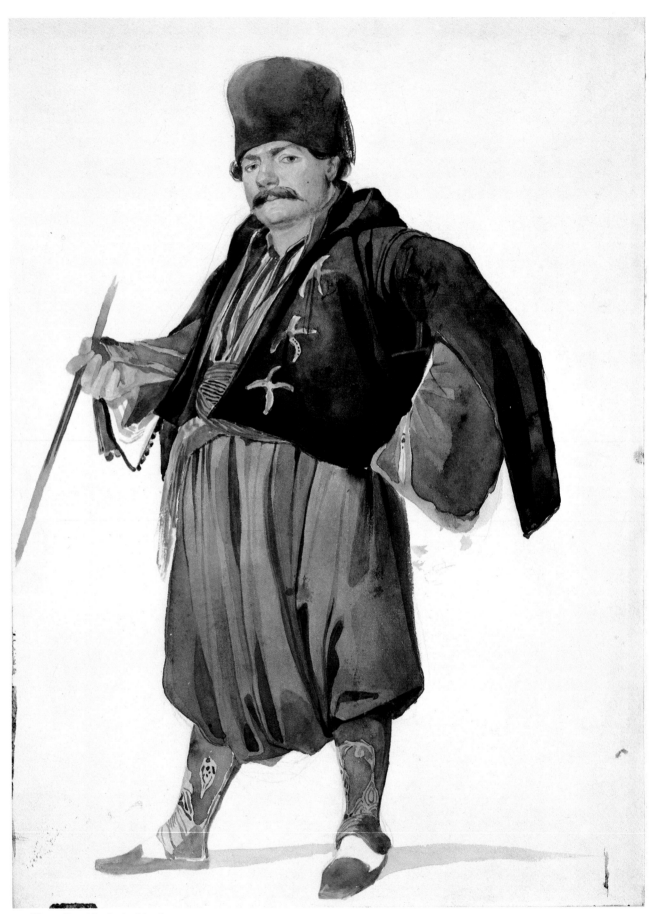

43 Gleyre *Demetrius Papiandriopolos*

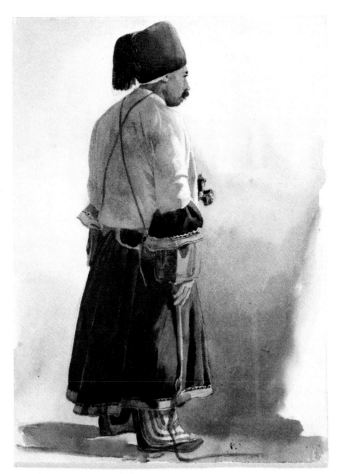

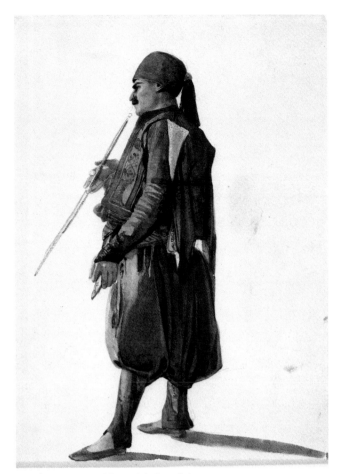

51 Gleyre *Tartar or Turkish Courier, Constantinople*

50 Gleyre *Cavass of the English Consul, Smyrna*

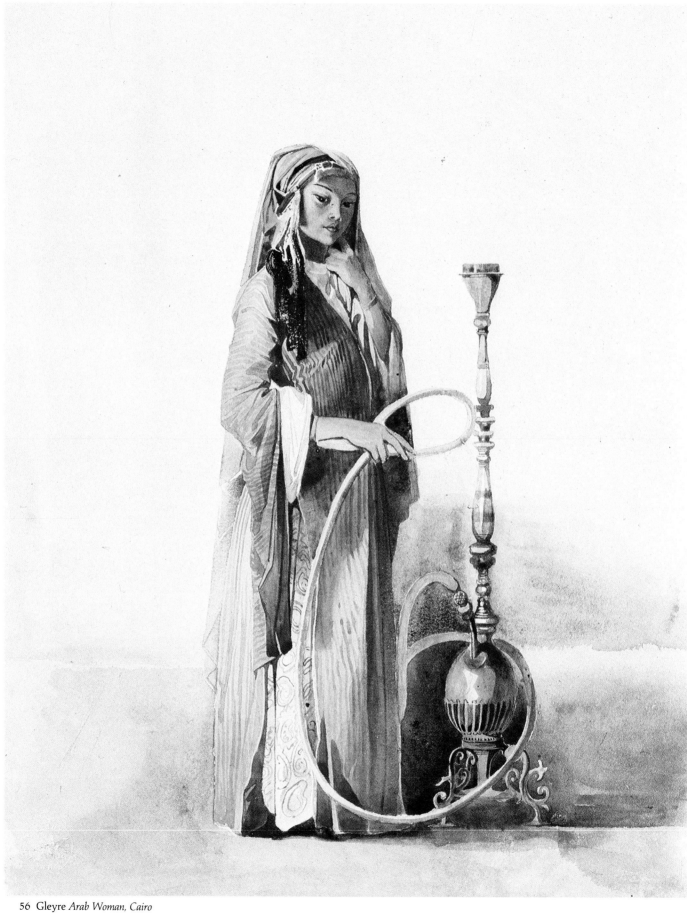

56 Gleyre *Arab Woman, Cairo*

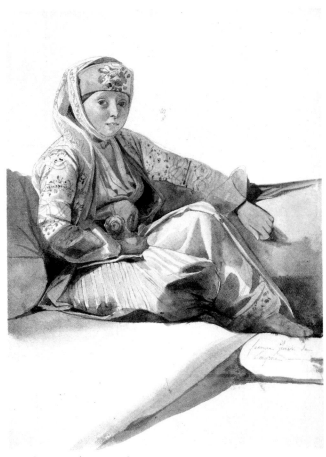

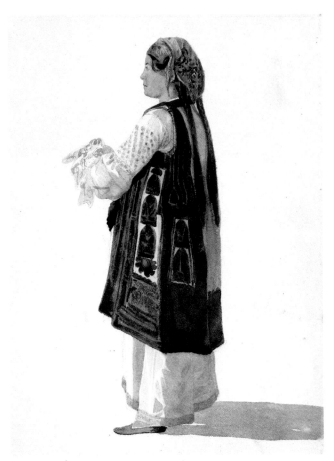

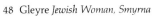

48 Gleyre *Jewish Woman, Smyrna*

47 Gleyre *Albanian Peasant Woman, Athens*

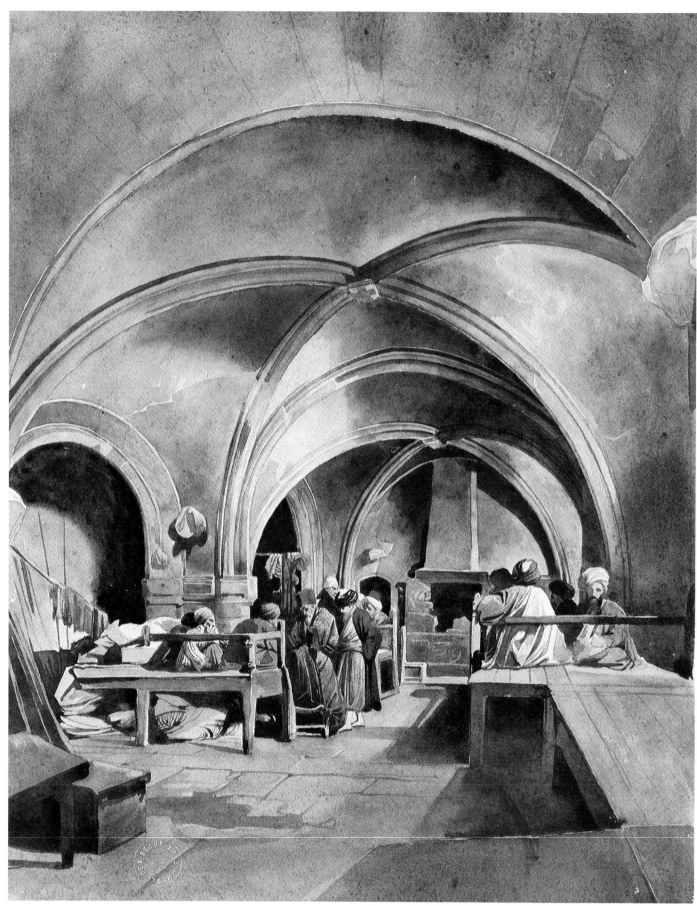

53 Gleyre *Palace of the Knights, now a coffee-shop, Rhodes*

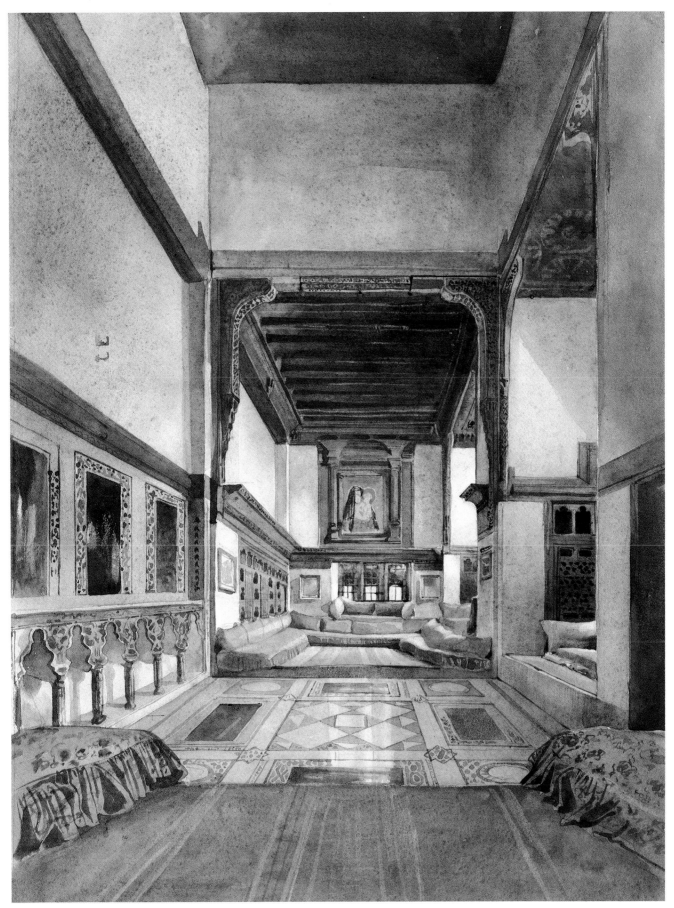

55 Gleyre *Copt Drawing Room, Cairo*

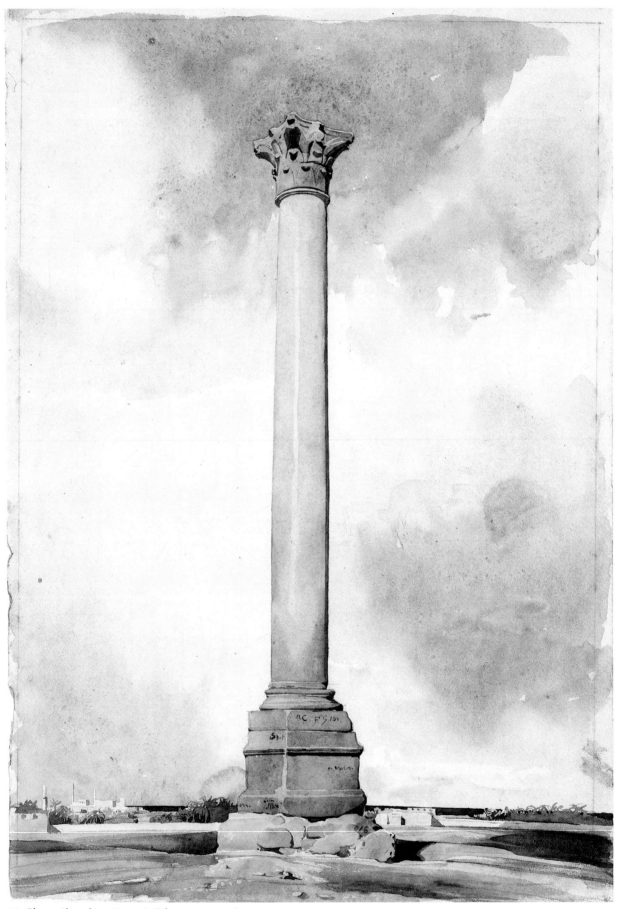

54 Gleyre *Alexandria – Pompey's Column*

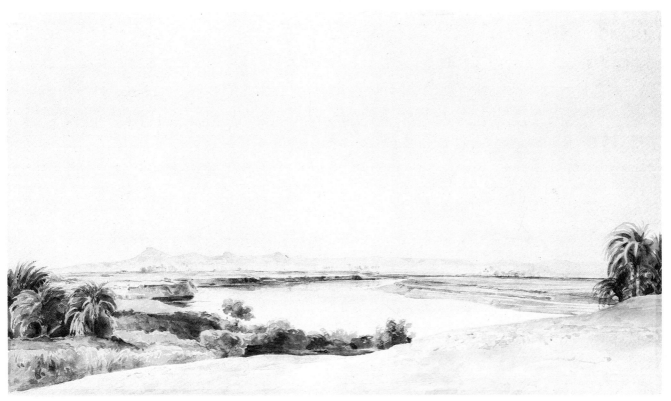

60 Gleyre *View from the south-east side of the Palace of Luxor, Thebes*

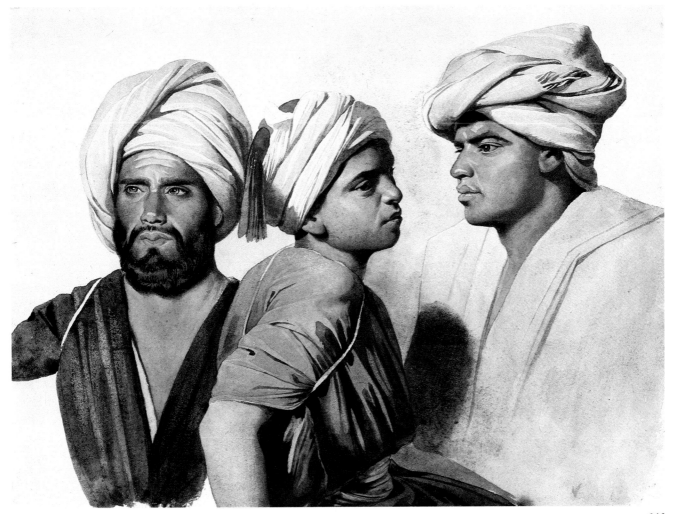

58 Gleyre *Three Fellahs*

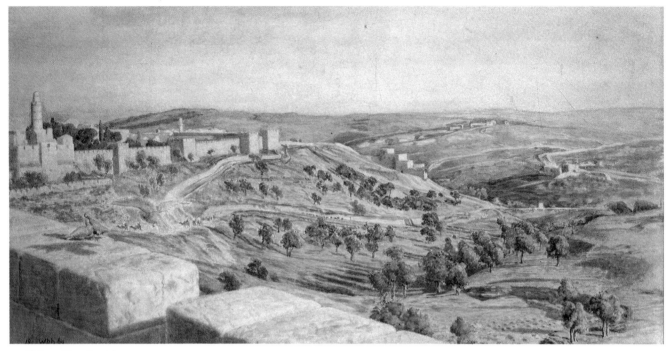

75 Holman Hunt *Jerusalem*

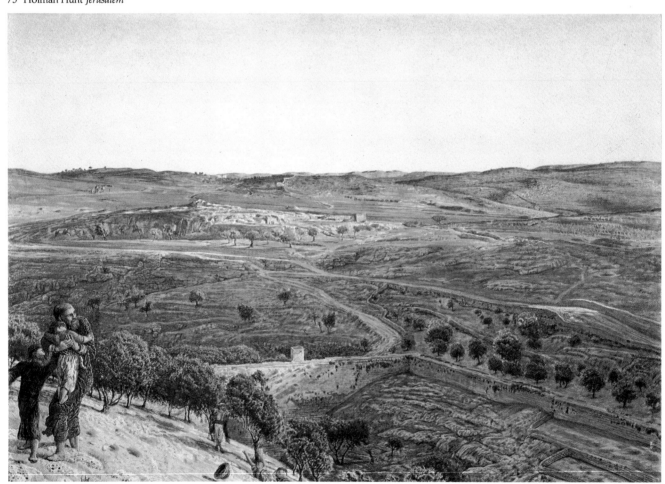

73 Holman Hunt *The Plain of Rephaim from Zion*

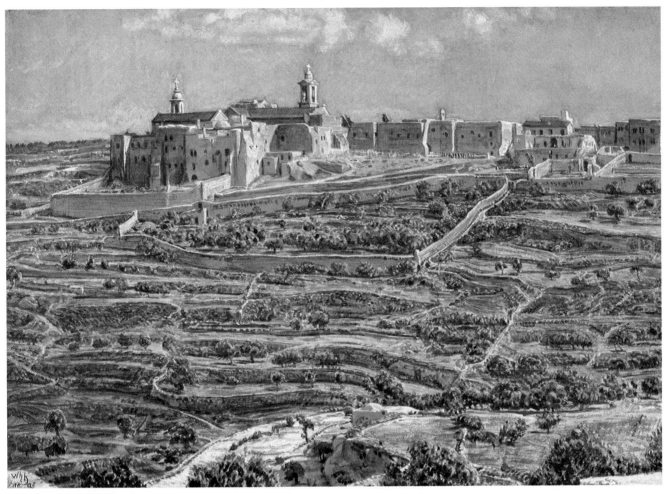

76 Holman Hunt *Bethlehem from the North*

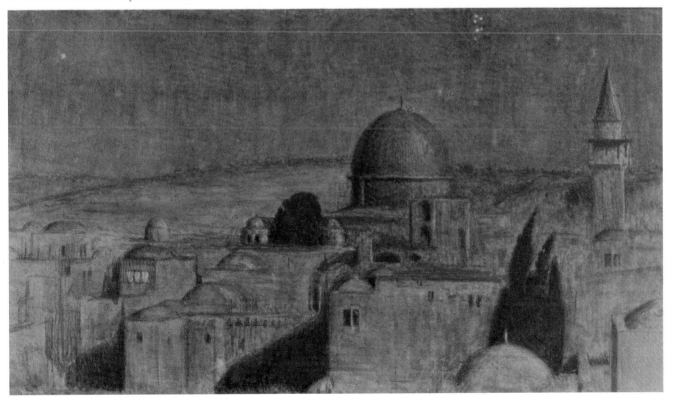

72 Holman Hunt *The Holy City*

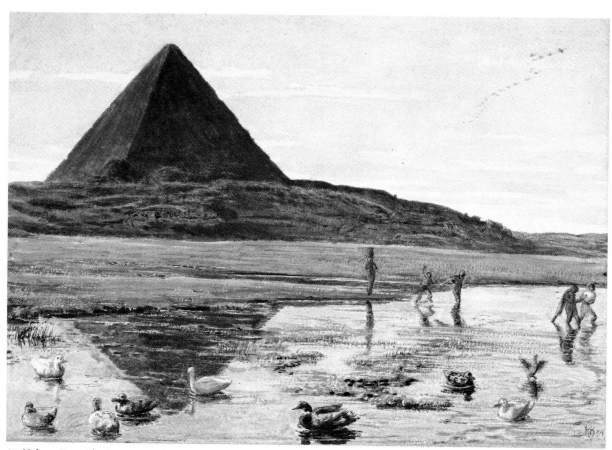

69 Holman Hunt *The Great Pyramid*

71 Holman Hunt *The Haunt of the Gazelle*

70 Holman Hunt *Arab Reclining by a Stream*

74 Holman Hunt *The Sleeping City, Pera*

47†
Albanian Peasant Woman, Athens 1834

Watercolour on paper: 32 × 23·5 cm
The Lowell Institute, Boston
[repr. in colour on p. 159]

In Athens, Gleyre was particularly active in recording a variety
of ethnic types. Although several drawings of Athenian men and
women in the style of Ingres survive, some inscribed 'Albanian'
or 'Turkish' since both races were very numerous in the city in
the early nineteenth century, this work appears to be the only
one Gleyre painted here in watercolour. It is especially
representative of the type of study Lowell desired, with the
emphasis clearly placed on the rich costume and broadly
indicated details; the figure in this case remains a general type,
rather than a specific woman chosen for her physiognomic
features.

Several factors in the handling of the paint in this study are
reminiscent of the watercolour techniques of Bonington, under
whom Gleyre had trained in Paris in 1825: the use of the dry
brush moved across the paint surface, particularly under the left
sleeve, the delicate handling of the areas around the sleeve, the
sparkling yellow headdress and the use of gum arabic to intensify
the line of the coat and the end of the plaits. The positioning
of the figure on the page was a format which Gleyre was to use
repeatedly, especially in Turkey (see Cat. 50, 51).

Gleyre copied the watercolour later in Paris (*Femme des
environs d'Athène*; MCBA D.1229), slightly altering the dress; the
left sleeve ends more abruptly in the copy, creating a more self-
contained composition. The face in the copy is even more
generalised and appears younger. There are several other
examples where Gleyre slightly altered the copies which he made
from the original works sent to him in 1840 by the Lowell
family. W.H.

PROVENANCE
Commissioned by Lowell; The Lowell Institute, Boston; 1949, on loan to the Museum of
Fine Arts, Boston (BMFA 120.49)

REFERENCE
Clément 1878, no. 519 (MCBA copy)

48†
Jewish Woman, Smyrna
September/November 1834

Watercolour and pencil on paper: 32 × 23·5 cm
The Lowell Institute, Boston (BMFA 108.49)
[repr. in colour on p. 159]

Lowell and Gleyre left the Greek mainland some time in mid-
September 1834; by the 18th of that month, they were becalmed
for ten days on the island of Syros before finally reaching Smyrna
(Izmir), the reputed birthplace of Homer, towards the end of
September. They remained in Turkey for more than a month and
a half and in late November began their voyage to the Egyptian
coast. Little is actually recorded of this part of the voyage in the
journals of either Lowell or Gleyre. However, many of the works
completed in Turkey, and in particular in Smyrna, are devoted
exclusively to portraits or costume studies. In Smyrna, only two
broad pencil studies of the city were made (BMFA 91.49 and
164.49), although much later Gleyre was to paint a work entitled
Souvenir de Smyrne (Clément 1878, no. 65), an unfinished fantasy
of the Turkish landscape.

The identity of the sitter in this watercolour is not recorded
in the Lowell journals, but the copy Gleyre made in Paris (MCBA
D. 1251) has, in the upper right-hand corner, the name 'Susanne'
added in Gleyre's handwriting. The name, however, does not
figure in the journals of Gleyre or Lowell.

This figure study of a Jewish woman, dressed in her finest
gown for the occasion, is not primarily a portrait. Gleyre's
preoccupations lay with the technique: the use of the white
tonalities, mixed with bluish-grey tints and accented by the gold
headdress and waist buckle, which create an exceptionally
harmonious composition. The finely delineated draperies curved
around the arms and knees remind us of Gleyre's deep interest
in classical drapery, of which he had seen many examples in
Athens. The model is seated, cross-legged, on a divan, a
customary pose in Turkey, which the artist was later to use

47

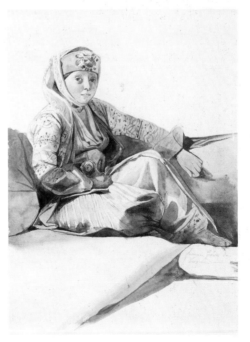

48

several times, most notably in his portrait of Angelica (Cat. 49). The casualness of the pose and the fluent technique create an impression of spontaneity which belies the carefully structured composition.

Smyrna in the nineteenth century had a large Jewish population which mingled easily with the Muslim majority. Gleyre no doubt sought out a female Jewish model because of the difficulties he had had earlier in persuading Muslim models to pose without veils; this prohibition did not apply to Jewish women in Smyrna or in Egypt, which made them more accessible to Western artists. Gleyre also painted other Jewish models while in Smyrna (eg. BMFA 182.49).

Gleyre drew a variant of this work using the same model but seen frontally (BMFA 67.49); the figure is represented cross-legged as in the present painting, but with her left leg crossed under her right knee. His copy of this watercolour (MCBA. D.1251) was never finished, the facial features being only sketched in. W.H.

PROVENANCE
Commissioned by Lowell; The Lowell Institute, Boston; 1949, on loan to the Museum of Fine Arts, Boston (BMFA 108.49)

EXHIBITION
1982, Rochester, New York, Memorial Art Gallery, *Orientalism* (no. 47)

REFERENCE
Clément 1878, no. 576 (MCBA unfinished version, as *Femme du Caire*); no. 551 (MCBA pencil version, as *Femme d'Athènes*)

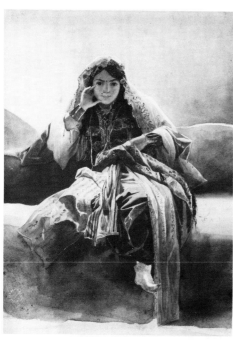
49

49†

Turkish Woman ('Angelica'), Smyrna
October 1834

Watercolour on paper: 36·8 × 27 cm
Musée cantonal des Beaux-Arts, Lausanne
[repr. in colour on p. 153]

While in Smyrna, Gleyre produced some of the most vivid and luminous watercolour portraits of the voyage. These were generally of women encountered through Lowell's hosts or through the friends of the guide Demetrius (Cat. 43). The most important of these, all executed within a few days in late October, 1834, were the portraits of the daughters of Mrs Narikos (BMFA 115.49 and BMFA 125.49) and the remarkable portrait of Mrs Langdon, the daughter of an 'Anglo-Swiss or Switzo-Englishman', as Lowell noted in his journal on 4 October (Lowell MS, vol. III), who had settled near Smyrna some years before. The latter portrait (BMFA 106.49) represents the model in an especially elegant Turkish costume and is one of the most subtle characterisations that Gleyre made at the time.

The present work evolved from a meeting arranged by Demetrius on 3 October, 1834, between Lowell and Gleyre and a Greek captain. The next day Lowell wrote in his journal that the evening had been spent in light-hearted conversation and the playing of card games (Lowell MS, vol. III, 4 October 1834). Also present at this soirée was the daughter of the hostess, a young girl named Angelica, the model for this watercolour. On 5 November, Lowell recorded that her full name was Angelica Calaphanti. It seems he was smitten by her dark beauty and even confided in his journal that he could not help flirting with her, a task made all the more difficult since they did not share a common language. Lowell asked Gleyre to execute her portrait, her sittings being rewarded by Lowell with a necklace and a small essence box.

In contrast to the subdued colours of the previous work, this watercolour radiates the ebullient colours considered by Western painters to encapsulate the charm and exoticism of Eastern costumes. Few other Oriental works by Gleyre delight so obviously in the use of colour. The intermingling of the scarves in the sitter's right hand creates a remarkably brilliant painted passage which is reminiscent of the North African watercolours of Delacroix. Gleyre's rendition of the complicated drapery folds around the left leg, as well as the translucent, airy effect of the head veil are exceptional. The pose was one that Gleyre used frequently in the Turkish portraits (Cat. 48).

The original watercolour from which Gleyre made this copy is in the Lowell Institute, on loan to the Museum of Fine Arts, Boston (BMFA 112.49). W.H.

PROVENANCE
Collection of the artist; 1874, inherited by Charles Clément; 1908, acquired from Clément's widow by the Musée cantonal des Beaux-Arts, Lausanne (D.1233)

EXHIBITIONS
1974, Winterthur, Kunstmuseum, *Charles Gleyre ou les illusions perdues* (no. 133, as *Juive de Smyrne*)
1980, New York, The Grey Art Gallery and Study Center, New York University, *Charles Gleyre, 1806–1874* (no. 23; BMFA original)
1982, Rochester, New York, Memorial Art Gallery, *Orientalism* (no. 47, BMFA original)

REFERENCE
Clément 1878, no. 526 (as *Juive de Smyrne*)

50†

Cavass of the English Consul, Smyrna

September/November 1834

Watercolour on paper: 32 × 23·5 cm
The Lowell Institute, Boston (BMFA 127.49)
[repr. in colour on p. 157]

The word *cavass*, also seen in the literature of the nineteenth
century as *cavas, carass, cawass,* or *kavass,* derives from the Arabic
word *kavas,* meaning an archer or a bowman. In the Near East,
but particularly in Asia Minor, the *kavas* was an armed policeman
usually attached as a guard to a foreign consulate or a high
government official. The post carried with it an element of
prestige and social standing. The *kavas* usually wore a highly
exotic and colourful costume, and was armed with a long sword
and an ornate ceremonial dagger. The hat seen in the present
watercolour is the felt cap, once covered by a turban but worn
alone by government officials according to the edict of Sultān
Mahmud III (1803–1839).

Clément noted (p. 519, no. 562) that the costume worn by this
figure was that of the *nizām*. He is seen in profile, as in many
of the portraits of government officials that Gleyre produced in
Greece and Turkey, holding what appears to be a pipe or a sword
in his right hand. The left hand proudly touches the tip of the
dagger, probably a natural posture for the guard, demonstrating
his resolve and strength. As in many of these works (see Cat. 47)
the interest for Gleyre and Lowell lay in the costume and the
physical type rather than in the individual.

At Lowell's request, Gleyre also painted the *kavas* of the
Dutch consulate in Smyrna (BMFA 105.49) and, later, the *kavas*
attached to the Austrian consulate in Constantinople (BMFA
121.49). Gleyre copied this figure in Paris (MCBA D. 1259) but
left the work as a monochrome drawing. W.H.

PROVENANCE
Commissioned by Lowell; The Lowell Institute, Boston; 1949, on loan to the Museum of
Fine Arts, Boston (BMFA 127.49)

REFERENCE
Clément 1878, no. 562 (MCBA copy, as *Officier turc*)

51†

Tartar or Turkish Courier, Constantinople

November 1834

Watercolour on paper: 32·3 × 23·5 cm
The Lowell Institute, Boston
[repr. in colour on p. 157]

Very little is known of the activities of Lowell and Gleyre in
Constantinople, their journals providing scant information about
this leg of the journey. A review of the seven works in the
Boston collection, documented in Constantinople, reveals that
Gleyre did not paint any of the celebrated sites or general views
of the city itself. Rather, they represent artisans, a butcher (BMFA
54.49), a porter (BMFA 68.49) and a water carrier (BMFA 71.49)
for example, and figure studies of the type already depicted in
Athens and Smyrna (Cat. 47, 50.)

The watercolour exhibited here of a courier, who, like the
kavas (Cat. 50), may have been attached to a foreign consulate,
is a documentary record of costume. The figure stands looking
away from the viewer, a pose often used by Gleyre in his
Constantinople watercolours, so that the facial features are lost
and the emphasis rests on the sombre dress. However, a richness
of texture is achieved both through the stippling of the courier's
jacket, as with the *Albanian Peasant Woman, Athens* (Cat. 47), and
the purposeful manipulation of gum arabic in the intense
shadows of the skirt. Gum arabic was not extensively used by
Gleyre in his Oriental watercolours. However, its presence here
foreshadows the importance he later placed on mastering the
technical difficulties inherent in conveying rich but varied black
tones, a technique which became central to his teaching after 1843.

Gleyre's copy in Lausanne (MCBA D. 1231) is exact. W.H.

PROVENANCE
Commissioned by Lowell; The Lowell Institute, Boston; 1949, on loan to the Museum of
Fine Arts, Boston (BMFA 109.49)

EXHIBITIONS
1974, Winterthur, Kunstmuseum, *Charles Gleyre ou les illusions perdues* (no. 132; MCBA copy)
1980, New York, The Grey Art Gallery and Study Center, New York University, *Charles
 Gleyre 1806–1874* (no. 28)

REFERENCE
Clément 1878, no. 522 (MCBA copy as *Courrier albanais*)

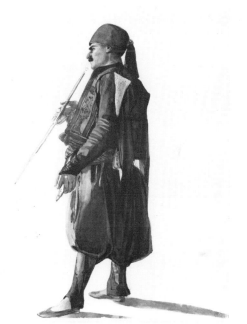

50

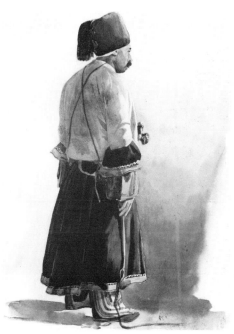

51

52†

Turkish Woman 1834

Pencil on paper: 32 × 23·5 cm
Inscribed bottom centre: *mànteau bleu, broderies noires*
The Lowell Institute, Boston

Unlike most of the drawings and watercolours Lowell sent to Boston in 1835, this portrait bears no indication of where or when it was executed . The journals of Lowell and Gleyre provide no clue, although the general simplicity and forthright nature of the design corresponds to the images of artisans which Gleyre produced in Constantinople (see Cat. 51).

Most European travellers to Turkey found the exotic beauty of veiled women tantalising. Flaubert wrote to his uncle from Constantinople on 24 November, 1850 (*Correspondance*, Pléiade ed., 1973, I, p. 715) that almost all women encountered on the streets were veiled in black gauze so that only a hint of the reddish lips was visible. He was struck by the glaring eyes above the veils, the pale skin set against the dark robes, which together created a curious, Romantic, phantom-like effect.

Gleyre's figure is wearing a long robe; he indicated on the study the designation *manteau bleu, broderies noires* as though he had intended to use the drawing as the basis for a watercolour. The costume shown here was generally worn for walking or riding, usually by the lower class of women. The muslin robe has long puffed sleeves which are sometimes left free to fall at the side and may reach the ankles; as with the Egyptian variant, the sleeves can be used as a headdress to cushion objects borne on the head. The veil tucked into the robe at the breasts is particularly Turkish in origin.

The drawing was almost certainly executed on the spot from a figure seen in the streets; as with other works of this type (Cat. 57), the combination of exact linear detail and spontaneous effect blend well into the whole. The draughtsmanship, derived from the drawing technique of Ingres, reveals Gleyre's precision and ability to render forms and volumes simply but effectively with an economy of means.

Gleyre did not copy this drawing in Paris, although several other figure studies of Turkish women are included in the Lausanne corpus. W.H.

PROVENANCE
Commissioned by Lowell; The Lowell Institute, Boston; 1949, on loan to the Museum of Fine Arts, Boston (BMFA 69.49)

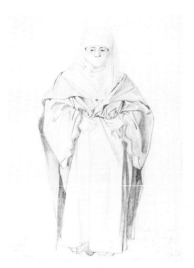

52

53†

Palace of the Knights, now a Coffee-shop, Rhodes
December 1834

Watercolour on paper: 32·3 × 25·5 cm
Musée cantonal des Beaux-Arts, Lausanne
[*repr. in colour on p. 160*]

On 9 December Lowell wrote in his journal (Lowell MS. vol. IV) that they were ready to leave Turkey to sail for the Egyptian coast, disembarking first in Alexandria. Lowell had chartered a boat called the *Bellerophonte* which Gleyre found to be sub-standard and, as he noted in a letter to his friend Jourdain (Journal d'orient, 18 December 1834), full of disagreeable odours and sights. Gleyre, however, recorded in minute detail the interior of the brig (BMFA 134.49), an extraordinary still-life in itself, as well as some of the sailors on board (BMFA 73.49).

Unfavourable winds forced the company to land at Rhodes. Gleyre found the island to be not only enchanting, but also decidedly more civilised and cultured than the rougher parts of the Turkish visit; Chateaubriand had earlier referred to the island as a '*petite France*' in the middle of the Aegean (*Itinéraire*, Pléiade ed. 1969, II, p. 954), a view shared by Lamartine when he stopped here in 1832. Viewing the harbour, Gleyre was even inspired to imagine the waves breaking against the rocks which served as the pedestal for the Colossus. As in Athens, Gleyre worked especially hard recording the intriguing medieval architecture rather than the island's inhabitants. so engrossed was Gleyre with the remnants of the structures built by the Knights of St. John that on 18 December Lowell noted his intention to 'remain several days to give Mr Gleyre time to make designs of some of the most remarkable objects here' (Lowell MS., vol. IV).

Rhodes had fallen to Turkey in 1522 and remained under Ottoman rule until 1912. Gleyre's view of the interior of the famous Palace of the Knights records the transformation in the eighteenth century of a medieval Christian building into a

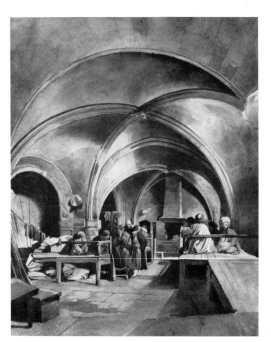

53

typically Turkish institution, a coffee-shop. Gleyre depicts about a dozen figures, drinking and engaged in conversation, seated cross-legged on raised daises, as was typical in Asia Minor and in Egypt.

In contrast to Gleyre's highly detailed rendering of the interior of the cloister of the Hospital of the Knights of St. John (BMFA 140.49), this view of the interior of the palace is a work of pure genre, depicting the coffee house as it was usually populated. In this respect, both its subject and its spontaneous, vigorous technique negate any sense of a studied composition, and relate it more closely to the African works of Delacroix (Cat. 11) and the Orientalist style of Bonington (see Stevens, p. 18).

The original watercolour from which Gleyre made this copy is in the Lowell Institute, on loan to the Museum of Fine Arts, Boston (BMFA 155.49). In the version shown here, there are some minor differences in colour, as well as a small correction of the perspective of the interior vaulting. W.H.

PROVENANCE
Collection of the artist; 1874, inherited by Charles Clément; 1908, acquired from Clément's widow by the Musée cantonal des Beaux-Arts, Lausanne (D.1263)

EXHIBITIONS
1974, Winterthur, Kunstmuseum, *Charles Gleyre ou les illusions perdues* (no. 145, as *Salle voutée*)
1980, New York, The Grey Art Gallery and Study Center, New York University, *Charles Gleyre, 1806–1874* (no. 33; BMFA original)

REFERENCE
Clément 1878, no. 568 (as *Salle voutée* and mistakenly placed under 'Aquarelles – Egypte et Nubie')

54†

Alexandria – Pompey's Column January 1835

Watercolour and pencil on paper: 38·3 × 26·6 cm
The Lowell Institute, Boston
[repr. in colour on p. 162]

Gleyre and Lowell left Rhodes in December 1834, sailing directly south towards the port of Alexandria. They reached Egypt near Christmas time, but could not disembark because of a two-week quarantine, noted both by Lowell (Lowell MS., vol. IV, 27 December) and by Gleyre with some irritation. While in port, however, Lowell wrote that they could see the huge Column of Pompey 'behind the houses and towering above them, looking just as it ought to look.' A plate in the Comte de Forbin's *Voyage dans le Levant* (Paris, 1819, no. 76) shows precisely the column's position in relation to the houses and surrounding harbour. Despite being forced to rest on the boat, Gleyre made good use of his time by painting a watercolour portrait of Lowell in Oriental dress (BMFA 9.65), the only portrait Gleyre made of his patron during the trip.

The Column of Pompey situated in the south-west section of the city, near the ancient walls and the Arab cemetery, marks the site of the Ptolemaic Temple of Serapis. Nearby stood the two famous obelisks which were taken to London and New York in 1878 and 1881 respectively. The column received its name from the belief that it marked Pompey's burial site. In fact, it was erected in AD 292 by the Roman prefect Posidius, in honour of the Emperor Diocletian. Curiously, although this was already known in the early nineteenth century (see Chateaubriand's discussion of the site inscriptions in Pléiade ed., 1969, II, p. 1152), the column nevertheless retained its more popular title throughout the century. A colourful description of the monument is contained in the reports of the Napoleonic mission (*Description de l'Egypte*, Paris, 1821, V, p. 508–18), as well as a

vivid account of the first attempt to measure the height, a scene illustrated in a watercolour of 1798 (Searight Coll., London). The column measures almost eighty-eight feet and has a base circumference of nine feet, tapering to six feet at the summit.

Gleyre's view of the column, with the sea in the distance, must have been executed after the quarantine was lifted in January 1835. In its simplicity, the scene is clearly a tourist's vision, but uncharacteristically, it lacks subsidiary objects by which a sense of scale can be appreciated. Despite the freely washed sky, Gleyre's realism is apparent especially in his attention to such details as the graffiti on the base. On most monuments they were to encounter in Egypt, graffiti were widespread and often in the most incongruous spots. When Flaubert visited the site for the second time in October 1850 (after, incidentally, he had sought out Gleyre in Lyon to ask advice for the voyage), he wrote to his uncle that the base of the column had the name 'Thompson' inscribed in such large letters that they could be seen for more than a quarter of a mile (*Correspondance*, Pléiade ed., 1973, I, p. 689).

This view is the only one Gleyre seems to have made in Alexandria. Perhaps he felt, as did Flaubert, that the city was still too European, and that more interesting monuments awaited them closer to Cairo. Gleyre did not copy this watercolour in Paris. W.H.

PROVENANCE
Commissioned by Lowell; The Lowell Institute, Boston; 1949, on loan to the Museum of Fine Arts, Boston (BMFA 130.49)

EXHIBITION
1980, New York, The Grey Art Gallery and Study Center, New York University, *Charles Gleyre 1806–1874* (no. 36)

REFERENCES
Berger 1974, p. 52
Newhouse 1980, p. 86

54

55†

Copt Drawing Room, Cairo January 1835

Watercolour and pencil on paper : 33·1 × 25·1 cm
The Lowell Institute, Boston
[*repr. in colour on p. 161*]

Towards the end of January 1835, Lowell and Gleyre began their voyage along the Nile, stopping first at Cairo. Here, as in Alexandria, very few works were executed : there are no general views of the city itself, or of its ancient and modern monuments. Even the pyramids merited only a broadly drawn, mundane design (BMFA 79.49). Of the works executed *in situ*, most are of individuals seen on the streets; the most accomplished work from Cairo is the work seen here.

In 1835, there were about 10,000 Copts in Cairo out of a population of almost a quarter of a million. Earlier, they had been the object of various repressive measures : in the eighteenth century, religious services in Latin were prohibited together with the riding of horses. With the enlightened reign of Muḥammad 'Alī (see Cat. 123), the Copts enjoyed religious freedom and established themselves as a wealthy class with the most prestigious houses. In Edward William Lane's classic *Account of the Manners and Customs of the Modern Egyptians* (London, 1835), there is a long description of the private houses of Cairo (1871 ed., I, pp. 5–25). They were two or three stories high, built around a central courtyard or *ḥawsh*, with separate entrances for the women (see Cat. 92). The view represented in Gleyre's watercolour is of the upper drawing room or *qā'ah* which was generally the largest room in the house. It was divided into two sections, one of which, the *līwān*, was slightly raised over the other section, the *durqā'ah*, which was frequently paved in lavish mosaic. The roof over this portion of the room was slightly more elevated, often reaching a height of about fourteen feet. The *līwān* contained mattresses or divans on three sides for entertaining guests, drinking coffee and smoking the traditional pipe. Usually various wooden cupboards were placed here, as

seen in Gleyre's watercolour, as well as shelves for holding utensils and perfumes. Paintings sometimes decorated the walls : in the Arab houses these were of abstract designs, while in Copt houses they were figurative. Lane's illustration of a typical *qā'ah* (I, p. 20) corresponds closely to Gleyre's representation.

Many Western travellers visited Copt houses in Egypt, including Flaubert who in a letter to his mother (*Correspondance*, Pléiade ed., 1973, I, p. 558f.) carefully described the *ḥawsh* of the house in Cairo, belonging to the Bishop Boutros. Gérard de Nerval was particularly charmed by the Copt houses (*Voyage en Orient*, Pléiade ed. 1958, p. 103) but found them completely uninhabitable for a Westerner.

Few watercolours by Gleyre demonstrate his documentary ability as well as this work. All the details, from the rich woodwork and the patterns on the floor to the varying textures of the walls, look forward to the works of Lewis (Cat. 93, 95). As is typical of Gleyre's documentary works of this type, there are no individuals in the scene with which the viewer can associate or use for scale. Gleyre later copied this work exactly in Paris (MCBA D. 1262). W.H.

PROVENANCE
Commissioned by Lowell; The Lowell Institute, Boston; 1949, on loan to the Museum of Fine Arts, Boston (BMFA 137.49)

EXHIBITIONS
1974, Winterthur, Kunstmuseum, *Charles Gleyre ou les illusions perdues* (no. 144; MCBA copy)
1980, New York, The Grey Art Gallery and Study Center, New York University, *Charles Gleyre 1806–1874* (no. 40)

REFERENCE
Clément 1878, no. 567 (MCBA copy)

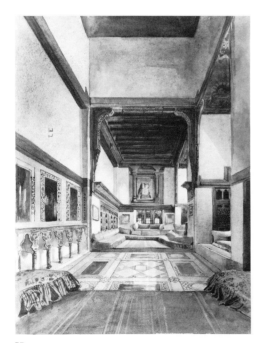

55

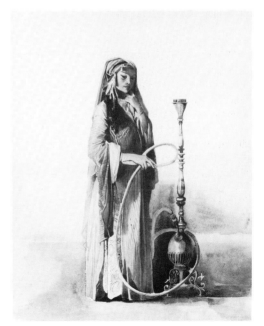

56

56†

Arab Woman, Cairo January 1835

Watercolour on paper: 30·1 × 23·5 cm
Musée cantonal des Beaux-Arts, Lausanne
[repr. in colour on p. 158]

The representation of this Arab woman corresponds strikingly
with Lane's description of the modern Egyptian woman in his
Account of the Manners and Customs of the Modern Egyptians
(London, 1835, 1871 ed., I, p. 448). Most women of the region
achieved full maturity by the age of fifteen or sixteen. Their oval
faces, olive complexions, and distinctive, almond-shaped eyes,
generally darkened at the edges with kohl, together with their
rich, intense black hair, full lips and expressive features made
them remarkably striking. The figure here is not veiled.
According to Lane the custom of veiling the face was not always
practiced by the lower classes; when the face was revealed,
women often showed a coquettish glance, not unlike the one
captured by Gleyre.

This Arab woman is dressed in a long vest (*yelek*), not unlike
the *quftān* worn by males, over the traditional shirt and trousers.
Her head veil, or *ṭarḥah*, is left hanging over her bonnet, the
traditional indoor attire for a woman. Her hair is braided with
small ornaments (*ṣafa*) and hangs over the right shoulder; Lane
noted that the number of braids usually varied from eleven to
twenty-five, but were always odd in number.

The pose of the figure next to the large pipe is indicative of
the importance of tobacco in everyday Egyptian life for all
classes. They enjoyed pipe smoking regularly, often beginning
early in the morning. The traditional pipe (called a *shibbuk* or *ūqd*),
is four or five feet long and made of wood; the stem is covered
with silk so that it remains cool when smoked. It is often this
type of pipe that is seen in Oriental portraits. However, the pipe
represented in this watercolour is Persian in origin and was used
only by the upper classes: it is called a *nargīlah* (after the Persian
word for coconut, the shape of the container in which water was
placed to cool the smoke) and had a long, flexible tube with an
amber mouthpiece attached to a large water container. Given
that the pipe rests on legs, it is a further indication that it was
owned by a wealthy patron. These facts imply that the figure
may be a servant, possibly of a rich Copt, posed before her
master's pipe. Neither Gleyre nor Lowell mentions the work or
provide any information as to its origins.

The original watercolour (BMFA 113.49) from which Gleyre
copied this work contains an important element not seen here.
Immediately below the pipe at the right is a caricature of Louis-
Philippe, cast in the shape of a pear. Gleyre, who was a life-long
Republican, and admirer of the Saint-Simonists, had a particular
aversion to the French king. He may have recognised the
similarity between the shape of the bulbous bowl of the pipe and
the caricature of Louis-Philippe rendered common currency by
Daumier two years earlier (see Newhouse 1980, p. 125, no. 38).
Flaubert also commented on the abundant caricatures of Louis-
Philippe in Egypt, including one in the inner chamber of the
Pyramid of Khyphron (Steegmuller, ed., 1979, pp. 53–54).
W.H.

PROVENANCE
Collection of the artist; 1874, inherited by Charles Clément; 1908, acquired from Clément's
 widow by the Musée cantonal des Beaux-Arts, Lausanne (D.1274)

EXHIBITION
1980, New York, The Grey Art Gallery and Study Center, New York University, *Charles
 Gleyre 1806–1874* (no. 38; BMFA original)

REFERENCES
Clément 1878, no. 580 (as *Femme de Sennar*)
Newhouse 1980, p. 86

57†

Fellah Woman with a Jug on her Head 1835

Pencil on paper: 37·5 × 26·2 cm
The Lowell Institute, Boston

The word *fellāḥ* is a general term applied in Egypt to a labourer
or a peasant of the land. The daughter or wife of a *fellāḥ* also
worked the land. Like most women of the lower classes, she did
not necessarily cover her face, particularly while engaged in her
work (see Cat. 78). Gleyre's delicate pencil study illustrates one
of the daily tasks for which she alone was responsible: the
gathering of the water supply for the family. This was
accomplished usually with two clay pots: a large, wide-mouthed
one (*qullah*) carried on the head, and a small-mouthed one (*dūraq*)
carried in the hand, as in Gleyre's drawing. It is interesting to
note that Lane attributed the unusually erect posture of Egyptian
women precisely to this traditional labour (Lane 1835, 1871 ed.,
I, 244).

In the early nineteenth century, the image of women gathering
water was an exceedingly common one: the Comte de Forbin
noted in his *Voyage dans le Levant* (Paris, 1819, p. 131) that it was
a sight seen virtually every few yards along the Nile, and Gleyre
noted in his journal that he frequently observed these women
at work. The image became almost ubiquitous in Orientalist
iconography being depicted by virtually all Western artists (see
Cat. 63, 77).

Gleyre's representation appears to be one of the few made
during the trip which romanticises his subject. The figure shows
no discernible marks from her travail, despite the harshness of
this work; the *fellāḥīn* were doomed to poverty and appeared
exhausted by an early age, as Suzanne Voilquin, a Saint-Simonian

57

who went to Egypt in 1835, recorded in her memoirs (R. Fakkar, ed., *Aspects de la vie quotidienne en Egypte à l'époque de Mehemmet-Ali*, Paris, 1975, p. 60). Similarly, Ida Saint-Elme, travelling in Egypt a few years earlier, noted that the misery associated with these women was worse than anything seen in Europe (*La Contemporaine en Egypte*, Paris, 1831, I, pp. 248–49 and III, p. 146ff). Apparently Gleyre and Lowell did not wish to have exacting records of this aspect of daily life, for none of Gleyre's representations of labourers portray the true poverty and misery of their existence.

In contrast to the elegant dress of *Arab Woman, Cairo* (Cat. 56), this figure is plainly dressed in the garb of the peasant, a long blue cotton or muslin shirt reaching to the feet, clasped at the throat and open at the breast; the immense sleeves could act as a veil and often served as a cushion on the head for carrying the water jug, as Gleyre himself remarked in his journal. This figure also wears a necklace (*ūqd*) and bracelets (*asāwir*) which, in spite of poverty, were a common adornment. She has four vertical marks on her chin, indicative of the common practice of tattooing among the lower classes. The tattoo was coloured blue or green and most frequently seen on the chin, cheeks and hands; the operation (*daqq*) was performed when a female child reached the age of five or six.

Gleyre later copied the work in Paris (MCBA D. 1300); variants, possibly with the same model, are also extant in Boston (BMFA 86.49) and Lausanne (MCBA D. 1299). W.H.

PROVENANCE
Commissioned by Lowell; The Lowell Institute, Boston; 1949, on loan to the Museum of Fine Arts, Boston (BMFA 93.49)

REFERENCE
Clément 1878, no. 610 (MCBA copy)

58†
Three Fellāhs
Trois Fellahs

Watercolour on paper: 24·4 × 32·9 cm
Musée cantonal des Beaux-Arts, Lausanne
[*repr. in colour on p. 163*]

Among the studies which Gleyre made in Egypt of individuals encountered on the trip are dozens of drawings and watercolours intended to record costumes or physiognomies, or simply to note interesting figures. While Lowell, as part of the contract with Gleyre, requested the artist to paint at least one figure study and one view of each place visited, Gleyre frequently produced additional studies for himself. It seems probable that he intended to use these in compositions to be executed after his return to France in 1838.

In addition to the watercolour of *Three Fellāhs* there are almost a dozen extant studies of heads, painted in oils on paper. In both media, these studies provide, in a sense, photographic records before the advent of the camera, an almost encyclopaedic representation of ethnic types of all ages. Gleyre rarely painted three figures on the same sheet; when he did, it was often for a specific composition as in his *Trois Musiciens arabes* (MCBA D. 1306). The present work is the only watercolour including figures. It was clearly made on the spot, and apparently was never intended for Lowell; the work stayed with Gleyre until his death and is here exhibited for the first time. Unfortunately, neither Gleyre nor Lowell indicated in their respective journals where or when, or under what circumstances the study was made although it must date before March 1835, when Gleyre stopped painting watercolours (see Cat. 60)

It is perhaps this work, more than any other watercolour in this exhibition, that best demonstrates Gleyre's extraordinary technical control of the medium. There are few works by the Orientalists before Gérôme's portraits (see Cat. 34) that show in such detail the precise naturalism of this work. The manner in which Gleyre captured the character of each of the sitters, at once academic and wonderfully spontaneous, reveals his facility in portraiture. Particularly noteworthy is the brilliant handling of shadows and highlights on the surfaces of skin and cloth. The deft depictions of the folds of drapery in the tunics and turbans once again recall the lessons Gleyre learned from studying the Parthenon sculptures. The composition and individual poses are taken from a drawing, *Trois Grecs* (MCBA D. 1249), which Gleyre made for himself and not for Lowell. Gleyre does not appear to have used any of these figures in later compositions, and it is unlikely that any of his students, among them Gérôme, ever saw the work. W.H.

PROVENANCE
Collection of the artist; 1874, inherited by Charles Clément; 1908, acquired from Clément's widow by the Musée cantonal des Beaux-Arts, Lausanne (D.1271)

REFERENCE
Clément 1878, no. 577

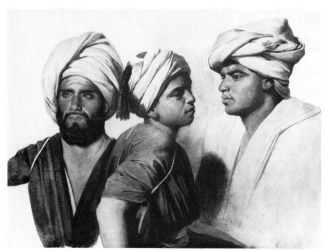

58

59†

Rhamseion, Thebes March 1835

Watercolour on paper: 28·6 × 47·4 cm
The Lowell Institute, Boston
[repr. in colour on p. 155]

The Rhamseion, or Ramasseum, was built on the west bank of the Nile at Thebes by Ramasses II as his mortuary temple. After the Napoleonic campaigns, the site was deemed one of the most picturesque in Egypt and was justly the object of excitement and awe. Further popularity was given to the fallen statue of Ramasses by Shelley's romantic poem *Ozymandias*, the Greek rendering of his prenames, User-ma'at-re'. The statue was originally a seated figure placed before the second pylon of the temple, which in the nineteenth century was in a state of ruin. The enormous size of the statue was noted by all travellers: it originally stood more than seventy-five feet high and weighed more than one thousand tons.

Gleyre made several studies of the site from various vantage points. Beside the one on view here, in which the angle selected is from the base looking towards the library, that is, looking northward, there is another looking southward (BMFA 156.49), as well as a drawing made for Gleyre himself and not given to Lowell, in which the statue is in the immediate foreground with the Colossi of Memnon in the distance (MCBA D. 1280; see Cat. 26). The statue of Ozymandias was in fact one of the most frequently represented works in nineteenth-century Orientalist iconography: apart from the well-known example by David Roberts (see *The Holy Land* etc., 1842–49), the beautifully detailed drawing by the architect Charles Barry, executed in 1819 (Royal Institute of British Architects, London), and the Turneresque watercolour of William Henry Bartlett of 1845 (Searight Coll., London) are especially outstanding renditions of the site. The statue was also extensively photographed by, amongst others, Beato, Le Gray, Frith and Du Camp.

While Gleyre often experienced a certain boredom during the Egyptian part of the trip, a reaction apparently common among nineteenth-century travellers in the desert, he nevertheless expressed an almost unbridled enthusiasm for the ruins at Thebes. He noted in his journal on 18 March that nothing prepared the traveller for the immensity and sublimity of these ruins and that the arts were wholly incapable of adequately representing the effect created by them. Gleyre did not attempt to do so, giving instead a direct factual documentation of the site.

As with the view of the Column of Pompey in Alexandria (Cat. 54), there is no sense of scale; the watercolour evokes the loneliness and awe described by all the travellers who visited this place.

Exceptionally Gleyre did not copy this work as he did with other works executed for Lowell; instead, he transferred the image directly onto canvas in oil (MCBA P. 1334). Another view of the site, but without the Ozymandias statue, was similarly transferred directly onto canvas in Paris between 1838 and 1840 (MCBA P. 1357). W.H.

PROVENANCE
Commissioned by Lowell; The Lowell Institute, Boston; 1949, on loan to the Museum of Fine Arts, Boston (BMFA 159.49)

EXHIBITIONS
1974, Winterthur, Kunstmuseum, *Charles Gleyre ou les illusions perdues* (no. 41; MCBA oil copy)
1980, New York, The Grey Art Gallery and Study Center, New York University, *Charles Gleyre 1806–1874* (no. 46)

REFERENCES
Clément 1878, no. 7 (MCBA oil copy, as *Architecture*)
Newhouse 1980, p. 91

60†

View from the south-east of the Palace of Luxor, Thebes
March/April 1835

Watercolour on paper: 22·7 × 40·1 cm
Musée cantonal des Beaux-Arts, Lausanne
[repr. in colour on p. 163]

When Horace Vernet recommended Gleyre to Lowell in Rome, he noted in particular the painter's ability in rendering landscapes. Yet, during the period of almost eighteen months which Gleyre and Lowell spent together, he produced very few traditional landscapes devoid of specific monuments or archaeological remains. Of these landscapes, almost half were painted in the early part of their voyage; there are only two in the Lowell Collection which specifically record the Egyptian desert: the image seen here (the original is BMFA 133.49) and a smaller work depicting a clump of palm trees (BMFA 157.49), which Gleyre later copied in oils (MCBA P. 1333). In addition Gleyre had at least five other watercolour and pencil studies of the desert which he did not give to Lowell (MCBA D. 1266–7 and D. 1286–9), indicating that his interest in recording the landscape was certainly more pronounced than his patron's.

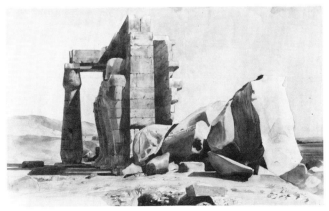

59

Gleyre was very ill at ease in the desert; Lowell noted in October 1835 that Gleyre 'detests the desert' (Lowell MS. vol. IV), but this was partly due to the fact that he was often affected by a variety of ailments which severely hampered his work. Nevertheless, this remarkable landscape is evidence that Gleyre, in common with other artists and writers (see Cat. 67), greatly appreciated the inherent pictorial values of the ominous, endless desert. Frequently in his journal, Gleyre remarked upon the colours of the mountains and the flat monotones of the sands. The site chosen for this image lies behind the famous temple which Gleyre recorded several times, (for example, the exacting drawing of the celebrated colonnade which he did not give Lowell [MCBA D. 1279], looking towards the Nile and the Libyan hills). The river itself is glass-smooth, as it was often described. Flaubert wrote on 14 February, 1850, that the Nile seemed like a 'fleuve d'huile' (Correspondance, Pléiade ed., I, 1973, p. 587). The colours of the distant hills too correspond to travellers' descriptions: Flaubert noted in the same letter that the hills here appeared violet and azure (I, p. 588), darkening near Thebes to a deep indigo against the Nile, this time referred to as a 'lac d'acier' (I, p. 597). A similar view to that of Gleyre was photographed by John Greene in 1854 (André Jammes Coll., Paris). Gleyre executed another watercolour of this area; taken closer to the Nile, it shows in the foreground the boat (or qangah, flying a French flag!), which Gleyre and Lowell used for the journey (MCBA D. 1266).

These works may have been amongst the last watercolours Gleyre made during the trip. By May 1835, having just left Thebes, Gleyre found he could no longer keep up the feverish pace of travel and work demanded by the stoic Lowell. Lowell noted in his diary (Lowell MS., vol. V) that Gleyre suffered from an inflammation of the gums and jaw, as well as his recurring opthalmia. Thereafter Gleyre produced only drawings for Lowell, many of them incomplete views of details (see Cat. 61, 62).
W.H.

PROVENANCE
Collection of the artist; 1874, inherited by Charles Clément; 1908, acquired from Clément's widow by the Musée cantonal des Beaux-Arts, Lausanne (D.1265)

EXHIBITION
1980, New York, The Grey Art Gallery and Study Center, New York University, *Charles Gleyre 1806–1874* (no. 48; BMFA original)

REFERENCE
Clément 1878, no. 570 (as *Paysage*)

61†

View of the Island of Philae June 1835

Pencil on paper: 27·4 × 43 cm
The Lowell Institute, Boston

The island of Philae, once known as the 'Pearl of Egypt', is situated at the first cataract, about two miles from the Aswān Dam. Known in Arabic as Jazirat Filah (literally, 'island of temples') and in ancient Egyptian as Pi-hak (probably meaning 'island of the source', since Hapi, the Nile god, was believed to live in a cave nearby) of which Philae is the Greek form. It is a small sanctuary about 1300 feet long and 450 feet wide, and originally marked one of the borders between Egypt and Nubia. There were several structures on the site, dating from the 30th dynasty to the Christian era; Justinian officially closed the pagan temples here in AD 543. The site only became sacred to Isis in the Late Period (25th dynasty onwards), due probably to the fact that the neighbouring island of Bigah had long been dedicated to her husband Osiris.

With the construction of a dam in 1903, the island was periodically submerged. The construction of the Aswan high dam seriously endangered the site, and between 1972 and 1980 all the monuments were reassembled on the nearby island of 'Agiliyyah where they stand above the water line.

Many travellers and artists expressed their enchantment with the island: Vivant Denon visited the site no fewer than six times before 1803. Gleyre and Lowell arrived there on 22 June 1835 (Lowell MS., vol. V) having visited Esna and Edfou. By this time Lowell's ophthalmia was so acute that he could barely see; he also suffered from severe diarrhoea, forcing Gleyre to leave Lowell there and move on up the Nile to the next camp. Lowell followed on 5 July.

While at Philae, Gleyre produced only two drawings of the site (see Cat. 62), neither of which he later copied in Paris. Gleyre's view is taken from the south-west tip looking northward. Immediately in the foreground is the so-called Pavilion of Nctanebo I (c. 380 BC) through which can be seen the columns of the Temple of Arensnuphis. The large gateway on the left is the first pylon of the Temple of Isis, which was more than 150 feet wide and 60 feet high. On the right, almost in the centre of the composition, is the Pavilion or Kiosk of

60

61

Trajan (see Cat. 62). This perspective of the island in its entirety was used frequently by later artists and photographers, for example, Maxime du Camp's photograph made with Flaubert, and Jean Borely's *Portrait of Charles Leonard Irby* (The Fine Art Society, London), where the island is seen in the background. Other views of Philae were executed by Lear (Cat. 82) and Roberts (Cat. 112).

Gleyre left no written records of his own impressions of the site; he noted only that he must remember the young girls who traversed the Nile on wooden planks. However, he does not seem to have incorporated that particular image in his later works. W.H.

PROVENANCE
Commissioned by Lowell; The Lowell Institute, Boston; 1949, on loan to the Museum of Fine Arts, Boston (BMFA 195.49)

62†

Philae, 26 June 1835

Pencil on paper: 27·2 × 40 cm
Inscribed bottom left: *Philae le 26 juin 1835*
The Lowell Institute, Boston

The date 26 June 1835, inscribed on the left of the drawing, is in Gleyre's hand. The work represents the Kiosk of Trajan at the south-east end of the island with the pylon of the Temple of Isis visible on the left. The kiosk, dating from about AD 100, contains fourteen columns in a typically ornate style common to later Egyptian architecture. These are closed by a wall which rises halfway up the columns, a characteristic feature of the smaller temples of this period. The interior walls are decorated with scenes representing offerings to Isis and Horus with the incongruous figure of the Emperor Trajan officiating at the ceremony. Gleyre apparently did not record these scenes.

This little temple, also known as 'The Pharaoh's Bed', was frequently represented both in painting and photography, and was in many ways the best-known monument on the island. Amelia Edwards wrote in *A Thousand Miles Up the Nile* (London, 1877) that the structure 'has been so often painted, so often photographed, that every stone of it . . . and the tufted palms that cluster around about it, have been since childhood as familiar to our mind's eye as the Sphinx or the Pyramids' (p. 208). Indeed, a spate of images similar to the one Gleyre depicted are known from this period: for example, Owen Jones's drawing of 1832–33 (Searight Coll., London) which was reproduced in his *Views on the Nile* (1843, pl. 21), shows the traditional landing site of the island, the point from which Gleyre made the drawing seen here; Frith too photographed the same location in 1858 (André Jammes Coll., Paris).

The Temple of Isis also figured in many other works throughout the nineteenth century, including Abel de Pujol's ceiling decoration in the Egyptian Antiquities Department in the Louvre and Poynter's famous canvas *Israel in Egypt* (1867; Guildhall Art Gallery, London), where the site is indicated in the clump of architectural monuments at the left. Poynter was a student of Gleyre, but it is unlikely that the image was suggested by the master.

The drawing typifies Gleyre's precision in this medium, reminiscent of the Ingresque qualities that mark his early work. Yet the delicate use of shading, and the handling of line and linear accents to delineate form, represents a more individual approach. W.H.

PROVENANCE
Commissioned by Lowell; The Lowell Institute, Boston; 1949, on loan to the Museum of Fine Arts, Boston (BMFA 172.49)

EXHIBITIONS
1980, New York, The Grey Art Gallery and Study Center, New York University, *Charles Gleyre 1806–1874* (no. 51)

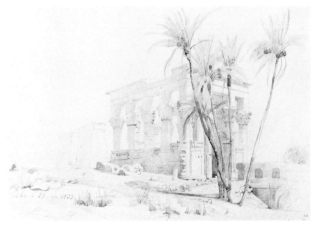

62

Goodall, Frederick 1822–1904

Son of an artist, Goodall made his precocious debut at the Royal Academy exhibition in 1837 with four watercolours. His first essays in oil were genre pictures and landscapes, but later he turned to subjects from British history. In 1852 he became an Associate of the Royal Academy. He went to the Near East for the first time at the age of thirty-six and from then onwards made a speciality of genre scenes and biblical subjects based on his first-hand experience of life in Egypt. Armed with letters of introduction from David Roberts, he arrived in Cairo in the autumn of 1858 and was based there until April the following year. By chance he met Carl Haag (1820–1915) and the two men sketched and travelled together, making expeditions to the pyramids at Gizah and to Suez. From the sketches and examples of Arab dress he brought back, Goodall painted *Early Morning in the Wilderness of Shur*. Exhibited at the Royal Academy in 1860, this work attracted the admiration of Roberts, Landseer, Clarkson Stanfield and many others, and established his reputation. He was elected a full Royal Academician in 1864. From 1868 until his death, his London home was in Avenue Road, near Regent's Park, where his studio was full of *mashrabiyyah* woodwork and other Egyptian artefacts.

63

The Subsiding of the Nile 1873

76 × 152 cm
Signed with monogram and dated bottom left: *FG 1873*
Guildhall Art Gallery, Corporation of London

Goodall made his second and last visit to Egypt in 1870–71. Basing himself at Saqarah, he spent several months, as before, making sketches of Egyptian places and people to be used as the raw material for future paintings. In 1872 he began working up some of these as a large composition and the result was *The Subsiding of the Nile*, exhibited at the Royal Academy in 1873 (no. 292). The work was conceived as a pendant to *The Rising of the Nile* (1865; present location unknown), a scene of people escaping from an inundated village. The reduced version of *The Subsiding of the Nile* exhibited here is a quarter of the size of the original. The view is of Gizah from the south-east, with the Great Pyramid on the right, the Second Pyramid on the left and the Sphinx just visible in the centre. The sheep in the foreground were painted from the flock the artist bought in Egypt and sent back to England to be used as models for pictures. 'I used my Egyptian sheep for this picture and all the studies I had made for it in the immediate locality, especially the ancient causeway supposed to have been built for transporting the stones of which the Pyramids are built,' he noted in his autobiography. 'The enormous quarries are on the other side of the Nile, some eight miles away. The most beautiful time of the whole year is when the Nile overflows almost to the foot of the Pyramids. As it subsides, there almost immediately springs up on the higher portions of the land the vegetation which affords without any cultivation an immense quantity of food for the Bedouin flocks' (*The Reminiscences of Frederick Goodall, R.A.*, London, 1902, pp. 383–84). Goodall generally saw Egypt in biblical terms but here the emphasis is more on the classical aspects of the scene. The feeling of order and clarity in the composition, along with elements such as the blocky architectural features, the road winding off into the distance, the glassy reflections in the water and the figure partially hidden behind a bank of earth, recall Poussin. Under the circumstances, it is tempting to see the old man being led along the road by a child as Goodall's Egyptian version of the blind Homer. M.W.

PROVENANCE
Probably commissioned from Goodall by the dealers Pilgeram and Lefevre; 1873, 4 April, acquired from them by Agnew's; 1873, 17 June, acquired by Charles Gassiot; 1902, bequeathed by him to the Guildhall Art Gallery, London

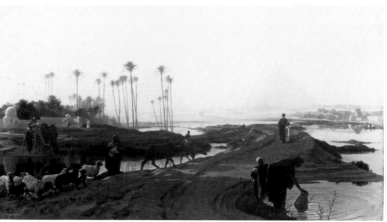

63

Gros, Baron Jean-Antoine 1771–1835

Gros received his initial training from his parents, both of whom were painters of miniatures, and later from the portraitist Mme Vigée-Lebrun (1755–1842). In 1785 he entered the atelier of Jacques-Louis David (1748–1825) and, with his support, left for Italy in 1793 at the beginning of the Reign of Terror. There he painted portraits of French society in Naples, Florence and Genoa, where in 1796 he was recommended to the Emperor by his consort Josephine. As a result of this meeting, Napoleon not only granted Gros a rare sitting but made him a member of the commission set up to select plunder from Italian museums and art galleries for the Musée Napoléon in the Louvre.

Though never asked to accompany the army to Egypt, Gros became the official chronicler of the campaigns fought between 1798 and 1800. While Vivant Denon in his *Voyage dans la Basse et la Haute Egypte* (1802; Cat. 18), and the encyclopaedic *Description de l'Egypte* (1809–29) provided scholarly and accurate accounts of every aspect of Egyptian life, Gros's turbulent and romantic battle scenes contributed far more effectively to the propagation of the Napoleonic legend.

Gros proved very resilient to political change in early nineteenth-century France; in 1814 he was made official painter to Louis XVIII and created Baron by Charles X in 1824. His relaxation of the severity of Davidian classicism made his atelier an attractive environment for young artists and during the last twenty years of his life, it became the training ground for over one hundred painters, including Lami, Roqueplan, Delestre, Delaroche, Riesener and Charlet.

His return to historical and mythological subject-matter from *c.* 1815 aroused the hostility of contemporary critics, who found paintings such as *Hercule et Diomède* (1835; Musée des Augustins, Toulouse) empty, dry and lacking the style of his earlier Orientalist work. Depressed by this obvious lack of success, Gros is thought to have drowned himself in the River Seine near Bas-Meudon on 26 July 1835.

64*

The Battle of Nazareth 1801
Le Combat de Nazareth

134·4 × 195·5 cm
Signed and dated bottom right: *GROS AN IX*
Musée des Beaux-Arts, Nantes
[*repr. in colour on p. 58*]

In its freedom of handling, brilliant colouring and dynamic composition, *The Battle of Nazareth* marked a radical break with the restrained rhetoric of the traditional battle scene and was of seminal importance for the next generation of Orientalist painters. Both Auguste and Géricault made copies of the work and the latter is known also to have owned a copy by P-F. Lehoux.

The scene depicts an episode during the campaigns in Egypt organised under the Directoire. Ostensibly to free the people from the Mamlūk oppression, these campaigns were also intended to establish a strategic and commercial foothold in North Africa and the Near East, a possibility diplomats had investigated as early as 1777.

The Battle of Nazareth took place on the plains near Loubia, twelve miles from Nazareth itself, on 19 Germinal an VII (8 April 1799). Gros records the remarkable victory of the 500-strong French army over 6000 Turks and Arabs, focussing on the gallantry of its leader, General Junot, who holds together the various incidents of the painting in the sweep of his right arm. Napoleon was quick to recognise the political expediency of representing one of the few successes of the expedition and on 25 April, barely two weeks after the event, announced a competition for the commission of the picture. Many leading artists of the day were attracted by the subject and the competition soon degenerated into a polemic between the partisans of Gros and those of Hennequin, who felt their candidate presented a more heroic version of Junot's actions. Whether out of jealousy, or simply to avoid any reference to the campaigns which were engendering increasing public hostility, Napoleon forbade Gros's completion of the painting, and ordered him to proceed instead with *The Pesthouse at Jaffa* (Cat. 65).

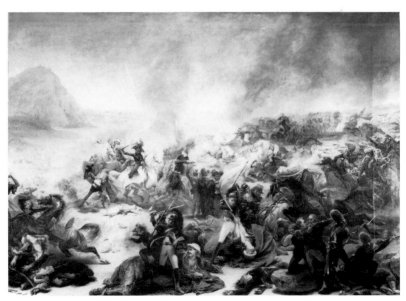

64

Gros, who had never travelled further south than Italy, made every effort to reconstruct accurately the details of the engagement: its location, the local colour and even the specific angle of the sun at the time of battle. He used a battle plan drawn up by General Junot himself, and copied details of Oriental costume and physiognomy from Vivant Denon's *Voyage dans la Basse et la Haute Egypte*. Despite this fastidiousness in the recording of detail, the image which Gros evokes of the Orient is almost overwhelmed by *'un sentiment d'exaltation guerrière'* (Anon., 1835, p. 265) in the warrior-like poses of the French officers, and in the bolder, less defined treatment of the frenzied battle scene. J.M.

PROVENANCE
Acquired from the artist by Bizet; 1828, 21–22 May, Bizet Sale, acquired by M. de Vaucourbon; M. Jazet; Urvoy de Saint-Bedan; 1854, presented by Urvoy de Saint-Bedan to the Musée des Beaux-Arts, Nantes

EXHIBITIONS
1826, Paris, Galerie Lebrun, *Ouvrages de peinture exposés au profit des Grecs* (no. 99)
1900, Paris, *Exposition Universelle* (no. 399)
1936, Paris, Petit Palais, *Gros, ses amis, ses élèves* (no. 3)
1959, London, Tate Gallery, *The Romantic Movement* (no. 199)
1974–75, Paris, Grand Palais, *De David à Delacroix* (no. 88; with exhaustive references)
1982, Nantes, Musée des Beaux-Arts, *Orients* (no. 1)

REFERENCES
Anon., 'M. Gros', *L'Artiste*, 1835, v, p. 265
Anon., 'Vente des tableaux, dessins et esquisses de M. Gros', *L'Artiste*, 1836, X, pp. 209–10
E. Chesneau, *Les Chefs d'école*, Paris, 1862, pp. 80–82
M. Nicolle, *Catalogue du Musée des Beaux-Arts, Nantes*, 1913, no. 1005
Rochester, New York, Memorial Art Gallery, *Orientalism*, catalogue by D. Rosenthal, 1982, fig. 9

65*

The Pesthouse at Jaffa 1804

Les Pestiférés à Jaffa

117·5 × 165 cm
Museum of Fine Arts, Boston
[*repr. in colour on p. 59*]

With the exception of minor alterations in the architecture in the background, this painting is almost identical to the full-scale version now in the Louvre which was executed in less than six months and rapturously received at the Salon of 1804. The

incident of Napoleon visiting the pesthouse took place on 11 March 1799, after plague had broken out in the city of Jaffa occupied by the French. In a poem written in honour of the painting, the artist Girodet recaptured the emotion of the scene:

Aussitôt tout s'émeut, tout accourrent le voir
Et dans leurs yeux mourants brille un rayon d'espoir,
Frappé de cécité, dans sa marche hâtive,
L'un d'eux prête à son chef une oreille attentive;
Sans garde, sans bâton, empresse d'accourir,
Si le héros lui parle, il est sûr de guérir.
(quoted J.B. Delestre, 1867, p. 93)

(All at once the men stirred with a note of surprise,
A glimmer of hope in their faint dying eyes,
From among them, a blind man, desperate to hear
The words of his leader, hastes to draw near,
Without guide, without stick, he tries to advance;
The hero can cure with a word or a glance.)

Napoleon's visit to the pesthouse and the capture of Jaffa itself, were, in fact, highly contentious events. British accounts of the episode pointed to the brutal slaughter of more than 3000 Turkish prisoners, and to Napoleon's ruthless abandonment of plague-ridden men whose condition threatened to impede his own retreat. Even on the French side doubts were expressed as to Napoleon's supposed benevolence. One eye witness, Bourienne, refers to Napoleon lightly kicking the infested men with the sole of his boot (quoted P. Lelièvre, 1936, p. 293) and Captain Etienne-Louis Mâlus, himself a plague victim, while commenting less on the Emperor's activities in the pesthouse, speaks strongly of the atrocities committed elsewhere in Jaffa (E. L. Mâlus, 1892, pp. 130–37). Gros's interpretation of the events gives no hint of this controversy. Following the report of the surgeon Desgettnes, he chose to portray Napoleon's great compassion as he willingly exposed himself to the plague in order to bring comfort to his men.

The development towards the final pictorial solution may be traced in a preliminary drawing (Louvre, R.F.2015) and in an oil sketch (Priv. Coll., Paris), in each of which Napoleon is shown supporting one of the stricken men. Initially set inside the lazaret,

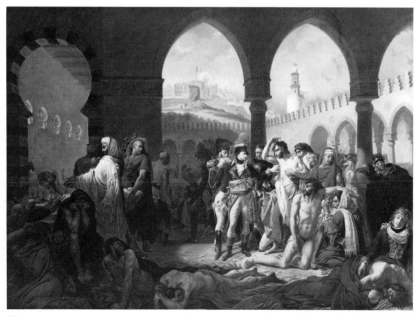

65

the scene is opened out to give Napoleon greater prominence against a composite view of Jaffa, based on an original plan by Tarachemy. In the final version, Napoleon's gesture becomes less naturalistic, but gains a supreme eloquence through its allusion to the healing of Christ. It is thus his position as moral and spiritual leader of the French people and not his military role which is most clearly stressed in this unequivocally propagandist image. As such, Gros realises his function as an official painter: 'Just as Charles le Brun painted the former Alexander, I should paint the new one' (quoted E. Chesneau, 1862, p. 79).

In his depiction of events in the Egyptian campaign, Gros inevitably recalled his own close participation in the chaotic Italian Wars, and particularly the two harrowing months of the Siege of Genoa in 1799. Here he clearly sympathises with the suffering of the common soldier, and introduces that element of pathos which was to colour other artists' and writers' interpretations of the Near East, notably Delacroix, Chassériau and Gautier. J.M.

PROVENANCE
?Commissioned by Marshal Mortier; 1st Duc de Trévise; Priv. Coll., England; 1934, Duc de Trévise; bought from him by the Museum of Fine Arts, Boston

EXHIBITIONS
1936, Paris, Petit Palais, Gros, ses amis, ses élèves (no. 29)
1938, New York, Knoedler and Co., Gros, Géricault, Delacroix (no. 3, ill.)
1938, Paris, Musée de l'Orangerie, Bonaparte en Egypte (no. 78)
1939, Springfield, Mass., The Romantic Revolt (no. 1)
1939, San Francisco, Museum of Art, French Romantic Artists (no. 3)
1955–56, New York, Jacques Seligman and Co.; Minneapolis, Institute of Arts; Cleveland Museum of Art, Baron Antoine-Jean Gros (1771–1835), Painter of Battles. The First Romantic Painter (no. 14)

REFERENCES
E. Chesneau, Les Chefs d'école, Paris, 1862, p. 79f.
J.B. Delestre, Gros, sa vie, ses ouvrages, Paris, 1867, pp. 90–96
E.L. Mâlus (ed. Général Thoumas), L'Agenda de Mâlus, Souvenirs de l'expédition d'Egypte 1798–1801, Paris, 1892, pp. 130–37
P. Lelièvre, 'Gros, peintre d'histoire', Gazette des Beaux-Arts, May 1936, pp. 292–93
W. Friedlaender, 'Napoleon as "Roi Thaumaturge"', Journal of the Warburg and Courtauld Institutes, 1940–41, IV, pp. 139–41
N. Schlenoff, 'Baron Gros and Napoleon's Egyptian Campaign', Essays in Honour of Walter Friedlaender, New York, 1965, pp. 157–60

66*

Sketch for 'The Cavalry Charge under General Murat at the Battle of Abū Qīr, Egypt: 25 July 1799' 1806

Charge de cavalrie, executée par le général Murat à la bataille d'Aboukir en Egypte: 25 juillet 1799

87 × 140 cm
Detroit Institute of Fine Arts

On 1 August 1798, at the Battle of the Nile in Abū Qīr Bay, Nelson destroyed the French fleet which had conveyed Napoleon to Egypt, thereby securing for Britain naval supremacy in the Mediterranean, and effectively sealing the fate of the French campaign in Syria. The news of the brilliant French land action also at Abū Qīr, and the victory over the Ottoman army under Mustafa Serasker helped to disguise the almost total annihilation of 55,000 troops in an apparently profitless expedition. Recognising the successful formula for propaganda established by Gros in his representations of the Battle of Nazareth and the events in Jaffa (see Cats. 64 and 65), Murat commissioned the artist to record the action at Abū Qīr almost immediately after the Salon of 1804.

This painting is the sketch for the final version now at Versailles, and was submitted to military officials for confirmation of the accuracy of details of the fighting. As in the

case of *The Battle of Nazareth* (Cat. 64), Gros based his representation on the report of a friend, in this instance General Berthier. He illustrates the culmination of the battle when Murat, seizing the initiative, charged the enemy ranks and finally confronted Mustafa (the figure at centre left turning away from Murat) and cut off two of his fingers. The Ottomans retreated to the fort in the background but were eventually defeated and Mustafa captured. One combatant who escaped was the leader of the Albanian contingent Muḥammad 'Alī. The dense composition combines a shallow picture plane, reminiscent of a classical bas-relief, with a wealth of action, sweeping from left to right across the canvas. Gros was careful to distinguish between the various physiognomies of the combatants, and to describe accurately the action, without distracting the eye by a proliferation of detail.

In an article in the *Revue des Deux Mondes* of 1848, Delacroix referred to the striking realism of Gros's battle scenes and praised his ability to evoke the frenzied heights of the conflict: 'He can paint the sweat which drenches his horses' manes in the heat of battle, and even the fiery breath from their nostrils. He shows you the glint of the sabre at the very moment when it strikes the enemy's throat' (1923, III, p. 179).

Contemporary critics drew analogies between Gros's glorification of this incident from the Egyptian campaigns and the heroism of Homeric legend. Indeed, by idealising contemporary subject-matter, through reference to classical prototypes, Gros established the vocabulary for modern-day history painting on an epic scale. J.M.

PROVENANCE
1828, 21 May, Paris, rue de Clery (former Salle Lebrun) unsold; M. Dicot (until 3 March 1847); Duc de Cambacères, Paris (until end of 1935); Duc de Trévise, Paris; Mr. Edgar B. Whitcomb Coll., Detroit, Michigan; given by Mr. and Mrs. Edgar B. Whitcomb to the Detroit Institute of Arts

EXHIBITIONS
1936, Paris, Petit Palais, Gros, ses amis, ses élèves (no. 33)
1938, Paris, Musée de l'Orangerie, Bonaparte en Egypte (no. 95)
1938, New York, Knoedler and Co., Gros, Géricault and Delacroix (no. 5)
1939, San Francisco, Museum of Art, French Romantic Artists (no. 4)
1940, New York World Fair (no. 230)
1952, Seattle, Art Museum, Nineteenth Century Paintings and Sculpture
1952, Hartford, Wadsworth Atheneum, The Romantic Circle (no. 4)
1954, Detroit, Institute of Arts, Paintings and Sculptures given by Mr. and Mrs. Edgar B. Whitcomb (p. 83)
1955, Rome and Milan (no. 55)
1955–56, New York, Jacques Seligman and Co. Inc.; Minneapolis, Institute of Art; Cleveland, Museum of Art, Baron Antoine-Jean Gros (1771–1835), Painter of Battles. The First Romantic Painter (no. 13)

REFERENCES
J. Tripier Le Franc, Histoire de la vie et de la mort du Baron Gros, Paris, 1880, p. 130
E. Delacroix, 'Le Baron Gros', Oeuvres Littéraires, III, Paris, 1923, pp. 173–74
N. Schlenoff, 'Baron Gros and Napoleon's Egyptian Campaigns', Essays in Honour of Walter Friedlaender, New York, 1965, pp. 162, 163

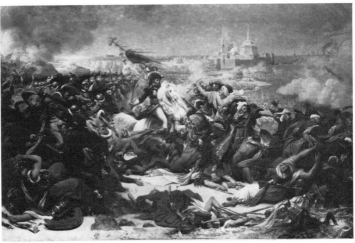

66

Guillaumet, Gustave 1840–1887

Son of a manufacturer in Puteaux (Seine et Oise), Guillaumet studied under Picot (1786–1868) and Barrias (1822–1907) and in 1857 entered the Ecole des Beaux-Arts as a pupil of Abel de Pujol (1785–1861). From 1861 he exhibited regularly at the Salon. The following year he set out to study in Rome but changed route on impulse, embarking at Marseille for North Africa. In spite of recurring bouts of malaria, this decisive voyage was to be the first of ten trips to Algeria and Morocco. At the Salon of 1863 he exhibited the *Prière du soir dans le Sahara* (ill. fig. 15; Musée d'Orsay, Paris), which attracted much favourable attention and was bought by the State for 4000 francs. This marked the beginning of a highly successful career and Guillaumet went on to win medals at the Salons of 1865, 1867 and 1872, and in 1878 he was made Chevalier de la Légion d'Honneur.

Guillaumet was immediately attracted to the southern extremities of Algeria around Biskra and the Hodna region south of Bou-Saada, where ethnic customs and lifestyles were still untainted by the presence of Europeans in the coastal towns. He spent much of his time among the people of the oases' *quṣūrs* or hamlets, depicting the inhabitants, their dwellings and their labours with a force and sympathy that led him to be regarded as the Orientalist counterpart to Millet.

From 1882 Guillaumet exhibited pastels at the Société des Pastellistes, a medium which, with its soft nuances of colour, was particularly suited to his sensitive observations. In 1883–84 he travelled for the last time to Algeria and in 1886 completed the journey to Italy he had begun twenty-four years earlier, where he was much impressed by Michelangelo.

Guillaumet died in Paris in 1887.

ABBREVIATED REFERENCE
Nouvelle Revue 1879 G. Guillaumet, 'Tableaux algériens', *Nouvelle Revue*, 1879, I, no. 1, pp. 144–58 (later published as part of *Tableaux algériens*, Paris, 1888)

67

The Desert (The Sahara) 1867
Le Désert (Le Sahara)

110 × 200 cm
Signed and dated bottom right: *G. Guillaumet 1867*
Musée d'Orsay, Paris
[*repr. in colour on p. 83*]

This powerful painting has been subject to much interpretation since its original showing at the Salon of 1868 and has been described as anything from '*un peu exagéré*' (Renan 1887, p. 408) to 'surrealist' (Rosenthal, 1982, p. 89). It belongs to Guillaumet's early, rather melodramatic work and very clearly illustrates the artist's technical and emotional quandry when confronted with the strangeness of an unfamiliar culture and climate. In *Famine en Algérie* (Musée des Beaux-Arts, Algiers), exhibited at the Salon of 1869, Guillaumet attempted to overcome this problem by referring to the examples of Géricault and Delacroix in the extreme pathos of the figures. In the work exhibited here, the artist is faced with the particular formal problem of a broad, fairly featureless terrain quite alien to European landscape traditions. The desolate, parched land is accentuated by the severe horizontality of the brushwork in the desert and sky, relieved only by the distant mirage and the haunting skeleton of the camel. The intense heat and light contribute to the infinite stillness of the image, so that the only movement is the 'almost imperceptible vibrating of the air above the scorched earth' (*Nouvelle Revue* 1879, p. 145). The sight of the noble camel, an animal passionately admired by Guillaumet, fallen prey to the vermin of the desert, is one which had also impressed Flaubert while on the shore of the Dead Sea in 1850: 'The hide, dried and stretched out by the sun, is intact, but has been gnawed from within until it is no thicker than an onion-skin' (Steegmuller, ed. 1979, p. 184).

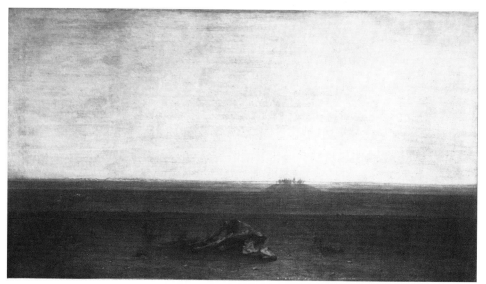

67

Guillaumet's concern in this painting, however, goes beyond straightforward realism. The camel, *'cet être abimé dans le mouvement de transformation universelle'* (Renan, 1887, pp. 419–20), could be read as a symbol of the struggle between Man and Nature, victim of the abstract destructive forces of the desert. The re-naming of the painting from its more specific original title, *Le Sahara*, perhaps confirms this reading of the image. J.M.

PROVENANCE
1888, gift of the artist's family to the State

EXHIBITIONS
1868, Paris, Salon (no. 1178)
1968, Berlin, Academie der Kunst, *Le Musée imaginaire* (no. 60)
1973, Paris, Musée des Arts Décoratifs, *Equivoques*
1975, Marseille, Musée Cantini, *L'Orient en Question* (no. 91)
1982, Rochester, New York, Memorial Art Gallery, *Orientalism* (no. 50)

REFERENCES
Ch. Sterling and H. Adhémar, *Musée Nationale du Louvre. Peintures: École français, XIXᵉ siècle*, Paris, 1958–61, 4 vols., no. 1026, ill.
A. Renan, 'Gustave Guillaumet', *Gazette des Beaux-Arts*, 1887, 2ᵉ pér., 35, pp. 404–22
Paris, Musée du Louvre, *Catalogue des peintures I. École Française*, 1972, p. 195
Ph. Jullian, *The Orientalists, European Painters of Eastern Scenes*, Oxford, 1977, p. 68, ill. 69

68

The 'Seguia', Biskra 1884

La Séguia, près de Biskra

100 × 155 cm
Signed and dated bottom right: *G. Guillaumet 1884*
Musée d'Orsay, Paris
[*repr. in colour on p. 94*]

Originally the Roman town of Ad Piscinam, Biskra was the capital of a wide district in western Algeria known to the Arabs as Aïn Salahin. After some years under Turkish sovereignty, it was captured in May 1846 by the Duc d'Aumâle, and named after a commandant killed in the Zaatcha insurrection of 1849.

The present painting is very different both in tonality and tempo from Guillaumet's earlier imagery, a transition which first occurs in *Le Labour à la frontière du Maroc*, exhibited at the 1869 Salon. As in *The Desert*, the landscape is used to enhance the mood of the scene. The figures are sharply accentuated against the barren rock and unwelcoming architectural features and, together with the intensity of light and the depth of shadow,

they stress the harshness of life in this desert settlement. The apparent ease and spontaneity of the composition, which depicts an everyday task in the life of the *fellāḥah*, belie the numerous close preparatory studies for the landscape and figures.

While Guillaumet's contemporaries in France had already begun to look at the fleeting, transitional qualities of nature, the climate in North Africa invited a very different interpretation: Guillaumet achieves a harmonious colouring through a precise understanding of the effects of the intense light and its consolidation of form, rather than a disintegration of the figure. Light fascinated Guillaumet not only as an artistic problem but also as a determining force on the very lives of the people of the *ksour*. In '*Un jour au soleil*' (*Nouvelle Revue* 1879, p. 144), he discussed the harmony created by violent oppositions of colour echoed in the harmony of the cycle of life, pointing to the oneness between Man and Nature. Here, this theme is taken up with a tenderness of observation characteristic of Guillaumet's representation of the *fellāḥah*, most particularly in *Les Femmes de douar à la rivière* (1872; Musée des Beaux-Arts, Algiers) and in *Les Fileuses de laine à Bou-Saâda* (1885; Musée d'Orsay). The heroic and timeless aspect of the rural population, a society untainted by the materialistic preoccupations of Western civilisation, invoked for Guillaumet, as for many of his contemporaries including Flaubert, Vernet (see Cat. 120) and Holman Hunt (see Cat. 72), images from the Bible. In these agricultural and pastoral scenes, he wrote: 'One could believe oneself transported to the bosom of those partriarchal families whose poetry characterises the first pages of Hebrew history' (*Nouvelle Revue* 1879, p. 150). J.M.

PROVENANCE
1885, acquired by the State

EXHIBITION
1885, Paris. Salon des Champs-Elysées (no. 1186)

REFERENCE
Ph. Jullian, *The Orientalists. European Painters of Eastern Scenes*, Oxford, 1977, p. 131, ill.

68

Hunt, William Holman 1827–1910

A founder member of the Pre-Raphaelite Brotherhood, William
Holman Hunt was the son of a London warehouse manager. He
entered the Royal Academy schools at the third attempt in 1844,
and made his exhibition debut the following year in Manchester.
Hunt was dissatisfied with current academic teaching, and his
search for an original style and iconography was influenced by
his discovery of Ruskin's *Modern Painters* and the poetry of
Keats, the innovative technique of David Wilkie, and his
discussions with John Everett Millais, whom he met *c.* 1844.
Hunt's 1848 Royal Academy exhibit, *The Eve of St. Agnes*
(Guildhall Art Gallery, London), based upon Keats's poem, led
to his friendship with Dante Gabriel Rossetti and thence to the
foundation of the Pre-Raphaelite Brotherhood in September of
that year. Hunt's first major figure painting with a landscape
background painted from nature, *Rienzi* (1848–49; Priv. Coll.,
England), was followed by *A Converted British Family* (Ashmolean
Museum, Oxford), exhibited at the Royal Academy in 1850 and
sold that autumn to Thomas Combe, who became a major
patron. Works such as *The Hireling Shepherd* (1851–52;
Manchester City Art Gallery) and *Claudio and Isabella* (1850–53;
Tate Gallery, London) helped to establish Hunt's reputation, but
in January 1854 he left England to join Seddon (*q.v.*) in Egypt,
thus turning his back on a most promising career. *The Light of
the World* (1851–53; Keble College, Oxford) and *The Awakening
Conscience* (1853–54; Tate Gallery, London) were shown at the
Royal Academy in 1854.

Following his return to England, Hunt exhibited in 1856 *The
Scapegoat* (Lady Lever Art Gallery, Port Sunlight), painted at the
Dead Sea and in Jerusalem between 1854 and 1855. *The Finding
of the Saviour in the Temple* (1854–60; Birmingham City Art
Gallery, see fig. 10), exhibited privately, established Hunt's
reputation as the founder of a new style of religious painting
based on accurate archaeological reconstructions of biblical
scenes. Its success was followed by that of *The Shadow of Death*
(Manchester City Art Gallery, see fig. 12), the outcome of Hunt's
second trip to the Holy Land, 1869–72, and *The Triumph of the
Innocents* (Walker Art Gallery, Liverpool), begun on his third
visit, 1875–78. Hunt's painstaking methods precluded a large
production of paintings in oil.

He was never elected to the Royal Academy, an institution
which he bitterly attacked, but rather allied himself to alternative
exhibiting bodies, such as the Grosvenor Gallery, and favoured
one-picture exhibitions for his major works. He was awarded the
Order of Merit in 1905 and died in London on 7 September
1910.

ABBREVIATED REFERENCE
Hunt 1905 W. Holman Hunt, *Pre-Raphaelitism and the Pre-Raphaelite Brotherhood*, London,
 1905, 2 vols
Note: All quotations of Hunt transcribed literally.

69†

The Great Pyramid 1854

Watercolour and touches of bodycolour on paper: 17 × 24·7 cm
Monogrammed and dated bottom right': *18 Whh 54*
Private Collection
[*repr. in colour on p. 166*]

The Great Pyramid, 450 feet high, was the first of three pyramids
to be built on the west bank of the Nile at Gizah during the
Fourth Dynasty (2680–2565 BC). Together with the adjacent
Sphinx this monument had become a tourist attraction for
Europeans by the time of Hunt's first visit to Egypt. By
11 February 1854 he had arrived in Cairo to meet Seddon, and
informed his friend and patron Thomas Combe, in a letter of
21 February, that they were about to go to the desert for a week
(Bodleian Library, Oxford, MS. Eng. lett. c. 296). Hunt and
Seddon pitched their tent near the pyramids of Gizah, and Hunt
began a watercolour of the Sphinx seen from behind, in which
the pyramids are relegated to the upper left-hand corner (Harris
Museum and Art Gallery, Preston). His reaction to the
monuments was informed by his Christian beliefs; he regarded
them as 'merely colossal tombs of pride'. This attitude,
compounded by his 'desire to appear superior to the *cockney*
visitors' to the site, prevented him from making a straightforward
topographical view (Hunt letter to J.E. Millais, 8 May 1854; John
Rylands University Library, Manchester, Ryl.Eng.MS.1216). He
described the pyramids in a letter to Millais of 16 March 1854
as 'extremely ugly blocks and arranged with most unpicturesque
taste', but felt, nevertheless, that 'while they are at hand it is as
well to make a sketch of them with some effect and circumstance,
to satisfy curiosity and one's own love of past experiences' and
hoped that 'it may be possible to gain some poetical feeling to
repay for the patience one must exert'.

Seddon's oil painting of the three pyramids executed at the
same time (present location unknown; 1978, with The Fine Art
Society, London) presented a poetic image of the scene by
recording the monuments silhouetted against a blazing sunset,
imposing in their magnitude. Hunt, on the other hand,
domesticated the image in the medium of watercolour,
concentrating on the play of light on the Great Pyramid and
carefully observing the people and the bird life in the vicinity.
The girl on the far bank balancing a red water pot on her head

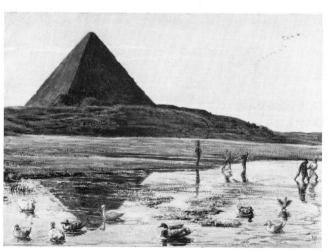

69

looks forward to *The Afterglow in Egypt* (Cat. 77, 78), while Hunt's interest in the *fellaḥīn* points to the fact that his trip to the Near East was motivated by the desire to produce major figure pictures *in situ*. J.E.B.

PROVENANCE
By 1897, in the collection of William Brockbank, Didsbury, Manchester; 1897, 27 February, Christie's, London (lot 34) bought by Agnew's; 1897, 2 March, acquired by E.G. Brockbank, Whitevale, Didsbury; 1968, 11 June, anonymous sale, Christie's, London (lot 155) bought by Leggatt, from whom acquired by the present owner

EXHIBITIONS
1906–07, Manchester City Art Gallery, *The Collected Works of W. Holman Hunt, O.M., D.C.L.* (no. 60)
1907, Liverpool, Walker Art Gallery, *Collective Exhibition of the Works of W. Holman Hunt, O.M., D.C.L.* (no. 19)
1907, Glasgow, Kelvingrove Art Gallery, *Exhibition of Pictures and Drawings by W. Holman Hunt, O.M., D.C.L.* (no. 25)
1969, Liverpool, Walker Art Gallery; London, Victoria and Albert Museum, *William Holman Hunt* (no. 134)
1974, London, Royal Academy, *Impressionism: Its Masters, its Precursors, and its Influence in Britain* (no. 16)

REFERENCE
W. Holman Hunt, letter to John Everett Millais, Williams's Indian Family Hotel, Cairo, 16 March 1854, MS. Arizona State University Library, Tempe (published in part in Hunt 1905, I, p. 380)

70†

Arab Reclining by a Stream 1854

Watercolour and touches of bodycolour on paper: 25·4 × 35·3 cm
Monogrammed and dated bottom left: *Whh 1854*
Sheffield City Art Galleries
[*repr. in colour on p. 167*]

In February 1854 Hunt wrote to Thomas Combe from Williams's Indian Family Hotel, Cairo: 'I believe that nearly any of the Arab men or the Egyptian could be induced to sit as models, for we have not discovered any supersititious or religious objection as I had been led to expect' (Bodleian Library, Oxford, MS.Eng.lett. c. 296). A further letter to Combe of 23 March, written after Hunt had returned from his first trip to the pyramids (see Cat. 69), states: 'At first I set to work at a water color sketch or two of landscape scenes and then at an arab, with the man there was no particular difficulty but this was not a sufficient trial of the question of getting models.' The trial was to begin with *A Street Scene in Cairo: The Lantern-Maker's Courtship* (1854–61; City of Birmingham Museum and Art Gallery), and it is possible that the Arab was persuaded to sit for this work because he was employed by a European.

70

The trip to the pyramids at Gizah had been motivated partly by Seddon's compassionate desire to be near a dying Englishman, Nicholson, who was to be buried in Cairo on 15 March (J. P. Seddon, *Memoir and Letters of the late Thomas Seddon, Artist*, 1858, pp. 49, 58–59). Hunt may subsequently have persuaded Nicholson's gentle and attentive French-speaking servant, one of the few Arabs with whom Hunt could communicate, to pose for this work. Certainly the way in which the sitter is perched by a stream, apparently intent on the contents of his cupped hand, is reminiscent of the figures in *The Hireling Shepherd* (Manchester City Art Gallery) meditating on a death's-head moth: the Arab, surrounded by bare earth, could well be reflecting on Nicholson's demise. A symbolic dimension to an apparently straightforward ethnographic study would be entirely characteristic of Hunt's work during the period in which he was contemplating his next major religious painting, *The Finding of the Saviour in the Temple* (1854–60; City of Birmingham Museum and Art Gallery; fig. 10).

The wash of the sky can be compared to that of *The Haunt of the Gazelle* (Cat. 71), its paleness an indication of the *khamsīn* winds. The brilliant colouring of the foliage reflects Hunt's initial enthusiasm for Cairo, while the use of bare paper to convey sunlit surfaces contributes to the limpid quality of *Arab Reclining by a Stream*. J.E.B.

PROVENANCE
By 1949, in the collection of Mrs Ernestine Mills; 1952, 12 March, Sotheby's, London (lot 37) bought by Leger Galleries; 1965, February, acquired by the Sheffield City Art Galleries

EXHIBITIONS
1949, London, Leicester Galleries, *The Victorian Romantics: An Exhibition of Paintings and Drawings* (no. 114)
1967, Matlock, Towney House, *Victorian Paintings*
1969, Liverpool, Walker Art Gallery; London, Victoria and Albert Museum, *William Holman Hunt* (no. 136)

REFERENCE
W. Holman Hunt, letter to Thomas Combe, Williams's Indian Family Hotel, Cairo, 23 March 1854, Bodleian Library, Oxford, MS.Eng.lett.c.296

71†

The Haunt of the Gazelle 1854
(The Gazelle, Desert of Gizah or Gazelle in the Desert)

Watercolour and bodycolour over traces of pencil on paper: 14·8 × 20·6 cm
Monogrammed and dated bottom left: *Whh 54*
Walker Art Gallery, Liverpool
[*repr. in colour on p. 166*]

Hunt's first trip to Gizah was not particularly productive in artistic terms, as the *khamsīn* winds, according to the artist's letter to Millais of 16 March 1854, 'disturbed the sand so much as to make sketching in colors a task of too much time for the result' (MS. Arizona State University Library, Tempe). Hunt's determination not to be impressed by the landscape – 'There are palm trees about which attract my passing admiration but for all else one might as well sketch in Hackney marsh' – was tempered by an admission that 'the desert is beautiful' (MS. *ibid.*), and a letter of 23 March to Thomas Combe reveals that Hunt would have regarded his nomadic adventure as 'the most delightful thing in the world' if it had been a holiday rather than a working visit (Bodleian Library, Oxford, MS.Eng.lett.c.296).

Hunt's output in pencil studies and watercolours was prolific on the return trip to Gizah from 20 April to 6 May, partly because Roberson's box of materials, including the canvas for *The Afterglow in Egypt* (Cat. 77) had been delayed. According to

Hunt's letter of 2 May to his sister Elizabeth, 'in filling up our time we provided ourselves with work in somewhat too liberal a spirit, for now that the box has come we have to remain a few days more to enable us to finish what we have begun.' The drawings included several pencil studies of *fellāḥīn* engaged in Mariette's excavations of the Sphinx (eg. National Gallery of Victoria, Melbourne; Mrs Elisabeth Burt Coll.; the late Stanley Pollitt Coll.) and, from the same sketchbook, *The Haunt of the Gazelle.*

Two other watercolour landscapes of the period, *Gazelles in the Desert* (Priv. Coll., England) and *Nile Sketch* (present location unknown, formerly Priv. Coll., United States) are longer in format than this watercolour, suggesting the immensity of the desert. *The Haunt of the Gazelle*, on the other hand, concentrates as much on the gazelle as on the desert background, the colours of which are carefully washed in. The image of an animal in an empty landscape looks forward to *The Scapegoat* (Lady Lever Art Gallery, Port Sunlight), but the closely observed gazelle, which testifies to Hunt's reluctance to become a topographical watercolourist (Hunt 1905), bears none of the symbolic weight of that painting.

This watercolour was first exhibited in 1889, when it was commended in the *Athenaeum* for 'the vividness of its local colours' and 'resplendent landscape'. 　J.E.B.

PROVENANCE
By 1906, acquired by Harold Rathbone; after 1913, acquired by John Lea; 1927, February, house sale of Lea's pictures, Redholme, Mossley Hill, Liverpool; acquired by Mrs E.L. Elias, his niece; 1952, April, bequeathed to the Walker Art Gallery

EXHIBITIONS
1889–90, London, Royal Society of Painters in Water Colours, *Winter Exhibition of Sketches and Studies. The Twenty-Eighth* (no. 308)
1906–07, Manchester City Art Gallery, *The Collected Works of W. Holman Hunt, O.M., D.C.L.* (no. 59)
1907, Liverpool, Walker Art Gallery, *Collective Exhibition of the Works of W. Holman Hunt, O.M., D.C.L.* (no. 55)
1911, Manchester City Art Gallery, *Loan Exhibition of Works by Ford Madox Brown and the Pre-Raphaelites* (no. 292)
1913, London, National Gallery of British Art, *Works by Pre-Raphaelite Painters from Collections in Lancashire* (no. 7)
1913, Bath, Victoria Art Gallery, *Autumn Loan Exhibition of Works by Pre-Raphaelite Painters from Collections in Lancashire* (no. 56)
1969, Liverpool, Walker Art Gallery; London, Victoria and Albert Museum, *William Holman Hunt* (no. 135)

REFERENCES
Hunt 1905, I, pp. 389–90
Anon., 'The Society of Painters in Water Colours', *Athenaeum*, no. 3241, 7 December 1889, p. 787
W. Holman Hunt letter to Elizabeth Hunt, Pyramids of Geezah [*sic*], 2 May 1854, John Rylands University Library, Manchester, Ryl.Eng.MS.1215

[The compiler would like to thank Mary Bennett for information relating to the provenance of this watercolour]

71

72† {#}
The Holy City　1854

Watercolour and bodycolour with touches of pencil on paper: 19·5 × 35 cm
Oldham Art Gallery
[*repr. in colour on p. 165*]

Hunt and Seddon arrived in Jerusalem on 3 June 1854 and within three weeks Hunt had established himself in the house of a missionary inside the city gates (J. P. Seddon, *Memoir and Letters of the late Thomas Seddon, Artist*, 1858, p. 96). From the roof of this house the artist had an excellent view of the mosques of the Haram al-Sharif, including the Dome of the Rock, looking east towards the Mount of Olives, which he depicted in this work and in the watercolour, *Jerusalem by Moonlight* (Whitworth Art Gallery, University of Manchester), first exhibited at the Royal Academy in 1856.

Although the focus of *The Holy City* is on the effects of moonlight on the scene, which Hunt found enchanting (Hunt 1905), the title is a reminder of the sacred nature of the Haram site, located 'exactly on the foundations of the temple enclosure built by Herod, replacing the temple precinct originally built by King Solomon' (Arthur Kutcher, *The New Jerusalem: Planning and Politics*, 1973, p. 19). The prominent dome dominating the skyline is that of the Mosque of Omar, built over the rock on which Abraham offered to sacrifice Isaac and from which Muḥammad ascended to heaven. Moreover, the phrase 'the holy city' has specifically Christian connotations, recalling St. John's vision of 'the holy city, new Jerusalem, coming down from God out of heaven, prepared as a bride adorned for her husband' (*Revelations*. 21:2). This passage was in Hunt's mind in mid-1854, for he wrote to John Lucas Tupper on 24 July about his first glimpse of Jerusalem: 'There was more than a ruined city there, one could see the Kingdom of Heaven rising above it' (MS. Huntington Library, San Marino). The letter reveals the extent to which Hunt's Christian faith had been deepened by contact with sites, such as the Haram and the Mount of Olives, which were steeped in the Gospels.

The Muslim occupation of the Temple Mount is indicated by the lighted window at the left of the watercolour, while the cypress tree on the right could be interpreted as a symbol of mourning for a site no longer under Christian jurisdiction. Such symbolic language was central to the more highly finished Academy exhibit *Jerusalem by Moonlight* (1984, London, Tate Gallery, *The Pre-Raphaelites*, no. 204) but in *The Holy City* the emphasis is on the calm beauty of the scene. 　J.E.B.

PROVENANCE
By 1894, in the collection of John Graham; 1894, 5 May, Christie's, London (lot 14) bought by Agnew's on behalf of Charles Edward Lees, Werneth Park, Oldham; by descent to his daughter Miss Marjorie Lees; 1952, October, presented by her to Oldham Art Gallery

EXHIBITIONS
1894, Oldham Art Gallery, *Loan Exhibition of Pictures* (no. 7)
1912, Manchester, Whitworth Institute, *Loan Exhibition of Water Colour Drawings by Deceased British Artists* (no. 285)

REFERENCE
Hunt 1905, I, pp. 408–09

73†

The Plain of Rephaim from Zion 1855/61(?)
(The Plain of Rephaim from Mount Zion)

Watercolour and bodycolour with surface scratching on paper: 35·5 × 50·8 cm
Monogrammed and dated lower left: *Whh 55*
Whitworth Art Gallery, University of Manchester
[*repr. in colour on p. 164*]

This watercolour depicts the view south-west of Jerusalem just beyond the city gates, with the slopes of Mount Zion in the left foreground overlooking the limestone terrain of the Valley of Hinnem. The Plain of Rephaim beyond is traversed by an aqueduct which carries water from Solomon's Pools to the Temple Mount; the convent of Mar Elias, at that time under Greek jurisdiction, can be seen in the distance. According to Frederick George Stephens, no doubt briefed by Hunt and following mid-nineteenth-century research into the topography of Jerusalem, 'the dry bed of the Pool of Gihon' is depicted in the right foreground (Stephens 1861); later commentators, however, have placed Gihon on the east of the city in the Kidron Valley (G. A. Smith, *Jerusalem: The Topography, Economics and History from the Earliest Times to A.D. 70*, 1907, I, p. 107).

Hunt was working on this picture in the evenings before his departure from Jerusalem (Hunt 1905) which accounts for the pink glow of the landscape. The figures may, however, date from 1860 to 1861, when the artist was working up a group of Eastern watercolours for exhibition. The man standing by the trees holding a set of pipes is a development of the shepherd in the 1854 drawing *Road going up from Gihon to Hinnom* (R.D. Franklin Coll.). He looks on as the trio in the far-left corner appears threatened by stone-throwing youths. The meaning of this incident is unclear, but the blue-clad man may personify King David shielding the children of Israel from attacks by the Philistines, a reference to II *Samuel* 5, which tells of the newly-anointed king's victory in the Plain of Rephaim. The baby he is clutching may also be an allusion to child sacrifices which took place in the Valley of Hinnem at the time of Jeremiah (*Jeremiah* 7:31). The theme of persecution foreshadows Christ's Passion, and Hunt's audience, well versed in making connections between the Old and New Testaments, would have been aware that Mount Zion was the site of the Last Supper as well as King David's sepulchre.

The Plain of Rephaim from Zion was one of four watercolour landscapes of the Holy Land exhibited in 1861, each bearing a frame with linear motifs embossed on a gold flat batten and enclosed within a painted border made to the artist's specifications. J.E.B.

PROVENANCE
1861, acquired from the artist by Ernest Gambart; 1861, acquired by Thomas Plint from the German Gallery exhibition; 1862, 7 March, Christie's, London (lot 192) bought by Agnew's on behalf of Sir John Pender; 1873, 30 January, Christie's, London (lot 470) bought by Agnew's; 1873, 12 February, acquired by Abraham Haworth; by 1906, in the collection of Mrs Arnold Herbert; 1961, presented to the Whitworth Art Gallery in memory of John Goodier Haworth by members of his family

EXHIBITIONS
1861, London, German Gallery, Exhibition of Hunt's pictures organised by Ernest Gambart
1878, Manchester, Royal Manchester Institution, *Exhibition of Art Treasures* (no. 182)
1887, Manchester, *Royal Jubilee Exhibition* (no. 1227)
1906–07, Manchester City Art Gallery, *The Collected Works of W. Holman Hunt, O.M., D.C.L.* (no. 53)
1907, Liverpool, Walker Art Gallery, *Collective Exhibition of the Works of W. Holman Hunt, O.M., D.C.L.* (no. 12)
1965, Ottawa, National Gallery of Canada, *Paintings and Drawings by Victorian Artists in England* (no. 63)
1969, Liverpool, Walker Art Gallery; London, Victoria and Albert Museum, *William Holman Hunt* (no. 160)
1972, Manchester, Whitworth Art Gallery, *The Pre-Raphaelites and their Associates in the Whitworth Art Gallery* (no. 43)
1973, Brussels, Europalia, Musées Royaux des Beaux-Arts de Belgique, Musée d'Art Moderne, *English Watercolours of the 18th and 19th Centuries from the Whitworth Art Gallery Manchester* (no. 57)
1974–75, Leningrad, State Hermitage Museum; Moscow, Pushkin Museum; Volgograd, City Museum, *English Drawings and Watercolours of the 18th and 19th Centuries from the Whitworth Art Gallery* (no. 96)
1979–80, The Hague, Gemeentemuseum; Budapest, National Gallery; Bratislava, Slovak National Gallery; Prague, Sternbeck Palace; Geneva, Musée Rath, *Pre-Raphaeliten Tekeningen, Weefsels en behangsels uit de Whitworth Art Gallery in Manchester* (no. 20)

REFERENCES
Hunt 1905, II, p. 34
F.G. Stephens, 'Fine-Art Gossip', *Athenaeum*, no. 1749, 4 May 1861, p. 603

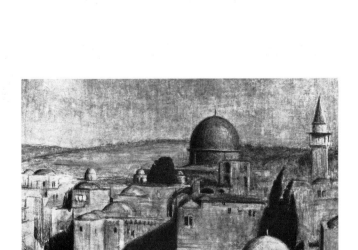

72

73

74†

The Sleeping City, Pera 1856/88

Watercolour and bodycolour, with scratching out and traces of pencil, on paper:
50·3 × 35·2 cm
The Visitors of the Ashmolean Museum
[repr. in colour on p. 168]

According to Julia Pardoe's *The Beauties of the Bosphorus*, 1838,
'there is certainly nothing which more impresses the mind or fills
the imagination of the traveller in Turkey, than the appearance
and situation of the burial places' (p. 130). In the mid-nineteenth
century Pera contained two Muslim cemeteries: the Petits
Champs des Morts, which overlooked the Golden Horn, and a
larger burial ground to the north-east, overlooking the
Bosphorus. The title *The Sleeping City, Pera* may suggest that the
larger cemetery was the site of Hunt's watercolour.

Hunt began this work in January 1856, while he was waiting
for a steamer to take him to Malta on the first stage of his return
journey to England. He had been deeply affected by his visit to
the Crimea the previous month. Unlike Tennyson, whose *Charge
of the Light Brigade* glorified British bravery from afar, Hunt was
shattered to see mouldering fragments of bone strewn over the
battlefield of Balaclava, 'being portions of human souls
habitations, dear as Heaven's love perhaps to some distant
widows, childless mothers, or fatherless children' (diary,
14 December 1855, John Rylands University Library,
Ryl.Eng.MS.1211). His contact with death may have inspired him
to record one of the Muslim cemeteries of Pera; both were

popular resorts for Europeans at that period. Hunt was probably
aware that Ottoman headstones, decorated with turbans,
indicated the rank of the deceased male, while a sculptured rose
branch (eg. on the coffin-shaped tombstone in the centre middle
ground of this watercolour) designated the grave of a woman
(see Pardoe, *op.cit.*, pp. 132–33). Much of the drawing's
symbolism which appears to relate to the Crimean War, such as
the newly-dug gaping grave in the lower left-hand corner, the
placing of two pieces of wood in the shape of a cross next to
a Muslim tombstone, complete with turban and inscription from
the *Qur'ān*, and the doves and crocii intimating peace and
renewal, however, was not in fact executed in 1856. A letter of
28 September 1888 from Hunt to Mrs Combe reveals that this
painting 'was brought home with the lower part left blank',
worked on at intervals over two decades, taken 'in hand to finish'
in the spring of 1888 so that it could be shown at the Royal
Society of Painters in Water Colours and only given 'the
complete general effect' on its return from exhibition. J.E.B.

PROVENANCE
*c.*1856, presented, unfinished, to Thomas Combe by the artist; 1868, returned to the artist;
1888, September, presented to Combe's widow; 1893, bequeathed by Mrs Thomas Combe
to the Ashmolean Museum
EXHIBITIONS
1888, London, Royal Society of Painters in Water Colours, *Summer Exhibition* (no. 273)
1973–74, Baden-Baden, Staatliche Kunsthalle, *Präraffaeliten* (no. 42)
REFERENCE
W. Holman Hunt letter to Mrs Thomas Combe, 28 September 1888, Bodleian Library,
Oxford, MS.Eng.lett.c.296

75†

Jerusalem 1869
(View of Zion and Pool of Gihon)

Watercolour over traces of pencil on paper: 25·5 × 49·2 cm
Monogrammed and dated bottom left: *18 Whh 69*
Mrs Elisabeth Burt
[repr. in colour on p. 164]

This watercolour depicts a section of the walls of Jerusalem,
Mount Zion and the Coenaculum dating from the fourteenth
century and built on the traditional site of the Tomb of David,
and the Valley of Hinnem to the south-west of the old city. Hunt
gave the work the title *View of Zion and Pool of Gihon* when it
was illustrated in his memoirs, suggesting that he agreed with
archaeologists such as Edward Robinson, rather than later
commentators, in locating the biblical Pool of Gihon on the west
side of Jerusalem. The landscape elements in this work are to a
certain extent a return to those in *The Plain of Rephaim from Zion*
(Cat. 73), while the townscape is depicted with as much care for
topographical accuracy as for the light effects.

Hunt had arrived in Jerusalem for his second visit at the end
of August 1869, and was shocked to find that new buildings
obscured more than half the city (Hunt letter to F.G. Stephens,
31 August 1869, Bodleian Library, Oxford, MS.Don.e.67). The
recording of sacred sites was thus given a certain urgency; Hunt
was still profoundly interested in the landscape of the Holy Land,
both as a background to his major new venture, *The Shadow of
Death* (1870–73; Manchester City Art Gallery) and for its own
sake. He was to write to Frederick George Stephens on 21 June
1870, on his return from Nazareth: 'I wonder a little at your
indifference to seeing this country – putting apart the Bible and
Testament histories, and surely they contain as much interesting

74

record as any books in the world. There is the natural formation of the country – the different national interests in the land and the wonderful facts these have caused to be enacted here to make it a land worth seeing as much as any on the face of the earth – for architectural remains certainly no country deserves to be compared with it' (Bodleian Library, Oxford, MS.Don.e.67).

The view from the southern windows of the house which Hunt rented in Jerusalem, Dar Berruk Dar, was of the 'country towards Bethlehem' (Hunt letter to F.G. Stephens, 20 December 1869, MS. *ibid.*) and may well have included part, at least, of the landscape depicted in this watercolour, which is described in the 1906 catalogue of Hunt's retrospective exhibition at the Leicester Galleries as 'Jerusalem seen from the West walls, looking over the valleys of Gihon and Hinnom towards Bethlehem.' J.E.B.

PROVENANCE
Coll. the artist; by descent to the present owner

EXHIBITIONS
1906, London, Leicester Galleries, *An Exhibition of the Collected Works of W. Holman Hunt, O.M., D.C.L.* (no. 38)
1906–07, Manchester City Art Gallery, *The Collected Works of W. Holman Hunt, O.M., D.C.L.* (no. 58)
1907, Liverpool, Walker Art Gallery, *Collective Exhibition of the Art of W. Holman Hunt, O.M., D.C.L.* (no. 27)
1947, Birmingham, City Museum and Art Gallery, *The Pre-Raphaelite Brotherhood (1848–1862)* (no. 91)
1969, Liverpool, Walker Art Gallery; London, Victoria and Albert Museum, *William Holman Hunt* (no. 222)

REFERENCES
Hunt 1905, II, p. 281, ill.
Leicester Galleries, *An Exhibition of the Collected Works of W. Holman Hunt, O.M., D.C.L.*, London, 1906 p. 43

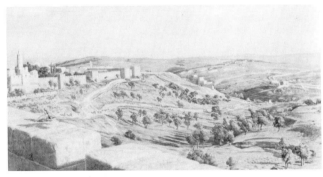

75

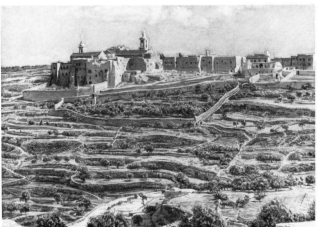

76

76† {.unnumbered}

Bethlehem from the North 1892

Watercolour, bodycolour and traces of pencil on paper, pasted on board:
25·8 × 35·9 cm
Monogrammed and dated bottom left: *Whh/1893*
Sir Humphry Mynors Bt.
[*repr. in colour on p. 165*]

Holman Hunt provided fourteen illustrations for Sir Edwin Arnold's poem *The Light of the World or the Great Consummation* (1891), reissued by Longman's, Green & Co. in 1893. This view of the Church of the Nativity and the Franciscan Convent, Bethlehem, executed as an illustration to the first part of Arnold's poem, derives from the month Hunt spent working on the project during his final trip to the Holy Land. He was, at this time, much struck with the beauty of the landscape, and decided to use watercolour for the views of Bethlehem and Jerusalem (William Morris Gallery, Walthamstow), although the illustrations were to be in various black and white media.

The nine preparatory drawings executed in connection with Arnold's poem were hung together on one wall at the Royal Society of Painters in Water Colours in late 1892. *Bethlehem from the North* was shown with the following quotation in the catalogue from *Mandeville's Travels*, written in the late fourteenth century: 'And towards the east end of the City is a very fair and ancient church with many towers, pinnacles, and corners, strongly and curiously made.' This suggests that Hunt wished the viewer to concentrate as much on the topography as on the religious associations of the scene. *The Times* noted that the works were 'full of such realism as can be imported into a sacred picture by means of a direct study of the localities', while Cosmo Monkhouse in the *Academy* compared Hunt's factual records of Bethlehem and Jerusalem, with their rocky terrains and prominent buildings, to Seddon's *The Valley of Jehoshaphat: Painted on the spot during the Summer and Autumn Months* (1845–55; Tate Gallery, London). A contemporary photograph of the site, taken by Bonfils, Beirut (Palestine Exploration Fund Coll., London), reveals both the accuracy of Hunt's depiction and also that the patch of bodycolour beneath the inscription represents part of the roof of a foreground building.

The monogram and date appear to have been added some time after the watercolour was executed, when Hunt's eyesight had deteriorated, and the ascription to 1893 is almost certainly due to a lapse of memory. It is however possible that he continued to work on this picture after its return from the Royal Society of Painters in Water Colours. J.E.B.

PROVENANCE
1892, the artist; 1908, 19 November, presented to Lady Constance Leslie, and thence by descent to her son, Sir John Leslie Bt.; 1941, 20 August, Sotheby's, London (lot 17) acquired by Sir Anthony Wagner on behalf of Sir Roger Mynors; 1943, presented to his brother, the present owner

EXHIBITIONS
1892–93, London, Royal Society of Painters in Water Colours, *Winter Exhibition of Sketches and Studies. The Thirty-First* (no. 253)
1906, London, Leicester Galleries, *An Exhibition of the Collected Works of W. Holman Hunt, O.M., D.C.L.* (no. 36)
1906–07, Manchester City Art Gallery, *The Collected Works of W. Holman Hunt, O.M., D.C.L.* (no. 57)
1907, Liverpool, Walker Art Gallery, *Collective Exhibition of the Art of W. Holman Hunt, O.M., D.C.L.* (no. 41)

REFERENCES
'Art Exhibitions', *The Times*, 28 November 1892
Anon., 'The Society of Painters in Water Colours. Winter Exhibition. (First Notice.)' (1892), *Athenaeum*, no. 3397, 3 December 1892, p. 786
C. Monkhouse, 'The Royal Society of Painters in Water Colours', *Academy*, XLII, no. 1074, 3 December 1892, p. 513

77*

The Afterglow in Egypt 1854/63

Arched top: 185·4 × 86·3 cm
Monogrammed, inscribed and dated bottom left: *Whh/Memphis 54–63*
Southampton Art Gallery
[*repr. in colour on p. 97*]

Hunt began working on this picture at the pyramids of Gizah shortly before 26 April 1854. At this point the canvas was approximately half its present size, and the artist concentrated on painting the head of the *fellāhah* girl and the view across the eastern side of the Nile towards the mountain range of the Gebel Mokattum. The difficulties of securing a reliable model (Hunt 1905) and the desert winds, which were once again hindering Hunt's progress, led him to inform his patron, Thomas Combe, on 27 April, that this work was 'in danger of being abandoned'. In fact the artist did not leave Gizah until 6 May, when the picture had been 'brought into a condition to be finished' (Hunt 1905).

One advantage of painting a *fellāhah* was that the model could be persuaded to pose unveiled (see Cat. 56). The costume and jewellery may well have been worked up with the aid of Lane's *Account of the Manners and Customs of the Modern Egyptians*, and it is possible that an illustration in this book (1846 ed., vol. I, p. 79) was the source for portraying the girl balancing a wheat sheaf on her head. Similarly the woman in the lithograph *Entrance of the Temple of Amun, Thebes*, published in David Robert's *The Holy Land, Syria, Idumea, Arabia, Egypt and Nubia*, 1842–49, may, as Kenneth Bendiner has suggested, have influenced the figure's pose and the way in which the water pot is balanced in her right palm.

Hunt informed William Bell Scott in a letter of 11 February 1860 that he intended finishing this picture and *A Street Scene in Cairo: The Lantern-maker's Courtship* (City of Birmingham Museum and Art Gallery) once *The Finding of the Saviour in the Temple* (ibid.) was completed: 'I cannot believe that Art should let such beautiful things pass as are in this age passing for good in the East without exertion to chronicle them for the future.' The canvas was extended *c.* 1860–61 and completed in late November 1863.

The title alerts the spectator to the fact that *The Afterglow in Egypt* is not a simple ethnographic study, and in 1886 Hunt explained that it was intended 'to express nothing but that the light is not that of the sun, and that although the meridian glory of ancient Egypt has passed away, there is still a poetic reflection of this in the aspect of life there' (Hunt 1886; see Cat. 69, 70, and 71). The frame, designed by the artist, incorporates pomegranate motifs, an allusion to Demeter, the Greek goddess of corn, whose other attributes include poppies and sheaves of wheat. J.E.B.

PROVENANCE
c. 1862–64, acquired from the artist by Ernest Gambart; by 1867, acquired by Charles P. Matthews; 1891, 6 June, Christie's, London (lot 60) bought by McLean; by 1907, acquired by Thomas Clarke; 1920, 27 February, Christie's, London (lot 149) bought in; 1926, 29 January, Christie's, London (lot 40) bought by H.H. Clarke; 1946, 26 April, Christie's, London (lot 151) bought in; 1946, presented by Dr H.H. Clarke to Southampton Art Gallery

EXHIBITIONS
1864 and 1865, London, The New Gallery, *Works by William Holman Hunt and Robert Braithwaite Martineau*
1867, Paris, *Exposition Universelle*, British Section, Oils (no. 53)
1877, London, Grosvenor Gallery, First Summer Exhibition (no. 46)
1969, Liverpool Walker Art Gallery; London, Victoria and Albert Museum, *William Holman Hunt* (no. 29)
1972, Coral Gables, Florida; University of Miami, Lowe Art Museum, *The Revolt of the Pre-Raphaelites* (no. 59)
1973–74, Baden-Baden, Staatliche Kunsthalle, *Präraffaeliten* (no. 44)
1983, Brighton, Museum and Art Gallery; Manchester City Art Gallery, *The Inspiration of Egypt: Its Influence on British Artists, Travellers and Designers, 1700–1900* (no. 331)
1984, London, Tate Gallery, *The Pre-Raphaelites* (no. 87)

REFERENCES
Hunt 1905, I, pp. 382–83
W. Holman Hunt, 'The Pre-Raphaelite Brotherhood: A Fight for Art', *Contemporary Review*, XLIX, 1886, p. 828
K. P. Bendiner, 'The Portrayal of the Middle East in British Painting 1835–1860', University of Columbia Ph.D. thesis, 1979, p. 109
W. Holman Hunt letter to Thomas Combe, Plains of Memphis, 26–27 April 1854, MS. Arizona State University Library, Tempe
W. Holman Hunt letter to William Bell Scott, Kensington, 11 February 1860, MS. Princeton University Library, Troxell Coll.
G. Holman-Hunt, 'History of the Pre-Raphaelite Movement', MS. Priv. Coll., n.d., pp. 505–06

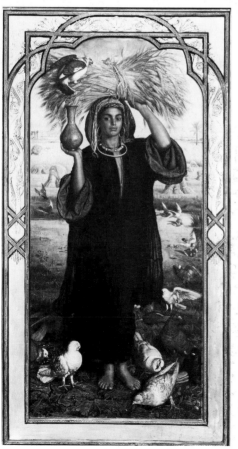

77

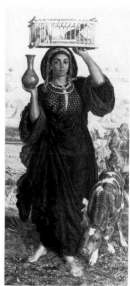

78

78† The Afterglow in Egypt 1860/63

82 × 38 cm
Monogrammed bottom left: *Whh*
The Visitors of the Ashmolean Museum
[*repr. in colour on p. 96*]

This painting, started in 1860, was initially intended as a compositional study for the full-length Southampton version of *The Afterglow in Egypt* (Cat. 77; Hunt 1886 and 1905). On 11 February 1861 Hunt offered the picture to T.E. Plint: 'The Egyptian girl, which is 32 × 14¼ inches will with frame be 300 Guineas. it is as you know, the sketch of a larger picture 6 feet in height. in three or four months it will probably be ready.' Hunt was over-optimistic about the date of completion and Plint decided instead to purchase *The Finding of the Saviour in the Temple* (City of Birmingham Museum and Art Gallery) and five of Hunt's Eastern watercolours, including *The Plain of Rephaim from Zion* (Cat. 73), from Gambart's 1861 German Gallery exhibition.

Originally the girl in the Ashmolean version was set in the centre of the composition, in keeping with its conception purely as a study for the larger painting. However, by late 1861 Hunt had decided to vary the treatment and was adding a brown and white calf lent to him by Maria Pattle Jackson. He wrote to a pupil, Miss E. Tuckett, on 13 November: 'Whenever I am interrupted by torrents of rain or storms of wind I have to change my work with the unconsoling reflection that my live model is growing out of all likeness to the outlines already done – and far too large for the space I have spare for him in my picture.' Problems of overcrowding led to the canvas being extended by about half an inch down the right-hand side. Hunt then added the boy, partly based on the figure in a red turban and blue loincloth in *The Great Pyramid* (Cat. 72) and the white calf, derived from sketches of cattle on the Nile (Mrs Elisabeth Burt Coll.).

On 19 August 1863 Hunt wrote to Mrs Pattle Jackson: 'If by chance . . . you have a little calf again at Hendon I shall ask you to let me come over for a day and finish the one in the little Egyptian which requires a few hours work to complete it'. The picture was probably finished in November 1863 and sold to Thomas Combe soon afterwards.

The linear pattern on the frame designed by the artist is similar to that of *The Plain of Rephaim from Zion*. The abstract tracery of the roundels is particularly suited to an Arab subject. J.E.B.

PROVENANCE
c. 1863–64, acquired by Thomas Combe; 1893, bequeathed by Mrs Thomas Combe to the Ashmolean Museum

EXHIBITIONS
1886, London, The Fine Art Society, *The Pictures of Mr. Holman Hunt* (no. 8)
1969, Liverpool, Walker Art Gallery, and London, Victoria and Albert Museum, *William Holman Hunt* (no. 30)

REFERENCES
Hunt 1905, vol. II, p. 203
W. Holman Hunt, 'The Pre-Raphaelite Brotherhood: 'A Fight for Art', *Contemporary Review*, XLIX, 1886, p. 828
W. Holman Hunt letter to T.E. Plint, Kensington, 11 February 1861, MS. Yale Center for British Art, New Haven
W. Holman Hunt letter to Miss E. Tuckett, Kensington, 13 November 1861, MS. J.S. Maas
W. Holman Hunt letter to Maria Pattle Jackson, Newnham Paddox, 19 August 1863, MS. Berg Coll., New York Public Library
W. Holman Hunt letter to Thomas Combe, 29 November 1863, Bodleian Library, Oxford, MS.Eng.lett.c.296
W. Holman Hunt letter to Thomas Combe, Kensington, 2 February 1864, MS. Priv. Coll.

79 Portrait of the Artist 1867/75

103·5 × 73 cm
Monogrammed and dated bottom left: *18 Whh 75*
Gallerie degli Uffizi, Florence

This painting was begun in London in 1867 as a pendant to the posthumous portrait of Hunt's late wife Fanny (Toledo Museum of Art), so that their son 'might have both father and mother to look at when another generation has found all of our places empty' (Landow 1982). Although the 1907 catalogue of Hunt's Liverpool retrospective exhibition states that 'the artist has depicted himself in the dress in common use in Syria, and constantly worn by him in his painting room', the cross-over gown of striped Oriental cloth was almost certainly made up to the artist's specifications for ease of movement while working, and bears little relationship to the specifically Arab dress of David Roberts (Cat. 115).

Hunt would have been aware that painting himself in Oriental costume was a means of asserting his place in an historical tradition: he had, for instance, seen Van Dyck's portrait of the Earl of Denbigh in a striped Eastern jacket (Cecilia, Countess of Denbigh, *Royalist Father and Roundhead Son*, 1915, ill. facing p. 78) during his visit to Newnham Paddox in August 1863. Moreover, the architectural setting and works of art on the right in the background reflect the artist's interest in the Renaissance, stimulated by his year-long stay in Florence, from where Seymour Kirkup wrote to William Michael Rossetti on 23 March 1867: 'They tell me he [Holman Hunt] is going to change his style & [*sic*.] give up preraphaelism & in fact he talks to me more of Titian than of the Beato [Fra Angelico]' (MS. University of British Columbia, Angeli-Dennis Coll.). This new style can be seen in *Portrait of the Artist*, which, as W. M. Rossetti noted in his diary of 11 February 1868, was 'painted with brushes of great length, so that he stands a good way off the canvas, and finds he can thus give features better as a general whole' (Rosetti, 1903).

79

The decision to paint himself in Oriental dress reflects Hunt's own assessment of his reputation as resting primarily on the works he painted in the Near East, and projects an image of the artist as intrepid explorer. The importance of this pioneering role for Pre-Raphaelite artists had been set forth in a letter that Hunt wrote to W. M. Rossetti on 12 August 1855 (Landow 1982), and his continuing adherence to the original Pre-Raphaelite ideal of 'truth to nature' is underlined by his wearing of the gold intaglio signet ring (Mrs Elisabeth Burt Coll.) given to him by Millais in 1853 as a pledge of affection and solidarity with the Brotherhood. J.E.B.

PROVENANCE
1907, presented by the artist to the Gallerie degli Uffizi

EXHIBITIONS
1875, Liverpool, *Fifth Autumn Exhibition* (no. 763)
1876, Philadelphia, *International Exhibition*, British Section, Department IV, Class 410 (no. 79)
1906, London, Leicester Galleries, *An Exhibition of the Collected Works of W. Holman Hunt, O.M.* (no. 12)
1906-07, Manchester City Art Gallery, *The Collected Works of W. Holman Hunt, O.M., D.C.L.* (no. 25)
1907, Liverpool, Walker Art Gallery, *Collective Exhibition of the Art of W. Holman Hunt, O.M., D.C.L.* (no. 28)
1907, Glasgow, Kelvingrove Art Gallery, *Exhibition of Pictures and Drawings by W. Holman Hunt, O.M., D.C.L.* (no. 17)
1971, Florence, Pitti Palace, *Firenze e l'Inghilterra: Rapporti artistici e culturali dal XVI al XX secolo* (no. 82)

REFERENCES
W.M. Rossetti, *Rossetti Papers: 1862 to 1870: A Compilation*, London 1903, p. 298
Liverpool, Walker Art Gallery, *Collective Exhibition of the Art of W. Holman Hunt, O.M., D.C.L.*, 1907, p. 28
G.P. Landow, 'William Holman Hunt's "Oriental Mania" and his Uffizi *Self-Portrait*', *Art Bulletin*, LXIV, December 1982, p. 646 (Hunt letter to John Lucas Tupper, Bayswater, 19 November 1867, MS. Henry E. Huntington Library, San Marino), p. 653 (Hunt to W.M. Rossetti, Jerusalem, MS. *ibid.*)

[The compiler would like to thank Dr Aileen Ribeiro for information relating to Hunt's costume in this portrait.]

Ingres, Jean-Auguste-Dominique 1780–1867

A highly successful establishment painter, Ingres was born in Montauban (Tarn et Garonne) in 1780, and became the accredited opponent of the emergent 'Romantic' school. He studied initially at the Toulouse Academy under Roques (1754–1847) and Vignan (d. 1829), before moving to Paris in 1797, where he entered the studio of Jacques-Louis David, (1748–1825). In 1801 he won the Prix de Rome with his *Ambassadeurs d'Agamemnon* (Ecole des Beaux-Arts, Paris), but delayed his departure for Italy until 1806, where he remained until 1824, spending the last four years of this period in Florence.

On his return to Paris, Ingres received the Croix de la Légion d'Honneur, and was elected to the Institut de France. In 1825 he opened an atelier which was immediately popular and attended by young artists such as Amaury-Duval, Flandrin, Ziegler and Chassériau (*q.v.*). During each of his stays in Italy (the second from 1835 to 1840 as director of the Villa Medici in Rome), Ingres executed numerous portraits and his popularity in official circles earned him several commissions for large-scale decorative work as well as smaller literary and historical genre scenes.

Like Gros (*q.v.*) Ingres travelled only within Europe, but by choosing overtly unclassical and exotic themes he sought to widen the range of subject-matter which could legitimately be included within the classical traditions of Western art.

ABBREVIATED REFERENCE
Momméja 1906 Jules Momméja, 'Le "Bain Turc" d'Ingres', *Gazette des Beaux-Arts*, September 1906, pp. 177–98

80

Odalisque and Slave 1842
L'Odalisque et l'esclave

76 × 105·4 cm
Signed and dated bottom left: *J. Ingres, 1842*
Walters Art Gallery, Baltimore
[*repr. in colour on p. 41*]

The theme of the odalisque follows a distinct pattern of development within Ingres's oeuvre, from the *Baigneuse* (1807; Musée Bonnat, Bayonne) to the famous *Bain turc* (Louvre, Paris), executed for Prince Napoleon in 1862. The present odalisque possibly refers back to the lost *Dormeuse* of 1808 painted for Queen Caroline of Naples (to which the *Grande Odalisque* [1814; Louvre] was intended as the pendant) and also to the 1828 *Baigneuse, Intérieur d'un harem* (Momméja 1906, p. 24).

This painting is a later variant of a subject first painted in 1839 (Fogg Art Museum, Cambridge, Mass.), differing only in slight formal refinements, such as the moderation of some of the patterned surfaces, the heavier necklace which more clearly accentuates the curve of the stomach, and in the addition of the landscaped courtyard, which allows some air to penetrate into the claustrophobic oppression of the earlier painting. With no first-hand experience upon which to draw for his representation of an odalisque, Ingres sought documentary authenticity in eighteenth-century travellers' accounts, and in particular the letters of Mary Wortley Montague describing the interior of the baths at Adrianopolis. He also referred to Persian miniatures, using Feriol's *Receuil de cent estampes représentant différentes nations du Levant* (1714), a publication owned by Delacroix.

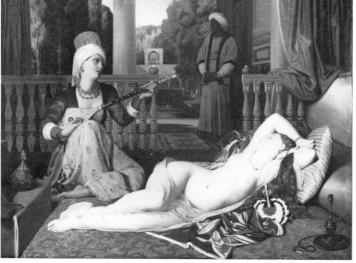

80

The cross-reference between the bather and the odalisque suggests Ingres's desire to Westernise an Oriental theme. A pencil drawing at the Musée Ingres, Montauban (inv. no. 867.2030), thought to be an initial sketch for the lost *Dormeuse*, bears the inscription *Mariucca, blonde belle via Margutta 106*, thus confirming the European origins of the odalisque prototype. This is further substantiated in a letter from Ingres to M. Marcotte, for whom the original version of 1839 was painted, in which Ingres stated his intention to paint 'a rather beautiful body, of generous proportions, and as baroque as possible (it is after all a Turk!)' (H. Delabourde, *Ingres, sa vie, ses travaux, sa doctrine*, 1870, p. 237).

Nevertheless, the odalisques were criticised for their lack of perspective and archaicising gothic qualities (*Journal de Paris*, 1819, quoted Thoré, 'Salon de 1845', p. 249), a criticism first levelled at his portraits of the Rivière family of 1805 (Louvre). In the *Odalisque and Slave*, the perspectival discrepancies in the scale of the figures and the uniform treatment of local colours against the warmer flesh tones flatten the picture into a formal surface arabesque. Although partially disguised through its references to the Renaissance nude, the painting represents a significant step towards the depiction of nudity in a modern context, albeit distanced in space and, to some extent time. Not all critics were blind to the erotic element in the *Odalisque and Slave* and, as Thoré observed in his review of the Salon of 1845, 'the face and the eyes clearly reveal the nonchalance and voluptuousness of a courtesan coming out of the bath' (*op. cit.*, p. 250–51). In general, however, the classical overtones in Ingres's representation of the nude left him morally irreproachable and more than compensated for any potential lack of taste. He thus avoided the extreme controversy provoked by Manet's more uncompromising *Olympia* (Musée d'Orsay, Galerie du Jeu de Paume, Paris), painted over twenty years later. J.M.

PROVENANCE
Painted for King Wilhelm I of Würtemburg; Delessert Coll.; Baron Gustave de Rothschild; Sir Philip Sassoon Coll.; Wildenstein and Co.; 1925, acquired by Henry Walters, Baltimore; bequeathed to the Walters Art Gallery

EXHIBITIONS
1844, Paris, M. Léopold, Boulevard Italien
1950, New York, Paul Rosenberg Gallery, *The Nineteenth Century Heritage* (no. 11.)
1951, Baltimore, Museum of Art, *From Ingres to Gauguin* (no. 6)
1951, Philadelphia, Museum of Art, *Masterpieces of Painting* (no. 51)
1952, Fort Worth Art Center, *Inaugural Exhibition* (no. 42)
1953–54, New Orleans, Isaac Delgado Museum, *Masterpieces of French Painting* (no. 53)
1954, Manitoba, Winnipeg, Art Gallery Association, *French Pre-Impressionist Painters* (no. 10)
1955, Paris, Musée de l'Orangerie, *De David à Toulouse-Lautrec, chefs d'oeuvre des collections américaines* (no. 37)
1960, Berkeley, University of California, *Art from Ingres to Pollock*
1961, New York, Paul Rosenberg Gallery, *Ingres in American Collections* (no. 52)
1965, Indianapolis, Herron Museum of Art, *The Romantic Era* (no. 29)
1967, Montauban, Musée Ingres, *Ingres et son temps. Exposition organisée pour le centenaire de la mort d'Ingres* (no. 114)
1967, New York, Wildenstein and Co., *An Exhibition of Treasures of the Walters Art Gallery* (no. 44)
1967–68, Paris, Petit Palais, *Ingres* (no. 198)

REFERENCES
Ch. Blanc, 'Ingres, sa vie et son oeuvre', *Gazette des Beaux-Arts*, January 1968, ill. opp. p. 18
Th. Thoré, *Salons de 1844–1848*, Paris, 1868, pp. 250–51
H. Lapauze, *Ingres, sa vie et son oeuvre*, Paris, 1911, p. 352
E. S. King, 'Ingres as a classicist', *Journal of the Walters Art Gallery*, 1942, p. 79–80
G. Wildenstein, *Ingres*, London, 1954, no. 237, pl. 83
Walters Art Gallery, Baltimore, *Catalogue*, 1982 (no. 6)

John, Augustus 1878–1961

Son of a solicitor, John was born and brought up in Wales. He attended the Slade School of Art in London from 1894 to 1898, gaining a reputation for flamboyant behaviour, wild love affairs and bohemianism. From 1901 to 1904 he taught painting at Liverpool University, also acting as co-principal with William Orpen of the Chelsea Art School. In 1903 he became a member of the New English Art Club. On a visit to Paris in 1907 he saw an exhibition of drawings by Puvis de Chavannes and met Picasso. Both experiences left their influence on his work, which for a while kept abreast of European avant-garde painting. John became an Associate of the Royal Academy in 1921 and a full Academician in 1928. His later work failed to live up to the promise of his youth.

81

Portrait of Colonel T. E. Lawrence 1919

80 × 59 cm
The Trustees of the Tate Gallery

Thomas Edward Lawrence, 'Lawrence of Arabia' (1888–1935), became fascinated with the desert and the Arabs after studying archaeology and taking part in excavations in the Near East. He worked for military intelligence as liaison officer with Emir Feisal and was the inspiration behind Arab hostilities against the Turks during the First World War, later describing his experiences in *Seven Pillars of Wisdom* (1926). From 1922 he served in the Royal Air Force under the name of 'T. E. Shaw'. He was killed in a motorcycle accident in 1935. Lawrence and Augustus John first met at the Versailles Peace Conference in 1919, during which this work was painted. Through Lord Beaverbrook, John had obtained a commission as official artist in Canadian War Records and it was in this capacity that he attended the conference, with a view to making portraits of its main participants. Lawrence was there as a member of the British Foreign Office delegation, interpreter to Emir Feisal and supporter of Arab interests. The two men struck up a friendship that lasted until Lawrence's death. 'He sat for me frequently in Paris and later in England,' John wrote. 'Lawrence actually enjoyed being painted and always seemed vastly tickled by the results' (*Chiaroscuro. Fragments of Autobiography: First Series*, London, 1952, p. 238). Three portraits in oil came out of their first meeting, and several drawings, though none relating directly to the present work (for an example, see *op. cit.*, ill. facing p. 240). Later portraits by John of Lawrence as 'Aircraftman Shaw' can be seen at the Ashmolean Museum, Oxford and the National Gallery of Canada. He also made a portrait of Emir Feisal at the conference, with whom Lawrence would converse in Arabic during sittings. This portrait shows Lawrence in the Arab dress he wore for the occasion and wearing the ornamental dagger presented to him by Feisal as a token of gratitude. Lawrence lent this to John, presumably in connection with the portrait. He mentioned it in a letter to the artist of 1 March 1920, after which John notes: 'I returned the dagger T.E. had confided to my care' (*ibid*, p. 247). It was perhaps this feature, along with the tough expression, that prompted Lawrence to refer to the work in letters to John as 'the rebellious one', as opposed to 'the goody-goody one' and 'a third (called by you a dud)', when the three portraits of 1919 were exhibited

at the Alpine Club Gallery in 1920. 'O.C. gallery tells me that you told him the other one (called the rebellious one) was mine: and I wanted to ask you about it', he wrote. 'I have told you I wanted it and I think it's wonderful . . . but the value of it beats me at present and so I can't offer' (*ibid*, p. 245). In spite of wanting the work for himself, Lawrence was greatly amused when it was bought by the Duke of Westminster. 'Really I'm hotter stuff than I thought: the wrathful portrait went off at top speed for a thousand to a *Duke!*' he exlaimed in a letter to John of 19 March 1920. 'Of course I know you will naturally think the glory is yours – but I believe it's due to the exceeding beauty of my face' (*ibid*, p. 246). M.W.

PROVENANCE
1920, acquired from the artist by the Duke of Westminster at the Alpine Club Gallery exhibition; 1920, presented by him to the Tate Gallery

EXHIBITIONS
1920, London, Alpine Club Gallery, *War and Peace Conference Portraits by Augustus John* (no. 8)
1930, Bradford, *Jubilee Exhibition* (no. 123)
1936, Caernarvon, *Eisteddfod, Arts and Crafts Section*
1939, British Council: Warsaw, Helsinki, Stockholm, *Contemporary British Art* (no. 44, ill.)
1946, Leeds, Temple Newsam, *Augustus John* (no. 35)
1955–57, Cardiff, National Museum of Wales (long loan)

REFERENCE
A. John, *Chiaroscuro. Fragments of Autobiography: First Series*, London, 1952, pp. 238, 245–46

81

Lear, Edward 1812–1888

In an age when many undertook long and arduous journeys to uncharted territories, Lear, who once called himself a 'Painter of Poetical Topography', was an unusually intrepid traveller. He lived for several years in Italy at the beginning and end of his career, and also in Greece, which he hoped to illustrate in its entirety. He toured many parts of Europe, Egypt, Palestine and Syria, and at the age of sixty travelled the length and breadth of India and Ceylon. He sketched all these places assiduously and at the same time wrote copious descriptions in his diaries and long, amusing letters to his sister and friends. He also composed his famous nonsense rhymes and stories, and published several illustrated travel accounts; but he did not succeed in his aspiration to be recognised as a serious landscape painter. When nearly forty years old, he attended the Royal Academy schools, sought advice from William Holman Hunt (*q.v.*) and exhibited at the Royal Academy and the British Institution. But his two most ambitious works, *Masada* (present location unknown) and *The Cedars of Lebanon* (present location unknown, see Cat. 84), were failures and, although he continued to paint small oils for patrons, from the late 1860s he aimed merely 'to topographize all the journeyings of my life' (letter to Lady Waldegrave, Cannes, 9 January 1868, LLEL, 1911, p. 91).

ABBREVIATED REFERENCES
LEL 1907 Lady Strachey, ed., *Letters of Edward Lear*, London, 1907
LLEL 1911 Lady Strachey, ed., *Later Letters of Edward Lear*, London, 1911
Noakes 1979 V. Noakes, *Edward Lear: The Life of a Wanderer*, London, rev. ed. 1979
MS. Journal E. Lear, MS. Journal, The Houghton Library, Harvard University
MS. Letters (Ann) E. Lear, MS. Letters to Ann, transcription in Priv. Coll.

[The compiler wishes to thank Vivien Noakes for her invaluable assistance in the cataloguing of the following works.]

82

Philae on the Nile 1855

34 × 53·5 cm
Signed and dated bottom right: *E. Lear 1855*
Inscribed on a label *verso* at top of frame: *Philae on the Nile Edward Lear 1855*
The Brooklyn Museum, gift of David Nash
[*repr. in colour on p. 57*]

The Island of Philae, just above the first cataract of the Nile, was for many nineteenth-century visitors the most attractive of Egypt's ancient sites. Lear was one of many who eulogised its beauty. On his first visit in February 1854 he camped there for ten days, writing to his sister Ann: 'It is impossible to describe the place to you any further than by saying it is more like a real *fairy island* than anything else I can compare it to. The Nile is divided here into several channels by other rocky islands, beyond you see the desert and the great granite hills of Assouan. The great T. of Isis, on the terrace of which I am now writing, is so extremely wonderful that no words can give the least idea of it' (letter to Ann, 7 February 1854; quoted Noakes 1979, p. 122).

Lear well appreciated the pictorial value of the scene: finding the Ptolemaic temples on the island the easiest of all the Nile antiquities to represent, he made twenty-five drawings from several different viewpoints (MS. Letters [Ann], 15 February 1854).

During the five years following his return, he used these sketches for about a dozen oil paintings. The present example is a view from the rocky bank of the Nile to the south-east of the island with the Kiosk of Trajan and to its left the first pylon

at the southern end of the Temple of Isis. Of the eleven paintings of Philae listed by Lady Strachey as sold by Lear between 1855 and 1858 (LEL 1907, pp. 314–15), the present exhibit could be either no. 116, acquired by William Nevill, or no. 118, acquired by Henry F. Walter. Another possibility is *The Island of Philae, above the first cataract on the Nile, from the south – afternoon*, one of the two Philae subjects exhibited at the Royal Academy in 1856 (no. 625).

Lear was no less enthusiastic on his last visit to Philae in 1867, finding it 'more beautiful than ever' (MS. Journal, 30 January 1867; quoted Noakes 1979, p. 220); this resulted in yet more watercolour and oil paintings.

The painting exhibited here, with its strong colours and emphasis on natural phenomena, such as the rocks and palm trees in the foreground, is characteristic of Lear; hence it is a more poetic rendering of the scene than that of David Roberts (Cat. 112). B.L.

PROVENANCE
Dr. Myer H. Salaman; 1970, 17 June, Sotheby's, London (lot 134) bought by J. Maas; bought from Maas by William Dally; 1980, 6 October, Sotheby's Belgravia, London (lot 10); Mr David Nash; 1980, presented by him to the Brooklyn Museum, New York

EXHIBITION
1865, Royal Academy, Summer Exhibition (no. 625, as *The Island of Philae, above the first cataract on the Nile, from the south – afternoon*)

83*

Jerusalem from the Mount of Olives, Sunrise 1859

40 × 60·3 cm
Signed with initials and dated bottom left: *EL 1859*
Signed, inscribed and dated on label *verso* and on the stretcher:
Jerusalem from the Mount of Olives, Sunrise From Drawings made by me in April/ May 1858 Painted for Sir James Reid – Edward Lear 1858/9
Private Collection
[*repr. in colour on p. 57*]

Lear's original intention of visiting the Holy Land with William Holman Hunt (see Cat. 72) in 1854 did not materialise; instead he travelled there from Corfu four years later. He arrived in Jerusalem on 27 March 1858 and the next day, Palm Sunday, explored the country immediately outside the walls. After visiting Petra, he returned to the city on 20 April and spent a week encamped on the Mount of Olives making drawings for a painting of Jerusalem at sunset which Lady Waldegrave had

commissioned (MS. Letters [Ann], 23, 28 April, 2 May 1858; 1977, 29 July, Christie's, London, lot 107, 174; Priv. Coll., England).

The present exhibit shows Jerusalem from an almost identical viewpoint, but at sunrise. In a letter to his patroness, he described 'an oblique North-East view', which included 'the site of the temple & the two domes, – and it shews the ravine of the valley of Jehoshaphat, over which the city looks: – and Absalom's pillar (if so be it is his pillar), the village of Siloam, part of Aceldama, & Gethsemane are all included in the landscape . . . add to all of which there is an unlimited foreground of figs, olives & pomegranates, not to speak of goats, sheep, & huming [*sic*] beings' (letter to Lady Waldegrave, Damascus, 27 May 1858; Taunton Records Office, Somerset). As well as the many drawings he accumulated, he also obtained photographs, and believed that the picture would be among his best.

Sir James Reid, for whom *Jerusalem from the Mount of Olives, Sunrise* was painted, had been Supreme Judge in the Ionian Islands when Lear was living in Corfu before his visit to the Holy Land. Reid had first suggested a painting of Jerusalem in February 1858 but for Sir Moses Montefiore rather than for himself (letter to Fortescue, Corfu, 27 February 1858, LEL 1907, p. 88). A year later Lear wrote to Ann that several of his paintings from his Holy Land trip were well advanced, including Lady Reid's Jerusalem (MS. Letters [Ann], Rome, 3 February 1859).

In the painting exhibited here, Lear appears to emulate some of the methods of his Pre-Raphaelite mentor, William Holman Hunt (*q.v.*), notably in the high viewpoint, the diagonal of the hillside, which is more strongly emphasised in the painting than in the drawings (eg. one signed, inscribed and dated 1858, sold Sotheby's, London, 13 March 1969, lot 138), and the detailed treatment of the plants growing among the rocks in the foreground.

The Mount of Olives had strong biblical associations, and although Lear's reasons for his choice of this viewpoint seem to have been purely pictorial, he was as much aware of the associations of the Holy City and its surroundings as were the many other visitors during the nineteenth century (see Warner p. 32, Bugler p. 28). B.L.

PROVENANCE
1859, painted for Sir James Reid; 1980, 29 February, Christie's, London (lot 14)
EXHIBITIONS
1980, London, The Fine Art Society, *Travellers Beyond the Grand Tour* (no. 3; ill. p. 12)
1983, London, The Fine Art Society, *The Travels of Edward Lear* (no. 89; ill. p. 41)
REFERENCES
LEL 1907, pp. 88, 315, no. 148
MS. Letters (Ann), Rome, 3 February 1859

82

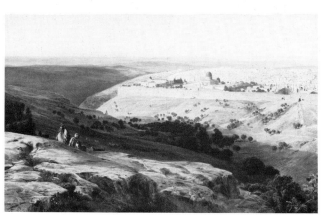

83

84

The Cedars of Lebanon *c.* 1862

68 × 113·5 cm
H. Fritz-Denneville Fine Arts Ltd
[*repr. in colour on p. 56*]

After leaving Jerusalem (see Cat. 83), Lear sailed from Jaffa to Beirut to visit the Lebanon in May 1858. He spent only a few days exploring the interior of the country because, although he found it 'wonderfully fine: – a kind of Orientalized Swiss scenery', the extreme cold of the mountains made him unwell and he had to return to the coast; but he did manage to make a 'drawing of the Cedars as a sign of my Lebanon visit' (letter to Lady Waldegrave, Damascus, 27 May 1858; LEL 1907, p. 109).

Two on-the-spot sketches are known: one inscribed and dated *The Cedars Lebanon 21.May 1858* (Victoria and Albert Museum, London; P.4-1930), the other inscribed and dated *The Cedars. Lebanon 20.21.May 1858* (Priv. Coll., London). The latter is similar in composition to a more finished watercolour, signed and inscribed *Edward Lear Lebanon 1858* (exhibited Norwich Castle Museum, 1957, no. 44), and also to the present exhibit.

Lear is known to have painted the cedars in oil at least four times (LEL, 1907, pp. 316–18, and Arts Council of Great Britain, *Edward Lear 1812–1888*, London, 1958, no. 6). The first (present location unknown) was one of two huge paintings with which he hoped to establish his reputation in England, and in September 1860 he went to Oatlands Park Hotel at Walton-on-Thames to paint from the ancient cedars in the grounds (Noakes 1979, pp. 177–79). The oil was finished in May 1861, the first for which he had received no help from William Holman Hunt, and later that year it was exhibited in Liverpool where it was favourably received. The following year, however, when it was exhibited in London at the International Exhibition, it was badly hung and was slated by *The Times*'s critic; nor did it sell until 1867. Severely depressed by this blow, Lear became increasingly disillusioned and isolated.

Lear's second version of *The Cedars of Lebanon* (the present exhibit) was painted by 1862 and purchased by Charles Roundell. Some years later Roundell was described by Lear as 'a great friend of mine' and as owning four of his pictures (letter to Fortescue, Turin, 31 July 1870; LLEL 1911, p. 123). B.L.

PROVENANCE
Charles S. Roundell, MP for Grantham and Skipton, and thence by descent; 1980, 6 June, Christie's, London (lot 118)
REFERENCES
LEL, 1907, p. 317, no. 226
LLEL, 1911, p. 123

85

The Pyramids Road, Gizah 1873

52·1 × 103·2 cm
Signed with monogram and dated bottom left: *EL 1873*
Inscribed on an old label *verso*: *A View of the Pyramids Road at Gizeh, with the avenue of Trees planted in 1868 by the Empress Eugenie, at the opening of the SUEZ CANAL*
The Fine Art Society, London
[*repr. in colour on p. 56*]

Before his first trip to Egypt in 1849, Lear foresaw that 'the contemplation of Egypt must fill the mind, the artistic mind I mean, with great food for the rumination of long years' (letter to Fortescue, Rome, 12 February 1848; LEL 1907, p. 8). Egypt was indeed a potent source of inspiration for his art: he visited the country on five occasions, in 1849, 1853–54, 1858, 1866–67

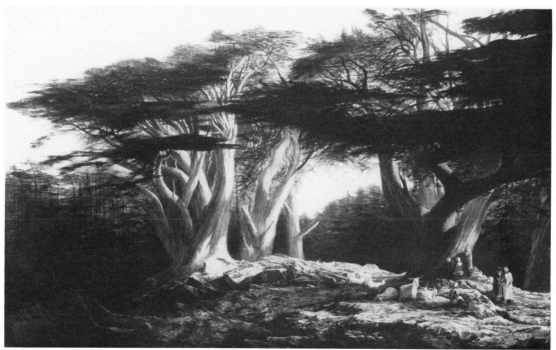

84

and 1872, and painted at least forty-six Egyptian subjects in oils as well as many watercolours and innumerable on-the-spot sketches.

The present exhibit resulted from his last visit in October 1872, when he spent a few days in Cairo on his way to Suez to pick up a boat for Bombay. Lord Northbrook, his friend and patron, who had invited him to India, had already asked him to paint 'two pictures of the Pirrybids' (letter to Fortescue, San Remo, 28 February 1872; LLEL 1911, p. 145), and now commissioned a drawing of Cairo from him (Noakes 1979, p. 263). In his journal Lear commented on how much the neighbourhood of Cairo had changed since his last visit five years earlier, especially in the area around the Pyramids: 'Nothing in all life is so amazingly interesting as this new road & avenue – literally all the way to the Pyramids!!! – I could really hardly believe my own senses remembering the plain in 1867' (MS. Journal, 13 October 1872). He sketched there on 13 and 14 October: 'I drew again at the head of the great Acacia avenue – but flies made the work *impossible*' (MS. Journal, 14 October 1872). A compositional thumbnail sketch for the present exhibit is included in this journal entry.

Later that year he finished a watercolour of the Pyramids Road (F. H. Sasse Coll.; exhibited The Fine Art Society, London, 1983, no. 78) and in 1873 he repeated the composition (the present exhibit) apparently for Lord Northbrook. Another view of the Pyramids of the same size was painted in the same year, also apparently for Lord Northbrook (1980, Christie's, London, lot 25; Priv. Coll.). The two pictures may be the 'Pirrybids' in Lady Strachey's list (LEL 1907, p. 318, nos. 272, 273). B.L.

PROVENANCE
?The Earl of Northbrook; The Fine Art Society, London

EXHIBITION
1983, The Fine Art Society, London, *The Travels of Edward Lear* (no. 80; ill. pp. 44–45)

Lecomte-du-Nouÿ, Jules-Jean-Antoine
1842–1929

The descendant of a noble Piedmontese family, Lecomte-du-Nouÿ was born in Paris in 1842. He entered the Ecole des Beaux-Arts in 1861 where he studied under Gleyre (*q.v.*) and Signol, and in 1864 became a pupil of Gérôme (*q.v.*). Like his fellow students Paul Lenoir and Albert Aublet, he was strongly influenced by the polished realism of the 'Néo-grec' School, and executed a number of meticulously detailed scenes drawn from antiquity. Though he exhibited historical genre, religious paintings and portraits from the Salon of 1863 onwards, official recognition came only in 1869, when one of his works was acquired by the State. In 1872, Lecomte-du-Nouÿ turned his attention to the Orient, and set out for Greece, Egypt, Turkey and Asia Minor, returning to France with a large store of very exact documentary information.

From the mid-1870s he received commissions for the decoration of the churches of St. Nicholas and Ste. Trinité (Chapelle de St-Vincent-de Paul) in Paris, and later executed religious cycles for churches in Rumania.

In 1895 he exhibited his first sculpture, and obtained an honourable mention for his *Mort de Gavroche* at the Salon of 1901.

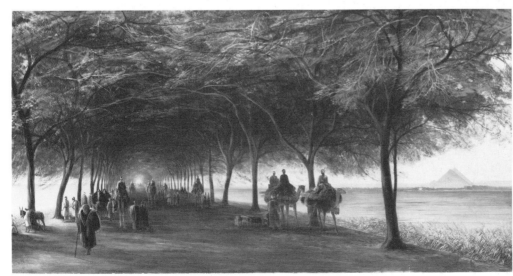

85

86

The Guard of the Seraglio: Souvenir of Cairo 1876

La Poste du Sérail: souvenir du Caire

74 × 130 cm
Signed and dated bottom left: *LECOMTE-DU-NOUŸ/1876*
Pierre Bergé Collection, Paris
[*repr. in colour on p. 99*]

This painting, perhaps Lecomte-du-Nouÿ's most direct reference to his travels in 1872, typifies the languid opulence of the artist's vision of the East. His choice of dramatic themes of despotism, violence and eroticism was affected partly by his readings of early romantic interpretations of the Orient; the *Porteur de mauvaises nouvelles* (1872; Musée du Luxembourg) and the *Ramsès dans son harem* (1885; with The Fine Art Society, London, 1978) are both drawn from Gautier's *Roman de la momie* (1870), and in 1885 he exhibited a painting based on Victor Hugo's *Orientales* (1829) as part of a polyptych dedicated to the poet.

Nominally inspired by Cairo, *The Guard of the Seraglio* reveals the fantastic architectural confections of which the Khedival royal family were so fond, with 'fairy-tale grounds' as reported by Emile Lott. The site is the Harem Pavilion of the Gazirah Palace on the island of the same name looking north-east across the Nile to Bulāq. Half a mile away the Mosque of Sinān Pasha can be seen although the artist has judiciously rearranged the surrounding minarets. The gleaming, lithe bodies of the black eunuchs and the indolent luxuriance of the chief guard, set against the dark entrance to the harem introduce an element of the voyeur, undoubtedly designed to titillate European sensibilities with its erotic overtones. Significantly, the painting had already found a purchaser by the time it was exhibited in 1877.

In the precise rendering of rich surface textures and vivid colouring, the painting risks becoming oppressively claustrophobic, but for its exterior location and the cool tones of the architecture in the subdued light of evening. In both his Orientalist painting and his other work, Lecomte-du-Nouÿ made frequent use of the eerie qualities of half-light to dramatic or melancholic effect. In *L'Heure du prière* (c. 1872; National Gallery of Jordan) an evocative half-light suggests the strange impression left by the religious ceremony, and in *La lune de miel; Venise au XVIe siècle* (Salon, 1875; present location unknown) a cool, reflected moonlight evokes the historic past of this romantic city. The exotic contemporary location of the present painting, however, could not conceal the essential '*caractère antique*' of the figures (Houssaye, 1877, p. 844) and many critics were of the opinion that the artist's new Oriental subject-matter was unsuited to the archaeological precision of his earlier 'Néo-grec' style. As early as 1865, Maxime du Camp had recognised the inquiring spirit behind Lecomte-du-Nouÿ's *Sentinelle grec* (present location unknown) but had warned against the emptiness of including detail for detail's sake, and an excessive preoccupation with '*le bric-à-brac*' (1867, p. 157).

For many academic and 'Néo-grec' painters, Orientalist detail served more to expand a repertoire of authentically and dispassionately observed facts than to enhance the specific meaning of a painting. J.M.

PROVENANCE
By 1877, Comte Daupias Coll., Paris; 1892, 16–17 May, Galerie Georges Petit, Paris (lot 143); 1977, November, Christie's, London (lot 8); 1977, Pierre Bergé Coll., Paris

EXHIBITION
1877, Paris, Salon (no. 1267)

REFERENCES
Thornton, 1983, ill. pp. 188–89
M. du Camp, 'Le Salon de 1865', *Les Beaux-Arts à l'Exposition Universelle et aux Salons de 1863, 1864, 1865, 1866 et 1867*, Paris, 1867, p. 157
A. Houssaye, 'Le Salon de 1877 – II', *Revue des Deux Mondes*, June 1877, p. 844
L-E. Duranty, 'Réflections d'un bourgeois sur le Salon', *Gazette des Beaux-Arts*, July 1877, pp. 79–80, ill. p. 81
Paris, *Catalogue des Tableaux anciens et modernes composant l'importante collection de M. le Comte Daupias*, 1892, pp. 116–17, ill. p. 117

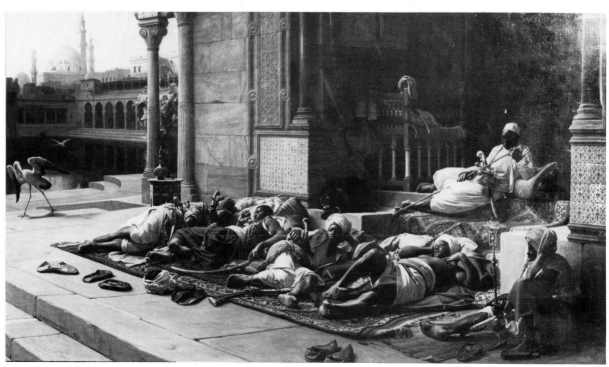

86

Lord Leighton, Frederic 1830–1896

Born in Scarborough, the son of a doctor, Leighton spent long periods of his childhood on the Continent, where his parents lived for the benefit of his mother's health. He received his first training at the Städelsches Kunstinstitut in Frankfurt in 1846–48 and 1850–52, latterly under the Nazarene painter Edward von Steinle. He was in Rome from 1852 to 1855 and there painted his *Cimabue's Madonna* (Royal Coll.), which attracted much attention at the Royal Academy in London in 1855. Based in Paris from 1855 to 1858, he came under the influence of the French neo-classicists. In 1859, after another short stay in Italy, he finally settled in London. With *Helen of Troy* (Priv. Coll.), exhibited in 1865, he began to paint the dreamy, sensuous pictures with classical themes and impassively beautiful female figures that make up the bulk of his mature work. His major large-scale essays in this vein are *The Syracusan Bride* (1865–66; Priv. Coll.), *The Daphnephoria* (1874–76; Lady Lever Art Gallery, Port Sunlight) and *Captive Andromache* (c. 1888; Manchester City Art Gallery). He painted a pair of large frescoes at the Victoria and Albert Museum, London, in 1870–73 and in the 1870s played an important role in the development of the 'New Sculpture'. Leighton became an Associate of the Royal Academy in 1864, a full Academician in 1870 and President in 1878. He was a respected public figure and entertained on a lavish scale at his home in Holland Park (now Leighton House).

ABBREVIATED REFERENCE
Ormond 1975 R. and L. Ormond, *Lord Leighton*, New Haven and London, 1975

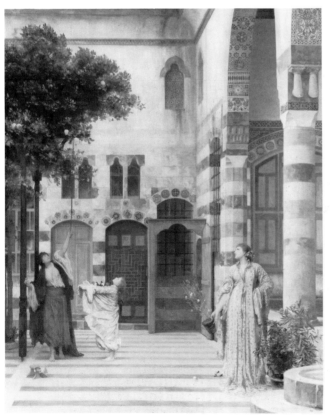

87

87*

Old Damascus: Jews' Quarter 1873–74

129·5 × 104·1 cm
Private Collection

Leighton travelled to North Africa and the Near East five times: in 1857 to Algiers, in 1867 to Constantinople and other parts of Asia Minor, in 1868 to Egypt, where Ismāʿīl Pasha provided him with a steamer, a French chef and an Italian waiter for his journey up the Nile to Aswān, in 1873 to Damascus and in 1882, fleetingly, to Egypt again (for a fuller account of his journeys, see Ormond 1975, chap XI, pp. 95–101). Arriving at Damascus in the autumn of 1873, he was more impressed by the distant prospect of the city than its interior but did enjoy the old houses 'of which some few are standing, though grey and perishing, and which are still lovely to enchantment' (Ormond 1975, p. 98). He had hoped to see Richard Burton (see Cat. 117), whom he had known since being introduced to him by his friend Mrs Sartoris in 1869, but was disappointed to find he was no longer British Consul there, having been transferred, against his will, to Trieste. Nevertheless, he did make an oil sketch of the house in which Burton and his wife had lived (Ormond 1975, no. 222). His well-known portrait of Burton, now in the National Portrait Gallery, London, was made in 1875. Leighton did much sketching in Damascus with a view to working up 'one or two pot-boilers', as he called them, on his return home. The main 'pot-boilers' to result were *Old Damascus: Jews' Quarter* and *Portions of the Interior of the Grand Mosque of Damascus* (Cat. 88). In both cases, the architectural details are plausible but Leighton made little effort to achieve any kind of authenticity with the figures, obviously using the same models as he used for other, non-Oriental subjects. There are also figure-compositions that reflect his experience of the Near East in their accessories, for instance, the *Study: at a Reading Desk* (Holt Bequest, Sudley) and the *Music Lesson* (Guildhall Art Gallery, London), both exhibited at the Royal Academy in 1877, but again the models are clearly European. Another result of the Damascus trip was the 'Arab Hall' Leighton added to his house in 1877–79. A fanciful imitation of an Islamic interior, this contains tiles, stained glass and woodwork brought back from Damascus, augmented by modern British furnishings designed in a matching style.

A study for *Old Damascus: Jews' Quarter* is at the Ashmolean Museum, Oxford. M.W.

PROVENANCE
By 1907, Lord Mildmay; Taxation Publishing Company Ltd; 1983, 25 November, their sale, Christie's, London (lot 66); acquired by Christopher Wood for the present owner

EXHIBITIONS
1874, London, Royal Academy, Summer Exhibition (no. 303)
1907, London, Royal Academy, Winter Exhibition (no. 163)

REFERENCES
Ormond 1975, pp. 98, 162, no. 218
E. Rhys, *Frederic, Lord Leighton, P.R.A.*, revised ed., London, 1900, pp. 29, 33
A. Corkran, *Frederic Leighton*, London, 1904, p. 101
Mrs Russell Barrington, *Life, Letters and Work of Frederic Leighton*, London, 1906, II, p. 205
E. Staley, *Lord Leighton of Stretton, P.R.A.*, London, 1906, p. 95
A. L. Baldry, *Leighton* (Masterpieces in Colour series), London, 1908, ill. opp. p. 24 (as *Gathering Citrons*)

88

Portions of the Interior of the Grand Mosque of Damascus 1873–75

158 × 120 cm
Harris Museum and Art Gallery, Preston, Lancs.
[repr. in colour on p. 66]

The 'Great Mosque', as it is now usually known, was built on the site of the Basilica of the Heart of John the Baptist during the Caliphate of Walid I (705–15). Leighton's picture is based on a small oil sketch made on the spot during his 1873 visit to Damascus (Ormond 1975, no. 217), studies of the *minbar*, hanging lamp and other details in one of his notebooks now at the Royal Academy (vol. IX), and possibly photographs (see Barrington, 1906, II, p. 208). Although the architecture is accurately recorded, the figures are implausible: the two Muslim men would not be praying in different directions, the faces of the girls on the left would be covered, and as females they would never be walking around on the mosque's main floor. M.W.

PROVENANCE
By 1897, Lord Armstrong; 1910, 24 June, his sale Christie's, London (lot 73) acquired by the Harris Museum and Art Gallery, Preston, Lancs.

EXHIBITIONS
1875, London, Royal Academy, Summer Exhibition (no. 215)
1897, London, Royal Academy, *Exhibition of Works by the late Lord Leighton of Stretton* (no. 71)
1906, London, Royal Academy, Winter Exhibition (no. 134)
1980, Royal Institute of British Architects, *George Aitcheson*

REFERENCES
Ormond 1975, pp. 98, 162, no. 216, illus. pl. 138
E. Rhys, *Frederic, Lord Leighton*, revised ed., London, 1900, pp. 29, 33, 111, ill. opp. p. 28
Mrs Russell Barrington, *Life, Letters and Works of Frederic Leighton*, London, 1906, II, p. 206
E. Staley, *Lord Leighton of Stretton, P.R.A.*, London, 1906, pp. 97–98
Preston Guardian, 2 July, 1910

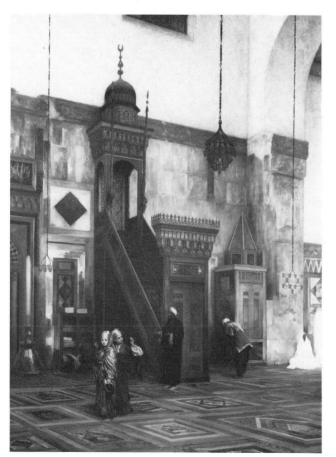

88

Lewis, John Frederick 1805–1875

Born in London, J. F. Lewis seems to have received little art education beyond that offered by his father, an engraver. By the age of twenty-one, he had decided to concentrate upon painting in watercolour, a medium particularly suited to his abilities, and in which he was to achieve his fame. Lewis spent most of his middle years abroad. He stayed for almost two years in Spain and Morocco from 1832 to 1834, and in 1837 he left England and spent the next fourteen years travelling through Italy, Greece and the Levant before finally setting up house in Cairo in 1841. Tantalisingly little is known about Lewis's decade in Egypt, although the last chapter of Thackeray's *Notes of a Journey from Cornhill to Grand Cairo* (London, 1846) gives a vivid account of the author's visit to the artist in 1844, when Thackeray found Lewis living in great style in a large Mamlūk house in the Ezbekiya quarter of Cairo, 'going about with a great beard and dressed up like an odious Turk' (p. 290).

The watercolours of Egypt that Lewis exhibited in the years following his return to England in 1851 earned him great critical acclaim, but, disheartened by the lack of financial reward, he turned to oil painting in the late 1850s. Thenceforth, Lewis was a regular contributor to the Royal Academy, but retained an habitual aloofness from the London art scene at his house in Walton-on-Thames.

ABBREVIATED REFERENCE
Lewis 1978 Major-General Michael Lewis, CBE, *John Frederick Lewis, R.A., 1805–1876*, Leigh-on-Sea, 1978

89*

A Frank Encampment in the Desert of Mount Sinai, 1842 – The Convent of St. Catherine in the distance 1856

Watercolour and bodycolour: 64·8 × 134·3 cm
Signed and dated bottom right: *J.F. Lewis 1856*
The Yale Center for British Art, Paul Mellon Collection
[repr. in colour on p. 51]

When this painting was first exhibited at the Old Water-Colour Society it drew volumes of praise from Ruskin, who wrote, 'I have no hesitation in ranking it among the most *wonderful* pictures in the world; nor do I believe that since the death of Veronese anything has been painted comparable to it in its own way.' What caught the critic's imagination was the extraordinary combination of microscopic detail and compositional unity and breadth, and the painting still ranks as Lewis's most outstanding achievement.

The Englishman in the picture is Lord Castlereagh, whose Near Eastern journey is recorded in his *Diary of a Journey to Damascus*, 1847. Castlereagh and his retinue, which included Count von Pahlen, A. Schranz (his hired artist), Mr Tardew (his physician), Shaykh Hussein (his guide) and Mahmoud (his dragoman), set off from Cairo to Damascus across the Sinai desert in mid-May, 1842, and spent five days encamped at Mount Sinai at the end of the month. In a letter to Lewis he commissioned the artist, for the generous fee of 200 guineas, to paint his portrait with his companions before he left Cairo, and the artist was free to decide upon the setting (quoted *Country*

Life, 21 June 1979). Lewis had already sketched some members of the party before they went, but it is not certain if he actually observed the group *in situ*. He may simply have drawn upon his sketches of the Sinai desert and of the monastery of St. Catherine made on another, undated, trip. The painting does not seem to have been finished until fourteen years after the original commission, despite Castlereagh's plea for an early completion date.

As Ruskin was quick to note, the picture is far from being a straightforward portrait. It represents a meeting between East and West, with Shaykh Hussein, whose homeland was Mount Sinai, standing on the left with the camels, and Castlereagh, dressed in Eastern clothes, recumbent amidst the Western refinements of books, furniture, a newspaper, a map and a bottle of Harvey's sherry on the right. The dead game represents the outcome of a day's shooting, a popular pastime among Western tourists. In the background is the monastery of St. Catherine (see Cat. 9), whose monks frequently extended their hospitality to travellers; the Christian shrines of the Chapel of the Burning Bush and the Tomb of St. Catherine were housed in the monastery, which stood alongside a mosque.

An oil replica of the painting (present location unknown) was exhibited at the Royal Academy in 1863. C.B.

PROVENANCE
1860, sold by G. R. Burnett; G. W. Moss; 1919, sold by C. D. Rudd; Mrs. Fiona Campbell-Blair; 1968, 4 April, Sotheby's, London (lot 76); R. T. Laughton; 1976, 14 April, Sotheby's, London (lot 68) bought by the Fine Art Society; 1977, gift of Paul Mellon to the Yale Center for British Art

EXHIBITIONS
1856, London, Old Water-Colour Society (no. 134)
1868, Leeds Art Gallery, *Exhibition of Works of Art*
1886, Liverpool, Walker Art Gallery, *Grand Loan Exhibition of Pictures* (no. 982)
1887, Manchester, *Royal Jubilee Exhibition*
1892, Southport, *Centenary Exhibition*
1970, Scarborough Art Gallery, *Paintings from the Collection of R. T. Laughton Esq.* (no. 50)
1971, Newcastle, Laing Art Gallery, *J. F. Lewis* (no. 74)
1981, New Haven, Yale Center for British Art, *Works of Splendor and Imagination* (no. 80)

REFERENCES
Lewis 1978, pp. 28, 40 (no. 564), fig. 47
J. Ruskin, *Academy Notes on some of the Principal Pictures*, 1856, reprinted in Cook and Wedderburn, *The Works of John Ruskin*, London, 1903–12, XIV, pp. 73–78
J. L. Roget, *A History of the Old Water-Colour Society*, London, 1891, II, pp. 145–46
R. Davies, 'John Frederick Lewis R.A. 1805–76', London, *Old Water-Colour Society's Club*, 1926, III, pp. 35–36, 39–40, ill. pl. VI
Major-General Michael. Lewis, letter in *Country Life*, 21 June 1979
R. Searight, 'An Anonymous Traveller Rediscovered', *Country Life*, 4 May, 1979
K. Bendiner, 'The Portrayal of the Middle-East in British Painting, 1835–1860', Ph.D. thesis, Columbia University, 1979, p. 213 ff.

90

In the Bezestein, El Khan Khalil, Cairo
(The Carpet Seller) 1860

Oil on panel: 58·5 × 45·7 cm
Signed and dated bottom left: *J. F. Lewis 1860*
Private Collection
[*repr. in colour on p. 46*]

This picture was exhibited at the Royal Academy in 1861 as *In the Bezestein, El Khan Khalil, Cairo*, and it is closely related in setting to the later *The Bezestein Bazaar* (Cat. 96), which seems to represent a longer view of the same street, including the same arch at the centre of the composition. Lewis frequently painted the two main Cairo bazaars, the Khan el Khalil (of which the Bezestein is a part) and the Ghooreyah. The Khan el Khalil, built in medieval times, specialised in the sale of swords, slippers, embroidered goods, silks and fabrics from Constantinople. The old gentleman in this picture is resplendent in Turkish dress, complete with sword.

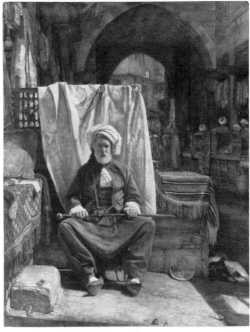

90

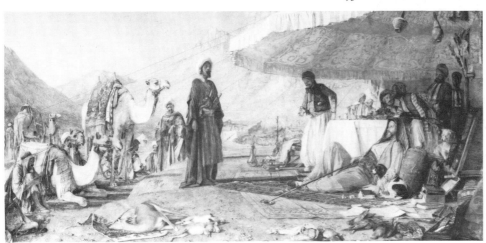

89

The painting was done soon after Lewis took the decision to abandon watercolours in favour of oils, and his consequent resignation from the Presidency of the Old Water-Colour Society in 1858. Although he had achieved fame with the exquisite watercolours exhibited on his return from Egypt, such as *The Harem* (1850; ? destroyed) and *A Frank Encampment* (1856; Cat. 89), he soon tired both of the labour that they cost him and of the fact that working in this medium was so 'thoro'ly unremunerative . . . no rest and such little pay' (Lewis 1978). But this painting, with its small, precise, touch and beautifully-observed detail, is very much closer in approach to the watercolours than the later oils, where the handling is broader and sketchy passages may be seen. It was Lewis's avowed intention, at the outset of his experiment with oils, to finish his paintings with as smooth a surface as possible. Holman Hunt recorded a meeting between Millais and Lewis in which the latter berated the Pre-Raphaelites for their lack of delicacy in oils, and in which he declared that he felt oils should not be more 'piled up' than watercolours. In other respects, Lewis admired the work of the Pre-Raphaelites, thinking that they represented the most promising development in English art, but his own approach to painting, though similar, was arrived at independently. C.B.

PROVENANCE
Sir Thomas Devitt, Bart; 1924, 16 May, Christie's, London (lot 119); acquired by Leggatt; 1976, 24 November, Sotheby's, London (lot 303)
EXHIBITIONS
1861, London, Royal Academy, Summer Exhibition (no. 266)
1978, London, The Fine Art Society, *Eastern Encounters* (no. 45; ill. p. 46)
REFERENCES
Lewis 1978, no. 582
P. and V. Berko, *La Peinture Orientaliste*, Brussels, 1982, ill. p. 80

91†

Edfou, Upper Egypt 1860

Oil on panel: 30 × 76 cm
Signed and dated bottom left: *J. F. Lewis 1860*
The Trustees of the Tate Gallery
[*repr. in colour on p. 51*]

The temple of Edfou, a Ptolemaic structure of later construction than many of the temples along the Nile, resembles Dendarah (see Cat. 110) in date, plan and mythology, and, like that temple, bears many well-preserved inscriptions. In the nineteenth century

Edfou was considered one of the most beautiful monuments on the Nile, but the subject was unusual for Lewis, who painted few strictly topographical views while in Egypt. It seems likely that he had been stung by Ruskin's review of *Waiting for the Ferry* (present location unknown), exhibited at the Royal Academy in 1859, in which the critic had lamented Lewis's restricted subject-matter and constant dwelling upon Arabs and camels, and urged him to paint the 'Sphinx, and the temples, and the hieroglyphics, and the mirage and the simoun, and everything that we want to know about' (*Academy Notes*, reprinted in E.T. Cook and A. Wedderburn, *The Works of John Ruskin*, 1903–12, vol. XIV, pp. 218–99). Lewis accordingly, included a temple in this work, shown the following year, although the painting received no comment from Ruskin.

The painting is far from being a conventionalised, topographical work, however, in that the architecture is subservient to the anecdote of the Bedouin encampment in the foreground. A preliminary sketch of Edfou drawn from the same viewpoint (H. Stokes, 'John Frederick Lewis, R.A. (1805–1876)', *Walker's Quarterly*, no. 28, 1929, ill. facing p. 19) seems to indicate that Lewis moved the minaret to the right in order to accommodate the tent in the finished painting, and so include elements of the ancient (the temple), medieval (the mosque) and modern (the tent). The juxtaposition of modern Egyptian life and ancient Egyptian civilisation is one that frequently occurs in the work of other artists (eg. David Roberts, *q.v.*), often implying some criticism of contemporary Egyptians who failed to live up to the ideals established by their illustrious ancestors. But there is no such moralising intention in Lewis's canvas. In pictorial terms, the painting represents no radical departure; the camel is identical to one that had appeared in the watercolour *A Halt in the Desert* (1855; Victoria and Albert Museum, London) some five years previously, and the recumbent Arab in the foreground is highly reminiscent of a figure in *Waiting for the Ferry*.

There is a watercolour version of the right side of the picture in a private collection and a similar, but smaller watercolour of the whole composition was sold at Christie's in 1981. C.B.

PROVENANCE
1894, 6 February, bought from H. Roberts by Agnew's, London; 1894, 22 February, purchased by the Tate Gallery (Clarke Fund)
EXHIBITION
1860, London, Royal Academy, Summer Exhibition (no. 350)
REFERENCES
Lewis 1978, p. 40 (no. 584), fig. 60
K. Bendiner, 'The Portrayal of the Middle-East in British Painting, 1835–1860', Ph.D thesis, Columbia University, 1979, p. 234

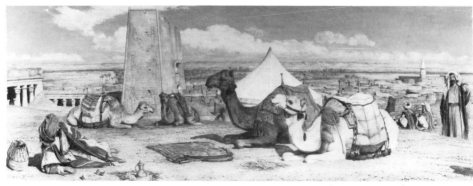

91

92

The Hósh (Courtyard) of the House of the Coptic Patriarch, Cairo; the patriarch is dictating to his secretary despatches to a convent in the desert, to be conveyed by the Arabs in waiting 1864

81 × 109 cm
Signed bottom left: *J. F. Lewis*
Private Collection
[*repr. in colour on p. 48*]

The juxtaposition of one race or creed with another is a theme in several paintings by Lewis. In this example the group of Copts around their patriarch face the Bedouin messengers waiting beside their camels; to the right, a venerable *ḥajj* (identified by his green turban) sits in front of a young Nubian slave; in the left foreground a boy and an unveiled girl, probably Copts, feed the animals. The impression of variety and abundance in this crowded scene reflects the heterogeneity to be found outside in the streets of Cairo. Lewis was probably also aware of William Holman Hunt's *Afterglow in Egypt* (Cat. 77) representing a young Egyptian girl surrounded by pigeons which, although not exhibited until 1864, had been published seven years earlier as an etching entitled *The Abundance of Egypt*.

By placing the animals so prominently in the foreground of his composition, Lewis deliberately displays his virtuosity in rendering texture and pattern. Other decorative elements such as the reflections in the water, the brightly coloured costumes and rugs, the architecture and the foliage of the tree are also carefully rendered, but some of the figures, notably the faces of the girl and of the *ḥajj*, are clumsily executed, and appear unfinished.

The scene is almost exactly described by Thackeray who visited Lewis in Cairo in 1844: 'First we came to a broad open court with a covered gallery running along one side of it. A camel was reclining on the grass there; near him there was a gazelle to glad J. with his dark blue eye . . . On the opposite side

to the covered gallery rose up the walls of his long, queer, many-windowed, many-galleried house. There were wooden lattices to those arched windows through the diamonds of which I saw two of the most beautiful, enormous ogling black eyes in the world, looking down upon the interesting strangers. Pigeons were flapping and hopping and fluttering, and cooing about. Happy pigeons you are, no doubt, fed with the crumbs from the henna-tipped fingers of Zuleikah' (*Notes on a Journey from Cornhill to Cairo*, London, 1845, pp. 284–85).

The painting shown here does indeed depict the courtyard of Lewis's house. This is confirmed by a drawing reliably entitled *Courtyard of the Painter's House, Cairo* (Victoria and Albert Museum, London, E. 5680–1910). The house was built in Mamlūk style, one of many houses still standing in Lewis's day (Lane 1836, I, pp. 6–24) and was almost certainly situated in the Esbekiya district of Cairo (see Artist's sale, 1877, [lot 176] *Interior of Upper Room in a House, Esbekieh, Cairo, occupied by J. F. Lewis, R.A.* This area underwent much reconstruction later in the century and it is unlikely that the house still exists.

Since Lewis was generally accurate in his representation of Cairo scenes, the title he gave to his picture for the 1864 Royal Academy exhibition is puzzling. It is possible that his house was owned by the Coptic Patriarch. It may have been the same house as that which was later occupied by another British resident in Cairo, a Mr Lockwood, and which was visited and drawn by Thomas Seddon in 1854 (J. P. Seddon, *Memoir and Letters of the late Thomas Seddon*, London, 1858, p. 38; Seddon's *Interior of a Deewan, formerly belonging to Copt Patriarch, near the Esbekeeyah, Cairo* [present location unknown] exhibited 1856, Royal Academy, no. 895).

A large unfinished watercolour version of this painting (City Museums and Art Gallery, Birmingham, no. 44/48) was mistitled before 1948 as *House of the Sheikh Amin-al-Suhaimi, Barb-al-Asfar, Cairo*. This house is another characteristic Mamlūk dwelling which has survived, but it is in a different part of the old city (J. Revault and B. Maury, *Palais et Maisons du Caire du XIVᵉ au XVIIIᵉ siècle*, Cairo, I, 1975, pl. LVI, fig. 27; see also a

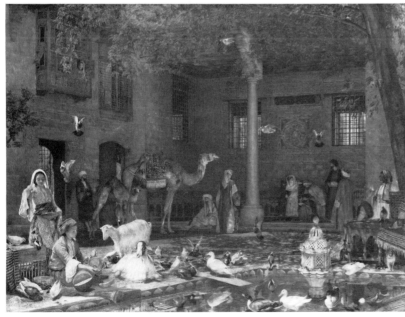

92

drawing by James Wild, 1842, Victoria and Albert Museum, London, E.3766–1938).

A small oil version also exists (Tate Gallery, London, no. 1688) which although more evenly executed is apparently a finished study for the exhibited painting (see Leverhulme sale, 1926, lot 171, ill. as 110·5 × 106·7 cm). The top of the painting shown here has been cut. The same courtyard, viewed from the *maq'ad* (gallery), also appears in a late oil, *The Mid-Day Meal, Cairo* (1875; Owen Edgar Gallery, London). B.L.

PROVENANCE
1875, William Leaf; Ralph Brocklebank; 1893, L. Huth; 1909, Holbrook Gaskell; 1924, Sir Thomas Devitt; 1926, 1st Viscount Leverhulme; 1926, 18 February, his sale, Anderson Galleries, New York (lot 171); Brooklyn Paramount Theatre, New York; 1976, 24 November, Sotheby's, London (lot 307); acquired by the present owner

EXHIBITIONS
1864, London, Royal Academy, Summer Exhibition (lot 110)
1878, Paris, *Exposition Universelle*
1901, London, Royal Academy, *Exhibition of Works by British Artists deceased since 1850* (no. 33)
1901, Glasgow, *International Exhibition* (no. 13)

REFERENCES
Lewis 1978, no. 590
Athenaeum, 7 May 1864, p. 651
Art Journal, 1864, pp. 157, 166

93

A Turkish School in the Vicinity of Cairo 1865

Oil on panel: 66 × 118 cm
Signed and dated bottom left: *J. F. LEWIS 1865*
Private Collection, Houston, Texas
[*repr. in colour on p. 49*]

Painted fifteen years after Lewis's return from Egypt, this picture is based on an earlier watercolour of 1853 which is far simpler in conception, with plain glass windows in place of the elaborate *mashrabiyyahs* and no ornamentation on the chest upon which the scribe leans. In the oil painting, Lewis was unable to resist his customary portrayal of the delicate play of light through the lattice work and the patterns it forms on the carpet. The setting is similar to many other paintings by Lewis, and was probably assembled from elements in the artist's own home in Cairo. The figure of the scribe is related to a drawing Lewis had made in Broussa (present location unknown) and he also reappears in Lewis's *The Commentator on the Qur'ān* (1869; Priv. Coll.).

The children are probably the sons and daughters of the Turkish middle classes in Cairo, their wholesome appearance contrasting strongly with contemporary descriptions of Egyptian children, who were often left unwashed and disease-ridden in order to avert the evil eye. Mid-nineteenth-century accounts of education in Egypt stress that reading and writing were unusual accomplishments for girls, and female illiteracy is referred to in paintings of the period (see Cat. 95, 121). However, Edward Lane conceded that some privileged girls were occasionally taught with boys in a public school, although they were generally veiled and had little to do with the opposite sex (Lane 1835, I, pp. 57–70). Islamic education consisted of memorising and reciting passages of the *Qur'ān* and certain prayers. Accordingly, there is a *Qur'ānic* inscription on the wall behind the schoolmaster that reads, 'There is no God but God, and Muḥammad is his prophet. In the name of God, the compassionate, the merciful, and praise be to God, the Lord of the faithful.' A government certificate on the wall probably proclaims the proficiency of the teacher.

Cats and birds frequently appear in Lewis's work (Cat. 92), but here the placing of the drowsy cat perilously near the pigeons forms an amusing analogy with the children under the watchful eyes of the schoolmaster and his stick.

There is an undated and virtually identical watercolour in the Victoria and Albert Museum, London. C.B.

PROVENANCE
C. P. Matthews; 1891, 6 June, Christie's, London, acquired by Mr Vokins; Stephen G. Holland; 1908, 25 June, Christie's, London (lot 68), acquired by the Rt. Hon. Lord Joicey; 1955, 13 May, Christie's, London, acquired by The Fine Art Society; F. C. Stringer; Priv. Coll., Houston, Texas

EXHIBITIONS
1865, London, Royal Academy, Summer Exhibition (no. 121)
1895, London, The Guildhall, (no. 49)
1901, London, Royal Academy, Winter Exhibition (no. 26)
1971, Newcastle, Laing Art Gallery, *J. F. Lewis R.A.* (no. 80)

REFERENCE
Lewis 1978, pp. 53, 95, 96 (no. 595)

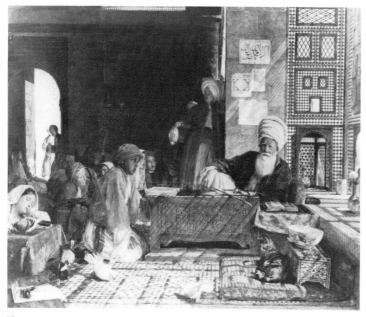

93

94
A Mamlūk Bay, Egypt 1868

Oil on panel: 35·4 × 24·9 cm
Signed and dated bottom left: *J. F. Lewis 1868*
Inscribed on the *verso*: *A Mimlook*
Private Collection
[*repr. in colour on p. 91*]

When this painting was first shown at the Royal Academy in 1869, it bore the title *A Memlook Bey, Egypt.* 'Memlooks', or Mamlūks, were a people of Turkish origin who had originally been brought to Egypt as slaves. They gradually rose above their humble station in the social hierarchy to become the virtual rulers of Cairo by the end of the eighteenth century, a development that was halted by Muḥammad 'Alī during the early nineteenth century. When Lewis was resident in Egypt in the 1840s there were still a number of Mamlūks holding positions of distinction in the army or administration; the title of 'Bay' was conferred on some of those who achieved this eminence.

Mamlūks were traditionally fair-skinned, but this sitter, like so many of Lewis's models, has a rather British air about him. Almost two decades after his return from Egypt, Lewis was undoubtedly relying upon British models as well as his Egyptian sketches to furnish material for his oil paintings. The Mamlūk also bears more than a passing resemblance to the seated Pasha in *The Hareem* (1850; Victoria and Albert Museum, London), providing another example of how Lewis constantly re-used the same figures in his work. The Mamlūk's costume is a mixture of authentic detail and artistic licence, and is probably based upon one of the many costumes that Lewis brought back from Egypt (some of which he wore to fancy-dress parties). The scimitar is of Ottoman origin and the cloak a plausible garment, but the paisley turban is somewhat unlikely. C.B.

PROVENANCE
1973, 15 June, Christie's, London (lot 52) bought by Colnaghi; Priv. Coll.

EXHIBITIONS
1869, London, Royal Academy, Summer Exhibition (no. 876)
1973, London, Colnaghi, *English Drawings, Watercolours and Paintings* (ill. XLV)

REFERENCE
Lewis 1978 (no. 601)

95
An Intercepted Correspondence, Cairo 1869

Oil on panel: 74·3 × 87·3 cm
Signed bottom left: *J. F. Lewis R.A.*
Private Collection, Houston, Texas
[*repr. in colour on p. 50*]

An Intercepted Correspondence, Cairo is one of many paintings by Lewis that depict harem life, but unlike most other harem pictures, it presents a narrative. A woman of the harem has just been discovered in possession of an illicit love-message in the form of a bunch of flowers, but the identity of the intended recipient remains something of a mystery. When the painting was first reviewed in the *Atheneum* (1869), it was suggested that the girl in green in the centre of the painting, discovered with the flowers by the woman grasping her wrist, had merely been acting as an intermediary; the message was destined for the woman seated on the floor, shielding her eyes with her hand, a gesture which was interpreted as one of shame. However, her jovial expression, and the fact that she may simply be protecting her eyes from the sun filtering through the lattice work, somewhat undermine this interpretation; the girl in green may herself be the guilty party.

The picture revolves around the notion that flowers were the love-letters of the illiterate in Near Eastern countries, and this would have been understood by Lewis's public. A number of popular books on the subject were published in mid-Victorian England, for example, *The Language of Flowers* published in 1869 by *The Young Ladies' Journal*, whose preface proclaimed that this form of communication originated in the East and had been popularised in England by Lady Mary Wortley Montague. The book's glossary could lead to the following interpretation of the flowers in the bouquet. The pansy, or heart's ease, exhorts the receiver to think of the giver, the anenome signifies that the giver feels forsaken, the *hibiscus syriacum* pays homage to the woman's delicate beauty and the roses probably symbolise love. In the vase beside the master of the harem stand larkspur (haughtiness), a rose (love) and a scarlet dahlia (instability), suitable attributes for an outraged husband.

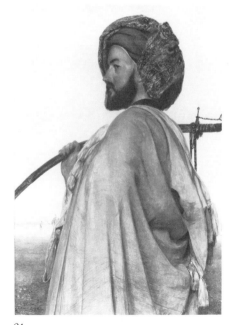

94

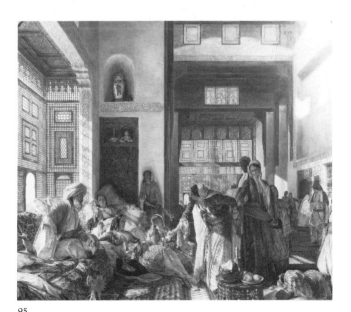

95

The mood of this painting is gently humorous, reminiscent of the amusing tales related by writers such as Gérard de Nerval and Lady Mary Wortley Montague of amorous escapades conducted by ladies of the harem who were able to reach their rendezvous undetected because of their veils. Certainly, the picture gives no hint of the drastic punishments of divorce, and sometimes death, that actually accompanied the discovery of a woman's adultery. Lewis's attitude towards Near Eastern women, and his pictorial treatment of such themes, is far closer to that of his French contemporaries who delighted in the colourful and erotic possibilities inherent in the depiction of harem life (see Cat. 80), than that of his fellow English artists, many of whom were appalled by the oppressive nature of this social institution.

The left side of the picture is very similar, but not identical, to the watercolour of *The Hareem* (1850; Victoria and Albert Museum, London). C.B.

PROVENANCE
Bought from the artist by Charles P. Matthews; 1891, 6 June, Christie's, London (lot 71), acquired by Agnew's; William Kenrick and thence by descent to Hugh Kenrick; 1979, 25 May, Christie's, London (lot 259); Priv. Coll., Houston, Texas

EXHIBITIONS
1869, London, Royal Academy, Summer Exhibition (no. 157)
1906, London, Royal Academy, (no. 109)
1920, Birmingham, City Museum and Art Gallery, on loan
1953, Birmingham, City Museum and Art Gallery, *Works of Art from Midland Homes* (no. 48)
1968, Sheffield, Mappin Art Gallery, *Victorian Paintings* (no. 71)
1971, Newcastle, Laing Art Gallery, *J. F. Lewis R.A.* (no. 83)

REFERENCES
Lewis 1978 (no. 602)
Atheneum, 1869, p. 674
Art Journal, 1869, p. 167
K. Bendiner, 'The Portrayal of the Middle-East in British Painting 1830–1860', Ph.D. thesis, Columbia University, 1979, pp. 200 ff.

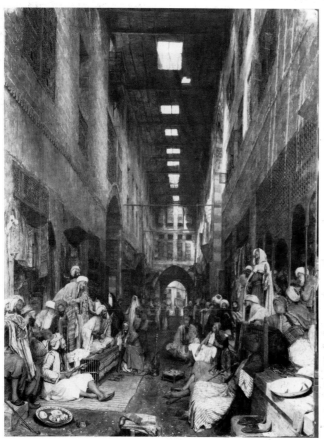

96

96

The Bezestein Bazaar of El Khan Khalil, Cairo 1872

Oil on panel: 113 × 85 cm
Signed and dated bottom left: *J. F. Lewis 1872*
Private Collection
[*repr. in colour on p. 47*]

This crowded composition, in which the brilliant reds and blues of the costumes stand out against the sombre background of the covered bazaar, matches Gérard de Nerval's description of the Bezestein bazaar given in *Voyage en Orient*, in which he likens the streets to those of *The Arabian Nights* with their 'narrow dark passages, overhung with cage-like windows, like our own streets from the middle-ages. The freshness of these almost subterranean ways is a refuge from the heat of the Egyptian sun' (Paris, 1958 ed., I, p. 173).

When the picture was first exhibited, its departure from Lewis's usual approach was noted. The reviewer for the *Art Journal* commented, 'We have been so long accustomed to discourse with Mr Lewis over his small pieces of microscopic finish, that anything larger brings with it a surprise for which there has been no preparation' (1874). Most reviewers spoke favourably of the animation of the composition, although others found the colours strident. The greatest accolade came from a Scottish collector who saw the work at the Royal Academy's private view. Thomas Woolner recalled the eposide in a letter to Lewis: 'Old Mr Graham of Glasgow, who has the most wonderful picture Turner ever painted, and also the beautiful Gainsborough of *Two Ladies* which cost him last year nearly £7,000 – he asked me to point out to him any remarkable work, and on enquiring I found that he had not seen your Cairo picture. I took him to it and pointed out with a great deal of satisfaction what struck me as its most prominent characteristics and beauties . . . I told him a work so entirely unique and original, and of such quality in art could not be valued in money, however large the sum . . . He looked at it much longer and asked me if I thought he could get it for £10,000, for he would willingly give it if it were possible to buy it' (Woolner MS., Major-General J. M. H. Lewis Coll.). Graham's attempt to purchase the painting was frustrated by the fact that the owner, David Price, refused to part with it. Woolner's anecdote both delighted and amazed Lewis, who was by 1874 an invalid recluse, suffering from serious doubts that all he had accomplished had been futile.

A similar, but smaller, watercolour is in the Cecil Higgins Art Gallery, Bedford. C.B.

PROVENANCE
1872, David Price; 1892, Thomas Woolner, R.A.; 1895, C. D. Rudd; 1920, Lord Leverhulme; 1925, David Grieg; acquired by the present owner

EXHIBITIONS
1874, London, Royal Academy, Summer Exhibition (no. 332)
1887, Manchester, Jubilee Exhibition (no. 873)
1893, London, Burlington House, Winter Exhibition (no. 45)
1910, London, Shepherds Bush–White City, Great Japan British Exhibition
1971, Newcastle, Laing Art Gallery, *J. F. Lewis R.A.* (no. 87)
1980, London, The Fine Art Society, *Travellers Beyond the Grand Tour* (no. 20)

REFERENCE
Lewis 1978, p. 98, ill. pl. 65

Marilhat, Prosper-Georges-Antoine
1811–1847

Born in Vertaizon (Auvergne), Marilhat was a pupil of Roqueplan and made his debut at the Salon of 1831 with a landscape of the Auvergne. In this year he joined the scientific expedition of Baron Karl von Hügel, travelling to Greece, Syria, the Lebanon, Palestine and Egypt, where the two men parted company; von Hügel continued his journey as far as India, while Marilhat remained in the Near East for a further twenty-two months.

The ten albums of sketches and drawings made during this, his only trip to the Orient, provided inspiration and material for his subsequent work, and although he specialised in landscapes and architectural paintings he also executed several portraits, including those of Muḥammad 'Alī, and his friend Chassériau (1834; Louvre), as well as two decorative schemes for the theatre in Alexandria.

From 1840 to 1844, Marilhat drew most intensely from his experiences in Egypt and won great critical acclaim at the Salon of 1844 with his *Souvenir des bords du Nil* (present location unknown), and *Arabes syriens en voyage* (Musée Condé, Chantilly). He did not, however, devote himself entirely to Orientalist paintings, but continued to exhibit landscapes of Provence and his native Auvergne, particularly from 1846 onwards.

Though he died young, at the age of thirty-six, Marilhat was greatly admired by the next generation of Orientalist landscape painters and exercised a profound influence on the early work of Fromentin and Pissarro.

97
Ruins of the al-Hākim Mosque, Cairo 1840
Ruines de la mosquée du Kalife Hakem au Caire

84·5 × 130·7 cm
Signed bottom left: *Marilhat*
Musée du Louvre, Paris

The Fāṭimid Mosque of al-Hākim (built 990–1013) lies inside the north wall of Cairo between the two great gates, the Bāb al-Futūh (Gate of Conquest) and the Bāb al-Nasr (Gate of Victory) to the east. Although much dilapidated and almost completely abandoned by the nineteenth century, it continued to attract artists and writers with its echoes of the grandeur of bygone civilisations. The artist, Lenoir, visited the mosque on a tour of Egypt and the Sinai in 1868–69, and Gérard de Nerval wrote at great length on Caliph al-Hākim in *Druses et Maronites* (1847).

This painting, exhibited at the Salon of 1840 as *Ruines d'une ancienne mosquée dans la ville des tombeaux au Caire*, captures both the monumentality of the ruins and the romanticism of the location. A preliminary drawing (Musée Fabre, Montpellier; inv. no. 876-3-120) shows Marilhat's initial concern accurately to record details of the architecture and topography. At a later stage, figures were added, the buildings originally visible in the background were transformed into misty ruins, and the shading became more expressive, thus enhancing the atmospheric effects of the scene. Théophile Gautier was deeply impressed by the evocative power of Marilhat's Near Eastern landscapes and recalled the effect of his *Place de l'Esbekieh au Caire* (present location unknown), exhibited at the Salon the year after his

return to France: 'On seeing this painting I became sick at heart, and yearned for an Orient in which I had not yet set foot' (July 1848, pp. 56–57). The freshness of the delicate pearl-grey tonalities so keenly observed by Gautier were characteristic of Marilhat's work of this period and were largely attributable to his preparation of the ground using bitumen, Cassel red, and broad touches of lacquer.

Marilhat's oeuvre falls into at least three different stylistic periods. The fairly traditional treatment of the early landscapes and portraits gives way to the luminosity and elegant draughtsmanship of his Orientalist work, while after 1838, under the influence of Cabat and his friend d'Augny, his work became somewhat mannered. In mythological works, such as *Paysage pastoral de la Grèce* (Salon, 1837; Musée Tessé, Le Mans) or the *Nymphes dans une clairière* (Salon, 1839; Musée Bargoin, Clermont-Ferrand), which were badly received by critics, Marilhat sought more self-consciously to achieve a grand manner reminiscent of Poussin. Towards the end of his life, as he retreated into a state of insanity, his colouristic preoccupations predominated and his style became more abstract. J.M.

PROVENANCE
1877, 23 April, acquired at the Oppenheim sale by the Louvre

EXHIBITIONS
1840, Paris, Salon (no. 1148)
1928, Cairo, *Exposition d'Art français, 1827–1927* (no. 65)
1930, Paris, *Centenaire de l'Algérie*
1931, Paris, Musée des Colonies, *Exposition coloniale*
1947, Paris, Musée de la France d'Outre-Mer, *Histoire de l'exotisme*
1949, Paris, Musée des Arts Décoratifs, *France-Egypte*
1955, Paris, Bibliothèque Nationale, *Gérard de Nerval* (no. 186)
1955, Nantes, Musée des Beaux-Arts
1955, Caen, Musée des Beaux-Arts
1960, Brest, Musée des Beaux-Arts
1971–72, Paris, *Quelques Aspects du Paysage Français du XXe siècle*
1973, Clermont-Ferrand, Musée Bargoin, *Marilhat* (no. 8, ill.)
1975, Marseille, Musée Cantini, *L'Orient en question*, (no. 108, ill.)
1982, Rochester, New York, Memorial Art Gallery *Orientalism* (no. 31)

REFERENCES
Thornton 1983, ill. pp. 34–35
Th. Gautier, 'Marilhat', *Revue des Deux Mondes*, July 1848, pp. 56–75
E. Feydeau, 'Voyages à travers les collections particulières de Paris', *L'Artiste*, 1858, III, pp. 269–71
H. Gomot, *Marilhat et son oeuvre*, Clermont-Ferrand, 1884, pp. 87, 99
J.M. Carré, *Voyageurs et écrivains français en Egypte*, Cairo, 1932, I, pp. 209–10
D. Menu, 'Prosper Marilhat (1811–1847) Essai de Catalogue', Université de Dijon, U.E.R. de Sciences Humaines, 1972, p. 84, no. 228
P. Miquel, *Le Paysage français au XIXe siècle 1824–74. L'Ecole de nature*, Paris, 1975, pp. 346–59

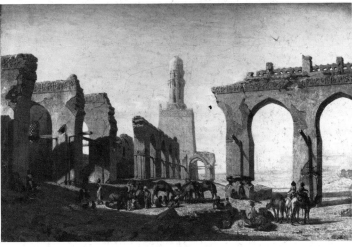

97

Matisse, Henri 1869–1954

Born at Le Cateau-Cambressis (Nord), Matisse moved to Paris in 1887 to study law. He began painting in 1890, and the following year he enrolled as a student of Bouguereau at the Académie Julian, Paris. In 1982 he transferred to the atelier of Gustave Moreau at the Ecole des Beaux-Arts, where he met the future Fauve painters, Marquet and Manguin. He made his debut at the Salon du Champs de Mars in 1896 with four paintings, and three years later met Derain, and then Vlaminck in 1901. Having spent most of 1898 in the south, Matisse acquired a taste for this region, working from 1904 at Collioure and St. Tropez with Signac and Derain, and then regularly at other places along the Riviera. Matisse visited Morocco briefly in 1906, and returned for two further visits during 1912. From 1901 he exhibited at the Salon des Indépendants and from 1903 at the Salon d'Automne. His work was collected by German, Russian and American patrons and included easel paintings, sculpture, ceramics and large-scale decorative works.

ABBREVIATED REFERENCES
Barr 1951 H. Barr, *The Art of Henry Matisse*, New York, 1951
Luzi 1971 M. Luzi, *L'Opera di Matisse: rivolta 'fauve' all' intimisme*, Milan, 1971

98*

The Blue Nude – Souvenir of Biskra 1907
Le Nu bleu – souvenir de Biskra

92·1 × 121·6 cm
Signed bottom right: *Henri Matisse* c. 1927 at the request of Claribal Cone via Michael Stein (see Cone Archives, Correspondence, Michael Stein to Etta Cone, 8 December 1926)
The Baltimore Museum of Art: The Cone Collection, formed by Dr. Claribel Cone and Miss Etta Cone of Baltimore, Maryland (BMA 1950.228)
[*repr. in colour on p. 108*]

Matisse was already an established member of the Fauve group when he visited North Africa for the first time in 1906. He spent two brief weeks in Biskra and Algiers. His stated intention for the trip was 'to see the desert' (quoted Barr 1951, p. 83, n.5). In effect, the immediate impact of the encounter with the Orient was the execution of a few sketches (eg. *Alger, paysage*, 1906; Statens Museum fur Kunst, Copenhagen) and the purchase of contemporary pottery and textiles which he introduced into a series of still-lifes executed on his return to Collioure (eg., *Le Tapis rouge*, 1906, Musée de Peinture et de Sculpture, Grenoble).

 One year later, in early spring, he executed the *Blue Nude – Souvenir of Biskra*. Apart from the palm fronds in the background, there is little in this painting to demonstrate the direct impact of North Africa. Painted in Collioure, it was linked to two recent technical innovations in Matisse's work: the execution in 1906 of three, harshly primitivising linoleum prints, which were exhibited together with the *Blue Nude – Souvenir of Biskra* at the Salon des Indépendants, 1907, and a group of fifteen to twenty sculptures created between 1905 and 1907. The pose of the nude in the painting is in part based upon one of these sculptures, *Reclining Nude*, which Matisse was modelling in clay in early 1907 before starting on this painting. The accidental partial destruction of this piece unintentionally turned the *Blue Nude – Souvenir of Biskra* into a painting which was both based upon a sculpture and became in turn the study for the reconstruction of the original damaged work.

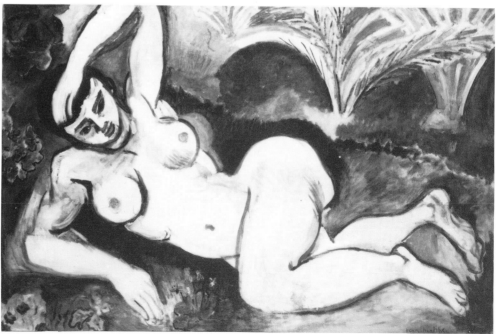

98

The colour of this nude is said to have been determined by a friendly competition with his fellow Fauve artist, Derain, as to who could paint the best figure in blue. When Derain saw the *Blue Nude – Souvenir of Biskra*, he apparently destroyed his own canvas (H. Purrmann, quoted Barr 1951, p. 94, n.3). The essential factors in the painting are the emphasis upon an unnaturalistic colour for the contour of the nude, rather than an overt use of flesh tones, and the uncompromising pose of the model. Although the latter found its genesis in Matisse's recent Fauve paintings, such as the figure drinking coffee in *Luxe, Calme, Volupté* (1904–05, Priv. Coll., Paris) and in the reclining woman centre right in *Bonheur de vivre* (1905–06, Barnes Foundation, Merion, Penn.), a comparison between *The Blue Nude – Souvenir of Biskra* and these earlier works reveals a rejection of the decorative properties of colour in favour of the constructive use of colour, through the bold, blue swinging line and the blocks of pigment which form the figure. This anti-decorative handling of colour links the painting back to Matisse's pre-Fauve works, such as *Homme nu* (c. 1900, Priv. Coll., New York). In addition, Matisse has virtually rid himself of any sense of three dimensionality in this work by distorting and flattening the figure, which thus seems to adhere to the flat picture surface. MA.S.

PROVENANCE
Until c.1913, Leo Stein, Paris; Paris dealer; Alphonse Kahn, Paris; Georges de Zayas, Paris; Marius de Zayas, Paris; 1920, December, bought by John Quinn, New York; 1926, October, Hôtel Drouot, Paris, Quinn Estate (lot. 61); bought through Michael Stein by Dr. Claribel and Miss Etta Cone, Baltimore; 1949, given by them to the Baltimore Museum of Art

EXHIBITIONS
1913, New York, Armory of the Sixty-ninth Infantry, *International Exhibition of Modern Art*, (no. 411)
1913, Chicago, Art Institute (no. 248)
1913, Boston, Copley Hall, (no. 129)
1920, New York, M. de Zayas Gallery, *Paintings by Matisse*
1924, New York, Brummer Gallery, *Exhibition of Works by Matisse* (no. 2)
1926, New York, *Memorial Exhibition of Representative Works. Selected from the John Quinn Collection* (no. 36)
1931, Basle, Kunsthalle, *Matisse*
1931, Paris, Galerie Georges Petit, *Matisse*
1948, Philadelphia, Museum of Art, *Henri Matisse : Retrospective Exhibition*
1951, New Haven, Yale University Art Gallery; Baltimore, Museum of Art, *Pictures for a picture of Gertrude Stein as a Collector and Writer on Art and Artists* (no. 18)
1952, New York, Museum of Modern Art; Cleveland, Museum of Art; San Francisco, Museum of Art; Chicago, Art Institute, *Matisse Retrospective*
1955, Richmond, Virginia Museum of Fine Arts, *The Cone Collection*
1956, Minneapolis, Walker Art Center, *Expressionism*
1970, Paris, Grand Palais, *Henri Matisse : Exposition du Centenaire* (no. 84)

REFERENCES
Barr 1951, pp. 49, 58, 83, 84, 94-95, 96, 99, 100, 150, 180, 199, 201, 208, 218, 262, ill. p. 336
Luzi 1971, no. 97
Ozenfant et Jeanneret, *La Peinture moderne*, Paris, n.d, n.p.
G. Stein, *The Autobiography of Alice B. Toklas*, New York, 1934, p. 21
J. Selz, *Henri Matisse*, New York, 1964
B. L. Reid, *The Man from New York . . . John Quinn and His Friends*, New York, 1968
L. Gowing, *Henri Matisse : 64 Paintings*, New York (Museum of Modern Art), 1966, p. 27, ill.
Baltimore, Museum of Art, *Handbook of the Cone Collection*, 1967 (revised ed.), no. 40, ill. in colour, p. 24
J. D. Flam, *Matisse on Art*, London, 1973, pp. 4, 12, 24, 49, ill. fig. 18
J. Elderfield, *Fauvism; The "Wild Beasts" and its Affinities*. New York (Museum of Modern Art), 1976, p. 118, ill. p. 117

99a

Moroccan Landscape spring 1912

Paysage marocain

115 × 80 cm
Signed bottom left : *Henri Matisse*
Moderna Museet, Stockholm
[*repr. in colour on p. 112*]

99b*

Moroccan Garden autumn 1912

Le Jardin marocain

117 × 81 cm
Signed bottom right : *Henri Matisse*
Private Collection
[*repr. in colour on p. 110*]

99c

The Palm Leaf, Tangier autumn 1912

La Palme, Tanger

117·5 × 81·9 cm
Signed bottom right : *Henri Matisse*
National Gallery of Art, Chester Dale Fund 1978
[*repr. in colour on p. 111*]

Despite their differences in tonality, these three paintings, representing the garden of the Villa Bronx, Tangier, Morocco, were intended to form a decorative triptych. The combination of one dominantly blue panel and two predominantly red ones is accounted for by the fact that *Moroccan Landscape* (Cat. 99a) was executed during the spring of 1912, when the vegetation in the garden had burst into luxuriant growth following the wet season, whereas the other two landscapes date from autumn 1912, when the garden had been scorched by the hot, dry summer season.

The pictures were executed during two separate visits to Morocco undertaken by Matisse in the course of 1912. Matisse returned to North Africa after a gap of six years (see Cat. 98) at the end of January 1912. He remained until the spring, returning again in October 1912 for a more extensive visit which was to last probably until February 1913. Basing himself at Tangier, he became enraptured with the light and the landscape and determined to integrate these elements into his work.

The reasons underlying Matisse's decision to return to North Africa on both occasions in 1912 are not clear. Prior to the first visit, Matisse had seen the 1910 exhibition of Islamic art at Munich and later that same year, had travelled to Spain where he had been particularly impressed by the moorish cities of Cordoba, Grenada and Seville. He might also, by 1912, have wished to escape the apparent domination by Cubism of the Paris avant-garde. In search of a viable alternative for his art he may have concluded that a visit to a land which encapsulated his new-found interest in Muslim art, the innovative force of southern light (already experienced at Collioure and St. Tropez between 1904 and 1906) and his established admiration of African art, was an essential move. It has been suggested that the visit might have occurred earlier than 1912 had Matisse not been delayed by the unsettled political situation in North Africa, which was not resolved until the Franco-German treaty of November 1911.

The decision to return to Morocco in autumn 1912 was probably motivated by two factors: Matisse's disappointment at the drabness of northern France, when compared to the scintillating colours which he had recently discovered in North Africa, and a continued unease with the pre-eminence of the Cubists and the Futurists in Paris.

Moroccan Landscape (Cat. 99a), executed towards the end of Matisse's first visit in 1912, is in large measure structured by the juxtaposed areas of dense tonalities – greens, blues and pink-mauves – suggestive of a thick, burgeoning plant life. These tonalities occur in other works completed during this same visit, for example, *La Fenêtre ouverte sur Tanger* (Museum of Western Art, Moscow) and *La Porte du Casbah* (Museum of Western Art, Moscow). Intending to work further on this painting, Matisse took it back with him to Tangier when he returned in October 1912. Shocked by the parched appearance of the private garden in which he had executed the painting, he embarked on the other two pictures which complete the triptych, *The Palm Leaf, Tangier* (Cat. 99c) and *Moroccan Garden* (Cat. 99b). In contrast to *Moroccan Landscape*, the paint in both of these later pictures is sparingly applied and the colours are provocative in their reds, oranges, browns and thin greens, all characteristic of the scorched landscape which Matisse wished to evoke. However, all three paintings display bold use of black outline. Rather than serving a descriptive purpose, these lines both create an intense patterning across the surface of the landscapes and provide a strong tonal contrast, in keeping with Matisse's view that black was not a medium for delineating the forms of objects, but should be seen as yet another colour available to the artist.

Apart from this decorative triptych, there are at least two other groups of paintings which Matisse viewed as similar forms: one consisting solely of three figures (*Fatma, la Mulatresse*, Josef Müller Estate, Switzerland, *Amido, le marocain*, Museum of Western Art, Moscow, *Zorah, La Marocaine*, Museum of Western Art, Moscow), the other of a figure and two townscapes (*La Porte du Casbah*, *La Fenêtre ouverte sur Tanger*, *Zorah sur la terrasse*, all Museum of Western Art, Moscow).

An intended visit to Tangier in the autumn of 1913 never materialised. However the impact of these two intense periods

of activity, 1912–13, on Matisse's subsequent work can be seen in the sparsely-handled, rigorously-decorative paintings, *Le Café arabe* (1913; Museum of Modern Art, New York) and *Les Marocains* (1916, Museum of Western Art, Moscow), as well as in the more superficial references to Oriental elements which persisted in his costume pieces (see Cat. 100) and still-lifes executed during the two succeeding decades. MA.S.

99a

PROVENANCE
1917, given by Mr Walther Halvorsen, Paris, to the Moderna Museet, Stockholm

EXHIBITIONS
1934, Copenhagen, Ny Carlsberg Glyptothek, *Henri Matisse*
1949, Lucerne, *Henri Matisse*
1950, Nice, Musée des Beaux-Arts, *Henri Matisse*
1951–52, New York, Museum of Modern Art; Chicago, Art Institute; San Francisco, Museum of Art, *Henri Matisse*
1970, Copenhagen, Statens Museum fur Kunst, *Henri Matisse*
1970, Paris, Grand Palais, *Henri Matisse, Exposition du Centenaire* (no. 113)
1982, Zurich, Kunsthaus; Dusseldorf, Kunsthalle, *Henri Matisse*

REFERENCES
Barr 1951, pp. 144, 145, 154, 155, ill. p. 380
Luzi 1971, no. 182
J. D. Flam, 'Matisse in Morocco', *Connoisseur*, August 1982, pp. 80, 82, ill. p. 85

99b

PROVENANCE
M. Knoedler and Co., New York; Marx Coll., Chicago; Priv. Coll., New York

REFERENCES
Barr 1951, pp. 145, 154, ill. p. 380
Luzi 1971, no. 166
J. D. Flam, 'Matisse in Morocco', *Connoisseur*, August 1982, pp. 80, 82, ill. p. 84

99c

PROVENANCE
By 1914, Prof. Oskar and Mrs Greta Moll, Breslau; ?1932, Galerie Tannhauser, Berlin (Justin K. Tannhauser); early 1940s, Weyhe Galleries, New York; by 1957, Mr and Mrs Alfred H. Barr, Jr.; 1978, purchased by the National Gallery of Art, Washington, D.C.

EXHIBITIONS
1952, Montreal, Museum of Fine Art; Berlin, Nationalgalerie, *Six Centuries of Landscape* (no. 64)
1956, Paris, Musée National d'Art moderne, *Henri Matisse, exposition retrospective* (no. 32)
1970, Paris, Grand Palais, *Henri Matisse, Exposition du Centenaire* (no. 114)
1982–83, Zurich, Kunsthaus; Dusseldorf, Kunsthalle, *Matisse*

REFERENCES
Barr 1951, pp. 145, 154, ill. p. 381
Luzi 1971, no. 167
S. and D. Salvmann, *Oskar Moll, Leben und Werk*, Munich, 1975, p. 63
J. D. Flam, 'Matisse in Morocco', *Connoisseur*, August 1982, p. 82, ill. p. 84

99a 99b 99c

100

Odalisque in Red Trousers 1921

Odalisque à la culotte rouge

65 × 90 cm
Signed bottom right: *Henri Matisse*
Musée National d'Art moderne, Centre Georges Pompidou
[*repr. in colour on p. 109*]

Executed nine years after his final trip to Morocco, this painting belongs to a series of Oriental costume pieces in which Matisse reworked Oriental, decorative motives around Western models, eg., *Les Trois Soeurs* (triptych, 1916/ second half 1917, Barnes Foundation, Merion, Penn.). Despite the brilliant explosion of colour and the use of patterned tiles in the background, this is, in many ways, a conventional image of an odalisque. In contrast to the uncompromisingly two-dimensional paintings of the previous decade (eg., *l'Atelier rouge*, 1911, Museum of Modern Art, New York; *La Leçon du piano*, 1917, Guggenheim Museum, New York), this model sits firmly within an illusion of three-dimensional space, created by the diagonal of the sofa on which she lies. Both in this respect and in her pose — arms behind her head and the somewhat provocative gaze — she both looks back to such nineteenth-century odalisques as Renoir's *Femme d'Alger* (Cat. 106) and forward to the more classical figure paintings of the 1920s (eg. *Nu à la chaise bleue*, 1934, Priv. Coll., Los Angeles; *Odalisque aux magnolies*, 1924, Marx Coll., New York). The picture was bought by a somewhat nervous Musée du Luxembourg in 1921, as Matisse's first painting in a French public collection.

The *Odalisque with Red Trousers* retains an important position within Matisse's work inspired by the Orient. First, the odalisque was an excuse for Matisse to paint nudes. In 1929, Matisse stated that he was unwilling to paint an odalisque which was 'artificial' and so he went to Morocco where he knew that such figures

existed ('Entretien avec Tériade', 1929, reprinted in H. Matisse, *Ecrits et propos*, Paris, 1972, p. 99). Second, the decorative patterning of the tiles in the background prefigures the large decorative panels of later years, such as the *Grande Decoration avec masques* (1953, National Gallery of Art, Washington, D.C.). MA.S

PROVENANCE
Galerie Bernheim-Jeune, Paris; 1922, bought by the state (Musée du Luxembourg)
EXHIBITION
See I. Monod-Fontaine, 1979, p. 48
REFERENCE
For full references see I. Monod-Fontaine, *Matisse* (catalogue raisonné des collections au Musée National d'Art moderne), Paris 1979, p. 48, no. 13

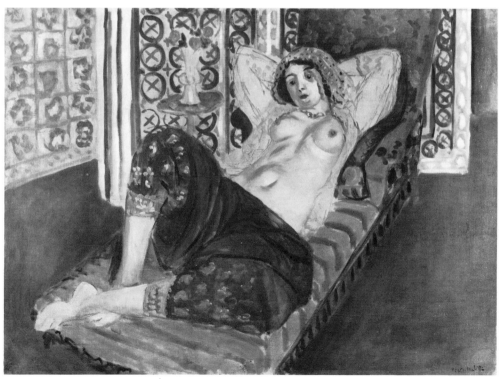

100

Melville, Arthur 1855–1904

Born at Loanhead of Guthrie, Melville started his working life as a grocer's apprentice, walking miles to attend evening classes at Edinburgh. In 1878 he travelled to Paris to study at the Académie Julian, and during his stay encountered the work of the Impressionists and began to paint in watercolours. A new interest in painting out-of-doors led to a prolonged visit to Grez-sur-Loing in 1879. The following year, Melville went to Egypt where he spent the next two years, living in Cairo but making occasional excursions to places such as Luxor, where he met Sir Flinders Petrie. In 1882 he continued his travels and embarked on a ship bound for India where he spent only a few days. An original plan to come back through Persia with a friend was abandoned, and Melville rode back alone across Asia Minor from Baghdad to the Black Sea.

On his return to England, Melville started to exhibit his Oriental watercolours in London and Edinburgh, where their innovative approach met with a mixed critical reception. While he was living in Edinburgh from 1882 to 1889, he befriended some of the Scottish artists of the Glasgow School, but in 1889 he moved back to London, where he was to be based for the rest of his life. Melville made several trips to Spain and Algeria during the 1890s.

101

Awaiting an Audience with the Pasha 1882/1887

Watercolour and bodycolour on paper: 66·6 × 100·3 cm
Inscribed bottom right: *Awaiting an Audience with the Pasha, Arthur Melville 1887*
Mr and Mrs Tim Rice
[*repr. in colour on p. 99*]

This painting was executed in 1882 and exhibited in London in the following year. Given that it is clearly dated 1887, it is assumed to have been further worked on by the artist between 1883 and 1887. In 1888, it was again exhibited in London, when

it may well have still been in the artist's possession.

This watercolour is probably based on a scene witnessed during Melville's first trip to the Near East undertaken in 1882. While riding through Asia Minor, he was twice attacked by bandits. On the second occasion he was robbed and left for dead in the middle of the desert near Mosul in present-day Iraq. The Arabs of the nearest village sheltered him and dressed his wounds, but the local pasha, though kind and hospitable, detained him for three weeks on suspicion of spying before allowing him to continue on his journey to Constantinople. During this time, Melville would presumably have had the opportunity to observe such scenes as this where local people have come to seek an audience with the pasha to obtain justice, give presents, or denounce their enemies. Certainly the building in the picture, with its wooden columns and rolled-up blind above the doorway, is closer to the architecture of Iraq than to that of Egypt.

Melville's use of watercolour at this stage in his career is reminiscent, in certain areas of detail, of the work of J. F. Lewis (*q.v.*). In this picture the lattice work and the pattern on the Turkish carpet are clearly delineated, but in later paintings Melville was to abandon this minute approach for a much freer method of working, where superfluous details were sponged out in the interest of a broader effect. The extraordinary luminosity of this picture was achieved by Melville's practice of painting onto paper which had been repeatedly saturated with Chinese white, first of all putting in the background using umber, and then filling in the patches of brilliant colour when the background was dry. C.B.

PROVENANCE
Until 1888, with the artist; Priv. Coll., Canada; 1982, acquired by The Fine Art Society, London; sold by them to Mr and Mrs Tim Rice

EXHIBITIONS
1883, London, Dudley Gallery, Spring Exhibition
1888, London, Royal Society of Painters in Water Colours (no. 199)
1983, Edinburgh, The Fine Art Society, *Tenth Anniversary Exhibition*

REFERENCE
A. E. Mackay, *Arthur Melville, Scottish Impressionist 1855–1904*, Leigh-on-Sea, 1951, pp. 70, 147 (no. 335)

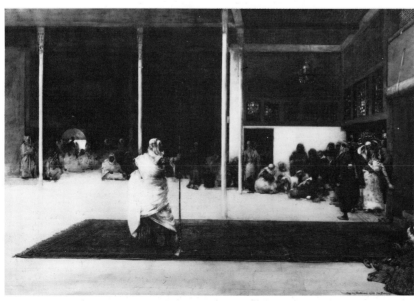

101

Müller, Leopold Carl 1835–1892

The leading Viennese Orientalist painter, Müller was born in Dresden, the son of a lithographer, and trained at the Vienna Academy under its director, Christian Ruben. His first career was as an illustrator on the city's satirical newspaper *Figaro*, but after a visit to Paris in 1867, when he saw and admired the work of Fromentin (*q.v.*) amongst others, he reverted to painting as his main occupation. From 1870 onwards he made frequent visits to Italy, and in 1873–74 travelled to Constantinople, Smyrna and Cairo. Fascinated by the quality of the light, he began to paint the Egyptian genre subjects for which he is best known. He visited Egypt nine times between 1873 and 1886. In 1875–76 he went in the company Hans Makart and other artist friends, living and working with them in the Musāfir-Khānah in Cairo. He sold much of his work to British collectors through contacts made in the city. This was a field of patronage which he was particularly well equipped to cultivate after becoming friendly with the Prince of Wales. He was appointed to an Professorship at the Vienna Academy in 1877, and was artistic supervisor and a major contributor to Georg Ebers's *Äegypten in Bild und Wort*, published in 1879–80. He died at Weidlingen, near Vienna, in 1892.

For a fuller discussion of Müller as the central figure in Viennese Orientalism, see G. Frodl, 'Wiener Orientmalerei im 19. Jahrhundert', *Alte und Moderne Kunst*, no. 178–79, 26, 1981, pp. 19–25.

102

Encampment in the Desert at Gizah 1874
Rast in der Wüste bei Gizeh

109 × 210 cm
Signed and dated bottom left: *Leopold Carl Müller/1874*
Private Collection, Houston, Texas
[*repr. in colour on p. 85*]

This picture shows the halt of a caravan, with the Great Pyramid and Second Pyramid in the background. Gizah was an obvious attraction for Orientalist painters: compare, for example, the view from a different angle in Frederick Goodall's *The Subsiding of the Nile* (Cat. 63). *Encampment in the Desert at Gizah* resulted from Müller's first visit to Egypt in 1873–74, and according to Boetticher (1898) was completed at the end of 1874 in a studio which he shared with Makart in Vienna. It is similar in size to the work of 1878 generally considered to be his masterpiece, the *Markt in Cairo* (Österreichische Galerie, Vienna), which may have been intended as a pendant, the pair together representing urban and desert gatherings of Arabs. Like *Markt in Cairo*, this painting depicts an animated crowd intended to show off to best advantage Müller's observation of different racial types, their characteristic gestures and poses.

Gerbert Frodl has pointed out (*loc. cit*, Frodl, 1981) that there was less demand for Orientalist painting in Austria than in Britain and France, perhaps because of its relative lack of political involvement in the Near East. As a result, the number of Orientalists based in Vienna was small: apart from Müller, the only noteworthy painters to make a speciality of Oriental subjects were his students, Charles Wilda (1854–1907), Rudolf Swoboda (1859–1914) and Franz Kosler (1864–1905), and they all depended on foreign, mostly British, patrons. M.W.

PROVENANCE
1893, 2–4 March, the artist's sale, Künstlerhaus, Vienna; 1898, G. Reichert; George McCulloch; 1913, 23 May, his sale Christie's, London (lot 37) acquired by W. W. Sampson; 1980, June, acquired from The Fine Art Society, London, by Kurt E. Schon Ltd, New Orleans; Priv. Coll., Houston, Texas

EXHIBITIONS
1875, Vienna Künstlerhaus
1898, Vienna, Künstlerhaus, *Funfzig Jahre Österreichischer Malerei* (no. 650)

REFERENCES
G. Ebers, *Aegypten in Bild und wert*, Stuttgart and Leipzig, 1879–80, I, ill. p. 189
F. von Boetticher, *Malerwerke des 19. Jahrhunderts*, Dresden, 1891–1901, II, part 1, p. 103, no. 22
A. F. Seligmann, *Karl Leopold Müller*, Vienna, 1922, p. 58

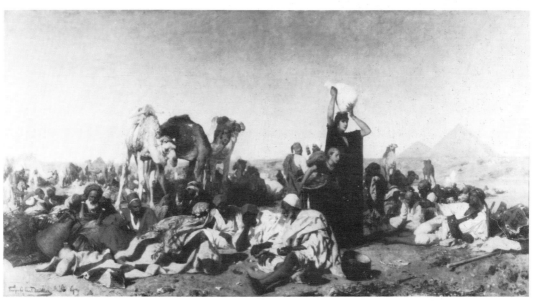

102

Müller, William James 1812–1845

Müller was one of the earliest British artists to set out to paint realistically the rich and varied world of the Orient. Born in Bristol, he soon gained a reputation for his ability to sketch with rapidity and assurance. In 1834–35 he travelled through Europe to Italy. In 1838, attracted by the more exotic subject-matter of the Near East, he travelled via Greece to Alexandria, arriving at Cairo in mid-November. After two weeks sketching in the bazaars, he ascended the Nile to Luxor where he drew the ruins and scenery on both sides of the river before returning to Cairo in mid-January.

On his return to London in 1839 he painted several Egyptian subjects in oils, exhibiting at the Royal Academy, the British Institution and the Royal Society of Arts; he also went on sketching trips to Wales and France.

In 1843, on the invitation of the archaeologist Charles Fellows, Müller and his young pupil Harry Johnson, travelled to south-west Turkey. Sailing from Smyrna (now Izmir) via Rhodes they joined the Fellows expedition in Lycia at the end of October. For three months Müller sketched both the rugged scenery surrounding the ruins of Xanthus, Pinara and Tlos, and the local nomadic tribes. Returning to Rhodes from the Lycian port of Telmessus (now Fethiye), the two artists sailed for England. Much of the remaining year of his life was spent working on and exhibiting his Lycian watercolours, as well as a few oil paintings.

He died in Bristol in September 1845.

103

The Carpet Bazaar at Cairo 1843

Oil on board: 62·2 × 74·9 cm
Signed and dated bottom left: *W. Müller Cairo 1843*
The City of Bristol Museum and Art Gallery
[*repr. in colour on p. 71*]

In Egypt from 1838 to 1839, Müller, like many other visitors, was amazed by the picturesque variety of the people in the streets: 'like humanity put into a kaleidoscope', he wrote (W. Müller, 'An Artist's Tour in Egypt', *Art-Union*, September 1839, p. 131). The subjects of his numerous sketches (listed in N. N. Solly, *Memoir of the Life of William James Müller*, London, 1875, pp. 83–84), reveal the range and extent of his interest in all that he saw and experienced.

On his return to England he exhibited paintings of the Egyptian temples, but more popular with his patrons were his lively and colourful street and market scenes. Whereas views of Cairo by David Roberts (see Cat. 113) are composed around the forms of the lofty minarets and ornate doorways of Cairo's Islamic buildings, Müller sought to evoke the city's atmosphere, particularly through the use of strong colour. In 1843, the date of this painting, he wrote in a letter from Bristol of his delight on seeing an Eastern bazaar for the first time. The scenes reminded him of pictures by Rembrandt: 'The sun streams through a little opening in the wall and falls on the figures, lighting them up with all but a supernatural brilliancy; reflection plays its part and bit by bit the whole is revealed; and as figure after figure pass by, some in the richest dresses and superb stuffs, while others, such as the pipe-cleaners, walk on shouting their avocations, and literally clothed in rags, you have a constantly changing picture before you' (quoted James Dafforne, 'William John [*sic*] Müller', *Art Journal*, October 1864, pp. 293–94). On that occasion Müller was referring to another bazaar picture, 'an Opium Shop at Monfaloot', but the scene described also resembles the present painting. There is also a description in Solly of a view which corresponds to this work (*op. cit.*, p. 65).

Müller's observation of the patterns formed by bright sunlight, filtering through the awnings on to the bazaar below, anticipates J. F. Lewis's more sophisticated rendering of similar effects (see Cat. 90, 96). B.L.

PROVENANCE
1896, Alfred East; 1918, presented by Mrs S. Lloyd in memory of her husband Alderman Samuel Lloyd, J. P., to the City of Bristol Museum and Art Gallery

EXHIBITIONS
1896, Birmingham, City Museum and Art Gallery, *Loan collection of paintings in oils and watercolours by W. J. Müller* (no. 21)
1925, Wembley Palace of Arts (W.28)
1928–30, Leamington Spa, Public Library and Museum
1955, London, Arts Council of Great Britain, *Narrative Painting* (no. 28)
1962, Bristol City Art Gallery, *William James Müller 1812–1845* (no. 23)
1969, London, Wildenstein and Co., *Pictures from Bristol* (no. 31)
1983, Brighton, Museum and Art Gallery; Manchester, City Art Gallery, *The Inspiration of Egypt* (no. 290)

REFERENCES
C. G. E. Bunt, *The Life and Art of William James Müller 1812–1845*, Leigh-on-Sea, 1948, pp. 69, 74, 92, ill. pl. 43
Bristol City Art Gallery, *Catalogue of Paintings*, 1970, K509, ill. p. 81

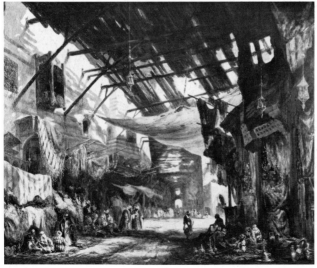

103

Pasini, Alberto 1826–1899

Pasini was born in Busseto and attended the Academy at Parma. From 1851 to 1853 he studied under Eugène Cicéri (1803–1886) in Paris, where he completed his training in the atelier of M.E. Isabey (1813–1890). He made his Salon debut in 1853. From his first visit to Persia in 1855, as part of the suite of the French legation to the Persian Gulf and Tehran, Pasini specialised in views of remote corners of Turkey and Persia. He travelled to Constantinople between 1868 and 1869 and to Asia Minor and Syria in 1873. Pasini was also a seasoned traveller within Europe and from 1878 visited Venice on several occasions, and made a journey to Spain with Gérôme from 1879 to 1883.

Principally a landscape and architectural painter, Pasini came under the influence of Théodore Rousseau and Fromentin in the late 1850s, though his later style reveals affinities with the 'Néo-grec' School of painters. Apart from his Orientalist work, he painted some genre scenes and subjects taken from Turkish history and was also known for his lithographic work.

After the Franco-Prussian War (1870–71), Pasini returned to Italy, but continued to exhibit at the Salon until his death in 1899.

104

104†

Entrance to the Yeni-Cami Mosque in Constantinople 1870

Porte de la mosquée Yeni-Djami, à Constantinople

156·8 × 115·5 cm
Signed and dated bottom left: *A. Pasini 1870*
Musée des Beaux-Arts, Nantes

The Yeni-Cami (New Mosque) was the product of the plans of the two *Valide Sultāns* (Queen Mothers). It was begun in 1597 by the Venetian Sophia Baffo, mother of Mehemed III, but suffered long delays in construction until its completion in 1663 by Tarkhan, mother of Sultān Mehmed IV. An extremely elegant building in both external and internal detail and with a remarkable sixty-six cupolas, the mosque was much frequented by European travellers, particularly after the Crimean War when restrictions on Christians visiting Muslim places of worship were relaxed. Pasini himself was greatly attracted to this building and in 1873 exhibited a scene of the 'Egyptian Bazaar', located on the south side of the mosque.

In this painting, Pasini shows the mosque not so much as a place of worship, but as the meeting place of a cross-section of male Turkish society. Like the beggar and the solitary dervish, the woman, on the right of the picture, is excluded from the general discussion to indicate her subordinate role, and her exclusion from public religious affairs. The older men in their traditional robes and turbans, and the *sarvels* (full trousers), embroidered waistcoats and white tunics of the younger men, are rendered with a precision typical of Pasini's keen observation; the wide range of colours harmonise with the overall grey tonalities of the architecture. The touches of local colour and various animated gestures of the figures to some extent recall Decamps, although they are observed with an impartiality which transforms the scene from the anecdotal to the documentary.

The tightness of handling and the concentration on the high finish of the brushwork place the painting firmly within the European Beaux-Arts tradition. Pasini clearly delighted in the defined geometrical lines of Oriental architecture and in the texture of the marble, which he transcribes in the unbroken smoothness of the paint surface. Castagnary, champion of the '*école naturaliste*', though vehemently opposed to the whole concept of Orientalist painting, was much impressed by this picture when it was first exhibited at the Salon of 1870: 'The harmony is so accurate, the drawing so fine, and the animated figures on the steps form such a natural scene, that, on seeing it, I wholly forgot my former detestation of orientalism' (*Salons*, 1892, p. 410). J.M.

PROVENANCE
1873, January, acquired by the Commission du Musée for the Musée des Beaux-Arts, Nantes
EXHIBITIONS
1870, Paris, Salon (no. 2182)
1872, Nantes, Salon des Artistes vivants (no. 579)
1931, Paris, *L'Exposition coloniale* (p. 35)
1980, Nantes, Musée des Beaux-Arts, *Orients* (no. 25)
1983, Pau, Dunkirk and Douai, Musées des Beaux-Arts, *Les Orientalistes de 1850 à 1914*
REFERENCES
C. Lemonnier, *Salon de Paris*, 1870, pp. 125f.
J.A. Castagnary, *Salons, I, 1857–1870*, Paris, 1892, p. 410
Nantes, Musée des Beaux-Arts, *Catalogue*, 1913, pp. 433–34, no. 1123

Phillips, Thomas 1770–1845

Born in Dudley, Thomas Phillips had an early training as a
craftsman through his apprenticeship to a japanner and glass
painter. His career in painting began when he entered Benjamin
West's studio and attended drawing classes at the Royal
Academy schools. During the 1790s he gradually built up a
reputation as a portrait painter, which led to his election as
Associate of the Royal Academy in 1804, and full Academician
in 1808. Although his early works were mainly confined to
portraits of men of science, Phillips soon widened his repertoire
to include lawyers, clerics and surgeons. His contact with such
patrons as Lord Egremont and the publisher John Murray also
resulted in commissions to paint the portraits of several members
of the aristocracy as well, and literary figures, including Byron,
Scott, Southey, Crabbe, Campbell and Coleridge.

105

Portrait of Lord Byron after 1835

76·5 × 63·9 cm
Signed with monogram bottom left: *TP*
National Portrait Gallery, London
[*repr. in colour on p. 89*]

During the summer of 1813 and the spring of 1814, Byron gave
a number of sittings to Thomas Phillips, from which two types
of portrait emerged. The first, of which there are four known
versions, shows Byron in a black cloak, the second, of which
there are at least three versions, shows the poet in Albanian
dress. The National Portrait Gallery painting is a smaller and later
replica of the upper part of the picture exhibited at the Royal
Academy in 1814 as *Portrait of a Nobleman in the dress of an
Albanian* (British Embassy, Athens), in which Byron stands in
front of a romanticised Greek landscape complete with swirling
mists and ruins. According to the artist's son (letter in the
National Portrait Gallery Archives), it was painted some time
after 1835, following the return of the original work to the
artist's studio. There is a similar version in the possession of the
publishers, John Murray.

The original portrait was painted when Byron was in his mid-
twenties, at the height of his fame as a poet. 1812 had seen the
publication of the first two cantos of *Childe Harold*, which were
followed by *The Giaour* and *The Bride of Abydos* in 1813, and *The
Corsair* and *Lara* in 1814. Byron himself obviously approved of
the picture, which complemented the Oriental settings of his
poems and affirmed his own image as a romantic adventurer.
Contemporary opinion as to whether it was a good likeness
varied: John Cam Hobhouse thought it did not look anything
like the poet (*Diary*, 19 March 1814), and Hazlitt considered the
face too smooth, although the picture conveyed something of
'the softness and wildness of character of the popular poet of the
East' (*Morning Chronicle*, 3 May 1814).

The costume, which is that of an Arnavut (an Albanian
tribesman), was one that Byron had obtained during his tour of
the Continent from 1809 to 1811, when he became an ardent
Hellenophile. He bought it in Epirus, and enthused about it in
a letter to his mother dated 12 November 1809: 'I have some
very "magnifiques" Albanian dresses, the only expensive articles
in this country. They cost fifty guineas each, and have so much
gold, they would cost in England two hundred' (*Byron's Letters
and Journals*, L. A. Marchant ed., London, 1973–76, I, p. 223).
When the portrait was finished, Byron offered the costume to
Lady Elphinstone to wear to masquerades, and it can now be seen
at Bowood House, Wiltshire. C.B.

PROVENANCE
1862, acquired from Henry W. Phillips, the artist's son, by the National Portrait Gallery

EXHIBITIONS
1969, London, Victoria and Albert Museum, *Berlioz and the Romantic Imagination* (no. 99)
1974, London, Victoria and Albert Museum, *Byron* (no. H8)
1979–80, Munich, Haus der Kunst, *British Painting and Munich 1680–1880* (no. 344)
1981, Hamburg, Kunsthalle, *Goya – The Age of Revolutions* (no. 532)
1982, Manchester, Whitworth Art Gallery, *Richard Payne Knight: The Arrogant Connoisseur*
(no. 193)

REFERENCES
D. Parker, *Byron and his World*, London, 1968, ill. p. 29
L. Marchand, *Byron's Letters and Journals*, London, 1973–76, vol I, p. 233; III, p. 60; IV,
p. 112–13
R. Walker, forthcoming catalogue raisonnée of Regency Portraits in the National Portrait
Gallery, to be published 1984

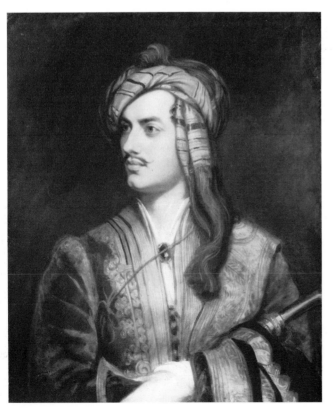

105

Renoir, Auguste 1841–1919

Born in Limoges (Haute-Vienne), Renoir moved with his family
to Paris in 1844. He received his initial artistic training at the
atelier of the painters of porcelain, Frères Levy. In 1860, he began
copying in the Louvre and two years later entered the atelier of
Gleyre (q.v.), where he met the future founders of Impressionism,
Bazille, Monet and Sisley, and began to paint modern figure
subjects and scenes drawn from contemporary life. Despite
acceptance at the Salon of 1864, the next fourteen years saw only
intermittent success with that establishment, encouraging Renoir,
together with Monet, Pissarro, Sisley and Degas, to found an
independent exhibiting body. Renoir's doubts about the artistic
objectives of Impressionism had significant repercussions on his
art during the 1880s, for which he sought a more timeless quality
through classicising nudes and monumental figure subjects. At
the same time he travelled to Italy, the South of France and twice
to Algeria (1881, 1882) in search of new subjects and fresh
artistic stimulus. He declined to exhibit at the eighth and final
Impressionist exhibition (1886), preferring to show at the Salon
and in one-man and small group exhibitions at the galleries of
Georges Petit and Durand-Ruel. In 1892, the State purchased his
Jeunes Filles au piano and from the following year he began to
spend his winters in the South of France, to which he moved
permanently in 1902. He died in 1919 at Cagnes
(Alpes-Maritimes).

ABBREVIATED REFERENCES
D. F. Daulte, *Auguste Renoir, catalogue raisonné de l'oeuvre peint* vol. I, Figures
 1860–1890, Lausanne, 1971

106*

Woman of Algiers or Odalisque 1870

Femme d'Alger ou Odalisque

69·2 × 122·6 cm
Signed and dated bottom left: *A. Renoir 70*
National Gallery of Art, Washington, Chester Dale Collection, 1962
[repr. in colour on p. 104]

Executed in the winter of 1869–70 in Renoir's studio, this
painting of his model Lise in Oriental costume owes nothing to
his first-hand experience of North Africa, which Renoir was not
to visit for another eleven years. The picture was accepted at the
Official Salon of 1870, together with *Baigneuse au Griffon* (Museo
de Arte, Sao Paulo), which also used Lise as a model. Whereas
this latter painting revealed debts to Courbet and Corot, the
Woman of Algiers declared Renoir's admiration for two other
formative influences on the evolution of Impressionism, Manet
and Delacroix.

The sultry, defiant gaze of the model, her horizontal pose
propped up against a pillow, with the carefully-placed still life
on the left, and the relatively shallow picture-space recall Manet's
nude courtesan, *Olympia* (1863; Musée d'Orsay, Paris), exhibited
at the Salon of 1865. Manet's painting was itself dependent upon
Titian's *Venus of Urbino* and it is possible that Renoir intended
Woman of Algiers to be read as the North African equivalent of
a contemporary nude, as well as an image of timeless, classical
beauty.

Significantly, however, Renoir's odalisque is fully clothed, in
contrast to the more usual nineteenth-century representations of

odalisques (eg. Ingres [Cat. 80], Chassériau, Gérôme [Cat. 31]). In
this respect and for many of its other compositional elements –
the confined space, the tiled walls, the costume and the exotic
trappings – Renoir's painting looks to Delacroix's picture of a
harem interior, *Femmes d'Alger* (1834; Louvre, Paris). Delacroix's
influence can also be seen in the scintillating colours and loose
brushwork which Renoir derived from the older artist's
Orientalist works and from his late and technically brilliant
works, such as the murals in the Chapelle des Anges (St. Sulpice,
Paris, 1853–61).

Arsène Houssaye, in a letter addressed to the reviewer of the
1870 Salon for the journal, *L'Artiste*, confirms this affinity
between Delacroix and Renoir: 'One can study the proud,
painterly temperament which appears with such brilliance in
Woman of Algiers that Delacroix could have signed it' (1 June
1870, quoted J. Rewald, 1973, p. 246). Houssaye
in the same letter also links Renoir's name with Monet as 'the
two great masters . . . who . . . say "nature for nature's sake"'.
While the studio setting and the references to visual prototypes
show no immediate concern to paint directly from nature, the
looseness of certain passages of brushwork might owe
something to Renoir's and Monet's shared experience at La
Grenouillère, on the River Seine in September 1869. Here, they
evolved the Impressionist technique of the rapid, comma-like
brushstroke of pure colour laid onto light grounds as the means
of capturing the transitory moments of nature.

Renoir painted one further overtly Orientalist picture in 1870,
Portrait of Mme. Stora ou L'Algérienne (D. 47). Two years later,
he executed another harem scene, *Parisiennes en costume algerienne*
(D.73), which was rejected by the Salon jury of 1872. Apart from
his copy of *The Jewish Wedding*, by Delacroix (see Cat. 107) and
the *Girl with a Falcon* (Cat. 108), he produced no other Orientalist-
inspired paintings until his first visit to Algiers in 1881.
MA.S.

PROVENANCE
Before 1914, an officer, rue de Téhéran, Paris; Priv. Coll., Germany; Dr G. F. Reber, Basle;
Paul Rosenberg, Paris; c. 1928, Hugh Perls, Berlin and New York; 1933, Mr and Mrs Chester
Dale, New York; 1962, given to the National Gallery of Art

EXHIBITIONS
1870, Paris, Salon, (no. 2406)
1904, St. Louis, Universal Exposition (French Section) (no. 463a)
1913, Munich, *L'Art français du XIXᵉ siècle*, ill. pl. 160
?1931, Paris, Grand Palais, *Exposition coloniale internationale*

REFERENCES
D. 48
J. Rewald, *The History of Impressionism*, London, 1973, pp. 243, 246, ill. p. 239
K. S. Champa, *Studies in Early Impressionism*, New Haven and London, 1973, pp. 49, 90, ill.
 fig. 88

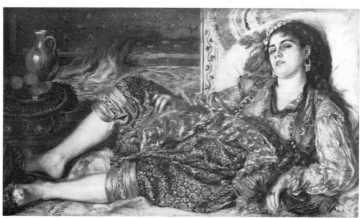

106

107

The Jewish Wedding (after Delacroix) 1875
La Noce juive (d'après Delacroix)

108 × 144 cm
Signed bottom left: *Renoir d'après E. Delacroix*
The Worcester Art Museum, Worcester, Mass.
[*repr. in colour on p. 106*]

This painting is a copy by Renoir after Delacroix's *La Noce juive* (105 × 140·5 cm; exhibited in the Salon of 1841; Louvre, Paris). It was commissioned by Jean Dollfus, an industrialist from Alsace, who was forming a collection of Impressionist paintings for his homes in Mulhouse and Paris. He made Renoir's acquaintance in 1875, and shared with him a deep admiration for Delacroix. The painting is related to the *Portrait de M. Choquet* (1876, D. 176), where the sitter's enthusiasm for Delacroix led him to ask Renoir to include behind his head the sketch for *Numa et Egerie*, one of the pendentives in Delacroix's decorative cycle executed in the Library of the Palais Bourbon, Paris (1840-46).

Renoir has provided a faithful transcription of the subject of Delacroix's painting. The image derives from a ceremony which Delacroix himself witnessed at Tangier on 21 February 1832 and belongs to a group of works executed in the years immediately following his brief visit to North Africa (Cat. 11, 12, 13). Delacroix took copious notes of the event (*Journal*, A. Joubin ed., Paris, 1933, I, pp. 127–30 and elaborated on the nuptial rites in an article for the *Magazin pittoresque* in 1842 (*Oeuvres littéraires*, I, Paris, 1923, p. 103 ff.). The ceremony took place in the house of the bride's parents and that access was permitted to the public, who looked on as musicians played a stream of music to which only the women, singly, would perform. Delacroix placed great emphasis on this scene, referring to it in a letter to Moreau, where he stated, 'It is imperative that I set about reproducing, while the memories are still fresh, the things which impressed me during my trip (in Morocco)' (*Eugène Delacroix, Lettres intimes*,

A. Dupont ed., Paris, 1954, p. 198).

Renoir's acceptance of this commission indicates that, unlike his fellow Impressionists, Monet, Degas and Pissarro, who studied another 'primitive' art in the Japanese print, the sources of his technique were the scintillating colours and exotic scenes of Delacroix's Orientalist works. This painting was executed six years after Renoir's technical innovations at La Grenouillère (see Cat. 106) and it reveals the fluent handling of his own Impressionist technique. The rear wall is constructed of feathery brushstrokes which cascade down the surface. The back of the man, seated in the right foreground, is a network of red, blue, yellow, purple, orange and green, whereas the counterpart in Delacroix is handled as blue-black. In sum, the shorter, more fluid brushwork throughout Renoir's picture brings action to Delacroix's more static, monumental work.

As in the *Woman of Algiers*, the balance between Delacroix's and Renoir's own technique in this painting is still uncertain. It was only later, when Renoir visited North Africa to view these scenes at first-hand, that he at last saw a way out of Impressionism by fusing colour with light, and technique with exotic subject-matter (see Cat. 109). MA.S.

PROVENANCE
1875, Jean Dolfus, Paris; 1911, Durand-Ruel, Paris; James J. Hill, St. Paul, Minnesota; Gertrude Hill Gavin; Knoedler and Co. Inc., New York, from which it was bought by the Worcester Art Museum

EXHIBITIONS
1940, Los Angeles, Los Angeles Museum, *The Development of Impressionism* (no. 64)
1948, Paul Rosenberg and Co., *Masterpieces by Delacroix and Renoir* (no. 30)
1955, Los Angeles, County Museum; San Francisco, Museum of Art, *Pierre Auguste Renoir* (no. 16)
1963, Bordeaux, Galerie des Beaux-Arts, *Delacroix, ses maîtres, ses amis et ses élèves* (no. 374)
1969, New York, Wildenstein and Co. *Loan Exhibition in Commemoration of the Fiftieth Anniversary of Renoir's Death* (no. 17)
1982, Rochester, New York, Memorial Art Gallery, *Orientalism*, (no. 68)

REFERENCES
D. 139
Worcester Art Museum, *News Bulletin*, vol. VIII, no. 8 (Supplement), May 1943, ill.
Worcester Art Museum, *Annual Report*, 1943, pp. 9, 14
Worcester Art Museum, *Art Through Fifty Centuries*, 1948, p. 83, fig. 114
Rochester, New York, Memorial Art Gallery, *Orientalism*, catalogue by D. Rosenthal, 1982, p. 145, fig. 144
Worcester Art Museum, *Catalogue of Paintings*, pp. 276–77, no. 1943.1

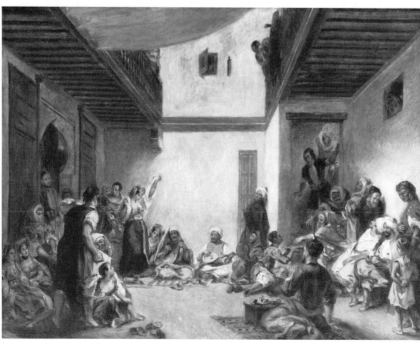

107

108

Girl with a Falcon 1880

Jeune Fille au faucon

126·8 × 78 cm

Signed and dated bottom right: *Renoir 80*
Sterling and Francine Clark Art Institute, Williamstown, Mass.
[repr. in colour on p. 105]

In contrast to his earlier Orientalist paintings, for example, *Parisiennes en costume algérienne* (D.73), the compositional sophistication and technical brilliance of this picture could invite the suggestion that 1880 may not be its correct date. Might it have been executed either during or after one of Renoir's two brief visits to Algeria in 1881 and 1882? Whilst some of the painting's impact springs from the evolution of Renoir's Impressionist technique during the 1870s, the vivid colours of the girl's dress especially the richness of the belt and headdress, and the blue-white background on the left set off against the blue-green of the right background, all point towards Renoir's hotter palette of the early 1880s. Similarly, the dense, impastoed paint applied to the thick, white ground of the figure relates less

to the thin glazes of Renoir's work *c.* 1877–80, than to the denser, more heavily-worked surfaces of the early 1880s. Furthermore, the picture's blond tonality could result from Renoir's discovery of the role of intense white light during his first Algerian visit of 1881. Finally, the first extant record of the painting is probably the sale, together with two other Algerian works, to Durand-Ruel on 22 May 1882 of a work entitled *Jeune Fille à l'oiseau*, almost certainly *Girl with a Falcon*.

Despite these mainly stylistic considerations, there are good reasons for leaving the execution of the painting in 1880. First, Daulte (D. 349) suggests that the model for the girl was Mlle. Fleury, a Parisian whom Renoir used *c.* 1880, which would place the picture in the sequence of Algerian costume pieces executed in Paris during the 1870s (see Cat. 107). This is reinforced by the fact that the model holds what appears to be a cuckoo, rather than a falcon, and the bird sits on her right hand, contrary to falconry practice. Second, during his Algerian visit of 1882, Renoir wrote to Durand-Ruel, his dealer, that he had already seen some very picturesque children and intended 'this time to bring you back figure paintings, which I was unable to do on my last journey [i.e. 1881]' (*Renoir en Italie et Algérie*, introduction by Georges Besson, Paris 1955, n.p.). While it is not entirely correct that Renoir executed no figure pictures during his first visit to Algeria (eg. D. 367–70), none of the 1881 studies was as monumental or as finished as *Girl with a Falcon*, and the use of thin glazes, which are particularly evident in the top left and right of the painting, rules out Renoir's second visit to Algeria in 1882 as a possible date for the painting. Finally, there is no evidence to suggest that Renoir ever deliberately mis-dated his paintings.

Therefore, it could be suggested that the painting was executed in 1880, prior to Renoir's first journey to North Africa, and that Durand-Ruel bought the picture from Renoir in May 1882, with a view to making a ready sale on the lively contemporary market for Orientalist subjects. The dealer may also, by *c.* 1884, have converted 'the bird' into a falcon, to meet popular expectations of Orientalist imagery. As a transitional work between the 1870s and the 1880s, the picture was sufficiently similar to the works which resulted from the Algerian trips to be in accord with both of the Algerian paintings purchased by Durand-Ruel on 22 May 1882, and with a further one purchased the following day. MA.S.

PROVENANCE
1882, 22 May, bought from the artist by Durand-Ruel; 1884, 30 December, sold to David; 1884–88, sold to Charles Leroux, Paris; 1888, 27–28 February, Vente Charles Leroux, Paris (lot 72); Durand-Ruel; 1909, Miss Anna Thompson, New York; 1928, bought from her by Durand-Ruel; 1937, 6 May, Robert Sterling Clark, New York; 1955, Sterling and Francine Clark Art Institute

EXHIBITIONS
1883, Paris, Durand-Ruel, *Renoir* (no. 3, as *Jeune fille à l'oiseau*)
1929, New York, Durand-Ruel, *Paintings by the Master Impressionists* (no. 15)
1930, Paris, Petit Palais, *Centenaire de la Conquête de l'Algérie* (hors catalogue)
1932, New York, Durand-Ruel, *Masterpieces by Renoir* (no. 2)
1934, Chicago, Art Institute, *Exhibition of Paintings and Sculpture* (no. 234)
1933, Paris, Orangerie, *Renoir* (no. 9)
1967, New York, Wildenstein and Co., *Treasures from the Sterling and Francine Clark Institute* (no. 33)
1973, Chicago, Art Institute, *Renoir Paintings and Drawings* (no. 32)

REFERENCES
D.349
A. Boime, *Thomas Couture and the Eclectic Vision*, New Haven, 1980, p. 111, ill. fig. v. 24
[The compiler is indebted to John House for information on the provenance of this painting and to Peter Stocks for identifying the bird]

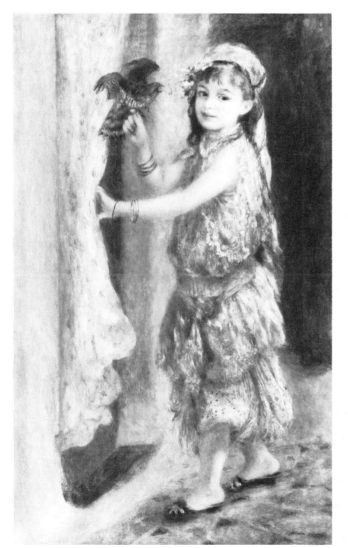

109

Arab Festival, Algiers. The Casbah 1881

Fête Arabe à Alger. La Casbah

73·5 × 92 cm
Signed and dated bottom right: *Renoir 81*
Musee d'Orsay, Galerie du Jeu de Paume, Paris
[*repr. in colour on p. 107*]

This painting is almost certainly a record of a religious
celebration witnessed by Renoir in the Casbah of Algiers. It is
one of six pictures he painted during his first trip to Algeria,
March–April 1881.

By the end of the 1870s, Renoir had become increasingly
uneasy with Impressionism, as a mark of which he returned to
exhibiting at the official Salon of 1878 and disassociated himself
from the Fifth Impressionist Exhibition of the following year. His
technique and subject-matter also became more diversified, with
the introduction of greater finish in his paintings (see Cat. 108),
the exploration of pure colour in a group of flower pieces
(*c.* 1880) and the execution of large, 'official' figure groups and
portraits (eg. *Mme. Charpentier et ses enfants*, 1878, D. 266).
Impressionism, at this time, even came under attack from its most
devoted supporter, Emile Zola. In two articles published in *Le
Voltaire* (18 and 22 June 1880, 'Le Naturalisme au Salon'), he
regrets the inability of the Impressionists to produce
masterpieces that could withstand the test of time. The opening
years of the 1880s saw Renoir, as well as Monet and Pissarro,
searching for the means by which the ephemeral images of
Impressionism might be stabilised through a reassessment of
subject-matter, artistic antecedents and colour. Renoir's two brief
visits to Algeria in 1881 and 1882 provided much important and
stimulating material for him. His decision to visit Algeria was
prompted by his admiration for Delacroix (see Cat. 106, 107) and
by his desire to see 'le pays du soleil' (letter to Théodore Duret,
[1881], quoted D., p. 45). Apart from echoing Delacroix's wonder
at the luxuriance of the North African vegetation (letter to Mme.

Charpentier, dated March 1881, quoted *Renoir en Italie et en
Algérie*, 1955, n.p.; letter to Théodore Duret [1881] quoted D., p. 45),
Renoir was also deeply impressed by the nobility and the biblical
character of the people, the mysterious women, and the light.

Jean Renoir reports that his father declared of Algeria:
'"Everything is white: the burnūses they wear, the walls, the
minarets, the road . . . And against it the green of the orange
trees and the grey of the figs"' (J. Renoir, *Renoir*, Paris,
1962, p. 228). The *Arab Festival* concentrates on this whiteness
in the Algerian light, yet the flashes of intense colour, especially
in the foreground, are evidence of Renoir's understanding of the
equally significant presence of rich colour, which he expressed
more overtly in such Algerian landscapes as *Champ des bananiers*,
Jeu de Paume, Paris, and *Ravin de la femme sauvage*, Jeu de
Paume, Paris.

The formal structure of *Arab Festival* is less stable than in the
paintings of his second visit to Algeria such as *La Mosquée à
Algers* (1882, Priv. Coll.). The successful introduction of stability
as a new formal ingredient into his work awaited Renoir's trip
to Italy, autumn 1881–January 1882, and his stay with Cézanne
at L'Estaque (January–March 1882). The impact of Renoir's
discovery of the light and luxurance of North Africa during his
first visit can however be found in works executed immediately
on his return to Paris in April 1881, notably *Le Déjeuner des
cannotiers* (1881, D. 379). MA.S.

PROVENANCE
1888, 8 December, on deposit with Durand-Ruel from the artist; 1892, 3 February, bought
from the artist by Durand-Ruel; from 1900, 31 January, Claude Monet; 1936, Wildenstein
and Co.; 1955, Mrs. Margaret Biddle; 1957, Gift of the Biddle Foundation, in memory of
Mrs. Margaret Biddle to the State

EXHIBITIONS
1906, Marseille, *Exposition Nationale coloniale: Exposition retrospective des Orientalistes*, (no. 53,
as *Fête au camp*)
1965, Lisbon, Palais de la F.I.L., *Un Seculo de pintura francesca, 1850–1950* (no. 120)
1967–68, Paris, Orangerie, *Vingt ans d'aquisitions au Musée du Louvre: 1947–1967* (no. 423)
1975, Recklinghausen, Museen der Stadt, *Der Einzelne und die Masse* (no. 203)

REFERENCES
Musée du Louvre, *Catalogue des peintures, I, Ecole française*, Paris, 1972, p. 322
H. Adhemar and A. Dayez, *Musée du Louvre, Musée de l'Impressionnisme, Jeu de Paumé*, Paris,
1973, p. 155
J. Rewald, *History of Impressionism*. London, 1973, p. 454, ill. p. 462

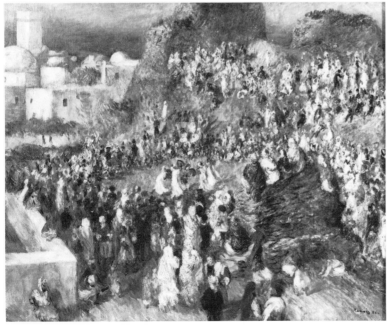

109

Roberts, David 1796–1864

Born in Stockbridge, near Edinburgh, the son of a cobbler, David Roberts received no formal art education. He started his career as a painter of theatrical scenery, panoramas and dioramas, doing studio work in his spare time. In 1830, spurred on by success at the Royal Academy, he became a full-time artist. Roberts travelled extensively in search of pictorial material, visiting Spain in 1832–33, Belgium in 1845, 1849, 1850 and 1851, France in 1822, 1832 and 1843, and Italy in 1851 and 1853. He also returned to his native Scotland every year. One of the first independent British artists to make the journey to the Near East, he spent eleven months in 1838–39 going up the Nile, seeing Cairo, the Sinai desert, Syria, Palestine and Lebanon, sketching virtually every monument of note on the way, many from several viewpoints. The sketches were reproduced as lithographs in the six volumes of *The Holy Land, Syria, Idumea, Arabia, Egypt and Nubia* published in the years following his return to England, and many of Roberts's oil paintings are based upon these compositions.

Robert's work was highly acclaimed during his own lifetime, but he trained no assistants and left no obvious successors.

ABBREVIATED REFERENCES
Ballantine 1866, J. Ballantine, *The Life of David Roberts R.A.*, Edinburgh, 1866
The Holy Land . . . and Nubia, 1842–49
 D. Roberts, *The Holy Land, Syria, dumea, Arabia, Egypt and Nubia*,
 London, 1842–49, 6 vols

110

The Temple of Dendereh 1841

119 × 212 cm
Signed and dated bottom left: *David Roberts 1841*
The City of Bristol Museum and Art Gallery
[*repr. in colour on p. 54*]

One of the last temples to be built on the Nile, Dendarah was begun in the time of the Ptolemys and added to by successive Roman emperors. It was dedicated to the cow-goddess Hathor, here married to Horus Behdeti of Edfou (Cat. 91). Although the temple is still in a good state of preservation, it suffered defacement at the hands of the fanatical early Christians who tried to obliterate the heads of the pagan goddess that graced the tops of the columns. When David Roberts first saw it in 1838, Dendarah was still only partially excavated, with sand reaching the roof in some places. The original zodiacal ceiling had been removed in 1821 and installed in the Louvre.

All travellers, including Roberts, were impressed by the beauty of the elaborate carvings which showed processions in honour of Hathor. Many found the sheer scale of the structure, which stood alone in a plain two miles from the river, to be awe-inspiring. Roberts was aware of the contrast between the temple's former splendour and its present state. His journal entry for 19 October 1838, as transcribed by Ballantine, records his emotions on first seeing Dendarah: 'I felt sad and solitary – not a soul but myself and my black guide within miles . . . and I reached my boat overcome with melancholy reflections on the mutabilility of human greatness and the perishable nature of even the most enduring works of human genius.'

It was not until he came back up the Nile ten weeks later that he made the sketch of the temple on which this painting is based. There is no trace of his gloomy ponderings in the broad theatrical sweep of the composition, which reminds one of Roberts's early training as a scene painter. The picture is related to plate 161 in volume IV of *The Holy Land . . . and Nubia*, 1842–49. C.B.

PROVENANCE
1841 David Barclay M.P.; 1910, 5 March, Christie's, London, anon. sale (lot 51); 1910 presented by Lord Winterstoke to The City of Bristol Museum and Art Gallery

EXHIBITIONS
1841, London, Royal Academy, Summer Exhibition (no. 223)
1975, Bristol, City Museum and Art Gallery; Swansea, Glynn Vivian Art Gallery, *Anthology of Victorian and Edwardian Paintings* (p. 4)
1981–82, Scottish Arts Council Touring Exhibition, *Artist Adventurer David Roberts 1796–1864*, (no. 18)

REFERENCES
Ballantine, 1866, pp. 88–89, 99, 175
D. Roberts, 'Eastern Journal', 2 vols., MS., National Library of Scotland, Edinburgh

110

111

The Gateway to the Great Temple at Baalbec 1841

74·9 × 62·2 cm
Unsigned
The Royal Academy of Arts, London
[*repr. in colour on p. 55*]

Interest in Baalbec in the Lebanon dated from the eighteenth century, when visits were first made by explorers such as Maundrell and Pococke in the 1730s, and Wood and Dawkins in the 1750s. By the time Roberts went there in 1839, Baalbec was becoming a more common destination for those tourists brave enough to risk the journey through the troubled surrounding countryside. However, Roberts saw himself as following in the tradition of the earlier explorers. Accordingly, he paid homage to some of the first visitors to Baalbec by including their names in this painting. Just visible inside the doorway on the right are the names of Irby and Mangles (naval officers who had made detailed measurements of the site in 1816), Wood and Dawkins (Wood published *The Ruins of Baalbec* in 1757) and Shaykh Ibrim (the pseudonym adopted by J. L. Burckhardt who visited Baalbec in September 1810).

Roberts arrived at Baalbec and set up camp on 2 May 1839, but unfavourable weather conditions – the rain drenched him and his bedding and brought on a fever – caused him to seek refuge in a nearby Greek monastery. He was, however, greatly revived by the splendour of the ruins and the richness of their ornament. He spent the next few days making a number of studies of the three temples from various angles, many of which were later used as the basis for oil paintings and lithographs. This picture shows the gateway to the Temple of Bacchus, a building which, at various stages in its history had been a Greek temple, a Christian church and a Muslim fortress. Here Roberts takes the opportunity to depict the elaborate carvings of acanthus leaves

and wreaths of vines. The famous dropped keystone, subsequently restored to its original position, hangs suspended over a group of apparently unconcerned men. Their presence in front of the temple acts both as an indication of the vast size of the doorway and as an implied criticism of the negligent attitude displayed by contemporary Arabs in allowing their architectural heritage to fall into decay. The letterpress to the lithograph based on this composition, and published in *The Holy Land . . . and Nubia*, 1842–49 (II, pl. 81), reinforces this point: 'These beautiful structures, though replete with interest and delight, carry with them a mingled feeling of humiliation at the transitory greatness of all human conceptions, and regret that such proud relics of genius should be in the hands of a people incapable of appreciating their merits and consequently heedless of their complete destruction.' C.B.

PROVENANCE
1841, Diploma work deposited by the artist at the Royal Academy on his election to membership

EXHIBITIONS
1843, London, Royal Academy, Summer Exhibition (no. 219)
1866, London, British Institution (no. 177)
1868, Leeds Art Gallery, *Works of Art Exhibition* (no. 1173)
1901, London, Royal Academy, Winter Exhibition, (no. 111)
1951–52, London, Royal Academy, *The First Hundred Years Exhibition* (no. 357a)
1961, Arts Council Touring Exhibition, *Diploma and Other Pictures from the Collections of the Royal Academy, 1798–1851* (no. 34)
1967, London, Guildhall Art Gallery, *David Roberts and Clarkson Stanfield* (no. 21)
1976, Edinburgh, Royal Scottish Academy *150th Anniversary Exhibition* (no. 4)
1981–82, Scottish Arts Council Touring Exhibition, *David Roberts, Artist Adventurer: 1796–1864* (no. 20)

REFERENCES
Ballantine 1866, pp. 137–39, 250
J. Maas, *Victorian Painters*, London, 1969, ill. p. 95
H. Guiterman, *David Roberts R.A. 1796–1864*, London, 1978, p. 17
K. Bendiner, *The Portrayal of the Middle East in British Painting (1835–1860)*, Ph.D thesis, Columbia University, 1979, pp. 101, 128

112

The Island of Philae, Nubia 1843

76·5 × 152·9 cm
Signed and dated bottom right: *DAVID ROBERTS. RA 1843*
Private Collection
[*repr. in colour on p. 52*]

The island of Philae stood just past the first cataract, at the entrance to Nubia. It presented a particularly welcome sight to the nineteenth-century traveller ascending the river, who had just navigated the turmoil of the previous stretch of water. One of the best-known landmarks in the whole of Egypt, it was sketched and described by everyone who visited the area (see Cat. 61, 62, 82), but the modern tourist is deprived of the view that greeted Roberts and his contemporaries, as the island was submerged following the construction of the Aswān Dam and the monuments were moved to a neighbouring island.

Many commented on the romantic and serene appearance of Philae, an impression no doubt heightened by the knowledge that the island had been one of the most sacred places in Egypt during the period of Greek and Roman rule. At that time, the neighbouring Bigah Island was sacred to Osiris, burial site of his legs and a place of pilgrimage. Roberts thought Philae 'a paradise in the midst of desolation,' the high barren rocks of the surroundings reminding him of Scotland and the setting of the island of Roslin, which also possessed religious ruins in the form of its chapel. In order to show the number of temples on the island, the artist chose to present a panorama of Philae viewed from Bigah. The painting shows from right to left, the pylon;

111

the birthplace of Horus; the Hypaethral temple or 'Bed of Pharaoh', built under the Emperor Trajan; and the Ptolemaic main temple dedicated to Isis. The whole view is bathed in a rosy glow suggestive of dawn or dusk. The general treatment of the subject reminds one of the commercial panoramas that David Roberts would have worked on at the outset of his artistic career.

The painting was engraved by L. Haghe in *The Holy Land . . . and Nubia*, 1842–49, I, as pl. 26. C.B.

PROVENANCE
1843, Mr Pell; Mr Dialus; 1852, 27 February, Christie's, London (lot 132) bought by Gambart; 1858, 20 February, Christie's, London (lot 132) sold by Charles Morgan, bought by Mr Butler; 1937, 19 February, Christie's, London (lot 156), sold by Capt. Butler, bought by Barber; 1983, 18 March, Christie's, London (lot 77), bought by The Fine Art Society; 1983, bought by the present owner

EXHIBITION
1843, London, Royal Academy, Summer Exhibition (no. 53)

REFERENCE
Ballantine 1866, pp. 92–93, 250

113*

A Street in Cairo 1846

76·1 × 63·4 cm
Inscribed bottom right: *David Roberts RA 1846*
Royal Holloway College, London University
[*repr. in colour on p. 53*]

Towards the end of December 1838, Roberts arrived back in Cairo after his three-month trip up the Nile. He rented a house, intending to spend some time drawing the monuments of the city, notably a few of its 400 mosques. He set about his task with an enthusiasm that was soon dampened by the practical problems he encountered. The artist complained in a letter to his daughter Christine that 'narrow, crowded streets render it very difficult to make drawings, for in addition to the curiosity of the Arabs, you run the risk of being squeezed to a mummy by the loaded camels, who, although they are picturesque in appearance, are ugly customers to jostle' (Ballantine 1866, p. 106). Nonetheless, Roberts left Cairo a month later with a large number of drawings that were later engraved by Louis Haghe for *The Holy Land . . . and Nubia*, 1842–49.

The view depicted here is based on a drawing made by the artist on 1 January 1839 (Nottingham, City Museum and Art Gallery), and it focusses upon the minaret of the Mosque of al-Ghamri (since destroyed). The letterpress that accompanied the lithograph of the work in *The Holy Land . . . and Nubia*, 1842–49 (III, pl. 13) gives the following description of the subject: 'This mosque is situated in the main line of the street leading to the Bab el Nasr. There are great beauty and symmetry in its minaret . . . It is surmounted by a bronze crescent, and the props, often decayed and unsafe, from which lamps are suspended during the feast of Rhamadan . . . The narrow streets, thus overhung by the houses on either side, are darkened but cooled by the exclusion of the sun's rays, yet those objects of beauty, the minarets of the mosques, frequently burst upon the observer as they rise above the buildings, and strikingly characterise the architecture of Cairo.'

The painting, executed seven years after Robert's return from Cairo, differs from the lithograph in a way that suggests that accuracy was not Robert's prime concern. Despite his frequently declared aim to increase the knowledge of Near Eastern architecture in England, Roberts felt free to alter certain details of the buildings on either side of the mosque, adding and subtracting elements at will. Striving rather for an overall effect, Roberts emphasises the dramatic contrast between the dark passage below and the light that falls diagonally across the street to illuminate the upper storeys of the building on the right and the minaret. C.B.

PROVENANCE
1846, Elhanan Bicknell; 1863, 25 April, Christie's, London, Elhanan Bicknell sale, (lot 75) bought by Agnew's; 1863, 6 May, sold by them to Duncan Fletcher; 1865, 20 May, Christie's London, Duncan Fletcher sale (lot 31), bought by Flatow; F. T. Turner; 1878, 4 May, Christie's, London, F. T. Turner sale (lot 47), bought by Thomas Taylor of Aston Rowant Gallery, Oxfordshire; 1883, 28 April, Thomas Taylor sale (lot 64), bought by Thomas Holloway under the pseudonym of Martin

EXHIBITIONS
1846, London, Royal Academy, Summer Exhibition (no. 91)
1951–52, London, Royal Academy, *The First Hundred Years of the Royal Academy 1769–1868* (no. 335)
1981–2, Scottish Arts Council Touring Exhibition, 'David Roberts, Artist Adventurer, 1796–1864' (no. 22)

REFERENCES
Ballantine 1866, pp. 163, 250 (no. 141)
J. Chapel, *Victorian Taste: The Complete Catalogue of Paintings at the Royal Holloway College*, London, 1982, pp. 131–32, ill. pl. 22

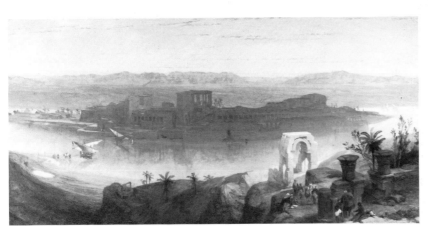

112

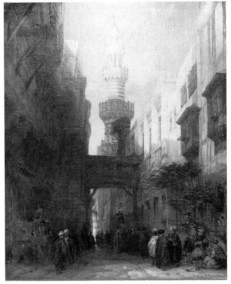

113

Schreyer, Adolf 1828–1899

This painter of swashbuckling Arab warriors was born in
Germany but made his reputation in Paris. He was trained at the
Städelsches Kunstinstitut in Frankfurt, then at the Düsseldorf
Academy. From 1849 he was based in Vienna, initially
specialising in landscapes and military subjects. He travelled in
Turkey, Wallachia and southern Russia with Prince von Thurn
und Taxis and accompanied the Prince's regiment as a war artist
during the Crimean War (1854–57). In 1861 he went to Algeria,
and the sketches he made there formed the foundation for his
subsequent work. He lived and exhibited in Paris from 1862 to
1870, returning to Germany during the Franco-Prussian War.

114*

Arab Horsemen

87 × 120 cm
Signed bottom right: *Ad. Schreyer*
Denver Art Museum, gift from the Lawrence C. Phipps Foundation
[*repr. in colour on p. 77*]

The restless, angry-looking figures of the Arabs, the amorphous
landscape setting and the loose, rapid brushwork make this a
completely typical work of Schreyer. In both subject-matter and
style, he was clearly influenced by Fromentin (*q.v.*). The
horsemen in the foreground appear to be chiefs discussing the
progress of the battle visible on the horizon to the left, their
troops waiting watchfully behind them. There are no clues as to
exactly where and when the scene is intended to be set, or whom
the Arabs might be fighting against. But the obvious
interpretation, surprising in view of Schreyer's French
connections, is that they are engaged in resistance against the
French in Algeria. This came to a head in 1871 when 100,000
tribesmen waged war on the occupying forces under the banner
of Islam and nationalism. M.W.

PROVENANCE
1958, presented by the Lawrence C. Phipps Foundation to the Denver Art Museum

Scott Lauder, Robert 1803–1869

Born in 1803, Lauder was unwilling to join his father's tannery
business in Edinburgh, and enrolled instead at the Trustees'
Academy. After a further period of study in London, during
which he drew assiduously from the Elgin Marbles, Lauder
started his painting career as a portraitist, depicting his family
and friends. He gradually expanded his work to include history
paintings, and subjects drawn from the writings of Sir Walter
Scott and the Bible. Although it is said that Lauder's initial
inspiration to become an artist came from seeing a beautifully
illustrated edition of *The Arabian Nights*, he never went to the
Near East. Instead, he spent five years in Rome from 1833 to
1838, earning a living from portraiture. On his return, Lauder
settled in London, and concentrated his efforts on trying to
achieve success at the Royal Academy. However, the prize of
membership eluded him, and by 1848 he had ceased to exhibit
there. He went back to Edinburgh in 1852 to take up the
Directorship of the Trustees' Academy, a position in which he
was to prove very influential upon a young generation of
Scottish artists that included W. Quiller Orchardson, John Pettie,
William McTaggart and John Herdman.

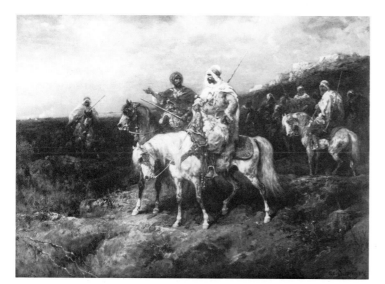

114

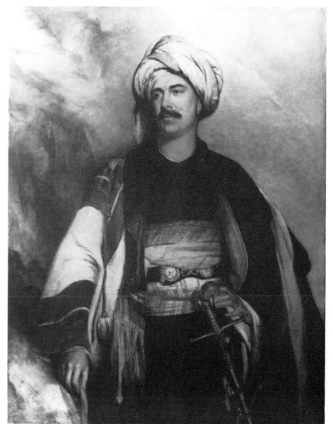

115

115
David Roberts Esq. in the Dress he wore in Palestine 1840

133 × 101·5 cm
Scottish National Portrait Gallery, Edinburgh
[repr. in colour on p. 88]

Robert Scott Lauder was an old friend of David Roberts; the two had met as young men in Edinburgh, and Roberts frequently acted as mentor and creditor to the younger artist. The picture was commissioned by a mutual friend, David Ramsay Hay, and later passed into the Roberts family. It was painted the year after Roberts's return from his eleven-month tour of Egypt and the Holy Land in 1839, and shows him in the clothes he bought while on his travels.

The convention of painting Westerners in Turkish costume had been popularised in the eighteenth century by artists such as J. E. Liotard and the genre took on a new lease of life in the early nineteenth century as souvenirs of voyages when explorers, scholars and writers began to travel in greater numbers to the Near East. Lauder's picture is firmly rooted in the traditions of romantic portraiture. This is particularly noticeable in the stance of the subject, his rather distant gaze and the indeterminate cloudy background which lacks the recognisable topographical features of pyramids or ruins that are usually found in such paintings of travellers. Roberts was evidently pleased with this vision of himself; in a letter to David Hay he praised the broad and dashing handling of paint and claimed that it was thought to be a good likeness (letter to D. R. Hay, quoted 1983, Edinburgh, p. 58). Nevertheless, it is obvious that Lauder romanticised his sitter's features, and the painting can hardly be considered a faithful rendering of Roberts's face. Comparison with a photograph of the artist by D. O. Hill (Scottish National Portrait Gallery, Edinburgh) taken four years after this portrait was painted show him to have coarser, blunter features than this picture would suggest. C.B.

PROVENANCE
1840, David Ramsay Hay; Henry Sandford Bicknell (Roberts's son-in-law); 1881, 9 April, Christie's, London (lot 436); acquired by Lady Selfe (Roberts's granddaughter); by descent to John Stanton (Roberts's great-great-grandson); 1979, 7 November, Christie's, London (lot 261); 1980, acquired by The Fine Art Society; Scottish National Portrait Gallery, Edinburgh

EXHIBITIONS
1840, London, Royal Academy, Summer Exhibition (no. 169)
1980, London, The Fine Art Society, Travellers Beyond the Grand Tour (no. 63; ill. frontispiece)
1983, Edinburgh, National Gallery of Scotland and Aberdeen Art Gallery, Masterclass: Robert Scott Lauder and his Pupils (no. 21; ill. frontispiece)

116

Seddon, Thomas 1821–1856

A member of the Pre-Raphaelite circle of artists, a friend of Ford Madox Brown, the Rossettis and William Holman Hunt, Seddon was acclaimed by Ruskin as 'the purest Pre-Raphaelite landscape painter'. He was born in the City of London, the son of a cabinet-maker. At sixteen he entered his father's business as a designer. In 1841 he visited Paris to study ornamental art and in 1848 won a silver medal from the Society of Arts for a design for a sideboard. Hoping to become a painter, he took drawing lessons from Charles Lucy at his school in Camden Town and attended life classes at the Artists' Society in Clipstone Street. He painted landscapes in North Wales in 1849 and at Barbizon in France in 1850. In the latter year he set up his own art school in Camden Town for the instruction of working men, the North London School of Design. He suffered a near-fatal attack of rheumatic fever in 1850–51, after which he became a devout Christian. He went to Egypt in 1853 and on to the Holy Land with Holman Hunt in 1854. The main result of this first Near Eastern trip, which lasted just over a year, was *The Valley of the Jehoshaphat*, now in the Tate Gallery, London. Seddon returned to Egypt in 1856 but died of dysentery in Cairo on 23 November. A memorial exhibition of his work was held at the Society of Arts in May 1857.

ABBREVIATED REFERENCE
Seddon 1858 J. P. Seddon, *Memoir and Letters of the late Thomas Seddon, Artist*, London, 1858

116†
Dromedary and Arabs at the City of the Dead, Cairo, with the Tomb of Sultān El Barkook in the background 1853/56

Top corners rounded: 30·5 × 41·9 cm
Signed [initials in monogram] and dated bottom right: *TSeddon 1856*
Private Collection, Houston, Texas
[repr. in colour on p. 85]

The buildings referred to in the artist's title as 'the tomb of Sultān El Barkook' are the early fifteenth-century *madrasah* of Sultān Farag and Tomb of Barqūq in the Eastern Cemetery at Cairo, here seen from the south-east. This may be one of the first pictures Seddon began in Cairo in 1853 (see below), or possibly the replica commissioned from him in 1855 (see Seddon 1858, pp. 141, 146). Shortly after his arrival in Cairo on 6 December he met Edward Lear, who took a friendly, encouraging interest in his work. 'I have been very glad of Lear's arrival,' he wrote to his fiancée Emmeline Bulford on 30 December, 'both because his advice as an experienced traveller has been very useful, and also because I have been able to consult him about the pictures I think of painting. He says that I have become accustomed to the language and habits of the people, and have settled down to work, in much shorter time than most persons, so my conscience is at ease. I have already painted a camel and Bedouin on a small canvas, 14 inches by 10 inches, which is finished, except the desert for a background' (Seddon 1858). The reference is clearly to the original version of *Dromedary and Arabs at the City of the Dead, Cairo*. It would be difficult to point to any specific influence of Lear in the work exhibited here. The combination of ancient Islamic architecture and idle Arabs is reminiscent of David Roberts, whose Near Eastern views Seddon would certainly have known. But the most remarkable feature of

Seddon's picture, his meticulous, documentary approach to the landscape, came out of his commitment to the principles of Pre-Raphaelitism, which won him the praise of Ruskin. 'Mr Seddon's works are the first which represent a truly historic landscape art,' the critic wrote, 'that is to say, they are the first landscapes uniting perfect artistical skill with topographical accuracy, being directed with stern self-restraint to no other purpose than that of giving to persons who cannot travel trustworthy knowledge of the scenes which ought to be most interesting to them. Whatever degrees of truth may have been attained or attempted by previous artists have been more or less subordinate to pictorial and dramatic effect. In Mr Seddon's works the primal object is to place the spectator, as far as art can do, in the scene represented, and to give him the perfect sensation of its reality, wholly unmodified by the artist's execution' (Seddon 1858, p. 171). 'Before I saw these,' he declared after visting Seddon's private exhibition in 1855, 'I never thought it possible to attain such an effect of sun and light without sacrificing truth of colour' (*ibid.* p. 137). M.W.

PROVENANCE
1855, if the original version, acquired from the artist by Lord Grosvenor; 1974, 18 October, Christie's, London (lot 85); 1978, March, acquired by The Fine Art Society, London; Priv. Coll.; 1981, November, acquired again by The Fine Art Society, from whom acquired by Kurt E. Schon Ltd, New Orleans; Priv. Coll., Houston, Texas

EXHIBITIONS
?1855, London, the artist's room, 14 Berners Street
?1856, London, Royal Academy, Summer Exhibition, (no. 474)
?1857, London, Society of Arts
1978, London, The Fine Art Society, *Eastern Encounters* (no. 58)

REFERENCES
Seddon, 1858, pp. 32, 141, 146
The Spectator, 14 April 1855, p. 392 (review of Seddon's private exhibition)
A. Staley, *The Pre-Raphaelite Landscape,* Oxford, 1973, p. 98
M. Verrier, *The Orientalists,* New York and London, 1979, no. 9, illus.

117

117

'Arab Shaykh' (probably Richard Burton) 1854

Top corners rounded 45·7 × 35·6 cm
Signed (initials in monogram) and dated bottom right: *TSeddon Egypt/1854*
Private Collection, Houston, Texas
[*repr. in colour on p. 86*]

As early as 12 December, only a few days after arriving in Cairo on his first trip to Egypt, Seddon noted in his diary that he had 'met a Mr Burton, who, knowing the Arabic language thoroughly, has taken the dress' (Seddon 1858, pp. 31–32). Soldier, diplomat, poet, linguist, translator, anthropologist, explorer and student of Islam, Richard Burton (1821–90) was a key figure in European-Near Eastern relations in the nineteenth century. When Seddon met him he had just undertaken the boldest of the many adventures for which he became famous. Earlier in the year he had managed to pass himself off as a Muslim, posing as a doctor from India to excuse his foreign pronunciation of Arabic, and enter the sacred city of Mecca. He commisioned Seddon to make a watercolour sketch of him to be used as an illustration in his description of his experiences, *The Personal Narrative of a Pilgrimage to El-Medinah and Meccah* (1855–56). In his letter to Emmeline Bulford of 30 December 1853, Seddon reported that he had made 'a portrait of Lieutenant Burton in full Arab costume, with a camel, for an account he is going to publish of his travels in Arabia, and his journey to Mecca' (*ibid.* p. 32). The watercolour, now in private collection (1983, Brighton Museum and Art Gallery, *The Inspiration of Egypt,* no. 329), was reproduced as a lithograph in volume I of Burton's book, facing page 228, with the caption 'An Arab Shaykh in his Travelling Dress'. It is similar to *Arab Shaykh,* and in the private exhibition Seddon held in 1855 to show the results of his Near Eastern journey, the watercolour of Burton seems to have been given the title *Shaykh with Camel lying down* (*The Spectator,* 1855). It is plausible, then, that the *Arab Shaykh* should also be a portrait of Burton. On the other hand, it shows marked differences from the watercolour portrait; the pose is similar but the outfit is different, the face looks older in the oil and the beard is shorter and greyer. These allow considerable room for the possibility that it may be intended to represent nothing more than a *shaykh*. Perhaps Seddon was pleased with his portrait of Burton and decided to make a larger, more finished variation in oil, cast virtually in the same mould as the watercolour portrait but intended to pass, and be sold, as a study of a real Arab. In which case, it may well be identifiable as the 'Shaykh' Seddon was finishing from an Arab model in Paris on his return journey in January 1855 (see Seddon 1858, p. 131). M.W.

PROVENANCE
c. 1950, Priv. Coll., Egypt; 1979, March, acquired by The Fine Art Society, London, from whom acquired by Kurt E. Schon Ltd, New Orleans; Priv. Coll., Houston, Texas

EXHIBITIONS
?1855, London, the artist's room, 14 Berners Street (as *Arab Shaykh*)
?1856, London, Royal Academy, Summer Exhibition (no. 9, as *An Arab shaykh and tents in the Egyptian desert Painted on the spot*)
?1857, London, Society of Arts
1980, London, The Fine Art Society, *Travellers Beyond the Grand Tour* (no. 90)

REFERENCES
?Seddon 1858, p. 131
The Spectator, 14 April, 1955, p. 392 (review of Seddon's private exhibition)
Connoisseur, July 1980, 204, no. 821, ill. (cover)
Coral Petroleum, *A Near Eastern Adventure,* n.d., ill. (cover)

Tissot, James 1836–1902

Born in Nantes to parents both of whom were involved in the clothing business, Tissot left home at about the age of twenty to study at the Ecole des Beaux-Arts in Paris, where he became a pupil of the neo-classical painters Lamothe and Flandrin. In the early 1860s he painted a number of historical subjects, several on the theme of Faust and Marguerite. He achieved fame and a considerable fortune with the scenes from modern life in high society that he exhibited from 1864. In 1871, after the Franco-Prussian War and the fall of the Commune, Tissot moved to London, where his studies of contemporary manners and customs, courtship and flirtation, usually featuring pretty young women in flouncy dresses, won him continuing success. Following the death of his Irish mistress Kathleen Newton in 1882, he returned to Paris to paint a series of large oils on the theme of *La Femme à Paris*. While working on the last of these, which showed a Parisian woman singing in church with a nun, he had a vision of Christ and became fervently religious, devoting the rest of his life to painting biblical subjects.

118

The Journey of the Magi *c*.1894

Les Rois mages en voyage

68·6 × 99·1 cm
Signed bottom left: *J. J. Tissot*
Minneapolis Institute of Arts
[*repr. in colour on p. 95*]

Tissot believed he could forge a new and better religious art by undertaking extensive research to determine how sacred figures and events might actually have looked. In pursuance of this idea he travelled to the Holy Land in 1886–87, 1889 and 1896, making sketches and taking photographs. His interpretations of biblical scenes appeared as the illustrations to voluminous New and Old Testaments published in 1896–97 and 1904 respectively. (For a fuller discussion of Tissot and his desire for authenticity in biblical painting, see Warner pp. 33–34.) The idea of showing the Magi mounted on camels at the head of a desert caravan is typical of his approach. This work is a version of an original watercolour now in the Brooklyn Museum, which is reproduced in colour in the *New Testament* (I, 1896, p. 28). Tissot painted a number of oil versions of his Bible illustrations. According to the inventory for probate of his house, there were seven New Testament subjects in his possession at his death (see Willard Erwin Misfeldt, 'James Jacques Tissot: a Bio-Critical Study', Ph.D. thesis, Washington University, 1971, p. 327); and four, not including the present exhibit, appeared in the *Vente Tissot* in 1903 (9–10 July, Hôtel Drouot, Paris, lots 6–9). In addition, there are photographs showing five Old Testament subjects (there may originally have been seven) in the albums the artist kept as a record of his work. However, only two of the documented oils of biblical subjects have been traced: this painting and *The Sojourn in Egypt*, now in the National Gallery of Ireland, Dublin. With its dry, rough surface and predominantly pale colour, *The Journey of the Magi* is characteristic of the artist's late work in this medium. M.W.

PROVENANCE
Possibly given by the artist or his heirs to the publisher of his illustrated *Old Testament*, Maurice de Brunhoff; 1970, 6 March, Christie's, London (lot 139) acquired by the Schweitzer Gallery, New York; 1970 acquired by the Minneapolis Institute of Arts
REFERENCE
M. Wentworth, *James Tissot*, Oxford, 1984, pp. 188–89, ill. col. pl. VI

118

Vernet, Horace-Emile-Jean 1789–1863

Born in his family's apartments in the Louvre, Vernet came from a line of distinguished painters. As grandson of the marine painter Claude-Joseph Vernet and son of Carle, who specialised in historical and biblical scenes, he received his early training at home, supplemented by tuition from François Vincent (1746–1813). He made his debut at the Salon of 1800. A loyal supporter of Napoleon I, he was enrolled as Chevalier de la Légion d'Honneur in 1814 for his part in the defence of Paris. From 1819 he attached himself to the Orléans branch of the royal family. Though mistrusted for his liberal sentiments by the restored Bourbon monarchy, Vernet was nevertheless patronised by Charles X, who appointed him Professor at the Ecole des Beaux-Arts in 1826 and successor to Pierre Guérin at the Villa Medici in Rome in 1828.

Vernet's reputation was thus firmly established by 1833, when he travelled for the first time to Algeria with the French army. Further voyages were made in 1837, 1839–40, 1845, and finally in 1853. Together with his nephew, Frédéric Goupil-Fesquet, Vernet was one of the first Oriental travellers to make use of the daguerreotype and in November 1839 recorded views of Alexandria, Cairo and Jerusalem, only months after the process had been made public.

Best known for his numerous large-scale battle-pieces and scenes of army life, Vernet worked with a wide range of subject-matter and in a variety of media. He made illustrations and caricatures for books and journals, paintings inspired by literature and the Bible and a sequence of popular lithographs executed in the 1820s, as well as Oriental genre scenes.

119

119

The Battle of Somah 1839

Le Combat de Somah

145 × 112 cm
Signed and dated bottom right: *H. Vernet 1839*
Musée Rolin, Autun
[*repr. in colour on p. 60*]

This painting, which commemorates the patriotic action of General Charngarnier, a native of Autun, at the Battle of Somah, was commissioned following a subscription raised by the citizens of the town. Fought on 24 November 1836, the battle was one of the decisive engagements in the French colonial wars in North Africa. According to a report issued by General Clauzel (de Fontenay, 1877, p. 26), Charngarnier, heavily under siege by the enemy, appealed to the patriotism of his men at a critical moment in the fighting and led the French army to victory. Vernet shows General Charngarnier rising above the surrounding carnage, calm in the face of impending death. The pose of the figure, though slightly larger in scale, echoes Gros's depiction of General Murat at the Battle of Abū Qīr (see Cat. 66). Yet, unlike Gros, Vernet's concern here is less with the dramatic evocation of battle than with documentary accuracy, and he accepted the commission only on the condition that he had the episode recounted to him by the leader of the second batallion, who had witnessed the scene.

Vernet had painted battle scenes from the beginning of his career, exhibiting the first, *Prise d'un camp retranché*, at the Salon of 1812. Many were bought by the Duc d'Orléans for the Palais Royale, but it was in the decoration of the Galerie des Batailles in Versailles that Vernet's most grandiose schemes were realised. His contribution to this project, instigated by King Louis-Philippe, included the enormous *Prise de la Smala d'Abd-el-Kader par le duc d'Aumâle* (1845; Versailles), and a variant of *The Battle of Somah*, executed as an *au-dessus de porte* with surrounding decorative borders. The voyages to North Africa allowed Vernet to enhance the pictorial interest of his paintings by including exotic physiognomies, Oriental weapons and costumes, as seen here in the fallen Arab horse and rider.

More than any other aspect of his oeuvre, the battle-piece aroused the critics' aversion to his pleasing, if characterless style. They considered his art to be non-intellectual and trivial, aimed solely at gratifying public taste and advancing his own personal success. Delacroix himself made reference to Vernet's remarkable ease of composition and noted in his journal that the main example to be learned from Vernet's popular success was 'to finish something when one had it in hand. the [*sic*] only means of creating a lot' (*Journal*, I, 19 August 1824, p. 118).

Even the most hostile of critics, however, had to concede the concern for authenticity and the in-depth military knowledge of this '*Raphael des cantines*' (Silvestre, 1862, p. 347). The characteristic features of Vernet's battle-pieces are perhaps best evaluated by Paul Mantz in *L'Artiste*, 1858: 'Horace Vernet's battles are not terrible, nor are they heroic, but they possess the clarity of a simple, carefully considered bulletin' (p. 81). J.M.

PROVENANCE
1837, 3 March, subscription fund opened on the initiative of the Mayor of Autun to commission a painting from Horace Vernet; 1838, 9 December, letter from Horace Vernet to the Mayor, explaining the delay in the delivery of the painting; 1839, 28 September, payment of 4000 francs from Ville d'Autun to Horace Vernet

EXHIBITIONS
1974, Castres, Musée Goya, *Fortuny et son temps* (no. 148)
1980, Paris, Ecole des Beaux-Arts, *Horace Vernet (1789–1863)* (no. 73)

REFERENCES
P. Mantz, 'Galerie du XIXᵉ siecle. Horace Vernet', *L'Artiste*, 1857, pp. 177–82
P. Mantz, *L'Artiste*, 1858, p. 81
Th. Silvestre, *Histoire des Artistes vivants. Les Artistes français*, 1862, p. 347
H. de Fontenay and Ph. Mariller, *Notice des tableaux, dessins, estampes, lithographes, photographes et sculptures exposés dans les salles du Musée de l'Hôtel de Ville d'Autun*, Autun, 1877, pp. 26–27
Ch. Blanc, *Une Famille d'artistes, Les trois Vernet. Josephe–Carle–Horace*–Paris, 1898, p. 19
A. Dayot, *Les Vernet*, Paris, 1898, p. 219

120

The First Mass in Kabylia 1854

La Première Messe en Kabylie

194 × 123 cm
Signed and dated bottom right: *Horace Vernet 1854*
Musée cantonal des Beaux-Arts, Lausanne

The Mass in the Kabylia mountain range to the south-east of Algiers, was celebrated on 14 June 1853, to mark the anniversary of the French landing in Algeria, and the submission of the native tribes. Vernet participated in the ceremony during the course of his final visit to North Africa, personally seeing to the construction of the altar; as a devout Catholic, the religious significance of the glorification of a Christian deity in a land of infidels did not escape him. He was deeply moved by the scene, and felt his painting to be by far the most important and sincere of the thirty exhibited at the Salon of 1855. Indeed, apart from the presence of some Arab soldiers, and the token inclusion of *burnūses* and *babushes* in the foreground, there is little to suggest the North African location of the scene.

From his accounts published in *L'Ilustration* (8 and 12 April 1856), Vernet appeared singularly unimpressed by Arab culture. He showed little enthusiasm for the mosques, pyramids or cities of Egypt and Algeria: 'Cairo', he wrote, 'is bigger than Algiers, only more wretched still' (quoted L. Lagrange, 1863, p. 453). The Holy Cities of Bethlehem and Jerusalem were, for him, the highlights of the tour, and he was especially inflamed by the sight of a cavalry encampment in the plains around El-Arisha and Gaza. According to one English biographer (*Art-Union*, 1844, p. 119), Vernet's desire to visit these countries was largely inspired by his reading of the Scriptures, which also seem to have coloured his actual experiences in the Orient. In particular, he was struck by the similarity between the costume of the Arabs and that worn in biblical times; the country, on both a superficial and a moral level, for him became '*la bible arabifiée*' (L. Lagrange, 1863, p. 455). In *The First Mass in Kabylia*, it is the profound religiosity of the occasion which Vernet chose to emphasise. The *repoussoir* foreground figures, the soldiers' rifles, and the abbot's clasped hands, all contrive to lead the eye up to the brightly-lit altar and cross, swathed in a mystic puff of cloud. The awesome grandeur of the Kabylia mountains hints at the presence of the deity and the humility of Man before the Almighty, though the force of expression is somewhat lost through Vernet's disposition towards the anecdotal and the picturesque. J.M.

PROVENANCE
Gift of E. Kaufmann to the Musée cantonal des Beaux-Arts

EXHIBITION
1930, Paris, Petit Palais, *L'Exposition du Centenaire de la conquête de l'Algérie* (no. 394, ill.)

REFERENCES
Anon., 'Living Artists of Europe No. IV. Horace Vernet', *Art-Union*, VI, May 1844, pp. 119–120
H. Delaborde, 'Horace Vernet, ses oeuvres et sa manière', *Revue des Deux Mondes*, 1863, 44, pp. 76–98
L. Lagrange, 'Artistes Contemporains – Horace Vernet', *Gazette des Beaux-Arts*, November 1863, p. 453

Wilkie, David 1785–1841

Born in the small town of Cults, Fife, Wilkie was initially trained at the Trustees' Academy in Edinburgh before moving to London to enrol at the Royal Academy Schools. Although he spent the rest of his life based in London, his early works depicted genre scenes of Scottish rural life; executed in a manner reminiscent of Dutch and Flemish masters, they earned him considerable praise. His fame in this field led to a series of important commissions, such as *Chelsea Pensioners Reading the Gazette of the Battle of Waterloo* (1822; Apsley House, London) painted for the Duke of Wellington. Though a genre scene, its celebration of a specific moment in recent history heralded Wilkie's interest in history painting. At the same time, Wilkie was developing a taste for travel, which led to a three-year tour of Europe from 1825 to 1828 and a six-month tour of the Near East in 1840–41. The object of this second journey was to investigate the possibility of painting biblical subjects in their authentic surroundings. Wilkie was detained in Constantinople and, after visiting the Holy Land, spent only a short time in Egypt at Alexandria while waiting for the boat home. He sketched many portraits of local dignitaries and started a number of Eastern and biblical scenes, none of which was completed owing to his untimely death on the return journey. Wilkie's funeral off the Straits of Gibraltar is commemorated in J. M. W. Turner's *Peace: Burial at Sea* (1841; Tate Gallery, London).

ABBREVIATED REFERENCE
Cunningham 1843, A. Cunningham *The Life of Sir David Wilkie*, London, 1843, 3 vols.

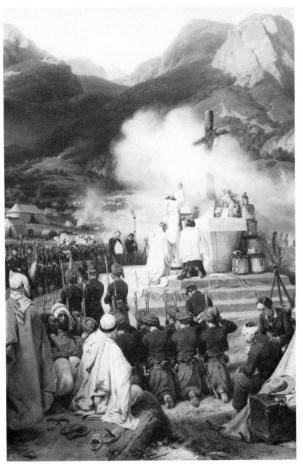

120

121

The Turkish Letter Writer 1840

Oil on panel: 68·6 × 53·4 cm
Signed and dated on frame of scribe's platform: *D Wilkie F. Constantinople, 1840*
Aberdeen Art Gallery and Museums
[*repr. in colour on p. 73*]

Sir David Wilkie set off on his tour of the Near East on
15 August 1840. He sailed down the Danube to his first
destination, Constantinople, where he had the leisure to wander
round the city, inspecting the bazaars and coffee shops and to
learn about Turkish daily life. At Topkanah, the suburb outside
Pera (see Cat. 74), he was struck by a scene in the outer court
of a mosque. His journal records 'a scribe of most venerable
appearance. He was reading a letter or a paper he had been
writing for two Turkish young women – one very handsome;
the way they were placed made an excellent composition for a
picture' (Cunningham 1843), III, p. 220). Soon afterwards, he took
up the idea suggested by this vignette, and began work on *The
Turkish Letter Writer*. Wilkie did not spend long on the picture.
He started painting it on 28 October and by 19 November he
had commenced work on *The Tartar Messenger* (Cat. 122), which
may imply that by that date he had finished all he was intending
to do on the former work. The painting was sent back to Britain
screwed to the lid of a packing case on 12 January 1841.

According to the letterpress in *The Wilkie Gallery*, the picture
shows two young women and a scribe to whom they have
dictated a love letter. Public scribes provided an essential service
in a largely illiterate country, and they offered a pictorial subject
rich in anecdote and innuendo. Both David Roberts (eg. *The
Letter Writer, The Holy Land, Syria, Idumea, Arabia and Nubia*,
London, 1842–49, III, pl. 31) and J. F. Lewis (eg. *The Scribe*;
present location unknown) found the subject irresistible. Wilkie
himself had already treated the theme of a narrative suggested by
a letter in *The Letter of Introduction* (1813; National Gallery of
Scotland, Edinburgh).

Wilkie's painting departs from the scene which he had
witnessed in one important respect: it shows a Turkish woman
and a Greek woman, rather than the two Turkish ladies Wilkie
had actually seen. Given the strained relationship between these
two countries at that date, it was unlikely that a Muslim and a
Christian would have been seen together and their juxtaposition
puzzled some observers. Even the letterpress to the engraving
of the painting in *The Wilkie Gallery* complained that 'while it
certainly adds to the picturesque variety of the composition, it
is rather inaccurate as to local usages.' It may be that Wilkie
wished to comment in this work not only on the variety of races
within the Turkish Empire, as he did in *The Tartar Messenger*
(Cat. 122), but also on the possibilities for peaceful co-existence
between Greek and Turk in the wake of the Greek War of
Independence (1821–29). C.B.

PROVENANCE
1842, 25–30 April, Christie's, London, Wilkie sale (lot 667); Lord Charles Townshend; Lord
Northbrook; James Price; 1895, Mrs M. V. Smith Cunninghame; Aberdeen Art Gallery and
Museums

EXHIBITIONS
1842, London, Royal Academy, Summer Exhibition (no. 714)
1842, London, British Institution (no. 98)
1874, London, International Exhibition (no. 202 or 203)
1887, Manchester, Jubilee Exhibition (no. 710)
1967, Paisley Museum and Art Gallery, *Ramsay and Wilkie*

REFERENCES
Cunningham 1843, III, p. 320
The Wilkie Gallery, n.d., n.p., engr. by R. Staines
Sketches in Turkey, Syria and Egypt, 1840–41, (no. pl. no.), 1843 engr. by R. Staines
K. Bendiner, 'Wilkie in Turkey: "The Tartar Messenger Narrating the News of the Victory
of St. Jean d'Acre"', *Art Bulletin*, June 1981, LXIII p. 267, ill. fig. 9

122

The Tartar Messenger Narrating the News of the Victory of St. Jean d'Acre 1840

Oil on panel: 68·6 × 53·3 cm
Private Collection
[*repr. in colour on p. 72*]

Wilkie began *The Tartar Messenger* while in Constantinople. It
was never finished since it was sent home to await completion
on his return from the Near East. It is closely related to *The
Turkish Letter Writer* (Cat. 121) in size, colour and approach, and
for most of their subsequent histories the two pictures belonged
to the same collections. In both paintings, Wilkie concentrated
on the figures, their inter-relationships and costume details. He
was fascinated by the mixture of racial types found within the
Turkish Empire, and in *The Tartar Messenger* he shows a Turk,
a Greek, an Armenian and a Jew. He regretted, however, that
since this was a Turkish subject, he could not introduce a female
figure amongst the men. He resolved this problem by including
the female children. The dramatic incident in this picture is
heightened by fixing the eyes of everyone in the coffee shop on
the narrator, though Wilkie could not resist the amusing episode
of the barber filling the mouth of his customer with shaving foam
on the left of the picture.

The painting is not based on any observed incident, but is an
imaginary scene showing a messenger relaying to the men in a
Turkish café news of the recent Anglo-Turkish victory over the
Egyptians at St. Jean d'Acre. The battle was the outcome partly
of expansionist policies pursued by the Egyptians in Syria, and
partly of Muḥammad 'Alī's desire to create a hereditary Pashalik
in Egypt (see Cat. 123). Notwithstanding her interests in Egypt,
Britain's sympathies were largely with the Turks on this issue,
reflecting widespread concern over the gradual dissolution of the
Ottoman Empire and the political vacuum which this was to
create in the Near East. The painting was also Wilkie's personal
celebration of the end of a war which had detained him in
Constantinople, delaying his planned visit to the Holy Land.

Kenneth Bendiner has underlined the picture's significance as
a reflection of changing British attitudes towards Turkey. It

121

exhibits a far more favourable attitude towards the Turks than previous works by other artists, which had stressed the Turks' role as the oppressors of the Greeks in their struggle for freedom. By placing the reference to the Turkish victory in a domestic rather than a military setting, which removed the need for violence and melodrama in his portrayal, Wilkie indicated his sympathy for the Turks. His highly acclaimed *Chelsea Pensioners Reading the Gazette of the Battle of Waterloo* (1822; Apsley House, London) had treated a similar theme of news of military victory in the same informal, anecdotal way. In that picture, however, the news is relayed by written word, rather than by word of mouth, upon which illiterate Turks relied. C.B.

PROVENANCE
1842, 25–30 April, Christie's, London, Wilkie sale (lot 666); Mr. Farren; Lord Northbrook; James Price; 1895, Mrs M. V. Smith Cunninghame; Agnew's; 1955, acquired by the present owner

EXHIBITIONS
1874, London, International Exhibition (nos. 202 or 203)
1887, Manchester, Jubilee Exhibition (no. 715)

REFERENCES
Cunningham 1843, III, p. 338–39, 363
Sketches in Turkey, Syria and Egypt, 1840–41, 1843, engr. by R. Staines
The Wilkie Gallery, n.d., n.p., engr. by W. Greatbach
K. Bendiner, 'Wilkie in Turkey: "The Tartar Messenger Narrating the News of the Victory of St. Jeane d'Acre"', *Art Bulletin*, June, 1981, LXIII, pp. 259–68, ill. fig. I

123

Muḥammad ʿAlī, Pasha of Egypt 1841

Oil on millboard: 61 × 51 cm
Inscribed bottom left: *David Wilkie ft/Alexandria May 11th 1841*
The Trustees of the Tate Gallery

Muḥammad ʿAlī, Pasha of Egypt from 1805 to 1848, was something of a legend in his own lifetime, earning praise for his Westernisation and modernisation policies at home, and notoriety abroad for his military aggression against the Turks. This portrait was painted in the wake of Egypt's defeat at the Battle of St. Jean d'Acre, an event which Wilkie had celebrated in *The Tartar Messenger* (Cat. 122). Notwithstanding his sympathies with Muḥammad ʿAlī's adversaries, Wilkie was happy to accept the invitation to paint the Pasha's likeness while he was waiting in Alexandria for the ship on which he was to

return to England. News of this project travelled fast to London; by 29 May J. M. W. Turner was discussing Wilkie in a letter to a friend, saying, 'I heard last Eving [*sic*] that he is now painting the Pasha's Portrait alias Mahogany face'.

In spite of warnings to the contrary, the artist found his sitter pleasant and co-operative, and was able almost to complete the picture in three sittings. Muḥammad ʿAlī was quite pleased with the result, although he felt that Wilkie had made him look too young by his tactful suppression of certain lines around the brows and eyes. Unlike David Roberts and J. F. Lewis, who also drew the Pasha, Wilkie chose to pose Muḥammad ʿAlī in a Western-style chair rather than on his customary divan. This may have been to enhance his subject's dignity in Western eyes, a point of crucial importance in the light of British attitudes towards him at the time.

The review which the painting received in the *Atheneum*, when it was exhibited at the Royal Academy in 1842, referred to Muḥammad ʿAlī as 'the absolute troubler of modern Europe . . . There is force and despotism, not merely in his shrewd eyes and firm lips, but in the attitude and in the hands which grasp nervously, with scimitar-like fingers, the elbows of his chair.' The reviewer was probably unaware that Wilkie had originally made a sketch of the Pasha holding his sword in a far more menacing manner, to which Muḥammad ʿAlī had objected, saying, 'the British have deprived me of my sword!' Indeed, the image presented here appears to modern eyes as that of a placid man, tallying with the artist Gleyre's description of him as 'anything but heroic'. C.B.

PROVENANCE
1860, 21 June, Christie's, London, David Wilkie sale (lot 388), acquired by Edinburgh; 1909, 4 December, Christie's London (lot 134), acquired by Sampson; 1919, 28 November, Christie's, London, Rt. Hon. Earl Brassey sale (lot 117), acquired by Permain; 1927, bequeathed by Henry Alexander Gordon, 4th Earl of Effingham, to the Tate Gallery, London

EXHIBITIONS
1842, London, Royal Academy Summer Exhibition (no. 116)
1958, London, Royal Academy, *Wilkie R.A.* (no. 43)
1983, Brighton Museum and Art Gallery; Manchester City Art Gallery, *The Inspiration of Egypt* (no. 292)

REFERENCES
Cunningham 1843, III, pp. 460, 462–9, 532
Atheneum, 1842
J. Maas, *Victorian Painters*, London, 1970, ill. p. 93
K. Bendiner, 'Wilkie in Turkey', *Art Bulletin*, June 1981, pp. 264–65, ill. fig. 7

122

123

North Africa and the Near East:
A Chronology of Events, Personalities and Publications *c.* 1798–*c.* 1922 *Compiled by Briony Llewellyn**

HISTORICAL EVENTS	ARTISTS

1770

1776
Luigi Mayer (d.1803) in Constantinople and elsewhere in the Ottoman Empire as draughtsman to Sir Robert Ainslie, British Ambassador (to 1794)

1780

after **1787**
Thomas Hope (1769–1831) in Constantinople for an extended period?

1790

1798
French conquest of Egypt: 'the most seminal event in the history of the modern Islamic world' (M. S. Anderson)
2 July: Napoleon Bonaparte lands his forces at Alexandria
21 July: 'Battle of the Pyramids' (actually at Imbaba, 9 miles away): Cairo occupied by the French
1–2 August: 'Battle of the Nile': Nelson destroys French fleet in Abū Qīr Bay
4–20 October: General Divan sits as advisory council with delegations from all parts of Egypt
21 October: Muslim insurrection against the French in Cairo; quelled

1797
Hope in Egypt and possibly elsewhere in Near East

1798–99
November–July: Dominique Vivant, Baron Denon (1747–1825) in Egypt with the French Commission on the Sciences and Arts; accompanies General Belliard to Upper Egypt to aid General Desaix's pursuit of fleeing Mamlūks; August: leaves Egypt with Napoleon

1799
Napoleon attacks Syria from Egypt
16 April: Battle of Mount Tabor: French victory over Turks
May: French attempts to take Acre defeated; retreat to Cairo
25 July: Ottoman Turks defeated by French at Abū Qīr
23 August: Napoleon leaves secretly for France, from Alexandria, with a few close associates, including Denon; Kléber left in command

1800

1800
28 January: Kléber ratifies treaty with Turks at El Arisha for evacuation of French troops from Egypt; 20 March: Kléber defeats Turkish army at Heliopolis; 14 June: Kléber assassinated in Cairo; succeeded by Menou

1801
21 March: British defeat French at Canopus near Alexandria
3 September: French surrender Alexandria and evacuate
Muḥammad 'Alī arrives in Egypt with Albanian troops as part of Ottoman force attempting to re-establish authority
Bay of Tripoli insists on increase of payment of safe-conduct money by USA; Four Years War ensues (1801–05)

1803
Mecca taken by Wahhabi forces

1804
March: Muḥammad 'Alī, now commander of Albanian troops in Egypt, expels Mamlūks from Cairo

1805
12 May: Muḥammad 'Alī declares himself Pasha of Egypt (confirmed by Ottoman Porte November 1806); ruler of Egypt, to 1848: virtually independent of Turkey; gradual modernisation of the country

1807
29 May: Selim III, Sultan of Turkey, deposed
British abolition of slave trade

c. **1807**
to 1812: Sir William Allan (1782–1850) in the Ukraine for several years; excursions to neighbouring regions to observe the Cossacks, Circassians and Tartars

1808
United States prohibits import of slaves
Mahmud II, Sultān of Turkey (accession 28 July); reputed to be the son of a French girl, Aimée Dubecq de Rivery, living in the Harem since 1784; to 1839: initiates process of westernisation with extensive programme of reforms
Stratford Canning (1786–1880) on British Government service in Constantinople

With acknowledgements to all contributors to the catalogue, and to Peter Stocks and to Rodney Searight

TRAVELLERS, EXPLORERS, ARCHAEOLOGISTS, INTELLECTUALS, DIPLOMATS, CULTURAL EVENTS	PUBLICATIONS	
		1770

1784
Première of Mozart's *Die Entführung aus dem Serail*, in Vienna

1786
W. Beckford, *Vathek*; oriental fantasy inspired by *The Arabian Nights*

c. **1787**
Napoleon, 'Le prophète masquée' MS; grotesque oriental fantasy found amongst his papers after his death

<div align="right">1780</div>

1791
Première of Mozart's *Die Zauberflöte*, in Vienna

1798
Panorama theatres opened in Leicester Square and the Strand; cycloramas of current events and interesting places from the work of famous artists displayed; many Near Eastern subjects (until 1856)
July: The French Commission on the Sciences and Arts accompanies Napoleon's forces to Egypt; consists of civil engineers, surveyors, cartographers, astronomers, botanists, surgeons, pharmacists, antiquarians, architects, artists, mathematicians, chemists, mineralogists, zoologists
22 August: Napoleon creates the Institut d'Egypte for the purposes of '(1) the progress and propagation of the sciences in Egypt; (2) research, study, and publication of natural, industrial, and historical data on Egypt; (3) advising on various questions concerning which the Government shall consult it'; it has four sections: mathematics, physics, political economy, literature and art

1799
July: discovery at Rosetta, by a French officer, of a black basalt stone with three scripts: Greek, Egyptian demotic and hieroglyphic; the key to the ancient Egyptian language
to 1803: Lord Elgin (1786–1841) ambassador to the Ottoman Porte; removes sculptures from the Parthenon in Athens for transportation to England (arrival 1804)

1790
J. Bruce, *Travels to Discover the Source of the Nile in the Years 1768, 1769, 1770, 1771, 1772, and 1773*

1792
C. Niebuhr (illus.), *Travel through Arabia and other countries in the East* (trans. R. Heron); description by the only survivor of a Danish expedition to the Yemen via Constantinople and Egypt.

1799
L-F. Cassas (illus.) *Voyage pittoresque de la Syrie, de la Phoenicie, de la Palestine et de la Basse Egypte*; 180 plates engraved from drawings by one of several artists employed by Comte de Choiseul-Gouffier, French Ambassador to the Ottoman Porte

<div align="right">1790</div>

1800
J. M. W. Turner's *Fifth Plague of Egypt* exhibited at the Royal Academy, London; in fact represents the seventh plague

<div align="right">1800</div>

1801
R. Southey, *Thalaba the Destroyer*; 'an Arabian tale'
L. Mayer (illus.), *Views in Egypt*; first of a series of volumes of views in the Ottoman Empire, for Sir Robert Ainslie, British Ambassador in Constantinople

1802
Baron Denon, *Voyage dans la Basse et la Haute Egypte*; widely circulated and influential series of views of the monuments of ancient Egypt

1806
to 1807: Vicomte de Chateaubriand (1868–1848) travels to Greece, Constantinople, Syria, Palestine, Egypt and Tunis

1807
T. Hope, *Household Furniture and Interior Decoration*; includes Egyptian interiors

1809
to 1810: Lord Byron (1788–1824) and John Cam Hobhouse (1786–1869) tour Greece, Albania, Asia Minor, and Constantinople
to 1817: John Lewis Burckhardt (1784–1817) exploring in Syria, Egypt and Arabia, as Shaykh Ibrahim ibn 'Abd Allah

1809
–1829: *Description de l'Egypte*; 24 volumes of plates and text representing the accumulated researches of Napoleon's *Institut d'Egypte* on that country's history, geography, science and culture

HISTORICAL EVENTS	ARTISTS

1810

1811
1 March: Massacre of the Mamlūks in Cairo; survivors flee to Sudan
to 1818: Egyptian War against the Wahhabis

1812
Algiers declares war on USA
Stratford Canning leaves Constantinople after four years

1813
Egyptian forces take Mecca

1814
Muḥammad, Bay of Tunis (to 1824)

1815
United States victory over Tripoli and Tunis

1815
Jules-Robert Auguste (1789–1850) wealthy artist and collector of Oriental art and curiosities in Syria

1820

1820
to 1822: Sudan conquered by Muḥammad 'Alī as private venture; under Egyptian administration until 1883

c. **1821**
Cotton link between Egypt and Lancashire established

1821
Greek War of Independence (to 1830)

1822
Muḥammad 'Alī intervenes in Greek War (to 1828)
Mawlāy 'Abd al-Rahman, Sultan of Morocco (to 1859)

1824
Demise of The Levant Company

1825–27
to 1827: Canning's second mission to Constantinople

1826
'The Auspicious Event': massacre of Janisseries in Constantinople; results in modernisation of Turkish army

1827
20 October: Battle of Navarino: Turkish fleet destroyed
Fly-whisk incident: Dey of Algiers strikes French consul: pretext for French invasion

c. **1827**
to 1829: Allan in Greece, Constantinople, Asia Minor

1828
to 1829: Alexandre-Gabriel Decamps (1803–1860) in Greece and Asia Minor: Smyrna; commissioned by French government to paint picture commemorating Battle of Navarino

1829
14 September: Treaty of Adrianople: end of Russo-Turkish War; results in growth of Russian influence in the Balkans

TRAVELLERS, EXPLORERS, ARCHAEOLOGISTS,
INTELLECTUALS, DIPLOMATS, CULTURAL EVENTS

PUBLICATIONS

1810

to 1813: Lady Hester Stanhope (1776–1839) travels from Constantinople to Palmyra; presides over Bedouin encampment there

1812

Burckhardt discovers Petra
Burckhardt discovers Abu Simbel
Premiére of Rossini's *L'Italiana in Algeri*, in Venice

1814

Summer: Lady Hester builds a house at Djoun in Lebanon, and lives there until her death (1839)
to 1815: Burckhardt on pilgrimage to Mecca and Medina

1815

to 1819: Giovanni Battista Belzoni (1778–1823) excavating in Egypt

1816

The Elgin Marbles are acquired by the British Museum
Belzoni sponsored by the British consul, Henry Salt (1780–1827) removes the head of the 'Young Memnon' ('Ozymandias') from the Ramesseum at Thebes

1817

Belzoni and others find opening into the Temple of Rameses II at Abu Simbel
Belzoni discovers the tomb of Seti I in the Valley of the Kings, Thebes

1818

Belzoni finds an entrance into the Second Pyramid at Gizah (Chephren)

1811

F. R. de Chateaubriand, *Itinéraire de Paris à Jérusalem*, (Eng. trans. 1814); personal account of a pilgrimage to the Near East; influential

1812

−1818: Lord Byron, *Childe Harold*; established the Near East as a setting for romantic experience: 'Oh! that the Desert were my dwelling-place,'

1813

Lord Byron, *The Giaour* and *The Bride of Abydos*; two of the poet's tales in Oriental settings
J. C. Hobhouse, *A journey through Albania and other provinces of Turkey in Europe and Asia, to Constantinople*; with Byron, 1809–10

1814

'Alī Bey el Abbassi, *Voyages en Asie et en Afrique*, (Eng. trans. 1816); ?earliest published account of a European (Domingo Badia y Leblich) in disguise in the holy places of Islam

1817

P. B. Shelley, *Ozymandias*; sonnet inspired by imminent arrival in London of the head of the 'Young Memnon' (Ramesses II) from Thebes
T. Moore, *Lalla Rookh*; collection of poems with Oriental settings

1819

J. L. Burckhardt, *Travels in Nubia*; first of the explorer's posthumously published accounts of his extensive travels in Egypt and the Levant

1820

to 1821: Belzoni's exhibition of copies and casts from the tomb of Seti I held in the Egyptian Hall, Piccadilly
London Society for Promoting Christianity among the Jews sends first mission to Jerusalem

1821

John Martin's *Belshazzar's Feast* exhibited in London
to 1833: John Gardner Wilkinson (1797–1875) in Egypt and Nubia; excavating at Thebes, 1824, 1827, 1828

1822

Linant de Bellefonds, French engineer and explorer, travels to Meroe in Nubia, the first European to see sites of Musawarat and Nagia;
one of his many expeditions in Egypt and Nubia

1822

Jean François Champollion (1790–1832) deciphers the Egyptian hieroglyphs
Donizetti's brother court *Kappelmeister* to Ottoman Sultān Mahmud II

1824

19 April: Byron's death at Missolonghi
to 1828: Robert Hay of Linplum (1799–1863) making a systematic survey of monuments in Upper Egypt, aided by scholars and draughtsmen

1825

to 1828: Edward William Lane's (1801–1876) first residence in Egypt: Cairo and two Nile trips

1827

E. Delacroix's *Death of Sardanapalus* exhibited at the Salon, Paris

1828

to 1829: Champollion and Ippolito Rossellini (1800–43) studying ancient monuments and inscriptions in Egypt on joint Franco-Tuscan mission

1829

to 1834: Hay's second expedition to Upper Egypt

1820

G. B. Belzoni, *Narrative of the Operations and Recent Discoveries . . . in Egypt and Nubia*, (Plates, 1820–22)

1821

J. S. Buckingham, *Travels in Palestine*; first of his several narratives of travel in the Near East

1822

J. L. Burckhardt, *Travels in Syria and the Holy Land*
J. F. Champollion, *Lettre à M. Dacier*; Egyptian hieroglyphs deciphered

1823

C. L. Irby and J. Mangles, *Travels in Egypt and Nubia, Syria and Asia Minor*; account of travels 1817–18, among earliest Europeans to see Petra and Abu Simbel

1824

J. J. Morier, *Hajji Baba of Isphahan*; popular picaresque tale with Persian characters and setting

1826

J. Carne, *Letters from the East*; early tourist's account of travels in the Near East; a further vol. pub. 1830

1827

J. C. Pacho, *Relation d'un Voyage dans la Marmarique, la Cyrendique et les oasis d'Andjelah et de Maradéh*

1828

J. J. Morier, *Hajji Baba of Isphahan, in England*

1829

J. L. Burckhardt, *Travels in Arabia*
V. Hugo, *Orientales*; collection of poems on Orientalist themes

HISTORICAL EVENTS	ARTISTS

1830

1830

4 February: Declaration of Greek Independence

14 June: French invade Algeria: Algiers, and later Boué, Bougie and Oran taken; 6 July: Day of Algiers signs Act of Capitulation

1830

April–October: Dauzats in Egypt, Sinai, Palestine, Syria, Asia Minor; as lithographer to expedition of Baron Taylor, in part to procure obelisk of Luxor

1831

Foundation of French Foreign Legion
Muḥammad ʿAlī despatches his son, Ibrahim Pasha, to conquer Syria; occupied until 1840

1831

from April: Marilhat in Greece, Egypt, Palestine, Syria, Lebanon with scientific expedition led by Baron Charles von Hügel; late 1832–May 1833: in Alexandria and Lower Egypt, painting portraits; returns to France on ship with Luxor obelisk

1832

Abd al-Qādir assumes title of Amir; leads resistance to French until 1847
Greece established as an independent state with Otto of Bavaria as king

1832

January–June: Delacroix accompanies diplomatic mission of Comte de Mornay to Sultān of Morocco: Tangier, Meknes; also in Algiers; notebooks provides material for next thirty years; profound impact on Orientalism
to 1833: Owen Jones (1809–1874) with Jules Goury (1803–1834) in Egypt

1833

8 July: Treaty of Unkiar-Skelessi: Russia and Turkey close the Dardanelles to foreign ships

1833

March–April: Roberts visits Tangier and Tetuan
May: Lewis visits Tangier
Vernet and William Wyld (1806–1889) to Algeria

1834

French military regime in Algeria; establishment of 3 divisions under a Governor General: Algiers, Oran, Constantine, each with a Service des Bureaux Arabes

1834

Allan in Morocco
June–late 1837: Gleyre travels extensively in Near East as draughtsman to John Lowell Jr.: Albania, Greece, Constantinople, Smyrna, Rhodes, Alexandria, Cairo, Upper Egypt, Khartoum; returns without Lowell via Syria, Lebanon
to 1835: William Henry Bartlett (1809–1854) in Palestine and Lebanon; first of six visits to Near East

1836

November: Chauzel, Governor-General of Algeria, attempts to take Constantine; 24 November: Battle of Somah (Algeria): French victory

c. **1836**

to 1838: Thomas Allom (1804–1872) in Constantinople, Asia Minor, Holy Land: Jerusalem

1837

October: Constantine taken by the French
Overland Route in Egypt established; Peninsular and Orient Steam Navigation Company receives contract from British Government to carry mails to India (to 1840)

1837

Vernet in Algeria
Eugène Flandin (1803–1876) accompanies French army to Algeria
to 1839: Frère in Algeria; witnesses taking of Constantine

1838

British occupy Aden (to 1839)
Abdul Mejid, Sultān of Turkey (to 1861)

1838

September–May 1839: Roberts tours the Levant: Egypt: Alexandria to Wadi Halfa; Sinai, Petra; Holy Land: Hebron, Jaffa, Jericho, Dead Sea, Bethlehem, Jerusalem, Nazareth, Tyre, Sidon; Baalbeck, Beirut; Alexandria (to 1839)
November–January: W. J. Müller in Egypt: Alexandria to Luxor (to 1839)

1839

24 June: Battle of Nezib (Syria): defeat of Turkish army by Egyptian army; Mahmud II tries to expel Ibrahim Pasha; European powers pledge support
3 November: Hatt-i Sharif of Gulhane promulgated: equality of all religions before the law: first of Turkish reforming edicts – the *Tanzimat*

1839

Dauzats accompanies military expedition of Duc d'Orléans to Algeria: Oran, Algiers, Bougie, Stora, Philippeville, Setif, Portes de Fer in Djurdjura mountains
to 1840: Vernet in Algeria, Egypt, Palestine with Frédéric Goupil-Fesquet; uses daguerreotypes to record views of Alexandria, Cairo, Jerusalem (P. G. J. de Lotbinère independently making daguerreotypes on the Nile)

1840

1840

15 July: Convention of London for the pacification of the Levant. European powers persuade Muḥammad ʿAlī to withdraw forces from Syria; in return the pashaliq of Egypt is made hereditary, he is created Pasha of Acre for his lifetime

1840

to 1842: Flandin with Pascal Coste (1787–1879) on French diplomatic mission to Persia
Summer–Autumn 1841: Lewis in Greece, Constantinople, Asia Minor: Brussa
October–May 1841: Wilkie in Constantinople, Jerusalem, Alexandria; dies at sea off Malta in June

1830

L. de Laborde, *Voyage de l'Arabie Pétrée*; account of travels with Linant de Bellefonds in 1828, illustrated mainly by the author
J. L. Burckhardt, *Notes on the Bedouins and Wahabys*

1830

1832

to 1833: Alphonse de Lamartine (1790–1869) travels to Syria and Egypt, via Constantinople

1832

L. de Laborde, *Voyage en Orient de l'Asie, de la Syrie*; magnificently illustrated
W. Scott, *The Talisman*; popular novel set in the time of Richard the Lionheart's Crusades
–1844: N. I. Rosellini, *I Monumenti dell' Egitto e della Nubia*; 3 multi-volume parts, 395 plates; the results of the author's expedition with Champollion

1833

Removal of an obelisk from the Temple of Luxor to the Place de la Concorde, Paris
to 1834: Robert Curzon (1810–73) tours Egypt, Syria, Asia Minor and Greece
to 1835: Lane's second residence in Egypt: lives in Cairo as Mansour Effendi

1833

C. F. Head, *Eastern and Egyptian Scenery*; illustrations with notes of journey from India to England via Egypt on the Overland Route 'to reveal the advantages of steam navigation'
J. E. De Kay, *Sketches of Turkey in 1831 and 1832 by an American*

1834

to 1835: Alexander Kinglake (1809–91) tours Constantinople, Asia Minor, Lebanon, Palestine, Egypt and Syria

1835

A. de Lamartine, *Souvenirs, impressions, pensées et paysages pendant un Voyage en Orient 1832–3*, (Eng. trans. 1848); in the footsteps of Chateaubriand
W. Wyld and E. Lessore, *Voyage Pittoresque dans la Régence d'Alger exécuté en 1833 et lithographié*; dedicated to Vernet with whom Wyld travelled
–1847: J. F. Champollion, *Monuments de l'Egypte et de la Nubie*; 4 vols, 446 plates

1836

E. W. Lane, *An Account of the Manners and Customs of the Modern Egyptians*; first comprehensive and sympathetic survey of a particular Islamic society
T. H. Horne, *Landscape Illustrations of the Bible*; engravings by W. & E. Finden after various artists based on travellers' topographical sketches
–1838: J. Carne, *Syria, the Holy Land, Asia Minor etc.*; illustrated by Bartlett, Purser and Allom

1837

to 1838: Curzon in Albania, Egypt (Wadi Natrun) and Constantinople

1837

F. Arundale, *Illustrations of Jerusalem and Mount Sinai*; the author's journey with F. Catherwood and J. Bonomi in 1833; probably the first 'infidels' to sketch in the *haram* area of Jerusalem
J. Pardoe, *The City of the Sultans*; portrait of Constantinople life compiled from her residence there
J. G. Wilkinson, *The Manners and Customs of the Ancient Egyptians*; a revised edn. of *Thebes and a general view of Egypt* (1834), for half a century the standard work on life in ancient Egypt
J. F. Lewis (illus), *Illustrations of Constantinople from drawings by Coke Smyth*; lithographs from before the artist's visit to the Near East
–1839: P. Coste (illus.), *Architecture arabe, ou Monuments du Kaire*; detailed early study of the Islamic architecture of Cairo

1838

to 1844: Charles Fellows (1799–1860) initiates a series of expeditions to south-west Turkey, mainly Lycia, and removes sculptured stones from Xanthus to the British Museum (eg. the Nereid Monument)

1838

Lord Lindsay, *Letters on Egypt, Edom and the Holy Land*; aristocratic Englishman's tour of the Levant, 1836–37
M. C. F. Volney, *Travels through Syria and Egypt in the Years 1783–4 and 1795*
–1839: J. Pardoe, *The Beauties of the Bosphorus*; popular series of views by Bartlett of Constantinople and environs
–1841: E. W. Lane, *The Thousand and One Nights*; first accurate though censored translation, with explanatory notes revealing Islam as a real and living culture

1839

Baron Taylor, *La Syrie, l'Egypte, la Palestine, et la Judée*; illustrated by Dauzats
Rev. R. Walsh, *Constantinople and the Scenery of the Seven Churches of Asia Minor*; illustrated by Allom
Vicomte de Marcellus, *Souvenirs de l'Orient*; based on a trip undertaken in 1820
–1849: C. Texier, *Description de l'Asie Mineure*; contains elaborate chromo-lithographs of Islamic architecture in Turkey, the result of journeys 1833–37

c. **1840**

T. Allom (illus.), *Character and Costume in Turkey and Italy*

1840

1840

R. Hay, *Illustrations of Cairo*; lithographs by several artists; the study of Egyptian antiquities revolved around Hay for nearly 10 years, 1824–34
E. Blondel, *Deux ans en Syrie et en Palestine, 1838–9*
T. Carlyle, On the Hero as Prophet: Mahomet; lecture rejecting the popular image of Muḥammad as a 'falsehood incarnate' (pub. in *On Heroes*, 1841)
J. Murray (pub.), *A Handbook for Travellers in the Ionian Islands, Greece, Turkey, Asia Minor and Constantinople*

HISTORICAL EVENTS	ARTISTS

1841
February: Battle of St. Jean d'Acre: peace between Turkey and Egypt

1841
?November: Lewis arrives in Cairo and lives there as an Ottoman Turk for nearly a decade

1842
Canning (later Viscount Stratford de Redcliffe) British Ambassador in Constantinople, the 'Great Elchi' (to 1846; 1848–58)

c. **1842**
to 1882: Amadeo, Count Preziosi (1816–1882) living in Constantinople, drawing its people and scenery for European residents and visitors; visits Egypt *c.* 1861–62

1842
to 1843: Richard Dadd (1817–1886) accompanies his patron Sir Thomas Phillips on a tour of the Near East: Greece, Constantinople, Asia Minor, Rhodes, Lebanon, Syria, Holy Land, Egypt

1843
Alexandre Bida (1823–1895) visits Constantinople, Syria
October–February 1844: W. J. Müller with pupil H. J. Johnson (1822–1884) in Asia Minor: Lycia; with archaeological expedition of Charles Fellows

1844
August: French war with Morocco: Tangier bombarded; 14 August: Battle of Isly: defeat of Moroccan army; Sultan of Morocco recognises French occupation of Algeria

1844
Flandin in Mesopotamia with archaeologist Paul Botta

1845
Vernet in Algeria

c. **1845**
to 1856: Félix Ziem (1821–1911) makes series of journeys to North Africa and Near East

1846
May: Biskra (Algeria) captured by Duc d'Aumâle

1846
May–July: Chassériau in Algeria: Constantine to visit Caliph 'Alī ben Ahmed; Algiers
Fromentin on brief secret trip with Charles Labbé to Algeria: Algiers, Blidah

1847
Fromentin returns to Algeria after successful exhibition of Orientalist work at Salon; Constantine and Biskra for eight months

1848
Abbas I, Viceroy of Egypt (to 1854)

1848
July–October: Lear in Constantinople, northern Greece, Albania

1849
2 August: death of Muḥammad 'Alī in Alexandria

1849
February: Lear briefly visits Cairo and Sinai
to 1850: Narcisse Berchère (1819–1891) in Egypt, Asia Minor, Greece

1841

to 1844: Curzon on British Government service in Constantinople and Erzerum

1841

E. Robinson, *Biblical Researches in Palestine, Mount Sinai and Arabia Petraea*; travels in 1838 in first attempt to establish the true location of biblical sites; widely read
J. G. Kinnear, *Cairo, Petra and Damascus, in 1839*; author accompanied David Roberts between Cairo and Jaffa
A. Dauzats and A. Dumas père, *Quinze Jours au Sinai*; record of a trip undertaken in 1839

1842

Literary Association founded in Cairo by Dr. Henry Abbott (1812–59), Emile Prisse d'Avennes (1807–79) and others
to 1843: Wilkinson returns to Egypt
to 1845: Prusssian expedition to Egypt, led by Karl Richard Lepsius (1810–84) and including James Wild (architect), Joseph Bonomi and Ernst Weidenbach (artists)
to 1849: Lane's last residence in Egypt: lives as before in Cairo, with wife and sister; working on *Lexicon*

1842

–1849: D. Roberts (illus.), *The Holy Land, Syria, Idumea Arabia, Egypt and Nubia*; 6 vols. of lithographs; first widely available large-scale illustrations of the Near East

1843

Gérard de Nerval (1808–55) in Egypt, Lebanon, Constantinople and Asia Minor
Eliot Warburton (1810–52) tours Egypt, Palestine and Syria

1843

O. Jones and J. Goury, *Views on the Nile from Cairo to the Second Cataract*
E. W. Lane, *Selections from the Kur-án*
Sir D. Wilkie (illus.), *Sketches in Turkey, Syria and Egypt 1840 & 1841*; posthumously published
F. Goupil-Fesquet, *Voyage en Orient fait avec Horace Vernet en 1839 et 1840*; illustrated by the author

1844

William Thackeray (1811–63) visits Athens, Constantinople, Jerusalem and Cairo, under the auspices of the Peninsular and Orient Steam Navigation Company

1844

W. H. Bartlett, *Walks about the City and Environs of Jerusalem*; first of several books of travel in the Near East written and illustrated by Bartlett from personal experience
C. Nodier, *Journal de l'Expédition des Portes de Fer*; illustrated by Dauzats, Auguste Raffet (1804–60) and others; the expedition in 1839
A. Kinglake, *Eothen*; whimsical and subjective account of travel in the Levant in 1835
S. Lane-Poole, *The Englishwoman in Egypt: Letters from Cairo, written during a residence there in 1842, 3, & 4, with E. W. Lane . . . by his sister*

1844/5

E. Warburton, *The Crescent and the Cross; or, romance and realities of eastern travel*

1845

Théophile Gautier (1811–72) in Algeria
Prisse d'Avennes, French scholar and artist working in Egypt, first for Muḥammad 'Alī and then independently, removes the Table of Kings from Karnac to France
to 1847: Henry Layard (1817–94) excavating at Nimrud, Nineveh and other Assyrian sites; discovery of winged bull and transportation to the British Museum

1845

W. H. Bartlett, *Views Illustrating the Topography of Jerusalem, Ancient and Modern*
Dr. C. L. Meryon (ed.), *Memoirs of Lady Hester Stanhope*

1846

Halicarnassus frieze removed from Bodrum, south-west Turkey, to the British Museum, by John Alison, sponsored by Canning

1846

J. P. Girault de Prangey (illus.) *Monuments arabes d'Egypte de Sinai et d'Asie mineur . . . de 1842 à 1845*
W. M. Thackeray, *Notes of a Journey from Cornhill to Cairo*; witty account of tour of the Levant in 1844
–1848: J. J. Ampère, 'Voyage et recherches en Egypt et en Nubie', series of articles in *Revue des Deux Mondes*

1847

De Goncourt brothers (Edmond 1822–96; Jules 1830–70) in Algeria

1847

Lord Castlereagh, *A Journey to Damascus through Egypt, Nubia, Arabia Petraea, Palestine and Syria*; aristocratic Englishman's 'Grand Tour' through the Levant, 1841–42, accompanied by a hired draughtsman, Anton Schranz
X. Marmier, *Lettres sur l'Algérie*
B. Disraeli, *Tancred, or the New Crusade*; novel recounting the modern 'crusade' of an idealistic young English nobleman; Disraeli toured the Levant 1830–31
J. Murray (pub.), *A Handbook for Travellers in Egypt*; written by J. G. Wilkinson, originally pub. as *Modern Egypt and Thebes* (1843)

1848

to 1851: Wilkinson in Egypt and Nubia

1848

H. Martineau, *Eastern Life Present and Past*; personal travel narrative and history, by a noted writer
W. H. Bartlett, *Forty Days in the Desert*; journey across Sinai to Petra, 1845
–1851: J. A. St. John, *Oriental Album*; plates by E. Prisse d'Avennes illustrating the people and costumes of Egypt
–1851: A. Dumas père, *Le Véloce ou Tangier, Alger et Tunis*

1849

to 1851: Layard's second expedition to Assyrian sites
to 1851: Gustave Flaubert (1821–80) and Maxime du Camp (1822-94) travel in Egypt, Palestine, Lebanon, Syria, Constantinople and Greece

1849

W. H. Bartlett, *The Nile Boat*; voyage on the Nile, 1845
R. Curzon, *Ancient monasteries of the Levant*; entertaining account of visits in 1833–34 and 1837–38 in search of manuscripts
J. Bonomi, *Grand moving panoramic picture of the Nile*; notes to accompany a popular entertainment
W. F. Lynch, *Narrative of the United States expedition to the River Jordan and the Dead Sea*
Sir A. H. Layard, *Nineveh and its Remains*; account of the author's first expedition to Assyria, 1845–47
–1859: K. R. Lepsius (ed.), *Denkmäler aus Aegypten und Aethiopien*; 12 folio volumes, 894 plates by Ernst Weidenbach, the result of an archaeological expedition, 1842–45, one of largest Egyptological works ever produced
Sir A. H. Layard, *Monuments of Nineveh*, 1st series; vols. of coloured plates of the archaeologist's discoveries in Assyria; 1853, second series

1850

c. **1850**
Bida in Egypt

1850
Belly with Léon Loysel on scientific expedition led by F-F. Caignart de Saulcy to Syria, Palestine: Dead Sea; April 1851: Lebanon; Alexandria, Cairo

1851
to 1853: Frère in Greece, Smyrna, Constantinople (for 18 months); continues on to Syria, Palestine, Egypt
Spring: Lewis and wife Marian leave Cairo for England, after wide acclaim for *The Hareem* in London

1853
14 June: Mass celebrated at Kabylia to mark anniversary of French landing in Algeria

1853
Fromentin spends nearly a year in Algeria: Mustapha, Blidah, travels south to El-Agouat
Vernet in Algeria
Fromentin returns to Algeria
Alfred Dehodencq (1822–1882) in Morocco: Tangier, Tetuan, Mogador, Rabat, Salé
December–April 1854: Lear in Egypt: Alexandria to Philae
December–October 1854: Seddon in Cairo and Holy Land; joined by Holman Hunt, travels via Damietta and Jaffa to Jerusalem

1854
Ottoman Sultān prohibits white slave trade
13 July: Abbas I of Egypt murdered; Muḥammad Said Pasha, Viceroy of Egypt (to 1863)
Ferdinand de Lesseps obtains concession for construction of Suez Canal from Muḥammad Said
Crimean War between Russia and Turkey, aided by Britain and France, initially over protection of Orthodox Christians in Ottoman Empire (to 1856)

1854
February: Holman Hunt to Cairo; June 1855: with Seddon to Jerusalem; trips to Dead Sea and elsewhere in Holy Land; travels through Holy Land, Syria, Lebanon and by sea to Constantinople, December, January 1856: visits Crimea
to 1863: Dehodencq lives in Cadiz and Tangier
Gérôme visits Greece and Constantinople
to 1855: William Simpson (1823–1899) artist-reporter in the Crimea; visits Circassia with Duke of Newcastle
to 1856: Schreyer in Turkey

1855
Pasini to Persia, attached to French legation, via Arabia
Bida in Athens, Constantinople, Crimea, Beirut, Holy Land: Jerusalem
Belly to Egypt: Cairo; Spring 1856: to Sinai with Berchère

1856
18 February: Hatt-i Humayun promulgated at end of Crimean War: second *Tanzimat* reform
Capitulatory treaty signed by Morocco with Britain

1856
Gérôme in Egypt with Berchère, Belly, Bartholdi, and Edouard Imer: July–October: Upper Egypt; November–February 1857: Cairo
Autumn: Seddon returns to Cairo after success of his Orientalist pictures; dies there in November
?Schreyer in Syria and Egypt

1857
Ottoman Sultān prohibits black slave trade
The Indian Mutiny
Battle of Ischeriden: French Foreign Legion takes Kabylia region of Algeria

1857
Belly returns to Egypt to make studies for *The Pilgrimage to Mecca*
Leighton visits Algiers
?Schreyer in Syria and Egypt

1858
Alexandria-Suez railway, via Cairo, opened

1858
March–May: Lear to Egypt; Palestine: Jerusalem, Petra; Lebanon; Syria: Damascus
September–April 1859: Goodall in Cairo, visits Suez; shares studio in Coptic house with Haag
Carl Haag (1820–1916) in Egypt with Goodall; from April 1859 travels to Jerusalem and on to Syria where lives with Bedouins; returns to Cairo for winter 1859–60

1859
25 April: construction of Suez Canal begun
Muḥammad 'Abd al-Rahmān, Sultān of Morocco (to 1873)
to 1860: Spanish war with Morocco

TRAVELLERS, EXPLORERS, ARCHAEOLOGISTS,
INTELLECTUALS, DIPLOMATS, CULTURAL EVENTS

PUBLICATIONS

1850
J. F. Lewis's *The Hhareem* exhibited at the Old Water Colour Society, London
to 1854: August Mariette (1821–81) discovers Serapeum at Memphis; the
beginning of many years excavating in Egypt; from his discoveries the first
national museum of antiquities in the Near East is formed

c. **1850**
A. Bida and E. Barbot, *Souvenirs d'Egypte*; vol. of lithographs

1850
F. R. Chesney, *The expedition for the survey of the rivers Euphrates and Tigris, carried
on by order of the British Government in the years 1835, 1836, and 1837*; an attempt
to establish an overland route to India via Mesopotamia
G. de Nerval, *Scènes de la vie Orientale*; concentrates mainly on Egypt

1851
Great Exhibition, London: several Islamic displays and works of art
to 1852: Bayard Taylor, the first American tourist in the Sudan

1851
J. P. Girault de Prangey (illus.), *Monuments et Paysages de l'Orient*; coloured lithographs
W. H. Bartlett, *In the Footsteps of Our Lord and His Apostles in Syria, Greece and Italy*

1852
Sir C. Fellows, *Travels and Researches in Asia Minor more particularly in the province
of Lycia*; the archaeologist's excavations and discoveries, 1838–44; an
abridgement of earlier accounts
J. Bonomi, *Nineveh and its Palaces. The discoveries of Botta and Layard applied to
the elucidation of Holy Writ*
M. du Camp. *Egypte, Nubie, Palestine et Syrie*; account of travels with Flaubert,
1849–51, illustrated with the author's photographs

c. **1853**
Jane Digby (1807–81) married Shaykh Medjuel El Mezrab; remains with him in
Syria until her death

1853
Richard Burton (1821–90) in Arabia; July-September in Mecca and Medina
disguised as a Pathan doctor
Gautier in Constantinople and Asia Minor
to 1861: W. Gifford Palgrave (1826–88) working as a missionary in Syria
(Zahleh)

1853
Th. Gautier, *Voyages pittoresques en Algérie*
L. F. Caignart de Saulcy, *Voyage autour de la mer morte et dans les terres bibliques*;
account of journey undertaken 1850–51
Th. Gautier, *Constantinople*

1855
Wilkinson's last visit to Egypt: Thebes
Exposition Universelle, Paris: Islamic items included

1855
Princesse Christine Trivulzio-Belgiojoso, *La Vie intime et la vie nomade en Orient*;
based partly on personal experience
B. Taylor, *Pictures of Palestine, Asia Minor, Sicily and Spain; or The Lands of the
Saracens*; impressions of Oriental life, based on a journey, 1852
–1856: R. Burton, *Personal Narrative of a Pilgrimage to Al-Madinah and Meccah*;
account of his visit in disguise to the sacred precincts of Islam
–1856: W. Simpson, *The Seat of War in the East*, 1st and 2nd series; lithographs
of the Crimea, establishing Simpson's reputation as an artist-reporter

1856
G. Meredith, *The Shaving of Shagput*; tale in 'Arabian Nights' style
P. de Molènes, *Aisha Rosa, souvenirs des rives du Bosphore*; tale in Oriental mode
P. Merimée, *Ballades et chants populaires de la Roumanie* reflects widespread interest
in popular cultures
C. Bossoli (illus.), *The Beautiful Scenery & Chief Places of Interest Throughout the Crimea*
E. Fromentin, *Un Eté dans le Sahara*
–1858: Princesse Belgiojoso, *Recits turco-asiatiques*

1857
C. Didier, *Sèjour chez le grand-chérif de la Mekke*

1858
Anthony Trollope (1815–82) in Cairo on behalf of the General Post Office
negotiating with the Egyptian Government for a contract to convey mail through
Egypt by railway

1858
E. Fromentin, *Une Année dans le Sahel*
J. Murray (pub.), *A Handbook for Travellers in Syria and Palestine*; written by J. L
Porter
Count Preziosi, *Stamboul: Recollections of Eastern Life*; coloured lithographs
portraying the people of Constantinople
–1859: F. Frith, *Egypt and Palestine photographed and described*; series of
photographs taken in 1856–57

1859
E. Fitzgerald (trans.), *The Rubáiyàt of Omar Khayyam*

1860 **1860**
Muslim and Druze massacre of Christians in Damascus and Lebanon

c. **1860**
Hercules Brabazon Brabazon (1821–1906) in Cairo, Syria, Palestine, Lebanon, Constantinople

1860
Berchère in Suez to record stages of cutting of Canal
Mario Fortuny y Marsal (1838–1874) to Morocco with Spanish military expedition

1861
The Organic Regulation negotiated by France, Britain and Turkey, establishing internationally guaranteed regime in Lebanon under Christian administrator responsible to the Sultān
Abdul Aziz, Sultān of Turkey (to 1876)

1861
Shreyer in North Africa: Algiers; and Near East?

1862
Gérôme in Egypt
Fortuny returns to Morocco to paint panorama commemorating Spanish victory at Tetuan
First of Guillaumet's ten trips to Algeria and Morocco (last trip 1883/4)
to 1864: Carl Werner (1808–1894) in Egypt and Palestine

1863
Ismail Pasha, Khedive of Egypt (to 1879)

1865
Lecomte-du-Nouÿ in Egypt with Félix Clément

mid **1860s**
Brabazon visits Algiers

1866
Establishment of Syrian Protestant College, later the American University in Beirut

1867
Sultān of Turkey visits London and Paris

1866
December–April 1867: Lear in Egypt: Alexandria to Wadi Halfa; to Jerusalem via Gaza

1867
to 1869: Church in Alexandria, Beirut, Jerusalem, Petra, Damascus, Baalbec, Constantinople and Athens
Leighton to Constantinople, Brussa, Smyrna, Rhodes

1868
October–November: Leighton in Egypt: on Khedive's steamer to Philae
to 1869: Pasini in Constantinople
Brabazon on first of three trips to Upper Egypt (also 1874 and 1877)

1868–69
January–1869: Gérôme with Paul Lenoir (d. 1881), Edmond About, Frédéric Masson and Bonnat (?) to Egypt: travel from Cairo to Fayoum; across Sinai to Palestine: Petra, Jerusalem.
Gérôme returns to France, the rest to Turkey and Greece

1869
November: Opening of Suez Canal; ceremonies attended by European royalty including Empress Eugènie of France, Emperor of Austria, Crown Prince of Prussia and Crown Prince of Denmark

1869
November: Gérôme, Bonnat, Lenoir, About and Masson attend opening of Suez Canal; Fromentin, Berchère, Vacher de Tournemine (1812–1872) and Frère (in suite of Empress Eugènie), also attend inauguration ceremony, as official guests
January–February: Simpson in Cairo for visit of Prince and Princess of Wales; March: to Jerusalem to see excavations of Charles Warren for Palestine Exploration Fund; April: Constantinople and Crimea; November: returns to Egypt for Suez Canal opening ceremonies
Gifford in Egypt and elsewhere in Near East?
to 1870: Henri Regnault (1843–1871) and Georges Clairin (1843–1919) in Morocco
August–June 1872: Holman Hunt returns to Jerusalem; excursions to Bethlehem and elsewhere in Holy Land

1860

A. Trollope, *An Unprotected Female at the Pyramids*; short story parodying contemporary tourism in Egypt
D. Urquhart, *The Lebanon* by a diplomat and Turcophile based in Constantinople; travelled in Lebanon 1849–50

1861

Librairie Hachette (pub.), *Itinéraire descriptif, historique et archéologique de l'Orient*

c. 1862

Count Preziosi, *Souvenir du Caire*; coloured lithographs portraying the people of Cairo

1862

International Exhibition, London: includes Islamic Art
Prince of Wales visits Egypt: Alexandria to Aswan; Palestine, Syria, Lebanon, Constantinople
to 1863: Palgrave travels in Arabia as a Syrian Christian doctor
Lady Lucie Duff Gordon lives in Egypt (Luxor) until her death (1869)

1862

G. Flaubert, *Salammbô*; historical novel set in Carthage; detail drawn from author's travels in Near East 1849–51

1863

E. Renan, *Vie de Jésus*; written in the Holy Land, 1860–61; portrays Christ in strictly human terms
N. Berchère, *Le Désert de Suez. Cinq mois dans l'isthme*; record of the artist's observations of work on the cutting of the Suez Canal
–1893: E. W. Lane, *Arabic-English Lexicon*; the Arabic scholar's monumental work to which he devoted more than thirty years of his life; an exhaustive thesaurus of the Arabic language

1864

to 1868: Topographic Survey of Jerusalem by Captain Charles Wilson and the Royal Engineers

1865

Palestine Exploration Society founded
to 1866: Palgrave in Abyssinia and Egypt

1865

C. Werner (illus.), *Jerusalem, Bethlehem and The Holy Places*; vol. of coloured lithographs
Ordnance Survey of Jerusalem; maps, plans and photographs of the city for Coutts Bank
Lady Duff Gordon, *Letters from Egypt, 1863–65*; a consumptive English lady who lived the last years of her life in Egypt, 1862–69; her letters reveal her sympathetic attitude to the ordinary people of the country; republished with additions from 1865–69, in 1875
W. G. Palgrave, *Narrative of a year's journey through central and eastern Arabia (1862–63)*

1866

Lepsius discovers Edict of Canopus at Tanis (Lower Egypt), bilingual stone confirming Champollion's system

1866

E. Lott, *The English Governess in Egypt*; popular and unsensational account of life in the royal harem of Egypt and Turkey
Gustave Doré's illustrated Bible published in Paris

1867

Mark Twain (1835–1910) visits the Near East as part of first American Mediterranean cruise
Felix Bonfils (1831–85) opens photographic studio in Beirut with his wife; one of finest and most prolific photographers of the Near East
Exposition Universelle, Paris: Islamic items included
to 1873: Palgrave British Consul at Trebizond; travels in Asia Minor

1868

to 1869: Prince and Princess of Wales visit Egypt: Cairo and Upper Egypt, Suez, Alexandria; also Constantinople, Crimea, Athens

1868

F. Bedford (illus.), *The Holy Land, Egypt, Constantinople, Athens, etc.*; series of photographs taken during a visit to the Near East in 1862 in the entourage of the Prince of Wales

1869

Cairo opera house opens, with Verdi's *Rigoletto*
to 1870: First Cook's Tour of Egypt and the Holy Land
to 1871: Burton British Consul in Damascus

1869

E. About, *Le Fellah: souvenirs d'Egypte*; dedicated to Gérôme with whom he travelled
Sir W. H. Russell, *A Diary in the East during the tour of the Prince and Princess of Wales*; chronicle of the royal tour in 1869 of Egypt, Constantinople and the Crimea
M. Twain, *The Innocents Abroad*; popular, humorous narrative of travel to Europe, Asia Minor, Lebanon, Syria, Palestine and Egypt in 1867

HISTORICAL EVENTS	ARTISTS

1870

1870
Attempts by settlers to govern Algeria through Commune d'Alger

1871
Resistance by Algerian tribesmen against the French

1872
Indo-European Telegraph Company links Europe with India across Black Sea to Tiflis, Tabriz and Tehran
British lay overland cable from Bushire to Karachi

1873
Mawlāy al-Hasan, Sultān of Morocco (to 1895)

1875
November: Disraeli purchases Khedive of Egypt's holding of Suez Canal shares

1876
Egypt bankrupt: establishment of Caisse de la Dette Publique: dual control by French and British
Bulgarian massacres by Turks
Abdul Hamid II, Sultān of Turkey (to 1909)

1877
Russo-Turkish War

1878
Congress and Treaty of Berlin between European powers; several areas in Near East affected: Bulgarian independence; understanding on spheres of influence in North Africa

1879
Muḥammad Tewfiq, Khedive of Egypt (to 1892)

1870s
Lecomte-du-Nouÿ visits Morocco
Frederick Arthur Bridgman (1847–1928) visits Egypt and Algeria several times

c. **1870**
to 1873: Constant in Morocco for two years with C. J. Tissot's diplomatic mission

1870
to 1871: Goodall returns to Egypt: Cairo, Sakkara

1871
Gérôme in Egypt and Constantinople
Fortuny and Clairin in Morocco: Tangier, Tetuan

c. **1872**
Clairin accompanies Tissot's envoy in Morocco: Tangier, Tetuan, Fez

1872
Lecomte-du-Nouÿ in Greece, Egypt, Asia Minor
October: Lear in Cairo and Suez
Gérôme in Egypt

1873
Pasini in Asia Minor, Syria
Leighton in Damascus
to 1874: L. C. Müller in Smyrna, Constantinople; on to Egypt, the first of nine visits there, last trip 1886
to 1874: Haag returns to Cairo

1874
Gérôme in Egypt
Girardet in Morocco; first of eight visits to North Africa

1875
Gérôme in Constantinople
to 1876: L. C. Müller working in Cairo with Makart and several other Austrian painters
December–March 1878: Holman Hunt returns to Jerusalem and Holy Land

1877
Simpson to Asia Minor: Mycenae, Troy, Ephesus; as artist-reporter on Schliemann's excavations

c. **1870**
E. Riou (illus.), *Voyage pittoresque à travers l'Isthme de Suez*; commemmorative vol.
of lithographs for inauguration of the Suez Canal, November 1869

1871
First performance of Verdi's *Aida*, in Cairo; commissioned by Khedive Ismail
Pasha, libretto by du Locle from synopsis by Mariette
to 1890: Heinrich Schliemann (1822–90) excavating in Asia Minor and Greece;
discovers site of Troy

1871
J. Murray (pub.), *A Handbook for Travellers in Constantinople, the Bosphorus,
Dardanelles, Broussa and Plain of Troy*
E. H. Palmer, *The Desert of the Exodus*; the author participated in the Ordnance
Survey expedition to Sinai, 1868–69, and visited El-Tih, Idumea and Moab for
the Palestine Exploration Fund, 1869–70
−1875: C. Werner (illus.), *Nile Sketches*

1872
to 1878: Wilfrid Scawen Blunt (1840–1922) and his wife Lady Anne, travelling
in North Africa, Egypt, Palestine, Asia Minor and (1878) Mesopotamia

1872
Comte de Gobineau, *Souvenirs de Voyage*
P. Lenoir, *Le Fayoum, le Sinaï et Pétra*, (Eng. trans. 1873); the author's journey
with Gérôme About and Masson in 1868

1873
First International Congress of Orientalists held in Paris; every two to three years
thereafter in various capitals

1873
J. Murray (pub.), *A Handbook for Travellers in Algeria*
J. Bourgoin, *Les Arts arabes*

1874
to 1875: Charles Doughty (1843–1926) travels in Syria, Holy Land, Sinai and
Egypt

1875
I. Burton, *The Inner Life of Syria, Palestine and the Holy Land*; the author's
experience of the Levant when her husband, Richard Burton, was consul in
Damascus, 1869–71

1876
to 1878: Doughty in Damascus; travels from there to north-west Arabia: Madain
Salih (Nabataean ruins), Nejd; with the Bedouin

1876
K. Baedeker (ed.), *Palestine and Syria. Handbook for Travellers* (German edn. 1880)
C. Warren, *Underground Jerusalem*; the results of surveys in the Holy City,
1867–70
E-M. de Vogüé, *Syrie, Palestine, Mont Athos: Voyage aux pays du passé*; journey
by an influential man of letters and positivist

c. **1877**
−1885: C. Warren. (ed.), *Picturesque Palestine, Sinai & Egypt*; 4 vols., illustrated
by Roberts, Goodall, Poynter, Werner, Alma-Tadema and other artists: lavish
pictorial coverage of Palestine; text by eminent Palestine explorers

1877
to 1881: Layard British Ambassador in Constantinople

1877
F. G. Burnaby, *On horseback through Asia Minor*; account of travels, 1876–77
A. B. Edwards, *A Thousand Miles up the Nile*; novelist and Egyptologist, an
account of her first voyage up the Nile, 1874
E. Prisse d'Avennes, *L'Art Arabe*; published in parts from 1869, coloured
lithographs of every aspect of Islamic art and architecture, studied in Cairo

1878
Arrival of Cleopatra's Needle (from Alexandria) in London; erected on Thames
Embankment
to 1879: Blunts journey to Nejd in Arabia

1878
K. Baedeker (ed.), *Egypt. Handbook for Travellers. Part first: Lower Egypt etc.*
(German edn. 1877)

1879
P. Loti, *Aziyadé*; novel based on his romantic entanglement with a lady of the
Harem during a visit to Salonika and Constantinople, May 1876–November 1877
Lady Anne Blunt, *Bedouin Tribes of the Euphrates*; wife of W. S. Blunt, travelled
with him in Syria, Mesopotamia and Arabia, late 1870s
F. Bonfils, *Architecture antique: Egypte, Grèce, Asie Mineure*; first of many
photographic albums of Near East by this talented family
−1880: G. M. Ebers, *Ägypten in Bild und Wort*; profusely illustrated with both
topographical and fanciful views by several different artists

HISTORICAL EVENTS	ARTISTS

1880

1880
Last major revolt in Algeria quelled by French

1880s
F. A. Bridgeman (1847–1928) visits Egypt and Algeria on several occasions
to 1914: Robert Talbot Kelly (1861–1934) spends many years painting in Egypt
Ludwig Deutsch visits Cairo on several occasions

1880
January: John Singer Sargent (1856–1925) in Morocco
to 1882: Bauernfeind's first visit to the Near East: Cairo, Jaffa, Jerusalem, Damascus
Autumn–1882: Melville living in Cairo; visits Luxor; March 1882: by sea to India; returns from Baghdad to Black Sea on horseback

1881
First wave of Jewish immigration into Palestine
Uprising in Sudan, led by the Mahdi
Public Debt Administration established by European banks: many areas of Turkish finance under foreign supervision
French army invades Tunisia from Algeria: navy seizes Biserta; Bay of Tunis accepts French protectorate

1881
?Gérôme in Constantinople, ? with Aublet (1851–1938)
March–April: Renoir in Algiers (March–April 1882, returns to Algiers)

1882
June: riots in Alexandria; Arabi Pasha takes control; July: British fleet bombard Alexandria; 13 September: British troops defeat Arabi Pasha at Tel el Kebir; 2 days later enter Cairo

1882
Leighton on fleeting visit to Cairo

1883
Evelyn Baring, later Lord Cromer (1841–1917), British Agent and Consul-General in Egypt (to 1890)

1883
to 1884: Theodore van Rysselberghe (1862–1926) in Morocco: Tangier
to 1884: Last of Guillaumet's ten trips to the Near East

1884
Etienne Dinet (1861–1929) with Lucien Simon (1861–1945) and brother to Algeria: live in Bou-Saada, Biskra and El Agouat
Vasily Vasilievitch Vereshchagin (1824–1904) in Jerusalem and elsewhere in Holy Land, making studies for fifty-four large paintings with biblical subjects, subsequently exhibited in major European cities
Brabazon in Morocco: Tangier

1885
Death of General Gordon at Khartoum

1886
Last of L. C. Müller's nine visits to Egypt
October–March 1887: James Tissot to Holy Land: Jerusalem, to collect material for his illustrated Bible

1887
George Frederick Watts (1817–1904) on honeymoon with second wife in Egypt: Nile voyage in Cook's dahabiyyah

1888
to 1893: Extension of railway from Balkans to Ankara, built by German-backed Anatolian Railway Company

1888
Bauernfeind in Syria: Damascus, Palmyra
Brangwyn on a cargo ship to Dardanelles, Constantinople and Black Sea

1889
Brangwyn on a cargo ship to Tunis, Smyrna, Trebizond
J. Tissot returns to Holy Land
November–April 1890: Vedder in Egypt with American manufacturer George Corliss

1890

1890s
Melville visits Algeria
Ludwig Deutsch visits Cairo on several occasions

1890
December–1891: Sargent in Egypt, Palestine, Constantinople, Greece

1892
Abbas II Hilmi, Khedive of Egypt (to 1914)

1892
Holman Hunt returns to Cairo (February) and to Jerusalem (March–May)
Charles Cottet (1863–1925) in Algeria; Tunisia?
to 1893: Sargent in Tunis

1893
Spring: Brangwyn in Morocco: Tangier, with colourist Dudley Hardy
Emile Bernard (1868–1941) visits Samos, Smyrna, Constantinople; Autumn: Palestine: Jerusalem; Alexandria to Cairo;
October 1894–May 1895: Palestine; then settles in Cairo until 1904

1894
Albert Besnard (1849–1934) in Morocco

1895
Nationalist Party in Egypt founded by Mustafa Kamel (1874–1901), champion of Egyptian nationalism, and others
to 1896: Armenian massacres by Turks
Mawlāy 'Abd al-'Aziz, Sultān of Morocco (to 1907)

1895
Clairin in Egypt with Camille Saint-Saëns

1880

Jean Nicholas Rimbaud, gun-runner in Aden and Abyssinia
to 1882: M. Flinders Petrie (1853–1942) carries out detailed survey of the Great
Pyramid (of Cheops) at Giza; his first of many excavations in Egypt during which
he used novel methods to advance the whole approach to Egyptology

1880

Dalziel's Bible Gallery Illustrations, engraved by the Brothers Dalziel; illustrated
by Holman Hunt, Leighton, Poynter, Madox Brown, Watts and many others

1881

Blunt purchases an estate near Cairo (Shaykh Obeyd) spends several winters there
Second 'Needle' from Alexandria removed to New York; erected in Central Park
Gaston Maspero (1846–1916) succeeds Mariette as Director of the Bulaq
museum of Egyptian antiquities

1881

H. Schliemann, *Ilios: the city and country of the Trojans; the results of researches . . .
on the site of Troy . . . in the years 1871, 72, 73, 78, 79*
Lady Anne Blunt, *A Pilgrimage to Nejd, the cradle of the Arab race*; the Blunts
travels, 1878–79
P. Loti, *Le Roman d'un Spahi*; novel based on his visit to Dakar and St Louis,
1873
–1885: Palestine Exploration Fund (pub.), *The Survey of Western Palestine*; 7 vols.;
papers written by eminent Palestine explorers; survey undertaken 1872–75 and
1877–79

1882

Egypt Exploration Fund founded in London by Amelia Edwards, Reginald Stuart
Poole and Sir Erasmus Wilson
Laurence Oliphant (1829–88) and his wife initiate scheme to colonise Palestine
with Jews

1882

W. S. Blunt, *The Future of Islam*; reveals the author's belief in Islamic nationalism
and his opposition to Western influences

1891

Howard Carter (1874–1939) begins his career in Egyptology

1892

Flinders Petrie becomes first professor of Egyptology in Britain (University
College, London), until 1933

1884

A. J. Butler, *The Ancient Coptic Churches of Egypt*

1893

Foundation of the Societé des Peintres Orientalistes; first official exhibiting body
for Orientalist painters
Exposition d'art musulman, Palais de l'Industrie, Paris; the first major exhibition
devoted solely to Islamic art; seen by Matisse
André Gide (1869–1951) in Algeria

1885

–1888: R. Burton, *A Plain and Literal Translation of the Arabian Nights*; 10 vols.,
a critical and popular success; Burton attempted to capture the exotic spirit of
the original with archaisms and flowery phrases

1894

First exhibition in Paris of Societé des Peintres Orientalistes

1886

S. Lane-Poole, *The Art of the Saracens in Egypt*
Palestine Exploration Fund (pub.), *Twenty-one Years' work in the Holy Land*

1887

E. Belhard and A. L. Palmiera, *Egypte et la Nubie: grand Album monumentals,
historique, architectural*; early collotype reproductions

1888

C. M. Doughty, *Travels in Arabia Deserta*; a record of the author's two years with
the Bedouin of Arabia, 1876–78
G. Guillaumet, *Tableaux algériens*; drawn from his frequent visits to Algeria,
notably the south

1890

E. Wallis Budge, *The Nile. Notes for travellers in Egypt*; Thos. Cook's guide book
to the principal monuments between Cairo and Khartoum

1892

K. Baedeker, *Egypt. Handbook for Travellers. Part second: Upper Egypt etc.* (German
edn. 1891); repub. with sections on Lower Egypt, 1898

1894

–1905: M. Flinders Petrie (ed.), *A History of Egypt*; 6 vols, contributions from
J. P. Mahally, J. G. Milne, S. Lane-Poole

1895

P. Loti, *Jerusalem* and *La Galilée*; poetic evocations of a visit to the Holy Land
–1908: H. E. Naville, *The Temple of Deir El Bahari*; record, in six parts, of
excavations sponsored by the Egypt Exploration Fund; the plates mainly from
drawings by Howard Carter

HISTORICAL EVENTS	ARTISTS

1896
14 March: Lord Cromer despatches Anglo-Egyptian force to Sudan

1897
First Zionist congress

1898
2 September: Battle of Omdurman: collapse of Mahdist regime in Sudan
The Fashoda Incident: meeting between General Kitchener and Captain Marchand in Sudan

1899
Anglo-Egyptian Condominium in Sudan (to 1956)

1896
J. Tissot returns to the Holy Land
Cottet in Egypt, Turkey?

1897
Dinet in Egypt
October–May 1898: Henri Evenepoel (1872–1899) in Algeria: Blidah

1898
Girardet in Egypt and Palestine
Bauernfeind returns to Jerusalem to live: dies there in 1904

1900

1903
Levant Consular Service established

1904
8 April: Entente Cordiale between Britain and France

1905
31 March: Kaiser Wilhelm II visits Tangier; initiates Moroccan Crisis

1906
Dinshawai incident in the Nile Delta: symptom of British autocracy and Egyptian resentment

1908
Hijāz railway between Medina and Damascus opened
July: Young Turks Revolution initiated

1909
27 April: Young Turks depose Sultan Abdul Hamid in favour of Muhammad V (to 1918)
Turkish massacre of Armenians
Muḥammad V, Sultān of Turkey (to 1918)

1902
to 1904: Sir Lawrence Alma-Tadema (1836–1912) in Egypt to attend inauguration of first Aswān Dam

From 1904
Dinet makes a summer home in Bou-Saada

1904
December–April 1905: Kandinsky in Algeria, Tunisia: Biserta, Tunis, Carthage

1905
to 1906: Sargent in Palestine and elsewhere in Near East

1906
Matisse in Algeria: Biserta

1910

1911
April: Fez taken by the French
Franco-German Convention on Morocco
to 1913: Italian campaign in Libya

c. **1912**
Arab nationalism: formation of two secret societies, al Fatat and al-'Ahd (to 1914)

1912
30 March: Morocco becomes a French protectorate
Gradual French infiltration and occupation of Morocco (to 1925)

1913
to 1914: Britain, Germany and Turkey agree on construction of Baghdad Railway

1914
18 December: Egypt declared a British protectorate; Khedive Abbas II deposed
World War I; Turkey enters on side of Germany (Treaty of Alliance, 2 August)

1916
Outbreak of Arab revolt against Ottoman rule
Sykes-Picot Agreement: British, French and Russian spheres of influence in the Levant determined

1917
2 November: Balfour Declaration: in favour of Jewish homeland in Palestine

1912
Spring: Matisse in Algeria, Morocco; Autumn–Spring 1913: returns to Algeria, Morocco

1920

1920
British and French mandates established in Near East

1922
End of Ottoman Sultānate; last Sultān exiled to San Remo

TRAVELLERS, EXPLORERS, ARCHAEOLOGISTS,
INTELLECTUALS, DIPLOMATS, CULTURAL EVENTS

PUBLICATIONS

1896
–1897: J. Tissot, *La Vie de Notre Seigneur Jésus Christ*; 'Tissot's Bible'; Eng. trans.
1897–98
E. Muir, *The Mamluk or Slave Dynasty of Egypt 1200–1517*

from 1897
Isabelle Eberhardt (Si Mahmoud) (1877–1904) in the deserts of North Africa,
often dressed as a man; married to a Spahi Slimène Ehnni in 1901

1898
Kaiser Wilhelm's tour of Holy Land (arranged by Thos. Cook)

1899
Gertrude Bell (1868–1926) undertakes extensive travels and archaeological
research in Syria, Asia Minor, Mesopotamia; 1916–21, advisor to British
Government on Arab politics in Iraq, dies there 1926

1902
R. Talbot Kelly, *Egypt, Painted and Described*

1900

1904
J. Tissot, *La Sainte Bible*; the Old Testament, published posthumously

1907
Maison de France established at Villa Abd el Tif in Algiers; an institute for artists
working in North Africa

1907
G. Bell, *The Desert and the Sown*; account of her journey through Syria to Asia
Minor, 1906

1908
Lord Cromer, *Modern Egypt*; Egypt as seen by its British residents
C. M. Doughty, *Wanderings in Arabia*; an abridgement of *Arabia Deserta* which
brought it the recognition it has maintained as one of the greatest of Near Eastern
travel books

1910
Exhibition of Islamic art in Munich; seen by Matisse and Kandinsky

1911
G. Bell, *Amurath to Amurath*; account of travels in Syria, Mesopotamia and Asia
Minor in 1910

1910

1914
to 1916: T. E. Lawrence (1888–1935) in Cairo, in Arab Bureau, part of military
intelligence

1916
to 1918: Lawrence in Arabia as liaison officer and adviser to Faisal, third son
of Sharif of Mecca, participating in Arab revolt against the Turks; enters
Damascus 1 October 1918

1920

1926
T. E. Lawrence, *Seven Pillars of Wisdom*

Bibliography

Works which themselves contain substantial bibliographies are marked with an asterisk.

GENERAL

*Jean Alazard, *L'Orient et la peinture française au XIXe siècle, d'Eugène Delacroix à Auguste Renoir*, Paris, 1930

Jean Alazard, 'L'Algérie et les arts de 1830 à nos jours', *Histoire et historiens de l'Algérie, 1830–1930*, Collection du Centenaire de l'Algérie, Paris, 1931, pp. 349–62

*Kenneth Paul Bendiner, 'The Portrayal of the Middle East in British Painting, 1835–1860', Ph.D. dissertation, Columbia University, 1979

Léonce Bénédite, 'Les Peintres orientalistes français', *Gazette des Beaux-Arts*, 3e période, vol. XXI, 1899, pp. 239–47

P. and V. Berko, *Peinture Orientaliste*, Brussels, 1982

Roger Bezombes, *L'Exotisme dans l'art et la pensée*, Paris, 1953

A. Boppe, *Les Introducteurs des ambassadeurs*, Paris, 1907

A. Boppe, *Les Peintres du Bosphore au XVIIIe siècle*, Paris, 1911

*James Stevens Curl, *The Egyptian Revival, an Introductory Study of a Recurring Theme in the History of Taste*, London, 1982

Gerbert Frodl, 'Wiener Orientmalerei im 19. Jahrhundert', *Alte und Moderne Kunst*, vol. 26, nos. 178–9, 1981, pp. 19–25

Peter Hughes, *Eighteenth-Century France and the East*, Wallace Collection Monographs, London, 1981

Philippe Jullian, *The Orientalists. European Painters of Eastern Scenes*, Oxford, 1977

André Maubert, 'L'Exotisme dans la peinture française du XVIIe siècle', thesis, Université de Paris, 1943

Linda Nochlin, 'The Imaginary Orient', *Art in America*, May 1983, vol. 71, pp. 118–31, 187–91

Hassan El-Nouty, 'Les Peintres français en Egypte au XIXe siècle', complementary thesis, Université de Paris, 1953

Ary Renan, 'La Peinture orientaliste', *Gazette des Beaux-Arts*, 3e période, vol. XI, 1894, pp. 43–53

*Valerie M. Romaya, 'Nineteenth-Century British Artists in the Middle East', M. Phil. thesis, University of Nottingham, 1977

*Lynne Thornton, *Les Orientalistes. Peintres voyageurs 1828–1908*, Paris, 1983

Michelle Verrier, *The Orientalists*, New York and London, 1979

ORIENTALIST EXHIBITIONS

Baltimore Museum of Art, *The Cult of Arabia*, 1972

Brighton Museum and Manchester City Art Gallery, *The Inspiration of Egypt. Its Influence on British Artists, Travellers and Designers, 1700–1900*, 1983

Cairo, Société des Amis de l'Art, *Les Orientalistes français: l'Afrique du Nord dans l'art français du XIXe et XXe siècles*, 1936

Cambridge, Fogg Art Museum, *North Africa Interpreted by European Artists*, 1943

Edinburgh, Talbot Rice Art Centre, and Norwich, Sainsbury Centre for the Visual Arts, *A Middle-Eastern Journey: Artists on their Travels, from the collection of Rodney Searight*, 1980–1

London, The Fine Art Society, *North African Traveller, Casablanca to Cairo*, 1974

*London, The Fine Art Society, *Eastern Encounters. Orientalist Painters of the Nineteenth Century*, 1978

London, The Fine Art Society, *Travellers Beyond the Grand Tour*, 1980

London, Leighton House, *The Middle East. Watercolours and Drawings by British and Foreign Artists and Travellers 1750–1900. From the collection of Rodney Searight*, 1971

*London, Leighton House, *The Islamic Perspective. An aspect of British architecture and design in the nineteenth century*, 1983

*Marseille, Musée Cantini, *L'orient en question. De Missolonghi à Suez, ou l'Orientalisme de Delacroix à Flaubert*, 1975

Marseille, Musée de Beaux-Arts, *Les Orientalistes provinçaux*, 1982–3

Nantes, Musée des Beaux-Arts, *Orients*, 1980

New York, Metropolitan Museum of Art, *The Image of the Turk in Europe*, 1973

Paris, Galerie Charpentier, *Les Peintres orientalistes français*, 1933

*Paris, Galerie Jean Soustiel, *Mahmal et Attatichs. Peintres et Voyageurs en Turquie, en Egypte et en Afrique du Nord*, 1975–6

Paris, Petit Palais, *Centenaire de la conquête de l'Algérie, 1830–1930*, 1930

Pau, Dunkirk and Douai, Musées des Beaux-Arts, *Les Orientalistes de 1850 à 1914*, 1983

Providence, Rhode Island School of Design, *French Painting in Africa*, 1935

*Rochester, Memorial Art Gallery of the University of Rochester, *Orientalism. The Near East in French Painting, 1800–1880*, 1982

Tours, Musée des Beaux-Arts, *L'Orientalisme dans les collections des Musées de Tours*, 1980

WORKS ON INDIVIDUAL ARTISTS

Auguste
*Donald Rosenthal, 'Jules-Robert Auguste and the Early Romantic Circle', Ph.D. dissertation, Columbia University, 1978

Bauernfeind
Hugo Schmid, *Der Maler Gustav Bauernfeind, 1848–1904*, Sulz, 1981

Belly
J. K. Huysmans, 'Art contemporain – Belly', *Les Chefs-d'oeuvre d'art au Luxembourg*, Paris, 1881

Conrad de Mandach, 'Artistes contemporains. Léon Belly (1827–1877)', *Gazette des Beaux-Arts*, 4e période, vol. IX, 1913, pp. 73–84, 143–57

Saint-Omer, Musée de l'Hôtel Sandelin, *Léon Belly*, 1977

P. Wintrebert, 'Catalogue de l'oeuvre de Léon Belly', thesis, Université de Lille III, 1974

Benjamin-Constant
C. D., 'Benjamin-Constant', *Les Arts*, no. 5, June 1902, pp. 26–8

William R. Johnston, 'Caliphs and Captives', *Bulletin du Musée de Montréal*, June 1972, pp. 11–16

J. Murray Templeton, 'Benjamin-Constant', *Magazine of Art*, 1891, pp. 181–8

Bonnat
Léonce Bénédite, 'Léon Bonnat (1833–1922)', *Gazette des Beaux-Arts*, 5e période, vol. VII, 1923, pp. 1–15

M. Pouget, *Léon Bonnat*, Paris, 1977

Gabriel P. Weisburg, *The Realist Tradition: French Painting and Drawing 1830–1900*, Cleveland Museum of Art and Indiana University Press, 1981, pp. 271–3

Brangwyn
Rodney Brangwyn, *Brangwyn*, London, 1978

Vincent Galloway, *The Oils and Murals of Sir Frank Brangwyn, R.A., 1867–1956*, Leigh-on-Sea, 1962

Chassériau
Arthur Baignères, 'Théodore Chassériau', *Gazette des Beaux-Arts*, 2e période, vol. XXXIII, 1886, pp. 209–18

Léonce Bénédite, *Théodore Chassériau, sa vie et son oeuvre*, 2 vols., Paris, 1932

Valbert Chevillard, *Un Peintre romantique. Théodore Chassériau*, Paris, 1893

Raymond Escholier, 'L'Orientalisme de Chassériau', *Gazette des Beaux-Arts*, 5e période, vol. III, 1921, pp. 89–107

Paris, Musée de l'Orangerie, *Chassériau*, 1930

*Marc Sandoz, *Théodore Chassériau 1819–1856. Catalogue raisonné des peintures et des estampes*, Paris, 1974

Dauzats
Alexandre Dumas (Pére) and Adrien Dauzats, *Quinze jours au Sinaï*, Paris, 1841

Paul Guinard, *Dauzats et Blanchard. Peintres de l'Espagne romantique*, Paris, 1967

Henry Jouin, *Adrien Dauzats, peintre et écrivain*, Paris, 1896

Decamps
Marius Chaumelin, *Decamps. Sa vie, son oeuvre, ses imitateurs*, Marseille, 1861

Charles Clément, *Les Artistes célèbres: Decamps*, Paris, 1866

Paul Mantz, 'Decamps', *Gazette des Beaux-Arts*, Ière période, vol. XII, 1862, pp. 97–128

*Dewey Mosby, *Alexandre-Gabriel Decamps*, New York, 1977

Delacroix
Eugène Delacroix, *Oeuvres littéraires*, 2 vols., Paris, 1923

Eugène Delacroix, *Journal de Eugène Delacroix*, ed. André Joubin, 3 vols., Paris, 1932

Eugène Delacroix, *Correspondance générale d'Eugène Delacroix*, ed. André Joubin, 5 vols., Paris, 1936–8

Raymond Escholier, *Delacroix, peintre, graveur, écrivain*, 3 vols., Paris, 1926–9

Jean Guiffrey, *Le Voyage d'Eugène Delacroix au Maroc*, 2 vols., Paris, 1909

George Heard Hamilton, 'Eugène Delacroix and Lord Byron', *Gazette des Beaux-Arts*, 6e période, vol. XXIII, 1943, pp. 99–110

George Heard Hamilton, 'Delacroix, Byron and the English Illustrators', *Gazette des Beaux-Arts*, 6e période, vol. XXXVI, 1949, pp. 261–78

René Huyghe, *Delacroix*, London, 1963

Lee Johnson, 'Delacroix's *Rencontre de Cavaliers Maures*', *Burlington Magazine*, vol. CIII, 1961, pp. 417–23

*Lee Johnson, *The Paintings of Eugène Delacroix. A Critical Catalogue 1816–1831*, 2 vols., Oxford, 1981

Lee Johnson, 'Delacroix's road to the Sultan of Morocco', *Apollo*, vol. CXV, 1982, pp. 186–9

*Eve Kliman, 'Delacroix's lions and tigers: a link between man and nature', *Art Bulletin*, vol. LXIV, 1982, pp. 446–66

E. Lambert, *Histoire d'un tableau. "L'Abd er Rahman, Sultan du Maroc" de Delacroix*, Institut des Hautes Etudes Marocaines, no. XIV, Paris, 1953

London, Arts Council, *Delacroix*, 1964

Jonathan Mayne, 'Delacroix's Orient', *Apollo*, vol. LXXVIII, 1963, pp. 203–7

Paris, Atelier Delacroix, *Delacroix et l'orientalisme de son temps*, 1953

Paris, Musée de l'Orangerie, *Voyage de Delacroix au Maroc, et exposition rétrospective du peintre M. Auguste*, 1933

A. Robaut and E. Chesneau, *L'Oeuvre complète de Eugène Delacroix, peintures, dessins, gravures, lithographies*, Paris, 1885

Jack J. Spector, *Delacroix: The Death of Sardanapalus*, London, 1974

Frank Trapp, *The Attainment of Delacroix*, Baltimore and London, 1971

Frère
Eugène Montrosier, *Artistes Modernes. Les Peintres de Genre*, nouvelle série, Paris, 1896, pp. 9–12

Fromentin
*Jane Abbott, 'An Annotated Bibliography (1937–1970) of Commentary on the Life and Writings of Eugène Fromentin', Master's dissertation, University of North Carolina, 1973

Prosper Dorbec, *Eugène Fromentin*, Paris, 1926

Eugène Fromentin, *Un Eté dans le Sahara*, Paris, 1857

Eugène Fromentin, *Une Anneé dans le Sahel*, Paris, 1859

Eugène Fromentin, *Voyage en Egypte, 1869*, Paris, 1935

Eugène Fromentin, *Lettres de jeunesse*, ed. Pierre Blanchon, Paris, 1909

Eugène Fromentin, *Correspondance*, ed. Pierre Blanchon, Paris, 1911

Louis Gonse, *Eugène Fromentin Peintre et écrivain*, Paris, 1881

Henry Houssaye, 'Eugène Fromentin', *Revue des Deux Mondes*, 3e période, vol. 20, 1877, pp. 882–95

La Rochelle, Museé des Beaux-Arts, *Eugène Fromentin: le peintre et l'écrivain*, 1970

Fouad Marcos, *Fromentin et l'Afrique*, Paris, 1974

*Pierre Martino, 'Fromentin: essai de bibliographie critique', *Revue Africaine*, 1914, pp. 153–82

*Barbara Wright, *Eugène Fromentin: A Bibliography*, London, 1973

Gérôme
*Gerald Ackerman, 'Jean-Léon Gérôme', 1824–1904, Ph.D. dissertation, Pomona College, 1971

*Dayton Art Institute, Minneapolis Institute of Arts and Baltimore, Walters Art Gallery, *Jean-Léon Gérôme (1824–1904)*, 1972–3, with an essay by Richard Ettinghausen, 'Jean-Lèon Gérôme as a painter of Near-Eastern life'

Emile Galichon, 'M. Gérôme. Peintre ethnographe', *Gazette des Beaux-Arts*, Ière période, vol. XXIV, 1868, pp. 147–51

Fanny Field Hering, *Gérôme, his life and works*, New York, 1892

Paul Lenoir, *Le Fayoum, Le Sinaï et Pétra. Expédition dans la Moyenne Egypte et l'Arabie Petrée sous la direction de J. L. Gérôme*, Paris, 1872

C. Moreau-Vauthier, *Gérôme, peintre et sculpteur, l'homme et l'artiste*, Paris, 1906

Edward Strahan, pseudonym for Evert Shinn, *Gérôme, a collection of the works of J. L. Gérôme in one hundred photogravures*, 2 vols., New York, 1881–3

Charles Timbal, 'Les Artistes contemporains. Gérôme', *Gazette des Beaux-Arts*, 2e période, vol. XIV, 1876, pp. 218–31, 334–46

Girardet
R. Burnard, *L'Etonnante histoire des Girardet, artistes suisses*, Neuchâtel, 1944

Paris, Hôtel Drouot, *Catalogue des tableaux provenant de l'atelier Eugène Girardet*, 20 March 1908 (preface by Léonce Bénédite)

Gleyre
Charles Clément, *Gleyre. Etude biographique et critique*, Geneva, Neuchâtel and Paris, 1878

*New York University, Grey Art Gallery and Study Center, and University of Maryland Art Gallery, *Charles Gleyre 1806–1874*, 1980, with an essay by Nancy Scott Newhouse, 'From Rome to Khartoum: Gleyre, Lowell and the Evidence of the Boston Watercolors and Drawings'

*Winterthur, Kunstmuseum, etc., *Charles Gleyre ou les illusions perdues*, 1974, with an essay by Jacques-Edouard Berger, 'Gleyre et l'Orient'

Goodall
Frederick Goodall, *The Reminiscences of Frederick Goodall, R.A.*, London, 1902

N. G. Slarke, *Frederick Goodall, R. A.*, Oundle, 1981

Gros
Anonymous, 'M. Gros', *L'Artiste*, Ière série, vol. IX, 1835, pp. 265–7

Anonymous, 'Vente des tableaux, dessins et esquisses de M. Gros', *L'Artiste*, Ière série, vol. X, 1835, pp. 197, 209–10

J. B. Delestre, *Gros, sa vie et ses ouvrages*, Paris, 1867

J. Tripier Le Franc, *Histoire de la vie et de la mort du baron Gros*, Paris, 1880

Pierre Lelièvre, 'Gros, peintre d'histoire', *Gazette des Beaux-Arts*, 6e période, vol. XV, 1936, pp. 289–304

Paris, Petit Palais, *Gros, ses amis, ses élèves*, 1936

Norman Schlenoff, 'Baron Gros and Napoleon's Egyptian Campaigns', *Essays in Honour of Walter Friedlaender*, New York, 1965

Guillaumet
Adolphe Badin, 'Gustave Guillaumet', *L'Art*, vol. XLIV, 1888, pp. 3–13, 39–45, 53–60

Léonce Bénédite, 'La Peinture orientaliste et Gustave Guillaumet', *Nouvelle Revue*, vol. L, 1888, pp. 326–43

Gustave Guillaumet, *Lettres d'un voyageur*, Paris, 1888

Gustave Guillaumet, *Tableaux algériens*, Paris, 1888

Paris, Galerie Georges Petit, *Vente de l'atelier de Gustave Achille Guillaumet, 6–8 February 1888*

Ary Renan, 'Gustave Guillaumet', *Gazette des Beaux-Arts*, 2e période, vol. XXXV, 1887, pp. 404–22

Holman Hunt
William Holman Hunt, *Pre-Raphaelitism and the Pre-Raphaelite Brotherhood*, 2 vols., London, 1905

*George P. Landow, *William Holman Hunt and Typographical Symbolism*, New Haven, 1979

Liverpool, Walker Art Gallery and London, Victoria and Albert Museum, *William Holman Hunt*, 1969

London, Tate Gallery, *The Pre-Raphaelites*, 1984

Ingres
Henri Delaborde, *Ingres. Sa vie, ses travaux, sa doctrine*, Paris, 1870

Henri Lapauze, *Ingres, sa vie et son oeuvre*, Paris, 1911

J. Momméja, '"Le Bain turc" d'Ingres', *Gazette des Beaux-Arts*, September 1906, pp. 177–98

Paris, Musée du Louvre, *Le Bain turc d'Ingres*, Les dossiers du département des peintures, no. 1, 1971

Paris, Petit Palais, *Ingres*, 1967

*Robert Rosenblum, *Ingres*, New York, 1967

*Georges Wildenstein, *Ingres*, London, 1954

Kandinsky
Will Grohmann, *Wassily Kandinsky, Leben und Werk*, Cologne, 1958

Wassily Kandinsky, *Complete Writings on Art*, ed. Kenneth C. Lindsay and Peter Vergo, Boston and London, 1982

*Hans K. Roethel and Jean K. Benjamin, *Kandinsky. Catalogue Raisonné of the Oil Paintings. Volume One, 1900–1915*, London, 1982

Lear
Philip Hofer, *Edward Lear as a Landscape Draughtsman*, Cambridge, Mass., 1968

Edward Lear, *Journals of a Landscape Painter in Greece and Albania etc.*, London, 1851

Edward Lear, *Letters of Edward Lear*, ed. Lady Strachey, London, 1907

Edward Lear, *Later Letters of Edward Lear*, ed. Lady Strachey, London, 1911

Vivien Noakes, *Edward Lear: the Life of a Wanderer*, London, 1968

Lecomte-du-Nouÿ
Guy de Montgailhard, *Lecomte-du-Nouÿ*, Paris, 1906

V. Sisman, *Lecomte-du-Nouÿ*, thesis, Université de Nanterre, 1981

Leighton
A. L. Baldry, *Leighton*, 'Masterpieces in Colour' Series, London, 1908

Mrs Russell Barrington, *The Life, Letters and Work of Frederic Leighton*, 2 vols., London, 1906

Alice Corkran, *Frederic Leighton*, London, 1904

*Richard and Leonée Ormond, *Lord Leighton*, New Haven and London, 1975

Ernest Rhys, *Sir Frederic Leighton, Bart., P.R.A.*, London, 1895

John Edgcumbe Staley, *Lord Leighton of Stretton, P.R.A.*, London, 1906

Lewis
Anonymous, 'British Artists: Their Style and Character, No. XXXII – John Frederick Lewis', *Art Journal*, New Series, vol. IV, 1858, pp. 41–3

Anonymous, 'John Frederick Lewis, R.A.', *Art Journal*, New Series, vol. XV, 1876, p. 329

Randall Davies and Basil S. Long, 'John Frederick Lewis, R.A. (1805–76)', *Old Water-Colour Society's Club*, vol. III, 1925–6, pp. 31–50

John Frederick Lewis, *Lewis's Illustrations of Constantinople, made . . . in the years 1835–6. Arranged and drawn on stone from the original sketches of Coke Smyth, by John F. Lewis*, London, 1837

*Major-General Michael Lewis, C.B.E., *John Frederick Lewis, R.A.*, Leigh-on-Sea, 1978

Newcastle-upon-Tyne, Laing Art Gallery, *John Frederick Lewis*, 1971

Hugh Stokes, 'John Frederick Lewis, R.A. (1805–1876)', *Walker's Quarterly*, no. 28, 1929

Marilhat
Anonymous, 'Marilhat, paysagiste. Fragments de ses lettres inédites', *Le Magasin Pittoresque*, 1856, pp. 347–50, 370–1, 403–4

Clermont-Ferrand, Musée Bargoin, *Prosper Marilhat*, 1973

Théophile Gautier, 'Prosper Marilhat', *Revue des Deux Mondes*, 5e série, vol. 23, 1848, pp. 56–75

Hippolyte Gomot, *Marilhat et son oeuvre*, Clermont-Ferrand, 1884

*Danielle Menu, 'Prosper Marilhat: essai de catalogue', thesis, Université de Dijon, 1972

Matisse
*Alfred H. Barr, Jr., *Matisse, His Art and His Public*, New York, 1951, new ed., 1966

Jean Clair, 'La Tentation de l'Orient', *La Nouvelle Revue Française*, July 1970, pp. 65–71

Jack D. Flam, 'Matisse in Morocco', *Connoisseur*, vol. CCXI, 1982, pp. 74–86

Mario Luzi, *L'Opera di Matisse dalla rivolta 'fauve' all'intimismo, 1904–1928*, Milan, 1971

Henri Matisse, *Ecrits et propos sur l'art*, ed. Dominique Fourcade, Paris, 1972

Paris, Grand Palais, *Henri Matisse, Exposition du centenaire*, 1970

Melville
*Agnes E. Mackay, *Arthur Melville, Scottish Impressionist, 1855–1904*, Leigh-on-Sea, 1951

L. C. Müller
Adalbert Franz Seligmann, *Carl Leopold Müller. Ein Künstlerleben in Briefen, Bildern und Dokumenten*, Vienna, 1922

W. J. Müller
Bristol City Art Gallery, *William James Müller, 1812–1845*, 1962

Cyril G. E. Bunt, *The Life and Work of William James Müller of Bristol*, Leigh-on-Sea, 1948

*Briony Llewellyn, 'William James Müller and the Middle East', M.A. report, Courtauld Institute, University of London, 1981

William James Müller, 'An Artist's Tour in Egypt', *Art-Union*, vol. I, 1839, pp. 131–2

William James Müller, 'Letters from Xanthus', *Art-Union*, vol. VI, 1844, pp. 41–2, 209–11, 356–8

N. Neal Solly, *Memoir of the Life of William James Müller*, London, 1875

Renoir
*François Daulte, *Auguste Renoir: Catalogue raisonné de l'oeuvre peint*, vol. I, *Les Figures (1860–1890)*, Lausanne, 1971

Renoir en Italie et en Algérie, preface by Albert André, introduction by Georges Besson, Paris, 1955

Jean Renoir, *Renoir*, Paris, 1962

Ambroise Vollard, *Tableaux, Pastels et Dessins de Pierre-Auguste Renoir*, Paris, vol. I, 1918, vol. II, n.d.

Ambroise Vollard, *Renoir*, Paris, 1918

Roberts
Anonymous, 'British Artists: Their Style and Character, No. XXXVI – David Roberts', *Art Journal*, New Series, vol. IV, 1858, pp. 201–2

James Ballantine, *The Life of David Roberts, R.A., Compiled from his Journals and Other Sources*, Edinburgh, 1866

Helen Guiterman, *David Roberts, R.A., 1796–1864*, London, 1978

David Roberts, *The Holy Land, Syria, Idumea, Arabia, Egypt and Nubia*, with texts by the Rev. George Croly, L.L.D., and William Brockedon, F.R.S., 6 vols., 1842–9

*Scottish Arts Council, *David Roberts, Artist Adventurer, 1796–1864*, 1981–2

Schreyer
Oshkosh, Paine Art Center and Arboretum, *Adolf Schreyer*, 1972

Seddon
John Pollard Seddon, *Memoir and Letters of the Late Thomas Seddon, Artist, By His Brother*, London, 1858

Tissot
*New York, Jewish Museum, *J. James Tissot. Biblical Paintings*, 1982, with an essay by Gert Schiff, 'Tissot's Illustrations for the Hebrew Bible'

*Michael Wentworth, *James Tissot*, Oxford, 1984

Vernet
Anonymous, 'Living Artists of Europe No. IV. Horace Vernet', *Art-Union*, vol. VI, 1844, pp. 119–20

Charles Blanc, *Une Famille d'artistes. Les Trois Vernet. Joseph – Carle – Horace*, Paris, 1898

Armand Dayot, *Les Vernet*, Paris, 1898

Henri Delaborde, 'Horace Vernet, ses oeuvres et sa manière', *Revue des Deux Mondes*, vol. 44, 1863, pp. 76–98

Amédée Durande, *Joseph, Carle et Horace Vernet. Correspondance et biographies*, Paris, 1864

Frédéric Goupil-Fesquet, *Voyage en Orient fait avec Horace Vernet en 1839 et 1840*, Paris, 1843

Léon Lagrange, 'Artistes contemporains. Horace Vernet', *Gazette des Beaux-Arts*, Ière période, vol. XV, 1863, pp. 297–327, 439–65

Paul Mantz, 'Galerie du XIXe siècle. Horace Vernet', *L'Artiste*, 6e série, vol. II, 1857, pp. 177–82

Olivier Merson, 'Artistes contemporains. Horace Vernet', *Revue contemporaine*, vol. XXXI, 1863, pp. 553–89

*Rome, Académie de France, and Paris, Ecole nationale supérieure des Beaux-Arts, *Horace Vernet*, 1980

Wilkie
Kenneth Paul Bendiner, 'Wilkie in Turkey: "The Tartar Messenger Narrating the News of the Victory of St Jean d'Acre"', *Art Bulletin*, vol. LXIII, 1981, pp. 259–68

Allan Cunningham, *The Life of Sir David Wilkie with His Journals, Tours and Critical Remarks on Works of Art and a Selection from His Correspondence*, 3 vols., London, 1843

David Wilkie, *Sir David Wilkie's Sketches in Turkey, Syria and Egypt, 1840–1*, drawn on stone by Joseph Nash, London, 1843

ORIENTALISM IN LITERATURE

J. M. Carré, *Voyageurs et écrivains français en Egypte*, Cairo, 1932

P. Jourda, *L'Exotisme dans la littérature française depuis Chateaubriand*, 2 vols., Paris, 1956

Marie de Meester, *Oriental Influences in the English Literature of the Nineteenth Century*, Heidelberg, 1915

Pierre Martino, *L'Orient dans la littérature française au XVIIe et au XVIIIe siècles*, Paris, 1908

Hassan El-Nouty, Le Proche-Orient dans la littérature française de la fin du Romantisme à la mort de Pierre Loti, thesis, Université de Paris, 1953

Hassan El-Nouty, *Le Proche-Orient dans la littérature française de Nerval à Barrès*, Paris, 1958

*Edward Said, *Orientalism*, New York, 1978

Byron Porter Smith, *Islam in English Literature*, Beirut, 1939

Francis Steegmuller (transl. and ed.), *Flaubert in Egypt: A Sensibility on Tour*, Boston, 1972

*Jean-Jacques Waardenburg, *L'Islam dans le miroir de l'Occident*, Paris, 1963

EUROPEAN RELATIONS WITH NORTH AFRICA AND THE NEAR EAST

*Thomas J. Assad, *Three Victorian Travellers: Burton, Blunt, Doughty*, London, 1964

Lesley Blanch, *The Wilder Shores of Love*, London, 1965

Frederick Jones Bliss, *The Development of Palestine Exploration*, London, 1906

Fred Gladstone Bratton, *A History of Egyptian Archaeology*, New York, 1968

Deborah Bull and Donald Lorimer, *Up the Nile*, New York, 1979

*Peter Clayton, *The Rediscovery of Ancient Egypt*, London, 1982

*Norman Daniel, *Islam, Europe and Empire*, Edinburgh, 1966

Raoul Girardet, *L'Idée coloniale en France de 1871 à 1962*, Paris, 1972

Philip K. Hitti, *Islam and the West. A Historical Cultural Survey*, Princeton, 1962

D. S. Landes, *Bankers and Pashas*, London, 1958

Peter Mansfield, *The British in Egypt*, London, 1971

John Marlowe, *Anglo-Egyptian Relations, 1800–1953*, London, 1954

Sari J. Nasir, *The Arabs and the English*, London, 1976

G. N. Sanderson, *England, Europe and the Upper Nile*, Edinburgh, 1965

*Sarah Searight, *The British in the Middle East*, London, 1969, revised ed. 1979

*A. L. Tibawi, *British Interests in Palestine, 1800–1901*, Oxford, 1961

Kathryn Tidrick, *Heart-beguiling Araby*, Cambridge, 1981

*Fani-Maria Tsigakou, *The Rediscovery of Greece*, London, 1981

Louis Vaczek and Gail Buckland, *Travellers in Ancient Lands. A Portrait of the Middle East, 1839–1919*, New York, 1981

S. H. Weber, *Voyages and Travels in the Near East in the Nineteenth Century*, Princeton, 1952

HISTORY OF NORTH AFRICA AND THE NEAR EAST

C. E. Bosworth, *The Islamic Dynasties*, Edinburgh, 1980

Shafik Ghorbal, *The Beginnings of the Egyptian Question and the Rise of Mehemet Ali*, London, 1928

J. Christopher Herold, *Bonaparte in Egypt*, London, 1963

Marshall G. S. Hodgson, *The Venture of Islam. Volume 3: The Gunpowder Empires and Modern Times*, Chicago, 1974

*P. M. Holt, *Egypt and the Fertile Crescent, 1516–1922. A Political History*, London, 1966

P. M. Holt (ed.), *Political and Social Change in Modern Egypt*, Oxford, 1968

Albert Hourani, *The Emergence of the Modern Middle East*, London, 1981

*Charles Issawi, *The Economic History of the Middle East, 1800–1914: A Book of Readings*, Chicago, 1966

Abdallah Laroui, *L'Histoire du Maghreb: un essai de synthèse*, Paris, 1970

*Reuben Levy, *The Social Structure of Islam*, Cambridge, 1969

Bernard Lewis, *The Muslim Discovery of Europe*, London, 1982

*Bernard Lewis, *The Emergence of Modern Turkey*, London, 1961

Afaf Lutfi al-Sayyid Marsot, *Egypt in the Reign of Muhammad Ali*, Cambridge, 1984

*Jamil M. Abun Nasr, *A History of the Maghrib*, Cambridge, 2nd ed., 1975

*Roger Owen, *The Middle East in the World Economy, 1800–1914*, London, 1981

V. J. Parry and M. E. Yapp, *War, Technology and Society in the Middle East*, London, 1975

*Francis Robinson, *Atlas of the Islamic World since 1500*, Oxford, 1982

*P. J. Vatikiotis, *The Modern History of Egypt*, London, 2nd ed., 1983

CONTEMPORARY PUBLICATIONS

A selection of works from the vast nineteenth-century literature on North Africa and the Near East is given in the Chronology. For fuller bibliographies, see Richard Bevis, *Bibliotheca Cisorientalia. An Annotated Checklist of Early English Travel Books on the Near and Middle East*, Boston, 1973, and Reinhold Röhricht, *Biblotheca Geographica Palaestinae. Chronologisches Verzeichniss der auf die Geographie des Heiligen Landes bezüglichen Literatur von 333 bis 1878 und Versuch einer Cartographie*, Berlin, 1890.

The Royal Academy Trust

The Trustees and Appeal Committee of the Royal Academy Trust wish to express their gratitude to the many companies and individuals who have already given their support to the appeal. Among many others they would like to extend their thanks to:

The Friends of The Royal Academy

Patron H.R.H. THE DUKE OF EDINBURGH, KG, KT

*The Friends of the Royal Academy
receive the following privileges*

Friends £18.00 annually
Friends (Concessionary).
£15.00 annually for full-time
Museum Staff and Teachers
£12.00 annually for Pensioners and
Young Friends aged 25 years and under
Gain free and immediate admission to all
Royal Academy Exhibitions with a guest or
husband/wife and children under 16.
Obtain catalogues at a reduced price.
Enjoy the privacy of the Friends' Room
in Burlington House.
Receive Private View invitations to various
exhibitions including the Summer Exhibition.
Have access to the Library and Archives.
Benefit from other special arrangements,
including lectures, concerts and tours.

Country Friends £10.00 annually for Friends
living more than 75 miles from London.
Gain free and immediate admission to
Royal Academy Exhibitions on 6 occasions
a year with a guest or husband/wife
and children under 16.
Receive all the other privileges offered to friends.

Artist Subscribers £30.00 annually
Receive all the privileges offered to Friends.
Receive free submission forms for the
Summer Exhibition.
Obtain art materials at a reduced price.

Sponsors £500 (corporate),
£150 (individual) annually
Receive all the privileges offered to Friends.
Enjoy the privileges of holding private
receptions at the Royal Academy when
appropriate and similarly of arranging
evening viewings of certain exhibitions.
Receive special Private View invitations,
complimentary exhibition tickets and
complimentary catalogue vouchers
for Royal Academy exhibitions.
Receive acknowledgement through the inclusion
of the Sponsor's name on official documents.

Benefactors £5,000 or more
An involvement with the Royal Academy
which will be honoured in every way.

*Further information and Deed of Covenant
forms are available from
The Friends of the Royal Academy,
Royal Academy of Arts, Piccadilly,
London W1V 0DS*

Benefactors

Mrs. M.G.T. Askew
Mrs. Hilda Benham
Lady Brinton
Mr. and Mrs. Nigel Broackes
Keith Bromley, Esq.
The John S. Cohen Foundation
The Colby Trust
Michael E. Flintoff, Esq.
The Lady Gibson
Jack Goldhill, Esq.
Mrs. Mary Graves
D.J. Hoare, Esq.
Sir Antony Hornby
George Howard, Esq.
Irene and Hyman Kreitman
The Landmark Trust
Roland Lay, Esq.
The Trustees of the Leach Fourteenth Trust
Hugh Leggatt, Esq.
Mr. and Mrs. M.S. Lipworth
Sir Jack Lyons CBE
The Manor Charitable Trustees
Lieutenant-Colonel L.S. Michael, OBE
Jan Mitchell, Esq.
The Lord Moyne
Mrs. Sylvia Mulcahy
G.R. Nicholas, Esq.
Lieutenant-Colonel Vincent Paravicini
Mrs. Vincent Paravicini
Richard Park, Esq.
Phillips Fine Art Auctioneers
Mrs. Denise Rapp
Mrs. Adrianne Reed
Mrs. Basil Samuel
Eric Sharp, Esq., CBE
The Revd. Prebendary E.F. Shotter
Dr. Francis Singer
Lady Daphne Straight
Mrs. Pamela Synge
Harry Teacher, Esq.
Henry Vyner Charitable Trust
Charles Wollaston, Esq.

Corporate Sponsors

American Express Europe Ltd.
Bankers Trust Company
Barclays Bank International Limited
Bourne Leisure Group Limited
The British Petroleum Company Limited
Christie Manson and Woods Limited
Citibank
Consolidated Safeguards Limited
Courage Charitable Trust
Coutts & Co.
Delta Group p.l.c.
Esso Petroleum Company Limited
Ford Motor Company Limited
The General Electric Co. PLC
The Granada Group
Arthur Guinness and Sons PLC
Guinness Peat Group
Alexander Howden Underwriting Limited
IBM United Kingdom Limited
Imperial Chemical Industries PLC
Investment Company of North Atlantic
Johnson Wax Limited
Lex Service Group PLC
Marks and Spencer p.l.c.
Mars Limited
Martini & Rossi Limited
Worshipful Company of Mercers
The Nestlé Charitable Trust
Ocean Transport and Trading Limited (P.H. Holt Trust)
Ove Arup Partnership
The Rio Tinto-Zinc Corporation PLC
Rowe and Pitman
The Royal Bank of Scotland plc
Save & Prosper Educational Trust
J. Henry Schroder Wagg and Company Limited
The Seascope Group
Shell UK Limited
W.H. Smith & Son Limited
Robin Symes Limited
Thames Television Limited
J. Walter Thompson Company Limited
Ultramar PLC
United Biscuits (U.K.) Limited

Individual Sponsors

Abdullah Ben Saad Al-Saud
Ian Fife Campbell Anstruther, Esq.
Mrs. Ann Appelbe
Dwight W. Arundale, Esq.
W.M. Ballantyne, Esq
Miss Margaret Louise Band
Godfrey Bonsack, Esq.
Peter Bowring, Esq.
Mrs. Susan Bradman
Cornelius Broere, Esq.
Jeremy Brown, Esq.
W.J. Chapman, Esq.
Major A.J. Chrystal
Henry M. Cohen, Esq.
Mrs. N.S. Conrad
Mrs. Elizabeth Corob
Raymond de Prudhoe, Esq.
Raphael Djanogly, Esq. JP
Mrs. Laura Dwyer
Mrs. Gilbert Edgar
Aidan Ellis, Esq.
Miss Rosemary Farmer
Robert S. Ferguson, Esq.
Graham Gauld, Esq.
Victor Gauntlett, Esq.
Lady Gibberd
Peter George Goulandris, Esq.
J.A. Hadjipateras, Esq.
Mrs. S. Halliday
A. Herbage, Esq.
Mrs Penelope Heseltine
Roger Hughes, Esq.
Norman J. Hyams, Esq.
Mrs. Manya Igel
J.P. Jacobs, Esq.
Mrs. Christopher James
Alan Jeavons, Esq.
Irwin Joffe, Esq.
S.D.M. Kahan, Esq.
S. Karmel, Esq.
Peter W. Kininmonth, Esq.
D.J. Lewis, Esq.
Bruce Lloyd, Esq.
Owen Luder, Esq.
Mrs. Graham Lyons
Ciarán MacGonigal, Esq.
Mrs. P.C. Maresi
Dr. Abraham Marcus
Mrs V. Mercer
Princess Helena Moutafian, MBE
Raymond A. Parkin, Esq.
Mrs. Olive Pettit
Mrs. M.C.S. Philip
Cyril Ray, Esq.
Mrs. Margaret Reeves
The Rt. Hon. Lord Rootes
Miss Lucy Roland-Smith
The Hon. Sir Steven Runcimar
The Master, the Worshipful
 Company of Saddlers
Sir Robert Sainsbury
R.J. Simia, Esq.
Steven H. Smith, Esq.
Thomas Stainton, Esq.
Cyril Stein, Esq.
James Q. Stringer, Esq.
The Hon. Mrs. Quentin Wallop
Sidney S. Wayne, Esq.
Frank S. Wenstrom, Esq.
David Whitehead, Esq.
Brian Gordon Wolfson, Esq.
Lawrence Wood, Esq.

There are also anonymous Benefactors and Sponsors